Wild, Unforgettable Philosophy

Wild, Unforgettable Philosophy

in Early Works of Walter Benjamin

Monad Rrenban

LEXINGTON BOOKS
Lanham • Boulder • New York • Toronto • Oxford

Institutions facilitating the research for and the writing of this book include the *Deutscher Akademischer Austauschdienst* (DAAD), the *Heinrich Hertz Stiftung*, the *Stiftung zur Förderung der Philosophie*, L'Ecole Normale Supérieure (Paris), and the Calgary Institute for the Humanities. A stipend from the University Research Grants Committee at the University of Calgary supported the production of the book.

LEXINGTON BOOKS

A division of Rowman & Littlefield Publishers, Inc.
A wholly owned subsidiary of The Rowman & Littlefield Publishing Group, Inc.
4501 Forbes Boulevard, Suite 200
Lanham, MD 20706

PO Box 317, Oxford OX2 9RU, UK

Copyright © 2005 by Lexington Books

All rights reserved. No part of this publication may be reproduced, stored in a retrieval system, or transmitted in any form or by any means, electronic, mechanical, photocopying, recording, or otherwise, without the prior permission of the publisher.

British Library Cataloguing in Publication Information Available

Library of Congress Cataloging-in-Publication Data

Rrenban, Monad.
 Wild, unforgettable philosophy : in early works of Walter Benjamin / Monad Rrenban.
 p. cm.
 Includes bibliographical references and index.
 ISBN 0-7391-0845-X (cloth: alk. paper) — ISBN 0-7391-1363-1 (pbk: alk. paper)
 1. Benjamin, Walter, 1892–1940. I. Title.
B3209 .B584R74 2004
193—dc22 2004019313

Printed in the United States of America

∞™ The paper used in this publication meets the minimum requirements of American National Standard for Information Sciences—Permanence of Paper for Printed Library Materials, ANSI/NISO Z39.48–1992.

Contents

List of Abbreviations	vii
Notes on Citation	ix
An Introduction	1
Philosophical Community	21
Philosophy/*Language*	21
Paradisal Play	27
"Feminine"	31
Round-Dance of Stray Feeling	39
For Secret Not Doom: Human's Proper Name	43
In God's Name	48
On Performing Philosophy	59
Form of Infinite Giving Up	59
Harmony of Some Old Words	74
History and the Drama of Philosophy	81
Doctrinal Form and Its Esoteric Need	89
Presentation and Its Doctrinal Tone	98
Prosaic Beauty	104
Image of Dramatic Beauty	121
Ru(i)ned	121
Tremor-Identity: Genius of Time, Gift of Crisis	138
Sobriety of Wild Reason	149
Immanence	161
Justice	177

Community of the Dead	199
from another planet	199
Honest Rhythm	204
Philosophical Race of Ridiculed Exception	213
Natural Ethics: Loyalty to Things	218
In Name of Inorganic Community: Ethical Body	233
Bequest: Unforgettable, Wild Solitude	259
Death of Art and Philosophy	271
Ir(r)enstraße	283
Notes	293
Bibliography	383
Index	413

List of Abbreviations

AP	Benjamin, *Arcades Project*
B	——. *Briefe*
C	——. *The Correspondence of Walter Benjamin*
GB	——. *Gesammelte Briefe*
GS	——. *Gesammelte Schriften* (usually cited solely with the volume number[s])
MD	——. *Moscow Diary*
O	——. *The Origin of German Tragic Drama*
R	——. *Reflections*
UB	——. *Understanding Brecht*
W	——. *Selected Writings*
WB	Scholem, *Walter Benjamin: The Story of a Friendship/ Walter Benjamin: Die Geschichte einer Freundschaft*
D	Joyce, *Dubliners*
P	——. *A Portrait of the Artist as a Young Man*
PE	——. *Poems and "Exiles"*
U	——. *Ulysses*
HK	Adorno, *Aesthetic Theory* (Hullot-Kentnor translation)
L	——. *Aesthetic Theory* (Lenhardt translation)

Notes on Citation

SIGN

< > indicates an insertion by the editor(s) of Benjamin's *GS*.

TRANSLATION

If the translation has been modified in any way, the pagination for the German text is italicized (e.g., *O*, 27/I:1, *207*).

An Introduction

I regret that I cannot comply with your request to the extent you desire.

—Kafka, "A Report to an Academy"

The day already lies on its death-bed . . .

—Georg Heym, "The Day"

The title of this study, *Wild, Unforgettable Philosophy*, may seem to require at least preliminary justification at the outset. It might be thought that Benjamin's writings, and perhaps especially his "early writings," do not seem particularly "wild," and that it is very unclear why "philosophy" would be considered either "wild" or "unforgettable." The appellation "wild" will, above all, be associated in the following study with philosophy as "form" or "universality." It will be suggested that Benjamin conceives the practice of philosophy, and indeed the kindred practice of art, as presentation of this form or universality that is unforgettable. This wild form or universality, this untameable and ultimately inexpressible form or universality, can be denied; one may claim or pretend to have forgotten it. One does so, however, only in (what will be discussed in this study as) a kind of dishonesty. The form or universality, philosophy, will be said to impel somehow the honesty of acknowledging it. Practices of philosophy, and of art, are especially effective admissions of this form or universality. The form "philosophy" will be elaborated in the following study as a concern underlying much, if not all, of Benjamin's "early" writings, even if the elaboration of this form may seem to require extrapolation from, as well as attempted recounting of, Benjamin's writings by this study.

There has been almost no discussion of Benjamin's writings in terms of this wild, unforgettable form, and indeed the mere association of Benjamin's

works with philosophy—notwithstanding a reception that does indeed discuss and foster such association—has been unwelcome for some of those who seem most interested in Benjamin's works. Often such Benjamin-readers confine their dismissal or disparagement of philosophy to remarks made casually in classes and conferences, although they also occasionally publish such remarks. A major reservation on their part seems at times to be that the association of Benjamin's works with philosophy has diminished or will diminish the prospects for "political" relevance. Although the notion of philosophy to be developed in the following study will be incompatible with certain ways of proclaiming political relevance, it will be suggested it is precisely in their inattentiveness to the form, philosophy, that such proclamations often stagnate in self-aggrandizing or in fretful proclamation of an already established meaning or relevance. In what might be called the more lamentable cases, such stagnation could well appear not unlike that of the intriguer who "is all intellect and will [ganz Verstand und Wille]," a prince transposing himself as "Cartesian God" into the political world and thereby bringing institutions toward their gloomier, very limited and limiting, potentials (*O*, 95–98/I:1, 274–77). Even considered apart from those embracing intrigue more relentlessly and willfully than most, certain kinds of irritation *with* philosophy will be countered in this study in favor of an irritation *of* philosophy. This study will not involve very extensive discussion of Benjamin's early political theory, but attempts will be made to show a political relevance of even the ostensibly most philosophical or aesthetic of his texts. In its style and its objects, Benjamin's early work will be considered for its registration of philosophy as a form, a force that can be presented in its permeation, and interruption, of discussions not only *of* philosophy and of aesthetic concerns but also of much that might be called "political" and "everyday."

The following study will concentrate on Benjamin's texts, and will not be as concerned as some studies with the possible associations that may be made between Benjamin's works and those of his predecessors or his contemporaries in what is called the Western philosophical tradition. This is not to deny the relevance of such associations, and attempts will be made to delineate along the way some of the importance in Benjamin's work of debates that he undertook with Plato, Socrates, Kant, the early German Romantics, Nietzsche, and others. Yet Benjamin's own training and development are extraordinarily eclectic, often involving interests that strain the bounds of much done in philosophy departments. Similar remarks could be made, of course, about others, such as Marx, Kierkegaard, and Nietzsche. This has not, however, always detered academicians. Particularly in the Anglo-American world, there has even emerged a quasi-domestication of Nietzsche (and, to some extent, Hegel) via the resources of what is generically called "analytic" philosophy.

If Benjamin's way of working is scarcely recognized by much academic philosophy, it is not a task assumed in this study to make his way of working palatable in the manner that some have been bringing Nietzsche into accord with prominent elements of Anglo-American academic philosophy. Even in the less-constrictive continental European context, in any case, there is frequently outright rejection of Benjamin's priority that the practice of philosophy be *Darstellung* of *Darstellung*, presentation of presentation, performance of performance. The following study will be devoted to aspects and implications of this priority; it will be concentrated on Benjamin's conception of the form, philosophy, as requiring of the practice of philosophy that it present itself as presentation, as performance, and thereby show itself open to the interminable drama of the mystery, which is the form, philosophy. As indicated by Benjamin's tendency to favor Plato over Socrates, this inextinguishable mystery, this inextinguishable form, leads Benjamin to draw extraordinarily selectively from streams, and often to turn them against their most influential currents. Those currents tend to suppress or dismiss mystery, not least as the practice of "philosophy" tries to purge itself of art. For Benjamin, however, art is an alluring object of analysis for, and is also integral to, the practice of philosophy.

To many, Benjamin's work may thus seem very un-"philosophical." As intimated above, this study will not be an attempt to "legitimize" Benjamin by alleging his obligations to, or similarities with, various writings by figures in the tradition of what is generally called "philosophy." Only for the sake of differentiation or greater nuance, there will be some comparisons (often in the notes) of Benjamin's philosophical views with those of some of his contemporaries, some of his successors, or some of our contemporaries. It will be contended, however, that much of Benjamin's work may be conceived as an attempt to contribute to saving philosophical language, a language-usage that he also even considers quite integral to such saving and indeed to the saving of a great deal else. The saving is for, and of, something that is scarcely conceivable even if it is always already, and indeed necessarily, "there" and "here" and "everywhere." It will be suggested in the following study that, for Benjamin's work, this necessary, scarcely conceivable, mystery could not be more important; this *form* "philosophy" is the *form* of everything, and neglect or disregard of this form could even be considered humanity's gravest untruth. Benjamin is attentive and responsive to certain intellectual influences, some of which will be discussed; yet in most contemporary traditions of what is called "philosophy" as well as in much of the reception of Benjamin's work, there has not been a lot of acknowledgement or consideration of either this *form* or of the kind of discourse of philosophy that Benjamin has ensue from this form. The form, philosophy, is an inextinguishable—a wild, unforgettable—impulse, and

yet the tradition of philosophy is largely a trap—a closure against this impulse. Notwithstanding the tenuous relationship of his works with much that is called philosophy, it will be contended his divergence from "tradition" is neither arrogant nor declarative and concerns rather the possibility for practices that effectively present themselves open to necessity—the necessity of the form, philosophy.

As noted at the outset and as will be elaborated occasionally in the following study, even very interested readers of Benjamin's work cannot agree whether or not that work is to be conceived as philosophy. Whereas Scholem insists Benjamin's "metaphysical genius dominates his writings," that it is always unmistakably, unambiguously, "the philosopher" speaking,[1] it has been declared more recently, but hardly for the first (or last) time, that "Benjamin was utterly non- and antiphilosophical."[2] As noted above and as will be evident from texts cited or discussed in this study, a philosophical reception of Benjamin, even in a quite Benjaminian sense of "philosophical," has persisted from early reviews or responses, such as those by Kracauer and especially by Adorno, to very recent essays and books. Yet other elements of the reception persistently dismiss, or are simply uninterested in, Benjamin's claims concerning the philosophical character of his work. One problem may be the views of some literary critics or cultural historians whose caricatures of philosophy are indeed uncorroborated by Benjamin's writings. Another problem is perhaps that much going by the name "philosophy" provokes if not invites such caricatures. Although those in philosophy-departments generally do not take well to Benjamin's writings, insofar as they are even aware of the writings (which one cannot assume, at least in the English-speaking world), some of Benjamin's writings are expressly on behalf of "metaphysics" and even more are expressly advanced as works of philosophy. His "genius," if one wants to use Scholem's term, nonetheless does indeed pose an unusual challenge, not only for many kinds of literary and cultural study but also for much going by the name of "philosophy." The following study will be an endeavor to elaborate that challenge without domesticating it by forcefully integrating it into the "history of philosophy," although—as noted already—efforts will be made to elaborate specific engagements of that tradition or to offer brief comparisons with writings associated with that tradition.

During conversations at Seeshaupt in 1916, Benjamin is supposed to have said that "he saw his future" to be that of a *Dozent* "in philosophy." Scholem recorded his own concern that no person "will understand" if Benjamin someday "lectures on the history of philosophy in an essential [wesenhafter] way," although "his course of lectures could be tremendous [ungeheuer] if there were true *questioning* and not labelling."[3] Benjamin was unable to get a job

in a philosophy department or any other university department. Although many factors presumably contributed to this, Scholem's concern about incomprehensibility might be considered prescient.

Apparently in the interest of making Benjamin comprehensible, in recent decades labeling has played an implicit and explicit role in some discussions of Benjamin's work, particularly in so much usage of the terms "modern" and "postmodern." One of the paradoxes in various writings allegedly defending rational conceptuality has been their aggressive application of these terms "modern" and "postmodern." Many of those addressed as postmodern theorists do not, in any case, adopt the characterization; Derrida, Nancy, Foucault, Lacan, Deleuze, and many others do not. Lacoue-Labarthe is fairly ironic and dismissive of common usages of "modern" and "postmodern." Guattari lambastes Lyotard's book (on postmodernism) as well as other theorists and outlooks deemed by Guattari to be the "post-modern" (with which many would, nonetheless, identify Guattari).[4] More importantly, much of what has been called "modern" by some shrill protagonists is a variation of Kant's transcendental "Ich" which Benjamin, who fosters the modern as inherently open, regards as a recent mythology. A lot of what gets called postmodern theory would be the breakthrough of the modern as conceived by Benjamin. It seems very unmodern, moreover, that usage of the terms "modern" and "postmodern" involved so much dogmatic labeling and that discussions about Benjamin's work were prone to dogmatism of this sort.[5] As will be elaborated throughout this study, many of Benjamin's writings expressly or implicitly have "the word" as a priority incompatible with complacent or rigid conceptualization. This priority has been either unwelcome or suppressed when and where thinking occurs in accordance with the priority of label.

The following study, particularly in the notes, will discuss a range of writings from the reception, including some careful studies concerning the "philosophical" in Benjamin's writings. This study will differ from the latter studies in various ways, as will be noted on occasion. Concerning the relative care taken in the following study to address secondary sources (again, almost entirely in endnotes), the most obvious, and perhaps sole noteworthy, justification—apart from drawing the reader's attention to studies that corroborate or elaborate points made—is that the study unfolds Benjamin's writings in ways often at odds with commentaries that are prominent or at least readily available. Attempts will be made to characterize and often elaborate on such divergences, also with respect to studies that are decades old but of continued influence in the public interpretation of Benjamin's work.

The main purpose of this study will be, however, to explore the character, and some implications, of "the philosophical" in what will be discussed as

"early" works of Benjamin. This study will adapt a distinction of "early" and "late" works that Benjamin himself made with regard to his writings. This distinction will be clarified toward the close of this introduction, and it will be stressed that such distinctions cannot justifiably be strict. In any case, the study can be said to be devoted primarily to exploring and advancing an aspect of the "early" writings that may perhaps be stated succinctly as follows: Outlining a potential of everything to be philosophized, which is a potential inherent in the *form* philosophy, many of Benjamin's writings concern this form as the *word* in perception and meaning, the word that is the death of recognition. The *word* in perception and in meaning, their potential to be philosophized, is the continual crisis of perception and meaning.[6]

One would expect stylistic demonstration of this outlook. Considering "the relationship of the work"—in this case *Origin of the German Mourning Play*—"and its first inspiration [Eingebung]," Benjamin says to his confidant, the philosopher-critic Florens Christian Rang (1864–1924): "each complete [vollkommene] work is the death-mask of its intuition [Intuition]" (*C*, 227/*GB*, Vol. 2, *406*).[7] Such a work may involve an intuition of its ultimate condition of possibility, but then the work presents itself as presentation; it presents itself as a death-mask of this intuition. Its ultimate condition of possibility is the ultimate condition of death, and death especially recalls this ultimate condition. Insofar as a work is philosophical, it presents itself as a mask of this condition; it keeps its manifestation openly a conjuration of the force ultimately bringing this conjuration to ruin. The kind of *memento mori* required by the philosophical resists manipulation, intrigue, and conceptual domination, and it does so by recalling every entity as a mask of death. In presenting itself as a death-mask, Benjamin's work is to attain a resonance of the mystery, the wild and unforgettable universal form, that it cannot entirely express.

The reference to resonance is appropriate in various respects. For Benjamin, death recalls the mystery that "sounds," the mystery that cannot entirely be seen in contents or made comprehensible in meanings. In this respect, death is an inextinguishable sound. Its sound may well be very faint. There is, after all, a prevalence of life-instinct. Flowers follow the sunlight as long as the latter is not excessive and other elements necessary for life, such as water, are sufficiently available. The pet dog does approximately what is expected of it and will normally thereby assure itself a more or less adequate room and board. The author tries to put words together in a manner that will not entirely preclude the possibility of surviving, for a period of time, as an author. A dilemma for the practice of philosophy is that specific solutions for the life-instinct are enacted as though they are the truth. It is, of course, hard

to imagine a life-instinct that does not entail some variation of the scenario in which the bird eats the worm and the human eats the bird. Philosophy questions, however, the naturalization of such processes. Eating is, for example, one of the most mythic—one of the least philosophical—activities, as not only many vegetarians have long noted. That we must eat (must live) is already mythic. The way we eat (including what we eat and the way we acquire it) is laden with mythic imperatives. Not being able to eat is one of the most extreme of these; as Marx says, maintaining or generating the appearances of one societal level or form comes to preclude effective regard for the life of another. Not the things and people are myth so much as their identification of truth with specific relations. Benjamin would say in one of his last writings: in a secret heliotropism, the past places every victory in question much as flowers break through in their struggle toward the sun (W 4, 390/I:2, 694–95). The more prevalent heliotropism is, however, one of living in disregard of death, in disregard of the past—the becoming-past—of the "present" and the "future." Against such disregard, Reb Evné says: "The future is the past coming."[8] In a similar vein, Benjamin suggests philosophy could be considered death in the "present" and in the "future." As a practice, philosophy could be considered a mask of death, a mask opening appearances to the force that cannot be made manifest in them.

Performances of the *work* overwhelming this study, performances of the *form* overcoming this work, could very conceivably be in the first person or in another pronominal form. Important is the kind of performance given to pronominal forms. The success of their performance will depend on performance of their inherent failure. Every run, every track, every *Rennbahn*, passes into death, and—at least in accordance with the association of ethics and destiny to be elaborated in the following study—*should* be performed as arising from death. Death could be called something else, of course; it could have another name. Death could be named Monad Rrenban, for any run emerges from, and will pass into, an origin or a necessity that it will never incorporate.

The feeling, which converges with the necessity, of being involuntarily drawn to ruination is hardly stoicism. At least according to Benjamin as well as others, such as Hegel, stoicism is shaken, destroyed, by what might, very simply, be called the death in life. Although living with a skeptical distance from his body and amusing himself by composing in his mind short sentences "about himself containing a subject in the third person and a predicate in the past tense," a stoic in a story by James Joyce is at least momentarily shaken by the realization that he is "A Painful Case" (*D*, 106, 105–15). As will be indicated in the following study, Benjamin too notes that stoics undergo a ruination of their sought self-containment.

Such ruination might seem implicit in the sparsity or relative terseness of acknowledgments in many continental European academic books, at least insofar as it could be considered a slight resistance of writing to identification with any form of "intersubjective" or institutional "life." Opposing the "reterritorialization" of philosophy in any institutional form, Deleuze and Guattari contend that a powerful impetus for philosophy is the feeling of shame in relation not only to "the extreme situations described by Primo Levi" but to much else as well, including "the meanness and vulgarity of existence" in democratic institutions, the prevalence of "thought-for-the-market," and the humiliation people may feel in relation to their life-possibilities.[9] With this "life," we tend more or less to make our peace.[10] "C'est la vie. That's scholarship. / That's business."[11] Yet it is conceivable that some follow death enough to risk disrepute by straining the tolerance of the "life" that they somehow lead. This might be a sense that could be added to the more obvious one of the following remark: "Welch ein Trost, daß man nicht leben muß" (What a consolation that one does not have to live).[12] It may be possible for writing to follow death enough, moreover, to convey stylistically its basis in a force that it cannot make explicit. Schooled by death, writing may be able to compel us to "hear a little of what we are unable to say."[13]

Such writing might seem incompatible with the complacency more strictly advancing a career ("I don't give a shite anyway so long as I get a job" *U*, 538) and will quite possibly not make your parents proud ("Do as she [your mother] wishes you to do. What is it for you? You disbelieve in it. It is a form: nothing else. And you will set her mind at rest." *P*, 241). In writing with death, stylistic and referential aspects must be openly very intermingled. An open conjuring will let mystery into its images; it will entail conceptualization open to what it cannot delimit. The works by Benjamin to be considered in the following study give particular prominence to this exercise as a philosophical exercise, and—in their way of doing this exercise—present themselves as works of philosophy. There will be no claim in this study to emulate or "appropriate" Benjamin, but effort has been made to present Benjamin's works in a manner that does not seem stylistically oblivious of those works. If it explores stylistic possibilities that might be somewhat opened by Benjamin's conception and practice of philosophy, this study of those works could perhaps also be construed as an attempt to write in performance of death.

Insofar as it is advanced under rubrics such as "Germanic studies" or even "Continental philosophy," Benjamin scholarship might often close itself off from strangers, and not only from the strangers who would reject or domesticate the so-called continental tradition with the resources of "Anglo-American" philosophy. The employment of Joyce quotations above and below should

appear in such a way that the exception is not to assert itself on behalf of its own properties (whatever they may be construed as) but rather to facilitate some kind of suspension of the criteria in relation to which it is an exception. To keep the Irish—or exile Irish—entry somewhat strange, the Joyce quotations have been, and will be, relatively unintegrated. This is not an attempt to keep Joyce out but rather an attempt to let him be a strain on the flow of what might otherwise be considered essayistic integration. The quotations will almost never be expressly elaborated under themes such as early twentieth-century modernism or modernist aesthetics that do indeed fairly obviously suggest themselves (in 1928, Benjamin claimed to be planning a book on "the three great metaphysicians" of current literature: Kafka, Joyce, Proust [W 2, 78/VI, 219]). The quotations will be sporadic, sometimes frequent and sometimes rare. They will appear as oblique commentary, elaboration, or response to Benjamin or to others. Their effect might seem somewhat interruptive (perhaps even welcomely so), not—it is hoped—as assertion but rather as a relevant suspension of flow. If Joyce is constantly strange to himself, constantly letting death enter life, his entry into this study should not be lucid in any straightforward sense. That entry is above all to evoke the death for which each mnemonic, each retrieval-ability, is defective and requires a constant periphrasis—a constant roundaboutness, a constant circumlocution.

> What anthem did bloom chant partially in anticipation of that multiple, ethnically irreducible consummation?
>
> *Kolod balejwaw pnimah*
> *Nefesch, jehudi, homijah*
>
> Why was the chant arrested at the conclusion of this first distich?
> In consequence of defective mnemotechnic.
>
> How did the chanter compensate for this deficiency?
> By a periphrastic version of the general text. (*U*, 609–10)

There are infinitely many ways of entering the general text, the text to which we all variously belong, but certain texts especially lend themselves to its periphrasis. Many of Benjamin's texts entered (and continue to enter) a vast array of contexts, and often did (and do) so by keeping themselves and those contexts problematic, implying a necessity for recurrent suspension of certainty. In the sense of philosophy that will be elaborated in the following study, the only certainty is uncertainty. Such is the general text to which we all belong. It is death already with us.

This study might well seem to have an aimless circularity. It might seem unable to open doors to real understanding. One should, it might be contended,

convey more clearly the *meaning* and *significance* of the project. One should resort to a more argumentative style. Perhaps not without reason, however, many have become wary of, or somehow hesitant concerning, such prescriptions. Critically adapting Kant, Benjamin often suggests understanding is a faculty of spontaneous concept creation risking neglect of what it cannot retrieve, cannot recall. It is a conceptual faculty risking loss of receptiveness. "Whereas the concept comes from the spontaneity" of the "understanding" or "intellect" (Verstandes) (*O*, 30/I:1, *210*), truth is "an intentionless being [ein . . . intentionsloses Sein]" (36/*216*). For this reason perhaps, the "destructive character," as portrayed in one of Benjamin's writings of the 1930s, "has no interest in being understood" (*W* 2, 542/IV:1, 397). The stylistic and organizational concessions to this character in the understanding accomplished by Benjamin's writings are much debated, and will be of some concern in the following study. As noted above, the study will correlatively involve stylistic and organizational efforts to present interaction of understanding with the unavoidable—the wild, unforgettable—destruction of understanding. There are aspects of what is sometimes called Benjamin's aphoristic style that may seem relevant in this regard. These aspects would be pertinent, for instance, to many usages of the copula in the following study. Superficially, such usages could seem identitarian, and yet the identities involved could open rather than close. For Benjamin, the early German Romantics could be exemplary in this respect; one might think of Novalis's remark that "[p]hilosophy is . . . homesickness [Heimweh]," which (notwithstanding the very credible possibility of other readings) at least conceivably associates philosophy with restlessness or lack of closure.[14] Another kind of usage of the copula in the following study is also suggested by Benjamin's practice; this concerns his usage of it to identify myth. This will be elaborated in the study. It may, however, be noted by way of introduction: according to Benjamin, myth itself provides the apodictic representation of itself as truth, and thereby can enable the philosophically inclined to say of myth that it *is*—precisely in its usurping claim to truth. The counter to such claims includes efforts that may somewhat indulge the risk of aimless circularity, the risk of returning to a constitutive concern as an unfulfilled concern. The following study will have four parts, each containing several small sections (a few of which contain subsections), but the reader could, with only some loss of conceptual momentum, begin with a part other than the first, or read individual sections in a random order.

It would be exaggerated, however, to say that the following study has an entirely aimless circularity or that it is devoid of argumentation. The reader preferring to read from beginning to end has not been forgotten, although straining of standard essayistic flow has seemed required by the concerns and

priorities of the study. Much of the remainder of this introduction will outline a sequence of the four main parts of the study and give somewhat more specific indications than those given above of how the study will be situated in relation to *some* relevant aspects of the "Benjamin reception," which is now very large and rapidly growing. As noted above, most discussion of secondary sources takes place in endnotes. It may be of help, however, to have at the outset some very general anticipations of the relationship of this study with some other tendencies in the reading of Benjamin's works, as well as some anticipations of threads of argumentation connecting the four main parts of the study and connecting sections within each of the four main parts.

The first part, "Philosophical Community," will concern the conception of everything as *language*. For this conception, all and everything will be considered to be in *linguistic being* (sprachliches Wesen) that is philosophical, or at least amenable to philosophical recognition, by virtue of its mourning of extant "languages" of perception or meaning. This part of the study will be in disagreement with those contending that one may not elaborate this conception of "linguistic being" with pertinence to more than one or perhaps a few of Benjamin's writings. In suggesting a very broad relevance, in Benjamin's work, of his very early view of linguistic being that has a distinct expressive potential in name, the study will develop the outlook that "name" is in "things" as their amenability to philosophical recognition. In this context, attempts will be made to elaborate community in name as philosophical community.

Doubts may arise (and do seem to arise) concerning Benjamin's conception of name as the language to which all other "languages" (the languages of things) communicate. There may correlatively be doubts concerning his view that name—considered independently of "things" (including the human things, the things of anthropology)—constitutes the entity using it (for Benjamin, the human). An attempt will be made, nonetheless, to extrapolate on Benjamin's attribution of philosophical significance to name as the sound for what it is not. This independence of name from meaning and referent makes name uniquely amenable to consideration of the community that will be elaborated in this study as the form, *philosophy*. It will be suggested that this form is the sole form or community to which all and everything belong.

The theological impulse behind this notion of community will not be downplayed, dismissed, or considered entirely dispensable (although each of these tendencies is to be found in the reception of Benjamin's work). All the main writings by Benjamin to be considered in this study will be elaborated in terms of their advancement of a variation of the view that every image may be conceived as "name" or "writing-image" for which the revelatory element—the revelatory sound—may be experienced as effective in, and yet

as ultimately unavailable for, perception or comprehension. As inextinguishable name in things, revelation effects as irrepressible silence and mystery.

This theological impulse involves the aforementioned convergence of ethics and necessity, a convergence that will be of recurrent concern in the following study. Benjamin's theory of the human's proper name, like many other theories of the proper name, is concentrated on this name as communicating no property of the person named by it. The specific proper name is obviously unnecessary; it could very conceivably be different. Benjamin's theory of the proper name indicates his allying of ethics with the necessity that appears solely as what cannot appear. According to this theory of the proper name, and indeed Benjamin's linguistic theory generally, a feeling for necessity mourns extant (relatively unnecessary) "languages" but requires play if it is to have effect in those "languages," if it is to accentuate their transience and thereby offset domination by them or in them. In this context of Benjamin's allying of ethics and invisible, unconceptual necessity, critical extrapolation will be given to aspects of Benjamin's notion of the "feminine." However irrelevant, ill advised, or fraught with problems a notion of a "feminine" principle may have been and may remain, consideration will also be given to ways in which this notion may enter linguistic theory that attempts to support performance of a withholding from overcertainty. Emphasis will additionally be placed on Benjamin's theory of play as exemplary of his openness to multiplicity; this playful openness will be stressed, for it is sometimes neglected in studies of Benjamin. Precisely in its mourning of appearances and expression, according to Benjamin, nature necessitates constant revision of the forms in which it is expressed. Benjamin accompanies the emphasis on necessary revision with an ethics (a kind of honesty) of such revision. There are many who doubt the political value of such performance. It will be suggested, however, that this theological confluence of ethics and necessity can keep expression open against the duplicity and the authoritarianism closed to "meaningless" suffering. Incompatible with complacency, the inherent bequest of name is philosophical community—the universal community of the wild, unforgettable form, philosophy.

The second part, "On Performing Philosophy," will be an examination of Benjamin's conceptions of the relationship of the aforementioned *linguistic* form—this wild, unforgettable form, *philosophy*—with the discipline and the style or practice of philosophy.

Sometimes drawing on, but also sometimes differentiating itself from, other studies of Benjamin, this examination will include efforts to contribute to the discussion of how Benjamin conceives his approach to philosophy as quite distinct not only from Fichte's but also from that of the early German Romantics (especially Friedrich Schlegel's). With regard to Benjamin's qual-

ified anti-Romanticism, particular attention will be paid to his critique of neologism in the practice of philosophy.

For Benjamin, various old words—above all, the divisions (such as ethics, logic, aesthetics) in the discipline called philosophy—are particularly resonant with the preponderance of *language* over concept and perceptions. Benjamin's discussions of divisions, gaps, interruptions, will be examined as exemplary of his notion of constellation. Notwithstanding a number of readings suggesting otherwise, Benjamin's outlook will emerge as distinct from the contentions of some thinkers, such as Heidegger, that a break with prominent aspects of the metaphysical tradition requires abandonment of much traditional terminology in favor of a founding sort of naming.

Disagreement will also be registered concerning claims that Benjamin equates divine creation and name-giving. No "decontamination," no thoroughly divine revelation, is assumed in Benjamin's practices or theory of naming. It will be contended, moreover, that the lack of relational connection detected by Benjamin in name, and in the "name" within thing, entails no complete severance of philosophy from "science" or "scholarship." This is often disputed in the Benjamin reception. Precisely on behalf of materiality, however, Benjamin opposes what he thinks is Hegel's brutality with regard to appearance. There have been Hegelian and Kantian objections to this theologically impelled notion of materiality, but an attempt will be made in this part of the study to explore the notion of performing philosophy as a kind of release of the ostensibly real world, a world not entirely avoidable in "this life," into ruination. This will run counter to the claims of many that Benjamin creates an opposition of ruination and the divine. The religiosity variously developed by Benjamin seems largely a philosophical experience that frees recognition for ruination—so much so that some critics find Benjamin's religiosity unduly impersonal and lacking in intersubjective relevance. Yet precisely something such as Benjamin's "esotericism," which attempts and calls for performance of the transience of pragmatic constraints, will be defended in the formulations concerning requirements of his ethics of necessity.

Such esoteric performance, amounting to discursive communication of preponderant incommunicability, involves the beauty of philosophy. Although it is a performance that is discursive in a distinct way by virtue of its mediation by certain basic philosophemes, the *art* of philosophy also involves performance of truth as no place or formulation. Hence, there can be a beauty of philosophy, whereby a discursive practice acquires or achieves an allure by presenting truth as no place or formulation. In disagreement with a number of Benjamin's critics (as well as some "philosophers" generally), this notion of beauty in philosophy will be discussed as less a dismissal of "intersubjectivity" or "scholarship" than concerned with a stylistic acknowledgment (within what

could be construed as intersubjectivity or scholarship) of the infinitude—the wild, unforgettable form—that requires and facilitates constant revision of its performance.

The third part, "Image of Dramatic Beauty," will involve further consideration of Benjamin's efforts to overcome the Socratic tradition of strictly separating philosophy and art. This consideration will concern the interaction of art and philosophy that may be discerned in Benjamin's conception and practice of philosophical criticism.

It will be contended that Benjamin concentrates criticism on the interaction of art and criticism within what may be conceived as the theological form, philosophy. This form emerges, as noted above, in the writing, the perpetual crisis, within perception and meaning. This crisis-character of Benjamin's theologically impelled conceptions of the interaction of art and criticism will be emphasized, for some have either read the theological influence as antimodern or taken it as indicative of a claim or a desire for the termination of the plurality of critical interpretations. Benjamin sometimes calls the critical-artistic crisis "allegorical," and—for reasons that will be noted in the main text—this notion of allegory will be given even greater prominence than it explicitly has in some of Benjamin's texts. In any case, his formulations concerning this perpetual crisis are ultimately opposed to, or at least destructively unfold, the mythic-religious; above all, they proffer neither escapist harmony nor a leap from death. Art, criticism, and death simply meet or converge in a beauty, an allure, that is also a hope. Death is a kind of marker for the force of mystery that impels the mourning by nature of history. The wild, unforgettable form mourns all appearances and formulations. Hope is on behalf of this nature that mourns history but never indulges claims of humans to extricate themselves entirely from history. In art and criticism, the mourning is preparedness to perform (to play, to acknowledge presentationally) the ultimately irrepressible object, the feeling, the form that mourns whatever is construed as history.

Play does not overcome or resolve mourning or melancholy, although this is sometimes suggested in readings of Benjamin's theory of play. Play simply overcomes relatively unplayful versions of mourning and melancholy. It will be stressed, moreover, that the playfulness fostered in Benjamin's criticism with regard to mourning is never simply "Catholic" or, more broadly speaking, non-Germanically "Christian" (as has occasionally been suggested) but is additionally mixed with, or tempered by, what Benjamin considers Judaic motifs of mourning and even some quite specifically "Germanic" motifs of mourning.

Benjamin's criticism highlights the constant intertwining and tension of convention (history) and expression (nature). This tension is indicative of the

philosophical impulse that he considers integral to art and criticism. For reasons to be elaborated in various sections of the following study, the constant tension may be termed the writing-image. Benjamin will thus be shown to accentuate the "writing-image" (notwithstanding the objections of some who detect no such effectiveness of extensions of the term "writing"—or the term "text"—in Benjamin's criticism).

Frequent attention will be paid to Benjamin's notions of the relationship of ethics with art and criticism, for it is this ethics (or pull toward justice, as could be said in adaptation of Nietzsche) that requires presentation of the theological form (the wild, unforgettable form, philosophy) as the dimension unfulfilled, and thus at best played, in presentation.

In accordance with the tense intertwining of nature and history, expression and convention, in presentation, art works are considered by Benjamin to be philosophical without ever quite ceasing to present themselves as artworks, and works of philosophical criticism are artistic without ever entirely ceasing to present themselves as works of criticism. It might well even be wondered whether Benjamin did not underestimate the potential for playful confusion of conventional or institutional "identities," although his writing is often indicative of a willingness to indulge such play to a considerable extent. For Benjamin, works of art and works of criticism (or indeed any moments of art and any moments of criticism) enter historically conventional bases for performance or presentation but present themselves as simultaneously beyond and yet limited by, albeit indeterminately limited by, those conventions (such as the genres of art and criticism used to "identify" them). Not least as a response, therefore, to the recurrent objection in the Benjamin reception that his practice of criticism is artistic to the point of abandoning criticism, Benjamin's conception and practice of the relationship of art and criticism will be discussed throughout "Image of Dramatic Beauty" and will be elaborated summarily at the close of that part.

The final part, "Community of the Dead," will be an exploration of nuances in Benjamin's view of death as the universal registration of the inherently philosophical form. This association of death, community, and the form that may be called philosophy is sometimes evaded or disregarded in discussions on Benjamin, which include some psychosocial reductionist treatments of his views on death, the allegation that he equates evil and philosophy, and the contention that he recognizes evil as the only reality. Although the association of death and community has more recently been raised and indeed increasingly fostered in studies of Benjamin's work, the accompanying dimension of philosophy is (if not rejected outright) still generally much less emphasized than seems proposed by Benjamin's writings (especially by the "early" writings to be examined in the following study). In "Community of

the Dead," an attempt will be made to elaborate Benjamin's association of death, and the death-related, with the universal nature—the philosophical form, the wild and unforgettable form—that mourns and ironizes "life."

Collective forms, and the individuation taking place within them, will be said to be allegorized by the *form*, philosophy. As noted above, this extension of Benjamin's usage of the term "allegory" will be elaborated at various points in the following study. In accordance with this extension, the part on "Community of the Dead" will suggest that the form, philosophy, impels a presentational rhythm that emerges from the community of the dead, the only community to which all and everything already belong. The honesty of ethics and freedom is that they do not deny this rhythm-producing exception to rule, this rhythm that is the only necessary rhythm common to all and everything. It is this rhythm that will warrant some remarks supplementing, and adding twists to, the quite careful work occasionally done so far that contrasts Carl Schmitt and Benjamin on the question of exception; certain allegations of the similarity of Schmitt and Benjamin will, in any case, be questioned. Benjamin will be shown to develop a comparatively nonexploitative notion of philosophical loyalty to the objectivity or truth that is in things as the nature almost oblivious to moral-legal order and machination. Truth is *almost* oblivious to moral-legal order and machination; its obliviousness would be complete if its indifference were not an *effective* indifference.

It will be suggested, in other words, that philosophical loyalty is based on what one might call the inorganic community of name, the universal semblance-destroying power that compels all and everything into ruination, into death. Notwithstanding some disregard or even disparagement in the reception concerning this dimension of Benjamin's work, considerable attention will be given to what will indeed be formulated as the inorganic community of name. This community of the semblance-destroying power will be discussed as the universal basis of the wild solitude that is rendered by Benjamin as a kind of death in "life." This power or force cannot be forgotten by humans; it is the necessity of which humans are reminded, in a potentially quite profound way, by death. Ethically formulated, this power or force must not be forgotten; it sobers against any euphoria of societal semblance, and against any finite "subjective" or "intersubjective" form.

Drawing on various ("early" and "late") works by Benjamin, as well as on some by Heiner Müller, Blanchot, and others, arguments will be made on behalf of an association of community with death as the untimely, interruptive force that always ironizes (or, more precisely, allegorizes) collective collaboration and competition. Either on behalf of certain "later" writings by Benjamin or on behalf of other outlooks, some have shown little patience with the notion of such a *form* of philosophy or community. On behalf of this *form*,

slight disagreements with certain tendencies in some of Benjamin's later work will be articulated, although it will be emphasized that distinctions of "early" and "late" Benjamin cannot credibly be very strict. On the basis of the discussions of the theological impulse as a necessary kind of "mysticism" in art and philosophy, it will further be stressed—somewhat in the context of critical discussion of remarks by Habermas—that leveling of practices of art and of philosophy are kept in abeyance by the grounding *in* death, *in* contemporaneous noncontemporaneity, whereby practices of philosophy and of art keep themselves strange to us, to themselves, and to each other. The strangeness is somehow familiarly strange or strangely familiar, for it is a strangeness that cannot be expunged from life. Practices of art and practices of philosophy cannot foster any leveling or conflation of anything; this impossibility is precisely what is at stake in the relevant presentations. Genre—regardless of the "community" to which it pertains—is sustained by presentation of the death, the transience, keeping genre limited and yet indeterminately limited.

In closing, it will be suggested that the survival of philosophy could, particularly in the age of "globalization," converge with notions of national culture insofar as the latter are able to present themselves in the universality "dead" to any guilt-context of "life."

With or notwithstanding the organization into these four parts, the aforementioned circularity, circumlocution, roundaboutness should indicate ways in which this study will be an endeavor not only to elaborate and often to advocate works by Benjamin but also to present—stylistically, as it were—acknowledgment of the death in life, the honest rhythm, which is indispensable for, constitutive of, the effectiveness of the *form* and the practice of philosophy. The practice of philosophy requires a presentation in which inquiry is shown to be provisional, ready for renewed inquiry. As noted already, there will be no claim to have appropriated or emulated Benjamin's style. The stylistic tendencies of this study should, nonetheless, at least conceivably be associated with the conceptions of philosophy that will be articulated in the course of the study. A further preliminary clarification of those conceptions will close this introduction.

Under the precept of philosophy as wild, unforgettable death in the name, the following study will be an analysis of "early works" by Benjamin. It will be contended that many of the relevant "early" works articulate or otherwise follow this precept concerning both the universal form and the practice of philosophy. Because the relationship of "early" and "late" Benjamin is in so many respects a very fluid one, no claim will be made to have entirely isolated an "early" Benjamin from a "late" or "later" one. Later works will,

therefore, occasionally be used (as they have been already) to supplement discussions of earlier works. As will be elaborated in a section toward the end of this study ("Death of Art and Philosophy"), Benjamin considers the works forming the basic object of analysis in this study—works up to, and including, the *Trauerspiel* study (1925)—to mark a specific phase in his writings.[15] Writings up to and including the *Trauerspiel* book will be of primary concern here, however, solely by virtue of the extent to which they *especially* address or concern themselves with the aforementioned form *philosophy* and the relationship of practices of philosophy with this form. It will generally be suggested, moreover, that these "early" writings (for example, the essay on language, the Hölderlin essay, the study of *Elective Affinities*, and the *Trauerspiel* book) have much more in common than is acknowledged or contended in a range of recent studies. In such works by Benjamin, in any case, there is considerable concern with (what will be called) the form and with the practice of philosophy as resistant to conventions of communication. As philosophical discourse, the practice cannot indulge any presumption to make convention dispensable; it cannot entail any presumed overcoming of convention in revelation. Basing philosophy on the nonanthropomorphic God (the God of death), however, Benjamin outlines and demonstrates the practice of philosophy in terms of its ability to break through the "living" surfaces, including the often unduly closed surface of "philosophy." God is dead, for we have killed God, Nietzsche suggests.[16] God was killed, however, partly out of our denial of death, our desperation to have the last word, which Benjamin—more than Nietzsche perhaps—suggested (in the very early 1920s) is an indication that the death of God is simply a myth (VI, 101-2). Of course, as Kierkegaard sensed before Nietzsche, little killed God as much as religion did, and Benjamin is not far from this view. For Benjamin, in any case, it is God as death that requires philosophy. God as death requires philosophy that shows itself always beginning anew; hence, Benjamin's precept of presenting presentation, performing performance. As such presentation or performance, philosophy is a roundaboutness in which concepts are always problematic, are insurmountably inadequate in relation to the resistance to semantic containment. Criteria of coherence and of order are palliatives of insight and control that are constantly to be strained by a writing in death.

Benjamin accordingly may be said to outline and attempt an *art* of philosophy based in no small way on the rhythm of death. In an artwork, the pertinent "language" is engaged with this rhythm that collapses perceptual and semantic contents. Visual artworks do this for color, music for sound, literature for name. The name-language, according to Benjamin, is the language of the human. In what amounts, as will be elaborated throughout the following study, to a culpability and a responsibility for other languages, this language of name

can—so to speak—combine the vividness, the image-richness, of visual art with the sound of music. Name is a possibility for things to be further opened to "God"; things can be opened to the *language*, to the *sound*, independent of—and yet underlying—appearances. Name can be their opening to death. Death is the sound that mourns life lived in denial of it. This mourning is not entirely incompatible with the normal mourning of the dead. In that mourning, feeling resists the necessity of what has happened; mourning attests to currently unrealizable or unrealized hope—perhaps that someone could have lived longer. In this respect, even some medical or other health-oriented efforts on behalf of longevity could at least conceivably indicate that appearances are mourned. This mourning would be the sound and the hope of mystery against "lived" appearances. In any case, art images this imageless mystery, and literary art—art in the language of names—may be especially effective in lending imageless *sound* to image. Such performance involves the beauty of art, according to some formulations by Benjamin. According to various formulations, it is also a beauty required of the practice of philosophy, which emerges nonetheless as a discursive performance that is distinct by virtue of the ways in which it is obviously reliant on basic philosophemes. There is an art of philosophy, even though practices of art and practices of philosophy play or perform within mediations or limits (however indeterminate, changing, and intertwined these may be) that are distinct from one another. Philosophy as criticism is especially noteworthy for the following reasons: the openly philosophical impulse of criticism distances the artwork and its reception from any putrefying embrace of appearances or formulations; the resistance of the artwork to discursive rendering precludes criticism treating philosophemes as questions for which there are satisfactory answers. Criticism may, therefore, very concretely and markedly demonstrate the periphrasis constitutive of the practice of philosophy. This periphrasis follows death as the incessant but often ignored rhythm of mystery.

As bearer of such rhythm of death, name is the crossing of image and imageless sound and has—among its expressive potentials—the constant possibility for philosophy as a practice. In name, semantic-referential community is constantly destroyed by mysterious community. This mysterious community is the wild, unforgettable community of death already in everything and everyone. Community in death is the only community that is not surrogate. Community in death is the community recalled, albeit often unwittingly, by the ridiculed extremes of any "living community." It is the community resonating in a person whose childhood of being a disturbance may have been bullyingly "understood" in various ways, only later to be "understood" as dyslexic. Even after the latter "understanding," moreover, this person might remain very much between the lines; existence between the lines might seem

to be a tension very openly accompanying this person's life. Perhaps that "between-the-lines" is where she or he dies in a car accident on a highway. More than most, such a person may resonate with belonging to the stubborn irretrievability that gets little tolerance in "functional life." This person may seem unusually *dead* in her or his own lifetime. Her or his name may especially evoke the encounter of meaning with the wild, unforgettable destiny that is death in life. Insofar as the name does that, there emerges its inherently philosophical moment. The drama of death intrinsic to name is the drama of the form, or community, of philosophy and it is the drama indispensably presented in any practice of philosophy.

Philosophical Community

Hope . . .
. . . you do not scorn the house of those mourning,
. . . you are at work
between mortals and heavenly powers,

where are you?

—Hölderlin, "To Hope"

PHILOSOPHY/*LANGUAGE*

As is well known, Benjamin's 1916 essay on language includes attempts to formulate linguistic theory through elaborations of the first, second, third, and eleventh chapters of Genesis. Benjamin suggests, however, that the Bible is only "*initially* indispensable" for consideration of the "essence [Wesen] of language" (*W* 1, 67/II:1, *147*). It seems unlikely that he is advancing a dogmatic application of the Bible.[1] The Bible is initially indispensable, perhaps only for linguistic theory emerging from cultures with the Bible as primary holy text. "On Language as Such and on the Language of the Human" (1916) concentrates on the first book of Moses, but its claims about language are evidently considered by Benjamin to be somehow affirmed by any religion that has a concept of revelation (*W* 1, 66–67/II:1, 146), and this seems to be reiterated in "The Task of the Translator," at least with respect to religions assuming textual revelation or holy writings (1921) (263/IV:1, 21). The affirmation by other religions is perhaps implied in notes from 1920–1921 that contain quotations of works concerned with the notion of name in Buddhism and in Brahmanic

texts (274–75/VI, 25–26). In any case, revelation is a communication of God to the human. Benjamin's elaboration of language on the basis of a text associated with revelation involves the idea that the ultimate determinant of language is considered to be the mystery that is called God. Revelation as communication of the ultimately incommunicable is the basis not only for philosophical consideration of language but for all practice of philosophy.

"Pure language" facilitates the practice of philosophy. Pure language is independent of specific meanings, referents, or users. One of the basic laws of "the philosophy of language" (der Sprachphilosophie) is that all specific languages supplement one another in their intentions toward "pure language" (257/13–14). The formulation "philosophy of language" may seem hackneyed and pretentious if considered only a subjective genitive (in which language somehow belongs, is analytically subordinate, to philosophy). From Benjamin's perspective, however, the formulation could be considered an objective genitive (in which philosophy belongs to, is inherent in, language). Without "meaning" (Bedeutung), language "would be nothing"; but philosophy of language is required in order that "the linguistic nature of recognition [Erkenntnis]" also be considered ("Das Urteil der Bezeichnung" [1916–1917], VI, 10–11). The linguistic nature of recognition is the dimension not subordinate to recognition, the nothing from which meaning emerges. Without this linguistic dimension, there would be no possibility and no need for the philosophy of language or indeed for any practice of philosophy.

No practice of philosophy would emerge if there were no tension of existence (or meaning) and pure language. The story of naming in the second chapter of Genesis is an attempt to help us imagine what the relative lack of such tension in paradise would be like. "God formed out of the ground all the wild animals and all the birds of heaven. He brought them to the man to see what he would call them, and whatever the man called each living creature, that was its name. Thus the man gave names to all cattle, to the birds of heaven, and to every wild animal."[2] The naming of nature by the human seems to entail that the "muteness" of nature is transformed into the bliss—the pure language—which is already the human's life. Yet even this story seems to depict nature in bliss "to a lower degree." In this lower degree of bliss, there is a residual inexpressibility that is later compounded in the fall. As God's word curses the ground and the appearance of nature is thereby fundamentally changed, there ensues a new muteness that is "the deep sadness [Traurigkeit] of nature" (*W* 1, 72/II:1, 154–55). The fall of nature takes place in conjunction with the fall of the name. As implied above, nature may always have hinted at mourning its lower degree of participation in pure language; even when the naming is God-like and blessed, to be named is perhaps always "an intimation of mourning." This intimation becomes mourning, however, as

there is no longer the one paradisal name-language and instead a multitude of human languages in which the name has "withered" (even though the name may still be the distinct medium granted by God to the human for recognizing things) (73/155). The name has withered in becoming less linguistic, in becoming subject to judgment. All philosophical recognition—including, of course, all philosophy as a practice—is based on the mourning of nature, nature's mourning of judgment.

In various places, Benjamin discusses a metaphysics of mourning. The term "metaphysics" and some associations with this term have perhaps contributed to a certain wariness about Benjamin's early philosophical auspices. In any case, this metaphysics concerns nature beyond any historical meaning that might be given to it. In its encounter with the "world of meaning [Bedeutung], of unfeeling historical time" (60/*139*), nature "finds itself betrayed by language, " and the "immense inhibition of feeling" (60/*138*)—the "inhibition of nature," the "immense damming up of feeling" (60/*139*)—"becomes mourning" (60/*138*).[3] The object of metaphysics is nature feeling disregarded in historical meaning.[4] According to Benjamin, therefore, it is a "metaphysical truth" that all nature would begin to lament if language were granted it. Mute nature impels philosophy as performance.

Philosophy must accordingly involve presentation of silence. To give language to nature would, after all, be "more than to 'make able to speak'" (*W* 1, 72/II:1, 155): It would be an allowance for necessary silence. There is thus "a double meaning" (einen doppelten Sinn) to the proposition that nature would lament if language were given to it. First, the proposition means that nature would lament about "language itself," about feeling left out of language; "[b]eing without language [Sprachlösigkeit] . . . is the great sorrow [Leid] of nature." The second meaning of the proposition is that nature would simply lament out of its incommunicable being—the pure linguistic being which it has only as what essentially cannot be expressed. As "the most undifferentiated, impotent expression of language," this lament "contains scarcely more than the sensuous breath." Yet it is the lament that "always" already "resonates," "even where only plants rustle." Nature mourns "[b]ecause it is mute," but "the inversion of this proposition"—the second meaning of the proposition that nature would lament if language were given to it—"leads even deeper into the essence of nature: the sadness of nature makes it mute" (72–73/*154–55*).[5] Maintaining itself against extant languages, nature withholding itself mourns indistinctly ("the noise of the waters / Making moan," "the waters' / Monotone" *PE*, 38). Nature mourns ("O sighing grasses" *PE*, 43) in a becoming-mute ("The bird that can sing and won't sing" *U*, 480). Philosophy is inextricable from presentation of this becoming-mute on behalf of the necessarily mute.

Philosophy cannot be philosophy—cannot be love of wisdom—without presenting itself as communication of incommunicability. If all mourning is "the deepest inclination to a state of being without language [Hang zur Sprachlosigkeit]," this state itself is "infinitely more than inability or dislike for communication"; "[w]hat mourns [Das Traurige] feels itself thoroughly recognized by the unrecognizable [erkannt vom Unerkennbaren]" (*W* 1, 73/II:1, *155*). Even if the "life and the language of the *human*" are in nature for the sake of redeeming it from muteness (72/*155*), nature is a state of *feeling* consummately recognized only by what cannot be recognized, of being expression that is essentially—"according to its whole innermost nature"— "only . . . *language*" (independent of specific appearances or meanings) (62–63/*141*). As this recognizing unrecognizability, pure language is felt; it is felt in mourning. On the basis of pure language, mourning facilitates and requires philosophical recognition.

Philosophical recognition could, in some sense, conceivably happen everywhere, for pure language is everywhere as communication of things and humans and, simultaneously, as communication of the inherent unrecognizability of things and humans. Appearance and meanings are communications from the unrecognizability that is pure language. Pure language is the "linguistic being" (das sprachliche Wesen) that is any communication of "spiritual being" (das geistige Wesen), whereas "spiritual being" is what is (or could be) communicated—the content (as meaning or referentiality)— associated with the communication (62/*141*).[6] We cannot conceive of anything that does not somehow communicate; everything perceptible or conceivable to humans communicates and is, therefore, *language*. Regardless of what is communicated or could be communicated, expression—"all expression [Ausdruck]"—is "to be classed as language" simply by virtue of being "a communication of spiritual contents [Mitteilung geistiger Inhalte]," a communication of contents perceivable or conceivable by the spirit or intellect of the human (62–63/*141*). That pure language is such a universal and necessary condition makes it the sole constitutive *form* and—in a manner of speaking— object or content of philosophy. It is *the* truth of philosophy that recognition cannot *not* be in pure language, the purely unrecognizable. The "word 'language' is by no means a metaphor in this usage," for "it is a recognition full with regard to content [eine volle inhaltliche Erkenntnis] that we can represent [vorstellen] to ourselves nothing which does not communicate its spiritual being"—its existence as something communicated—"in expression [Ausdruck]" (62/*141*). The content of this recognition is full, for linguistic being—as expression—is the condition and the possibility of everything recognized or recognizable. "An existence entirely without relationship to language is an idea," but this idea must enter *language* in order to be expressed

as idea, in order to be "fruitful in the realm of ideas" (62/*141*). Ideafruitfulness includes the possibility of an existence unrelated to *language*, for the very posing of this possibility is already something communicating, something that is *language*. "[W]e can imagine a total absence of language in nothing" (62/*141*). Fenves characterizes this as follows: "we cannot represent to ourselves the total absence of language, although we can think the barren Idea of languagelessness." Fenves suggests that the latter "worldannihilating fantasy" creates ineradicable, and yet (by Benjamin) disregarded, tensions for Benjamin's presumption (through the aforementioned notion of "the word 'language'" as definitely no "metaphor in this usage") to have "secured the nonmetaphorical character of his own discourse."[7] It seems clear, however, that Benjamin's claim to literalness in usage of the word "language" is at least supposed to derive from the nothing that Fenves finds unduly disregarded. The nothing is an idea that we can have, but once we have it, it is communicating to us, albeit as inextinguishably incommunicable. Precisely this ubiquitous, inextinguishable incommunicability, moreover, assures the possibility of philosophy; there is—in principle—nothing that could not be philosophized, for the nothing in everything is the *form* and possibility of philosophy.

The convergence of linguistic being with the form and thus with possibility of practicing philosophy may be inferred from the beginning of the first sentence in "On Language": "Every manifestation of human spiritual life can be conceived as a kind of language. . . ." (Jede Aüßerung menschlichen Geisteslebens kann als eine Art der Sprache aufgefaßt werden. . . .) Maintaining the exploratory tone, the sentence continues: "this conception, in the manner of a true method, everywhere opens up new formulations of questions" (diese Auffassung erschließt nach Art einer wahrhaften Methode überall neue Fragestellungen) (*W* 1, 62/II:1, *140*). The method of considering everything as *language* must open up new formulations of questions everywhere, for *language* is always only the force breaking down any delimitation by or of spiritual being. Philosophy is a method everywhere opening up new questions, for it adheres to the distinctness of "spiritual being" and "linguistic being." The spiritual being communicating itself in language is "not language itself." Linguistic theory must begin with the distinction of "spiritual being" and "linguistic being." Benjamin wants to avoid the pervasive risk of linguistic theory falling into the "great abyss" of beginning with the "hypothesis" that "the spiritual being of a thing consists precisely in its language" (63/*141*). Beginning with this hypothesis, and thereby reducing language to communicated contents, would annul philosophizing, although this beginning is a pervasive temptation—one could perhaps say occupational hazard—among those ostensibly doing philosophy. Benjamin asks: "[I]s it . . . the temptation to place

the hypothesis at the beginning that constitutes the abyss for all philosophizing?" (74 n. 1/*141 n. 1*).[8] It is to this temptation of conflating the linguistic into intellectual meaning that much "philosophy of language" has succumbed.[9] Just as consideration of the linguistic requires philosophy, however, philosophy requires the priority of the linguistic. As an instance of this convergence of philosophy and language, the "task" (Aufgabe) of linguistic theory is to hover over the "abyss" of the hypothesis identifying spiritual being and language (*W* 1, 63/I:1, 141). This hovering presupposes intersection of spiritual being and language but also some freedom of the latter from, and (one might say) within, the former. Philosophical method everywhere opens spiritual being to linguistic being.

Contrary to any Kantian epistemological scorn for "mantic" experiences, philosophy must concern (as Benjamin reportedly said to Scholem in 1918) a "concept of experience" encompassing realms of the human's connection with the "world . . . not yet penetrated by recognition [Erkenntnis]." As a discipline, philosophy should be prepared to have this transcendent impulse emerge anywhere. A "philosophy"—Scholem quotes—"that does not include the possibility of soothsaying [Weissagung] from *coffee grounds* and cannot explicate [explizieren] it cannot be a true philosophy."[10] In such an explication, the profane world cannot encompass linguistic being, and yet the very profanity of everything, the very transience of everything, attests to the power of linguistic being. The possibility that any "person, any thing, any relationship can mean anything else [kann ein beliebiges anderes bedeuten]," Benjamin says several years later, does not require stopping at the *arbitrary*, at the *Beliebiges*, but offers instead "a destructive, but just [gerechtes] verdict" on the "profane world" (*O*, 175/I:1, *350*). As just, this verdict destroys domination by specific meanings and is the only verdict ultimately sustained always and everywhere. In this *allegorical* verdict, transitions attest to the force of transition, the force of the mourning nature that is never entirely manifest. Wherever it is "historically imprinted," wherever it is a "scene" (Schauplatz), nature has a numismatic quality (172–73/*348–49*).[11] Nature resembles a coinage system; any scene of history is allegorized by the circulatory power of nature—linguistic being—that is the invisible force determining the scene. ("Any object, intensely regarded, may be a gate of access to the incorruptible eon of the gods." *U*, 413) The justice of allegorical power is that it renders the profane world not dependent very "strictly on the detail"; in a simultaneous devaluation and elevation of "the profane world," the allegorical power makes requisites "incommensurable" with "profane things" (*O*, 175/I:1, *350–51*). It makes them incommensurable with profane meanings. Spiritual being—appearance, meaning—is devalued by linguistic being that is effectively an elevation. Auschwitz was an attempted removal of this linguistic

force. The death-machines could be considered denials of death—of philosophical value—in life; life and death were supposed to receive the meaning given by the executors.[12] In its justice, allegory forces everything into the power of philosophy, the power of linguistic being.[13]

PARADISAL PLAY

Linguistic being cannot be reduced to spiritual being but "the deep and incomparable paradox" of identifying spiritual being and linguistic being has an important and warranted application. That much has been at least implied above. This paradox and its justifiable application is expressed in "the ambiguity [Doppelsinn]," the *double-meaning*, "of the word 'logos.'" The word "logos" serves to keep spiritual being and linguistic being from conflation into one another, and yet also presupposes their contact (admittedly, indeterminate contact) with one another. The paradox of the contact—the paradox of the identity—of spiritual being and linguistic being is a solution in "the centre" of linguistic theory but "remains a paradox, and insoluble, if placed at the beginning" (*W* 1, 63/II:1, *141–42*). To begin with the distinction of spiritual being and linguistic being—the distinction making philosophical method an exercise of always beginning anew—is to emphasize that there is communication *in*, not *through*, language. It is to emphasize that linguistic being does not let itself be used by meaning. "There is . . . no speaker of languages, if this means someone who communicates *through* these languages." As noted already, the spiritual being communicated is no demarcation or delimitation of linguistic being. "Spiritual being communicates itself in a language and not through a language—that is to say: it is not outwardly [von aussen] identical with linguistic being" (63/*142*).[14] The profane—outward—effectiveness of the communication is not identical with linguistic being. Yet that profane, outward communication is not entirely distinct from linguistic being. The passing away of outward communication, the latter's transience, demonstrates the identity of linguistic being and spiritual being. The unity of language as infinitude (Unendlichkeit) with language as immediacy (Unmittelbarkeit) is "language" as the "medium" in which what is communicated cannot be externally limited or measured. Infinite language is the immediate mediation of any communication (*W* 1, 63–64/II:1, *142–43*).[15]

"[I]mmediately" (unmittelbar) in any communication, "[*t*]*he linguistic being of things is their language*." Unable to be a means (un-mittel-bar), the linguistic being of things is the language from which they can never be entirely separated. For linguistic theory to be understood, this proposition (that the "linguistic being of all things is their language") must be brought "to a clarity

which also annihilates in it every appearance of a tautology" (*W* 1, 63/II:1, *142*). The proposition is untautological, for it relates two distinct, yet united, dimensions: language as appearance and language as uncircumscribable mystery. There is unity of immediacy and infinitude in the language of things. As implied already perhaps, this extension of the noun "language" is not anthropomorphism. It is "untrue" to say that we recognize "no language other than that of the human." That the lamp, the mountain, and the fox communicate to the human is evidenced in "recognition [Erkenntnis]" of them "and perhaps also in art" (64/*143*). Art could be said to respond especially to the *linguistic* in these communications but *Erkenntnis*—however unwittingly—is also always a nonrecognition, for whatever is recognized arises in infinite, uncircumscribable language. "We cannot recognize [erkennen] the lamp because we do not speak its language" (VII:2, 788). Any communication of things with each other and with us is inextricable from this language that is not recognizable to us. ("A gust of wind enters through the porch with a sound of moving leaves. The lamp flickers quickly." *PE*, 222) As the wind gusts through the porch, we may hear it move the leaves and see it flicker the lamp but this communication of the wind to the leaves and to the lamp, as well as the communication of all of this to us, takes place in language simultaneously withholding itself from us.[16]

Name is, on the one hand, a variation of this simultaneous conveying and withholding. The unity of spiritual being and linguistic being in name is, on the other hand, fundamentally distinct from such unity in things. To the proposition that the "linguistic being of things is their language," Benjamin adds the proposition that the "linguistic being of the human" is the human's "language" (*W* 1, 64/II:1, *143*), but insists further: the name, the human's language, is the medium in which "the spiritual being that communicates itself is *language*" (65/*144*). The name does not communicate everything about any human (for everything about any human is intertwined with the languages of things and is thus a withholding as well as a conveying). Yet name does communicate the constitutive spiritual being of the human; it communicates that the spiritual being of the human is *language*. Whereas *the* "spiritual being" of things—the spiritual being entirely converging with linguistic being—is "not perfectly communicable," as is suggested when "we call things mute" (VII:2, 786), *the* spiritual being of the human is name and this medium of name—entirely communicating the spiritual being communicating in it (the human)—is "language itself" communicating "itself absolutely" (*W* 1, 65/II:1, 144–45). *The* spiritual being of things—what things are—is never expressed in this or that communication. *The* spiritual being of the human is communicated entirely in name and as name. The name is not a communicated referent or meaning; this negative description indicates the unique,

complete linguisticality of name. Name is the "quintessence" of the "intensive totality of language": "Where spiritual being in its communication is language itself in its absolute wholeness, only there is the name, and only the name is there" (65/*144*). The uniquely intensive linguisticality of the name is the "metaphysical" basis for calling the name "the language of language" and calling the human (the one who "speaks in name") "the speaker of language," indeed "its only speaker" (65/144–45). As noted above, there is no speaker of language if this means someone presuming or endeavoring to communicate through language. The spiritual being called the human is, however, identical with the linguistic being in which the human communicates: name. "*[I]n name the spiritual being of the human communicates itself to God*" (65/*144*, also see VII:2, 788–89).[17] Name communicates entirely *the* spiritual being of the being communicating in it: the human.

In addition to this unique intensive linguisticality, the language of name is extensively unique; it is the language to which all other languages can communicate (as is suggested by the aforementioned biblical motif of the human naming things). As the lamp, the mountain, and the fox communicate themselves, there is something for the human to name (*W* 1, 64/II:1, *143*). Everything communicating, everything linguistic, can conceivably be named. "All nature, insofar as it communicates itself, communicates itself in language, and so finally in the human"; the human can thus name things and is "the lord [der Herr] of nature" (65/*144*).

Without claiming to defend Benjamin's notion of "Herr," it may be reiterated that this naming is no mastery through reference or meaning. In either the extensive or the intensive uniqueness of the language of the name, nothing essential about things is communicated besides that they are instances of linguistic being. As suggested already, this also pertains to the things of anthropology, the things that might be named with reference to humans. The human "cannot communicate itself" through or by (durch) the language of the name "but only in it" (65/*144*). It has been said above that the human is name; yet it is only as nothing besides language that the human is name. Any other aspect of being or seeming human—and indeed any other aspect of name—is abstraction from nature. Insofar as it is oriented by this abstraction, the extensive power of name is not strictly linguistic. In its linguistic being, name is only language and thus "meaningless [bedeutungslos]."[18]

Following Benjamin's biblical adaptation, this meaningless linguistic being could be conceived as a residual moment of paradise in the name.[19] This moment is effective in nonparadisal name as freedom of language from the play or caprice of judgment. The latter is the "play or caprice [Willkür]" from which the prototype—Adamic name-giving—is "far removed." Adamic naming is a confirmation of "the state of paradise" as requiring "as yet no need to

struggle with the communicative significance [mitteilenden Bedeutung] of words" (*O*, 37/I:1, 217). Struggle with communicative significance, a prevalence of judgment, is not yet so inescapable, for all is God's word. In the beginning, "God was the word" and "[e]verything" heard, seen, felt by the human was this "living word"; "the origin of language was as natural, as close, and as easy as a child's game [Kinderspiel]" (*W* 1, 70/II:1, 151).[20] The biblical motif (in Genesis 2:7) of God breathing "breath into the human" suggests not only the paradise of immaterial, pure (child's) play in name but also a kind of continuance of this play in nonparadisal conditions. The sound of name is the symbol of this. (As will be indicated below, Benjamin's usage of the term *symbol* is often somewhat more precise.) This sound symbolizes the immateriality and pure spirituality of the incomparable "magical community" of "human language" with things. Notwithstanding Benjamin's stark formulations, it seems very unlikely that he is absentmindedly suggesting that things do not sound at all. In accordance with the aforementioned independence of name (from referent, meaning, and agent), however, "the sound" (Laut) of name is "the pure, linguistic form-principle" (*W* 1, 67/II:1, *147*). This pure linguistic form-principle is later termed by Benjamin the "symbolic" element in name. As a hearing of words in terms of specific referents, "empirical hearing [empirische(s) Vernehmen]" undermines words; in this context, the words "possess . . . an obvious, profane meaning [Bedeutung]." Yet empirical hearing does not annul linguistic sound. The "more or less hidden symbolic side" of words is not extinguished; there remains the "idea," as "something linguistic," as the symbolic element "in the essence of any word" (*O*, 36/I:1, *216*). Apart from communicative context, the name is concrete, for it has not been subordinated to abstraction. The name-language in its "concrete [konkreten] elements" has relation with paradisal "immediacy." This relation involves the name as something other than mere means, something other than the immediacy or "magic" of judgment, something other than the "abstract elements" based on human "judgement" about what is external to names (*W* 1, 70–72/II:1, 152–54). This residual relation is a possibility for a linguistic play distinct from merely conceptual play or conceptual caprice.[21]

The linguistic feeling, which turns into mourning about extant language, requires play in such language if there is to be any effect of this feeling. The "language of pure feeling" is a "music" that could in no way resonate if lament had no play (*W* 1, 61/II:1, 139). Play provides the semblance of a "purposefulness" (Absichtlichkeit) that is indispensable if "mourning" is not to be limitless, if it is not simply to sink (373/*260*; see also *O*, 82/I:1, 260). If a creation has the "feeling (of mourning)" as its "enlivening soul," that creation must be a "play" (Spiel); solely in play, the linguistic feeling demonstrates its freedom from and in actual language (*W*, 61/II:1, *139*). The "lin-

guistic principle" of the mourning play is the "word in transformation" (60/*138*) and "play" ensues from this principle (61/139).[22]

This musical play conversely cannot dispense with mourning.[23] Only the "most profoundly perceived [vernommene] and heard [gehörte] lament becomes music" (*W* 1, 61/II:1, *140*). In its mourning of perception, the linguistic feeling is heard as the feeling that is independent of perception but sounds within perception. The "essence of mourning-play" is defined in the aforementioned "wise old saying" that "all nature" would begin to lament if language were lent to it (60/*138*). The silence of suppressed lament, the silence of nature withholding itself from "communication," may be heard anywhere and everywhere. Performance of this hearing is admittedly very difficult, for it enters meaning in order to strain the tolerance of meaning.

There is thus a tendency to confine such performance to the practice of art and perhaps of philosophy (which, as suggested above, could be said to emerge, however, from the form "philosophy" without being entirely identical with, or the sole representative of, this form). Predominance of "communication" is diminishment of linguistic "value and dignity." An "utter predominance of meaning [Sinnes]," for example, cannot receive a "formful" (formvollen) translation (*W* 1, 262/IV:1, *20*). Linguistic form requires performance of the incommunicable. Writing understood magically or immediately (in a linguistic magic and immediacy rather than a magic and immediacy of judgment) must be understood "un-*mittel*-bar," as unable (un-. . .-bar) to be a means (Mittel).[24] Linguistically nondevastating, linguistically salutary, effect is possible not "through the transmission of contents but rather through the purest disclosure of the dignity and essence of language." Such performance is based on the "secret" of language. It performs this secret as secret, as mystery. Yet such performance of language can be highly political (*C*, 80/*GB*, Vol. 1, *326*). Benjamin's emphasis on such practice or play has been dismissed as "aporetic" or as concerned only with language on holiday.[25] Politics without linguistically impelled play is, however, devastating; it is at best a swindle and at worst totalitarian.

"FEMININE"

Benjamin's conception of such performance, or play, may be introduced by consideration of his views of the "feminine." In Genesis (2:20–23), the man's naming of the animals is followed by God's creation of a mate for the man from one of the man's ribs. The man names the mate "woman."[26] That the initial task of naming was bestowed on the man exclusive of the woman is not

a concern for Benjamin; he simply notes that after the fall (Genesis 3:20) the creature initially named "woman" (2:23) is named "Eve" (in Hebrew, "Havvah," that is, "life") by the man (who is no longer "man," but "Adam").[27] In remarks cited by Benjamin, Paracelsus associates Eve with a "[j]oyfulness [Fröhligkeit]" compensating after the fall for Adam's gloomy "sorrow [Traurigkeit]" (these traits are intermingled in the "descendants") (*O*, 146–47/I:1, *324*).[28] This role of joyfulness could be a resonance of paradisal play; it keeps mourning from sinking into a stagnant version of itself. Although Eve's initial role in the temptation might be construed as a start of sociality as the presumption to knowledge of good and evil, establishing the parameters of this presumption has historically been mostly a domain of men. From momentarily considering the woman a way to possess "knowledge" (Erkenntnis), man develops himself into this very attempt to possess through "Erkenntnis" (*W* 1, 230/VI, 73). Even as the man initially names the woman in the biblical story, she joins the nature that feels a hint of mourning and muteness while being named. In various early writings, moreover, Benjamin casts woman as resistance to the prevalence of judgment over name. This resistance to extant languages is presented as a philosophical performance.

Much like youth, woman has historically been silenced and yet has thereby also been a promise—or a threat—of rich expressive potential. Just as silence is "the inner frontier of conversation" (*W*, 7/II:1, 92), Sappho and her friends retain a silence that "sits enthroned above their speech" (9/95). The "unproductive" one, in contrast, burdens silence by tending to ask as though language were nothing besides a matter of question and answer; ultimately listening "enraptured" to little besides his own voice, he "hears [vernimmt] neither words nor silence" (7/92). This approach to language, this "language," removes the soul of Sappho and her friends; they "receive no sounds from it and no salvation." Yet their soul is actually not carried away by this language, for they "entrusted nothing to it" (9/95). As a missed and yet somehow lingering linguistic potential, woman converges with youth. Youth is a neglected greatness, a cheated power, that may be said to be lamented in every conversation (6/91). Youth endures as the "melody" still heard by all "souls" as they heed "the sources of the unnameable despair" flowing in them (10/96). Responsibility may thus be felt toward "the feminine" (das Weibliche) as the enduring force of mystery in love (VI, 69).[29]

A history of woman being bullied into silence brings, of course, another kind of displacement with it. In their convergence with lost youth, female characters in Dostoevsky's *The Idiot* fall into "an overwrought yearning for childhood," into what in "modern terms" might be called "hysteria" (*W* 1, 81/II:1, 240). In a state of cajoled submission, women may become meanspirited. ("Some woman ready to stick her knife in you hate that in women . . . we are a dreadful lot of bitches I suppose its all the troubles we have

makes us so snappy." *U*, 700) Benjamin focuses more on another kind of lunacy. The "crude and toneless" wafting of words over Sappho and her friends is so devoid of any sound of withdrawn nature—so devoid of the nature to which the women have been consigned—that the speaking women compensate with a garrulousness, with a lunatic language, which is a talking devoid of object and indeed is not any recognizable language (*W* 1, 9/II:1, 95). Demented displacement emerges from the silence prohibited from lending silence expression.

From the role of listener, however, woman may emerge with an almost guiding feeling for what cannot be possessed. The latter is, of course, language without presence; it is veiled like the past (10/95), which is never closed (9/95), and it is in the future like silence (10/95). Yet the one speaking —the man "possessed by the present"—"ought to entrust himself" to the listening woman so that she may lead his calumny to the abyss in which his soul—his past—lies as "dead field." She may show his calumny to him (8/*93*). ("Certainly she remembers the past. Lynch says all women do. Then she remembers the time of her childhood—and mine, if I was ever a child." *P*, 251) If "every woman has the past and in any case no present," the prostitute "guards the sense [Sinn] from the understanding [Verstehen]," restrains "the misusage of words," and—says Benjamin—"refuses to let herself be misused." The prostitute saves conversation from triviality and from hypertrophic greatness. She ruins. She turns everything into the unclosed past. "Each manliness [Mannheit] is already past" and the torrent of words passes "into her nights" (*W* 1, 8/II:1, *93*). (This night recurs as a defining force in Benjamin's writings; the radiant is true, great, expressionless, asexual, and "of a supramundane sexuality" only "where it is refracted in the nocturnal" [52–53/130].) If men are more or less a removal of words from listening, "a society of males" would be devoid of "genius [Genius]." Genius conversely "lives through the existence of the feminine [Weiblichen]"; "[w]herever a work, an action, a thought arises without knowledge about [das Wissen um] this existence, there arises something evil, dead" (53/129). Such evil, such deadness, ultimately confirms Paracelsus's "gloomy" conception of melancholy. Benjamin is interested, however, in what he characterizes as a dialectical conception (*O*, 147/I:1, 325). In such a dialectical conception, it would seem, *feminine* hearing mourns and plays away *masculine* desperation for an answer.

> Ah, now he heard, she holding it to his ear. Hear! He heard. Wonderful. She held it to her own. . . . To hear. . . .
> Bloom through the bardoor saw a shell held at their ears. He heard himself faintly that they heard, each for herself alone, then each for the other, hearing the splash of waves, loudly, a silent roar.
> . . . anear, afar, they listened.

> Her ear too is a shell, the peeping lobe there. . . .
> The sea they think they hear. Singing. A roar. . . .
> . . . George Lidwell held its murmur, hearing: they laid it by, gently.
> —What are the wild waves saying? he asked her, smiled.
> Charming, seasmiling and unanswering Lydia on Lidwell smiled. (*U*, 280)

Smiling in response to the question about what is said by what is heard, the unanswering listener may disarm questions seeking an answer. She is the word breaking through the concept while playing the concept. Silence may enter the listener's eye in such a way that the questioner too begins to hear the silence, the intractable yonder, to which the listener somehow gives birth. ("A liquid of womb of woman eyeball gazed under a fence of lashes, calmly, hearing. See real beauty of the eye when she not speaks. On yonder river." *U*, 284–85)

Implicit in remarks by Benjamin quoted already is, of course, the female not only more or less without presence but also the female thereby relegated to inspirational monument. Benjamin is not the male so considering himself the present and the future that he subscribes to the image of woman suffering as monumentalized token gesture to an otherwise disregarded past. ("The past is consumed in the present and the present is living only because it brings forth the future. Statues of women, if Lynch be right, should always be fully draped, one hand of the woman feeling regretfully her own hinder parts." *P*, 251) Benjamin sometimes propagates, nonetheless, an image of woman as inspirational reservoir. It is not only, therefore, that he compares "immaculate conception" (woman's "rapturous notion of purity") with "conception [Empfängnis] without pregnancy" ("most profoundly the spiritual mark of the male genius [des männlichen Genius]") (*W* 1, 53/II:1, 131).[30] He contends all women are mother to "das Genie," "all women"—as the genius says—"gave birth to me" and "no man" had any role in this conception (*W* 1, 9/II:1, 94)— a condition seeming to make "me" the son of God and turning "my" mother, all "my" *mothers*, into the Virgin Mary.[31] Woman is immaculate listener giving birth to male genius. ("Thrilled, she listened, bending in sympathy to hear. / Blank face. Virgin should say: or fingered only. Write something on it: page." *U*, 284) In the model of the woman who "guards the conversations," *conceives* or *receives* (empfängt) "the silence [das Schweigen]" (*W* 1, 9/II:1, 94), the prostitute, too—the listening female prostitute guarding "the treasure of the everyday," as well as "the everynightness" (Allnächtlichkeit) which is "the highest good" (8/93)—*receives* or *conceives* (empfängt) "the creator of what has been [des Gewesenen]" (9/94), the "genius" (Genie) bringing death to life, bringing night to the day (8–9/93–94).[32] Woman is inspirational listener for the male, bringing the dead and dark past into the present for the future.

Benjamin also makes remarks naturalizing an alleged weakness of women and he disparages them for this. Life failures of Goethe's Tasso and Grillparzer's Sappho (each of whom is a "genius" [Genie]) are differentiated with the summation: "All spiritual differences of the two figures lie anchored in their physical ones: Sappho is woman [Weib], Tasso is man."[33] Benjamin's later remarks dismissing women writing on Romanticism are infamous.[34] His dismissal of Buber's philosophical outlook includes a characterization of Buber's thinking as "womanly."[35] In the essay titled "Goethe's *Elective Affinities*" (1922), Benjamin associates woman with surreptitious, escapist harmony (e.g., W 1, 340/I:1, 181).

Notwithstanding such views and remarks (summarized in the previous two paragraphs), there has also been indication above that it is somehow important to Benjamin to be critical of the process leading men abstractly to grasp "the feminine" (das Weibliche) under "the simultaneous images of the whore and the untouchable beloved" (230/VI, 73). He is especially critical of the latter image. The Christian ideal of virginity is the most extreme and most consequential formulation of a basically pagan idea of innocence. As Christian thinking elevates the life of the virgin to ahistorical immanence, this is the counterpart of myth grounding primal guilt in the sexual drive (335/I:1, 174). ("O Mary, refuge of sinners, intercede for him! O Virgin Undefiled, save him from the gulf of death!" *P*, 126) Benjamin criticizes Goethe's casting of Ottilie's chastity into this Christian ideal (*W* 1, 335/I:1, 174). ("and they always want to see a stain on the bed to know youre a virgin for them all thats troubling them theyre such fools too you could be a widow or divorced 40 times over a daub of red ink would do or blackberry juice no thats too purply" *U*, 690–91) The *Trauerspiel* book also notes the martyr as "radical stoic" may be a woman aiming to dominate "emotions" (Affekte)—"a state of emergency in the soul"—with the "new, antihistorical creation" that is chastity. The latter "physical asceticism" is but a variation of female antihistorical shape, a shape even longer established in the role of woman in "domestic devotion" (bürgerliche Devotion) (*O*, 73–74/I:1, 253). In the latter regard, Benjamin himself at least once uses the pejorative characterization "Weibertreue"—womanly fidelity (*W* 1, 24/II:1, 111). His objection to the role of images of virgin, devoted mother, and housewife concerns the attempted exculpation from history by attachment to a semblance of history. The "untouchableness" of Ottilie's "semblance" keeps her out of reach for her beloved Eduard and deprives her of the "character" that would enable expression to be free and open; such "semblance-like nature" is also evident in Charlotte as the "mother and housewife" whose noble appearance of purity, irreproachability, and passivity has the price of her repressive "indefiniteness" (Unbestimmtheit) (336/I:1, 175). From his early student days onward, Benjamin criticized such images of woman.[36]

Yet images of female dissociation from history can acquire a subversive power, as has been noted by many. Images not only of virginal pregnancy but also of birth without pregnancy may evoke the freedom of inspiration and production—the escape and the uprootedness—indispensable for the writer, whether male or female.[37] Saying the "spiritual one . . . conceives without becoming pregnant," Benjamin opposes Socrates' views of "spiritual procreation [Zeugung]" as "discharge of desire" and of "spiritual conception" as "pregnancy" (Socrates teaches that "the knower [der Wissende] is pregnant with knowledge [Wissen]") (*W* 1, 53/II:1, 131). A human procreator cannot make pregnant with the divine and it is not divine to be pregnant with a human; immaculate conception or conception without pregnancy connote the life-remoteness necessary to give birth to death. It has been said that, not only for male writers, woman may be a birth of death for writing.[38] In this context, woman as the birth-giver gives birth to a creation without procreator and conceives without being pregnant; the creation is from and for the dead and dying. ("Pity they feel. To wipe away a tear for martyrs. For all things dying, want to, dying to, die. For that all things born. . . . Because their wombs." *U*, 284) Genius is born of all the dead and dying. As "das Genie" *forgets* or *unlearns* (verlernt) "humans" by way of the mother, all become "mother to me." It is not *intellectual failure* that the mother—like the female prostitute (Benjamin's earlier texts do not seem to say anything about male prostitutes)—gives birth to "a hundred dead poems" or that the "Genie" is dead in birth or that women "want to receive [empfangen] something dead [Totes] from me" (*W* 1, 8–9/II:1, 94).[39] It would be intellectual failure, rather, not to release the dead and forgotten, not to give birth to death. It has been an intellectual failure of men—conceiving as though pregnant, creating as though giving life—that they cannot quite mourn on behalf of the dead, cannot quite lament their own isolation from the dead.

Apparently as though male is masculine and female is feminine, Benjamin describes a setting in which a man speaks with other men or perhaps even converses with himself (man to man). No one watches over lament. This despairing conversation "resounds in deaf space and blasphemously grabs into the greatness." If it is to lament itself, male calumny—the obscene triumph of the word constructions—requires the female: the men "must stand up and slay their books and steal themselves a woman; otherwise they will secretly throttle their souls" (*W* 1, 9/II:1, 94–95). The dichotomy of men's relationship with Eros is expressed in this solution of destroying books and stealing a woman: intellectual pursuits have so long been emptied of Eros that they have next to nothing to do with it; desire has been so devoid of spirit—language-spirit—that it is released largely in the possession of women.[40] Men's eroticism is scarcely more than glaring, just as so much of its music is self-satisfiedly canonic (a tune) and its language and "philosophy" are proclamatory.

She looked fine. Her crocus dress she wore, lowcut, belongings on show. Clove her breath was always in theatre when she bent to ask a question. Told her what Spinoza says in that book of poor papa's. Hypnotised, listening. Eyes like that. She bent. Chap in dresscircle, staring down into her with his operaglass for all he was worth. Beauty of music you must hear twice. Nature woman half a look. God made the country man the tune.... Philosophy. O rocks! (*U*, 283)

It is largely in a setting of men among men that Socrates tries to philosophize. Socrates' tendency toward a kind of male hermeticism is indicated, according to Benjamin, by the praise—in the *Symposium*—of the love between men and male adolescents and by the lauding of it "as the medium of the creative spirit." In the thorough sexualization of "the spiritual," more importantly, Socrates regards the question as a circumscribable emission from which a circumscribable answer is born. "The Socratic method . . . is completely different from the Platonic. The Socratic inquiry is not the holy question which awaits an answer and whose echo resounds again in the response." Its dissimulation or irony is forcible, even impudent; "it already knows the answer all too precisely." The Socratic question "hounds the answer." Cornering the answer "as dogs would a noble stag," the Socratic question is "neither tender nor so much creative as it is conceptive." Not "genius-like," the Socratic question is like the Socratic irony hidden within it. To use "a terrible image for a terrible thing," it is "an erection of knowledge [Wissens]" (*W* 1, 53/II:1, 131). ("Keep your pecker up, says Joe." *U*, 324) Attempting to subordinate Eros to his male-hermetic purposes, Socrates "poisons" youth, "leads them astray," for "most barbaric" in this figure is that he—"this unartistic [unmusische] human being"—is "the erotic centre of the relationships of the circle around Plato" (*W* 1, 52/II:1, 129). His wife Xanthippe deals Socrates the "ironic justice" (54/132) of clichéd womanness that is the counterpart to his clichéd maleness. ("—... What useful discovery did Socrates learn from Xanthippe? / —Dialectic, Stephen answered." *U*, 190) If Socrates had actually learned dialectic, Benjamin implies, such polarities of "male" and "female" would not so readily have entered his relations.

Notwithstanding this critique of "masculinity," Benjamin's proposed interaction of "feminine" and "masculine" requires that the "feminine" is not without the "masculine." He criticizes German classicism and Romanticism for evoking the individual as a beautiful soul so *inward* that its "masculine contour" is lost (*O*, 160/I:1, 337). Evidently assuming (for the purposes of his discussion at least) lesbian love is also thoroughly feminine love, Benjamin worries that this love—which could be "the most profound, the most splendid and the most erotically and mythically perfect, indeed even the most radiant" love—wins its perfection in well-nigh complete withdrawal, in being "so totally of the night." Solely from this night, there cannot emerge a work,

an action, or a thought. "Where it develops out of this feminine itself, it is flat and weak and does not break through the night" (*W* 1, 53/II:1, 130). "Genius" (das Genie) must, of course, fail in life (VII:2, 536). This is, however, a failure so effectively suspending the criteria of success in life that it shows the failure of those criteria; it thereby ironizes their closure against expressionlessness, against death.[41]

Benjamin realizes, however, that the association of man with *masculinity* and of woman with *femininity* has begun to be ironized by history. This is no Socratic irony dominating life with implied knowingness but is rather the ironizing power of death in life. The living identifications of woman with feminine and of man with masculine may be dying. The epitaph of man-masculinity may have been written, although some may have slept through this.

> BELLO: *(Ruthlessly)* No, Leopold Bloom, all is changed by woman's will since you slept horizontal in Sleepy Hollow your night of twenty years. Return and see.
>
> *(Old Sleepy Hollow calls over the wold.)*
>
> SLEEPY HOLLOW: Rip van Winkle! Rip Van Winkle!
>
> BLOOM: *(. . . cries out)* I see her! It's she! . . . But that dress, the green! And her hair is dyed gold. . . .
>
> BELLO: *(Laughs mockingly)* That's your daughter, you owl. . . .
>
> BELLO: Changed, eh? . . . How many woman had you, say? Following them up dark streets, flatfoot, exciting them by your smothered grunts. . . . Blameless dames with parcels of groceries. Turn about. Sauce for the goose, my gander, O. . . .
>
> BLOOM: . . . Let me go. I will return. I will prove . . .
>
> BELLO: Too late. . . . Your epitaph is written. You are down and out and don't you forget it, old bean. (*U*, 494–95)

Benjamin's friend and former schoolmate Herbert Blumenthal (later Belmore) had said "very nicely" that "the man must be gentle, must become feminine, if the woman becomes masculine" and Benjamin replied that he too had long felt this way. Whereas Blumenthal's "simple formulas" for man and woman—"spirit-nature/nature-spirit"—might also be true, Benjamin cautions against "speaking concretely" in this regard and prefers to speak instead of "the masculine and the feminine," for both so "pervade in the human!" Europe, he thinks, consists of "individuals" in whom there is the masculine and the feminine; it does not consist "of men and women" (*C*, 34/*GB*, Vol. 1, *126*).[42] Masculine and feminine elements are only *historically* borne, respectively, by what are known as male and female sexes.[43]

DR. DIXON: *(Reads a bill of health.)* Professor Bloom is a finished example of the newly womanly man. His moral nature is simple and lovable. Many have found him a dear man, a dear person. He is a rather quaint fellow on the whole, coy though not feebleminded in the medical sense. He has written a really beautiful letter, a poem in itself. . . .

BLOOM: O, I so want to be a mother. (*U*, 464–65)

We ultimately do not know what role those beings known as men and women might have in relation to the "feminine." We do not know how this principle ultimately functions in relation to sexes. Although the "existence of the feminine [Weiblichen] guarantees the asexuality of the spiritual in the world" (that is, guarantees the irrelevance of sex to spirit as pure language), "the greatest secret" remains how the "existence of the woman [Weibes]" does this. "Human beings have not been able to solve" this secret. One problem in this regard is simply that humans gravitate toward a masculine spirit, tending to regard "genius [Genius]" as not the expressionless one breaking out of the night but rather an expressive, explicit one swinging or waving or vibrating in the light (*W* 1, 53/II:1, *130*). Benjamin thinks the "Garden of Eden" today has been "repurified" by "spirit" seeking possession through "knowledge" (Erkenntnis). In a way, men have long been Eve-like; this is the "female sexuality" that men have long chosen to adopt as their own. The snake of temptation can disappear. As Benjamin suggests that there remains simply the question of whether this is paradise or hell, he must realize that it cannot be paradise (230/VI, *73–74*). If it were paradise, there would have been a very different feminization of masculinity. The latter feminization, regardless of where and in whom it might emerge, might not—probably will not—be called "feminine" (developments in and between the sexes already seem too altered for such an expression to have much currency). Whatever effectiveness had by it will, however, be a withholding from "overnaming." That will be its performance.

ROUND-DANCE OF STRAY FEELING

"Overnaming" is Benjamin's expressly approximate, provisional characterization of a relation of human language to thing-language. This relation is also the "overcertainty" (Überbestimmtheit) prevailing in "the tragic relationship between the languages of human speakers." Such overcertainty is the predominance of semantic judgment; it is a tragedy that humans cannot function without such domination. This is not, however, tragedy in the classical sense—at least insofar as the latter is supposed to purge mourning. Overcertainty not only provokes but also paradoxically sustains mourning in humans

and things. Overnaming is the "deepest linguistic reason" for all "sadness [Traurigkeit]"; it is "the linguistic being of the sad [sprachliches Wesen des Traurigen]" and it is the linguistic reason for "all deliberate muteness [Verstummens]" of things (*W* 1, 73/II:1, *155–56*). As lament about overnaming or as deliberate muteness of things before overnaming, mourning is constantly provoked by overnaming. "[A]ctual language" provokes the "stray" (verirrte) feeling that has no basis in this language (61/*139*). There is no classically tragic conclusiveness to end stray feeling. Precisely in the multiplicity of languages, meanings, and peoples, linguistic being in nonparadisal circumstances shows its essential resistance to understanding (*W* 1, 273/VI, 24–25).[44] Play among meanings is the sole possibility of *doing justice* to their linguistic being. This dance among meanings does not hypostatize this or that meaning or hypertrophically elevate semantic and referential meaning as such (as does overnaming) but rather opens itself to the flux of language within and between meanings. The tragedy of humans' inability to function without judgment of meaning does not annul the necessity and the freedom for the play of mourning perpetually suspending such judgment.

If the mourning about meaning emerges from the freedom that is linguistic feeling, the playful impulse is integral to this mourning. The "lament of mourning" raised by the stray feeling must always "dissolve itself"; it must conjure itself and redeem itself anew in a constant playful cycle of "tension and release of feeling" (*W* 1, 61/II:1, *139–40*). Tragic "irrevocability," in contrast, involves a concluding "ultimate reality of language and its order" (61/*139*), which is reality under an "eternal rigidity" of spoken word (61/*140*) whereby—in the end—a pure word as pure bearer of meaning seems to have made every speech tragic (59–60/138). Mourning play cannot be antipluralistic; although it is the definitive element, mourning is only a tone on the scale of feelings. There can be no "pure" mourning play (61/140). Something symphonic emerges, for the "musical principle" in quest of revelatory sound must show its dispersal; the musical principle is accompanied by a "dramatic principle" of rupture and splitting (60/138). There is a "round-dance," a constantly unsettled and unsettling movement, of alternating feelings including the comical, the terrible, the horrifying, and many other feelings (61/*140*). The "endless resonance" is of a sound that cannot be contained in meaning (60–61/138–*40*). Rupturing and splitting, this endless resonance is nonetheless only possible in the play of mourning. Mourning remains the definitive element. The mourning play reaches its "peak" in comedic "playful transitions" but this is a transformation of comedy into mourning play and not the reverse (*O*, 127/I:1, 306). Mourning recurs to break comedic clarity. Stray feeling mourns the meaning of this or that mourning and it mourns the meaning of any play; it assures further play of mourning.

—Yes? Buck Milligan said. What did I say? I forget.
—You said, Stephen answered, *O, it's only Dedalus whose mother is beastly dead....*
—Did I say that? he asked. Well? What harm is that? ...
—Don't mope over it all day, he said. I'm inconsequent. Give up the moody brooding.
His head vanished but the drone of his descending voice boomed out of the stairhead:

> *And no more turn aside and brood*
> *Upon love's bitter mystery*

... Fergus' song: I sang it alone in the house, ... Her door was open: she wanted to hear my music. Silent with awe and pity I went to her bedside. She was crying in her wretched bed. For those words, Stephen: love's bitter mystery.
Where now? ...
Phantasmal mirth, folded away: muskperfumed.

> *And no more turn aside and brood.*

Folded away in the memory of nature.... Memories beset his brooding brain....
In a dream, silently, she had come to him, her wasted body within its loose graveclothes giving off an odour of wax and rosewood, her breath bent over him with mute secret words, a faint odour of wetted ashes.
Her glazing eyes, staring out of death, to shake and bend my soul.... The ghostcandle to light her agony. Ghostly light on the tortured face. Her hoarse loud breath rattling in horror, while all prayed on their knees. Her eyes on me to strike me down....
Ghoul! Chewer of corpses!
No, mother. Let me be and let me live.
—Kinch ahoy!
Buck Milligan's voice again sang from within the tower. It came nearer up the staircase, calling again. Stephen, still trembling at his soul's cry, heard warm running sunlight and in the air behind him friendly words. (*U*, 14–18)

The play impelled by mourning has every image as a writing-image. Writing-image or script (Schriftbild) is "image of *sound*" (Bild des *Tones*). Name is always a sound for what it is not; this independence from meaning and referent makes it uniquely amenable to consideration of linguistic being. The writing-image may in some way communicate a meaning or referent but its sound also communicates its reliance on linguistic being that is not such meaning or referent. The name is, of course, a sound that is not equivalent to

the still silent revelatory sound. The name is a ruptured and split image of the sound of this linguistic music. The writing-image is not a visual—"pictorial, hieroglyphic"—transplantation of "the thing signified"; as the word-mystic would deduce, the writing-image is rather derived from revelatory sound that it shows to be determinant but not entirely perceptible (*C*, 239/*GB*, Vol. 2, *437*). It is in this respect that every image is writing-image. The revelatory element—the revelatory sound—is experienced solely in perceptual imagery and this imagery is to be read as writing that simultaneously conveys and withholds (*O*, 214/I:1, 388–89).[45] The symbol can "be neither read nor written." In perception, there are signs that are readable and writable, but revelatory sound is the imperceptible symbol in perception. As suggested already: sign must appear in perceptual flux, for sign has no self-sufficiently pictorial significance; symbol cannot be read in itself, for reading is mediated by the perceptual flux in which the revelatory sound of symbol does not itself appear entirely. Sign, perception, and symbol are the "three configurations in the absolute surface" and the "first and third must *appear* [*erscheinen*] in the form of the second" ("Notizen zur Wahrnehmungsfrage," VI, 32).[46] In the perceptual flux conveying above all the withholding of symbol, image is writing-image accessible to everyone—the seeing and the blind, the speaking and the mute, the hearing and the deaf. Deaf-mutes, for example, can quite conceivably very well hear—and record hearing—this conveying of withholding.

> Bald deaf Pat brought quite flat pad ink. Pat set with ink pen quite flat pad. . . .
> . . . Talk. Talk. Pat! Doesn't. . . .
> Listen. Bloom listened. Richie Goulding listened. And by the door deaf Pat . . . listened. (*U*, 277, 279, 282)

The image as writing-image is image as name. Image as name is conceivably everywhere as the perceptual juncture of symbol and sign. Name is everywhere as the perceptual (and, therefore, tense) conflux of sign and symbol. The revelatory sound—the revelatory word—in writing-image can humanly be neither deciphered nor produced ("FLORRY: And the song? / STEPHEN: Spirit is willing but the flesh is weak" *U*, 481) but every word has this "pure life of feeling." As noted above, every word can bring the dynamic of symbol and sign to the fore, for the word as mere natural sound—as orthographic-phonetic entity—echoes into the "pure sound of feeling" (*W* 1, 60/II:1, *138*). Name is amenable to such echoing, for name very obviously is itself subject to the transience and transformation ensuing from the cyclical relationship of image and linguistic echo; the resistance of a specific name to being considered a vessel for the pure sound

of language is an echo of the latter sound. ("A voiceless voice sang from within." *U*, 263) Name is a writing-image of itself. *Being and Time* (1927) and other texts by Heidegger suppress the writing-image insofar as they try to provide name of the name.[47] Although it might be wondered if something similar does not happen in Benjamin's identification of the name and the human, Benjamin is wary of what he considers to be Heideggerian attempts at transcription of eternal ideas (e.g., letter of March 7, 1931, *C*, 372/*GB*, Vol. 4, 19). There are indeed ways in which Benjaminian listening must destructively continue beyond Heidegger's fundamental-ontological orientations.[48] The "purity" of nature's "feelings" cannot eject linguistic "purgatory." To lament, to register its withdrawal, the feeling of word in name must enter, and show itself entering, this purgatory (*W* 1, 60/II:1, 138). By pointing to this purgatory as purgatory, by showing itself in a round-dance, name *does justice* to the word-feeling that remains stray. Perception conceived as writing image can correlatively have appearances and meanings give way to the sound of secret that is no sound of anything perceptible. Name is everywhere as writing-image conveying and withholding the sound that is the secret of destiny.

FOR SECRET NOT DOOM: HUMAN'S PROPER NAME

The human's proper name is the point "where human language participates most intimately in the divine infinity of the sheer word." This follows from it communicating no property of the person that it names; it can be no "finite word," no "knowledge" (Erkenntnis) (69/*149*). No "knowledge" (Erkenntnis)—besides, perhaps, of an etymological sort—accrues from the proper name (69/150). The theory of the proper name is accordingly "the theory of the frontier between the finite and the infinite language" (69/149).

For a text written by Benjamin in the early 1930s, the Judaic "secret name" is a metaphor for participation in divine infinity. In this text, Benjamin associates his own secret name with an angel ("Agesilaus Santander," *W* 2, 712–13/VI, 520–21 [first version], and 714–16/521–23 [second version]).[49] The secret name "holds all the life-forces in itself" (first version) or "connects the life-forces to one another in the most stringent bond" (second version) (712/*520* and 206/*522*). It contains or joins what recognition cannot contain or join. In a somewhat disputed allegation of the angel's vindictive character and Satanic appearance (its "claws" [713/521 and 715/523]), Scholem contends that the title of Benjamin's "Agesilaus Santander" (perhaps ostensibly combining the name of a Spartan king, Agesilaos, with the name of the northern Spanish city Santander) is an anagram

for "Der Angelus Satanas" "ornamentally sealed . . . with a superfluous 'i.'"[50] Angelus Satanas is, of course, the fallen angel.[51] In any case, not only does this name in no way enrich the one bearing it (*W* 2, 712/520 and 714/522), not only does it deprive him of much, but it deprives him "above all, of the gift of appearing wholly as he was of old" (712/*520–21* [first version]). That is to say: "much of his image falls away when the name becomes audible"; what is lost, "above all," is "the gift of appearing humanlike [menschenähnlich]" (714/*522* [second version]). Always new (715/523 [second version]), the angel is perhaps heard but never quite seen or seeable (notwithstanding what we might think of as appearances, be they Satanic or not). Even if the angel—as a divine force—comes to be identified by us with this or that loved one, the angel assures that we do not know the appearances of this person in any symbolic—complete—sense. In the identification of the angel with a "you" who is a loved one, I may "hear" the angel; yet this angel then simply "no longer has any face besides / yours which I do not know."[52] The angel is the sound of secret turning appearances into writing-images.

Whereas separation of plastic representation (implying resemblance) and linguistic reference (excluding resemblance) was one of the main principles ruling Western painting from the fifteenth century to the twentieth century, the abolishment of this separation was signalled in Paul Klee's juxtapositions of plastic representation and writing "in an uncertain, reversible, floating space."[53] Klee's manner of painting is "*écriture par excellence*" and has "literary roots." The drawings can be regarded as writing disempowering anthropomorphism. Drawings made in World War I and shortly thereafter of Kaiser Wilhelm II as "an inhuman iron-eater" became by 1920 the *Angelus Novus*, the new angel, the machine angel, with "enigmatic eyes." The onlooker may feel forced to ask whether the angel proclaims complete calamity or the rescue that is disguised within this calamity; at any rate, Benjamin feels this angel to be taking rather than giving.[54] Yet the taking from the human is ultimately only the nonanthropomorphizable given. The machine-age uprooting and unleashing, shattering even those delusions of control that it ostensibly encourages, may indeed have contributed to the literary, phantasmagoric depictions by painters such as Klee. Those depictions may not, moreover, be reduced to outbreaks of compensatory egoism.[55] They depict, rather, an outbreak of writing. They provide particularly vivid indications of the power of literature. So conceived, literature is nonanthropomorphic mourning.[56] It mourns anthropomorphism. To this extent, all art is writing. Heiner Müller's response to Adorno's statement on the barbarism of writing poetry after Auschwitz is to propose: "after Auschwitz, only poems."[57] Art as writing is paradoxically a complement to death camps, mass bombings, transportation

crashes, cancerous atmospheres. Kafka's often cheerful world interwoven by angels is the complement of the modern scientific, military-industrial developments that could eliminate most, if not all, living on this planet (*W* 3, 326/letter of June 12, 1938, to Scholem, *C*, 564/*GB*, Vol. 6, 111–12). Art and machine both demonstrate that to deny writing, to confine perception to anthropomorphic ordering, is doom. The language of the name—the language either implicitly or very obviously (in the form of words and letters) entering Klee's paintings—frees perception from representational confines.[58] Writing is a disaster or catastrophe for representation. The taking-away is then a kind of gift, as Blanchot suggests with his notion of writing as the gift of the disaster.[59] The gift of disaster or catastrophe is freedom from the doom of anthropomorphic denial of writing in perception.

Whereas the female figure sent to Benjamin by his secret name-angel becomes a most protracted, "most fateful detour [verhängnisvollsten Umweg]" (*W* 2, 713/VI, *521* [first version]), the philosophically necessary element in proper name is not the fatefulness or doom but the detour. The doom was that the detour seemed to become the one road. That can happen. Happiness consists, however, of the "conflict" (Widerstreit) combining the charm of unique, new, and unlived with the bliss of a *once more*, a *having-again*, a *having-lived* (715/523 [second version]). Such conflict combining new and old attests to the freedom of linguistic being in spiritual being. The only philosophically necessary element of proper name is such conflict that combines old and new, primordial and unique, regardless of how much this philosophical approach of constant detour may be denied by this or that historical doom, which subordinates to habit or convention.[60] A liberatory aspect of allegory is its treatment of convention and expression as "inherently conflictive [von Haus aus widerstreitend]" (*O*, 175/I:1, *351*). *Der Widerstreit* is not a bad German translation for Lyotard's *Le Différend*, a book also discussing the proper name as a name that does not communicate any property of the person with which it is associated.[61]

As suggested above, it is this kind of independence from communicating properties that makes the "human name"—the human proper name—the "deepest image [Abbild]" of the "divine word" (*W* 1, 69/II:1, *149*). The proper name is the deepest image of the philosophically necessary secret, the secret that remains secret. The secret of the proper name is, of course, independent of specific words and letters and of living associations with them (*W* 2, 712/VI, 520 [first version] and 714/522 [second version]). Jews' appreciation of this secret was presumably bolstered by so often having names issued by governments; even before the Shoah, Jewish emigrants from Europe reportedly often lacked the devotion sometimes found among other ex-Europeans to the old name and its specific sound.[62] The secret of the proper

name is evoked by the sound of mysterious destiny and not the sounds of letters; misspelling the name or changing its ethnic or cultural form does not change this sound, however much it might damage or complement the ability to hear this sound.

> then the music seemed to recede, to recede, to recede, and from each receding trail of nebulous music there fell always one long-drawn calling note, piercing like a star the dusk of silence. Again! Again! Again! A voice from beyond the world was calling.
> —Hello, Stephanos!
> —Here comes The Dedalus! (*P*, 168)

In each proper name, the secret is calling both as destiny and as ethics. The secret is the ultimate necessity and it is the basis for ethics to rise above mythical hypostasis of this or that social form. Betraying the calling of secret within proper name, Molly cannot quite help dwelling on the social sounds of names rather than on the secret sound.[63] Eduard in Goethe's *Elective Affinities* has a glass with the initials E and O engraved on it, for his name at birth was Otto (also the name of a lifelong friend); the adopted name "Eduard" is, in Benjamin's assessment, somehow "inauthentic [unecht]," "arbitrary, chosen on account of its sound." The glass is also an omen of his future love (with Ottilie, represented by the "O"). His frustratingly superficial development of this love seems, furthermore, not unlike his enthusiasm over the sound of a new name (*W* 1, 305/I:1, 135).[64] Indicative of a certain attitude toward the social, this name change anticipates the lack of that resoluteness which alone would have enabled him to love in a way keeping fairly obvious societal pressures in abeyance. People in love are indeed "attached above all else to their names" (*W* 1, 467/IV:1, 119). They are attached to the secret inherent in proper name. The protests by "mothers of the disappeared" may also be construed as survival of the secret of the proper name against those who assumed right of recognition (and execution). Respect for the secret is distinct, moreover, from mere exploitation of it. Hans Schwerte, a professor in Aachen who facilitated the first German monograph devoted to close discussion of Benjamin's early works (that by Witte), was somewhat recently discovered to have been an SS officer under a different name (Hans-Ernst Schneider); secret destiny in proper name—whether the new or the old one—would have required "Schwerte" to juxtapose this secret destiny with the SS life more than he seemed prepared to do as he initially attempted (after the discovery by Dutch researchers and journalists of his activities as Schneider) to defend certain alleged (but evidently fairly trivial) practical imperatives of his entry into the SS life.[65] For the son of Eichmann, too, loyalty to the secret inheritance of proper name requires disloyalty to the most obvious

historical inheritance.⁶⁶ He must be loyal to his secret destiny, not to the historical inheritance that denied secret destiny. In its independence of any recognizable association, the proper name marks the ethics of loyalty to secret destiny; this loyalty is always in conflict with notions of historical destiny or historical fate. Nothing "binds" a human so much to language, therefore, as her or his proper name (*W* 1, 305/I:1, *134*). The proper name guarantees "each human" her or his "creation by God" (69/II:1, *150*). The freedom, which is also the insurmountable difficulty, of the ethics inherent in proper name is this bond with ever-determinant, never entirely manifest linguistic being.

Irrespective of what a name may etymologically or otherwise semantically convey, and irrespective of what name-givers intend, the giving of a proper name is dedication of children to God (69/II:1, 150).⁶⁷ A "pure address" is indeed "impossible," and the "most secret proper name" can have effect only by risking "contamination and detour within a system of relations."⁶⁸ Such risk is distinct, however, from the contamination of empirical and pure by mythic vision (*W* 1, 315/I:1, 148). As presumed conflation of empirical and pure, mythic vision suppresses the name in perception. It suppresses conflict. It is a fate that is not the nameless in name, the linguistic being in name, but a law against which name is not raised. For Benjamin, this "nameless law" is the "doom" (Verhängnis) implied by the sparseness of most of the proper names in *Elective Affinities* (the main characters are identified only by first names: Eduard, Otto [the Captain], Ottilie, Charlotte, Lucianne, and Nanny). The fateful law "fills" the characters' lives with "the pallid light of a solar eclipse," a passive, mythic vision distinct from the proper name's relationship with secret; the eclipse is a dimming that stultifies in the representational being of a contamination. The one character addressing the stifling mythic vision does so solely in order to reinforce it; named only by surname, Mittler is a meddling preacher who does not rise above his self-perceived position of mediator (Mittler): his "self-love allows no abstraction from the traces which seem given to him in his name," a name seeming thereby to degrade him (*W* 1, 305/I:1, *135*).⁶⁹ With secret very pointedly or obviously as its only irrevocable inheritance, however, proper name is the death knell of any specific contamination.⁷⁰ It is no mythification of this or that contamination. Benjamin's musings on the detour created by his angel suggest that even a doomful contamination—an overwhelmingly fateful detour—ultimately confirms the unrecognizable secret. On the basis of secret, doom can be mourned; it is no tragedy in the classical or closed-off sense. Yet the main characters in *Elective Affinities* do not hear the secret to which every proper name beckons. ("What's in a name? That is what we ask ourselves in childhood when we write the name that we are told is ours." *U*, 209–10)⁷¹ The main characters in *Elective Affinities* do not hear their own names as linguistic being that creates

tension with any mythic perception. They do not hear the proper name as "the word of God in human sounds" (*W* 1, 69/II:1, 150).

IN GOD'S NAME

The word of God in human sounds involves the convergence of ethics with the necessity that appears solely as what cannot appear. Against the prevalent tendency to consider "morality [Sittlichkeit]" and religion fundamentally independent of one another, the young Benjamin suggests religion may be the sole possibility of "pure will" or the moral law acquiring concreteness. In the relevant religiosity, community is felt as resistance of common or shared shapelessness to whatever is formulated as extant morality (II:1, 50–1).[72] This necessary community, this community of necessity, renders it impossible to embrace unequivocally any considered extant morality. The ethical impulse of morality requires the suspension of any extant morality in order that the necessary force, which surpasses morality, may be considered. The "inner striving for union with God" cannot rest with the pursuit or the fulfillment of secular causes.[73] Religiosity as "form" of "ethical education" is a process of lending shape ever anew to the ethical. The ethical requires keeping shape responsive to shapelessness. The highest in the human is "shapeless [gestaltlos]"; no attempt should be made to give it shape other than in a "noble act" (II:1, 50–51).[74] In the noble act, the ethical and the religious unite; community is performed as preponderant shapelessness.

In Kabbalistic tradition, according to Scholem, the name of God is "the 'essential name,'" for it has "no 'meaning' [Sinn]"—that is, "no concrete signification [konkrete Bedeutung]."[75] With "no concrete, particular meaning of its own" to "the human mind," the name of God is that through which everything else acquires a "meaning"; it is "something absolute" reflecting "the hidden meaning and the totality of existence."[76] The power of the name "God" derives, moreover, from the inadequacy of this name before the power defining it—"the creative word of God."[77] The power of the name of God derives from its accentuation of the independence of God, which is also an independence from this name. The revelatory and creative word of God speaks "to us" but remains "infinitely interpretable"; it is perceptually and semantically reflected with "beams of light [Strahlen] or sounds [Laute]" that we catch less as "communications" than as "appeals."[78]

Benjamin too may be said to have sought, or at least emphasized the largely incomprehensible power of, a "symbol-doctrine" (a "symbol-teaching" [Symbollehre]) in which God forms "the unattainable centre."[79] God is the essence that all and everything simultaneously are and yet are not. God is pure

language (*W* 1, 254, 261/IV:1, 10, 19). Pure language is essential "difference."[80] Benjamin does not contrast God and language but seems to regard God as the inner limit of spiritual being in relation to linguistic being. God is pure language that is always everywhere and always beyond; God is pure language that requires everywhere to be beyond whatever might be construed as its manifest, communicated being. God is the idea within and beyond any idea. The "idea of God" is the "circumference" of ideas (*W* 1, 315/II:1, 141). The idea of God concerns the unsurpassable pure language in which every idea is beyond any concept or meaning that we might have of it.[81]

> What was after the universe? Nothing. But was there anything round the universe to show where it stopped before the nothing place began? It could not be a wall; but there could be a thin thin line there all round everything. It was very big to think about everything and everywhere. Only God could do that. He [Stephen] tried to think what a big thought must be; but he could only think of God. (*P*, 16)

God is an incomparably big idea. Lending the name of God its power, God shows the incomparable independence of God's own power.

> God was God's name.... *Dieu* was the French for God and that was God's name too; and when anyone prayed to God and said *Dieu* then God knew at once that it was a French person that was praying. But, though there were different names for God in all the different languages in the world and God understood what all the people who prayed said in their different languages, still God remained always the same God and God's real name was God. (*P*, 16)

In the power of the name of God that is not God, there is feeling of being recognized by the inextinguishably unrecognizable.

God is opposed to understanding. The creative word of God is necessary; understanding is not. In each and every word, therefore, the creative word of God—this irrevocable necessity—keeps word independent of understanding. No human word has "an accidental relation to its object," at least not in the sense that the word is merely "a sign for things (or recognition [Erkenntnis] of them) agreed by some convention." Sign and word are irreversibly distinct. "Language never gives *mere* signs" (*W* 1, 69/II:1, *150*). The name is never just a grammatic-semantic sign. ("for the grammar a noun is the name of any person place or thing" *U*, 700) The creative word of God is in proper name and indeed in any name as the resistance of word to grammatic-semantic-referential ordering. This resistance is linguistic being that might communicate perceptual or semantic content but is irreducible to such content (*W* 1, 69/II:1, 150). The creative word of God is the insubordination of linguistic

being vis-à-vis such content. As though the word is just a sign, the "bourgeois conception of language" considers the "means of communication" to be "the word," the "object [Gegenstand]" of communication to be "the thing [die Sache]," and the "addressee" of communication to be "a human being." Yet linguistic being is freedom from this triad of functions. The overflow is the basis of Benjamin's proposed alternative conception of language; this conception "knows no means, no object and no addressee of communication" (65/*144*).[82] The overflow of word in name is unforgettable, is presupposed, regardless of how forgotten it may be by us. It is unforgettable, for it is God's remembrance (*W* 1, 254/IV:1, 10). In its resistance to, or disturbance of, closures of perception or meaning, the name demonstrates this unforgettable word of God, this word within name that is more than can be recognized by understanding and its attendant fears.[83] Understanding is oriented by speech, and Benjamin seeks the *writing* resisting this. Scholem remarks that Benjamin's 1916 essay "On Language" is opposed to a "reprehensible conception . . . of phonetic language as 'means of understanding [Verständigung].'"[84] Every word may be characterized as writing resisting speech—resisting any would-be community of understanding. The community of writing is the community of things and humans in God's word, the word that cannot be understood.

If one looks more and more at a word, intention toward "meaning" (Bedeutung) may give way to intention toward the "word-skeleton," "the word without representation" (das Wort ohne Vorstellung).[85] Intending "secret [Geheimnis]," intending "the insoluble [Unlösbare]," is alone "objective"; Adam's giving of names to the animals is directed against any mythic conception of the name as a riddle posed to be solved (*W* 1, 267–68/VI, *17–18*). The "realm of language" is a "critical medium" extending between signifier and signified (228/23).[86] Language is neither signifier nor signified; it is between them, depriving each of aseity. That is its critical function. Without apparent irony, Benjamin chooses to illustrate the inherent critical power of language by considering the example of the word "tower." "Turm" (tower) may be "the signified [Bedeutete]" but the word "Turm" does not communicate or indicate "'a' tower" or "'the' tower" so much as it communicates "something originary [<U>rsprüngliches]"—the "spiritual being" that is "a definite, originary spiritual being [ein bestimmtes, ursprüngliches geistiges Wesen]" (VI, 15–16). The originary spiritual being is linguistic being. The word communicates—symbolizes—"incommunicability" (15). It communicates symbolic, incommunicable, linguistic being; linguistic being is the critical medium between signifier and signified, and it is the critical medium disregarded in most logic. Logic is concerned not with the justifiability of its "law" (Recht) but with judging according to meaning determined by

this law ("Das Urteil der Bezeichnung," VI, 10).[87] If "truth" lies in the word, however, only "intention" or at most "recognition [Erkenntnis]" lies in the concept (*W* 1, 91/VI, 15).[88]

The last proposition has a premise, of course, indicating that another logic—the logic of word over recognition and concept—has primacy. This logic will be elaborated in the following chapter. This logic is, in any case, ignored not only by most contemporary philosophy but also by most contemporary culture. Recalling a tourist in a bookshop in Tokyo asking whether there is the definitive book, Derrida also recalls silently answering affirmatively.[89] Yet the question itself may, of course, indicate a fixation on implicit or explicit superlatives that might well be expected in the pervasiveness of vocabularies of sport, advertising, and other such forms of competition; with regard to language, this general tendency may include the brutality, albeit so often a naive one, in which people insistently ask about, and are concerned with showing, "the point." Benjamin refers to a pushy "grinning" semblance of empirical significance; this is a semblance based on "the spoken image [Lautbild]" and "explicit [Ausdrücklich] in the maximum." The "word-image," in contrast, is only "virtual"; it shows "postulated but undiscovered [ungefundene] significance [Bedeutung]" that is "expressionless in the maximum" (VI, 15).

As "[t]he word" itself—distinct from the pushy significance—"grins," this "word-skeleton," this word displaying the virtuality of any image of it, is a "[w]eakening" not only of "communicative" but also of "symbolic" power (15). The word-skeleton mocks attempts at living as though there could be either a communicative or a symbolic bypassing of death: the "bourgeois" linguistic theory is not to be rejected by a "mystical" one for which "the word"—the human word—"is absolutely the essence of the thing." The "thing in itself," it must be stressed, "has no word," has no human word; the thing in itself is "created from God's word," whereas it is "recognized [erkannt] in its name according to a human word" (*W* 1, 69/*150*).[90] God's creative word is only reflected in name; "[n]ame reaches the word as little as recognition [Erkenntnis] reaches Creation" (*W* 1, 68/II:1, *149*). From mysticism, Benjamin retains the teaching of a "primordial and God-willed unity" manifesting itself only in a weakened way in the variety of existing languages (273/VI, 24–25). As Benjamin breaks with Wyneken over the latter's support for the German war effort, he invokes the expressionless as a power demanding scorn for easy, irresponsible expression (*C*, 76/*GB*, Vol. 1, 263). Responsible expression shows the word to have primacy and must accordingly avoid any implication or claim of being this word. In the language essay, also written during the war, Benjamin reiterates: "Things have no proper names except in God" (*W* 1, 73/II:1, 155).

Loyalty to things, loyalty to the word, feels bullied by claims to the proper name of things.

> I . . . approached and read:
> 1st July, 1895
> The Rev. James Flynn (formerly of St. Catherine's Church,
> Meath Street), aged sixty-five years.
> R.I.P.
> The reading of the card persuaded me that he was dead. . . .
> I walked away slowly along the sunny side of the street, reading all the theatrical advertisements in the shop-windows as I went. I found it strange that neither I nor the day seemed in a mourning mood and I felt even annoyed at discovering in myself a sensation of freedom as if I had been freed from something by his death. I wondered at this for, as my uncle had said the night before, he had taught me a great deal. He had studied in the Irish college of Rome and he had taught me to pronounce Latin properly. He had told me stories about the catacombs and about Napoleon Bonaparte, and he had explained to me the meaning of the different ceremonies of the Mass and of the different vestments worn by the priest. Sometimes he had amused himself by putting difficult questions to me, asking what one should do in certain circumstances or whether such and such sins were mortal or venial or only imperfections. . . . (*D*, 9–10)

Bless me, father, Dollard the croppy cried. *Bless me and let me go.* (*U*, 284)

The young Benjamin doubts that anyone besides the Church would still venture "the mediatory role between the human and God" or "would like to introduce it into education" (II:1, 51). *Amor dei* is not, at any rate, a recognition eliminating the human's dualistic relationship with God (22). Somewhat later, Benjamin says: Eros binds nature; its inherent or primordial work is the binding of "nearness and distance," a binding discernible in each particular bond. It does not, however, always prevail. The "powers" (Kräfte) of nature may be "unbound [ungebunden]" (*W* 1, 400/VI, 86). There is the nondivine. There is even hate. No commanding presence, God prohibits anyone from assuming the role of spokesperson and yet also removes the legitimacy of anyone who dismisses God. In the religion imagined by the young Benjamin, there is a dualistic relationship with God and the human must accordingly struggle to lend belonging-to-God even a hint of expression (II:1, 22). The dualism is attenuated by belonging to God but confirmed by struggle for God. Integral to what the young Benjamin still called "enlightenment-oriented, reformist work" is a "strictly dualistic conception of life" (a dualism that Benjamin says he shares with Buber) (*GB*, Vol. 1, 70–71). The human belongs to God; yet struggle for God shows the

human to be incapable of speaking for God. Presentation of this incapability is a divine struggle.

The name is a unique medium for this presentation and—as the potential for such presentation—name underlies any being, or could even be said to resonate as linguistic being of every being. The second biblical story of the first human's creation has God's breath breathing into a human created from the earth; in this only *such direct* reference (in the whole story of the Creation) to "the material" in which the Creator's will (otherwise generally considered "creation without mediation") is expressed, the human is not made as God speaks the word (*W* 1, 67–68/II:1, 147–48). Even if Benjamin must be reminded that Adam's rib or rib cage is another material referred to in the story of creation (this time, a material used to create Eve), this does not detract from his main point that the human is the only being not somehow *already* named by God's word (and the only being that names its own kind) (69/149).[91] As namer, the human has a freedom from God that is also a freedom from material languages of nature. In its unique freedom, name is devoid of any necessary connection with this or that context in which it is used. This has been mentioned above with regard to the sound of name. Heard with regard for revelation, the sound of name is independent of referent and semantic content. The name has letters or characters, moreover, but no specific character, letter, or combination of letters is necessarily presupposed; the material composition of name could conceivably be entirely different. It is sound without any material correlate that is *necessary* to it. This lack of any specifically necessary material correlate is the *purity* of its sound, its *pure spirituality*. In comparison, other languages are *nonacoustic*; they are not so independent of matter. Within the "unacoustic" languages issuing from "matter [Material]," there may indeed be a "material community of things" and this may occasion usages such as sculpture or painting that translate into "an infinitely higher language" still of the same specific material sphere (*W* 1, 73/II:1, *156*). The uniqueness of name remains, however, its lack of any specific material correlate that is necessary to it. As suggested already, this is connoted by the story of the separation of name—its freedom—from God. Not created from the divine word as the creating God spoke, the human is "invested with the *gift* [*Gabe*] of language and is elevated [erhoben] above nature" (67–68/148). The "whole of nature" is, of course, "imbued" with the "nameless unspoken language" that is "the residue of the creative [schaffendes] word of God" (74/157). In the name, however, the word of God is not simply "creative" (schaffend) but also "receptive" (empfangend); it is distinctly "receptive to language" (sprachempfangend), receptive to the resonance of linguistic being in nature. The relevant "birth" of language in name—this "Empfängnis"—is a receptive conception, a birth, of "the nameless in name" (69/150). In its

unique immateriality, the name is uniquely amenable to presentation of the derivation from the nameless.

This derivation is the "unity," which is the word of God, in the translating movement by "higher language" of "lower" languages. Until the word of God "unfolds" in "ultimate clarity" (74/157), the "infinity of all human language"—the alleged intensive and the alleged extensive infinity of the name (the name as the language of the human and the name as the language into which all other languages may be translated)—"always remains limited and analytical" in comparison with "the absolutely unlimited and creative infinity of God's word" (68/149).[92] The inextinguishably secret element of word does not realize its independent existence in the "profane" or in "'profane'" objects. The intention to secret will thus ultimately be disappointed. It will not, however, be entirely disappointed, at least insofar as the "subjective semblance [Schein]" made concerning "the secret [Geheimnis]" of object or incident grounds itself in the "objective" basis that is participation of object or incident in secret (*W* 1, 267/VI, *17*). This ground or basis can be presented insofar as there is avoidance or at least attenuation of formulations based on the wish to bypass this ground. It may be that many riddles "can be solved through the mere image [das blosse Bild]" but they can be "redeemed only through the word"— through the intensive linguistic character of the name, the independence of the name as word from specific extensive significance. This word is presupposed by every riddle or puzzle (not only by modern riddles such as homonyms and various puzzles in which words are already built into the solving process but also by puzzles that might not initially involve words). In accordance with its "core" (Kern) that is "symbol of a noncommunicability [Nicht-Mitteilbarkeit]," the word of redemption persists independently of any solution (267–68/*18*). The persistence of this incommunicability creates the sole inherent task of name.[93]

In this task, the "creative [schaffenden] word of God" is the name ("the cognizing [erkennender] name") reaching out to translate but is also "the judgment [richtendes Urteil]," the judgment of God, "suspended over the human" about to name (*W* 1, 74/II:1, *157*).[94] The immediate element in name is not the recognizing or cognizing meaning but the intensively infinite element that creates the need again and again for presentation of the suspension of human judgment. Great writings and especially sacred writings present this element that is outside of recognized meanings; they present it as immediate and yet virtual. In accordance with the correlative precept that language (as distinct from recognized meaning) is to be translated, these writings may be said to "contain their virtual translation between the lines." If the translation is of language more than of semantic-referential meaning, it too will show itself to be virtual; the translation will show itself to be a translation of

the nameless in name. The syntactically literal translation has a "limitless trust" in the unity of its literalness with the freedom of language, with the language between the lines (*W* 1, 262–63/IV:1, *21*).[95] Only as a "conception" (Empfängnis) with "spontaneity" coming from this free *language* or linguistic being does the name—the human's proper name as well as the name of things—demonstrate linguistic community of humans and things with God's creative word (*W* 1, 69/II:1, 150). This community in name seems to echo as Nancy (adapting Bataille) articulates "literary" communism as the "resistance" that precedes rather than being invented and is disregarded only in a very fundamental dishonesty.[96]

Linguistic community is performed as no specific usage of language and indeed as no specific language or conglomeration of languages. No one human language and no conglomeration of human languages can reveal this incommunicable ground of pure language. Although the German language, for example, does not express everything that could conceivably be expressed "*through* it" and could, therefore, express more than it does, it could not be an equivalent of linguistic being. One might even say the German language is "the direct [unmittelbare] expression of that which communicates *itself*"— that which gets communicated—"in it," but this "'itself' is a spiritual being," a dimension of semantic content, always ultimately surpassed by linguistic being (*W* 1, 63/II:1, *141*).[97] Pure language—linguistic being—is the basis, moreover, of all "suprahistorical kinship [Verwandtschaft]" of languages. Languages are essentially akin in what exceeds their respective verbal contents. Only in the "totality" (Allheit) of linguistic "intentions" is pure language attainable (*W* 1, 257/IV:1, 13). This totality is no assembly of languages, for languages are essentially akin (as stated already) only in language always beyond communicated contents. The totality of linguistic intentions is between the lines of every language and preponderant over any interaction of languages, although language usages vary considerably in their stylistic demonstration of this.

In God's community, as noted already, the ethical imperative of considering beyond recognition and understanding converges with the necessity that the community of pure language, the incommunicable ground of everything and everyone, always ultimately prevails. Recognizable only as this inexhaustible force not ultimately recognizable by humans, the ground of community is symbolic, unrealizable, useless. The "ethical idea" is "*real* [*wirklich*]" for "creators of communities" only insofar as they feel "the symbolic, useless value of the community," insofar as they accept that "ethicalness [Sittlichkeit]" of community can be no more than a "symbol" for humans (*C*, 52/*GB*, Vol. 1, *164*).[98] Only God can think the symbol. Only God can think what is God's alone (*W* 1, 268/VI, 18). Grounders of community ground what

can be recognized and expressed only as unrecognizable and inexpressible. It is thus that Benjamin can conceive of the silent one, the listener, as the unappropriated source of "meaning [Sinns]," the source from which the one speaking "receives" (empfängt) meaning. Benjamin even suggests the speaker somehow realizes that the listener has "inextinguishably serious and good" traits. The speaker—this blasphemer of language—wants to be converted by the silent one. Conversation strives for silence (6/II:1, 91). Silence is good not as subordination, opportunism, acquiescence, or attempt to gain control; this would be the victory of speech (functioning as ostensible silence). The good and necessary *meaning* received from the listener is useless, symbolic. The listener grounds community, not simply by listening to what is said but by listening in a way that also opens to the necessarily unsayable. Resonance is lent to the symbolic ground in which all and everything converge. Useless community is grounded anew.

If ethics is a performance of listening to inextinguishable silence, the human "goal-setting spirit" ("*culture*" as the "natural upward development of humanity") must shun self-satisfied, easily integrated ideals such as those generally perpetrated in schools. This spirit bequeaths a spirit of revising values and not one of reproducing them (II:1, 12–16).[99] There is, as suggested in notes of around 1917–1918, a "symbolism in recognition" (die Symbolik in der Erkenntnis) (VI, 40) whereby "morality" (Moral) is "something from the realm of recognition [etwas aus dem Bezirk der Erkenntnis]" but distinct from "conviction" (Gesinnung) (93). Earlier remarks refer to an "ethical programme of our time," that is, a "Gesinnung"—but perhaps more in the sense of fundamental attitude, way of thinking, ethos—standing "*beyond specific scientific* [*wissenschaftlicher*] *theses*" and allowing growth beyond "our present" in order that we may effectively be "sub specie aeternitatis" (Spinoza's formulation in the *Ethics* for "under the form of eternity"). Meaningfulness is not surrogate only insofar as it reaches into this eternal community of everyone and every generation. Only such a "meaningful [sinnvoll] continuity in all development" would assure that "all history not disintegrate into the special wills [Sonderwillen] of particular times or indeed particular individuals" (II:1, 13–14).[100] This meaningful continuity or ethos is the meaning that compels without being realized; it is the silence that may always be heard but never spoken. It is the silence to which all and everything belong; yet it is the silence in which all and everything are made strange to themselves. Considered "sub specie aeternitatis," considered in pure language, all and everything communicate this incommunicable community. For this community necessitating constant revision of the forms in which it is expressed, ethics is obligation to such revision (on behalf of the community of the incommunicable). In the second part of Bataille's *L'Abbé C*, the narrator, Charles, remarks on

this convergence of necessity and community: "there is, in principle, nothing hopeless about us, unless it is the utterances to which we are bound by dishonesty."[101] In any case, the community of the incommunicable ultimately breaks down the dishonesty opposed to it; the ethical concern with performance of the community of silence is concern with performing the necessary.[102]

For Benjamin, there is accordingly the translator's "task" of literally rendering syntax, a task so thoroughly overthrowing the reproduction of meaning that it risks leading "directly into incomprehensibility." Not preserving the state of its own language so much as allowing its language to be effected by the foreign language, this translation letting itself be effected by the syntax of the original above all lets pure language resonate (*W* 1, 260–62/IV:1, 17–20). The task (Aufgabe) of the translator is a giving up (Aufgabe) of both the original language and the receiving language to *language* as neither concept nor specific language.[103] Hölderlin's translations of two tragedies by Sophocles were regarded in the nineteenth century as "monstrous examples" of syntactic literalness (*W* 1, 260/IV:1, 17). These translations as well as other translations by Hölderlin embrace the immense danger inherent in translation: the danger that the gates of a language expanded and forced open will slam shut and simply enclose the translator in silence. As "meaning [Sinn] plunges from abyss to abyss until it threatens to become lost in the bottomless depths of language," however, that "sense [Sinn]" is so fleetingly "touched by language" can be profound demonstration of "the harmony of the languages" (262/21).[104] The harmony of languages requires constant expansion, modification, revision of those languages. Even if this is done in the hope that languages would someday be equal to the harmony, such a goal is kept from ersatz completion only in demonstration that languages are not equal to the harmony.

In name, linguistic harmony or community is performed as the inextinguishable tension of word with semantic or referential content. The "true effect" follows only from "intensive" orientation of words into their kernel of innermost "muteness [Verstummens]" (*C*, 80/*GB*, Vol. 1, *327*). Some detect in Benjamin's views on name a disregard for livable relations of "God, humanity, and neighbor." Why, however, should Benjamin's lack of emphasis on a "commanding Presence" be considered neglect of "togetherness" or "interhuman communicative relation"?[105] For Benjamin, true effect involves above all performance of word withholding itself, and such performance is to deprive ostracization, denigration, or killing of any conclusive legitimation. Short shrift might seem to be given by Benjamin's early linguistic outlook to the question of how "to put a stop to continuous misfortune and unhappiness."[106] Yet refusal (such as Benjamin's) of strict separation of the theological and the profane—the divine and the instrumental—keeps expression

somehow open to suffering that may have no legitimacy in this or that meaning, this or that politics. Inseparable from the mourning of nature mutely withholding itself, the word in name is incompatible with perceptual and semantic complacency. The incompatibility of linguistic being with appearances and meanings is name within all and everything. Name in each being renders that being philosophizable. Each appearance or meaning belongs to philosophical community, to the *form* philosophy. Distinct from any perceptual or semantic content, a linguistic bequest of name is this philosophical community.

On Performing Philosophy

They philosophize about no object more rarely than about philosophy.

—Friedrich Schlegel, *Athenäum*, fragment 1

FORM OF INFINITE GIVING UP

Questioning and Infinite Form

As word in perception and meaning, philosophical form is the universal *linguistic* form in which philosophy as a practice is possible and necessary; the practice of philosophy would not be possible without this form and this form cannot be conceived discursively without the practice of philosophy. The discursive practice of philosophy is not containable by propositional logic; in this respect, Benjamin does not succumb to what Deleuze and Guattari characterize as the *illusion of discursiveness* ("when propositions are confused with concepts").[1] For Benjamin, moreover, it seems the practice or performance of philosophy could, but need not necessarily, take place as clearly or recognizably emerging from the discipline of philosophy, to which Benjamin (as will be elaborated below, especially in the section on "Harmony of Some Old Words") nonetheless ascribes considerable importance. The performance of philosophy presupposes simply the linguistic-philosophical form that is inexpressible yet determinant necessity. The practice of philosophy communicates, within discourse (within conceptualization that is constantly open to abandonment and revision), this fundamental incommunicability. The linguistic-philosophical form is name that is everywhere and anywhere and is an inextinguishable potential for the

performance of philosophy. Upon being confronted with Benjamin's priority of the word, many might object that one cannot expect to do philosophy everywhere. As form, however, philosophy *is* everywhere, even if it is not, and cannot be, lived in any exhaustive way and is, in any case, largely ignored. It was suggested above in the discussion of linguistic community as philosophical community (the part titled "Philosophical Community") that philosophy is a form making the practice or performance of philosophy at least a potential of each and every human perception and expression. The young Benjamin thinks all specialized studies and disciplines could be undertaken in a university community that is "progenitor and guardian of the philosophical form of community." At this point, he suggests that "the form of philosophy" is a vocational and professional form enabling "[t]he community of creative humans" to elevate "every field of study to universality." This community would then be devoted to "the metaphysical questions" of Plato, Spinoza, the Romantics, and Nietzsche rather than to the mode of questioning characteristic of "limited, scholarly department philosophy" (begrenzten wissenschaftlichen Fachphilosophie) (*W* 1, 42–43/ II:1, *82*). Even as Benjamin is less naive about what could happen at a university, he stresses a universality of philosophical form that would be no answer to those metaphysical questions. Regardless of how amenable metaphysical questions may be to consideration of this universal form, this form itself has no answer and indeed no question. The unity—the "quintessence" (Inbegriff)—of scholarship is, after all, of "higher magnitude [Mächtigkeit]" than can be elicited by any questions or even by some kind of "quintessence" (Inbegriff) of all the "numerically infinite, finite—that is, given, poseable—questions." The unity of "scholarship" (Wissenschaft) is the "infinite task" (unendliche Aufgabe) that is not given "as question" (VI, 51–52).[2] The unity of scholarship is this task, for the unity of everything is this task. "[B]eyond all question," eluding "every manner of questioning" (jeder Fragestellung), truth is "unity in being [Einheit im Sein]," is not "unity in concept." The "unity" in "the essence [Wesen] of truth" is "thoroughly immediate and direct determination [durchaus unvermittelt und direkte Bestimmung]" (*O*, 30/I:1, *210*). The persistent possibility of performing philosophy, of philosophy as performance, is this immediate and direct unity for which there is neither question nor answer.

As Benjamin insists that philosophy is not a matter of question and answer, he diverges from a basic Socratic notion of philosophy. Benjamin implicitly follows Aristotle in regarding Socratic dialectic (and its "if . . . , then . . ." argumentation) as based on judgment and not based in things; such judgment prevails in mathematics and physics, perhaps, but is not the basis for philosophy.[3] Reiterating a remark noted above, Benjamin says: The "totality [Ganzheit]" of philosophy, the "system" of philosophy, remains of a "higher

magnitude" than can be solicited by the "quintessence" or "sum total" ("Inbegriff" can be translated in various ways) of all the "problems" of philosophy. There is a "unity" in the solution of all of these problems. This unity is the aforementioned linguistic or philosophical form that is a mysterious (wild), yet determinant (unforgettable) necessity. Questioning cannot arrive at this unity. Even if there were a question leading to "the solution of all problems," there would immediately arise a "new" question concerned with the ground of the "answering" (Beantwortung) (*W* 1, 333–34/I:1, *172*). As Benjamin stresses again and again: Philosophy remains beyond question and answer, for the "answer"—the "unity," the "system"—of philosophy is "of higher magnitude than the answers to the infinite number of poseable, finite questions." The infinite number of questions capable of being posed—the legendary infinity of "further questioning [Weiterfragen]," a legend occasioning "shallow interpretations" of philosophy "as infinite task" (217/I:3, *833*)—is a quantitative infinity of finite questions. In contrast, any practice of philosophy brings any question back to the unity for which question and answer are qualitatively lacking.

As the immediacy that cannot be reached by questioning, this unity or form of philosophy constitutes philosophy as performance, which is not containment, of the unity or form. The "form of truth" does not belong to a methodologically determinable "coherence [Zusammenhang] in consciousness" (*O*, 30/I:1, *209*). Much neo-Kantianism in Benjamin's day and indeed the prominent variants of neo-Kantianism today are somewhat uninterested in this form. This immediate form of philosophy is not in any way the Kantian epistemological one. For Kant to have attempted articulating the fullness of divine cause would, of course, probably have placed him in the tradition of speculative metaphysics that he rejected and is now called pre-Kantian. No less than his predecessors, however, Kant tends to disregard the distinctness of "'experience [Erfahrung]' and recognition [Erkenntnis] of experience" (*W* 1, 94–96/VI, 35–37; see also 103/II:1, 161).[4] This is the basis of a further problem. In the presumed givenness of the kinds of experience (taken by the "Critiques" as premises) and in the logic (by which Kant deduces certain conditions as necessary and universal conditions for the possibility of these experiences presumed given), there is a "fatal [verhängnisvolle] confusion of validity [Giltigkeit] and rightness [Richtigkeit]." Validity of a deduction from a premise about experience does not make this deduction right. Kant's proof of "how" and "that" certain concepts are synthetic a priori equates this validity with "rightness" ("Über die transzendentale Methode" [Summer 1918], VI, 52–53). Integral to overcoming such confusion of validity and rightness is that philosophy overcome the transcendental ego ("the subject nature" of the "cognizing [erkennenden] consciousness") which

Kant deduces as the synthetic a priori, as the necessary and universal condition of the possibility of human experience. The notion of transcendental ego is "mythology" and, with regard to its truth content or suppression thereof, "the same as every other recognition-mythology [Erkenntnismythologie]" (*W* 1, 103/II:1, *161*). Benjamin resists any conflation of recognition and experience; the practice of philosophy is considered instead to emerge from the "being [Sein]" that gives truth and idea the "supreme metaphysical significance" expressly granted to them in "the Platonic system" (*O*, 30/I:1, *210*).[5] In Benjamin's "Platonism," of course, this significance of truth and idea is effective in what may be translated into a linguistic a priori, the linguistic being of name, as the given and yet ultimately unrecognizable form of philosophy.

In a kind of denial of this form, neither Kant nor his "successors" (neo-Kantians) "recognize that not science [Wissenschaft] but language *gives* the concepts to be examined" (VI, 53). As Benjamin suggests in various texts, each name symbolizes the force from which concepts emerge, and concepts are not themselves this force. The force symbolized is the linguistic being in which all and everything converge. Solely on the basis of this symbolic unity (46), *Wissenschaft* is the infinite task; it is "an infinite, absolute" synthesis independent of relative syntheses (52). Kant's epistemology tends to absolutize what he advances as the concept of scientific experience (*W* 1, 94/VI, 35). Infinity of task in this epistemology is turned by neo-Kantians into a "perfectly empty sort of infinity," into a quantitative infinity, that is not really an a priori one ("Zweideutigkeit des Begriffs der 'unendliche Aufgabe' in der kantischen Schule" [Summer 1918], VI, 53).[6] Under the influence of positivism, neo-Kantians acquire a "conviction" compatible with this quantitative and empty task: the conviction that "*science* [*Wissenschaft*] is the proffered fact [das darreichende Faktum]." The methodological counterpart of this "facticity-swindle [Faktizitätsschwindel]" is the synthetic a priori proof (VI, 53). The empirical is a given of science, and epistemology is quasi-mathematical proof of the possibility of this given. The latter model of proof, like the facticity-swindle that is its given, amounts to an attempt to purge language. As a "coercive means" of "proof" (*O*, 28/I:1, *208*) that follows the didactic model implying the elimination of the problem of presentation or performance, mathematics demonstrates "its renunciation of the realm of truth," its renunciation of the realm which languages themselves inherently "intend [meinen]" (27/*207*).[7] Languages themselves intend the form that can only be performed as form without question or answer. Method in projects of philosophy is correlatively no didactic matter (*O*, 27/I:1, 207). Based neither on a given facticity nor on logical deduction from the premise of such a given, method or logic in philosophy emerges from the immediate linguistic being that is the infinite task derived from the word in name.

Word in Name: Guilt of Experience and Rhythm of Thinking

As suggested already, the word in name is the possibility of philosophy (regardless of whether or not philosophy is a practice identified obviously with the discipline of philosophy, the discipline to be elaboated in "Harmony of Some Old Words" below); name is in every recognition as opening to the unrecognizable, to linguistic being, as the essential being that unfolds by withholding itself. Every appearance and meaning is ultimately name. In this sense, perception is not an empirical realm so much as a *linguistic* one. As "[t]he absolute experience," as "symbolic-systematic concept," language unfolds itself in varieties of language, "one of which is perception" (*W* 1, 96/VI, *38*). Name is the force of the *linguistic* in everything. Contained neither by the empirical nor by forms of logic deducing from the premise of such experience, the "systematic supremacy of philosophy . . . over all science as well as mathematics" is that it has its sole expression in language—the language of names—"and not in formulas or numbers." Expressly following Hamann, Benjamin advances philosophy as partly an attempt to surpass constrictions of "mathematical-mechanical" recognition of experience by "relating recognition [Erkenntnis] to language" (107–8/II:1, *168*). As the word necessarily withholding from appearances and concept, name breaks through as experience that requires philosophizing against the constraints of didacticism.

> It was the hour for sums. Father Arnall wrote a hard sum on the board and then said:
> —Now then, who will win? Go ahead, York! Go ahead, Lancaster!
> Stephen tried his best, but the sum was too hard and he felt confused. The little silk badge with the white rose on it that was pinned on the breast of his jacket began to flutter. He was no good at sums, but he tried his best so that York might not lose. . . . Then Jack Lawton cracked his fingers and Father Arnall looked at his copybook and said:
> —Right. Bravo Lancaster! The red rose wins. Come on now, York! Forge ahead!
> Jack Lawton looked over from his side. The little silk badge with the red rose on it looked very rich because he had a blue sailor top on. Stephen felt his own face red too, thinking of all the bets about who would get first place in elements, Jack Lawton or he. Some weeks Jack Lawton got the card for first and some weeks he got the card for first. His white silk badge fluttered and fluttered as he worked at the next sum and heard Father Arnall's voice. Then all his eagerness passed away and he felt his face quite cool. He thought his face must be white because it felt so cool. He could not get out the answer for the sum but it did not matter. White roses and red roses: those were beautiful colours to think of. And the cards for first place and second place and third place were beautiful colours

too: pink and cream and lavender. Lavender and cream and pink roses were beautiful to think of. Perhaps a wild rose might be like those colours and he remembered the song about the wild rose blossoms on the little green place. But you could not have a green rose. But perhaps somewhere in the world you could. (*P*, 12)

The equation of the page of his scribbler began to spread out a widening tail, eyed and starred like a peacock's. . . . The music came nearer and he recalled the words. . . . (*P*, 102–3)

The linguistic continuum of words in names is the inheritance and the bequest of any practice of philosophy; the continuum or form of philosophy sustains any performance or practice of philosophy and the performance or practice of philosophy sustains attentiveness to this continuum or form. Questions concerning "the essence [Wesen] of recognition, law, art" are, therefore, related to the question concerning "the origin [Ursprung] of all human expressions of spirit [Geistesäusserungen] in the essence [Wesen] of language" (*C*, 108/*GB*, Vol. 1, *437*). For a phase of his writing, Benjamin speculates on the possibility of a "metaphysics" involving the formation of "a pure, systematic continuum of experience" and concerned with the "true significance [eigentliche Bedeutung]" of experience (*W* 1, 105/II:1, *164*). Even if this implies a convergence of discursive system with symbolic system that was not anticipated by Benjamin for very long, his writings of principal concern in this study regularly suggest that the practice of philosophy is derived from, and oriented by, what could be called linguistic continuum.

The performance of philosophy is derived from, and oriented by, this continuum that is the form of "the uniform and continuous multiplicity of recognition" (die einheitliche und kontinuierliche Mannigfaltigkeit) (108/*168*) and is a multiplicity uniform and continuous in, and as, what the 1916 essay on language calls linguistic being. Such identification of multiplicity with the uniform and continuous is formulated in the 1916 essay: "every language"—every thing language as well as every human language—"contains its own incommensurable, uniquely constituted infinity" (64/*143*). The infinite is not conceptually or otherwise sublatable; every "language" is incommensurable, incapable of being leveled by (or conflated with) another, and this recalcitrance attests to the power of infinitude, which is experience. As the aforementioned *form*, philosophy is this experience. In this sense, which is fundamental for the study at hand, philosophy is not simply deduction from linguistic being. In the latter sort of "systematic symbolic context," philosophy may be deduced "as language," whereby philosophy is "absolute experience" (96/VI, *37*). Whereas Nancy distinguishes absolute experience (an absoluteness of experience, or quite simply "experience") from philosophy (which is preceded and

succeeded by the thought or, more precisely, by the freedom that is experience), Benjamin at least sometimes regards philosophy (in the sense of the continuum independent of, or at least irreducible to, any and all discursive display) as experience.[8] As Benjamin implies, and as Nancy may also imply in a remark on "the *tone* of the autonomous Law," the performance of philosophy is constituted by resistance of the music of linguistic being to recognition.[9] It is constituted by the music of linguistic being emerging as ideas in names, names that are resistant to one another by virtue of infinitude—linguistic being—within them. Without opening to linguistic being, any discourse of "philosophy" would lose connection with the constitutive force of philosophy. "Truth, bodied forth [vergegenwärtigt] in the round-dance of presented ideas, resists being projected, by whatever means, into the realm of recognition [Erkenntnisbereich]" (*O*, 29/I:1, *209*; see also I:3, 931). As the form "philosophy," linguistic being facilitates and orients the discourse of philosophy; this form—linguistic being—requires performance that is at least residually a dance of words in names.

In response to its form, what will be elaborated below as the discipline of philosophy *openly* presupposes what other instances of philosophical recognition also presuppose and manage to convey, however unwittingly: certain core concepts that function as orientation to the symbolic, otherwise incommunicative character of this form. The "symbolic concepts"—concepts somehow more linguistic than semantic—overcome the "semblance of a recognizing human"—whether this be Kant's postulation of recognition in "consciousness of a recognizing subject" or Leibniz's in an "object" (in recognition "identical with the object"). Symbolic concepts overcome the "false disjunction" of subject and object (*W* 1, 276–77/VI, *45–46*).[10] Symbolic concepts are names that seem to present themselves in their sole a priori, the *linguistic* derivation (which, philosophically conceived, is a task), and seem to orient usage of these and other names into performance of the continuum or form that is neither recognizing subject nor recognized object.

Yet, for philosophy in the more general sense of philosophical recognition and practice, it is also the case that each name is an incessant linguistic task, and—as name—anywhere is this task constituted by linguistic form or continuum.

For any practice of philosophy, as is presumably clear by now, *language* is not simply an irresistible force but also an obligatory one. This intertwining of necessity and ethics in philosophy is a dimension of Benjamin's work that will be noted and elaborated recurrently in this study. As Benjamin struggles with reflection on "the linguistic foundations of the categorical imperative," he seems to be moving toward consideration of *language* as the categorical imperative (*C*, 108/*GB*, Vol. 1, 436). In this regard, Nancy seems not far from

Benjamin; Nancy discusses the categorical imperative as the absolute freedom that impels thought.[11] Adapting Benjamin, it may be said that linguistic being is a guilt that is philosophy (the form, philosophy) in each moment of history. Guilt is "the highest category of world history," the category guaranteeing the "Einsinnigkeit" of "events" (note of 1918, VI, 92). The one sense—the *Einsinn*—is the linguistic continuum, the sense determinant and yet recognizable only as unrecognizable. Language as such manifests itself solely as the word pushing each moment beyond satiation; it is the name giving each moment the guilt that is linguistic community.[12] This one sense, this community in linguistic being, is the feeling of unfulfillable debt that is the ground of philosophy—the ground, philosophy.

Any practice of philosophy is parabolic in the sense that it is defined by this unfulfillable obligation, which is its ground, its form. Its task is its ground or form. The "historical task [geschichtliche Aufgabe]," Benjamin suggests in a relatively early text, is one of so shaping immanence that immanence becomes "visible and dominant in the present." It is a task that cannot be fulfilled by pragmatic details. The "immanent condition" can be comprehended only in "its metaphysical structure," as is suggested by references to the "messianic" realm or to the "idea of the French revolution." The immanent condition is respected only insofar as the parabolic character of such references is preserved. Benjamin refers to a "parable"—a "Gleichnis"—of the "highest metaphysical state of history" (*W* 1, 37/II:1, *75*). This parable turns everything toward what everything essentially is but neither practically nor conceptually can be. Immanence converges with transcendence. As Benjamin later puts it, phenomena are not "incorporated" (einverleibt) or "contained" (enthalten) in ideas, and conceptualization cannot be the equivalent of ideas "in themselves." Concepts may at best enter a "mediator role" (Vermittlerrolle) lending phenomena "participation in the being [Sein] of ideas" (*O*, 34/I:1, *214*). In the idea, "the particular [Einzelnen]" is distinct from the particular falling under the concept and remaining "what it was" (namely, "particularity" [Einzelheit]); in the idea, there is a "Platonic 'redemption' [Rettung]" enabling the particular to become "what it was not—totality [Totalität]" (46/*227*). Benjamin's usage (here and elsewhere) of the term "totality" might seem to run the risk, decried by Rosenzweig and Lévinas (as well as Adorno), of philosophy presuming to absorb or annul particularity. Benjamin's insistence on the intransigence of the indeterminate stuff of particularity will, however, be elaborated below. As has been intimated above, in any case, precisely that indeterminate stuff retains the transcendence necessary for philosophy. Presenting particulars as the linguistic being (totality) that they essentially are but pragmatically and conceptually are not, philosophy is a performance that is conceivably everywhere and yet, in an essential

sense, necessarily nowhere. To put it somewhat differently: the form, philosophy, is the ubiquitous possibility of the practice of philosophy as parable of transcendence.

> It had better be stated here and now at the outset that the perverted transcendentalism to which Mr S. Dedalus' (Div. Scep.) contentions would appear to prove him pretty badly addicted runs directly counter to accepted scientific methods. Science, it cannot be too often repeated, deals with tangible phenomena. The man of science like the man in the street has to face headheaded facts that cannot be blinked and explain them as best he can. (*U*, 415)

Conceivably everywhere as parable of transcendence, philosophical consideration of the factual and particular takes place in the eidetic—in the image—and not in the generalizing concept. The eidetic presents the thing in its relationship with the essence that is no phenomenal or conceptual property.[13] Yet Benjamin's notion of the eidetic is a transformation of Platonism. The image is word. This is, nonetheless, no straightforwardly Romantic mysticism. For Benjamin, philosophical presentation presents the mediateness of its, and any, relationship with idea. According to Benjamin, Friedrich Schlegel seeks a "non-visual intuition [unanschauliche Intuition] of system" in language that is to enable thinking to be beyond discursive mediateness or concrete-visual relevance. Beyond "discursivity" and "demonstrability" (Anschaulichkeit), Schlegel's thought, moving in "terminology," considers the "term, the concept," not only to contain "the seed [Keim] of the system" but also to be basically "nothing other than a preformed system itself." The concept is the "adequate" expressive form of reflection that is itself "the intentional act" of "absolute comprehension of the system" (*W* 1, 139–40/I:1, *47*). Not only for Schlegel but also for Novalis and Schleiermacher, wit (Witz) is a lightning-like manner of bringing a reflexive, medial (as distinct from instrumental) relationship with concepts into appearance. In "the attempt to call the system by name," in the attempt to "comprehend [erfassen]" system "in a mystical individual concept," the "systematic contexts" are considered to be included in the concept (140/*48–49*). This "positive emphasis" in Schlegel's "concept of critique" is, oddly enough, not far from a "mystical spirit" in Kant's "terminology" (142/52). Although entailing an otherwise more creative and productive "positive meaning [Bedeutung]" than Kant's concept of critique (which is ultimately oriented by the judging consciousness), the early Romantics' concept of critique also concerns an "elevation [Erhebung] of thinking above all relationships [Bindungen]" to the point at which insight into the falseness in those relationships "magically" (zauberisch) brings "recognition [Erkenntnis] of truth" (142/*51*). Benjamin too seems to regard thinking as "a transcendent intransitivum," an unconditional lack of a direct

object (note from around May 1918, VI, 43). Benjamin's writing may correlatively be said to have no time of development, at least in the sense that its coordination and intertwining are not subordinate to communicative or persuasive sequence.[14] This freedom from context is not, however, disregard of it. In a 1939 review of Albert Béguin's Romanticism study, Benjamin does discuss Romanticism as the completion of a process "which the eighteenth century had begun"—"the secularization of the mystical tradition." Yet even this somewhat sympathetic review is expressly critical of Romantic mysticism (and criticizes Béguin's unhistorical presumption of "[u]nmediated interest") (*W* 4, 154–55/III, *558–60*). Nowhere, moreover, does Benjamin endorse or enact a Romantic mysticism whereby certain words effect a direct revelation of the essence of things.[15] "[G]eneral validity [Allgemeingültigkeit]" is no timeless context. It belongs, at best, to a time—a nowtime—that is "*logical*" in recognizing the catastrophic relationship of truth with it (*W* 1, 276/VI, *46*). As performance, therefore, philosophy is a kind of parable (if that is the right word) of the catastrophe and not a Romantically mystic denial of it.

Even Friedrich Schlegel seems to concede that there is "something perilous" in Romantic conceptual mysticism (*W* 1, 138/I:1, 45–46). Perhaps for this reason, Benjamin emphasizes a Romantically negative moment or emphasis that is an attenuation of the Romantically "positive" mysticism. The Romantics could not indefinitely overlook an immense discrepancy between the claim and the achievement of their theoretical philosophy; the word "critique" comes in handy with its implication that a critical work, regardless of its "validity [Geltung]," cannot be conclusive. "Critique" includes admission of the unavoidable inadequacy of the Romantics' "efforts," description of this inadequacy as "necessary," and thus maintenance as well as utilization of this "unavoidable negative moment." However much Benjamin portrays the Romantics' utilization of the negative moment as an almost cynical attempt to recover ground lost in the overestimation or mysticism of the positive moment, there is no indication that he dismisses the need for some such allusion of critique to "the necessary incompleteness of infallibility" (142–43/52).[16]

If the basis of any practice of philosophy is the word as nemesis and inexhaustible source of the concept, Friedrich Schlegel is indeed perhaps exemplary insofar as his "terminological tendency" might not only be typical of "all mystical thinking" but also indicative of an "a priori" underlying "every thinker's terminology" (*W* 1, 141/I:1, 50). Schlegel wishes to show that words "often better understand themselves" than do those using them and that "philosophical words" must have "secret bonds of association" among them. Philosophical usage of words requires respect for the secret that words keep to themselves. Such usage belongs to that attempt at reaching "a

coming-to-understanding and a making-understandable [Verständigen und Verständlichmachen]," which requires and leads to "the purest and most genuine [gediegenste] incomprehensibility" (141/49).[17] The purest and most genuine incomprehensibility is distinct from an imposing conceptual morass; it is accomplished rather in a difficult but careful interchange with understanding. Benjamin stresses that this exercise is difficult, for understanding cannot be disregarded by philosophy (as performance) but is also not the foremost obligation of philosophy (as form or as performance). In the word as insatiable symbol, "the idea comes to self-understanding [Selbstverständigung]" and this understanding is "the opposite of all outwardly directed communication" (*O*, 36/I:1, *217*). The symbolic being of the name "determines [bestimmt] the givenness [Gegebenheit] of ideas" (36/*216*); as "pre-existent [ein Vorgegebenes]," ideas are "provided for consideration [Betrachtung]" (30/*210*) and are given "without intention, in the act of naming [im Benennen]" (37/217). "[P]hilosophical contemplation [Kontemplation]" is, therefore, a "renewal" restoring "the primordial apprehension [ursprüngliches Vernehmen] of words" (37/*217*). The philosopher's recurrent "task [Sache]" is to show the "primacy" of "the symbolic character of the word" (36/216–17). More diligently than Schlegel, however, Benjamin stresses—and maintains openness to—the lingering tension of communicative and symbolic; he conceives and practices philosophy as discursive and concrete now-time presenting its inadequacy in relation to the symbolic element in names.

As devotion to the word in thing or to thing as word, the function of practicing philosophy in perception is to ruin—but obviously not to claim dissolution of—empirically determinable appearances. "[E]mpirical reality" (die Empirie) does not determine truth (36/*216*), for "[t]he being [Sein] of the object [Gegenstandes] lives from the being of the idea," the idea as ground of thing (I:3, 929). It is impossible for "phenomena to be criteria for the existence of ideas," and it is impossible for ideas to "serve recognition [Erkenntnis] of phenomena" (*O*, 34/I:1, *214*). The "being" (Sein) of the name, the being "removed from all phenomenality," bears the "power" determining the "essence" (Wesen) of "empirical reality" (Empirie) (36/*216*). This name distinguishes itself, however, from Romantic, thoroughly nonvisual, linguistic mysticism. Ontology (says Benjamin in a rare explicit reference to ontology) is not a "palace" that can dispense with the "dimension of paintings [Gemälden]" ("Zum verlornen Abschluss der Notiz über die Symbolik in der Erkenntnis," VI, 39).[18] There can be, Benjamin contends, a relatively powerful and authentic "semblance" (Schein) in which "the nothing appears" (das Nichts erscheint). This is possible, of course, "only in the visual realm" (*W* 1, 223/I:3, 831). Such a possibility of nonappearance appearing pertains, Benjamin seems to mean, to the realm that is visualized or (perhaps especially, but not only, among those

without sight) could be imagined as though visualized. The primal force—origin—cannot, in any case, show itself without such a visual dimension. It cannot show itself without events. In its "rhythm," origin—*Ursprung*—does indeed pull in "the material of genesis [Entstehungsmaterial]." To appear as a rhythm, however, origin must have something recognizable in which to resonate. The material of genesis is this "stream of becoming" in which origin is "a whirlpool" (*O*, 45/I:1, *226*).[19] There remains, of course, something "leap-like, without connection, unrecognizable as such [sprunghaft, unzusammenhängend, unerkennbar schlechthin]." This enters the "now of recognizability only brokenly, inauthentically, unreally" (nur gebrochen, uneigentlich, unreal) (*W* 1, 277/VI, *46*). Not recognizable in "the naked, manifest existence of the factual," the rhythm of the "original [Ursprüngliche]" is apparent only to the "dual insight" that considers this rhythm restoration, but incomplete restoration. Precisely by showing its incompleteness, the rhythm shows itself to be restorative (*O*, 45/I:1, *226*). The rhythm restores by maintaining itself as unclosed perception. As the juncture of idea and perception, name facilitates restoration of rhythm between them. Ideas are given to us less as a "primordial language" (Ursprache) than as a "primordial apprehension" or "primordial hearing" (Urvernehmen). In the *Urvernehmen*, "words possess their naming nobility [benennenden Adel]" and are thus "unimpaired by cognitive meaning [erkennende Bedeutung]." Yet the primordial does not thereby annul or overcome perceptual mediation; primordial language is simply heard as not *entirely* manifesting itself as appearance (36/*216*).[20] Name facilitates hearing the primordial language that lends to appearances resonance of what determines them and yet is beyond them.

As this dynamic of the referential and the symbolic functions, the rhythm of name has neither Romantic nor Fichtean resolution. Ontologically transposing reflection into the positing absolute "I" (*W* 1, 128/I:1, 29), Fichte bases "the immediacy of recognition [Erkenntnis]" on "its vivid [anschauliche] nature" (a nature that one can look at, *an-schauen*) (123/*21*). In this immediacy, he seeks "the origin and the explanation of the world" and thus advances a "philosophical process" for eliminating from reflection the infinity clouding immediacy (125/*25*)—that is, a process for excluding "the infinity of the action of the 'I' from the realm of theoretical philosophy" (123/*22*). Yet intuition or vision (Anschauung), even so-called intellectual intuition or vision, cannot be thinking of "the being of ideas" (*O*, 35/I:1, 215). To this extent, the Romantic concept of reflection is a corrective. Not only concerned with guaranteeing "the immediacy of recognition [Erkenntnis]," the Romantic concept of reflection is an attempt to keep open to infinity, to offer an openness or "inconclusiveness" (Unabschließbarkeit) whereby each reflection becomes an object for the following one (*W* 1, 123/I:1, *21*).[21] The

Romantics nonetheless tend, as implied already, to sublate "being [Sein] and positing [Setzung]" in a reflection of the "self" (Selbst), in a "thinking" distinct from thinking in relation to an object (*W* 1, 128/I:1, 29).[22] For Benjamin, the rhythm of the name requires thinking independent of positing in relation to perceived objects, but this thinking is subordinate to the imperceptible object.

The object in itself and thinking of it are so intertwined that Benjamin needs "a good portion of stupidity" in order to think "a decent thought." In his concepts, thinking is unreservedly, almost blindly, subordinate to its "material [Stoff]."[23] The tendency toward blindness as well as toward stupidity is required by the nonempirical, intransigent stuff. To put it another way: the empirical is known solely in its relationship with its indeterminate stuff. Not opposed to its object, "true critique" is comparable to a chemical substance attacking another solely in a dismantling that "does not destroy" this other substance but "unveils" its "inner nature." The unveiled inner nature is the unveilable light of intransigent matter. In such unveiling, the dominant chemical matter—"diathetically," by predisposition—"attacks the *spiritual* things," attacks the spiritual being suppressing its intransigent source. The attacking matter is "light" (*C*, 84/*GB*, Vol. 1, *349*). Yet it is a blinding light—a light opening to infinity and thus tending toward blindness concerning appearances. The "light of theory" is "infinite," regardless of "how limited [begrenzt] objects may be" (letter of December 4, 1915, from Benjamin to Fritz Radt, *GB*, Vol. 1, 298). The infinity of theory is the light that does not "appear in language" (*C*, 84/*GB*, Vol. 1, 349). The infinity of theory is the task invisible in language; or at least it appears solely as rhythm of name breaking down perceptual and conceptual aseity. This rhythm of name is the rhythm of theory. Its blinding and stupefying light comes from the resistant nowhere that is everywhere.

Name in Truth: Nonrelational Rhythm

That it has "no relational connection [Relationsbeziehung]" (I:1, 928) does not, however, sever idea from "science" or "scholarship."[24] The significance of "ratio" is, of course, distinct from the tendency toward scholarship as untheoretical, as devoid of any awareness of "ideas," at best drawing on "a vague concept of 'hypotheses.'" The counterparts of such a tendency are variants of activism and aestheticism believing in the "purity of a world without theory," a state only possible "in convulsion and violence [im Krampf und Gewalt]" (*GB*, Vol. 1, 298). Precisely as nonrelational, idea offsets such brutality. As noted above, however, that there is "no true recognition [Erkenntnis] and no recognized [erkannte] truth" does not preclude "[c]ertain

recognitions [Erkenntnisse]" being "required for the presentation of truth" (*W* 1, 279/VI, *48*). Hegel's relative disregard of the material relation is, moreover, too cavalier. The idea "absorbs" the "succession of historical expressions" but—for this reason—is not "to construct a unity" out of them (*O*, 46/ I:1, 226–27). The rhythm of idea unfolds only if unencumbered by conceptual attempts to ensnare relations.[25] The "essentiality [Wesenheit] of the thing" is the essentiality pertaining to the thing "apart from all relations [Relationen] in which it could be thought" (I:1, 928). Yet the freedom from relations is effective as the symbolic within them. "All recognitions [Erkenntnisse]" have a "latent symbolic content [Gehalt]" making them "bearers of a powerful symbolic intention" (VI, 39). In this symbolic intransigence, recognitions or relations simultaneously facilitate and require the rhythm that is variously elaborated by Benjamin as the philosophical rhythm and the rhythm of philosophy.

Erkenntnis can maintain its own critique on the basis of the necessity, the rhythm, that impels such critique. Benjamin chooses the adjective "erkenntniskritische" over the adjective "erkenntnistheoretische" for the "Erkenntniskritische Vorrede" (Epistemo-critical Prologue). An earlier note titled "Erkenntnistheorie" (epistemology or theory of knowledge) also stresses that "*being* true [Wahr*sein*]" is "unrecognizable [unerkennbar]" and connected with an "Infinite *Giving* Up [Unendliche Auf*gabe*]" (*W* 1, 276/VI, *45*). The task (Aufgabe) is a constant giving (-gabe) up (Auf). In the task of philosophy, recognition is again and again given up. In its "origin [Ursprung]" ("the Platonic theory of ideas"), according to the "Erkenntniskritische Vorrede," philosophy (as a discipline and, perhaps Benjamin also means, as a broader practice) has one of its "profoundest" and most valuable "intentions" in the emphasis on truth as "form" that is not "object of recognition" (*O*, 30/I:1, *209*). The idea is "present [gegenwärtig]" only for the "essence" (Wesen) of the object (I:3, 928–29). Variants of neo-Platonism devoted to remembering as "a visual realization of images [eine anschauende Vergegenwärtigung von Bildern]" overlook that "true anamnesis" does not take "the image of the idea" into "the image of perception" (I:3, 937; see also *O*, 35/I:1, 215). In philosophy, the image of perception is rather taken into that of the idea. Kant's "mystical" terminology may thus be construed as an attempt to give its "concepts of origin [Ursprung]" to "the symbolic load," to "the inconspicuously glorifying dimension of authentic recognition [Erkenntnis]." Authentic recognition considers the painting to be in the palace (VI, 39). The picture image is in—and is recurrently to be given up to—the inconspicuously glorifying dimension of music.

> He stood still in the gloom of the hall, trying to catch the air that the voice was singing and gazing up at his wife. There was grace and mystery in her atti-

tude as if she were a symbol of something. . . . *Distant Music* he would call the picture if he were a painter. (*D*, 207)

Critique again and again presents picture in the inconspicuously and interminably distant music of linguistic being.

If "configuration" (Konfiguration)—"arrangement" (Zuordnung)—of "material elements [dinglicher Elemente] in the concept" serves "[p]resentation of ideas," this presentation shows ideas to be virtual; although ideas are the "objective interpretation" (objektive Interpretation) of phenomena, the objective "arrangement" (Anordnung) of phenomena is "virtual" (*O*, 34/I:1, 214–15). It presents itself solely as virtual. The -*heit* of the true, the *Wahrheit*, is the state of truth being recognizable as unrecognizable. This is the premise of a philosophical relation. "Wahr*heit*" of a relation with things—of a "Sachverhalts"—is "the function of the constellation [Konstellation] of the *being*-true [Wahr*sein*]" of all remaining relations with things, "sämtlicher übrigen Sachverhalte." The remaining circumstances or states of affairs constellate—shine—not as facts still to be known but as truth letting it be recognized that it is not recognized (*W* 1, 276–77/VI, 45–46). As performance, philosophy relates phenomena in concept-usage compatible with this requirement of constellation. After all, any being entering an idea becomes an abbreviation—albeit obscurely—of "the rest of the world of ideas," for every monad—every idea—indistinctly contains all the others; every idea contains "the image of the world." As the "objective interpretation" of phenomena, the idea issues the "task" (Aufgabe) of an "objective interpretation of the world" (*O*, 47–48/I:1, 228). In this task of world, phenomena are stars to be so arranged conceptually that ideas constellate in the arrangements or configurations. "Ideas are to things as constellations [Sternbilder] are to stars." The determinant significance is the dark background; ideas are "eternal constellations [ewige Konstellationen]." The relevant "significance" may be conveyed solely in concepts approaching the phenomenal elements as "points" in such "constellations [Konstellationen]"; ideas are neither the concepts nor the phenomenal laws of things (34/*214–15*). Ideas constellate in phenomena and in concepts as unseeable, nonconceptual.

> [I]ndices appearing and disappearing were eyes opening and closing; the eyes opening and closing were stars being born and being quenched. The vast cycle of starry life bore his weary mind outward to its verge and inward to its centre, a distant music accompanying him outward and inward. What music? (*P*, 103)

As form and thus as performance, philosophy releases concept and representation (picture making) into primordial music. The music is primordial, for it is not the sound of any concept or phenomenon. In Benjamin's translation of

Plato's theory of ideas from the priority of vision into that of hearing, the symbolic—nonconceptual and nonphenomenal—element is the essence of any word.[26] As stressed above, this priority of hearing does not entirely shun the representational function of name as conceptualization of properties. The rhythm of philosophy as practice depends on name being taken up as the juncture of perception and the silent symbolic music. More precisely, name as the juncture of perception and primordial music facilitates and requires the performance of philosophy.

It somehow follows from the infinite task of the symbolic language given in name, moreover, that the three steps for work on "good prose" are: "a musical stage when it is composed, an architectonic one when it is built, and a textile one when it is woven" (*W* 1, 455/IV:1, *102*). The music inspires, the building erects, and the text weaves back into the originary music.[27] Benjamin's own "texts" could, accordingly, be considered what the word "text" etymologically says—"woven fabric" (Gewebe).[28] Woven into the expressionless, construction leaves open the possibility—even the requirement—that the text be woven over and over again. Its inspiration—its music—is incorporated nowhere; it must be played anew to prevent the stultification of construction. That the philosophical heritage is name as infinite task, as ever-renewable giving-up to symbolic form, is no license to resignation with regard to concept; it is precisely the opposite. The word facilitating and requiring philosophy is the philosophy that is inherent in word and opposes resignation to concepts. That a "conceptual order" may be regarded by later interpreters as "serving the originary [originären] presentation of the world of ideas" probably depends on the intensity with which the initial "thinkers strove to outline the image of reality" (*O*, 32/I:1, *212*). Many of those called philosophers shun formal continuity, continuity of form, through claims for concept which indicate that this intensive striving for the image of reality has been abandoned or perhaps never undertaken. The philosophers lending formal and thereby historical continuity to philosophy are those reaching so beyond recognition that the primordial force of language may be heard in concepts. As implied already in passing, this acoustic inheritance and bequest can have unusual force in the relatively few basic words of philosophy.

HARMONY OF SOME OLD WORDS

The ubiquitous possibility of philosophizing does not discredit the notion of philosophy as a discipline. As one might put it in adaptation of terminology Benjamin occasionally used, discursive system is not necessarily incompatible with symbolic system. Benjamin criticizes disregard of discursive media-

tion as he refers to Friedrich Schlegel's lack of "full clarity" about "systematic intentions"; in the *Athenäum* period, which is of greatest interest to Benjamin, Schlegel did not possess the "logical power" necessary to bring systematic thoughts out of his "still rich and passionate thinking" (*W* 1, 137/I:1, 44). The attempt "to comprehend the system absolutely" is the "essence" of Schlegel's "mysticism." This is the opposite of Kant, whom Schlegel—like Benjamin in this respect—eventually criticizes for trying to comprehend the absolute systematically (with polemicized systematic reason) (138–39/*45–46*). In comparison with Schlegel of the *Athenäum* period, Benjamin is more interested in the function of discursive system in philosophy. In contrast with many of Kant's tendencies, however, Benjamin is primarily interested in how such a system maintains the integrity of the symbolic system. The discursive system is not advanced as conceptual inclusion and exclusion but as performance of symbolic inclusion. The "fullness of positivity" is not "polemic and negation"; discursive "systems" are "true" in maintaining and "false" in negating (I:3, 931). This fullness of maintaining involves discursive philosophical system as inheritance and bequest of symbolic system.

Efforts such as those of Benjamin and Rosenzweig to shun the negative system did not amount to an exodus from anything that could be called philosophy so much as an attempt by many younger people (in diverse ways and devoid of fixed program) to avoid anthropocentrism and its amenability to legitimation of brutality. In very distinct ways, Hegel and Kant polemically negate, and many of their epigones or successors were and are often even more brutal in this regard. Rosenzweig's *The Star of Redemption* (1921), much of which was written at the Balkan front during World War I, is an indictment of philosophy (particularly Hegelianism) as a "compassionate" but "cruel" lie, the lie that mortality does not obviate human "cognition of the All."[29] This lie is committed by systems that either discursively exclude what does not fit into them (Kant) or discursively include all that does not fit into them (Hegel). For Benjamin, in contrast, truth requires "entry" (Eingehen) and "disappearance" (Verschwinden) (*O*, 36/I:1, *216*). It requires an end of intention; "truth is the death of intentio" ("die Wahrheit ist der Tod der intentio"), the death of intentionality ("Arten des Wissens" [approximately 1921], VI, 48). For those philosophers of Benjamin's generation striving to break out of idealism and correlative versions of system, there were already recent precursors, and the most obvious was perhaps Husserlian phenomenology; it is possible, however, that Husserl's work was too similar to certain strains of neo-Kantianism—not least with regard to the transcendental ego and its intentionality—to be exemplary for Benjamin or for kindred spirits, such as Rosenzweig with his turn of speculation to theological teachings or Bloch with his theoretical messianism (and its lack of concern about Kantian epistemological constraints).[30] With regard to the variants of

discursive system most opposed by Benjamin (pre-Kantian metaphysics, Kantianism, Hegelianism), a specific remark by him is especially noteworthy: As "the death of intention," truth is not ultimately determinable in "conceptual intention [Begriffsintention]" (*O*, 36/I:1, *216*; see also I:3, 937). Superceding pre-Kantian, Kantian, and post-Kantian discursive syntheses, a more certain unity prevails. If the coming philosophy is a deep struggle for certainty (for "systematic unity or truth"), it involves unpredictability and boldness (*W* 1, 100/II:1, 158). The struggle of philosophy for certainty is determined by, and open to, the certainty of uncertainty.

The principal words of philosophy comprise an inheritable basis for fostering this struggle. "[E]very brutality [Gewaltsamkeit]" may be kept in abeyance insofar as "a quiet, clear fire" is constantly illuminating "the images [Bilder] of those first and simplest ideas to which productivity [Produktivität] always comes back in order to be able to grow and to develop [sich entfalten]" (*GB*, Vol. 1, 299). As inheritance and bequest keeping brutality in abeyance, these basic ideas require images in which recognition gives way to its ultimately unrecognizable justification. At least for a phase, Benjamin considers Kant—with the exception of Plato—to be "perhaps the only" philosopher reaching beyond the priority of the "scope" and the "depth" of "recognition" to the priority of the "justification [Rechtfertigung]" of recognition. Kant's is the only relatively recent philosophy providing historical continuity of "decisive and systematic consequence" (*W* 1, 100/II:1, 157–58). This continuity—this inheritance and bequest—is sustained insofar as Kant releases principal coinages of philosophy from speculative metaphysics by keeping open the gaps between these coinages. Kant also creates new constraints, of course, and these are compounded by most neo-Kantianism. "[P]rolegomena to a future metaphysics" are to be acquired on the basis of Kant's "typic," but this metaphysics is to be a "higher experience" (102/*160*). In the *Critique of Practical Reason*, the typic of the moral law is advanced as the possibility of moral reason emerging as neither an empiricism nor a mysticism (a presumption of intuitive union with God).[31] Whereas the typic is a kind of analogy for what remains symbolic, Benjamin is interested in opening Kant's austere typic somewhat more to the *higher experience* of what might be considered a Hamannian-Platonic moment. More generally, and in contrast with associations commonly made with the Kantian system, this transcendent moment and Kant's basic divisions—epistemology, ethics, and aesthetics—complement one another. If the Platonic dialogue "plays the role of system, the necessity of which is evident only to those philosophers who know that the truth is not a coherence of recognition [Erkenntniszusammenhang] but a symbolic intention," the latter symbolic intention is that of "system-divisions [Systemglieder] towards one another" (VI, 39). In their

symbolic intention toward one another, the fundamental divisions in the discipline of philosophy recall that justification is unrealized in recognition.

These divisions in the discipline of philosophy maintain a discontinuity straining subsumptive "system-logic" (Systemlogik) (*O*, 33/I:1, *213*). The superiority of "the trichotomy of the Kantian system"—the triad of Kant's critiques (epistemology, ethics, and aesthetics), "the absolute trichotomy of the system, which in this threefold aspect is related to the entire realm of culture"—is, of course, not only that it resists any preceding metaphysical monolith but also that it is a basis for resisting the synthesis advanced in post-Kantian formalistic dialectics (*W* 1, 106/II:1, 165–66).[32] In this context, fundamental divisions in philosophy are obviously not self-satisfied disciplinary demarcations but openings into the realm greater than them separately or together. The "great divisions [Gliederungen]" determining "not only the systems, but also the philosophical terminology—logic, ethics, and aesthetics, to mention the most general—do not have their significance as names of special disciplines but as memorials [Denkmale] in the discontinuous structure of the world of ideas" (*O*, 33/I:1, *213*). As the divisions memorialize the discontinuities among them, they memorialize the mysteriously great and constitutive task of philosophy. The "greater" the object, the more prominent are the interruptions in consideration of it (I:3, 927–28).

Yet the great object of philosophy, this object greater than recognition, is the object of all intelligibility. The discontinuity required for philosophy as presentation is the discontinuity required for intelligibility. The "existence of the *mundus intelligibilis* depends on the irrevocable [unaufhebbaren] distance between pure essentialities [Wesenheiten]," just "as the harmony of the spheres depends on the orbits of stars which do not come into contact with each other" (*O*, 37/I:1, *217*). As presentation (and regardless of whether it is presentation within or outside a recognizable discipline called philosophy), philosophy is a presentation of this dependence on discontinuity. Philosophy presents discontinuity at the fundamental or disciplinary level of the principal divisions within the discipline of philosophy, but is also the carrying and the cultivation of such presentational discontinuity in each specific inquiry. Complete neither unto itself nor in connection with other fragments, the fragment in philosophy as presentation maintains rather than polemically negates; it opens into the unshowable harmony to which all and everything belong. Benjamin is critical of Schlegel and Nietzsche in many respects. The aphoristic styles of Schlegel and Nietzsche are, nonetheless, salutary in fragments that are opposed to most claims of realizing system and yet somehow bound to the possibility of a congruence between a discursive system and a symbolic one (*W* 1, 135–37/I:1, 40–44). In this congruence of fragments and symbolic system, distance or discontinuity between fragments is the unsublatable harmony. Philosophy as presentation or performance follows

and presupposes unsublatable harmony. Any profound harmony requires allowance for distance or discontinuity.

Just as "irrevocable [unverrückbare] distance" is the "precondition" of the "reciprocal relationship" prevailing in "every profound harmony," harmony in the discipline of philosophy is not produced by the "essentialities [Wesenheiten]" with each other; a "prestabilized," supremely objective harmony emerges "from the essentialities like the melody of the spheres from the circulation of the stars" (I:3, 928). Harmony is the invisible, nonconceptual continuum between the gaps. The principal names in the discipline of philosophy—and, indeed, all names in any performance of philosophy—are in a presentational discontinuity lending resonance to their symbolic-linguistic continuum.

"Ignorance" (Unkunde) of "discontinuous finitude" often thwarts "energetic attempts at renewal of the theory of ideas," as is evident in early Romanticism insofar as "truth" is approached as though it has "the character of a reflexive consciousness" rather than a "linguistic character" (*O*, 38/I:1, *218*; see also I:3, 938). More than it shows tension in its relation with linguistic being, the Romantic concept sometimes tends to be presented as though it entirely unites with linguistic being. Saying it "is equally fatal for spirit to have a system and to have none," and suggesting spirit "will simply have to resolve, therefore, to combine the two," Friedrich Schlegel considers the "organon of this combination" to be "nothing other than the conceptual term," albeit ultimately a multiplicity of terms (*W* 1, 140/I:1, *48*).[33] This notion of organon may lend conceptuality greater *linguistic* or *symbolic* weight than Benjamin seems to give it. However provisionally or temporarily, the conceptual term seems to be considered realization of its linguistic-symbolic force. Schlegel's conceptual amalgamations and blurrings are, moreover, considered by Benjamin to be unfruitful mixings in this "positive tendency" at the basis of Schlegel's "multiplicitous attempts to determine the absolute" (*W* 1, 138/I:1, *45*). This conflative tendency indicates Romantic aestheticism. Regardless of how legitimate it might be that Schlegel would attempt (during the *Athenäum* period) to fulfill his "systematic intention" by focussing on the "concept of art" (138/*44*), his conception of "the absolute" as "the system in the shape [Gestalt] of art" (138/*45*) shows disregard of the "system-value of ethics"; the "aesthetic interest" dominates everything in Schlegel as artist-philosopher and philosophizing artist (137/*44*). The system-value of ethics is, however, that ethics has no determinable system, no system-shape. The "moral lesson" has "no system"—no realizable system— and thus sets itself "an unfulfillable task" (II:1, 51). Ethics resists the transfigurative claims of symbolist—Romantic—aesthetics; ethics saves aesthetics precisely by prohibiting it claim to a Romantically transfigurative power. Ethical critique

does not sublate aesthetic critique, but aesthetic critique also does not sublate ethical critique (*W* 1, 140/I:1, 48; see also *W* 1, 219/I:3, 835). This discontinuity of aesthetics and ethics is indicative of the discontinuity integral to the discipline of philosophy.

As implied already, the linguistic being of the language of names requires accentuation of gaps or discontinuity between names, but old names of philosophy—the basic divisions as well as various other old and distinctly philosophical words—uniquely lend themselves to this linguistic task. In a letter to Hofmannsthal, Benjamin introduces an architectural conception of philosophy that may initially seem to incur or adopt the pretensions of those systematizers criticized by him. If names are the house of language, the very distinctly philosophical names comprise a foundation for this linguistic house. The "house"—the "inherited palace"—of "every truth" is language and this palace "is constructed [errichtet] out of the oldest *logoi*." Yet the construction enters a blessed order facilitating the struggle to have the "surface" of philosophy's old words—otherwise "encrusted" in concept—so loosened that hidden "forms of linguistic life" may resonate (*C*, 228–29/*GB*, Vol. 2, *409*). In this letter of January 23, 1924, to Hofmannsthal, Benjamin thus seems to echo the longing of Hofmannsthal's Lord Chandos for the language in which "the mute things speak to me," the language in which "I will perhaps some day in my grave give account of myself to an unknown judge." This language is not Latin, English, Italian, or Spanish but rather one with yet unfamiliar words.[34] This still strange language, this hidden determinant in words, can be indirectly released under the influence of old words of philosophy that are not made all too familiar by concepts. Philosophical "remembrance" (Erinnerung) can occur again and again "in the old words" (I:3, 938). Whereas Friedrich Schlegel's recurrent attempts at reflection as intentional registration of the absolute entail numerous neologisms and continually renewed naming of the absolute (*W* 1, 139–40/I:1, 47–48), Benjamin regards the history of philosophy as "struggle" (Kampf) for the presentation of ideas, "struggle for the presentation of a few, constantly recurrent words" (*O*, 37/I:1, *217*). Such struggle on behalf of these few divisional words, which may (as Benjamin seems increasingly to think) best take place in the pronouncedly indirect form of elaborating various other words (also often old words) in their resistance to intention, recalls the hidden harmony in the symbolic-linguistic continuum.

Contrary to what is perhaps frequently assumed, various old words—especially the divisions of philosophy—can attest to the perseverance of language over concept. The linguistic power sealed in various old names—including, for example, "destiny" (Schicksal) and "character" (Charakter)—requires resistance both to the conceptual encrustment of tradition and to rigid

proclamations of the new (*C*, 229/*GB*, Vol. 2, 409).[35] As Heidegger seeks to break with the tradition of metaphysics, he comes to explore ways of abandoning traditional philosophical terminology in favor of a founding, poetic naming.[36] Suggesting in a somewhat similar vein that Benjamin was a poet and not a philosopher, Arendt contends that Benjamin uses metaphors to bring about the oneness of the world poetically.[37] Adorno makes an (admittedly virulent) anti-Heideggerian objection to this.[38] Irrespective of how indispensable it may be for conceptual elaboration or dehypostatizaton of terminology, neologizing is in certain respects considered philosophically dubious by Benjamin; his "anti-idealist" impulse prohibits philosophy from naming the phenomenal world as though for the first time.[39] Benjamin neither presumes the possibility of complete decontamination nor equates divine creation and name-giving.[40] As possibility of sustaining tension of linguistic being and unavoidable contamination, the old words facilitate unsettling of conceptual complacency. New "terminologies—an unsuccessful act of naming in which intention has a greater share than language—are," in contrast, "devoid of the objectivity which history gave to the principal coinages [Hauptprägungen] of philosophical reflections" (*O*, 37/I:1 *217*). History gave this objectivity by virtue of the unique resistance of these coinages—these words—to history.

This resistance is the tone of philosophy, a tone of the discipline (as quite conceivably independent of departments) of philosophy but also a tone that is effective in any presentation to be called philosophy. It underlies the resistance of all ideas to conceptual domination or sublation. The latter resistance is the harmony of ideas. The "harmonious" or "sounding" (tönende) relationship of the named, countable multiplicity of "essentialities [Wesenheiten]" is called "truth" (*O*, 37/I:1, *218*). No more, perhaps even less, than other ideas, essentialities—in their countable multiplicity—cannot be conflated. In the "irreducible multiplicity [unreduzierbare Vielheit]" of ideas, as noted already, "essentialities" (Wesenheiten) relate to one another like suns that "do not touch one another" (I:3, 928). The task of philosophy is to present this "prestabilized" harmony of ideas that ultimately do not reach one another (through "touching" or "contact" [Berührung] as "Communication" [948]) and yet are not unaffected by one another. The relationship of harmony and multiplicity in philosophy as presentation is not unlike the relationship of harmony and multiplicity in languages. As long as human history and pure language are in any way distinct, there is an obvious sense in which it is not degenerate that there is an insurmountable multiplicity of human languages (although many a linguistic mystic claims such degeneracy); the linguistically essential is rather the harmony that does not annul multiplicity (*W* 1, 273/VI, 24). The harmony of ideas is similarly that they relate to one another in the kind of discontinuity with which suns relate to one another (*O*, 37/I:1, *218*).

Whereas not every usage of language is devoted to presentation of this discontinuous harmony of ideas, philosophy must present names in a discontinuity accentuating the gaps—and thus the harmony—between them. "[S]olely" (allein) in the "realm [Bereich] of philosophy" (a formulation which, in this text, seems to mean philosophy as practice) must truth come to appearance. This appearance is no watertightness or airtightness. It is not what so many seem to expect from philosophy or seem to think philosophy expects of itself. It is instead "a resounding [Tönen] akin to music" (*W* 1, 272/VI, *23*). Yet it is also the resonance unique to philosophy. The practice of philosophy is conceivable anywhere, with any object of consideration. Practices of philosophy present themselves, however, emerging from the old basic divisions as well as from various other old words, albeit with varying explicitness or acknowledgment. One of the consequences of "deconstruction" (admittedly, a relatively new word) has been discussion of old philosophical words without the encumbrance of many earlier conceptual hypostatizations. Regardless of whether or not the institutions self-acclaimedly associated with philosophy are—philosophically considered—in need of this newness more than Benjamin realizes, even Benjamin may be said to suggest recurrently that department "philosophy" has largely become a travesty of philosophy. The relative newness of deconstruction may be (or may have been) necessary for the old words to echo renewedly the harmony, the philosophical tone, in which words are profoundly without adequate concepts and without an articulable unity that would sublate the gaps between them.

HISTORY AND THE DRAMA OF PHILOSOPHY

In any case, no name either has an adequate concept or offers a sublation of its differences with other names. Each name has idea within it as word; this idea is no concept and is not submerged by a conceptually determinable relation with other ideas. The persistence of ideas ensues from history never being an adequate answer for them. This is especially obvious, as suggested above, in the words of philosophical systems. If "referred to the world of ideas" rather than to "the empirical world," "systems, such as Plato's theory of ideas, Leibniz's monadology, or Hegel's dialectic"—systems that, as "conceptual frameworks," have largely "long since become fragile"—not only "still preserve their meaning [Sinn]" but "very often unfold it more fully." This meaning is neither conceptual nor empirical but is rather a "validity" (Geltung) that these systems retain "as outlines of a description of the world" (*O*, 32/I:1, *212*). Any philosophical validity derives from the wrenching or eliciting of concepts into immersion in the limitless world; this is immersion in the word in any name, for the word in name

is entry to the world of ideas, the world beyond conceptual and empirical history. The "task" (Aufgabe) of "immersion" (Versenkung) in the "real [reale] world" (48/*228*) requires philosophy or "philosophical history"—"the science [Wissenschaft] of origin"—to recognize that the idea absorbs history, makes investigations concerning the idea in principle without historical limits (47/228). As stressed above, this approach is possible everywhere and anywhere, even with coffee grounds. Although obviously not entirely revealed in history, God renders history in principle limitless. Benjamin's notion of "origin" (Ursprung) is an overloading ensuing from implicit and explicit association with the category of revelation (I:3, 935).[41] The "concept of revelation"—of revelation as the sole complete convergence of spiritual and linguistic being, expression and expressionless—is the center of linguistic theory and the most intimate connection of linguistic theory with the philosophy of religion. As the "highest spiritual being," revelation is based on the language of name and on the spiritual being that communicates itself as linguistic being in this language—the human (*W* 1, 66–67/II:1, 146–47). Otherwise forgotten revelation is manifestly effective, above all, as history overloaded with the human's real world, that is, the world of ideas (I:3, 936), which are the words in names. This overloading of history is the drama determinant in practicing philosophy.

With history as no answer for ideas, history—the "order of the profane"—cannot be divine. It is "the cardinal merit of Bloch's *Spirit of Utopia*" to "have repudiated . . . the political significance of theocracy" (*W* 3, 305/II:1, 203).[42] The consequences of this repudiation were, however, not quite drawn in Bloch's book. Scholem complains of various features, especially of the "emanations of the central Christology that is foisted upon us here."[43] Agreeing with Scholem, Benjamin concedes that his "philosophical *thinking*" diverges enormously from Bloch's book (*C*, 160/*GB*, Vol. 2, 75); he says a little earlier to Ernst Schoen that even the important convergences of the book with his own "convictions" do not enable it to correspond anywhere "to my idea of philosophy" (158/*72–73*).[44] Benjamin's attitude at the time has been characterized as avoidance of "Bloch's this-worldly eschatology and . . . optimistic utopianism."[45]

There have, nonetheless, been attempts to align Benjamin's theory of ideas with the concept of symbol-intention in Bloch's *Das Prinzip Hoffnung* (1959). With reference to the "'anticipating function' [Bloch]," to the "*outline of a better world*," it has been suggested not only that the "idea" is transformation of the ostensibly real into "the possible" but also that "the ideal character" of the idea treats "this possible" as "not-being [Nichtsein] and in no way as nothing [Nichts]," treats it as "the latent *being* of a non-existing being [Nichtseienden]." The idea as "objective interpretation of the world" is "interpretation of objective possibilities."[46] For Benjamin, however, the idea is

not not-being but is indeed nothing. The being of the idea appears as nothing (see page 69). Yet at least one more study on Benjamin has very emphatically turned the Blochian orientation into a norm. According to this norm, "the relevance of Benjamin's theory of knowledge—as well as that of speculative thought in general—should be sought today" "precisely" in terms of the Blochian alignment of objective interpretation with interpretation of objective possibilities.[47] This alignment more or less dispenses with Benjamin's emphasis on preponderant symbolic intentionlessness.[48]

If a "mystical conception of history" can involve the "philosophy of history" providing "essential teachings" on the "relation" of the profane with the "Messianic," however, the most basic teaching is that "nothing historical" can assume the consummative, completing, creating capacity which is solely the Messiah's (W 3, 305/II:1, 203). This teaching has history disturbed by nature and has versions of nature (or naturalizing) disturbed by history.

In Kant's writings and even in Kant's ethics, Benjamin detects a "*despot*" whose "spirit relentlessly *he*-philosophizes certain insights." Especially in later writings, moreover, Kant "hounds and senselessly hits at his frontrunner, logos" (C, 125/*GB*, Vol. 1, *455*). In this sense, logos could be considered an unmanly destruction. ("*Argumentum ad feminam*" U, 477; "BLOOM: . . . Here's your stick. / STEPHEN: Stick, no. Reason. This feast of pure reason." U, 527–28) Logos is not the manly assurance with which the so-called philosophical tradition has so often associated it.[49] The categorical imperative is "incontestable" in its "minimal programme" of recognizing moral law as universal, unto itself, and incapable of being a means. Its despotism is that its principal function is to exonerate from critique. Those espousing it feel released from criticizing the orders that they daily perpetuate, for it cannot enter the realm of means anyway. It is not a freedom within shape and scarcely has consequence for shape. There can, in contrast, be critique in which the shapeless pointedly, unsettlingly, contradicts legal order (W 1, 241–42/II:1, 187–88).[50] Too readily, Kant facilitates removal of critique from such drama.

Critical freedom in shape is the force of ruination. The ostensibly real world is released into the coming world of ruination. In Benjamin's conception of critique, the divine is not a "reactionary" "return to the past of a purer origin." Ruination is the possibility of recognizing the otherwise unrecognizable divine. Ruination is not opposed to the divine.[51] Although "the most profound" antithesis is that of "coming world" to "world," it is an antithesis that lends profundity to their encounter (W 1, 226/VI, 99). The profundity is that critique may free—free "with recognition" (erkennend)—"the future from its distorted [verbildeten] form in the present" (38/II:1, 75). In critique, recognition has the future as the divine certainty of uncertainty; the future

destroys any other certainty of the present. In the "becoming-obvious [Offenbar-Werden]" of "the divine," "the life of the performer [Darstellers]," the life of the one performing, is subject to "a great process of fulfilment [Erfüllungsprozess]" whereby the "decline of the world" (Weltuntergang)—the decline of the scene of history—is both "destruction [Zerstörung] and liberation [Befreiung] of a (dramatic) performance [einer (dramatischen) Darstellung]." Destruction intrinsic to history is a liberation for performance in it (226/VI, 98–99).[52] This is the kind of performance suggested by Benjamin's notion of a philosophy of the history of violence.

Philosophy of the history of violence is no more but also no less than an "attitude [Einstellung] towards temporal data." It is a "critical, discriminating and deciding" attitude about such data. The translation of "Einstellung" as "attitude" should not imply a self-satisfied posturing. For the latter, German-speakers would tend to use the word "Attitüde"; as a way of avoiding such a connotation, Jephcott's translation of "Einstellung" as "approach" has much to say for it. Benjamin's proposed attitude is, in any case, neither "Attitüde" nor the grand and subsumptive approach normally associated with the philosophy of history. Philosophy of the history of violence is a critique of the closure of history from the force, of "decay" (Verfall). The abolition of the state through revolution might demonstrate unalloyed expression of this divine (as distinct from historical) force, but there can be no certain recognition in this regard. Divine violence is invisible and can only be assuredly effective as the critique of mythic violence; this is critique of the establishment and preservation of closure, for the latter violence can be recognized (251–52/II:1, *202–3*; see also "Die Bedeutung der Zeit in der moralischen Welt" [a note of 1921], VI, 97–98). Mythic violence closes against what it cannot incorporate. Critique is a task, in contrast, as long as various conditions for "the system" are lacking (*W* 1, 38/II:1, 75). It is a task as long as ruination prevails over history. It is the task of criticizing denial of ruination.

It may well be that myth—as the policing power—is or has become scarcely recognizable.[53] Many policing actions—even relatively banal ones, such as some academic intrigues—nonetheless display themselves as mythic once criticism of them becomes possible; a way of acting or a form of expression may come to be considered as undue closure. This is not to say that acts or expressive forms are ever entirely mythic or ever could be; nor is it to say that one might not produce or reproduce myth while intending or trying to dispense with it. Yet criticism can at least conceive of forms as myth precisely in their eagerness to perpetuate authority over criticism. Children often bump into this incompatibility of myth and critique.

> —Well, my little man, said the rector, what is it? . . .
> —Father Dolan came in today and pandied me because I was not writing my theme. . . .
> —. . . I told him I broke them [my glasses], sir, and he pandied me.
> —Did you tell him that you had written home for a new pair?, the rector asked.
> —No, sir.
> —O well then, said the rector, Father Dolan did not understand. You can say that I excuse you from your lessons for a few days.
> —Stephen said quickly for fear his trembling would prevent him:
> —Yes, sir, but Father Dolan said he will come in tomorrow to pandy me again for it.
> —Very well, the rector said, it is a mistake and I shall speak to Father Dolan myself. Will that do now? (*P*, 57–58)

Adults tend to be very determined to find some way of transforming the child's critique back into compliance with myth; foremost priority is perpetuation of the authority that was criticized in the first place.

> —By the bye, said Mr Dedalus at length, the rector, or provincial rather, was telling me that story about you and Father Dolan. . . .
>
> Mr Dedalus imitated the mincing nasal tone of the provincial.
>
> Father Dolan and I, when I told them all at dinner about it, Father Dolan and I had a great laugh over it. *You better mind yourself, Father Dolan, said I, or young Dedalus will send you up for twice nine.* We had a famous laugh together over it. Ha! Ha! Ha!
>
> Mr Dedalus turned to his wife and interjected in his natural voice:
> —Shows you the spirit in which they take the boys there. O, a jesuit for your life. . . .
>
> He reassumed the provincial's voice and repeated:
> —*I told them all at dinner about it and Father Dolan and I and all of us we had a hearty laugh together over it. Ha! Ha! Ha!* (*P*, 72–73)

Occasionally, however, even an adult will brood critically.

> A lot of those policemen, whom he cordially disliked, were admittedly unscrupulous in the service of the Crown. . . . Never on the spot when wanted but in quiet parts of the city, Pembroke Road, for example, the guardians of the law were well in evidence, the obvious reason being they were paid to protect the upper classes. (*U*, 535)

Even if one might not be sure that something should be addressed as myth (there is presumably, after all, resonance of truth, of language as such, in what otherwise seems to be myth) or there seem unacceptable risks to defying

myth (it is very rare that one can tactically "win" with such a decision, although win and lose become very unsuitable concepts—precisely because they are so mythic), myth manifests itself as denial of the truly historical.

The truly historical is "religious-pragmatic." It is divine in keeping the pragmatic free of organicism. The recourse of late Romanticism and the Historical School to a self-acclaimed "organic" contemplation draws on the ideal of immediate naturalness and on the correlative developmental standard of a "beautiful" people or nation. This oscillation between ethical and aesthetic organicism abandons the "realm of truly historical . . . consideration" by refusing to "recognize [erkennen]" the world in its multiplicity, in its "layerings" (*W* 1, 284–85/VI, 96–97).[54] Independent of such leveling and denial of multiplicity, quite intangible aspects of religious and educational tradition show themselves as release from myth (*W* 1, 250/II:1, 200).

Benjamin notes the early Romantic outlook that any coinciding of religion and history involves an attempt at "*thinking* and life" of "the higher sphere." This contrasts with Late Romanticism, for Late Romanticism positivistically invokes "religious and historical facts" to suggest life feelings are in accord with historical order. The quiet fall of Christianity is the Christian "morality [Moral]" that is, as Schlegel suggests, not "quiet and lively enough." Christian morality does not lend resonance to silence as silence; it instead uses history to keep silence silent. Christian morality seems "aroused"; the German word "erregt" often has sexual connotations. Christian morality seems "male (in the broadest sense) and ultimately unhistorical." The imposition upon history is dismissal of the silence in history (*C*, 88–89/*GB*, Vol. 1, *362–63*). ("Why I left the Church of Rome." *U*, 481)

Yet Benjamin is not without reservation concerning the early Romantic attempt at orgiastic disclosure of all secret sources of the tradition. This attempt to have tradition overflow unswervingly into all of humanity is an attempt to achieve for religion what Kant supposedly achieved for "theoretical objects": to show the "form." Benjamin's response to Kant and the early Romantics is that form is ultimately unrealizable. He even asks whether there is "a *form* of religion" (*C*, 89/*GB*, Vol. 1, *363*).[55] The theological moment indispensable for doing philosophy is at best a form exercised as determinant but undisclosed silence.

The latter silence is the absolute dependence that is recalled by the practice of philosophy. The only legitimate rule would be one converging with this dependence. There is no such rule. Preparation for a possible or potential culture might entail an antinomian attempt to bring the notion of culture to safety from "a chaotic time." Yet if Goethe suggests "there is no true culture without despotism," this despotism is to attack itself, to transform itself from a "physical"

despotism into an "ideal [ideellen]" one (letter of November 21, 1912, to Ludwig Strauß, *GB*, Vol. 1, 77–78).[56] In case this seems to license those eager to endorse a cultural despotism or to foster a complacency about cultural despotism, it should be stressed that Benjamin's potential physical sanctuaries—student organization, school, university, book, essay, this or that companion, even the proletariat—are never considered vehicles of the ideal. Benjamin's cultural despotism or antinomian ethics is, above all, devoted to eroding itself, for the ideally despotic is the rule of pure language (which could indeed be called the form of religion); it is intrinsically oriented toward the erosion of the conventionally despotic. In order to reach beyond "the feeling of a conventional dependence" to a "feeling of absolute dependence [der schlechthinnigen Abhängigkeit]" (mentioned in Friedrich Schleiermacher's *Der christliche Glaube*), cultural ethics requires humility (II:1, 33). The related uncompromising, antipedagogical longing for a school that could be loved may be "hostile to the present," "arrogant," even "undemocratic" (II:1, 41).[57] Such hostility, arrogance, and undemocratic attitude may be directed at conventionally based authority but—precisely for this reason—must itself resist temptation to alliance with such authority. The feeling of what is unspeakable and yet has the force of the true is, after all, feeling of dependence on God. The humility required by this feeling is the inherent humility of philosophy. As performance, philosophy performs the historical impossibility of its task.

Performance of the impossibility of converging with absolute dependence is required by all disciplines if they are to be in any way responsive to their symbolic-linguistic basis (*O*, 36–37/I:1, 216–17). The "insights" of the individual sciences remain inferior as long as they, "so to speak, nomadically—now here, now there" so regard language in terms of "sign-character" that their terminology has an "irresponsible arbitrariness" (*C*, 228–29/*GB*, Vol. 2, 409).[58] As the absolute dependence, theological form undermines such self-satisfaction in specific sciences or in some combination of specific sciences. With regard to the latter combination, Benjamin remarks: "[O]rigin [Ursprung]" is not to be sought in any "eclecticism of the modern academy" (I:3, 926). The philosophical form of community is not necessarily served by law students being lectured on literary questions and medical students on legal questions; the respective disciplines must instead perform themselves as subordinate to the philosophical form in which their specialized training and specialized schools may be rendered problematic (*W* 1, 42–43/II:1, 82). Concerning the "object of psychology," therefore, Benjamin suggests consideration be given to how God is "at work" in shaping the human (VI, 66).[59] Just as intensive consideration of each discipline must lead into the symbolic core creating interruptions or gaps within the discipline, the translation between disciplines must not simply be the translation of specializations but—much

more than this—translation of the communal form constitutive of each and all of them. If there is a "reasonable sense" to be connected—however "provisionally"—"with the word 'metaphysical,'" then "metaphysical" is the "recognition [Erkenntnis]" trying "to recognize [erkennen] science [Wissenschaft] a priori as a sphere in the absolute, divine context of order." God is the necessary and universal condition of the possibility of autonomous science (not only ethics but every science) (*C*, 112/*GB*, Vol. 1, *422*). Divine autonomy is the freedom of science from its presumed accomplishments. Without this freedom, it would not be science. In a manner of speaking: Without God, science would not be science. In its idea independent of manifestations and independent of the ideas of other sciences, each science has the autonomous core requiring philosophical humility. This autonomous core is the common philosophical form in which each science must have humility about its manifestations.

As Benjamin disparages Kantian epistemological "experience" as "only a modern and religiously particularly infertile" "metaphysics or mythology" (*W* 1, 103/II:1, *162*), he proposes a metaphysics that is to have the "universal power to tie all of experience immediately to the concept of God, through ideas" (105/*164*). As idea independent of concept and independent of other ideas, the linguistic power in name is the possibility of transforming recognition into a philosophical power that is also a theological power. In this theological power, there is constant circulation amid levels of meaning for any given name and constant exploration or accentuation of the gaps between names. For the correlative discipline or program of philosophy, the "concept of experience" is to be created by a "concept of recognition [Erkenntnis] gained from reflection on the linguistic nature of recognition" (108/*168*). The linguistic nature of recognition keeps recognition in absolute (as opposed to relative) dependence on the symbolic force. Notwithstanding an appreciation for Benjamin's emphasis on the prevalence of the "symbolic" (Symbolischen) over the "dominating [herrschaftliche] character of concepts," the first book on Benjamin was partly an attempt to translate Benjamin's early writings from their esoteric language into a more mainstream philosophical one and even suggested a kind of accord with Hegel's procedure of sublating in "determinate negation."[60] Adorno similarly contends that Benjamin's "bequest consists of the task . . . to catch up with [einzuholen] the intentionless through the concept."[61] Although "confrontation [Auseinandersetzung]" with history does enable a philosophical outlook wanting to be "canonical" to show "most clearly" its "ultimate metaphysical dignity," this dignity and a justifiable canonical status do not derive so much from concept catching the intentionless as from performance in history of the theological force determining history but not entirely revealed in it. Only on the basis of such performance

could philosophy of history—*Geschichtsphilosophie*—ever be, in Benjamin's view, the clearest emergence of the "specific affinity [Verwandtschaft]" of a philosophy with "true doctrine [Lehre]" (*C*, 98/*GB*, Vol. 1, *391*).

"Lehre" may be translated as "teaching" or "doctrine"; "Lehre" in the practice of philosophy is taught as determinant form that cannot be taught. The affinity of this performance with theological doctrine is that it does not presume to be theological doctrine. The practice of philosophy is—and shows itself to be—"a part of the 'doctrine' [Lehre]."[62] The concept of doctrine—effective in Benjamin's writings for more than ten years following 1916—includes "the philosophical realm" but "definitely" transcends it.[63] The philosophical realm or philosophy as a practice is not equal to at least one notion of the realm of philosophy; the performance of philosophy is not the symbolic system—the constitutive force or form of philosophy—that has no question or answer. As suggested already, such a double-definition of philosophy—as discursive practice and as symbolic ground or form—could (insofar as it is effective in some way in his writings) distinguish Benjamin from those who tend to regard philosophy as a discursive practice with a ground of free experience (experience of freedom) that is not "philosophy." For Benjamin, the practice of philosophy performs the ground, the teaching or form—philosophy—for which there is a concept but only a very openly unfulfilled concept. "[P]resentation" (Darstellung) of truth, and not the imparting of instructions to recognition, is "the law" of the "form" of philosophy. The "exercise" (Übung) of this form (*O*, 28/I:1, 208) is the "alternative" to the "Western system-concept" (I:3, 925). Philosophical form defined as doctrine is exercised as esoteric (*O*, 28/I:1, 207, and I:3, 925). The form is presented, is performed, in history as not incorporated in history.

DOCTRINAL FORM AND ITS ESOTERIC NEED

"[I]n its finished shape [abgeschlossenen Gestalt], philosophy will be doctrine" but "it does not lie in the power of mere thought to confer such finishedness [Abgeschlossenheit]." Philosophy is constituted and defined by doctrine, by theological form, by what has often been referred to above as the *form*, philosophy. "Philosophical doctrine," philosophical teaching, cannot—of course—avoid being "based on historical codification." Demonstratively presenting reliance on historical codification, however, such doctrine or teaching opens this codification to the unfinished relationship with theological doctrine or teaching (*O*, 27–28/I:1, *207*).[64] The latter doctrinal form is experience in its most irreducible and thus religious element. As a practice, philosophy is based on experience that includes religion "as the true [wahre]

experience [Erfahrung]" (*W* 1, 104/II:1, *163*). Nothing can be said "about" the "God" and "doctrine [Lehre]" of "this" religion but the religion is ultimately not simply a "dualism"; its "ethical concept of unity [sittlicher Einheitsbegriff]" is "honesty [Ehrlichkeit]" and "humility [Demut]" (II:1, 34). In the practice of philosophy, such honesty and humility are concerned with the doctrine—the teaching-form—that determines but is not entirely revealed. The ensuing "exercise" of "form" enters all epochs, conceding "the uncircumscribable essentiality of truth." The "Epistemo-Critical Prologue" continues: This exercise is a propaedeutic, an introduction, that may—following scholasticism—be dubbed "treatise." The term "treatise" refers, "albeit latently, to the objects of theology, without which truth cannot be thought." The treatise shows that it cannot maintain itself on the basis of "its own authority"; it shows its lack of instructional "conclusiveness [Bündigkeit]." The authority presupposed in the treatise is the doctrine that the treatise cannot make entirely manifest or circumscribable (*O*, 28/I:1, *208*). So conceived, doctrine is the "highest sphere" of the divine context that has its "quintessence" and "primal ground" in God (*C*, 112/*GB*, Vol. 1, *422*). In late 1917, Benjamin says that "only" in the vein of Kant and Plato, and by "the revision and further development of Kant," will philosophy be able to "become doctrine or, at least, be incorporated in it" (*C*, 97/*GB*, Vol. 1, 389). Although his devotion to Kant's writing diminished shortly thereafter, and his anticipation of the practice of philosophy becoming doctrine soon became much more qualified (if not nonexistent), doctrine continues for some time to be conceived by Benjamin as a requirement that philosophical presentation be esoteric. In order to show itself essentially outside or beyond its manifest or circumscribing existence, philosophical presentation must be esoteric.[65] It must be perpetually strange, not only to those encountering it but also to those practicing it. The esotericism is to be perpetually renewed on behalf of the irreducibly religious, doctrinal form.

Benjamin clairifies this notion of religious, doctrinal form. Arguing that the "realm of religion" is the "foremost" of those "realms" for which Kant does not achieve "true systematic integration" (wahrhafte systematische Einordnung) (*W* 1, 108/II:1, *168*), Benjamin once says the "task of the coming philosophy" is to discover or create a "concept of recognition [Erkenntnisbegriffes]"—a concept of "pure recognition [der reinen Erkenntnis]"—relating "the concept of experience [Erfahrungsbegriff] *exclusively*" to a "transcendental consciousness" (104–5/*163–64*) that is the "pure epistemological (transcendental) consciousness" underlying "[a]ll genuine experience." Benjamin hyphenates the adjective "epistemological"—"erkenntnis-theoretischen"—and thereby implies a transcendental consciousness with the incessant power to theorize recognition (104/*162*). *Genuine experience* theorizes recognition.

For the correlative "consciousness," Benjamin retains Kant's term "transcendental" but relates it to what Kant distinguishes as the "transcendent."[66] The realm of religion is considered by Benjamin to be indispensable as the "transcendental" is freed from its confinement to subjective "experience"; the "pure epistemological (transcendental) consciousness"—the consciousness incessantly (that is, religiously) theorizing recognition—is "stripped of everything subjective" (104/162–63).

In the unity of philosophy and religion, the determinant and incessantly theorizing authority—doctrine—disempowers whatever might be construed as subjective consciousness and requires the aforementioned honesty and humility.

> —You . . . , he observed, talking of body and soul, believe in the soul. Or do you mean the intelligence, the brainpower as such, as distinct from any outside object, the table, let us say, the cup? . . .
> —They tell me on the best authority it is a simple substance and therefore incorruptible. It would be immortal, I understand, but for the possibility of its annihilation by its First Cause, Who, from all I can hear, is quite capable of adding that to the number of His other practical jokes. (*U*, 554)

The First Cause—the omnipotent and omniscient practical joker—is the ground of philosophy; it has been referred to above as the ground or form, philosophy. A theological outlook can facilitate consideration of the universal transcendent element. The coming philosophy, "in its universal element," is either "to be designated as theology" or to "be superordinated to theology" (*W* 1, 108/II:1, 168). The universal element is the mystery that can be discovered and presented—performed—everywhere and anywhere. The dichotomy of faith and knowledge often seems not to exist for Benjamin; yet there may be at least an echo of his outlook in Derrida's citation of a "law" of "untimeliness" undoing "all contemporaneity" and opening "the very space of faith," a law designating "disenchantment" as the "*very resource*"—the "first and the last" resource—"*of the religious*."[67] Whether they are scientific, practical, mathematical, political, philosophical, or literary, spiritual (that is, human) utterances have "universal validity"—from the perspective of philosophical universality—insofar as they are "bound to the question of whether they are able to raise claim to a place in developing [werdenden] religious orders." The adjective "werdenden" indicates that the universality—albeit real and already there—is still "becoming." What the becoming orders will be is not predictable (*W* 1, 294–95/II:1, *244*).[68] The universal religious element is neither subjective consciousness nor ultimately this or that religion; everywhere and yet entirely realized nowhere, the religious force makes the theorizing of recognition—makes the practice of philosophy—in principle possible

anywhere. The possibility of *genuine experience*—the possibility of the theorizing of recognition, the possibility of the practice of philosophy—is the universal religious force that is no specific religion.

In addition to the "philosophical concept of existence" being accountable to "the religious dogmatic concept [Lehrbegriff]," therefore, the latter is accountable to "the epistemological basic concept [erkenntnistheoretischen Stammbegriff]" (*W* 1, 110/II:1, *170–71*). Considered from the perspective of epistemology that carries recognition into a theorizing mode, religion is doctrine relevant solely in its force devoid of mediation. As an immediate and continuous relation with the "unity of experience," as a "concrete totality of experience," religion is recognized by philosophy initially "only as doctrine" (109/*170*). Doctrine is the universal possibility to philosophize experience, to open to experience as philosophical; doctrine does this by not quite manifesting itself. Mediating meanings of religion are ultimately irrelevant. The "true language" is the "truth or doctrine" to which the sacred text especially belongs, but belongs "without mediating meaning" (262/IV:1, *21*). For the practice of philosophy, the specific historical meanings of religion are important only insofar as they may be said to attest, in some way, to the universal force of the ahistorical in history. Philosophy is theology for the sake of including "historically philosophical elements" (historisch philosophische Elemente) (108/II:1, 168), elements in history lending themselves to philosophizing of historical mediation. This modern approach to religion is not a matter of surgically removing various aspects of this or that historical religion in order to make it suitable for a new kind of religiosity (II:1, 34). For the relevant notion of philosophy, doctrine is in religion as the element pushing religions outside themselves and into philosophy that is itself religious in regarding the immediate force of transcendence as universal and necessary.[69]

Philosophical disillusionment with historical religions could indeed be religiously significant. As a stranger to "all religions and *Weltanschauung*-associations" and occupying "no religious position," awakening youth is considered by the young Benjamin to be movement showing "the direction of that infinitely distant point in which we know [wissen] religion" (II:1, 72). Religion is known solely in the immediate experience of infinity interminably distant in experience; it is the experience of infinity in its distance, not as quantity but as a more fundamental infinitude. This experience is, moreover, the only given knowing. It is the only knowing that is given. It is, in a way, the only knowing. "Wissen" (knowing) belongs to "the totality [Gesamtheit] of time," the same totality in which "religious feeling" is rooted (33). Any other recognition or ostensible knowing is abstract, derivative. The transcendental consciousness is the basis for the "Erkenntnisbegriff" that "makes not only mechanical but also religious experience logically possible." All experi-

ence may be logically deduced from this given transcendental, transcendent consciousness. This is Benjamin's basic philosophical logic: in relation to the given that is transcendent knowing (the knowing of transcendence), every other recognition or knowing is derivative, secondary. This is "not" to say that the "recognition" makes God possible. It "definitely does," however, "make the experience and doctrine of God possible" (*W* 1, 105/II:1, *164*). Experience and doctrine—experience and the teaching form—of God are possible in recognition of immediate and yet interminably distant infinity. Philosophy and religion coincide in this recognition of the unrecognizable. Benjamin refers to an "atmosphere" ethereally burning everything nonreligious (*C*, 88–89/ *GB*, Vol. 1, 362–63). Everything nonreligious is nonrational. Little is less religious (and thus less rational) than religion. "[R]ationality" requires spirits "free" with regard to religion; philosophy is to move beyond the parameters of the initial languages, beyond the West, and to consideration of religions that are not those to which Westerners are accustomed. Not affirming specific religious orders, moreover, philosophy is to keep moving toward yet unforeseeable ones (*W* 1, 294–95/II:1, 244–45).[70] The religious element keeps philosophy (whether as discipline or as practice more broadly conceived) defined by the universally transcendent transcendental; the convergence of religion and philosophy keeps both in the universal continuum of unanticipatability.[71] In this unity, philosophy and religion are free for the full power of the future.

On the basis of the religious element as universal transcendence, the philosophy of the future—the coming philosophy—transforms the most profound contemporary, anticipatory intimation into recognition (*W* 1, 100–110/II:1, 157–71). For this recognition, the contemporaneous is never separated from the universal, discontemporaneous power. The latter is the aforementioned sole given of recognition. The "form"—"real [sachliche] universality," "philosophical universality"—requires "interpretation" (Auslegung) with a "contemporaneity" that is "true" (294/II:1, 244). Religious philosophy or philosophical religiosity presents true contemporaneity as universal discontemporaneity.

> Began in Italian and ended in pidgin English. He said Bruno was a terrible heretic. I said he was terribly burned. He agreed to this with some sorrow. . . .
> . . . remembered that his countrymen and not mine had invented what Cranly the other night called our religion. A quartet of them, soldiers of the ninety-seventh infantry regiment, sat at the foot of the cross and tossed up dice for the overcoat of the crucified.
> Went to the library. (*P*, 249)

Not able to stop at a specific religion, the religiosity of philosophy is a library religiosity or, more precisely, it is a religiosity for which expression is

writing. It is a religiosity that is devoid of naïveté about expression; it is a religiosity conceding that expression has only a virtual and indeed dissimulative relationship with God. Philosophy is impelled by the immediacy of God's infinity—by the immediate transcendence of the finite—to perform the virtuality as virtuality, the dissimulation as dissimulation.[72] In the "historical religions," there may be a naive religiosity that has a very honest relationship with the "deep and almost unrecognized need [fast unerkannten Not]" out of which any religion "must be born." This naive honesty is relatively unaffected by the social specificity—the mediateness—of the religion. Those recognizing a religion as a specific social phenomenon are, however, too complicated for such naive religiosity; with their complexity, any such "primitiveness" would be cynical feigning (II:1, 31). They must move on, and are dishonest if they do not.

> —It is a curious thing, do you know, Cranly said dispassionately, how your mind is supersaturated with the religion in which you say you disbelieve. Did you believe in it when you were at school? I bet you did.
> —I did, Stephen answered.
> —And were you happier then? Cranly asked softly, happier than you are now, for instance?
> —Often happy, Stephen said, and often unhappy. I was someone else then.
> —How someone else? What do you mean by this statement?
> —I mean, said Stephen, that I was not myself as I am now, as I had to become. (*P*, 240)

There is no return to a naive religiosity, and most nowadays are beyond it, whether they admit this or not. There is also no basis for a comfortable darkness of esotericism claiming a knowing presumed apart from the problematizing tendency of the age. Nobody has the secret ("the arcanum") (*W* 1, 294/II:1, 244). The risk—the "weakness"—imparted by "every esotericism to philosophy" is "oppressively clear" in the "vision" (Schau) required of "the adepts of all the teachings [Lehren] of neo-Platonic paganism" (*O*, 35/I:1, 215). This is an apparent allusion to neo-Platonic attempts to create an esoteric knowledge that would unite Plato's forms with Aristotle's insistence on concrete universals. The weakness or risk of indulging those esoterics claiming to know somehow apart from history is to be offset by Benjamin's esotericism. The only knowing in Benjamin's philosophical religiosity or religious philosophy concerns the universality and the necessity that are inherently modern in problematizing appropriative knowing.

Any practice of philosophy is devoted to the secret had (in an appropriative way) by nobody and is religious in recognizing the secret as secret in everything and everyone. The religiosity of philosophy and the philosophical in religion are universality as asociality in the social. Genuinely religious objectivity is this nonappropriable secret of asociality. Nonappropriability is the

need and the possibility of religion. Not surprisingly, therefore, the young Benjamin suggests the "need" (Not) in youth is "greatest" and "the help of God" is "nearest to youth" (II:1, 72). Youth feel the need for, and the divine help of, the nonappropriable. As Benjamin conceives its practice, philosophy is also constituted by this religious, nonappropriable impulse.

As suggested already, it is this impulse that legitimizes the esotericism, the difficult language, of philosophy. "[C]harm and accessibility" cannot be major criteria of writing that attempts to "lend an ear" to those "most objectively [am sachlichsten], most unaffectedly and most unobtrusively" articulating not only "need" (Not) but also "hardship [Drangsal]" (*W* 1, 294–95/II:1, *244*). The hardship ensues from the need—from the devotion to what cannot be said; the latter need for what cannot be said is the objective, dispassionate, unimposing restraint of philosophy. Not an easy esotericism but rather an esotericism emerging out of the objective difficulty of saying the unsayable, "[t]he language of philosophy" keeps its distance from "ordinary" language in a manner not entirely unlike dark and ambiguous oracle. As performance, philosophy too must circumlocute something that cannot be expressed. It too is "periphrastic" (umschreibend) (*W* 1, 274/VI, 26). Philosophy "can hope for" the "presentiment and description" of "the true language" (259/IV:1, *16*) but its task—once called by Benjamin the "task of ontology"—amounts to no more and no less than so loading recognitions "with symbolic intention" that they "lose themselves in"—are "taken up with"—truth or doctrine "without founding [zu begründen]" it; they must not seem to found truth or doctrine, for "the foundation [Begründung]" of truth or doctrine is "revelation, language" (VI, 39), *language* that simultaneously appears and withholds from appearance. As the language of a practice following the impracticable language of revelation, the esotericism of philosophy follows doctrine appearing to recognition as the ground that cannot appear. The esotericism of the practice of philosophy follows from the quasi-mystical dilemma of recognition in its unrecognizable ground.

"All of philosophy [Die ganze Philosophie], including the philosophical sciences, is doctrine [Lehre]" (38), and doctrine—necessary and universal ground of recognition in unrecognizability—requires philosophy as esoteric performance, as performance of comprehension with regard for incomprehensible ground. Kant's language often demonstrates this despite what he sometimes tries to do with his language. In Kant's "esotericism," the "meticulousness [Akribie]" of his terminology is "only pride about the mystery [Mysterium] of its birth," the mystery that his "critique" might not appreciate but also cannot "eradicate." This birth from mystery is not the Socratic conceptual birth; it is pointedly more mysterious. The "ground" (Grund) of Kant's "mysticism" is the "powerful intention toward symbolic impregnation of all recognitions [gewaltige Intention auf symbolische Schwängerung

aller Erkenntnisse]" (39). The symbolic impregnation is impregnation with mystery always already and necessarily there but never entirely revealing itself. Such impregnation is performance of doctrine. Only someone who "knows absolutely nothing of philosophy" does not "feel wrestling in Kant *the thinking of doctrine itself*" and "thus does not comprehend him . . . as a tradendum to tradition [zu Überlieferndes]" (*C*, 97–98/*GB*, Vol. 1, *389*). In philosophy as performance, tradition bequeaths doctrine as mysterious ground; this inheritance requires renewed esotericism, for words in philosophy are not to abandon their doctrinal—their symbolic—value in favor of a pedantic one.

For Benjamin, it is an ethical task constantly to revise the contents of tradition on behalf of the medium of tradition. The association of ethics and necessity involves, or calls for, performance of the transience of contents. Tradition is sustained by the quasi-mystical esotericism that wrenches or elicits content into performance of the medium that is no semantic or perceptual content. Not least in regarding "the ethical side of history as inaccessible" to any "particular consideration" and advancing instead the "postulate" of a "natural scientific" method and manner of consideration (105/*408*), Kant's philosophy may be "undeveloped" with regard to history as an infinite task constituted by the catalytic relationship of doctrine with recognition (98–99/*391*). Kant ultimately undervalues the ethical force with which doctrine impels recognition to be beyond itself, to be transcendent. In its refusal of the Kantian "Kritizismus" and the latter's constriction of "Kritik" (*W* 1, 117/I:1, *13*), the Romantic concept of *Kritik*—an "exemplary instance of mystical terminology"—is more emphatically an "esoteric cardinal concept" (141–42/50–51); whereas it may be consistent with Kant to advance the word *Kritik* as an "esoteric term" for "the incomparable and completed philosophical standpoint" (117/13), "terminological relations" in the Romantics' concept of "Kritik" lead to circumspect objectivity, productivity, and creativity that are considerably beyond the unproductive, merely judging, transcendental consciousness determined under Kant's concept (142/50–51; see also 117/13). Benjamin is not, moreover, fostering an otherwise repressed complementarity of discourse and "judgement," as though the latter is simply the inextinguishable moment of arbitrariness in the rationality of the former. Such a view of the complementarity of discourse and judgment has not surprisingly included a somewhat moralistic criticism of Benjamin as too unsystematic and "disjointed" (sprunghaft).[73] For Benjamin's early works at least, intersubjectively based discursive validity is still judgment, and judgment is ultimately arbitrary. The ethical task is one of moving discourse into performance of the quasi-mystical ground that is inherently esoteric but is not human judgment, esoteric or otherwise; the ethical task is the task of *lan-*

guage that is neither discourse nor judgment. The ethical task is, however, a linguistic one for which even Romanticism is inadequate. The ethical task is language as the doctrine ultimately withholding completion from philosophical presentation and requiring such presentation to renew performance of this incompleteness.[74]

In a philosophical perspective, theological heritage can persist solely in the undisguisedly profane.[75] Like syntactically literalist translation, performance of philosophy is based on a "genius [Ingenium]" respecting the "yearning" for pure language by displaying the profanity of access to this language (*W* 1, 258–59/IV:1, 15–17). Showing a "rigour" lacking in the Romantic method, Hölderlin emphasizes a "concrete determination" of "absolute form" (183, 200 n. 323/I:1, 117 n. 315). In this vein, Benjamin is increasingly concerned about the risk that the practice of philosophy loses "contact with the temporal extension" and changes into "the atemporal, intensive *interpretation*" (*C*, 224/*W* 1, 389/*GB*, Vol. 2, *392*). He is accordingly one of those members of his generation who, in their effort to save philosophy from "philosophy," come to think "the genius [Genius] of a pure metaphysician" is more readily expressed "in all spheres other than in those traditionally held to be appropriate for metaphysics."[76] Perhaps it is a Judaic motif in Benjamin's works that they present theology and openly profane material in a complementary relationship. Openly relativizing itself, the investigation gives itself a trace of truth, which cannot be shown.[77] As a practice, philosophy performs profaneness or relativeness as inextinguishable from its performance of the aforementioned *sound* of name, the sound without any specific spatial correlate necessary to it (see especially pages 19, 30, 40–44, 53–54 in this volume). Benjamin's approach is, of course, less "musical" than the Kabbalistic ones, as described by Scholem.[78] The accountability of the practice of philosophy to semantic relevance is its nonmusical constraint; precisely the attenuation and the relativization of musical impulses by their profanation in such meaning recall the need for the exercise of doctrinal form constantly to begin anew. Such is the outlook of Benjamin's quasi-Kabbalistic approach to the profane "text."[79] Benjamin's "dream" is not particularly "classic" or strictly "Western."[80] As the young Scholem begins to explore the world of Jewish mysticism, he is baffled by his own anticlassicism.[81] Benjamin's writing— particularly in his early work, but also in much of his later work— demonstrates such anticlassicism in its practice and defence of an esotericism that is also peculiarly mystical, presenting itself as determined by what it cannot quite reveal and can scarcely conceptualize. ("Woman's reason. Jewgreek is greekjew. Extremes meet." *U*, 471) Space is name; there is always a residue of intrinsic recalcitrance and incommunicability. As text or name, the profane sounds its withdrawal from perceptual-semantic containment. Renewed

deployment—new performance—is necessary if perceptions and words are not to become subordinate to their conventional and didactic value. The indispensable "esoteric" (Esoterik) of philosophical practice is based on doctrine presenting itself—constantly sounding in new ways—as mysteriously determinant force (*O*, 27–28/I:1, 207).

PRESENTATION AND ITS DOCTRINAL TONE

As the constitutive element in philosophical presentation, doctrine is a sound that has no correlate in whatever might be considered shown. The momentary in philosophical presentation is in no way monumental; it evokes rather a realm that cannot be monumentalized.[82] Insofar as Benjamin shifts from "systematic philosophy" toward "the task of commenting on the great works," this suggests a worry about "brutality"; the one symbolic perspective endures instead in a productive "scene" (Schauplatz) that is always "provisional arrangement" (Provisorium).[83] The "primary characteristic" of the treatise is, after all, "abandonment of the uninterrupted operation of intention" (*O*, 28/I:1, *208*). Determinant symbol resonates only in presentation of the transience of concrete manifestations and meanings. Presentation in Benjamin's early texts may overtax the reader with a "doctrinal tone"; this tone of word in name nonetheless so accentuates transience that the naming of the concrete seems less doctrinaire than is naming in writings by Heidegger.[84] Each moment obviates completeness of naming and name; each moment robs perception or statement of completeness. The new and the primordial, difference and repetition, thus unite in a tone seeming to call for ever-renewed consideration of the problem of presentation. It is "characteristic of philosophical writing to stand anew, with each turn, before the question of presentation [Darstellung]" (*O*, 27/I:1, *207*). As the sound interminably without extensive correlate, doctrinal tone is heard in philosophy solely as presentation presenting itself as transient.

Although Benjamin's notes up to and around 1920 associate the aforementioned "Symbolic Concepts" (Symbolischen Begriffe) with Goethe's concept of "primal phenomena" (Urphänomene) (*W* 1, 277/VI, *46*) and characterize "primal phenomenon" (Urphänomen) as "a systematic-symbolic concept" and as symbolic "ideal," Benjamin's eventual critique of Goethe's concept is intimated in the remark that Goethe's nature research is premised on the notion of symbols disclosing themselves "in prophetic insights [seherischen Einsichten]" (VI, 38). The adjective "seherischen" has a significance perhaps not automatically suggested by the translation "prophetic." Seeing (Sehen) and the seer or visionary (Seher) have primacy for Goethe. It is, as Benjamin

would say in the *Elective Affinities* essay of 1922, a "mythic face" of sensory nature that tends to triumph (*W* 1, 315/I:1, 148). For Benjamin, life does indeed have "a moment of irreducible perception." This moment of "seeability" (Anschaubarkeit) is the perception "constitutive in the descriptive natural sciences," the "biological sciences." Theory emerges, however, from the force of the unseeable. Physics and chemistry involve the "theoretical realm"; in this realm, it is possible to abstract from "seeability." For such a "purely theoretical sense" of "idea," concepts derive from idea as "task" (Aufgabe) (VI, 38). Idea as task is heard as the unseeable. It is not what Goethe hears. He only hears sounds subsumed in the myth of all-encompassing, infinitely alive, sensory appearance (*W* 1, 315/I:1, 148). Benjamin, in contrast, hears words in perception, and he hears them as unseeable, unlivable ideas.[85]

The practice of philosophy releases word over and over again. "[P]hilosophical contemplation [Kontemplation]" is a release of "the idea" as "word" from "the innermost of reality [Innersten der Wirklichkeit]"; it is as the innermost of reality that the released word claims "its naming rights anew" (*O*, 37/I:1, *217*). It is the linguistic impulse, not the semantic or referential one, that renews its claims. The impulse of pure language releases sensory nature from any myth of semantically determinable appearance or of phenomenal appearance. Pure language shows itself solely in tension with semantics and with what is construed as phenomenal appearance. In the tension with phenomenal appearance, it contrasts with Goethe's aforementioned "contamination" of "pure" and "empirical" realms (*W* 1, 315/I:1, 148; see also page 47 above). Ever-renewed claiming of the rights of name is remembrance of the tension of pure and empirical; it is antithetical to their mythic reconciliation. Nor is this remembrance of the word to be identified as "Platonic anamnesis"; it does not concern "a concrete visualizing of images [eine anschauliche Vergegenwärtigung von Bildern]." Remembrance of the word is, rather, remembrance of "primordial apprehension," "primordial hearing" (Urvernehmen) (*O*, 36–37/I:1, *217*). As inheritance and bequest of philosophy, primordial apprehension hears the symbolic word in name and hears the constant tension of name and perception.

One of Benjamin's more famous or infamous remarks is that Adam is "the father of the humans and the father of philosophy"; there is, Benjamin suggests, a primordial hearing that is ultimately the "attitude" (Haltung) not of Plato but of Adam (37/*217*). In view of Benjamin's early language philosophy, this statement need not be taken to deny that even Adam is a father whose name-giving provokes mourning from what is named by him (see pages 22–23 and 32). Regardless of whether or not one accepts Benjamin's view that Adam's naming is exemplary in its relationship with—its hearing of—things' linguistic being, however, Benjamin does not seem to

be citing Adam as just a father who teaches what he judges he has seen or can see or could conceivably see. For Benjamin at least, Adam (before the fall) is within the attitude of primordial hearing. This attitude enters the practice of philosophy as the freedom of word in name. The freedom of this attitude or hearing can sicken with insecurity and doubt before meanings imparted by a father telling stories based on what he judges himself to see and to have seen.

> Stephen walked on at his father's side, listening to stories he had heard before, hearing again the names of the scattered and dead revellers who had been the companions of his father's youth. And a faint sickness sighed in his heart. He recalled his own equivocal position in Belvedere, a free boy, a leader afraid of his own authority, proud and sensitive and suspicious, battling against the squalor of his life and against the riot of his mind. (*P*, 91)

From the innermost experience of word, the father as self-acclaimed panopticum instills fear, pride, sensitivity, and suspicion; the squalor of life and the riot of mind are the word that the panoptic father seems not to hear. Late Romanticism attempts to develop a "power" (Macht) of "observation" for history much as a benign father's eye or look would develop with the child. Although such fatherly love might somehow be "exemplary" with regard to peaceful human "growth," the "educative authority" (erzieherische Befugnis) of the historian is especially unsteadied by unpredictability, unpeacefulness, and bloodiness in the field of consideration. The organicism of the late Romantic Historical School is a "view" (Anschauung) lacking the "power [Kraft]" to recognize the world in its layerings (*W* 1, 285/VI, 96–97). In primordial hearing, layers accentuate the gaps between them and thus the sound that is without a perceptual correlate. The practice of philosophy is not constituted by the fatherly eye. It is born of hearing what cannot conceivably be seen.

This hearing is the theological basis of philosophy. Impelled by hearing the sound without spatial correlate, this theology is a ceaseless movement in, beyond, and between layers of meaning.[86] Whereas an "absolutism of method" is indicative of the loss (since the Middle Ages) of "insight into the wealth of layers" (*W* 1, 284/VI, 95), theology can still foster this wealth by illuminating the "correlation" (Zusammenhang) of layerings (285/97). The correlation of layerings is the mysterious tension between them. If the correlation is to be "illuminated" (erhellt) by theology, the layerings must *not* have their "natural tension" dissolved by "mediating philosophemes" (285/97). The correlation of layers is no bridging of them. In theological rhythm, "there are no transitions [Übergänge] between the levels of meaning [Sinnstufen]" (I:3, 926–27). Goethe turns away from this theological rhythm insofar as he subordinates all sound—

including "the gentlest word of reason"—to a myth of appearances that annuls distinctions in its concept of nature (*W* 1, 315/I:1, 148).[87] A "school" of "fruitful skepticism," in contrast, seeks origin via "theological traditions [Überlieferungen]" concerned with unbridgeable "meaning-levels" of things and especially of words (I:3, 926–27). The unbridgeability gives this skepticism its distinctly theological rhythm. Sustaining movement amid levels without resting at any level or agglomerate of levels, this skepticism follows the rhythm of the sound without agency. This theological rhythm is indispensible for practicing philosophy.

In this rhythm, communicated meanings are deployed in ways keeping them open to the symbolic origin, to the inheritance and bequest of an ultimately symbolic form, to the words in names. This rhythm of philosophy allows for the continuance of thinking. This is more unusual than one might initially assume. It is even unusual, perhaps especially unusual, among those who have come to call themselves philosophers. It is distinct from the "department" or "field" (Branche) so banding philosophers together that they have removed themselves from "their own thought" and each conducts philosophy as though beginning before the creation of the world or somehow incorporating this creation into personal "directing [Regie]."[88] On behalf of the ultimately uncircumscribable form and against any abdication of thought to grand enclosure, Benjamin's writings stop at unlikely, ostensibly insignificant or unworthy, places as he attempts "in ever new ways to make philosophically fruitful what has not yet been foreclosed by great intentions."[89] Such practice of philosophy strains departmental provincialism of "philosophers" by following the rhythm of the symbolic form of philosophy.

As the sole manifestation of an intention, according to the *Trauerspiel* book, the symbolic—that is, "canonical"—form would have the authoritative practice of quotation. Benjamin refers to "das autoritäre Zitat." This adjective "autoritäre" came into existence in the second half of the nineteenth century and has included meanings, now somewhat out of date, that simply indicate that someone or something has authority. The more prevalent current sense of the word would, however, translate as "authoritarian."[90] Regardless of which sense Benjamin is invoking in this text, he suggests the "authoritäre" quotation involves, above all, an intention (if intention is the right word) that is "more almost educative [mehr fast erziehlichen] than didactic [lehrenden]" (*O*, 28/I:1, 208).[91] The authority does not derive from semantic context (be it old or new) so much as it involves the usage of such a context to evoke the inexhaustible impetus for beginning anew. The symbolic impetus does not and cannot tolerate the settling of meaning; quotation (like other practices of philosophical writing) must be unsettling and must encourage further unsettling. Benjamin suggests that quotations in his own work are like armed wayside robbers leaping out to relieve the stroller of "conviction" (*W* 1, 481/IV:1, 138).[92] Such quotation, as Benjamin

would later suggest, is one instance of the kind of interruption that is fundamental to "form-giving" (*W* 4, 305/II:2, *536*). From the perspective of much (indeed, perhaps all) of Benjamin's work, the sole justifiable canonical standing of practices of philosophy would pertain to the rhythm of a tradition without conviction in or about meaning. The sole object of philosophical "conviction" (Überzeugung) is the "knowledge" (Wissen) that is no "intention of recognition [Erkenntnis]" but rather expressionless—not explicit but rather silent ("Notizen über 'Objektive Verlogenheit'" [1922–1923], VI, 61–62).

Philosophy as a practice is, in the broadest possible sense, thinking. Thinking must "constantly" begin anew and—in this "roundabout way"—return "to the thing itself [die Sache selbst]." As thought of the thing persists, extensive realization seems inadequate to intensive impulse. Philosophy requires constant detour. "Presentation as detour [Umweg]" is "the methodical character of the treatise." In the method of constant detour, philosophy presents itself as presentation; the practice of philosophy is no royal road but rather presentation performing itself as presentation, as extension inadequate to the thing itself. Presentation is the method of philosophical detour. "Presentation" (Darstellung) is the "quintessence [Inbegriff]" of the "method" that is "detour [Umweg]" (*O*, 28/I:1, *208*). According to the Kant essay, a principal problem of philosophy is the relationship of the concept of psychological consciousness with the concept of divine, transcendental consciousness (the concept of "the sphere of pure recognition [Erkenntnis]"). Although the association of philosophy with any concept of consciousness would subsequently play a diminishing role in Benjamin's work, even the Kant essay is consistent with later works by suggesting that the aforementioned problem may require recourse to "the age of scholasticism" and is the "logical place" for many of the problems raised anew by phenomenology (*W* 1, 104/II:1, *163*).[93] Even for this essay, the sole compelling logic is that psychological consciousness be wrenched or elicited again and again into consciousness of its derivation from the transcendent force. Scholasticism was already familiar with this issue of gradation among degrees of spiritual or mental being vis-à-vis linguistic being (*W* 1, 66/II:1, 146). As thinking, philosophy demonstrates its engagement with linguistic being by not resting at any level or any assemblage of levels of apprehension or meaning. According to the *Trauerspiel* book and related writings, "contemplation" (Kontemplation) receives impetus for its incessant reaching beyond surfaces—for its "constantly renewed deployment [Einsetzens]" (*O*, 28/I:1, *208*, and I:3, 926–27)—as it follows "levels in the apprehension [Auffassung] of things" (I:3, 927) or "levels of meaning [Sinnstufen] in the examination of one and the same object" (*O*, 28/I:1, *208*). The impetus for detour and the "justification" for the "intermittent rhythm [intermittierenden Rhythmik]" is that philosophical breath must be caught (I:3, 927; *O*, 28/I:1, *208*). Such catching of breath keeps the practice of philosophy from being asphyxi-

ated into something that would be less thinking than it would be something else. The "incessant pausing for breath is the form of existence most proper to contemplation [die eigenste Daseinsform der Kontemplation]" (28/*208*). To initiate another detour while presenting it as detour—as presentation—is already to catch philosophical breath. It is already indicative of thinking.

The practice of philosophy thus pauses before facts of history. It does so in order to think of origin, to think of idea. Origin underlies actual findings (it comprises "their pre- and post-history," the history from which they emerge and into which they pass away) but it is not anything that could be "brought out from the actual findings [dem tatsächlichen Befunde]" (46/226; see also I:3, 935, 936, 947).[94] ("He wouldn't vouch for the actual facts, which quite possibly there was not one vestige of truth in." *U*, 542)

> The difficulties of interpretation . . . and of counterestimating against an actual loss by failure to interpret the total sum of possible losses proceeding originally from a successful interpretation. (*U*, 596)

Regardless of criteria that might allow an interpretation to be deemed successful, the idea or origin shaping historical manifestation or articulation is not realized in manifestation or articulation. No specific shape realizes idea or origin. In every phenomenon of an idea, in "every original phenomenon [Ursprungsphänomen]," there is "shape [Gestalt]" under which "an idea constantly deals [sich auseinandersetzt] with the historical world." In this ever-changing shape, the idea deals with the historical world "until" the idea "lies there completed in the totality of its history." Until then (and this completion has not yet ever happened), history and idea are in the tension of the dialectic of uniqueness and repetition. Philosophical "consideration" (Betrachtung) must be based on the guidelines of this "dialectic" showing "uniqueness and repetition to be conditioned by one another in everything essential" (*O*, 45–46/I:1, *226*). In this dialectic, or in this "experiment" (for which Nietzsche's teaching of the eternal return may be relevant, if only in a qualified way [I:3, 935–36]), any repetition of idea is attenuated by the newness of event or by the newness of renewed reading of the idea, and any newness of event or of renewed reading is attenuated by idea. Dominance by idea would be the end of facts; dominance by history would be dominance by facts. The idea is not the sound dominant as history but is rather the sound without correlate in the facts of history. As always new and suspending the possibility of closure about idea, history is even the complement of idea, for the practice of philosophy must perform this unfinished relationship of history and origin.

> STEPHEN: . . . [T]he fundamental and the dominant are separated by the greatest possible interval which . . .

THE CAP: Which? Finish. You can't.

STEPHEN: *(With an effort)* Interval which. Is the greatest possible ellipse. Consistent with. The ultimate return. The octave. Which.

THE CAP: Which? (*U*, 471)

The refrain of its task in history is marked for philosophy by the vibrating intervals or ellipses between levels of meaning. These intervals or ellipses register the constitutive—only theoretically conceivable—doctrinal tone. The latter tone is ultimately the teaching of the ideal truth for which there is not yet even a question. YHWH calls for hearing beyond what is seen and understood. It is the tone of the end of history. This apocalyptic tone is the task constantly opening existence (preventing its closure).[95] Whereas Goethe's nature research and literary writing concern nature as "the chaos of symbols that is not religiously, apocalyptically ruled and ordered" (VI, 38), Benjamin translates Goethe's concept of primal phenomenon from "the pagan nature-contexts" into the concept of origin in "the Jewish context of history." In a "theological sense" lending "authenticity" (Echtheit), nature is mediated by constantly changing history and determined by the correlatively open—that is, Jewish—idea. As changing history obviates *pagan* closure and theology opens history to idea, history and theology keep one another open and alive (I:3, 953–54).[96] In the rhythm of origin, changing history occludes closed conceptions of nature, and history is kept open by nature that cannot be entirely manifest in it. The correlative movement from changing history to open nature and from theological idea to history is the rhythm of philosophy. As performance of history that is simultaneously transience and opening to idea, philosophy is constituted by apocalyptic—that is, doctrinal—tone. Philosophy presents its basis on a tone that this presentation itself cannot issue or carry and has only as constitutive task.

PROSAIC BEAUTY

Philosophy as presentation or performance—"Darstellung"—is a priority in much European writing, and it is a particularly self-conscious priority in writings by early German Romantics, Nietzsche, Kierkegaard, certain German Jews emerging before World War II (e.g., Rosenzweig, Bloch, Benjamin, Horkheimer, and Adorno), and somewhat more recently in writings by various figures in Europe (Blanchot, Derrida, Agamben, and others). Yet in Benjamin's lifetime as in other times, such philosophers have been the exception rather than the rule, at least in or around institutes or departments of "philosophy."[97] This is obvious in the Anglo-American world. Notwithstanding its

considerable diversity, even post–World War II German academia has developed a slight tendency to foster not only researchers of literature who are primarily "historians" or "philologists" of literature (or of "culture") but also researchers of philosophy who appear, or pronounce themselves, to be "historians" or "philologists" of philosophy. Some of the others in departments or institutes of philosophy in Germany have adopted variants of neo-Kantianism (universal pragmatics, transcendental pragmatics, discourse ethics) that have relatively little tolerance for consideration of presentation, performance, or style. Benjamin even says of the *Critique of Pure Reason*, however, that it would not likely have so "shaken Kleist to the quick" if "Kant's prose itself" did not present "a limes"—a threshold—of "high art-prose." "[G]reat scientific creations" must be artistic.[98]

Science must be art if reflexivity is to be demonstrated in the external appearances of science. Nothing whole can be brought together in "knowledge" (Wissen) or in "reflection" (Reflexion), says Goethe in *Materialien zur Geschichte der Farbenlehre*. Knowledge lacks "the internal" (das Innre) and reflection lacks "the external" (das Äußere); if *external* and *internal* are to be shown in interaction, science must be art. We must "think of science [Wissenschaft] as art if we expect from it any kind of wholeness [Ganzheit]." The artwork presents the whole that does not appear in the artwork; this presentation makes the work an artwork. The whole is the art in the work; art is the whole of the work. Art "is always wholly presented [sich . . . darstellt] in each particular art work," and science too should always "show itself completely in every particular object treated [einzeln Behandelten]" (*O*, 27/I:1, *207*).[99] Art is presented in each work, each work shows itself to be art, insofar as the whole is presented in the work as simultaneously beyond whatever is construed as the work. Science shows itself completely in every particular treated object insofar as the whole, the essence, of science is shown to be simultaneouly beyond any manifestation of science.

Philosophy is accordingly a performance of the tension of particular and inexpressible whole; the inexpressible whole is registered in performance of the particular. A "configuration" in philosophy must, as Adorno says, meet the criterion of "the *aesthetic* dignity of words."[100] In his lack of such art, Socrates shows his insensitivity to "the expressionless" (that has often been considered "the feminine") (*W* 1, 53/II:1, 130). Benjamin's art of philosophy is particularly obvious in the styles of certain texts: the dialogue form (in "Dialogue on the Religiosity of the Present" or briefly in "Metaphysics of Youth"); the usage of stories—such as the biblical story of paradisal naming and the fall—in important philosophical contexts; above all, various attempts to use a mosaic—or montage technique—in "Metaphysics of Youth" (at least once called a "cycle" [*C*, 71/*GB*, Vol. 1, *241*]), the *Trauerspiel* book, *One-Way*

Street, and especially the *Passagen-Werk*. Style incorporating dialogue, stories, and montage give his texts an openly prosaic quality. Prose resonates with the whole by showing itself unable to be the whole (*W* 1, 172–78/I:1, 98–109). Especially Benjamin's texts using montage technique seem to do this. With less connecting elaboration than is customary in academic writing, his texts often cohere as relatively discontinuous assemblages of quotations, sentences, and discursive excursuses that are themselves quite dense and difficult. Benjamin's texts may be conceived in terms of the constellations discussed above (see page 73). Unable to rest with any one level or any assemblages of levels, the movement amid unbridgeable levels presents or registers the whole that cannot be expressed. In this sense, philosophy or criticism as conceived and conducted by Benjamin may be considered "allegory," "literature."[101]

Philosophy as art is perhaps especially required in criticism. The artwork requires respect for the ideal. There is neither question nor answer for the ideal. If we had the question for the ideal, that question would simultaneously be the answer. Such a question, such a problem, remains an ideal. If "the system" could be reached by questioning, this "formulability alone" could be carried out and thus "would transform itself" into existence of the ideal—an existence that is, however, "never given" (*W* 1, 333–34/I:1, *172–73*). The existence of the ideal is not given; yet philosophemes are often treated as mere question-and-answer problematics. Artworks especially resist the latter approach. This resistance is their philosophical importance, their affinity with the ideal of the problem. In its unique "affinity [Verwandtschaft] with the ideal of the problem," in this "most profound affinity [Affinität] with the ideal of the problem," the artwork does not compete with philosophy but has "the most exact relation with philosophy" (334/*172*; see also 219/I:3, 835). In their show of multiplicity as well as their relative resistance to discursive solution, the artworks keep faith with the ideal that is not question or answer. On this basis, the artwork may be construed to have an appearance of this ideal (*W* 1, 333–34/I:1, 172–73). If this appearance may be so construed, it is on the basis of the artwork requiring that criticism encounter it—the appearance—as presentation of the philosophical impossibility of formulating the ideal (334/173). The artwork may thus be said to require an art of criticism, a criticism presenting the impossibility of formulating the force determining it. Philosophical criticism emerges as an art of science or scholarship in the manner that is suggested by Goethe's remarks quoted above.

The artwork and criticism encounter one another in the philosophical community of the ideal that remains strange. In this community, artwork and work of criticism are strangers to each other; they are strangers to each other, however, in the philosophical dimension making them also strange to themselves. In this vein, community in strangeness also underlies Benjamin's proposals

for syntactically literal translation of works of literature; not subordinating to the receiving language, the translation instead makes the latter language strange to itself for the sake of expanding its already existent relationship with community that is linguistically rather than semantically determined. Drawing on the 1916 essay, one could say that the translation translates the linguistic being already shared by the two languages but hitherto not so resonant in either of them (see pages 54–55 and 57). Criticism considering the artwork as a stranger to be approached with respectful interest is like someone wanting to get acquainted with someone else who is "beautiful and attractive" but "reserved," bearing within "a secret [Geheimnis]." In the case of the two people and in the context of respect for the inherently strange, it would be "reprehensible" for the interested party to want to force the other into an ostensible abandonment of this impenetrability; but it may be permissible to inquire about siblings and about "whether their nature [Wesen] could perhaps explain somewhat the enigmatic character of the stranger." The explanation is not to diminish the strangeness by formulating as though strangeness were thus eliminated, as though it were explained away. The siblings may provide access to the strangeness but the explanation must be philosophical; it must respect essential secret. It is also only in this community of strangeness—the community of philosophy, the community of what was above called the *form*, philosophy—that artwork and criticism meet in what is essential to each. The "siblings" of "all genuine [echten] works" point to, indeed are "in," "the realm of philosophy" (*W* 1, 333/I:1, *172*; see also 219/I:3, 835). In the context of this notion of the realm of philosophy, criticism must present, must perform, its convergence with the art work in essential strangeness, in the ideal for which there remains no question or answer. This performance is integral to the practice of criticism as philosophy.[102] The performance is, however, also the art of criticism. The realm of philosophy—the realm of the inherently strange, the realm of the *form*, philosophy—requires an art of criticism.

The philosophical community—the community of the inherently strange—emerges in beauty. Beauty is constituted in the breakdown of myth. Myth identifies time with place. The time of beauty was initiated by the migration of peoples and remains temporality for a world in which mythic time is not entirely credible or viable ("Zu einer Arbeit über die Idee der Schönheit" [note from around 1919–1920], VI, 128).[103] Community of beauty is ultimately no time of place; it is a time of no place, a time of truth, a time of philosophy. "[E]verything beautiful is connected in some way to the true." Everything beautiful is determinable in "its virtual place in philosophy." The beauty shows its place as only virtually in philosophy, as only virtual in relation to truth. The form *philosophy* is no place, for truth is without place. Philosophy

can only be virtually effective in the artwork (or anywhere else, for that matter). The appearance of the ideal in the artwork shows that the latter's relationship with the ideal is virtual. The appearance of the ideal is an appearance showing that it itself is not the ideal. An "appearance of the ideal of the problem" can thus be "discovered" in "every true art work" (*W* 1, 334/I:1, *173*). ("What is that beauty which the artist struggles to express from lumps of earth" *P*, 189) The true artwork is place showing that there is no place of truth. It thereby begins philosophical criticism. Criticism must correlatively demonstrate that "the virtual formulability of the truth content of the art work"—the formulability which remains virtual—is "the supreme philosophical problem," the definitively philosophical problem. Seemingly "out of reverence for the work" but just as much "out of respect for the truth," criticism "pauses" (innehält) before "formulation itself" (*W* 1, 334/I:1, *173*). It may be said: The beauty of the artwork requires of criticism that it too be beautiful, that it too pause for philosophical breath and present (what might be construed to be) its manifest being as no realization of its essential one. Like the artwork, criticism must suspend any temptation to identify truth with this or that place—or with this or that formulation. Such is the art of criticism. Presentation of the tension of time in place is the beauty of art and criticism, as indeed it is the beauty of all nonmythic community—of all community that does not somehow try to identify time with a specific place.

Beauty in the realm of philosophy—beauty in the *form*, philosophy—includes the beauty of all practices of philosophy and not just of philosophy as art criticism. In presenting place as not truth, philosophy presents the force intrinsic to writing, intrinsic to writing that is Messianically free prose rather than any already written placement of history.[104] Even where sentences are very weak, someone speaking can carry each single sentence by means of "voice and facial expressions" and can put sentences into an "often unsteady and vague but nonetheless impressive train of thought" as though "a grandly outlined drawing" were being drafted "in a single, powerful stroke." Writing, in contrast, characteristically commences and pauses "anew with each sentence" (I:3, 927). The practice of philosophy is defined by this presentational starting and stopping, detour and pause. In "contemplative presentation" (kontemplative Darstellung), in presentation guided by writing rather than speech, there is "no goal to sweep away or to enthuse." The practice of philosophy does not commence with place so much as with the problematizing pause before place. The presentation is "sure of itself only where it requires the reader to pause [innezuhalten] in the stations of the consideration" (927–28). It is sure of itself only in sharing essential uncertainty. This presentation guided by writing is a manner of writing prosaically; it is prosaic prose. It goes out of its way to show that it does not quite reveal the doctrinal

On Performing Philosophy 109

word: on "this side" of "the commanding doctrinal word [Lehrworts]," "prosaic soberness" is "the only manner of writing befitting philosophical recognition [Erkenntnis]" (928). The difficulty of following, or indeed of practicing, philosophy is a consequence of such practice being inherently writing, inherently prosaic. Image is historically codified, functions considerably within the bounds of such codification, and resonates with truth only by having its historical codification presented as not truth. From the latter prosaic standpoint, history is a strict limit and yet an indeterminate, incomplete limit; history is writing. The "difficulty" of philosophy is only its demonstration that "the presentation is an inherently [eigenbürtige] prosaic form" (927).[105] The prosaic beauty of philosophy is that it presents itself, performs itself, as writing.

Prosaic beauty is required of the practice of philosophy by Messianism, and the fragmentation in Benjamin's writing may be conceived as presentation recalling that the Messianic is determinant but unfulfilled. Benjamin's efforts at prosaic beauty have not been widely accepted—even by sympathetic readers. Among such readers, the Romanticism study (1919–1920) has provoked objections to the typical "weakness" of Benjamin: quotation with scarcely more than a sentence of commentary, a tendency in which difficult quotations devoid of "further discussion" lead to a "renunciation of comprehensibility."[106] More severe variations of this kind of assessment hit upon Benjamin's work during his lifetime. Shortly after being written, the study of Goethe's *Elective Affinities* received a rejection suggesting the author's "juvenility" had led "digressions" (Exkurse) to assume more importance than the "core" (Kern).[107] According to Benjamin's Messianism, however, the most important *core* is respected only insofar as an openly digressive relationship is maintained with it. The Romanticism study is actually kept rather normal stylistically; the inauthentic criteria of conventional scholarship have to be fulfilled in a dissertation. The "attitude" of conventional scholarship is especially inauthentic for a study with this topic, for such an attitude is incompatible with what is necessary for consideration of the Messianic core of Romanticism (*C*, 139–40/*GB*, Vol. 2, 23). The same kind of core is also purposely disguised by Benjamin as he writes the prologue for his attempted habilitation thesis; he translates linguistic views from the more openly theological 1916 essay (which was only circulated among friends and never prepared for publication) into the costume of a quasi-Platonic theory of ideas (*C*, 241–42/*GB*, Vol. 2, 464; *C*, 261/*GB*, Vol. 3, 14). Although even Benjamin concedes that they result partly from haste (*C*, 242/*GB*, Vol. 2, 464), difficulties of his style are expressly conceived and developed to strain criteria of institutional communication.[108] Without straining expectations concerning communicative competence, philosophy could not attain beauty. The beauty of philosophy is that

it entails communicative competence solely to recall what such competence is not. The relevant practice of philosophy shows that it does not incorporate the necessity and the freedom of the uncircumscribable, Messianic, linguistic core.

This beauty is obviously not the lucidity often celebrated as the beauty of scholarship. In the formal report of July 7, 1925, to the philosophical faculty at the University of Frankfurt, Hans Cornelius remarks on an obscurity of philosophical outlook and of manner of presentation in the submitted manuscript. This obscurity is particularly evident in the "Epistemo-Critical Prologue" (which, in the submitted version, did not include the more obviously philosophical sections of the prologue that appear in the eventually published text).[109] Although Benjamin is known to be "reasonable and intelligent," Cornelius concludes, "his incomprehensible manner of expression . . . must be interpreted" as a "lack of clarity" concerning the relevant material and may well indicate that "he can be no guide [Führer] to students" in the "field" of scholarship on art.[110] The word "Führer" has (and presumably had) sinister connotations less automatically for the German-speaker than it may now have for those not well acquainted with German. Although the former German Democratic Republic (East Germany) discouraged usage of the word "Führer" and encouraged the usage of readily available alternative terms connoting guidance rather than leadership, "Führer" historically signifies any guide or leader—political or otherwise; a driver's license is officially a "Führerschein" and a travel guide is conventionally referred to as a "Reiseführer." In a well-known paragraph titled "The Fourth Guide [Der vierte Führer]," therefore, Benjamin says Paris taught him "arts of straying" and he compares these with exploration of a forest or a child's labyrinth-like jottings ("A Berlin Chronicle" [1932], *W* 2, 598/VI, *469*). This is, of course, a "Führer" distinct from anything imagined by Cornelius for students. Elsewhere in the "Berlin Chronicle," Benjamin adds: "Searching in vain [Das vergebliche Suchen]" is as important for memory as is "fortunate [glückliche] searching"; a reporting and even a "narrative" (erzählend) approach must be set aside for the sake of epic and rhapsodic encounter with "ever-new places" or "ever-deeper layers" (611/*487*). Submitting to a text—even copying it—may take one into depths and recesses of the text not accessible to the reader who is not commanded—not led or guided—by it (*W* 1, 448/IV:1, 90).[111] For philosophy, in any case, fruitful understanding is never extricable from interest in what is not readily understandable or from willingness not to understand. Willingness not to understand is willingness to follow text, which is entirely distinct from following a person. It does not mean giving top grades to the student handing in what the institution would expect one to judge a failure; it requires, however, that one not presume to judge why the student did this, that one not cloak one's institutionally guided judgment in moralistic verbiage, and that one remain open to the possibility of the judgment being wrong (in some way or other). One does not have to submit to a

person in order to be circumspect in judgment of the text of the person. The ideal of text—of *language*—has no historical correlate. Albeit within the bounds of some kind of discursive understanding, the beauty of philosophy is presentation of determination by the doctrinal form that cannot be understood.

Benjamin's monadological procedure has been contrasted with "abstract generalization."[112] This is especially noteworthy in the context of the encounter of Cornelius and Benjamin. A teacher around whom even Horkheimer and especially Adorno tried to maneuver without a great deal of intellectual respect, Cornelius may have been too bound to Kantian epistemology—however modified—not to balk at Benjamin's approach.[113] Cornelius considers his own philosophy to overcome the lack of clarity following from "concepts" based on "prescientific [vorwissenschaftlichen] thinking," such as the concept "of the thing (the 'substance') existing independently of our perception." He embarks on an examination that is to pursue "logically [folgerichtig] the question of the origin [Herkunft] of all conceptual formation" and to find thereby "its systematic completion in the derivation of categories" ("sorts [Arten] of conceptual formation") "from the unity of consciousness."[114] This transcendental consciousness is, of course, a variant of the Kantian subjective "Ich" and not the transcendent transcendental consciousness discussed by Benjamin (see pages 5, 61–62, 75, and 90–102 in this volume). Benjamin's transcendent transcendental consciousness, or at least his transcendent emphasis—his emphasis on the transcendent—is stylistically effective as language transcending conceptual and perceptual meaning. Finding Benjamin's would-be habilitation thesis "exceedingly difficult to read," Cornelius notes that a "lot of words" are used without the author feeling obliged to explain their "sense" (Sinn) even though they are given "no generally established meaning" or—"if they are understood according to their customary meaning [ihren üblichen Bedeutung]"—"yield no clear sense [klaren Sinn]" (VI, 771). Cornelius's objection need not—and probably may not—be regarded solely as demonstration of his insensitivity to Benjamin's linguistic views and philosophical style. Those views call, nonetheless, for a style in which words break out of ostensibly established communicative contexts.[115] Disorientation such as that described by Cornelius is planned to some extent. The word in name has a strained, monadological relationship with the conventionally assumed, or indeed in any way understood, content of the name. Benjamin's proposed "style" or "form" is based on "the power of the word" (Macht des Wortes) (I:3, 926).

> He found himself glancing from one casual word to another on his right and left in stolid wonder that they had been so silently emptied of instantaneous sense until every mean shop legend bound his mind like the words of a spell and his soul shrivelled up sighing with age as he walked on in a lane among heaps of dead language. His own consciousness of language was ebbing from his brain and trickling into the very words themselves which set to band and disband themselves in wayward rhythm. . . . (*P*, 178)

The beauty of philosophy is the wayward rhythm of the word in name. This rhythm, showing the tension of word and concept, gives the treatise the rigor and intransigent resolution that comprise the sole possibility for so dissolving "the rigor mortis of science" that scholarship can be turned into a political deed. A major dilemma within scholarship is that the rigor mortis, which lauds and practices understanding as an end in itself, considers itself rigor and resolution.[116] It has been suggested that there was a certain wisdom in Benjamin's initial choice of trying in Frankfurt to habilitate in "modern German philology" (neuerer Germanistik); in this discipline, there had recently been a paradigm change from positivistic approaches to text and history. Benjamin could assume that his "speculative philosophic-theological" motifs would more likely be appreciated here than in the department philosophy represented by someone such as Cornelius.[117] Looking back on the habilitation attempt with some bitterness, Benjamin reiterates his view that the *Trauerspiel* book was a kind of protest against the institution of scholarship: the "beautiful child" sleeping "behind the thorny hedge of the following pages" will bite at any attempted bridal kiss from a prince in "the blinding armour of scholarship [Wissenschaft]." There will be no marriage between this book and scholarship wearing such armor. While giving the apprentice cook—the conventional scholar—a long-overdue "clip around the ears" that "should ring [gellen], resounding [schallend] through the corridors of scholarship [Wissenschaft]," the master chef—Benjamin—also wakes the beautiful child, the "poor truth" (which pricked itself while getting ready to weave itself a professor's gown) (*C*, 295/I:3, *901–2/GB*, Vol. 3, *164*).[118] The word is to ring resoundingly against the blinding armor of concept, the armor worn by scholarship—including much university philosophy—in its denial of the necessity for art or "Darstellung" in scholarship. The blinding armor of scholarship is, in many respects, its seeing or the tendency to conduct its expressions as if they facilitate such seeing. The rigor and resolution of philosophy as "Darstellung" is, in contrast, that it sees levels and does not rest in any one or any combination of them; it does not rest with the kind of seeing blind to what cannot be seen. The very movement of its seeing is acoustic, for it is the movement—the rhythm—of what cannot be seen or conceptualized as though seeable: the truth that has no place.

It may be somehow fitting that Benjamin's style disturbs academicians and that many reject claims made by Benjamin on behalf of his style. At a congress on art history and the Frankfurt School (held in 1991 at the Museum für Kunsthandwerk in Frankfurt am Main), a well-known art historian referred to a cynicism underlying Benjamin's attempt to submit such an incompetently formulated study as a habilitation thesis.[119] A quasi-Habermasian philosopher (Albrecht Wellmer) and a well-known scholar of

German literature (Gerhard Kaiser) some time earlier publicly expressed doubts about whether they would have accepted the thesis.[120] More sensitivity to the book has become evident, and yet, it would scarcely fulfill its own mandate if it were to find a happy home—be well habilitated—in the university. In this regard, there may be good reason to caution against simply hoping for a translation of the book "back into German."[121]

Perhaps as a small part of a larger drive to perpetuate a certain kind of lucidity, a lucidity also invoked and abided by self-acclaimed radicals, there is a tendency so to trim Benjamin's thorny hedge that the beautiful child awakened by Benjamin's impertinence in relation to university scholarship is hardly noticeable.

> The reproductive force of authority can get along more comfortably with declarations or theses whose content presents itself as revolutionary, provided that they respect the rites of legitimation, the rhetoric and the institutional symbolism which defuses and neutralizes whatever comes from outside the system. What is unacceptable is what, underlying positions or theses, upsets this deeply entrenched contract, the order of these norms, and which does so in the very *form* of works, of teaching or of writing.[122]

A risk in undertaking reformulation as a presumed maturation of Benjamin's allegedly juvenile style may be scholarship snuffing the beautiful child that it feels it cannot stand to hear. An institution may show little interest in performing itself as no place of truth, even if only to perform truth as no place.

The *Trauerspiel* book seems to foster a movement among disparate levels that is to prevail against any rigor mortis of lucid overview. As treatise (Traktat), it is to respect its uncircumscribable ground by shunning distinctions between theme and excursus. In a description elsewhere of the "Arabic form" of tract or treatise (Traktat), Benjamin says the ultimate breakdown of the distinction between "thematic and excursive expositions" is accentuated by inconspicuous numbering of chapters (the lack of any verbal headings) (*W*, 462/IV:1, 111). In this regard, Wittgenstein's *Tractatus logico-philosophicus*—which has only numbers as headings—is more of an "Arabic" treatise than is *Origin of the German Mourning Play*, where verbal headings play a role.[123] The latter book has, nonetheless, considerable straining and stretching of thematic organization: there are simply two big chapters (one comparing tragedy and mourning play, the other outlining the importance of allegory for the emergence of mourning play) and the prologue (as an excursus on pertinent concerns in epistemology and aesthetics); following the then-common German practice, the eventually published text has verbal headings of many small sections—within the prologue and within the two chapters—that appear in the table of contents and at the tops of the pertinent pages; each of the two chapters has three parts, each of

which contains many or several sections separated from each other by spatial gaps, and each part is visually distinguished only by beginning on a new page, by having an epigraph (called "Motto"), and by being demarcated (spatially and with a page number) in the table of contents.[124] In many respects, such features give the book an appearance of relatively unimposing thematic structure. The "ornamental density," the "unbroken" nonpictorialness—elsewhere said by Benjamin to be characteristic of the abolishment of distinction between thematic and excursive expositions in a treatise (*W* 1, 462/IV:1, 111)—is somewhat disturbed and broken by the three basic divisions, the demarcation of parts within the two main chapters, and by the many subheadings. In the basic division and especially in the division into so many small pieces, however, the considerable discontinuity tends to confirm Adorno's view that Benjamin's philosophy is "athematic" in the manner of the new and uncompromising musical composition which is without "development [Durchführung]" or the distinction of "theme and elaboration [Entwicklung]" and instead treats each "musical idea," indeed each "note," as "equally near to the centre."[125] Such comparison of musical and philosophical composition does not discount the association of the latter with something that might be called "argument."

That Benjamin's writing seems, nonetheless, simultaneously more theological and more pictorial than Adorno's is perhaps highlighted by Benjamin's comparison of the constructive technique of treatise with medieval mosaic.[126] The basis for this comparison is implicitly beauty, the performance of place as no place of truth. Mosaic and treatise both have their "highest development in early Christianity" (I:3, 927) or at least have their "supreme western development" in the Middle Ages. Most important for Benjamin, however, is that an "authentic affinity [Verwandtschaft]" makes their comparison possible (*O*, 29/I:1, *209*). The "mosaic-like work [musivischen Arbeit]" of philosophy involves most obviously "the paradoxical relation of micrological technique" with "the often powerful [gewaltigen] dimensions" of "portrayal [Zeichnung]"—with the "great pull" of the portrayal, "the great pull of the carrying-through of conceptions [Gedankenführung]" (I:3, 927). The paradox is that "truth content" (Wahrheitsgehalt) itself requires "the most precise immersion in the details of a material content [Sachgehalts]" and this most precise immersion—the "micrological processing" (*O*, 29/I:1, *208*)—is ultimately not "fragmentary" (fragmentarisch) (I:3, 948). Not only does the immersive micrological interpretation evaporate the "material contents" (927) in the sense that it opens to the invisible force within and between fragments but also any thematic basis is enhanced by the disparate relationship of particular excursuses with it: in "The Concept of Treatise" (the first section of the eventually published prologue), Benjamin stresses that the presentation

of philosophy involves a "brilliance" (Glanz) increasing correlative to indirectness in the relationship of fragments with their "basic conception" (Grundkonzeption) (*O*, 28–29/I:1, *208*).[127] Fragmentation "into many arbitrary [willkürliche] forms" enables the "presentation" to have the great pull emerge "almost" as though from the very arranging or combination of particular and extremely disparate notions. Immersion in the particular and the disparate sustains the relationship of presentation and transcendent force (I:3, 927). The momentum of philosophy is maintained much as "fragmentation [Stückelung] into capricious [kapriziöse] particles" is more a complement than diminishment of "majesty" in mosaics. Out of "the particular [Einzelnem] and the disparate," there emerges the immensely powerful teaching of "transcendent force" in both the "sacred image" (Heiligenbildes) of the mosaic and "the truth" of philosophical presentation (*O*, 28–29/I:1, 208). Beauty involves performance in the rhythm of the force that is no place.

As suggested in Plato's *Symposium*, truth is not so much beautiful in itself "as it is for Eros"; truth "is not so much beautiful in itself, as for whomsoever seeks it." Despite the "hint of relativity" in such remarks, the beauty peculiar to truth is not "a metaphorical [metaphorisches] epithet" (30–31/*210–11*). For us, truth retains its being-unto-itself only by virtue of its beauty. In beauty, truth is respected as secret. Loved and not pursued, truth is no "unveiling" destroying "the secret [Geheimnis]" but a "revelation [Offenbarung] which does justice to it [die ihm gerecht wird]" (31/211). A just revelation reveals that truth is not entirely revealed. The affinity of mosaic and treatise is their engagement—their showing—of the force that they cannot show. For the characterization of the "method" of philosophical style, the "metaphor" (Gleichnis) of mosaic-like work may be accompanied by that of vessel: for the "interpretative consideration" (interpretierende Betrachtung), which is philosophy, to "perceive" (erblicken) the "vessel [Gefäß] of truth content," the truth content "locked [verschlossene] within" becomes "more obvious" (sichtbarer) as the "walls" (the facts or words as material contents) become "glassier" (gläserner)—that is, begin to volatize, to evaporate (I:3, 927) in the sense mentioned above. Truth proves to be no vessel. Trying another metaphor, Benjamin says: there is a "cremation [Verbrennung]" of the work and the "form" of the work thereby reaches "its most brilliant degree of illumination [zum Höhepunkt ihrer Leuchtkraft]." Yet Benjamin again stresses: showing itself in this "process" that could "be described metaphorically [gleichnisweise] as the immolation [Aufflammen] of the veil entering into the realm of ideas," the content of beauty does not appear in any "unveiling." The "content [Gehalt]" of beauty is, as Plato suggests, truth (*O*, 31/I:1, *211*). Beauty is simply the possibility for truth, which does not itself appear, to be presented as the power of secret. This beauty is a precondition of the practice of philosophy—all philosophy, not only philosophy as art

criticism.[128] If it had no beauty, the practice of philosophy could not communicate the otherwise incommunicable mystery that is its basis.

Benjamin's extrapolation of Plato's theory of the relationship of truth and beauty is integral to his adaptation of Plato's idea-theory for the theory of name. For Benjamin, the idea in name facilitates the beauty of performing the symbolic force, which is unto itself and frees each name from concept. For Adorno, in contrast, the essay form entails conceptualization eluding any obligation to the Platonic idea that is eternal and entirely in and for itself.[129] This apparent disagreement is perhaps behind Adorno's objection that "Benjamin's concepts . . . tend to an authoritarian concealment of their conceptuality."[130] For Benjamin's proposed and attempted philosophical style, however, the word—the idea—in name is simply a necessary abatement of concept.[131] Concepts are to enter a style giving way to the force determining names and yet not ultimately articulable in names—that is, not ultimately articulable in names as concepts. Even Adorno concedes the need for such philosophical style, although obviously with nuances concerning concept that distinguish him from Benjamin. This concession has been noted often above. For Benjamin anyhow, the only possibility of presenting truth is to present it as self-presentational. Truth *is*, regardless of what we do or say about it. The beauty of philosophy ensues from the "essence of truth" as "the self-presenting realm of ideas." This "presentational moment in truth" is "the refuge of beauty as such." As long as beauty openly presents itself as semblance that is not truth, it remains in the service of self-presentational truth (*O*, 31/I:1, *211*). The "beauty is certainly not what is essential." It is not truth. Truth will continue—with or without beauty. Beauty is a human communicative condition. The responsibility of the philosopher—discussed above as the responsibility of the language of name—nonetheless does not permit neglect of beauty (*C*, 217/*GB*, Vol. 2, 373).[132] Without beauty, philosophy could not be recognized as philosophy; it could not function in accordance with the performative responsibility somehow inherent in name and thus constitutive of the practice of philosophy: to communicate *core* as incommunicable. Benjamin's acceptance of this responsibility may be noted against suggestions that his early works dismiss the intersubjective dimension by subordinating everything to a dualism of linguistic medium and communication. For Benjamin, the latter tension of word and communication is simply the ever-renewable possibility for the performance that is the beauty of philosophy.[133]

The concept of "philosophical style" is "free of paradox" (*O*, 32/I:1, 212). The association of philosophy and style is no paradox. A well-known specialist on the German baroque has, nonetheless, objected that the theory of ideas led Benjamin to do everything possible to give his work (the *Trauerspiel* book) a "status" distinct from that of "scholarship" (Wissenschaft): the "demand for

'Darstellung'" invokes "something aesthetic" (Aesthetische) and "Benjamin's presentation" accordingly "takes a stand against every scholarly method [wissenschaftliche Methode]."[134] As suggested above, however, Benjamin's prologue may partly be conceived as an outline for an art of scholarship. Many insist, of course, that scholarship or science is incompatible with the "aesthetic components" of the philosophical style proposed by the prologue.[135]

> JOHN ELLINGTON: *(. . . with carping accent)* Esthetics and cosmetics are for the boudoir. I am out for truth. Plain truth for a plain man. Tanderagee wants the facts and means to get them. (*U*, 474)

Yet there is a necessity for art in science, a necessity dissolving the ostensible paradox of proposing an art of philosophy; it has been outlined above as the necessity for beauty in philosophy.

This necessity does not, moreover, annul all distinctness of work of philosophy and artwork. Benjamin's notion of art or artistic rhythm as a force in philosophical writing, or his correlative references to an artistic beauty of philosophical writing, might seem to provoke the objections of Badiou that such views belong to a passing age in which philosophy subordinates itself to poetry. Yet Benjamin's views entail no subordination of the "genre" philosophy to that of "poetry," although (as will be further elaborated in the following part, "Image of Dramatic Beauty") the relationship of artworks and works of philosophy is indeed considered by him to be intimate (as well as complex).[136] Benjamin's consideration of style in philosophy does not quite entail regarding the treatise narrowly as "art work."[137] The philosopher attains instead "the elevated middle [erhobne Mitte] between the researcher [Forscher] and the artist." Contrary to the simple elitism connoted by the characterization, "elevated" might be considered to concern the aforementioned ability to present the fundamental tension in historical semblance, and "middle" could be taken to pertain to the shapeless, expressionless basis for presenting this tension. In any case, Benjamin suggests the practice of philosophy is not the conceptual deduction (deduction into concepts) characteristic of research but is also somewhat distinct from the metaphorical determinateness (the "picture-image [Bildchen]" of the idea world) in the artwork (*O*, 32/I:1, *212*; see also I:3, 931).[138] As a distinct practice, philosophy is an attitude performed with regard (whether self-conscious or not) for the harmony of the few old words—the systematology—especially resistant to chains of conceptual deduction as well as to metaphorical determinateness.[139] In the relevant philosophical style, there is the "art" of "pausing" (Absetzens) in contrast with "the chain of deduction" and "the perseverance of discourse [Ausdauer der Abhandlung]" in

contrast with "the gesture of the fragment" (*O*, 32/I:1, *212*). Integral to the discursive perseverance of philosophy, the art of pausing (this art of catching linguistic-philosophical breath) is accompanied by a "fullness of concentrated [gedrängten] positivity" distinct from "negating polemic" and a "repetition of motifs [Motive]" distinct from "shallow universalism" (32/*212*; see also I:3, 931, 936). Repetition of motifs and fullness of concentrated positivity combine as each reentry itself invites further exploration, further reentry. This invitation is thus persistently discursive as it pauses, in accordance with the art of philosophy, before already realized articulations in order once again to alter perception and conceptualization.

Benjamin refers to a "retarding style" with a "philosophical function" (I:3, 926). His proposals concerning philosophical style are partly inspired by the retarding style attributed by the early Romantics to the novel. In the latter retarding style, the novel constantly accentuates limitedness while constantly extending itself. Goethe's *Wilhelm Meisters Lehrjahre* is a prototype: the difficulty experienced by Wilhelm in his attempt to realize *Hamlet* shows the theater piece in a "retarding nature" making it seem highly "akin [verwandt]" to the "essence [Wesen]" of this novel (*W* 1, 172–73/I:1, 98–99).[140] The "retarding nature" of Goethe's novel is, in any case, especially obvious in the "style" demonstrating the intrinsic limitedness of each extension (*W* 1, 172/I:1, 99). Goethe's text is never "hasty"; the retarding tendency involves "Romantic irony" as a "lingering" or "dwelling" (Verweilung) in everything perceived or presented. Ironizing but lingering, the text attains "accents" that are "(metrical) and melodic" rather than "logical."[141] The ironizing of limit by music is an accenting by what is beyond limit, for this ironizing takes place as lingering in limitedness but unbound by any specific limit. Benjamin suggests this intrinsic power of the novel form even neutralizes irony in it; what is a bold stroke of irony in other genres is inherent in the novel form (*W* 1, 172/I:1, 98). Without any "rule-like form of presentation" enclosing them, "every one" of the "reflections" in a novel is "limited by itself"; the "retarding character" of the novel is its ability to reflect anywhere without being bound by external limit and yet simultaneously to accentuate pure—that is, inherent—limitedness of existing in externality (172–73/98–99). Such a retarding "stylistic principle" is also the function of the method of "presentation" in philosophy (I:3, 926). With the outlook of this stylistic principle, Benjamin works against a tendency shortly thereafter also opposed by Adorno: the tendency—particularly prevalent since nineteenth-century post-Kantian philosophy—to lose a power of concretion and experimentation as the philosophical essay is demoted to aesthetics (where indeed there is a semblance, a *Schein*, in which interpretation finds refuge from the grand philosophies no longer interested in concretion).[142]

Philosophy must perform indeterminate limitedness, for history is an inherent limit but no specific limit in history is philosophically necessary. Performance of this condition is the beauty of philosophy; this has been suggested often enough above with the notion of philosophy as presentation that is inextricable from place but presenting truth as no place. As also noted above, this conception of philosophy is opposed not only to most conceptions of systematic philosophy but also to the common tendency to situate the philosopher close to the researcher (and even to regard her or him, the philosopher, as a lesser kind of researcher). In the latter tendency, it is as though the aforementioned presentation—performance—has nothing to do with "the task of the philosopher" (*O*, 32/I:1, 212). Benjamin neither confines himself to "the somewhat specialist field of so-called intellectual history [Geistesgeschichte]" nor suffers from the common German "rancune" against the "intellectually stimulating [Geistreich]" (a rancor sickening the German tradition since Hegel faulted the literary expressiveness of the French Enlightenment).[143] Such rancune persists and does so beyond Germany; it may sometimes be related to tendencies in Germany but these incorporate many "Anglo-American" analytic, pragmatic, and even positivistic impulses that, of course, often have much to do with what developed as Viennese philosophy of the 1920s and 1930s. Not only in departments of philosophy but also in most departments of the humanities and social sciences, there has emerged an international "defensive discourse" attempting to expose certain kinds of writing as "gratuitous play (aestheticism) devoid of scientific or theoretical seriousness, as well as of political or ethical responsibility."[144] Even a relatively recent attempt to restore to art and aesthetics some of their lost sovereignty concludes insisting on no interaction of the crisis-creating or problem-creating tendency of art with communicative rationality—no "Zusammenspiel" of the beautiful and the true.[145] For Benjamin's early works (and for many of his later ones), political or ethical responsibility and scientific or theoretical seriousness are inconceivable without the play of art in philosophy. Art is, as indicated above, also very important as an object of philosophy; hence, Benjamin's practice of the art of philosophy as criticism.

Image of Dramatic Beauty

> He knew himself to be rejected, incapable, and from then on scholarship was a horror for him, because he defiled scholarship, because he went too far and was thereby destroyed. . . . He would have liked to return with a new language suited to express the experienced secret.
>
> —Ingeborg Bachmann, "Das dreißigste Jahr"

RU(I)NED

The Socratic separation of poetry and philosophy or at least a correlative institutional scission of "the poetic word and the word of thought"[1] was apparently confronting Benjamin as he wrote in 1912: "I am not yet able to decide whether philosophy or literature will prevail in my university studies" (VII:2, 532). As a university student, Benjamin was especially interested in Plato, Kant, and current variants of German neo-Kantianism; but even his very early writings develop priorities emerging eventually as an "interest in the philosophical content [Gehalt] of literary writing and of art forms" (*W* 2, 78/VI, 218). In the latter regard, his Romanticism dissertation refers to art as "probably the most fruitful" among the Romantics' determinations in the medium of reflection; the Romantics' concept of art criticism has a distinct rigor and implies a unique philosophical fertility of art (*W* 1, 149, 138/I:1, 62, 44; see also 150–51, 156–57/64–65, 73–74). Although Benjamin (as elaborated above) tends to emphasize and foster a subordination of reflection to primordial linguistic feeling and (as will be elaborated below) correlatively does not quite adopt the Romantic view of reflection arising "from nothing," there is an inkling of his own outlook as he formulates the Romantic outlook that "poetic

feeling" is a reflexive "point of indifference" (150/63). For Benjamin, the artwork is an object engaging the objectivity no longer bound to objects. More emphatically stressing insurmountable mediateness than do the Romantics, however, Benjamin advances artistic and critical indifference based on a force of ruination making every image a writing-image. In its ultimate independence from, or indifference to, any referential and semantic function, name signifies the force indifferent to signification. Conceived as name or writing-image, image is imperfect entry into the force without signification. If "every image is only writing-image [Schriftbild]," the image is "only signature, only monogram of essence [Wesens], not the essence in its veil [Hülle]" (*O*, 214/I:1, 388). Art and criticism demonstrate their complementary philosophical fertility by presenting image as writing-image, as image of nature that is the force ruining signification. As noted already, the resistance of the artwork to discursive rendering discourages criticism treating philosophemes as questions for which there are satisfactory answers; the openly philosophical impulse of criticism distances the artwork and its reception from any putrefying embrace of appearances (or of formulations). Attenuating the customary scission of art and philosophy, Benjamin's criticism registers the intertwining of art and philosophy in this drama of image as ruin and writing.

The critical image, the image in criticism, is image of deformation and in deformation. Like nature in this respect, art conveys the determinant powers of history withholding themselves from history (*C*, 224/*W* 1, 388–89/*GB*, Vol. 2, 392–93). The distinct kind of seeing ultimately required by these powers is a "pure seeing [Sehen]" directed not to "the space and to the object" but to color as medium not belonging to objects. The highest level of color "appears objective [gegenständlich] but not spatially objective [raumgegenständlich]" (*W* 1, 51/VI, *111*).[2] The colors of deformation "culminate in red," for this is a color associated with decomposition: the "deeper colouring" accompanying "the actual earthly decline" in autumn, "the phosphorescence of rotting bodies," and the "colour of rust" (Rostfarbe) (VI, 121–22). "Rust" (Rost) is even etymologically connected with red (Rot) (123) and red is the color of shame—blushing, the color of wishing to pass away (122).[3] The sole correlate of pure seeing is semblance in transition. Yet semblance is "pure" not only in "unending dissolution" ("eternal transience") but also in "becoming" (Werden) and in diminishment, extinguishment, or subdual: it appears no less authentically in "sunrise" (Morgenrot) than in "sunset" (Abendrot) and may also be "diminished, extinguished or subdued semblance" as in "the grey Elysium," the gray realm of the blessed dead, evoked in paintings by Hans von Marées (1837–1887). These "three worlds of pure semblance"—dissolution, becoming, and subdual (or diminishment or extinguishment)—all belong to imagination; they attest to deformative nature. Deformation is, of course, not

only seen—is not only "pure semblance [reiner Schein]" (which is no specific semblance) in "the world of light"—but is also "in the acoustic" (the night decreases noises to a single great hum) and "in the tactile" (atmospheric contacts dissolve clouds into the blue or into rain) (*W* 1, 281/VI, *115–16*).[4] Such "appearances of deformation in nature" are, in any case, effective in "the world of the appearances of imagination [Phantasieerscheinungen]" (*W* 1, 281/VI, *116*). Artistic presentation of natural deformation is the critical object; the object of criticism is this objective presentation. Whereas "commentary" seeks "material content" (Sachgehalt), criticism seeks the deformative force in and of such content; criticism seeks "truth content" (Wahrheitsgehalt) (297/I:1, 125).

This truth content appears solely as beauty in deformation; beauty of art is not a beauty facilitating life as living semblance. Benjamin tends to abandon notions of "pure semblance" and increasingly distinguishes artistic beauty from beautiful semblance. The latter semblance survives as semblance only if attractive enough to its living semblance-environment; its allure to this environment defines its living to the exclusion of what is not this environment. This beauty for living is, therefore, not the beauty of art. There is "[n]othing actually living" that is "truly beautiful" (VI, 129). The artwork does indeed have beauty necessary for some kind of bodily survival; the theory of the beautiful obviously cannot simply ignore "the beauty that is bodily alive [die leiblich lebendige Schönheit]" (*W* 1, 350/I:1, *194*). The beauty essential for living as semblance is, nonetheless, shown by art to be incomplete or imperfect. The mechanical—the contrivance, the means—in the artwork is the "imperfection [Unvollkommenheit] for which beauty [Schönheit] is *essential* [*wesentlich*]" (VI, 90) and "this essentially beautiful manifests itself in its shape [Gestalt] . . . mostly as semblance" (*W* 1, 350/I:1, *194*); the constitutively "artistic [Musische]" is the "perfection" (Vollkommenheit) for which "beauty is accidental" (VI, 90). The artistic shape has a residue juxtaposing its living semblance (which essentially needs beauty) with the excess, the perfection, that is not such semblance and does not need beauty. That for which beauty is essential—"[e]verything essentially beautiful," even "the most unalive" (Unlebendigsten)—"is always and essentially bound with semblance," albeit "in infinitely various degrees" and least of all in musical works. The paradox of art is reliance on beautiful semblance for communication of a beauty reliant on no living semblance. The life of everything living is "higher" insofar as there is relief or release from the realm of the essentially beautiful; the life of anything living is superior insofar as it is independent of its life as semblance (*W* 1, 350/I:1, *194*). Art may have an "ideal" of beauty presenting itself as body; distinguishing itself from semblance, however, art only communicates beauty that is an "idea." Art can satisfy this idea only by

presenting the idea as "intuition of secret" (Anschauung des Geheimnisses) (VI, 129, 128). The beauty of artistic presentation is the paradoxical one of constructing secret that remains secret.

In this respect, art is of the night. It cannot be premised on an attempt to return to the day. Artworks are "models of a nature that awaits no day" and "no Judgement Day." Rescuing the night, artworks belong to nature withholding itself from the scene of history and thus from domestication; artworks are "models of a nature that is not the scene of history and not the dwelling place of humans" (*C*, 224/*W* 1, 389/*GB*, Vol. 2, *393*). Cixous's Mme. Lion remarks on the depth and the beauty of the night; the night lends her a feeling of imminent birth of transformation (whereas the breathing of the night is not seen by her corrupt colleagues and superiors).[5] At night, Hölderlin's "blind" poet-singer hears the Redeemer killing and giving life; this translates at midday into hearing the voice of the "great" and "brazen" Thunderer whose "house quakes" and who enables the song to live.[6] The mysticism of art is perception hearing the night and so blind to the day that the day may be somehow shaken, taken aback, by art.[7] Hearing the night in day is the artistic possibility carried in every image as its writing.

There is accordingly a power of name intrinsic to artistic painting. This power of name casts construction into a combination of representational being with the force of deformation. The mark (Mal) as such—"the medium of painting [Malerei]," the medium of artistic painting—is obviously distinct from mere "sign" (Zeichen). The name in artistic painting has, however, a function simultaneously beyond and within the medium of mark. As artistic, this name is not title so much as it is critical name already in the artwork. It is, on the one hand, the compositional element that facilitates interaction of the medium of *Mal* with the "representation" (Vorstellung) enabling us to "name" (benennen) the picture. We can thus say something about the picture. As the force of criticism in the picture, on the other hand, name as compositional element is not simply interaction between representation and medium of mark; it is simultaneously a power enabling the picture to transcend mark (*W* 1, 84–86/II:2, *605–7*).[8] The latter power is a linguistic dimension assuring a "being-present-at-hand" (Vorhandensein) that remains open to what transcends; painting is name, for painting is in the dynamic or tension of representation and transcendence. A painting, a school of painting, or an epoch of painting may be distinguished according to whether the representational name or the linguistic word within name has primacy. In older paintings, such as those by Raphael with "configurations of humans, trees, animals," it is primarily the name that has entered the medium of *Mal*; in more current paintings, it is often the "guiding" or "directing" (richtende) word (the linguistic element) (*W* 1, 85–86/II:2, *606–7*). Artistic painting is anyhow always

picture as writing-image; it is always name fostering the contact, which is also the tension, of the representational and the transcendent.[9]

In the artwork, nature withholding itself is the theological symbol that can only be experienced allegorically. With this view, Benjamin opposes the classicist bifurcation of symbol as total expression and allegory as mere conventional sign. Classicism traditionally regards symbol as the prerogative of art to see the general in the particular; the symbol is a kind of transformation of appearance or image into the infinite, which is otherwise unreachable and ineffable. Classicism regards allegory as seeking the particular for the general; allegory is image for the concept, the transformation of appearance into a comprehensible, delimited, expressible concept.[10] For Benjamin, in contrast, the symbol is theological, not aesthetic; in entering experience *allegorically*, it pulls the artistic convention or means constantly beyond itself into its unfree, imperfect, broken relationship with preponderant nature. Benjamin's *Trauerspiel* book opposes both the classicist definition of allegory as "a mere mode of designation" and the neoclassicist dismissal (exemplified by remarks in Schopenhauer's *The World as Will and Representation*) of allegory as writing.[11] The latter view regards writing as no more than a mere "conventional system of signs." For Benjamin, allegory is indeed writing but—precisely as writing—embodies the tension of nature and convention. The "authentic documents of the modern allegorical way of looking at things" ("the literary and visual emblem-works of the baroque") (*O*, 162/I:1, 339) indicate that allegory is devoid of the "disinterested self-sufficiency [unbeteiligten Suffisanz]" found in "the . . . intention of the sign" (165–66/342). Entering the reality scarcely noticed by the artists and thinkers of classicist symbol, moreover, baroque allegory conveys—with an emphasis that is "unprecedented" (albeit hidden under "extravagant pomp")—the aforementioned "unfreedom, imperfection and brokenness [Gebrochenheit]" in "physis." Physis is oddly "sensual, beautiful," for it is irresistibly within us and beyond us. The baroque tension of nature and contrivance is threatening or disturbing to neo-Kantians of Benjamin's day (Hermann Cohen and Cohen's student Carl Horst). For Benjamin, these neo-Kantians represent an "undialectical mode of thinking" incapable of fathoming the "synthesis" that is also the conflict of theology and art (176–77/*352–53*).[12]

As this theologically conflictive synthesis of nature and history takes place in allegory, in image as writing-image, meaning or significance is openly subject to, is a figure for, the nature enriching it. Allegory has no "symbolic" expressive freedom, no "classical harmony of shape," no "humanity [Menschliche]," for it is open above all to the independent force of death (*O*, 166/I:1, 343). There is no artistic symbol, no plastic or sculptural symbol, no image of organic totality, for the meaning of nature has no body. The "writing-image" or

"image of writing" (Schriftbild) is a "fragment [Bruchstück]" that is "amorphous" in having its significance increased by nature that is no incorporable meaning. This can be illustrated by actual writing, such as very graphic typography or "overloaded metaphor" showing the push "toward the picture" (zum Bilde) to be a displacing rather than placing effort (175–76/*351–52*). In other media too, displacement presents a literary image—writing-image—in which physis disrupts pictorial aseity. The only "contemplative calm" (kontemplative Ruhe) is that of a "dialectic," a "dialectical movement," based on immersion in, and powerful roaring from, "the abyss [Abgrund] between pictorial being [bildlichem Sein] and meaning [Bedeuten]" (165–66/*342*). The latter meaning cannot be picture. For allegory, nature expresses "significance" (Bedeutung) or "sense" (Sinnes) in an emblematic, a hieroglyphic, "presentation" (Darstellung) (170/*347*).[13] This is obviously not hieroglyph as pictorial realization of referent (see page 42 above). It is, rather, emblematic—hieroglyphic—presentation in which meaning is a force determining but not realized in image. Children demonstrate a preliminary version of such "hieroglyphy" as they too write open the image. A potentially "infinite intensification" is possible as a child de-scribes (*be-schreibt*), "scribbles on," "writes [dichtet] into," a picture. In this way, the child "learns script [Schrift]," "indeed a poetic, creating script [eine dichtende, schaffende Schrift]" (VI, 113; see also W 1, 411/III, 20–21, and W 1, 436/IV: 1/2, 610). As in baroque allegory, the significance of the hieroglyph—the writing—is that of nature which cannot quite show its significance. In baroque allegory, the "utterly purposeful [planvoll], constructive linguistic gesture" of "bombast" fails to make the significance of the "hieroglyphic" "audible" (lautbar) (*O*, 200–201/I:1, *376*). The significance roars as silence.

The silence is heard by a theological ear that can say something about itself only by writing, even if it speaks. As inextinguishable mediation, writing is the tense synthesis of the theological and the thetic or positing. All speech is mediated by writing. The ideal of logos does enable us, "without contradiction," to "conceive of a more vital, freer usage of revealed spoken language, in which this language would lose none of its dignity." Realization of this ideal cannot be imagined, however, for writing as system of codification (174–75/*351*). Writing so mediates our unideal speech, moreover, that writing may *not* be said to derive from speech. In accentuating the mediate, historical, and conventional character of human linguistic expression, writing even does more than speech to lend expression to determinate mystery; in writing, this mystery resonates in the open tension of expression and convention. Speech is more prone to succumb to the parochial presumption of unmediated expression. As the universal language, in contrast, music might seem a possibility of unmediated expression; yet precisely this relative independence of music from historical and conventional semblance too readily

leads to disregard of mediation of music by history and convention. More obviously incorporating the tension of convention and expression, writing not only has a unique expressive potential but may also be said to be the dynamic of convention and expression effective in all arts; all arts may be conceived as writing. If oral language is "thesis" (thetic, positing element) and music ("the last language of all humans after the building of the tower [of Babel]") is "antithesis," the "synthesis" is writing (214/*388*). Writing synthesizes thetic convention and antithetic sounding impulse by presenting both as elements in this synthesis that neither sublates.[14] This is the artistic synthesis.

As writing-image, the artwork already has theologically impelled criticism within it. The rune is no longer the letter that is thought to unite idea, image, and cosmos magically. The scrutiny of theological learning breaks down such "symbolic beauty"—the "false semblance of totality"; the artwork emerging as writing-image is an allegorical "fragment [Bruchstück]." Theological scrutiny manifests itself in this allegorical profundity transforming "things and works into stirring [erregende] writing" (*O*, 176/I:1, *352*).[15] Things and works are presented as bearers of the synthesis, which is also the tension, of the profane and the theological. In the *Trauerspiel* book, the theological scrutiny partly follows what is examined and partly is interpolated into it. Benjamin suggests, in any case, that the conflict of "sacred validity" and "profane comprehensibility" (*O*, 175/I:1, *351*) manifests itself variously in the baroque; among other things, he cites not only the aforementioned thwarted bombast (210/384) but also measures introducing a wildness of sound into otherwise logical and classical facades (205–6/380–81) and "metaphor" that—like every other such gesture—is ultimately emblematic (197–200/374–76) of the uncontainable creaturely impulse of language to a "fullness of sound [Klangfülle]" (210/384). In allegory, physis is theological as the force that impels criticism within the artwork's construction and of the artwork's construction; the construction is shown in the force that the construction cannot entirely incorporate.[16] Anticlassicism is a constant of Benjamin's writing. He had long opposed those indoctrinated and indoctrinating into unquestioning and bored regard for Goethe and Schiller, a regard generally accompanied by unreceptiveness and antagonism to modern art (II:1, 38). He found it highly questionable too that ancient Greek culture should be taught as "a fabulous realm of 'harmony' and 'ideal'" (40–41). The artwork is certainly no longer conceivable as symbolically unified and unifying whole; the work is construction of unconstructable physis.[17] Critical "examination" is required, for art (in the case of poetry, *das Gedichtete*, the poematized) cannot "be compared" with the specific work ("with the poem"). What is made into a work (what is poetized, the *Gedichtete*) presents itself as not essentially this particular work. It is the ground, the "sphere," which is "simultaneously

product and object" of the critical "examination" (*W* 1, 18/II:1, *105*). Producing image as writing-image and having this image as its object, criticism is the conflict between construction and nature. The critical thrust already effective in artworks is a philosophical impetus that contributes considerably to Benjamin's attraction to criticism, for it not only lends itself to philosophical formulation but also tends to keep such formulation critical of itself.

Knowledge is ultimately only reliable and thus philosophical where it settles in what is dead to the living and livable. Critical "[m]ortification of the works" is not "the Romantic awakening of consciousness in the living works" but "the settlement of knowledge [Wissens] in dead ones" (*O*, 182/I:1, *357*; see also *C*, 224/*GB*, Vol. 2, *393*). The works are dead in initiating criticism of their own construction. This destructive basis of criticism in the unfreedom of physis is ultimately irrelevant to any Romantic notion of free and beautiful life. ("Free. Soul free and fancy free. Let the dead bury the dead. Ay. And let the dead marry the dead." *P*, 248) For Benjamin, criticism—along with the artwork—is married to the dead. The marriage is not, of course, to this or that now dead and formerly living appearance. Whether in criticism or in criticism within the artwork, the marriage with the dead is rather guilt about signification. This guilt is all that is known in a philosophical sense. As allegory settles in the collision of "transitoriness" with "eternity," it accordingly becomes guilt preventing signification from "finding its meaning-fulfillment in itself" (*O*, 224/I:1, *398*). Eternity registered as physis—the force of death—makes meaning-fulfillment unconscionable. The "origin [Ursprung]" of the "allegorical outlook" is confrontation of "guilt-laden physis" with the pantheon of gods (226/*400*); the latter "idols" are entered into "meaningful [sinnreichen] juxtaposition . . . with bones of the dead" (222/*396*). The meaningfulness is the emblematic, hieroglyphic displacement from eternal nature into transient history. Not only the baroque "passion tale [Leidensgeschichte] of the world" but any "allegorical contemplation [Betrachtung]" is essentially "significant" only in "stations" of "decline" or "decay" (Verfall) (166/*343*). Even the aforementioned instances of transformative semblance as becoming and subdual (page 122) are ultimately illustrations of the force of decay. Decaying structure conveys physis obviating fulfillment of meaning. For the "structure" of the baroque mourning play, Benjamin appropriately uses a term normally used for musical style: "Faktur" (*O*, 179/I:1, *355*). The bond of ruination and music is the former's registration of the latter as the force independent of semblance. All art has relationship with semblance, but music is the art least bound by semblance (as has been noted above [page 123]). In its utmost power, in the power not seeming simply to disregard mediation (pages 126–27), music ruins semblance. In its extended (philosophical) sense as un-

realizable and perfect semblancelessness, music underlies any structure. Art performs this ground and thereby not only initiates its own criticism but also keeps criticism performing this same philosophical ground: the music of ruination.

This critical—this ruining—ground is the structure of art. In the baroque mourning plays, especially in those by Pedro Calderón de la Barca, the structure shows through like the masonry of a building from which the plaster has come off (*O*, 179/I:1, *355*). The masonry assuring survival of the artistic building is visible solely as the invisible force of death. The German baroque mourning plays have "claim to interpretation" by virtue of the "idea" of the "plan [Bauplan]" speaking from the ruins of these "great constructions." That this idea is expressed "more impressively" than in lesser constructions ("however well preserved the latter may be") follows from the German mourning play being in "the spirit of allegory," being "conceived from the outset [konzipiert von Anfang an] as ruin [Trümmer], as fragment [Bruchstück]" (235/*409*). The ruin is not, of course, fragment that is totally dissociated and unto itself; it is fragment showing itself in the power of what it cannot show, what cannot be contained in its appearance. The plays "are set up for the critical decomposition [Zersetzung] that the course of time exercises on them"; they are set up for criticism as "mortification of the works" (181–82/*357*).[18] The birth of the work as artwork is the birth of death within it. ("—The most profound sentence ever written, Temple said with enthusiasm, is the sentence at the end of the zoology. Reproduction is the beginning of death." *P*, 230–31) Birth is the beginning of death if conceived from the philosophical ground of guilt-inducing physis. This birth of death is the birth of criticism in the artwork.

The critical law of art is intractable thingness that breaks down any unity imposed upon it. Whereas tragedy operates with a presumed independence or complete release from "the world of things" (an exclusion of the "profane world of things") (*O*, 133–34/I:1, 312), the "law of the mourning play" is different (136/*315*). The "world" of things rages so oppressively that a mass of scholarly annotations seems to point to a nightmare of realia burdening action. Things with a life of their own point to a transcendent force recalled in "dreams," "ghostly apparitions," or simply "horrors of the end" (134/*312*). As implied already, intractable thingness is, above all, decay. In the baroque, fragments piling up "ceaselessly" become significant—highly significant—solely in the confrontation with inexorable decay. The "intensification" (Steigerung) created in accumulation and repetition of antique stereotypes takes these stereotypes beyond any reminiscence-function and into a "construction" (Bau) ostentatious in its failure to unite "realia, rhetorical figures, rules" other than in its own and their ruination. The "complete vision [vollendete Vision]" of

"the new whole" is the ruin (178–79/*354–55*). The baroque "theory of 'tragedy'" thus takes the "laws of ancient tragedy" "separately" from one another and from the myth sealing them together; the "components" become "lifeless" (leblose). Notwithstanding the baroque's classicist self-misinterpretation, "'rules' of ancient tragedy" enter an allegorical "breaking-up and smashing [Zerbröckelung und Zertrümmerung]" (188–89/*364*). Many twentieth- and twenty-first-century writings continue this baroque process of reworking tragic motifs into allegories that render the mythic elements lifeless, render them into things in ruination. Myth is critically transformed.

Nobody is on top of things. Contrary to the limit set to art and to history as time is subsumed by the tragic (*W* 1, 55/II:1, 133–34), the subject of destiny in the mourning play is not determinable; there are instead "constellations" (*O*, 131–32/I:1, 310–11). Neither unwittingly nor purposely does anyone have the key to time. Benjamin's first inkling of what he would develop in the *Trauerspiel* book supposedly came at the sight of the king's crown worn crookedly on his head in a Geneva production of the twelfth-century Spanish heroic epic *El Cid* (*W* 3, 336/VI, 534). In the baroque mourning play, the sovereign is creature (*O*, 85–86/I:1, 263–65) and the courtier as intriguer also personifies fallen or creaturely sensibility (95–98/273–77). The classicist pedagogical authority of Aristotelian poetics is undermined. Aristotelianism belongs to the "didactic intention" of the German baroque mourning plays, but amounts to an almost entirely "alien theory." From this theory, the plays contrive a kind of naturalizing authority for actions; but the actions themselves ultimately override and undermine this authority (98–100/277–78).[19] The theory is alien to the plays; the plays are alien to most of the Aristotelian precepts relevant to ancient Greek tragedy. The didactic "gravity" (Gravität) of the German baroque drama may entail extensive borrowing from precepts of ancient Greek drama but is not derived from them (*O*, 128/I:1, 307). As will be elaborated below, this gravity attests to another kind of futile will. Sensation reacts, in any case, against attempts to subordinate it to will. The antithesis of "naive stirrings" (naiven Regungen) and dictatorial spirit in the baroque is a specific instance of the conflict of "sensation" (Empfindung) and "will" (Wille). The latter conflict may end in madness; the disillusionment of the "power-will" can, however, also be sobering. Mourning about will can be a sobering disillusionment of will. Mourning is a "mood" opening in a salutary way to the naive stirrings, to sensation, that cannot be controlled. On the basis of the mood of mourning, the ideal courtier in the Spanish baroque mourning play is able to enter "an unlimited compromise with the world" (98–99/276–77).[20] The compromise is unlimited, for it is compromise with the creaturely world, the world of sensation, the world that ruins the *apparatus* of will.

If ruination is all that is entirely irresistible, knowing and beauty are inextricable from one another (*O*, 182/I:1, 358). Only in ruination is detail or entity really known. This known detail or entity is the beautiful detail, for only in ruination is detail or entity engaged with the irresistible. Ruin is the beauty of the conclusive, the irresistable, breakthrough of nature into life. Enduring beauty is "an object of knowledge [ein Gegenstand des Wissens]" and there is nothing beautiful without "something essentially worthy of knowledge" (Wissenwürdiges im Innern) (182/*357*). This relationship of knowing, ruin, and beauty is, of course, most precisely elaborated by Benjamin with reference to the German baroque mourning play. It is in ruination that the "form" German baroque mourning play maintains "the image of the beautiful [Bild des Schönen]." Others may "shine resplendently as on the first day" but this form is already "on" the "last" day (235/*409*).[21] What endures is an "object" (Gegenstand) that "settles" in "thought-out constructions of ruins [durchdachten Trümmerbauten]" (*O*, 182/I:1, *357*), for (as Benjamin had said already in the *Elective Affinities* essay) the opposition of semblance and "the expressionless" (das Ausdrucklose), an opposition essential to beauty, is the sole possibility of the expressionless showing itself anywhere. In an art presentation, the opposition of semblance and expressionless must be thought out if the expressionless is to be "unambiguously" (eindeutig) named in criticism. The naming is unambiguous in the sense that it bases itself on the only basis of knowing: ruination. Although beauty would cease if semblance were to vanish from it, the manifestly living can incorporate an intense and clear polarity whereby semblance is simultaneously "triumphant and fading" (*W* 1, 350/I:1, *194*; see also 351–52/196).[22] The "semblance of beauty as such [Schein der Schönheit schlechthin]" is a fading that is triumphant by being open to constant transition and devoid of identification with any specific semblance (*W* 1, 350/I:1, 193). The beauty lauded by the ignorant, in contrast, is (as the *Trauerspiel* book suggests) an identification with some semblance or other. Beauty has nothing "inalienable [Eigenstes]"—nothing unto itself—for "the ignorant" (den Unwissenden) (*O*, 181/I:1, *357*). The ignorance of the ignorant is their disregard of all that can be known—the inalienable, the ruination. To resist this denial of death—this denial of all that can be known—is the philosophical beauty of art.

Ruination ultimately destroys and survives ignorance; that is its role in art, which is the philosophical importance of art for criticism. The German baroque mourning play is "recalcitrant [spröde]" to the ignorant (181–82/*357*). The ignorant want semblance hypostatized against ruination. In a way, we all live ignorantly; we live to perpetuate semblance against ruination. As art opens semblance to death, this opening to knowledge is (of course) opening to what cannot be lived. There would be no problems of scholarship, no problems of

art, indeed no love entanglements if there were an end to the tension of living and knowing; there would be utopia facilitated by "soberness" (Nüchternheit) and "obduracy" (Sprödigkeit) concerning any delimited moral order and concerning the deterrent effect of this order on the unfolding of appearances (II:2, 619).[23] Although there is not this utopia that is beyond the disjuncture of life and knowing, the allegorizing power of death does exist to express the opposition of semblance and expressionlessness. Presenting themselves in ruination, allegorical references initiate criticism of semblance (*O*, 182/I:1, 357).[24] Criticism is, in turn, born of this spirit of art. Just as the "allegorical artwork" bears "the critical decomposition already, as it were, in itself," so there is in this work "the birth of criticism out of the spirit of art" (I:3, 952).

This destructive approach to semblance must, accordingly, be taken up and renewed in criticism. Every later critic of an artwork must interpret what over time becomes conspicuous and historically strange, the semblance made archaic by passing time and already destructively encountered by the artwork itself (*W* 1, 297–98/I:1, 125). Philosophical criticism bases itself on—and revives—this "decay of effect [Wirkung]" (the decay diminishing the appeal of earlier "charms") (*O*, 182/I:1, *358*). In the German baroque mourning play, semblance is so ostentatious that it has already quite demonstratively begun to die off. This crumbling of semblance is the work presenting its amenability to criticism (182/357). Regardless of how much there may—and must—remain interpretative dispute about whether or not a specific construction has this amenability, criticism is the exercise of considering whether there is simply a semblance of truth content following from material content or instead material content that follows from truth content (*W* 1, 297–98/I:1, 125). In the latter case, the artwork seems to philosophize itself and readily let itself be philosophized. That would be, as suggested already, its sole inalienable beauty. Beauty is like "revelation" by bearing within itself history that somehow suspends itself on behalf of secret; in beauty, history has begun to philosophize itself. Beauty presents history but does so with regard for idea; "geschichtsphilosophische"—historico-philosophical—orders show idea to be secret much more than it is effect. Beauty "does not make the idea visible but rather the latter's secret [Geheimnis]" (351/*196*). Insofar as the artwork "maintains itself as ruin," "all ephemeral beauty [ephemere Schönheit] falls away completely" and there is "transformation of material contents into truth content." This transformation—*Umbildung*—is not a transfiguration or complete dissolution of material content. It is, rather, such content in the beauty—the irresistible knowledge—that is ruination. In turn, philosophical criticism is a "rebirth," a reawakening, of "the beauty [das Schöne] of works." This is the undeniable role of philosophy in criticism (*O*, 182/I:1, *357–58*). This role of philosophy in criticism may not be denied, for the sober beauty of philos-

ophy itself is already (and very concretely) in the artwork as the knowledge and the allure of necessary ruination.

If presentation of history as writing-image, as signature-of-meaning that ruins historical meaning, is the beauty and the philosophical justification of art, it is necessary to avoid "philosophical barbarism" (not to mention lack of methodology and reason) that entails "banal philosophemes" conflating semblance and beauty, making beauty a living semblance (*W* 1, 351, 350/I:1, 195, 194). As ru(i)ned, the artwork not only has its philosophical justification but requires a correlative conception of philosophy in criticism. *Origin of the German Mourning Play* is both an attempt to give a "philosophical foundation [Fundierung]" to baroque philology (of emblem-books, poetics, manuals, and various secondary and other primary materials) (*O*, 163/I:1, *339*) and an attempt (especially in the second main part) to elaborate and defend "the philosophical content [Gehalt] of a vanished and misunderstood art form, the allegory" (VI, 216; *W* 2, 78/VI, *218*). Scholem refers to an attempt to elaborate and defend the distinctly philosophical character of allegory.[25] For Benjamin, an "epistemological elaboration" (erkenntnistheoretischer Ausbau) of allegory (*O*, 163/I:1, 340) concerns a "natural history [Naturgeschichte]," a "primal history [Urgeschichte]," of "signifying [Bedeutens] or of intention" (166/*342*). Baroque allegory is ultimately amenable to this elaboration; it resists the philosophical barbarism that would conflate living semblance and beauty. Baroque allegory has history as a "material moment" (stoffliches Moment) in an emblematic presentation; "signifying nature" puts forth its victorious "transfixed face" and this transfixing of face renders history subordinate to nature, makes it a mere prop of nature (170–71/*347*). This is the modernism of allegory and the allegory that Benjamin seems to regard as inherently modern.[26] The artwork does not have nature so permeate history that history is mythically eliminated. History is ruined, not ejected. This has been stressed above: Conveying that meaning is related solely in a "writing-image" (Schriftbild) (*C*, 238/*GB*, Vol. 2, *437*), art converges with philosophy—and is so important philosophically—in the beauty of image devoid of symbolic beauty. In turn, the critic is like a paleographer reading surface writing that refers to, but cannot quite expose, a faded text (*W* 1, 298/I:1, 125). The faded text of nature allegorizes—ruins—the surface text; the beauty of philosophy already in the artwork is performance of this ru(i)ned image. That performance of ruin and writing-image initiates criticism in the work and requires furtherance of such destruction in the critical reception.

If critical image is always writing-image, literature is—from this philosophical perspective—the quintessential imaging. In the rhythm endemic to name (as discussed above), literature has appearances convey the force determining

them and yet withholding itself from them. "Poesy" is an "imperfection [Unvollkommenheit]"; it presents itself as imperfect, for "beauty [die Schönheit]"—the beauty necessary for survival as living semblance—"is essential" to it. It presents itself as imperfect in relation to the music—the semblancelessness—of truth; the latter is music as the "perfection" (Vollkommenheit) for which "beauty [Schönheit] is accidental" (VI, 126). Truth does not need history and thus does not need beauty; in the rhythm endemic to name, literature is uniquely able to sustain resonance of the tension of semblance (for which beauty is essential) and the truth-music (for which beauty is accidental). Painting and sculpture translate "the mute language of things" into a "higher"—an artistic—but "similar" language; music "rescues the name as pure sound" but "at the cost of its separation from things."[27] Literature has its distinct expressive potential as name that is sound-figure maintaining referential relevance. The "resounding" of music is thus conceived as no fulfillment of the mute world but rather as "dedicated" to the mute world—the mysterious world; it "promises" the mute world "the redemption" that is more than "conciliation" (Aussöhnung) (*W* 1, 355/I:1, *201*). As an endless feeling impels it to seek "redemption," to seek "the redemptive mystery" that is "music" ("the rebirth of feelings in a supersensory nature"), "play" (Spiel) or "interplay" (Widerspiel) between "sound" (Laut) and "meaning" (Bedeutung), between sound and semantic-referential meaning, is "a ghostly, terrible one" (ein Geisterhaftes, Fürchterliches) (*W* 1, 60–61/II:1, *139*). The play between such meaning and sound is ghostly and terrible in recalling the redemptive music impelling the play but not realized in it. It is the writing-image haunting the realm of conciliation, the realm of living semblance, with the reminder that all is not well. Characterized by the transition of dramatic time into "the time of music," the mourning play distinguishes itself from the "closed form" of tragedy, from the latter's "temporal character" that is "exhausted and shaped in the dramatic form" (57/*137*). In its own rhythm as writing-image of imperfection, literature is a distinctly effective juxtaposition of semblanced thing and semblanceless music.

Literature is distinctly suited, moreover, to present thing-language that is musical in its interruption of sentimentality turning music into beautiful semblance. (". . . music issued. . . . The sentiment of the opening bars, their languor and supple movement, evoked the incommunicable emotion. . . . His unrest issued from him like a wave of sound. . . . Then a noise like dwarf artillery broke the movement. It was the clapping that greeted the entry of the dumbbell team on the stage." *P*, 75) The material content of literature mocks the sentimental (and only ostensible) release of emotions by music, which becomes semblance insofar as it seems to offer release ("the prelude of a waltz" *P*, 78). Poetry can, of course, also move toward such semblanced music.

La la la ree. Trails off there sad in minor. Why minor sad? . . . They like sad tail at end. . . . La la la ree. I feel so sad today. La ree. . . .
 Too poetical that about the sad. Music did that. Music hath charms Shakespeare said. (*U*, 279)

In contrast with such musical-poetical charms seeming to avoid the thingness that interrupts living semblance (presents semblance as semblance), literature—poesy—refracts "[c]ompletion [Vollendung] of music" (VI, 126) by accentuating the lack of musical completion.

Considered from the perspective of "literature" (Dichtung), and especially from the perspective of the mourning play, opera is a "product of decline" (Verfallsprodukt). This is cultural decline or decadence; the "soul of the work" disappears as there is surrogate removal of obstacle or inhibition and thus of mourning about obstacle or inhibition. Whereas Nietzsche lauds opera (prototypically Wagnerian opera, the "'tragic' *Gesamtkunstwerk*") as a kind of "primal cry [Urlaut] of all creatures," Benjamin objects to the tendency of "operatic plot and operatic language" so to diminish the inhibition by semantic-referential "meaning" (Bedeutung)—and by intrigue based on it—that "obstacle" (Hemmung) to the expression of feeling disappears. The dramatic "structure" (Gefüge) and the scenic structure are "emptied" (entleert) (*O*, 212–13/I:1, *386*). The eventual decline of *Trauerspiel*—its dissolution into opera—is partly attributable to the German baroque "self-indulgent delight" at "mere sound"; Benjamin refers to oratorio-like intermezzi, musical overtures, choreographical interludes, the choreographical style of the intrigue, and the quasi-operatic pastoral play (213, 211–12/*387*, 385).[28] Writing is suppressed or disregarded as the "home" of significance or meaning (Bedeutung); it is suppressed or disregarded as the mediation by convention. Such suppression or disregard of writing is an inability to mourn. Mourning is based on dammed-up feeling, not on expressed feeling. "[M]eanings" (Bedeutungen) are "the origin [Ursprung]" of mourning about them; meanings and the "intriguer"—the "master of meanings [Herr der Bedeutungen]"—are "responsible" (schuld) for the mourning about meanings. If richly significant irony echoes and intimates even in the words of the intriguer, this attests to the tension of the onomatopoeic, sounding impulse with the inextinguishably conventional dimension of meaning (*O*, 209–10/I:1, 383–84). Mourning is the echo of feeling that does not find its complete sound.[29]

As the force of mediateness in meaning production, writing is no acoustic ecstasy. In the baroque, the "chasm [Kluft] between signifying script [bedeutendem Schriftbild] and intoxicating spoken sound [berauschendem Sprachlaut]" necessitates a "gaze into the depths of language," for—notwithstanding performances of the plays—the writing is, of course, not transfigured in

sound; the "world" of writing remains "completely self-sufficient" in its tendency to display "its own force [Wucht]" (*O*, 200–201/I:1, *376*). Its own force is the aforementioned hieroglyphic one; nature enters writing neither in conventional sign nor in symbolic completeness but allegorically (175–76/351–52). Not surprisingly, this allegorical element provoked various "rationalist" objections in the later reception of the plays (200/376). Although Benjamin advances a criticism moving beyond the antitheses in the German baroque, it is not in dismissal that he notes the latter's view of "meaning" (Bedeutung) as an affliction (like "an inescapable disease") and as "the reason for sadness [der Grund der Traurigkeit]" (209/*383*); in this passage, he is drawing on his own earlier formulations about mourning and language (in the 1916 essay on language [see page 40 above]). In accordance with mourning as what could be conceived as linguistic being simultaneously within every manifestation and transcending every manifestation, however, the play of mourning presents the growth of writing "out of music" (*O*, 214/I:1, 388) in the ability of word, syllable, and sound to be emancipated from "any traditional meaning-association" by becoming "thing that may be exploited allegorically." It is not only pomposity but also "the fragmentative, dissociative [zerstückelnde, dissoziierende] principle of the allegorical approach" that led to the capitalization of the first letter of nouns in German orthography; a fragmented piece of "disintegrated [zertrümmerte] language" no longer serving the purpose of "mere communication" becomes a "newly born object" with allegorical "dignity" (207–8/*381–82*). This allegorical dignity not only attests to the growth of writing out of musical impulse but is also the basis for the literary presentation of the obstacle of writing—as convention—to this growth. As it presents the tension of semblanceless musical impulse and convention, literature presents itself as writing.

In literature, therefore, writing is the "figure [Figur]" of "what is read [Gelesene]" (215/*389*). The harmony of color exists only in the medium of "vision [Anschauung]," and musical harmony has "infinite possibilities" (which are "only systematically" limited) (*W* 1, 48/VI, *109*). In its own force, however, name is music in perception and perception in music. Interweaving perception and semblanceless sound, the "basic law of literature"—the *Grundgesetz des Schrifttums*—is that the significance of a work correlates with an inconspicuous and intimate bond of material content with truth content (297/I:1, 125). The bond is inconspicuous in being kept from identification with living semblance (ultimately, the bond cannot be seen) and is intimate in being kept from surrogate, illusory overcoming of semblance (in the manner of opera, as Benjamin criticizes it). As suggested above, however, even nonmusical and nonliterary arts (architecture, sculpture, painting) are based on "the letter" that is "sound-figure" (*O*, 214/I:1, *388*).[30] The sound-

figure of letter is neither fulfillment in living semblance nor complete independence from it. Semblancelessness has authority for art without ever being realized in art. A "dialectical" solution of the antinomy of semblanceless authority "lies in the essence of writing itself" (*O*, 174–77/I:1, 350–53). Writing is the synthesis that is also the tension of semblanceless musical impulse and semblance. Although literature is most obviously defined by this "dialectical" solution of the antinomy of semblanceless authority and living semblance, all arts have writing-image as this solution. As echo of inextinguishable semblancelessness in inextinguishable mediation by semblance, writing-image is criticism already effective in all art.

The scission of philosophy and art is attenuated by this complementary relationship (this intertwining) of criticism and artwork. In artwork and criticism alike, criticism is the ru(i)ned and ru(i)ning image. Objections to extensions of the word "text," as such extensions have been undertaken in the reception of Benjamin's works, are often questionable.[31] In a later work, Benjamin compares "written history" with the "white light" underlying "the colors of the spectrum." Referring to "the pure colorless light of written history," he suggests that such "historiography" (Geschichtsschreibung), such writing of history, is a "common ground"—the German text actually says, "point of creative indifference" (*W* 3, 152/II:2, *451*).[32] As creative common ground, writing is indifference to color. The light of writing is colorless. On the basis of this colorless ground of writing, appearances are allegorized and also tend to allegorize. This extension of Benjamin's notion of allegory seems warranted. A fairly recent book refers to the late Hölderlin's "allegory."[33] Although initially Schiller's disciple or protégé and under the influence of Johann Joachim Winckelmann's classicist ideal, Hölderlin increasingly adopts the presentational power of writing as a sobering of appearances.[34] Appearances are ru(i)ned and are themselves ru(i)ning. They preclude classicist hypostasis. Even Hölderlin's Sophocles translations demonstrate this, as tragic meaning collapses under the linguistic force that neither tragic meaning nor any other accessible meaning can contain; these translations come from Hölderlin's late period, which is dubbed "baroque" by Hellingrath and Benjamin (*O*, 189, 230/I:1, 364–65, 403).[35] Benjamin's discourse may also be construed as a variation of what the *Trauerspiel* book calls "allegorical textual exegesis" (allegorische Schriftexegese) (*O*, 175/I:1, 350–51). The "allegorical trait" of Benjamin's philosophy generally is its proviso that there can be no claim to unmediated presentation of meaning. All is writing; "reality" is like a palimpsest.[36] As writing-image, reality is presentation of the tension of reference and the ultimately colorless force of irresistible ruination. Fostering the artwork in its own critical destruction and letting this destruction serve as a caution to discursive rendering, Benjamin's criticism tremors.

TREMOR-IDENTITY: GENIUS OF TIME, GIFT OF CRISIS

Benjamin's criticism tremors, as indeed does all practice of philosophy. His criticism tremors, however, in the combined philosophical force of the artwork resisting discursive rendering and criticism distancing the artwork and its reception from specific appearances and formulations. Criticism does what narrowly empirical research cannot do. It performs the tension of semblanceless music and living semblance. Revelation exists "in the metaphysically acoustic sphere"; it must be "heard [vernommen]" (*W* 1, 112/II:2, *609*).[37] It must be heard, for it is necessity itself and yet cannot be seen. To Scholem's protest about a "theological transfer of *Anschauung* to the acoustic sphere," Benjamin responds that the "spheres" of *Anschauung* and *Vernehmen* are "not to be separated."[38] *Anschauung* is—in its purest form—a looking or, more broadly, a perception that is based on metaphysical, theological hearing. Artworks perform this perceptual tension. Artworks cannot reach, can only more or less "be like [zu gleichen]" "primal images [Urbilder]." "Primal image" is Goethe's term; primal images (considered by the ancient Greeks to be protected by the Muses) are not only "invisible [unsichtbaren]" but also "vivid [anschaulichen]." For Benjamin (if not for Goethe), primal images bring an otherwise suppressed tension into the realm of *Anschauung*. Although the artwork's "resembling [Gleichen]" of primal images (contrary to any "pernicious materialistic misunderstanding") "cannot, in principle, lead to equivalence [Gleichheit]" or be an "imitation [Nachahmung]," it involves a relationship of "what is perceptible in the highest degree [des höchsten Wahrnehmbaren]" with intuition—"with what in principle is only intuitable [zum prinzipiell allein Anschaubaren]." This intuition—this looking at, *Anschauung* or *Anschauen*—is concerned with perceptual content in relation to a feeling that is pure and only intuitable. This feeling irreducible to specific appearances is a hearing of the scarcely perceptible, and yet entirely necessary, completion of the content. This completion is intuitable as necessary, for the content or object is always irreducible to its appearances. Although this completion never appears, it is somehow announced and felt. This hearing is made possible by the content announcing itself in "feeling" (Gefühl) as "pure." The relevant "Anschauen" is the "sensing," "apprehension," "hearing" (Vernehmen) of the "necessity" of "content" (Inhalts) becoming "completely perceptible [vollständig wahrnehmbar]." This completion remains perceptible, however, solely as intuited "necessary perceptibility [notwendige Wahrnehmbarkeit]." This solely intuited necessary perceptibility is the "ideal of art," which "never appears purely in the art work itself"—never appears purely in the work that is mere perceptual object—but only announces itself (as pure) in the perceptual object (*W* 1, 180/I:1, *111–12*).[39] According to Benjamin's transformation of Goethe's notion of "Urbilder," the metaphysically—that is, theologically and

philosophically—acoustic initiates, and remains the ground for, criticism of the perceptible in the work.

The acoustic feeling for philosophical necessity must (in a manner of speaking) moisten or fill eyes with tears that remove the visible world from those eyes (*W* 1, 348/I:1, 191). The visible world offers neither remedy nor placebo to this feeling. The consequence is not, however, resignation about the visible world. The relevant tears let things somehow speak their names ("Sonette," VII:1, 29). Names emerge as transformation of the visible by music. This contrasts with Stifter's writings, which entail language showing "feelings and thoughts" largely in space "deaf" to the possibility of "redemption in liberating expression [Äußerung]" (*W* 1, 112/II:2, *609–10*).

There can be angelic resonance of "music" and an ensuing veiling of image by tears (348/I:1, 191–92); semblance promises to fade and longs for "dimming" (Trübung) and thus for perfection (348/*191*). In this Dionysian "tremor" (Erschütterung), space gives "resonance" (Resonanz) to "emotion" (Rührung) that is itself, in its deepest realization, "transition" (Übergang) executed in the "downfall [Untergang] of semblance" (348–49/*192–93*). Stifter's writings lack presentation of "tremor [Erschütterung]" (112/II:2, *609*), as indeed does Ottilie in *Elective Affinities*, who does not go under as a result of "external danger [Not] or force [Gewalt]" but rather as a result of the "kind" of semblance that she acquires, the "declining semblance" to which she binds herself (349/I:1, *193*).[40] She wishes, above all, to be a beautiful semblance; this beauty seems essential to her and it is her demise. It is no accident that she and Eduard are a couple of acclaimed beauty (*W* 1, 344/I:1, 186). Unlike such fixation on a specific declining semblance, Dionysian tremor liberates space by opening it to the force of decline within it; semblance is opened to the destruction simultaneously within it and transcending it. In her defiance, the young woman in the novella within *Elective Affinities* is "not essentially beautiful" (348–49, 344/*192–93*, 186). Against a perplexed Job-like passion of ultimately submissive agony under beautiful semblance, there may be music of love (348/*191*). This is the music resonating against living semblance to facilitate a transformation of it. This is, of course, no entry into unmediated infinitude; that is not physically possible. In the finite force of "inclination" (Neigung), emotion (the "great" emotion of the tremor, not the self-satisfied "small" emotion) is able to bring semblance to decline (348–49/*191–92*).[41] In the artwork, the critical tremor ensuing from the philosophical angel is a removal of the visible world but also a reentry—an opening or transformative entry—into that world.

> He closed his eyes. . . . His eyelids trembled as if they felt the vast cyclic movement of the earth and her watchers, trembled as if they felt the strange light of some new world. His soul was swooning into some new world, fantastic, dim, uncertain as under sea, traversed by cloudy shapes and beings. (*P*, 173)

To live, to err, to fall, to triumph, to recreate life out of life! A wild angel had appeared to him, the angel of mortal youth and beauty, an envoy from the fair courts of life, to throw open before him in an instant of ecstasy the gates of all the ways of error and glory. On and on and on and on! (172)

The artwork is dissonant vision. Imagination and *prophetic vision* (Sehertum) are polar opposites that enter any artwork. Neither can alone be the basis of the work. Imagination concerns "emergent deformation" (werdende Entstaltung), recognizes only "perpetually changing transition" and is "the genius [Genie] of forgetting." Prophetic vision concerns "nascent formation" (werdende Gestaltung) and is "the genius [Genie] of presentiment [Ahnung]" (*W* 1, 282/VI, *116–17*). Modern allegory, which has been discussed above as allegory as inherently modern, is dissonant encounter of imagination and vision. For Benjamin, allegory thus eludes very precise definitions of it as obvious or blatant personification in narrative (even if such personification is construed to be partly about the capacity of language to signify many things at once).[42] In modern allegory, moreover, vision—and indeed prophetic vision—is too attenuated by imagination to ally with most teleology. Not devoted to any teleology of "earthly" or "ethical" bliss (any Enlightenment teleology for which "human happiness" is "the supreme purpose of nature"), baroque teleology submits creatures solely to "mysterious instruction" (geheimnisvolle Unterweisung) (*O*, 170/I:1, 347). Overwhelming allegory as personification is a parabasis of irony, an ironical parabasis, an irony that is no trope, an irony that provokes and destroys all tropes.[43] Image-dissonance is integral to the ironizing temporal ground (although there may—as will be noted below, at the close of the remarks on "Destiny of Ethics" toward the end of this chapter—be reason to refer to this dissonance as allegory rather than irony). Only "image-dissonance [Bilddissonanz]" makes temporal order "perceptible [sinnbar], audible [lautbar]" (*W* 1, 29/II:1, *117*). Image is dissonant as perception of sound—feeling, time—that has no spatial correlate. That is the critical tremor.

Hölderlin's "Blödigkeit" performs and articulates the philosophically acoustic element. Hölderlin's advice—"Sei zur Freude gereimt" ("Be rhymed towards joy")—points to a basis in "the sensory order of sound [Klanges]." The identity in rhythm is not "substantially" (substanziell) but only "functionally" a "law" (Gesetz). The rhyming is not "*to*" (*auf*) joy and the relationship is not "*with*" (*zu*) joy; the rhyming is "towards" (zur) joy and the relationship is "of" (von) joy (29/*117*). The temporal order of the rhythm is insatiable; it cannot be substantially realized. In the "glatte Fügung" (smooth construction), says Hellingrath, "unities" become "definite [fest]" and "stereotypical," and the word appears as "subordinate element" in "rigid, handed-down combinations"; timing is closed, without caesura. The "harte Fügung" (hard construction), in contrast, is "more irrational, less clear, less

bound."[44] For Benjamin, the construction diminishing stereotypicality, rigidity, and hackneyedness could be said to involve the rationality of idea—of word—undermining the rationality of semblance. In Scheerbart's *Lesabéndio*, Benjamin notes, the "strict construction" (strenge Fügung) of the narrative concerns nothing besides the technical process of building an interstellar tower; this sober, persistent process symbolizes "a real idea" (II:2, 619). Even in less-utopian conditions, idea is the symbolic dimension allegorizing semblance. In Hölderlin's "Blödigkeit," the sober complementarity of imagery and ideas emerges as unlimited against any appearance that is static and limited in and by itself (*W* 1, 35/II:1, 125–26). Ideas keep appearances open. The idea involves "the true" (das Wahre) dominatively entering "sensory fulfillment"; in such fulfillment, however, "shape" (Gestalt) becomes a "spreading" (Umsichgreifen) that is "infinite" (unendliches) and "always more unlimited" (immer unbegrenzteres) (31/*120*). In Hölderlin's later poetry, "inner identity" involves divine time that accordingly ornamentalizes space (30, 27/118–19, 115). The expressionless is "hearable" (vernehmbar), the *Elective Affinities* essay states, in caesura—for example, in the falling silent of the heroic figure in tragedy or in the "protest [Einspruch]" in the rhythm of Hölderlin's hymnic poetry (341/I:1, *182*). A counterrhythm of time in space attests to the rationality that can have appearances give way, however momentarily and faintly, to the philosophical sound—the linguistic being—which is no space and has no space.[45]

That is the rhythm of philosophy, the rhythm of reason, in art. As implied above, spatial and spiritual orders in such rhythm enter no "same [gleiche]" identity but rather an "identical [identische]" one (*W* 1, 27/II:1, *114*).[46] Their identity with one another does not annul their distinctness. It is, rather, "a half-doubleness" in which sameness—doubling—is half (so to speak) in the rhythm (*W* 1, 29, 26–29, 32–35/II:1, 117, 113–18, 122–25). The "spheres" of space and time—the orders of the living and the divine, the "concrete and spiritual forms [anschaulichen und geistigen Formen]"—are with and among one another in a "balancing" (Ausgleichung) (25–27/*112–14*). A "peculiar doubling" enables each "shape" (Gestalt) to be bound in "spatial determinations" and yet also to carry in itself "a purely immanent sculpture [Plastik] as expression of its existence in time" (30/*119*). Art-philosophical bearing of time without spatial correlate contrasts with mythological "idyllic world-feeling" (29/117); the latter unwittingly isolates parts by forcing them into an idyllic "connection [Verbindung]" (24/*110*). An attempt to include the true mythologically in poetic activity (31/120) remains a weak "duality" (23/110), for an unduly constrictive version of the absolute deprives parts of the possibility of actually engaging the absolute and the dualism ensues (25–26, 33–34/113, 122–23). In Hölderlin's later peculiar doubling of space and time (concrete

and divine), the gods indeed give "the object" limiting destiny and they themselves become "the immeasurable shaping" (die unermeßliche Gestaltung) of destiny (30–31/*119–20*) but the god must thereby "serve" song (32/*121*).[47] This motif recalls perhaps the gods in non-antique or anti-antique Western allegoresis who so enter the vagaries of existence that they project into the world alien to them, become evil and become creatures (*O*, 225/I:1, 399). The creaturely sensation ultimately serves song by presenting pictorial dissonance; as the god is subordinated to carrying out the "law" of the song (*W* 1, 32/II:1, 121), the functional law—the goal and path—of poetry is visible solely in pictorial "dissonances" (29/117). In this rhythm, things show their own "direction of concentration"; in this direction, they struggle for idea and thus determine within purity of shape (29, 30/117, 119). Sensation must struggle for idea and determine within purity of shape, for it is incorporated in no manifestation. Sensation can manifest itself solely in a rhythm of image dissonance.

In this rhythm, shape is near and limiting as well as strange and open. Although the purpose of poetry is progressive sublation of the "difference [Unterschied] between shape and shapelessness" (31/*120*), the "basis [Beruhende]" of "all relations"—the "origin" (Ursprung) of "poetic shapes" (25/*113*)—is an "inner law" in which the sublation must limit itself (32/121; see also 34–35/124). As the song and the poet are no longer differentiated and the poet becomes simply a shapeless "unity" of shapes and world (35/125), the entry of "the spiritual" (das Geistige)—the spiritual as "sculpture [Plastik] of the shape" (30/*119*)—does not eliminate the necessity that the poet (as "principle of the shape") be a limiting as well as carrying force (35/*125*). The intensity, the inner temporal form, is a spiritual arbitrariness but it is one emerging only as a kind of walk (27/115). ("There was a lust of wandering in his feet that burned to set out for the ends of the earth." *P*, 170) No traditionally mythological affinity and dependence, poetry is a sober walk (*W* 1, 26–29/II:1, 113–18). It is no German classicism. Insofar as it reacts to the Kantian cleft between sensibility and understanding, Weimar classicism involves attempts to unite nature and spirit in "the moment" (the *Augenblick* [the view—*Blick*—of the eyes—*Augen*]), the "ecstasy," of "the great beholders" (der großen Schauenden). This aestheticist ecstacy is only an insulation against experience (II:1, 31–32).[48] No space can be a solution of time. Time in the poet always encounters some space or other that must—as it were—be walked across: "Does your foot not walk upon the true, as on carpets? [Geht auf Wahrem dein Fuß nicht, wie auf Teppichen?]" These words from "Blödigkeit" seem "strange" (fremd), as though "from the eastern world" (*W* 1, 26/II:1, *114*). The preceding sentence—the first line of the poem—is a question too and also has a "majesty [Hoheit]" that could be formulated as a

"vastness [Weitlaufigkeit]" evocative of "something Oriental [Orientalisches]" (26/*113*). In any case, what Benjamin calls Oriental shape sublates the "Greek shaping principle" that remains dualistic precisely by closing shape against shapelessness (while claiming to overcome or subdue the latter). The Oriental and mystical principle—a principle overcoming limits—is (as demonstrated and advanced in "Blödigkeit") shape always open but—precisely for that reason—never quite tractable (34/124).

(... *Under the umbrella appears Mrs. Cunningham in Merry Widow hat and kimono gown. She glides sidling and bowing, twisting japanesily.*)

MRS CUNNINGHAM: *(Sings)*

 And they call me the jewel of Asia.

MARTIN CUNNINGHAM: *(Gazes on her impassive)* Immense! Most bloody awful demirep! (*U*, 509)

Near and distant, the so-called Oriental image is carried by an unshowable and yet inextinguishable bearer. The rhythm of this bearer is the aforementioned counterrhythm. A "penetrative caesura" (eindringliche Zäsur) giving "distance" from shape and from the world of shape (*W* 1, 35/II:1, *125*) facilitates appearance of the "representation itself," which is distinct from—but carries—the "onrushing change of representations" (340–41/I:1, 181–82); "the transport" of shape "presents itself" (340/I:1, 181). Presenting itself as near and distant, the carrier ruptures or interrupts by showing itself removed from the rhythm of succession that it carries. In "the rhythmic succession of representations," the "caesura" is a "counter-rhythmic rupture" (340–41/181).[49] It seems, "in the oddest way," "strange and almost killing" as Hölderlin advances the image of being held upright on golden leading-strings; as with other images in "Blödigkeit," the "rigidity and inaccessibility" combine to recall "oriental vision" (*W* 1, 31–32/II:1, *121*). Not unlike the aforementioned transfixed countenance recalling nonpictorial nature (page 133 above), rigidity and inaccessibility comprise intransigence that is full of mystery. Intractable life is daunting and requires boldness or courage; yet it is also paradoxically no occasion for worry, for it is the shapelessness always already determinant in shape. "Boldly, therefore, my genius, / Step into life and have no care! [Drum, mein Genius! tritt nur / Bar ins Leben und sorge nicht!]" (28/*116*) The caesura is strange to the rhythm of succession and yet strangely familiar as the carrier of this rhythm. It is freedom of the intrinsic lack of freedom; it is destruction by the indestructible. Benjamin, Hölderlin, and most moderns consider the counterrhythm to be the imperishably free rhythm of art. ("He would create proudly out of the freedom and power of his soul ... a living thing, new and

soaring and beautiful, impalpable, imperishable." *P*, 170) The rhythm is protest or interruption, for it can appear only as what cannot appear. The caesura constantly created anew in art works is the force of rhythm or counterrhythm that is everywhere—with each step, each succession—and yet, of course, nowhere.

> He started up nervously from the stone-block for he could no longer quench the flame in his blood. . . . Evening would deepen above the sea, night fall upon the plains, dawn glimmer before the wanderer and show him strange fields and hills and faces. Where? (*P*, 170)

Art is the ever-renewable and never complete step from life to Life.[50] It counters supposed *immediate feelings of lived life, warming of the heart* and *mood* (*W* 1, 19–20/II:1, 107).[51] Life lived—life that someone *erlebte*—may assist in the production of poetry but is not the producer of "true literature [wahren Dichtung]," of true art. Irrespective of the possibility or likelihood that it is a roman à clef, Friedrich Schlegel's *Lucinde* (1799) is "touched by life too early." It expresses too little of depth, shadows, yearning. This book on love lacks "true yearning" ("Lucinde" [note from sometime after mid-1918], VI, 131–32). True longing is Life. It is not life. Art is bound to nature withheld from whatever might be construed as livable realization. The modern has no genuine possibility for the "naive" innocence that regards lived life as "immediate contact with all powers and shapes of the cosmos" and finds "symbols" in some accessibly pure, powerful, and beautiful shape (II:1, 127).[52] "Pain" (Schmerz), Benjamin maintains, may be the sole "spiritual [seelische] constitution" in which the post-ancient's "inner being" (Inneres) can be related "with both full purity and full greatness to the whole [Ganzen] of nature, the whole of the cosmos" (II:1, 126). In its purity and greatness, inner being is withheld from, unable to find, spatial solution. Life as "ultimate unity" is the "task" determining itself through the poem that is "solution" (*W* 1, 19–20/II:1, 107). The poem is, however, a rhythmic and not a substantial solution. This has been stressed above. Rhythmically "identical" with Life (29, 25/117, 112), the poematized is a "coherence of shape" (Gestaltzusammenhang)—a hanging together of shape—resonating with "unalterable [unwandelbaren]" destiny (26/*113*). Unalterable destiny, the life of the artwork, is life that is necessarily given but cannot be substantially lived.[53] The determinant life of art is not people or individual but life of a "pure art work," the artwork's own unlivable life (*W* 1, 35/II:1, 125–26). Adorno also suggests the nondiscursive "language of suffering," based on the ever-determinant "in-itself" that society cannot contain and can scarcely tolerate, may attain some kind of resonance in art.[54] All arts and artworks are constituted by this unlivable life. All arts are oriented toward imagination ultimately outside of color (*W* 1, 48/VI, 109). In its longing and

regret, art presents the tension of existence with the Messianic. This tension is art's rhythm. Art may be heard—by the "hearer" or "apprehender" (Vernehmender)—as a possibility of learning from the "yearning" (Sehnsucht) that is ultimately not fulfilled by the artwork (265/*124*).[55]

The rhythm of art is longing for the determinant, yet substantially unrealizable, force. If "all artistic media" lend "scope" (Raum) to "expressionless force [Gewalt]," they do so with the requisite sobriety; space does not, after all, fulfill expressionless force. Hölderlin refers to "occidental Junoian sobriety" (*W* 1, 341/I:1, *182*).[56] A female counterpart of the Roman god Jupiter, Juno is goddess of female fertility and of women generally. Artifice ("Old father, old artificer, stand me now and ever in good stead" [*P*, 253]; "the great artificer whose name he bore" [*P*, 170]) is led by fertility, by this goddess-mother, to the expressionless. Under the influence of spirit as expressionlessness (as *linguistic being*, to use the formulation of the 1916 essay on language), the identity of space and time, the identity of this father and this mother, is a "structure [Gefüge]" giving prominence to the *mother* in every *father*, to "the temporal identity dwelling in every spatial relation [aller räumlichen Beziehung einwohnende zeitliche Identität]," to "the absolutely determining nature of the spiritual existence within the identical extension." This identity of spirit with extension, of time with space, is the aforementioned rhythm of dissonance (*W* 1, 28–29/II:1, *117*). Ensuing from freedom that is the necessity resting with no space, such soberness about space is, as shall be elaborated below, sacred (352/I:1, 196–97). Hölderlin's later creations are "sacredly sober"; they come from a "spiritual life" based on the possibility and the necessity of such "soberness" (Nüchternheit) (35/II:1, *125*).[57] In this soberness, longing and necessity converge.

The convergence of longing and necessity is the genius of art. Ironizing its own spatial self, the work presents the indestructible process of ironizing. The work is ultimately a revelatory "mystery of order." It is not, as Herder suggests, a concrete realization of the revelation and mystery of "creative genius [Genialität]" (*W* 1, 164–65/I:1, 86–87).[58] As "sacred-sober [heilig-nüchtern]," "genius [der Genius]" is productivity with a purity deriving solely from "clear consciousness" of "material sources [sachlichen Quellen]" (*GB*, Vol. 1, 299). The material sources are not sacred or pure; sacred or pure is the genius that shows them to be opportune. This is no traditionally mythological transcendence in which everything is already "blessed." As no space and yet in space, the counterrhythm or rhythm of genius is solely the sober longing and necessity of time. It shows space to be determined by time that does not appear in space. Even while showing the closing of opportunity, and perhaps especially while doing so, genius is the temporal relation of opportunity. It presents the questionableness of space seeming to close off time. If "opportunity

[Gelegenheit]" is the "spiritual-temporal identity (the truth) of the situation," the "centre" is opportunity, is genius, and everything is "opportune [gelegen]" (*W* 1, 28–29/II:1, *116–17*). This "unity" or "identity" involves the "construction [Fügung]" so intensifying the exchange of time and space (spirituality and concreteness) that "situation" is "expression" (Ausdruck), that space is "identity" of "the situation [Lage]" and "the opportune [Gelegne(n)]" (19, 24–26, 27/*106, 111–13, 115*).

Even in this rhythmic identity, of course, genius is no space—either of the work or of the artist. It simply turns space into opportunity, into space resonating with time. The "Gelegene"—the opportune—is the "relation of genius [Verhältnis vom Genius]" and "not *to* genius [nicht *zu* ihm]" (29/*117*). The rhythm of caesura accordingly interrupts the "Dichtung," and does so with an element beyond the writer as person (*W* 1, 341/I:1, 182). Hölderlin's formulation "opportune for you" (gelegen dir) does not turn the *du* (*you*) into "something stored, something spatial" (Gelagerten, Räumlichen) (29/II:1, *117*).[59] The "you" is not a space or even a temporal force stored up in space. Not a person, the relevant you is a free (but thereby necessary) temporal force. ("He felt his cheeks aflame and his throat throbbing with song." *P*, 170) The artist serves "genius" (Genius), is immersed in it as a right bestowed by the "work" (II:1, 70).[60] Genius is the right of time confined to no space and confining to no space.

The "untouchableness of the centre" (*W* 1, 331/I:1, 169) reflects into history as the "bright" day that is the "sober" day (352/196). This day is bright in its soberness concerning appearances. Illuminated with the time not spatially realized, the day appears as "a shape of the inner sculpture of existence." Appearing as the supreme shape thought by the poet, the day appears "resting, in tune with itself in consciousness [ruhend, mit sich selbst einstimmend im Bewußtsein]" (30/II:1, *119*). The day appearing in tune with itself is dissonant with its appearances. Inner light, the bright and sober light, is refracted solely in the downfall of spaces. This contrasts with Goethe's writing, which tends to presuppose an "interior" that has light "veiled" but "refracted" in "colorful panes" (352/I:1, *197*). Goethe's complacency or mythification of the colors or spaces of the day is countered by the brilliant or bright light reigning in the novella (within *Elective Affinities*); this brilliant or bright light makes everything "sharply contoured" and, from the outset, somehow pushing toward "the day of decision," the day that "shines into the dusk-like Hades of the novel" (331/*169*). That day of decision (Tag der Entscheidung) is a cutting—*Scheidung*—from or away from—*Ent*—the world of semblance; it suspends the conciliatory day prevailing as the haze—the color-satiety—in the novel. The role of this day of decision in Benjamin's analysis is the utopian one that effectively revives no more than hope. In a slightly different

context, it is clear Benjamin thinks, nonetheless, that the relevant "experience" (Erfahrung) sustains decision. In this regard, decision is "beyond" all later happening and comparison and is thus experienced as "essentially singular and unique," for decision cannot be *founded* honestly on "lived experience" (Erlebnis) (347/190). In Benjamin's analysis, the artwork is shown to be longing that is already an opening to the time—the colorless time—which is no space.

Such sobriety concerning color is the counterrhythm that is the symbolic force of word; as caesura that is "pure word," the longing is the necessity unfulfillable in space (340/181).[61] The caesura is pure word, for it is colorless. Its colorlessness is its independence from moral order. Whereas moral legend attempts to bind feeling to semblance, a harmony of words may be the basis for a transformation of moral legend, but it can be exhausted by no appearance and, therefore, by no moral order—old or new. The day resting in tune with itself does not rest in appearances but in the rhythm of the word-harmony, which is no harmony of accessible meaning.

> He drew forth a phrase from his treasure and spoke it softly to himself:
> —A day of dappled seaborne clouds.
> The phrase and the day and the scene harmonized in a chord.
> Words. Was it their colours? . . . No. . . . Did he then love the rhythmic rise and fall of words better than their associations of legend and colour? (*P*, 166–67)

> Words. . . . [I]t was not their colours: it was the poise and balance of the period itself. . . . [W]as it that, being as weak of sight as he was shy of mind, he drew less pleasure from the reflection of the glowing sensible world through the prism of a language many-coloured and richly storied than from the contemplation of an inner world of individual emotions mirrored perfectly in a lucid supple periodic prose? (*P*, 103)

Devoted to colorlessness, the sober lucidity of prosaic rhythm cannot be the lucidity commonly lauded in contemporary culture (and in much contemporary cultural study and "philosophy"). The latter lucidity is intoxicated with what can be said as though it is entirely seen. The alternative prosaic lucidity may well thus seem reflection of an inner world of emotions that are individual in comparison with the culture glutted in the harmony of moral semblance. Prosaic lucidity plays on a linguistic harmony of crisis. Even as lucid and supple prose seeming (as Joyce says) perfectly to reflect feeling, the sober rhythm is based ultimately on feeling that cannot be entirely said, let alone be entirely seen. The task of working "within" language for the sake of "the crystal clear elimination of the unsayable" coincides with "the genuinely objective, the sober way of writing" (der eigentlich sachlichen, der

nüchternen Schreibweise) (*C*, 80/*GB*, Vol. 1, *326*). The unsayable is the objective. The task of eliminating it is distinct from denying or suppressing it. The task is, rather, to think beyond what has been said or could be said; the task is sobriety about the sayable. Although it may seem unsober to state something so definitely, this objective thinking is not only the task but is also the precondition of art. Art would not be possible without this thinking. The thoughtful or pensive—*Nachdenkliches*—in Hölderlin's "Chiron" is not anywhere; it is rather the time that is light and yet nowhere. Hölderlin asks: "Where are you, that is pensive! . . . Where are you, light?" (Wo bist du, Nackdenkliches! . . . wo bist du Licht?)[62]

As the "thinking" (denkenden) day in "Blödigkeit" emerges rather than the "joyful" (fröhlichen) day (figuring in the second version of "Dichtermut"), the adjective "thinking" pertains not to a "characteristic" (Eigenschaft) but to a "gift" (Gabe). This gift of thinking is an already received gift. A being has its spiritual identity—its identity in time—as thought. "Thinking" (Denken) is the "gift" that is the very "condition of the spiritual identity of the being" (Bedingung der geistigen Identität des Wesens). This condition, this gift, must nonetheless be constantly made. It must be made anew if no space is to be awarded primacy over time. Imagining that the day "is granted" (sei gegönnt) is distinct from "a traditional mythology that has the day as a present [den Tag schenken läßt]" (*W* 1, 30/II:1, *119*). No mythologically secured present (in either of the two obvious senses of the word "present"), the gift of the day is the possibility of the day being made, which is the possibility of the day being thought. The day is thought only if appearances are not considered its essence. It is thought only if it appears as writing. The thinking day is the day in writing. In thought as writing, the rhythm of pure word maintains itself by ruining surface meaning. A writer's good day is made as preservation of a recurrent idea or dream.[63] The recurrent idea is the day as "einstimmend"—the day "with one voice" (ein-stimmend)—but this voice gives ever-new impetus for thinking (*W* 1, 30/II:1, *119*). The gift, the harmony, of thinking creates dissonance, as each shape "finds its concentration"—its ability to be thought, its basis in temporal relation—"in itself" and "once again" with each and every instantiation (28–29, 30/117, 119). The gift of the day, the tremor of time, is the essential tremor that is made anew as the day is thought.

The sobriety of name is the tremor of thinking. The pure, colorless word in name effects crisis, effects caesura, in beautiful semblance. As name in appearance (an appearance that can also obviously be a formulation), the pure—colorless—word turns occasion into occasion for thought. In this capacity, name shows its distinct sobriety. This inherently critical element of language, its inherent crisis, is a given. It is a given, a gift, of necessity. Yet it is, of course, also a struggle. Thinking is the colorless word amid the semblance of

life; thinking is this tremor of Life—of colorless word—that is not life which is lived. If the positive may be conceived as a force breaking through a dualistic relationship of life and Life, language is based "solely in the positive, wholly in what strives for the most profound unity with life." Precisely on the basis of this convergence of longing with necessity, "everything critical" is turned inward, somehow away from appearances, in order to recall crisis in them; language is essentially "crisis" (*C*, 84/*GB*, Vol. 1, *349*).[64] Whether as criticism in the artwork or as criticism unfolding the work, the crisis of name interrupts semblance. All and everything unite in word as crisis. This harmony of crisis inheres in—what the 1916 essay "On Language as Such" formulates as—the relationship of linguistic being and spiritual being. The tension of linguistic being and spiritual being involves the name (later characterized as the symbolic word of name) in everything. This harmony in crisis impels a distinct performative responsibility of the language of name but it is also the wild performative ground—the name-ground—of art and, in turn, of its criticism. The crisis, the gift, of thinking as the counterrhythm of the pure, colorless word is constitutive of the performance of art and criticism. The colorless word is the wild word of philosophy, of reason.

SOBRIETY OF WILD REASON

As the Romantics stress, the multiplicity of and in artworks is indicative of a harmony. In this harmony, as Benjamin formulates it, each artwork symbolizes the ideal that is no posable problem (*W* 1, 218/I:3, 834). Each artwork symbolizes what has often been referred to above as the form, philosophy. This is what might seem a very allegorical symbolizing. The ideal of the problem—the unposable problem that is philosophy (the form, philosophy) and harmonizes artworks—"lies buried in the multiplicity of works and the mining [Förderung] of this ideal is the business of criticism" (334/I:1, *173*). With the answer being transcendent, however, there is ultimately only a concept of what is at stake (218/I:3, 834). The mining by criticism simply concerns an "affinity" with the ideal (334/I:1, 172). Along with "mining," therefore, words such as "support," "furtherance," or "promotion" should perhaps be kept in mind as translations of "Förderung." The "affinity" (Verwandtschaft) is the aforementioned acoustic-philosophical feeling or form independent of—and thus requiring sobriety about—any cause–effect relation specifiable in this or that scientific analogy (208/VI, 44).[65] As Benjamin later suggests, the latter kind of scientific explanation is inadequate for a task requiring "interpretation" (Auslegung) concerned with embedment of "events" (Ereignissen) in "the great inscrutable course of the world" (*W* 3, 152–53/II:2,

451–52). Quite early, therefore, he calls for logic proving the proposition that a totality, which might indeed contain a system of cause and effect, cannot be cause or effect—can "never" be "definitively defined" by a system of cause and effect (VI, 92). For this logic to be proven, there must be renewal of the "old sense" of philosophical concept formation: concept formation must be concerned with establishing "the becoming of phenomena in their being [Sein]." This "monadological" approach is so to mold the "construction" (Bau) that the isolation of idea from totality is shown to be attenuated by totality (*O*, 47/I:1, *228*). The harmony in the multiplicity of artworks especially requires—somehow demands—a critical approach presenting itself in the mysterious totality of being.

The harmony in and of the multiplicity of works requires, however, a critical approach somewhat distinct from that presupposed in Friedrich Schlegel's view of the "critical procedure" as the "absolutizing of the created work." Schlegel's view does seem to be endorsed as Benjamin refers to "the generation [Erzeugung] of the blinding in the work" and says this "blinding [Blendung]"—as "the sober light," as the "idea"—"extinguishes the multiplicity of works" (*W* 1, 185/I:1, *119*). It is solely in its sobriety about appearances that this blinding light extinguishes multiplicity. For Benjamin (much more emphatically than for the Jena Romantics), the very persistence of multiplicity recalls that the problem, the form, of philosophy is transcendent. The persistence of some multiplicity or other accentuates that the ultimate "content" of the critical idea is the "answer," the "system," for which the question is "virtual" (virtuelle) (*W* 1, 217–18/I:3, *833–34*), "non-existent" (334/I:1, 172). As it dwells on multiplicitous appearance or veil in the artwork, criticism presents the impossibility of unveiling the secret that is the idea of the work (351/195–96). In the phase of writing the *Trauerspiel* book, Benjamin increasingly stresses multiplicity, including multiplicity of ideas. Ideas function as "stars" and not as "the sun of revelation." Not shining into "the day of history," ideas "shine only into the night of nature." Insofar as this shining has relevance for the day, it shows the day in the night of nature that cannot be revealed, the nature that presents itself as invisible (*C*, 224/*W* 1, 389/*GB*, Vol. 2, *393*). If art criticism may rise toward "the true view of the beautiful [wahren Anschauung des Schönen]"—toward "the view of the beautiful as secret"—it may do so, it is also stressed in the *Elective Affinities* essay, not by raising a veil but by having the "most precise recognition [genaueste Erkenntnis]" of veil as veil, by recognizing veil as ultimately "essential" (*W* 1, 351/I:1, *195*). It is essential that there be some veil or other; there is always some veil or other. That is the perspective of the artwork. This perspective cautions criticism but also thereby defines it. The light of criticism respects multiplicity but respects it as the persistence of nature withholding itself from

history. So conceived, multiplicity stands for the idea (or ideas) of criticism and the ultimately nonformulable ideal, nonformulable form, of philosophy.

It may be that semblance is otherwise everywhere "deception." Insofar as it enters the beauty not identified with any specific appearance, however, "the beautiful semblance is the veil [Hülle] before what is necessarily most veiled [dem notwendig Verhülltesten]." The object of beauty would prove "infinitely inconspicuous [unscheinbar]" if it ever could be "[u]nveiled" ([e]nthüllt). The flight from unveiling is revelation itself. It is "divinely conditioned" that the relevant "inconspicuousness"—*jenes Unscheinbare*—will flee into nothing if unveiling is attempted. "[S]ecret" amounts to the "divine" ground of beauty; veil is "divinely necessary." Involving "semblance" (Schein) as "necessary veiling" of all "things for us," "the beautiful" (das Schöne) is neither the veil (the specific semblance) nor the veiled object (whatever the semblance veils) but "the object in its veil." In the context of beauty, unveiling can only be confrontation with what cannot be unveiled. In beauty, things perform the divinity fleeing unveiling (*W* 1, 351/I:1, *195*). Beauty is the paradoxical solution given by art to the problem that art creates in some sense. For Goethe, the latter is the problem of a profound, "essential identity" of "'true', visible nature in the art work" with the "perhaps invisible, only intuitable [anschaubaren], *ur*-phenomenal" nature "present in the appearances of visible nature" (181/*113*). The paradox of the artistic solution to this problem is, according to Benjamin, that the visible and the invisible are identical in a beauty for which the invisible must be effectively and interactively strange to the visible and not, as Goethe suggests, mythically sealed from and by the visible.

The strangely invisible in the artwork may be called Life, in the aforementioned sense. Beauty is the unity of visibility with the invisibility inextinguishably strange to visibility. It is by initiating its unfolding "alienly and forcefully" (fremd und gewaltig) that the formal, general "law" of poetic construction lends shapes their "identity" in destiny (25/II:1, *113*). The Hölderlin essay conceives of this exercise as one of shaping "inner form," "inner shape," or "special inner identity of the shape" (30/*118*). In poetry or elsewhere, such synthesis is more magical—less circumscribable—than suggested by Wilhelm von Humboldt.[66] Notwithstanding such reservations, which might anticipate those much later developed by Heidegger concerning Humboldt's linguistic theory, Benjamin's Hölderlin essay adapts Humboldt as well as Hellingrath and others.[67] Humboldt's view of linguistic synthesis may be summarized as follows. As it couples with extant order or means, time as freedom is capable of giving new meaning to an old "lodging" or various other changes to what was there before. The freedom of time as expressive impulse is the supplement that recreates itself; it always remains to be recreated again. The "*synthetic* procedure" creates "something that does not lie, *per se*, in any of the conjoined

parts." The supplement and the synthesis are identical as inspiration and not quite extinguishable goal.[68] The "inner linguistic form"—language as "*producing*," as activity (Energeia), and not as product (Ergon)—is the supplement that always remains "left over" in language.[69] Benjamin says: the *Gedichtete*, which is "synthetic unity" of the spiritual and the concrete in poetry, receives particular shape as "inner form" of the particular creation (*W* 1, 19, 25/II:1, 106, 112). In the "inner form," poetic "law" or "identity" is rhythmic entry of the particular into the "middle [Mitte] of all poetic relations" (25/*112*) and thereby into "the untouchable middle of all relation" (die unberührbare Mitte aller Beziehung) (35/*125*). To this extent, the inner form of poetry is the immanent force of Life that is alien to whatever might be construed as lived life (25–26/112–13). In inner form, the artwork displays its constitution by what it cannot display. To show this paradox of its essential identity is, of course, the artwork's intrinsically critical element.

As critical in identity, art presents itself in a force incapable of being conjured. It is no longer justifiable to regard "the essence of artistic culture" as transfigurative "semblance." In the baroque, "semblancelessness" (Scheinlosigkeit) breaks through. This happens despite the German authors' attempts to supplant the "humble" (Klein), the "secret" (Geheimnis), with the merely "enigmatic" (Rätselhaftes) and the merely "concealed" (Verstecktes). Various trappings (such as extravagant prefaces, epilogues, and dedications), as well as the pursuit of the "Gesamtkunstwerk" (that would interlock all the arts), are indicative of grandiose illusions of immediate, public unconcealment—illusions of eternalizing a given place here and now. Precisely the futility of these gestures shows that the "typical baroque work" cannot ultimately attain adequate veiling for resistant "content" (Gehalt) (*O*, 180–81/I:1, *356–57*).[70] The content resists attempts to give it an entirely revelatory veil. In all artworks, this content is the madness insubordinate to conjuration. If one direction of the artwork is the "conjured appearance," the other is the "offspring of madness" (*W* 1, 341/I:1, 182). Between appearance and madness, there is art as the sole possibility of presenting the vitality of the nature that is our unfathomable destiny (396/VI, 81–82). In this dynamic of construction presenting its subordination to destructive nature, the artwork presents itself as intrinsically criticizable.

Criticism is antagonistic to closure. Emerging from the interaction of history and nature, criticism is anticlassicist; this has been mentioned above.[71] It is indicative of a classicistically closed, anticritical foundation that Goethe's artistry has a "speechless numbness" (sprachlose Starre) before a nature evoked as mythic, dark, and sunk in itself (*W* 1, 314/I:1, *146–47*). Nature mythically dark and sunk in itself remains noninteractive and Goethe's theory of art correlatively affirms "uncriticizability" (178/110).[72] According to

Goethe, the "essence" of material contents keeps itself concealed (*W* 1, 314/I:1, 146). He suggests the "riddle" (Rätsel) about how to present material contents is soluble by artistic technique in which material contents are simply to affirm a *border* or *limit* (Grenze) vis-à-vis their "truth content," a border between "an upper exposed level and a deeper hidden level" (313/146, *145*). Artistic technique does no more than accentuate "the mythic powers," the powers obviating criticism. The *Gedichtete* is "mythic material layer of the work" (313–14/146). Reinforcing this conjoining of perception and myth against criticism, experiments (undertaken for his *Theory of Colours* [1810]) are believed by Goethe to demonstrate *empirically* the identity of "perceptible appearances" (wahrnehmbaren Erscheinungen) and conceptually impenetrable primal phenomenon (Urphänomen)—that is, "intuitable primal images" (anschaubaren Urbilder) (314/*147*; see also 315/148). Benjamin, in contrast, considers Messianic nature to be the force of criticism; it is the basis for criticizing appearances. In opposition to Goethe's mythically imbued "idolatry of nature" and "[r]ejection of all criticism" (316/149)—and against the attendant forsaking of "philosophical inquiry [Ergründung]" (314/*147*), Benjamin affirms a natural power of criticism in the artwork. Paradoxically both immanent to the work and autonomous in relation to it, this power of open-ended interaction of construction and mysterious nature is in the work as its inherent criticizability.

Benjamin adapts Friedrich Schlegel's emphasis on autonomy in "the object—or creation-side" in art. Schlegel's emphasis on autonomy contrasts, of course, with Kant's. Kant delegates autonomy to consciousness; in aesthetics, Kant delegates autonomy to the faculty of judgment and its rule of taste—to something negative (149–55/*62–72*).[73] Especially in the *Elective Affinities* essay, Benjamin's criticism develops as a variation of Schlegel's practice of understanding the work entirely from itself (VI, 216; *W* 2, 77/VI, 218).[74] The objectively autonomous power in *Elective Affinities*—the "sense" (Sinn) of this novel's form, the "tone" of this "literary work" (Dichtung)—counters Goethe's portrayal of Ottilie's suffering and death as atoning sacrifice: the latter being of the heroine is not the "whole of the presentation [Darstellung]" (*W* 1, 309/I:1, *140*). The presentation of the work reaches beyond the parameters ostensibly set by Goethe. *Elective Affinities* "presents" love in the "fate" or "destiny" (Schicksal) of Eduard and Ottilie as an unnecessarily self-thwarting "bitterest passion" dominated by the *vita contemplativa* and its resignative view or intuition. This presentation of the autonomous work takes place largely by way of the novella within the novel. Permeated with "freedom and necessity," the novella enters *Elective Affinities* like a "picture in the darkness of a cathedral," a "picture" or "image" (Bild) that "presents" (darstellt) the cathedral itself and communicates an otherwise unavailable perspective on the place (352/*196*).

The perspective of the novella is the perspective hinted elsewhere in the novel by slight resonances of critical presentation in the portrayal of the main characters. It is the perspective of freedom in relation to appearances, the freedom that is the necessity of nature prevailing over appearances. On this basis, the work is presentation of its own criticizability.

As the work indicating refusal to rest with its appearances, criticism constitutes the artistic creation and may renewedly be unfolded by subsequent criticism of the creation. Formulating the early Romantic outlook, Benjamin outlines the reflexive subject as basically the artwork itself and the critical "experiment" as accordingly not reflection "*on*" (*über*) an unalterable creation but rather "unfolding" of reflection "*in* a creation [*in* einem Gebilde]" (151/65–66). Criticism is the force overcoming matter. (A comparison with chemistry is used in the Romanticism study, although Benjamin later used a comparison with alchemy rather than chemistry [page 175 below].) Criticism is in the work solely as the process of matter production that subjects all matters to it. Schlegel says of Goethe's *Wilhelm Meister* that the work "presents itself [stellt sich . . . selbst dar]" (*W* 1, 178/I:1, *109*).[75] The work presents itself as the freedom and the necessity in which the autonomous force of matter-production overcomes matter. In the Hölderlin essay, Benjamin says: The "task," the "prerequisite" (Voraussetzung), of the artwork is thereby also "the ultimate ground [der letzte Grund] accessible to analysis" (*W* 1, 18/II:1, *105*). The ground of the work is criticism. From the outset, the work and criticism have this reciprocal relationship. As "fulfillment" of the "artistic task," "objectivity" or "truth" (19/105) simply enables the song "freely" to select—"with art"—"the objective" (32/*121*). Objectivity or truth is the aforementioned autonomous force producing matter and assuring independence from any realized matter. Whereas aspects of Greek mythology might deem this freedom to be hubris, the true—the objective—requires it. This freedom influences art and enables art to influence as art (29–32/118–22). The freedom is no classicist freedom and it is ultimately no Romantic freedom (see the sections "Ru(i)ned" and "Tremor-Identity" above). Much like the artifice of Daedalus, the artwork with a destiny of criticizability is immersed in the destiny of certain uncertainty.

> —Stephens Dedalos! Bous Stephanoumenos! Bous Stephaneforos! . . .
> . . . Now, as never before, his strange name seemed to him a prophecy. So timeless seemed the grey warm air, so fluid and impersonal his own mood, that all ages were as one to him. . . . Now, at the name of the fabulous artificer, he seemed to hear the noise of dim waves and to see a winged form flying above the waves and slowly climbing the air. What did it mean? (*P*, 169)

Certain uncertainty is the critical presentation in the work and constantly renewable in subsequent criticism. As noted already, there will be debate about

whether specific attempts at art and criticism are effectively critical presentation. This does not discredit the notion that art and criticism are presentation of certain uncertainty. The latter is simply the unposable, insoluble philosophical ideal shared by criticism and "genuine" artworks alike (*W* 1, 333, 218/I:1, *172*, I:3, 834).

This critical force is intolerable for passion, at least insofar as passion wants the beautiful above all else. In such a context, even the "most fleeting disappearance of beauty" throws passion into despair. The "disapproval" with which Charlotte and—following Charlotte—Ottilie turn away after hearing the story that appears in the text as the novella is passionate; they find it intolerable to relinquish beauty (*W* 1, 344/I:1, *185*).[76] The beauty of art and criticism comes from no such fixation on beauty. As even he disparages whatever "is false, artificial, trying to be pretty or handsome instead of being expressive, that which is genteel and affected . . . , all that is show of beauty or grace, all that lies," Auguste Rodin counters with the "character" of "Nature," "the vital truth" which alone can give art "beauty."[77] In a somewhat similar vein, Benjamin suggests: Sheer nature is oblivious to any duality of veil and veiled; art juxtaposes such duality and the natural obliviousness to it. Neither nature nor art tries to be beautiful; they want only to unite—to show the unity of—veil with the force that cannot be unveiled. There is unity of veil and veiled only "in art and in appearances of sheer nature" (*W* 1, 351/I:1, *196*). Sheer nature appears solely as the force making appearance transient; art presents this force by ironizing appearance. Ironizing the notion of nakedness as unveiling, nakedness in art illustrates the unity of veil and veiled. Art has "the essentially beautiful"—that for which beauty is essential—abated so that nakedness is no unveiling but rather a presentation of the unity of veil (the body) with veiled (the nature that cannot be revealed entirely in or by the body). The human's naked "body" (Körper) reaches a "being [Sein] above all beauty [Schönheit]—the sublime—and a work above all creations [Gebilden]," the work of "the Creator [Schöpfers]." Undressing the young woman "not out of lust but for the sake of life" (removing wet clothes to save her from a fatal chill), the young man in the novella has no contemplative, observing relationship with her naked body. He perceives rather the "majesty" (Hoheit) that her body has acquired in the love compelling him to save her (352–53/*196*). If such a presentation is still beauty and is thus, as Kant might say, limited by the specific objects in which it appears ("a relational-character is the basis of beauty"), it is nonetheless engaged with limitless, critical (semblance-destroying) sublimity (351/*195–96*).[78]

Reaching the sublime is not, of course, elevation into it. "*Pure* imagination" exists "only outside of the human" (VI, 122). Art is indeed thus outside of the human. Yet no artwork can entirely abandon the human. The artwork must appear. Even a musical work appears (as notation, instrumentation,

performance); even the long silences included in, or constitutive of, certain modern compositions (such as some of those by Karlheinz Stockhausen or, more obviously, John Cage) somehow *appear*.[79] Standing "beyond all elevation in the sublime," the life of the artwork is sacred solely by virtue of soberness about its appearances (*W* 1, 35/II:1, *125–26*). With the sublime as its "uniquely objective object" (einzig objektiven Gegenstand . . .), the aforementioned tremor is emotion in transition, avoiding fixation on semblance (349/I:1, *193*). In Goethe's tendency to treat a "world of gentle, veiled beauty" as the "middle" of literature (344/*186*), not only does the "death symbolism" in the "fate [Geschick]" of Ottilie fulfill a mythic archetype of sacrifice (309/*140*) but the "downfall" of both Eduard and Ottilie—in this respect like Werther's suicide in Goethe's *The Sorrows of the Young Werther*—is also treated as "atonement" for the injury done by the sensuous to mythic order (312/144). In the attendant beauty determined by semblance, the "reconciliation"—"mythically" promised "in life and dying"—is also "semblance-like." Artistically considered, Ottilie's beauty in the novel thus threatens the "salvation" won by the two friends in the novella "from their struggles" (342–43/184). This threat is carried, of course, not by Ottilie alone. In contrast with the beauty of the novella no longer inflating—no longer stuck on—semblance (348–49/191–92), Goethe scarcely allows a "struggle" between duty (in this case, legal-conventional marital obligation) and inclination in the novel (312/144). Whereas those in such a powerful bond of emotion with semblance are not "moved in their innermost being by music" (349/192), the "truly loving"—for whom beauty is not decisive (343/*185*)—are "in the realm of music" (348/*191*), the mysterious realm of music that evokes the promise of "redemption"—more than of "conciliation"—for the mute world (355/201 [see page 134 above]). This mysterious musical realm requires the sobriety that perhaps always prevents a hymn from being "beautiful" (*W* 1, 341/I:1, *182*).[80] In the music of mystery, the beauty of this or that space is inessential; the sober beauty of art shows that no space is the limitless sublime.

The sobriety of the artwork derives from the strangeness of the Life that determines appearances but is entirely revealed in none. The sobriety of the work is the critical dimension in which Life turns itself upon appearances. Goethe's novel is thus saved by "the delicately formed novella" (*W* 1 352/I:1, 196) appropriately titled "The Strange Neighbouring Children" (Die wunderlichen Nachbarskinder). The adjective "wunderlichen" could be translated as "wayward," "strange," or "odd." Given their emphasis on a departure from conventional expectations, all of these (as well as other such) meanings could be relevant. The adjective "wondrous" (a possible translation of "wunderlichen" but more commonly associated with "wundersamen") would avoid

the seemingly pejorative connotations of other alternatives, but precisely these connotations are necessary; the "neighbouring children" seem "strange," "wayward," "odd"—*wunderlich*—to the characters of the novel (333/*171*).[81] The novella is *wunderlich* in the novel. In the construction of the novel, the novella is the major breakthrough contributing to sobriety about beautiful semblance; the rest of the novel can scarcely tolerate this breakthrough.

The novella is strange to the semblance-intoxicated eye. The "grace" or "charm" (Anmut) of the woman in the novella is accompanied by "ein befremdendes Wesen"—an *odd, displeasing, strange* being—robbing her of "the canonical expression of beauty." The novella softens predominance of semblance. Such softening of semblance counters passion about semblance. Passion has a "chaotic side" that must erupt "devastatingly" unless "inclination"—this "more spiritual element"—is able to "soften [sänftigen] semblance" (*W* 1, 344/I:1, *186*).[82] Semblance is softened by wildness unattached to semblance. The wildness of the woman in the novella contrasts with the "empty, pernicious [verderbliche] wildness," the "false wildness," "the hostile gleaming" (das feindliche Glänzen), of Lucianne (Charlotte's dazzling and manipulative daughter), which is—befitting her name borrowed from the Latin verb *lucere* (to shine)—a glaringly sunny gleam. The "wildness" contorting the young woman in the novella is the "urgent, healing" wildness of "a more noble creature" (*W* 1, 344/I:1, *185–86*). Softening semblance, this noble wildness is also quite distinct from Ottilie's semblance of softness. The epigraph of the first part of Benjamin's *Elective Affinities* study is Klopstock's statement that one choosing blindly has eyes steamed by sacrifice (*W* 1, 297/I:1, 125). Ottilie chooses with eyes steamed by the mythic order seeming to require her sacrifice; she is blind by feeling compelled to soothe the eye of this order. Goethe refers to Ottilie as an "eyebright"— an *Augentrost*, an eye-consolation—to the men who see her (eyebright is a plant formerly used as a remedy for weakened eyes). Even Ottilie's name represents a "mild light"; in the name of Ottilie, the patron saint of those suffering eye maladies, a cloister was founded on Mount Odilien (Odilienberg) in the Black Forest. The "gentleness" (Sanftmut) of Ottilie is, in any case, a moon-like, affectedly secretive, "mild shimmer." As though opposed to such conduct submissively serving a semblance of secret (which is actually a usurpation of secret), the woman in the novella is "the sober light" (das nüchterne Licht) integral to the "real [rechte] wildness" of her and her eventual partner; her light wakens the young man to the power of what he cannot see. Her "furious attack" (above all, her leap into the river) is "directed against the eyesight of the beloved"—the man who until now seems unable to notice either her feeling for him or her reluctance about the impending marriage to another man. Whereas he had hitherto let his feelings remain in the power of his eye settled on semblance, her attitude is that of a love "averse to all semblance" (344/*186*).

Aversion to semblance constitutes the ethics of art. This obviously counters Goethe's proclamation that "[t]he struggle of the ethical is never suited to an aesthetic presentation" (312/*144*).[83] For Goethe, aesthetic presentation has completeness in a mythic seal encompassing perception of appearances. For Benjamin, art is defined by the Messianic force of nature and this nature is a kind of freedom—a prosaic, sobering freedom—within perception. *Mal* accordingly involves perception in its affinity with "the entire metaphysical being of the human" and involves imagination with some connection to "the human's yearning" (Sehnsucht des Menschen), a longing that necessarily has a moral element and a moral validity (*W* 1, 264/VI, *123*). In such uniting of natural necessity and ethical longing, the prosaic—semblance-resistant—core of the artwork struggles to produce effects of colorlessness in color. Nature as deformation and idea as struggle are both integral to art. Both "nature unforming itself" (die sich Entstaltende Natur) and "ideas" are essential elements of the "pure conception [Empfängnis]" on which artworks are based (281/*116*). The pure conception consists of nothing realized in the appearances of the work, but rather consists of the impulses of deformation and struggle effective in and as the work. Pure imagination is concerned only with nature, creates no new nature, and is thus no inventing power (282/117), whereas the "light of ideas struggles with the darkness of the creative ground and—in this struggle—produces the colour-play [*Farbenspiel*, kaleidoscope] of imagination" (VI, 114). Both the red culminating earthly imagination (see page 122 above) and the Romantic blue of ideas (if that may be considered their color) are heading toward, and determined by, the "colorlessness of the higher light"—"the [c]olorless light of reason" (VI, 121–22). Every artwork is based on a struggle of idea(s) with deformative imagination. Freedom from appearances is struggle with the force of nature prevailing over appearances. It is the aforementioned struggle with, entry into, unfreedom in physis (pages 125–26 and 128). This convergence of free yearning with necessity is the colorlessness that unites ethics and nature.

Uniting imagination and idea (deformative nature and ethical yearning), colorless reason is criticism in and of the work.[84] Redemptive "correspondences," such as Benjamin's criticism discerns in the novella within *Elective Affinities* (*W* 1, 351–52/I:1, 196), instantiate correspondence between the ideal as "the a priori" of the artwork's "content" (179/111) and the critical methodological a priori that may be cited under the category of idea (179/110–11). The a priori ideal—deformative nature in imagination—has a correspondence with the a priori idea struggling to lend expression to this deformation. Benjamin's response to the "fundamental systematic question" of the relationship of the ideal of art ("the ideal of its content") and the "idea of art" ("the idea of its form") (183/117) is that "[t]he ideal of <the> problem is

an idea" (218/I:3, *833*). The ideal of the constitutively philosophical problem, which is immanent and determinant without entirely appearing or being posable, corresponds with the idea—the form, the struggle—of the work. The idea or inner form is shape presenting itself in deformative, immanent, ideal content. Various works by Benjamin stress that the "a priori ideal"—the "immanent necessity" of the artwork "to be there" (19, 79, 158/II:1, *105–6*, *238*, I:1, *76*)—is an "idea" underlying each artwork (79, 194 n. 202/II:1, 238, I:1, 76 n. 195) and is, as the Hölderlin essay puts it, in specific works as their respective "inner form" (19/II:1, 106).[85] The artistic "content" and form are one in the immanent necessity that is the sole constitutive object of criticism (*W* 1, 18–19, 79/II:1, 105–6, 238). The unity of deformation and struggle is the immanent necessity of criticism.

As stressed often above, the immanent necessity of criticism is brought into play by the artwork. Many kinds of expression show a "magic" connecting them to the inexpressible (*C*, 80–81/*GB*, Vol. 1, 327). The artwork is, however, unique. In perceived nature, the "true, intuitable, *ur*-phenomenal nature" is "present but concealed [präsent aber verborgen]"—that is, "faded by the appearance [durch die Erscheinung überblendet]." Solely art is the possibility of the true, intuitable, *ur*-phenomenal nature becoming "visible in a portraying manner [abbildhaft sichtbar]" (*W* 1, 181/I:1, *113*). The ideal is elicited by art in the realm of portraying; in this realm, art elicits ideal contents. It is only in the realm of art that *ur*-phenomena—ideals—present themselves "adequately" to the "intuition" or "perception" (Anschauung). The ideals remain, of course, outside of the appearance in which they are intuitable or perceptible. The "*ur*-phenomena" "stand" (stehen) in art; they do "not lay before" (liegen ... nicht vor) it (315/*148*). The ideal contents of the artwork are solely deformation within it. The artwork only symbolizes the ideal (218, 333–34/I:3, 834, I:1, 172). In other words, the ideal is shown to appear solely in a mediated way. Precisely the performance of mediateness as mediateness demonstrates the freedom of the symbolic ideal from mediateness. The symbolic force so enters the portraying element that there emerges a basis for philosophical criticism of the work. As suggested already, the existence of differing views about whether this or that work achieves effective presentation of the symbolic force does not invalidate the contention that artistic construction must be conceived as lending scope or resonance to the force destroying construction.

As is demonstrated in Benjamin's emphasis on the novella within *Elective Affinities*, criticism is an exercise of having the ideal of the problem, the ideal that cannot be posed, "appear in the art work, in one of the appearances of the work" (218/I:3, *834*). It has been indicated above that the appearance does not, of course, become the ideal. To this extent, Benjamin shares Goethe's

view of science. In "scholarship" (Wissenschaft), the idea simply "represents" or "stands for" (vertritt) the *ur*-phenomena by illuminating "the object of perception [Gegenstand der Wahrnehmung]"; it does so without being able to transform this object in "intuition" or "perception" (Anschauung) (315/I:1, *148*). The illumination does not entirely take perception out of itself.

With this emphasis, Benjamin diverges from Friedrich Schlegel. According to Schlegel, not only is a kind of Platonic idea "the real ground of all empirical works" but this "unity of art, the continuum of forms itself, as one work" is also a possibility in criticism of that "invisible work" absorbing the "visible work" (167/90). In such a conception of the critical procedure as absolutization of the work in the infinity of art (185, 183/119, 117), the early Romantics demonstrate a neglect, indeed an incomprehension, of the ideal of art (179, 183/111, 118) and thus lose precise connection with the content integral to art (179/111). Resisting this aspect of the Romantic category of critical idea, Benjamin conceives of the ideal as intransigence of content (183–85/117–19). For Benjamin, the idea is not "the immanent form" of the ideal; or at least, it does not entirely reveal the immanent form of the constitutively philosophical problem (which, as Benjamin stresses, cannot be posed or answered). The idea is, rather, itself ideal in the sense that the idea belongs to the ideal and facilitates no realized form of the ideal (218/I:3, 833–34).

Content is, therefore, not Romantically dissolved by idea as form. In their "most profound affinity [Affinität]" with the unposable ideal problem of philosophy, artworks are not "virtual" but "real" (wirkliche) "creations" (Gebilde), creations very really unable to be "the question" (217/*833*).[86] Artworks are so really not the symbolic, ideal system of philosophy that criticism is, in turn, confronted with its virtuality, its basis on a virtual question, a question that does not exist. Yet Benjamin does not, of course, opt for Goethe's notion of a pure content that ultimately requires artistic rigor as mythic closure (*W* 1, 183–84, 200 n. 323/I:1, 117–18, 117 n. 315). Benjamin does not follow Goethe's adaptation of an ancient Greek tendency to direct "the most profound questions of philosophy" into "the shape of mythical solutions"; correlatively, as noted already, he does not follow Goethe's refusal to recognize "criticizability as an essential element in the art work." To offset such an anticritical, antiphilosophical conception of artistic content, Benjamin retains a variation or adaptation of the early Romantic critical category of idea (183–85/118–19). No mythic perception, idea requires criticism within construction and criticism of construction. Yet it also requires construction—this or that determinate object—as itself a critical force. If criticism in construction must—somewhat un-Romantically—always concern some perceptual content or other, it is Hölderlin who is exemplary in combining such a determinate object, which is neglected by the Romantics, with a methodical sense

shunned by Goethe (200 n. 323/*117 n. 315*).⁸⁷ In the methodical sense, the artwork keeps appearances from ecstatic assumption of finality and thus attests to the philosophical force of critical idea; in the un-Romantic sense, the artwork deprives critical formulation of any mystical surpassing of the intransigence of some content or other.

IMMANENCE

Natural Imbalance

The persistence of some multiplicitous content or other in the artwork does not thwart criticism so much as complement it; the veil recalls the unveilable. The latter "content" (Gehalt) is not deducible from its "material" (Sache); truth content is a "seal" that "presents [darstellt] the material." As a presenting seal, as a presenting "form," this "content of the material" (Gehalt der Sache) is not, in other words, to be deduced from insight into the "continued existence" (Bestand) of the material or through inquiry into the latter's "determination" (Bestimmung). Nor, however, is it to be deduced on the basis of some "hunch" (Ahnung) (*W* 1, 299–300/I:1, *128*). The presentation is of a Life that is recognizable only as unrecognizable. The materiality of the artwork is philosophically relevant in so really—so materially—recalling that the material is not the answer or question for philosophy; it is recalled that natural life is not historical life. To unfold "clearly and unclouded by human life," the "natural life" puts any specific historical "presence [Präsenz]" in abeyance; this natural life renders historical presence "virtual," not "pragmatically real." Instead of "pure" history, instead of history conceived or perceived as though independent of nature, there is "natural history [natürliche Geschichte]," nature's story—"die natürliche Historie"—that is only readable from the "essentiality" (Wesenheit) that is a condition complete and unto itself (*O*, 47/*227–28*; see also I:3, 947). A correlative chronicle involves "[p]hilological interpolation" giving way to "the intention" of the "content [Gehalts]" that itself "interpolates history"; this chronicle is "interpolated history" (*C*, 176/*GB*, Vol. 2, 137). Criticism retells this natural content, this natural life, that the work already somehow tells as its inextinguishable critical basis.⁸⁸

The critical story within the work presents itself as story of a nature that can have no inviolable story told about it. The *Elective Affinities* essay may be construed as an instance of the storytelling more explicitly proposed and attempted in some of Benjamin's later writings.⁸⁹ Goethe's *Elective Affinities* began as a novella to be included in *Wilhelm Meisters Wanderjahre* but developed into a novel ennobled by "The Strange Neighbouring Children," the "novella" told as a story by an otherwise fairly incidental character (*W* 1,

329–30/I:1, 167).⁹⁰ The latter novella fulfills the standard literature-lexicon definition of "novella": a "story" (Erzählung), usually given in prose, concerned with an occurrence (or occurrences) that could indeed have happened and based on a central conflict. In a very compressed manner, such a story tends to evoke something new or even outrageous whereby a conflict may be carried through to a "decision" (Entscheidung).⁹¹ As seems to be recognized by Charlotte and perhaps Ottilie, the outrageous moment is the leap into the river. With this leap, the woman awakens the young man's hitherto slumbering feeling for her. More importantly, the leap thereby awakens him to join her in a decision against previously established bonds and for more powerfully felt, mysterious ones. The *law of the novella-form*, the law evident in this novella within *Elective Affinities*, is that "the secret [Geheimnis]" is "an essential characteristic" (*W* 1, 331/I:1, *169*). This secret is not a specific secret but secret that remains secret, tellable only as the elusive, yet determinant, secret. Insofar as Benjamin's writings take a "direction" seeking "a more and more concrete connection to the detail," they do so for the sake not only of "exactitude" but also of "substance [Gehalt]" (VI, 216; *W* 2, 77/VI, *218*). Exactitude concerning detail in artworks is obligated to content, to substance, never contained by history but rather always interpolating, overtaking, history. The work so overtaking itself, so remaining open to the nature overtaking any specific historical content or reception, provides the basis for criticism as the story that can be told of the work again and again in new ways.

Up to a point, Benjamin is guided by the early Romantic view of the work overtaking itself. In such a view, as elaborated by Menninghaus (with some adaptation of Benjamin's writings), the parabasis in Aristophanic comedy—the chorus addressing the audience on behalf of the poet—is a caesura of the work by the artwork. According to the Romantic view, moreover, "reflexive Selbstüberholungsstruktur" (reflexive structure that overtakes itself) is more integral to, less conspicuous in, the novel; for Schlegel, Goethe's *Wilhelm Meisters Lehrjahre* is exemplary and Cervantes's *Don Quixote* is prototypical.⁹² It is unclear whether Benjamin follows the Romantics' regard for the novel—among all forms of artistic presentation—as "the supreme symbolic form" (by virtue of its fashioning of "self-extension" and "self-limitation" to a level at which they are indistinguishable) (*W* 1, 172/I:1, 98). Although Romanticism itself might not very emphatically stress the etymological relationship of "romantic" and novel (Roman), it does suggest "[a] philosophy of the novel" is "the keystone" of a "philosophy of poetry as such." In Benjamin's formulation of this Romantic outlook, the novel is a unique demonstration of art destroying ecstasy. In artistic ecstasy-destruction, a mechanical reason is the "mystical constitution" exceeding limited and ephemerally beautiful forms by resting solely in untouchable, indestructible sobriety (173,

176/99–100, 106).[93] The novel is amenable to criticism, for it is "prosaic" in both basic senses of the word: as prose, it is an extension that may (in principle and relatively readily) be continued by further prose; as prosaic, it extends itself without allowing itself claim to symbolic ecstasy in any extension (*W* 1, 174–75, I:1, 102–3). In the latter regard, Schlegel's *Lucinde* combines various limited forms (besides the strictly novelistic) into a multiplicity that takes them—and the novel itself—beyond any specific limited form. Such mixing of genres is evocative of the unity of all "poetry" in one unlimited, transcendent "work" (174/102). The latter "Work" is "the absolutely necessary autoproduction in which all individualities and all works are annihilated."[94] Benjamin objects, of course, that the alliance of all "concepts of art-theory" with the absolute emerges in the Romantics' own formulations on the basis of their questionable disinterest in distinctions (*W* 1, 172/I:1, 98). It is difficult, nonetheless, not to notice an echo of Benjamin's own outlook as he formulates a theory of the prosaic for the Romantics' conception of criticism. As the sober ground of the work overtaking itself, the "prosaic kernel" is the basis of criticism (178/109).

In Benjamin's major early discussions of novels, the prosaic kernel—the transcendent work—is imbalanced hope. Works of Dostoevsky stand in a tension of hope and novel-form.[95] In Benjamin's distinct version of this tension, Dostoevsky's *The Idiot* proffers a new world—but at best as a hope largely foundering in what remains a "novel" (*W* 1, 78–81/II:1, 237–41). *The Brothers Karamazov*, in comparison, may seem greater; it is more fragmentary, however, for the "tempo" (Zeitmaß) of *The Brothers Karamazov* is novelistic in the narrow sense—it is "hybridized [bastardiert] with the epic," with the epic as forced closure, as forced balance. The tempo of "the novel" *The Idiot*, is not "novelistic" (romanhaft) in this sense, for—right up to the "catastrophe"—the events lack any "balance" (Ausgleich) (II:3, 979).[96] Creating a catastrophe for balanced existence, hope is the destructive power of secret withholding itself from such balance. Hofmannsthal once has Balzac suggest that any human existence worth a "presentation" is consumed with burning itself away and takes from the world only whatever serves this burning.[97] Although the "significance" of the catastrophe for the conclusion in the "novel" *Elective Affinities* "remains phenomenal," remains contained by phenomena somehow isolated from secret, this catastrophe acquires an "enlivening power"—however perplexing—through the "novella." Secret is catastrophic by having a prosaic force that deprives history of ecstatic balance. With secret as "the catastrophe" that is "set in the middle as the living principle of the story," the novella is "more prosaic" than the novel (*W* 1, 331/I:1, *169*). Imbalanced—catastrophic—as a constitutive source of hope, secret enters the novella to render the novel more prosaic; the imbalanced

hope released in the novel by the utopian novella is the secret force of nature breaking through ecstatic, nonprosaic, denials of—closures against—such destructive force of secret.

As suggested already, Benjamin's criticism of *Elective Affinities* is to demonstrate that the critical survival or interpolation of secret nature as the core of the work is possible on the basis not only of the novella within the novel but also of certain traces in the main text of the novel. Interpolation by imbalanced hope occurs in the main text of Goethe's novel, albeit fleetingly, as Ottilie and Eduard part following a late rendezvous to discuss their foundering relationship. "Hope soared away over their heads like a star falling from the sky."[98] The characters are unaware of this last "caesura" of the work by the work (*W* 1, 354–55/I:1, 199–200).[99] The characters' catastrophe is suffered less as catastrophe by the characters than by the work on their behalf. The work suffers the hope that the characters can no longer tolerate hearing. Agony in love is the persistence of music, even if only faintly heard, that has little or no corroboration in existence; there is no "crowning," but rather a "first, weak anticipation," "an almost still hopeless shimmer of dawn" (*W* 1, 349/I:1, *191*). This dawn does not break into the day of the main characters, but it is felt in the work. As a caesura not heard by Ottilie and Eduard, the comparison of hope with a falling star indicates a last hope cherished by the work for those who have entirely ceased hoping (354–55/199–200). The "symbol of the star" enters as an "experience" (Erfahrung) (354/*199*)—a "feeling"—of hope fulfilling "the sense of the occurrence" (355/*200*), the sense that has long been obliterated in the "lived experience" (Erlebnis) (354/*199*). With this sense of hope where there is otherwise no hope, Goethe enters—however unwittingly—the "attitude of the storyteller" (355/*200*). Storytelling has catastrophe show itself where it would otherwise be disregarded, would otherwise simply be lived. Telling the story of hopelessness is paradoxically hope. The sole purpose of hope is to tell the catastrophe that is otherwise simply lived. "Only for the sake of those without hope is hope given to us" (35/*201*).[100] Hope in an artwork is criticism incipient in it.

Inextinguishable secret, which—in its critical function—is hope, secures no space; it secures only the freedom that is also death. This freedom of nature is the secret that can—and does—destroy history. Inextinguishable secret is the same nature that brings catastrophe not only as hope uncontainable by history but also as disaster for history. Opening to this condition, the human feels "driven along" with the world to "a cataract," a veritable waterfall of released experience. With the "hereafter [Jenseits] . . . emptied of everything in which even the faintest breath" of "the world"—the living, breathing world—"is active," the baroque gains from the hereafter "a wealth of things" that are

not subject to eschatological shaping and tend "to evade every shaping [Gestaltung]." Heaven is now "a vacuum" that could one day destroy the earth "with catastrophic violence" (*O*, 66/I:1, *246*). Poetics and manuals of the baroque thus indicate (however unwittingly) a distinctly unclassical theory of drama. Correlative "wildness and recklessness" of the German dramas also show an independence of the works from the authors' classicist aspiration (inherited from the Renaissance) (58–60, 188–89/238–40, 364). Whereas the classicism of Goethe and Schiller indulges the temptation to a tragic renewal of myth, the writers of the baroque mourning play wrote historical dramas transforming history into natural history—history no longer subordinated to myth. Baroque poetic culture is committed to the chronicler's stringency. This stringency is not bound to an "'essence' [Wesen] of history"; it allows historical material to enter a "complete freedom of plot" (gänzliche Freiheit der Fabel) (120/299; see also 121–23/300–302).[101] The freedom of plot is the freedom of death in life; death is mystery uniting everything and everyone in a course that remains open-ended. Receptiveness to this mystery assures a future to mourning play, its "open future" (*O*, 113/I:1, *292*).[102] As mystery uniting everything and everyone in its open-ended course, "[t]he world" is indeed "recognizable [erkennbar] *now*" (*W* 1, 276/VI, *46*). As the mystery of death in life, this world is always knowable.

Criticism is this knowing. The "monadological character of criticism" is thus opposed to intersubjective corroboration of a perceptible "frame." It is opposed to *das Mitsehen des Rahmens*. In an artwork, there is "content" that is "historical" but also an "essence" or "being" (Wesen) that is "ahistorical" and "has no history."[103] The only essence relevant to art is this essence that cannot be secured in historical space. Intersubjectively shared historical frame is subordinate to critical being; regardless of their history, all belong to—and somehow know—critical being. The work sober with regard to its historical being opens to its critical being, which is eternal being. As implied already, criticism is prosaic in a double sense. Criticism combines the obvious, "proper" meaning of "prose [ungebundener Rede]," which pertains to the open-ended "form of expression" assumed by criticism, with the "figurative" meaning of the prosaic, which pertains to the object of criticism—that is, to "the eternal, sober continuance of the work" (*W* 1, 178/I:1, *109*). Unbound—*ungebundener*—language usage, usage that can readily be continued, is combined with eternalization sobering any ecstasy of this or that specific historical bond. The promise of "perfection" (Vollkommenheit) in philology is not a promise of "completion" (Vollendung). This promise of perfection is wary of promising completion. "[M]orality" (Moralität)—as the intersubjective frame—is continually extinguished while the "fire" of morality is not (*C*, 175–76/*GB*, Vol. 2, *136–37*). The fire of morality wants perfection more than it wants completion; it is in constant

tension with morality (as intersubjective frame). The fire of morality is the force of nature rendering historical appearances incomplete; it is the eternally sober force that keeps history open. The promise of perfection in critical philology maintains hope.

Philosopher-Saint

In accordance with the notion of the form *philosophy* that has been discussed recurrently in this study, hope may be conceived as the promise of philosophy. Hope arises from the performance of the form *philosophy* in the artwork and is the basis for criticism. In *Elective Affinities*, there is a "promise" that is "purer" than the rule of myth in this novel (*W* 1, 329/I:1, 167). The correlative "view [Anschauung] of the perfection [Vollkommenheit]" of this novel may arise in criticism insofar as the latter is a practice of philosophy (334/*173*). In this context, the promise of perfection is philosophy in the artwork and in criticism. It is as the promise of perfection that philosophy in the artwork obviates the rule of myth. Natural character gives "the answer of genius [Genius]" to the "mystical enslavement of the person to the guilt context." In this liberation by character from mythic guilt context, "[c]omplication" becomes "simplicity" and "fate [Fatum]" becomes "freedom" (*W* 1, 205–6/II:1, 178). Such an emphasis by Benjamin is not quite indicative of "a desire to terminate the endless task of criticism by resort to an 'idea' or 'truth' which becomes its atemporal, ideal telos."[104] The answer of genius, which is the simplicity and the freedom of character, renews relations with the ideal—the perfection—for which history has neither answer nor question. The answer of genius is a philosophical answer. It shows that the clarity and perfection of *the* answer is not yet realized. Whereas the ancient hero—as "tragic hero"—was (notwithstanding a variety of actions) "always the same, always the same self, defiantly buried in itself," the modern hero—"to all intents and purposes a philosopher"—has a "limited" and "imperfect" (unvollkommenes) consciousness that is out for clarity and perfection. The philosopher-saint (Hamlet, Wallenstein, Faust) has a very unclassical goal: that "the absolute human" enter "its relation to the absolute object."[105] The philosopher-saint, however unwittingly or unwillingly, is allied with the divine object rendering history prosaic, dispelling any mythic solution of history. In this unrest with history, the philosopher-saint in the work anticipates the continuance of the work in criticism.

Yet a philosopher-saint has no smugness vis-à-vis myth. Insofar as it follows its ultimately theological object, philosophy is in confrontation with myth. In *The Gay Science* (as Benjamin notes) as well as in *The Birth of Tragedy*, *Twilight of the Idols*, and elsewhere, Nietzsche suggests that Socrates' complacency about his death sentence (a human sacrifice in the

name of the gods) betrays philosophy to the machinations taking place through law, which (as will be elaborated below, in "Community of the Dead") is the ultimate instance of myth according to Benjamin. In Socrates, Plato annihilates "the old myth" and yet simultaneously adopts it (*W* 1, 52/II:1, 130). Socrates seems ultimately to disregard ways in which myth can be opened to its own orientation by the absolute (that is, by its own insatiable fire as morality). Philosophical encounter with myth is struggle on behalf of the theological—the absolute—object.[106] In this regard, there is perhaps no greater influence on Benjamin than Hölderlin, who says a "weakness" may be evident in the self-comprehending "tendency" of "Greek representations" (ancient Greek mythological representations), but disregard of myth may be "our weakness," "the lack of destiny [das Schicksallose]," the dysmoron, that we cover up with skill or propriety.[107] The affinity of myth and art is that both are unifying forces devoted to the transcendent. Benjamin's Hölderlin essay suggests that "the poetized" (das Gedichtete), according to the "truth" of the strongest poetic achievements, is "a sphere kindred to the mythic" (*W* 1, 20/II:1, *107*). Art struggles with and against myth, for myth claims the divine object that only orientates art—that only orientates with a theological-critical, philosophical impulse. Socrates' "philosophy" lacks the art that would have enabled and required him to engage myth in a way leading out of it and into its transcendent—its philosophical—fire.

The art of philosophy, like the philosophy in art, requires engaged sobriety rather than smugness with regard to myth. Myth amounts to a presumed answer to the mystery that does indeed unite all and everything. Even the tragic hero or heroine demonstrates an inkling of this mystery. For this figure, myth is momentarily released into its incomprehensible basis; that basis warrants, however, no pedagogical smugness concerning myth. Whereas the "ironic silence of the philosopher, the coy, mimelike silence, is conscious" as Socrates sets "the example of the pedagogue," the "sacrificial death" in tragedy, the death preceded by silence, is "unconscious," uncomprehending. The tragic hero or heroine preserves silence as the mysterious need quashed by the mythic morality. Even the *Symposium* shows some such drama as it ends with a "sober light" falling upon the discourse, falling upon the seated Socrates, Agathon and Aristophanes facing one another as dawn breaks; this sobriety is Plato's language usage—the dialogue—addressing itself as this side of something greater than itself to which it nonetheless belongs. Such sobriety is obviously distinct from Socrates' self-satisfied, "rational," anti-artistic "spirit." In such sobriety, moreover, both tragic and comedic closures are resisted (*O*, 117–18/I:1, *297*).[108] There is, of course, the aforementioned profound expressionlessness in tragedy and an "intellectual" (intellektuale) purity or freedom in comedy. Tragedy and comedy are even effective in one another. As evident in Platonic dialogue, however, philosophy

requires that tragedy and comedy—"both of these forms of language and recognition [Erkenntnis]"—drop away ("Molière: Der eingebildete Kranke" [note from around 1918], II:2, 612). With the persistence of philosophy in it, art breaks through the limits of tragedy and comedy. It breaks through the mythic containment of tragedy and the intellectual superiority of comedy. The drama of mystery ensuing from this persistence of philosophy is the art, the drama, forsaken by Socrates as he surrenders to myth rather than struggle with it. Shunning engagement with those very mysterious forces implicitly or explicitly claimed by myth as it unites so many in a form of life, Socrates lacks the art that would have made him a philosopher rather than a pedagogue.[109]

The absolute object, the theological object, is the basis of the reciprocity of art and philosophy. As art of philosophy or as philosophy in art, the relevant mystery-drama works through myth to let the transcendent fire, which is also the immanent fire, burn. Should the life of an artwork be "fashioned [gebildet] in forms of Greek myth," it is not formed "in them alone"; myth, in this case, is the "Greek element" that is "sublated" and "balanced against another element," which Benjamin—as noted above—provisionally names "the oriental element" (*W* 1, 35/II:1, *126*). (Rochlitz wonders if this may be called a Judaic element.)[110] The "most powerful content" of this "asiatic spirit" is "the absolute." That this "spirit of the orient has the real contents of the absolute at its disposal" is evident in the unity of religion, philosophy, and art (Benjamin writes without punctuation or conjunction, "Religion Philosophie Kunst") but "above all" in the underlying "unity of religion and life" ("Über das Mittelalter" [from June 1916 or before], II:1, 132). With regard to this unity of religion and life, it is apparently not a problem here for Benjamin that the "asiatic ornament" is mythologically saturated (133). The relevant mythology belongs perhaps to the storytelling that he later cites as exemplary (*W* 3, 143–66/II:2, 438–65). The "unrestrained immersion" of the "asiatic spirit" in the absolute (II:1, 132) is quite distinct from that of the "medieval spirit" insofar as the latter entails art, philosophy, or theology that is "rational-magical," formalistic affectedness (132–33). In a manner somewhat comparable to his earlier characterization of asiatic immersiveness, Benjamin fosters the baroque world-image that is devoid of medieval eschatology (*O*, 81/I:1, *260*). ("And as no man knows the ubicity of his tumulus nor to what processes we shall thereby be ushered nor whether to Tophet or to Edenville in the like way is all hidden when we would backward see from what region of remoteness the whatness of our whoness hath fetched his whenceness." *U*, 391) For Benjamin, the reciprocity of art and philosophy takes place above all in their affinity with the immanent, yet entirely mysterious, absolute that alone constitutes their religiosity.[111]

Although scarcely mentioning philosophy, the Hölderlin essay's discussion of poetry could well be construed as a discussion of the open-ended task of

philosophical saintliness in the artwork. As much as possible, the formation of a "world-image [Weltbildes]" in poetic "objectivity" must eliminate "every reliance on conventional [konventionelle] mythology" (*W* 1, 31/II:1, *120*). Its presentation of the world-image must be independent of narratives of containment. Even though myth—as a seal uniting people in a version of social order—may be a power necessary to the functioning of social order and may thus be less dispensable than traditional mythology, the kinship of poetry with myth does not remove the requirement that poetry transform myth—in this case "a myth of one's own" (26/114). A few years after the Hölderlin essay, Benjamin wrote: The "beauty of a literary work [Dichtung] holds its own *in spite of* a show of mythical elements," although this work "would not be 'beautiful' without such elements" (VI, 128). As a seal or allure uniting people, myth may be integral to—but not entirely constitutive of—the beauty of a poem. In the words of the Hölderlin essay: The autonomous power of the *Gedichteten* entails not "myth" but rather—"in the greatest creations"—only "mythic attachments [Verbundenheiten]" formed into a "shape" that is "unique, unmythological, and unmythic and not further comprehensible to us [uns näher nicht begreiflicher]" (*W* 1, 35/II:1, *126*). The artwork must ultimately dispel myth; the latter functions in the artwork only to facilitate consideration of the transcendent, autonomous, incomprehensible force unifying all and everything.[112] This has more recently been explored in Handke's *Publikumsbeschimpfung*, which involves actors addressing theater and the audience as mythic social forms, and otherwise deviating considerably from the expectations of such forms; in this process, the drama and the audience may be gradually wrenched a little beyond such forms.[113] In accordance with the devotion of his criticism to the force that transcends myth and yet is ostensibly lived as though effective in myth, Benjamin suggests the "analysis of great works of literature" will encounter not myth but rather "a unity" which is an "actual expression of life" and "produced by the force [Gewalt] of mythic elements struggling against one another" (*W* 1, 20/II:1, *108*). Myth may well be a power lived, in some sense, as though it unifies life, but art may initiate struggle between different myths on how to live life, whether the myths be explicit religions or somewhat more implicit ones, such as capitalism (*W* 1, 288–91/VI, 100–103).[114] Actual life—Life—is, however, the incomprehensible core independent of specific shapes; it requires a "relation" of "inner life" (*W* 1, 35–36/II:1, *126*). This "innermost being [Wesen]" of the "singer"—of the poet—is the latter's "border [Grenze] against existence [Dasein]" (27–28/*115*). The extensive form holding existence together as lived myth is transformed by the philosopher-saint's inner form into formation of the objective world-image. The latter image is presupposition and task of the artwork and of its criticism.

Melancholy

A melancholic inner life thus creates a border against existence, or a sense of limit to existence in its prevailing construals, so that the latter construals may be worked into objective world-image. Notwithstanding the constant risk of "lunatic ecstasy" or of the deepest depressive misery, melancholic contemplation may be drawn to prophetic gifts and supreme knowing that question the limits of so-called *external* knowledge (*O*, 148–49/I:1, *326–27*). The risk of introversion—"immersion" (Versenkung)—simply sinking into itself is all the greater if this "passionate contemplation" feels itself confronted with history that is a complete lack of dignity for thought; such sinking is especially a risk if passionate contemplation feels itself confronted with nothing besides its antithesis—the ensnarement of history by the extroverted, conceited, satanic zeal of various intriguers (141–42/*320*). Unlike many, Benjamin does not associate melancholy definitively with such alternation between activity and disgust about activity. He does not associate melancholy definitively with an "affectivity" (Affektivität) in which the relation of intention and object simply alternates from "attraction" (Anziehung) to "repulsion" (Entfremdung). There can rather be a mourning "capable of a special intensification [Steigerung]," a "continuous deepening [Vertiefung] of its intention," a "profundity" ("Tiefsinn," a deep sense or meaning) "characteristic above all of the sorrowful [Traurigen]" (139–40/*318*). Such mourning is on behalf of a world more natural than psychological; a world more natural than psychological gives mourning its profundity. This nature is not the nature confined to survival of living organisms but is rather the Life not completely revealed in organisms and yet determinant of them. The profound world of the sorrowful is the nature to which all belong whether they are active or contemplative. It is the inner world had by all as a realm not realized in historical existence, however that existence might be construed.

As a "world" opens "under the gaze of the melancholic," this gaze is not simply the subject having the gaze. The "presentation" of the ("partly explicit [entfaltet], partly implicit [unentfaltet]") "laws" of the mourning play is not devoted to "the condition of feeling" (Gefühlszustand) in either the poet or the public but rather to "a feeling [Fühlen] removed from the empirical subject." No feeling is the subject experiencing it. Feeling is "motorial behaviour" responding to "a concrete construction [einem gegenständlichen Aufbau] of the world"; the concrete construction is the "a priori object" of the feeling. The a priori object of any feeling must be a concrete construction of the world. Only the highest intention would no longer be concrete. Not so high, mourning is a feeling. It is, however, especially "bound" to "the fullness [Fülle] of an object"; this "astonishing persistence" of "intention" is characteristic of no feeling besides the "motorial attitude" of mourning. Love is a possible exception but it is not "playfully" persist-

ent (139/*318*). The love addressed in this way by Benjamin is evidently not a philosophical love, for the latter love of wisdom seems to be considered by him to be constituted by play of mourning. It is integral to the unique persistence of mourning that it plays its object. Mourning is identical with the persistent return of the object as a problem of presentation, as a problem of play. There is thus "the presentation [Darstellung] of history as mourning play" (142/*321*). A Counter-Reformation influence requiring typology to adhere to a medieval disparagement of melancholy is countered by the German baroque mourning play in style and language suggestive of the Renaissance speculation that features of "weeping contemplation" (weinenden Betrachtung) reflect "a distant light" shimmering back from "the ground [Grunde] of immersion" (157/*334*). In mourning, the problem of presentation is turned into the a priori object by the distant light from the ground of immersion. The a priori object of every feeling is the latter's "presentation" (Darstellung); the presentation is the "phenomenology" of the feeling (139/*318*). The phenomenology of mourning is, however, determined by the problem of presentation. Mourning is thereby phenomenology per se. With its extension constantly sobered by the divine ground of its immersion, mourning is the breakthrough of philosophy, love of wisdom. Mourning is integral to love of wisdom. Sobering extension, melancholic immersion acquires the profundity of orientation by what all share as their most profound world.

Insofar as it is determined by presentation as insoluble problem, melancholic immersion is the aforementioned hope that occludes closure of world. It is the stretching of worlds toward each other, to the common world—or, if one prefers, universe—that is affinity with the ideal for which there is neither question nor answer.

> . . . Away! Away!
> The spell of arms and voices: the white arms of roads, their promise of close embraces and the black arms of tall ships that stand against the moon, their tale of distant nations. They are held out to say: We are alone—come. And the voices say with them: We are your kinsmen. And the air is thick with their company as they call to me, their kinsman, making ready to go, shaking the wings of their exultant and terrible youth. (P, 252–53)

Everyone and everything unite solely in the persistence of the feeling, the nature, spawning flight that is never assuredly unencumbered. As can be especially felt in youth, the flight is exultant and terrible, free and catastrophic, certain only in its uncertainty. The profundity, the genius, of melancholy is to show this common natural dilemma. The "images and figures" of the German mourning play seem "dedicated" to the "genius of winged melancholy [Genius der geflügelten Melancholie]" depicted in the wood engraving "Melencolia I" by Albrecht Dürer (*O*, 158/I:1, 335).

It has been suggested, however, that not the "feminine" figure of melancholy in Dürer's engraving but the "masculine" one in Shakespeare's *Hamlet* is the emblem of the theory of melancholy underlying the criticism in the *Trauerspiel* book.[115] Hamlet is indeed presented by Benjamin as the only baroque figure corresponding to (and carrying through) the conflict of the medieval disparagement of melancholy and the neo-antique (Renaissance) view of sublime melancholy. As the life of Hamlet—before its extinction— "points to the Christian providence" changing "his mournful images" into "a blessed existence," this entry of his "melancholic immersion" into "Christianness [Christlichkeit]"—this overcoming of his saturnine character and acedia by "Christian spirit"—is a life in which melancholy "encounters itself" and thereby "is redeemed" (löst . . . sich ein). Melancholy encounters itself and redeems itself as inextinguishable secret. Secret impels mourning of extension and renders extension as presentation, as occasion for play. The playful yet studied emergence of the "secret [Geheimnis]" of Hamlet's "person," along with the emergence of the "secret of his destiny" in a homogeneity seeming complete to him, is emergence of secret as secret, of secret that is homogeneous as constant opening for play. Those deemed wise might presume to have the "space" of "silence," the space of secret, as their word. Only as unlivable, however, is secret a constant (and thus completely homogeneous) basis for playing history in a philosophical way. On this irrepressible basis, Shakespeare could strike "Christian sparks" from otherwise largely rigidified baroque melancholy (*O*, 157–58/I:1, *334–35*).[116]

In this vein, moreover, consideration of the Spanish variant of baroque mourning play is necessary in order to deal with "the idea of German mourning play" (*O*, 235/I:1, *409*). Showing expressive possibilities in play (playful engagement of language) not reached by the German baroque (49, 84/229–30, 263), works by Calderón demonstrate "the completed art form [vollendete Kunstform] of baroque mourning play," the precise harmonization of play and mourning with one another that gives validity to the word and the object "mourning play" (81/*260*). As the pinnacle of the artistic potential of the form "baroque mourning play," this completion is, of course, not substantial but formal. It is a rhythm of play with the immanent, yet transcendent, force of nature. The Catholic culture of Spain facilitates the formal dialectic of setting whereby conflict is playfully reduced—unfolded, resolved—in royalty that thus becomes a secularized redemptive power to which nature is obligated (*W* 1, 381/II:1, 272; *O*, 81, 93/I:1, 260, 271–72). Astral or magical destiny in Calderón's mix of pagan and Catholic convention (*O*, 130/I:1, 309) is indicative of the "destiny-drama" in which a "self-enclosed world" emerges via the "canonical artistic means" of reflection; there is constant framing and miniaturization of the transcendent (83/*262*). Benjamin's usage

of "canonical" is obviously distinct here from his occasionally pejorative ones. It is, moreover, the quasi-Romantic artistic achievement and not the monarchic-ecclesiastic sovereignty that is important for Benjamin.[117] He focuses on a formal rhythm that does not entail claim to make the transcendent substantially present.[118] Benjamin's celebration of Calderón's magical "pagan-Catholic convention" against the "great paucity of non-Christian notions" in the German mourning play (*O*, 130/I:1, *309*) or even his celebration of Hamlet's eventual Christianness cannot be isolated from the aforementioned *Oriental*—perhaps Judaic—openness. "The time of destiny [Schicksal] is the time that can be made *simultaneous* [*gleichzeitig*] (not present [gegenwärtig])" ("Zum Problem der Physiognomik und Vorhersagung" [a note from around 1918–1919], VI, 91).[119]

Although Shakespeare (with Christianness) and Calderón (with pagan-Catholicism) more effectively redeem mourning in play than do their German counterparts, this redemption of mourning is not an annulment of mourning or of its validity. Benjamin does not say that mourning is a "specious sanctity" presenting itself as redemption; he says this, rather, of the German baroque version of mourning. Not mourning but the German truncation of it becomes immersion unable to rise from itself.[120] Even the immersive tendency of the otherwise specious, truncated German variant of mourning hints at hope (in comparison with devilish mirth also in the plays) (*O*, 98, 127/I:1, 276, 306). Benjamin praises Hofmannsthal's *The Tower* (a reworking of Calderón's *La vida es sueño* [*Life is a dream*]), moreover, for leaving behind Calderón's "Christian optimism" (and its prince of perfection) in favor of a "truthfulness [Wahrhaftigkeit]" in which Prince Sigismund suffers demise by the maneuvering forces of political conspiracy; no "Christian heaven" prevails as this mourning play strips itself of Romanticism and shows "the strict characteristics of the German drama" (III, 33). Benjamin's endorsement of Hofmannsthal's drama not only leans more strongly in the direction of mourning than of play but also obviously qualifies his celebration of the formally self-enclosed and playful Spanish, Catholic work.[121] At the very least, it reinforces the impression that there is no devaluation of mourning as he critically unfolds the idea of baroque mourning play via examinations of the Christian element of Shakespeare and the Catholic-pagan element of Calderón (examinations facilitating what might be considered prolegomena to a theory of the "origin of the mourning play" [I:3, 947]). Obviously not adopting German Protestantism manifesting itself in either a rigidly antinomic existence or a desperately compensatory moralizing, Benjamin once suggests from his "being as Jew" that he realizes lament and mourning have their "own right," a "perfectly autonomous order." The constraint of German culture with regard to lament, and the correlative inability of this culture quite to

accept the unique and outstanding linguistic mourning in the mourning play, lead Benjamin to think that the primacy of mourning in Hebrew culture could be a corrective (*C*, 120/*GB*, Vol. 1, *442–43*). The German dilemma (the "national" element hindering presentation of "the idea of the mourning play" [I:3, 946]) is not mourning but rather unnecessary fettering of the ability to mourn. The autonomy of mourning is preparedness to play the ultimately irrepressible object—the feeling that mourns.

Benjamin detects a productivity of mourning, one guiding his own critical work, in Dürer's engraving and in the German baroque mourning play. Seemingly crystallized in Dürer's "Melencolia" (1514) and its association of the melancholic with longing for remote horizons, the "dialectic" of Saturn concerns an only apparent dualism of contemplative inwardness and distant cold, dry star. From the Renaissance confrontation with the problem of separating ordinary, pernicious melancholy (leading to madness and depression) from sublime melancholy, there had already emerged, and continued to emerge, reformulation of saturnine melancholy into a theory of genius (*O*, 149–51/I:1, *327–29*).[122] In Dürer's engraving, the "gloomy" forces of Saturn are accordingly offset or modified by allusions to Jupiter (exemplified by the weight-balance or by the magic square in which each row of numbers adds up to the same sum). Under the influence of Jupiter, harmful tendencies become beneficial; "Saturn becomes the protector of the most sublime investigations" (*O*, 151/I:1, *329*). The German baroque mourning plays also give way somewhat to such a dialectic. Too painful and thus mournful to be stoic insensibility, the deepening "contemplative paralysis" follows less from stoic "rational pessimism" than from stoic practice; the latter estrangement from surroundings and body turns into a painful and productive deadening of affects. In the "heavy degree of mournfulness," the "pathological" state becomes incomparably productive as objects acquiring an independence from humans' conscious relations with them become ciphers of "enigmatic wisdom." This scenario is anticipated in Dürer's engraving with the "utensils of active life . . . lying around unused on the floor, as object of brooding [Grübelns]"; the engraving and the baroque merge brooder's "knowing [Wissen]" and scholar's "researching" (Forschen) (140/*319*).[123] The German baroque mourning plays enter this productive melancholy, albeit in spite of the authors' intentions.[124] Unfolding this productivity (in works by Shakespeare and Calderón, as well as in tendencies obscurely within the German works), Benjamin's criticism also merges brooder's "Wissen" with scholar's research (albeit in a way of considering that frees itself from the brooding which stops following "the object" and is fixated on what has already been perceived or said about "it" [I:3, 926]). The brooder's knowing of the intransigent and inaccessible converges with scholarly research that plays secret as a force within history.

Destiny of Art and Criticism

To mourn and play history on behalf of secret is the ethical impulse of criticism and that of the artwork itself. A unity of the "ethical and historical" surpasses the classicist preference for a combination of the "mythic and philological." In a dimension beyond myth and philological determination of myth, the work survives as "the blazing funeral pyre" (*W* 1, 298/I:1, *126*). Some scholars still conceive of totality as a Hegelian end point (the idea "in the totality of its history") in relation to which there currently remains no true alternative besides scholarly closures of and about history.[125] For criticism, however, the work burns over its own historical appearances and over those of its reception. The "past" (Gewesene) may be conceived as "wood"—"heavy logs"—and "lived experience" (Erlebte) as ashes—"light ashes"; both are surpassed by the burning of the "living flame" of truth. The flame, the blazing funeral pyre, is the "growing" work. The growing work is not fully realized in any appearance or reception but precisely this assures its growth or at least potential for growth. If the "commentator" is "chemist," the "critic" is "alchemist." Whereas "wood and ashes" remain the sole objects of the chemist's analysis, the alchemist recognizes that "only the flame itself preserves . . . the enigma of the living." The enigma preserved by the artwork is life as an inextinguishable enigma. The work renders history not as myth (philologically determinable myth) but rather as inextinguishably enigmatic. The critic "inquires about the truth"; the work requires this (*W* 1, 298/I:1, *126*). The "specific historicalness" of artworks is "disclosed," therefore, not in "art history" but only in interpretation for which "relations of art works with one another" are "timeless" (yet "not without historical relevance") (*C*, 224/*W* 1, 389/*GB*, Vol. 2, *392–93*).

The relations of all with one another are essentially or ultimately timeless—such is their destiny, it was suggested above, of time that cannot be *made* present—but art requires that this timelessness be presented in history. Other forms of life do not make this timelessness essential to presentation, whereas the work of art (like the work of philosophy) is—"according to what is essential in it"—"ahistorical" (223/388/*392*). As interpretative recognition "through immersion," "great criticism" is not simply historical or comparative education (*W* 1, 293/II:1, *242*); the content or substance must be elicited at the expense of deducible general rules or effects relevant to historical-comparatist approaches (*O*, 44/I:1, 224–25). If "positive criticism"—which Benjamin at least once proposes should concentrate on "the particular art work"—is to attain "a presentation of great contexts," it must account for "the truth of the work"; art requires such accounting, just as philosophy does (*W* 1, 293/II:1, *242*). Great contexts are those of immanence, those of destiny. Although the *Trauerspiel* book might obviously be said to concentrate on immanence of many particular works, it

does explore a transcendent immanence—a philosophical impulse—that Benjamin considers to unite various works.[126] Benjamin's roughly outlined "literary historical" excursus (containing a chronology mentioning Shakespeare as founder and Calderón as crowner of baroque mourning play) is accompanied not only by a brief "cultural" excursus mentioning the role of Protestantism in the German mourning play but also by an "aesthetic" excursus stressing the philosophical impulse behind the book (I:3, 915–16). As Benjamin indicates elsewhere, his considerations on Calderón and Shakespeare are related to the unfolding of the "idea" of the German mourning play, or even somewhat of the *idea* of mourning play (including, say, the *idea* of the European mourning play), and thus to the totality requiring the monadological immersion that makes the *Trauerspiel* book "no contribution to the history of literature" (946–48). Even their own dramaturgical realia release the mourning plays from classicist historicism; they release the plays from the German dramatists' didactic attempts to recreate tragedies in a quasi-Aristotelian sense (*O*, 100/I:1, 278). The release of destiny by artworks is a wrenching of history into the force of uncertain nature. "Where there is destiny, a bit of history has become nature" no longer malleable for intentions; destiny is "latent resistance" to history (*W* 1, 365/II:1, *249–50*). Concerning the eternal meaning of existence, the "philosophical determinations [Bestimmungen]" in an artwork's "structure" (Struktur) comprise this compelling and resistant "determinateness" (Determiniertheit) of destiny (377/*266*; see also *O*, 129/I:1, 308).

Whether as philosophy in art or as the art of philosophy, criticism is this resistance of nature to history. This resistance is not based on that bombastically and ostensibly liberatory space of much literary Expressionism.[127] Nor is it based on a space requiring "text-immanent" or "close" reading in the manner of New Criticism; the "individual texts" do not have that kind of "integrity" and are instead to be "blasted."[128] Critical examination must "initially" be done with reference to "single examples" of the relevant "relations," but the latter relations involve "unities" that are "wholly unascertainable [durchaus nicht erfaßbar]" (*W* 1, 20/II:1, *108*). The tension of particular appearance and the unascertainable is the drama of art. Although the German baroque mourning plays have an inconsolably empty and graceless melancholy (*O*, 70–71, 81, 84, 93, 123–24, 139–40, 158/I:1, 250, 260, 263, 271–72, 302–3, 318–19, 335), this does not entirely annul the drama in which the pragmatic events (*Haupt- und Staatsaktion*, the courtly settings rendered in a quasi- or pseudo-historical political content) of baroque mourning play abandon the Christian mystery-play and the Christian chronicle and thereby revive the tension of asking about redemption. In their "immanence" (Immanenz), the dramas analyzed by Benjamin as baroque mourning plays are "secularized" Christian

dramas, "secularized" mystery-plays (78–79, 113/257–58, 292). The plays of the "crude" (rohe) German theater have an "intense [inniges] life" without substantial historical solution. This profoundly felt life is also the genius of winged melancholy depicted by Dürer (158/*335*). Benjamin opposes this immanence to the notion of "unlimited immanence of the ethical [sittliche] world in the world of beauty"; he opposes it to the Romantic, aestheticist, "theosophical" immanence putting the individual in an infinite unfolding that is "sacred" (heilig) in the sense of being entirely "within God's saving grace" (heilsgeschichtlichen) (160/*337*). Benjamin's objection to any notion of symbol as "indivisible bond of form and content" in beauty is that this notion leads either to "formal analysis" disregarding "content" or to "aesthetics of content" disregarding "form" (159–60/*336*). The immanence, and indeed the beauty, of philosophy in art and criticism emerge rather in a mask that is no substantial solution for the mysterious form effective in it. To put it somewhat differently: No finite form—no mask—can conceal the unrest of mysterious content behind it. The mask of immanence—the mask of the form, philosophy—in art and criticism is the mask of resistant nature.

JUSTICE

Criticism and Justice

In a note of 1918, Benjamin refers to a cyclical philology. In this philology, the "highest continuity" is that of the "object [Gegenstand]" but this state of there being one sense—this "Einsinnigkeit"—is also modified by the terminology. The terminology is not presupposed but is rather a "matter" of consideration (VI, 93–94). Benjamin never suggests either that truth content "can be defined once and for all" or that it "excludes a plurality of interpretations."[129] For Benjamin, the plurality of interpretations is a necessary byproduct of truth content that is contained by no interpretation, just as the plurality of languages is a by-product of there being no existing true language. Philology may present a "layer of the historical" but the "connection" between regulative, methodical, and logical concepts remains hidden to humans (*C*, 176/*GB*, Vol. 2, 137). The connection cannot be defined once and for all, for what is essential may not be assumed to be realized in history (whatever that is considered to be). In the "rhythm" of storytelling (according to a late text by Benjamin), the teller and the audience listen not to a human voice so much as to the Voice of Nature. They belong to the latter voice (*W* 3, 149, 159/II:2, 446–47, 460). In criticism, the rhythm of this natural community is presented by interpretation that keeps terminology open to modification. The term *justice* can especially require this.

In this way, justice is conceived as the longing of nature in history. "Justice [Gerechtigkeit]" is "the ethical category of the existent"; it is "condition of the world" or "condition of God" and not in the "possession" (Besitz) of individuals or of society.[130] The rhythm of justice is the cycle of mourning and playing history on behalf of secret. The tribulations and suffering of children and youths are perhaps especially prone to enter this hopeful rhythm. Benjamin's youthful "Romanticism" is expressly one recovering an objective "world-weariness" (Weltschmerz), a suffering placated by no institutional place (II:1, 47). Such weariness, particularly as it emerges in children, may be the resistant rhythm of a natural community of suffering.

> He heard the choir of voices in the kitchen echoed and multiplied through an endless reverberation of the choirs of endless generations of children and heard in all the echoes an echo also of the recurring note of weariness and pain. All seemed weary of life even before entering upon it. And he remembered that Newman had heard this note also in the broken lines of Virgil, *giving utterance, like the voice of Nature herself, to that pain and weariness yet hope of better things which has been the experience of her children in every time.* (*P*, 164)

Benjamin refers to a childlike agitation that is a "movement" longing for truth (II:2, 616–17). Even *The Brothers Karamazov* presents illuminating and emancipatory children's episodes (615) and unfolds "the unlimited healing power of the childlike life" (*W* 1, 81/II:1, *240*). This life is the stirring movement of the child Alissa in Gide's *Strait Is the Gate* and even more so of the childlike Myshkin in *The Idiot*.[131] Their infantile withholding is objective, is the longing for justice to nature, for this withholding is philosophical. The infantile withholding is philosophical insofar as it requires critical terminology that keeps itself open to modification—that is, keeps itself open to the cyclical rhythm of nature mourning and playing history.

The artwork requires that criticism enter this cycle. Genius is born not in a philologically determinable moral order but in an infantile silence vis-à-vis such order. The paradox of artistic expression is that its constitutive object is inexpressible. The paradoxical birth of genius in infantile silence may be the basis of all sublimity (*W* 1, 203–4/II:1, 175). This kind of silence emerges from the continuity of everything and is performed in art as this continuity. The continuity of art is its withholding from history. Artworks are unsuited to the kind of continuity advanced in maturation schemata (*C*, 223/*W* 1, 388/*GB*, Vol. 2, 392; see also I:3, 918). It is in such a sense that artworks may be conceived as windowless monads; their immanence is to present what is heard from, yet fundamentally eludes, appearances of history.[132] Art hears what is silent—inexpressible—to history, that is, its constitutive acoustics, which roars as silence. This roaring silence is contrasted by Benjamin with the quiet

in Stifter's work. The "world-being" (Weltwesen), the "language" that is the origin of all speaking, is heard only by a "contact" quite distinct from the "quiet" (Ruhe) in Stifter's writings, which not only tend to exclude "acoustic sensation" and be visually oriented but also tend to show Stifter to be "spiritually mute" (*W* 1, 112/II:2, *609–10*). Speaking is born of what cannot be seen, or be said as though it could be seen. Its basis can only be heard as what is withdrawn from history. The request to God not to be led into temptation and instead to be saved from evil is the request for justice, for the just condition of the world.[133] The just condition of the world is the linguistic being, the world-being, providing the impulse to justice. Apart from certain considerations given by him to children, Stifter lacks "a sense for justice in the highest sense of the word"; he lacks a sense for "elementary relations of the human with the world in their purified justifiablility [Rechtfertigkeit]" (*W* 1, 111/II:2, *608*). Relations of purified justifiability cannot be seen alive. Stifter separates the "impulse of purity" from the "yearning for justice" (112/609) as he attempts to regard the visual as pure; Stifter ultimately does not hear what cannot be seen and thus shows his lack of yearning for justice. Benjamin would later suggest that the just person is the apex of a creaturely hierarchy reaching "down into the abyss of the inanimate" (*W* 3, 159/II:2, 460). As impulse into and from the abyss of the inanimate, justice is the unlivable and inherently critical element of artworks. This seems to be implied in Benjamin's characterization of critical "interpretation" as "presentation" of ideas that are—by virtue of their "intensive infinity"—monads (*C*, 224/*W* 1, 389/*GB*, Vol. 2, *393*). In its monadic basis, art initiates criticism hearing the just, silent impulse of nature and requires criticism to have terminology open to this impulse that mourns and plays history on behalf of inextinguishable secret.

Tragedy and Justice

Tragedy spawns and yet suppresses critical silence. The morally infantile silence in tragedy is only an initial rise of sublime genius against guilt context. The human's realization of being "better" than the gods "remains muffled [dumpf]" and "robs" the human of speech (*W* 1, 203/II:1, *175*). This realization happens but may not be quite corroborated in speech. The heroic content is a protest of the community but is also a protest ultimately disallowed by the community—this *Volksgemeinschaft*. The heroic content is in the community as language is in the community, and the disallowance of this content is a disallowance of language (*O*, 108/I:1, 287). The lingering feeling of ambiguity concerning guilt and atonement is resistance to restoration of "the 'moral world order' [sittliche Weltordnung]" (*W* 1, 203/II:1, *175*).[134] In the ultimately silent rebellion before the edict of pedagogical tragic speech, it is noticed that

"visual images" and the "structure of the scenes" "reveal a deeper wisdom than the poet himself can put into words and concepts"; the heroic figures "speak, as it were, more superficially than they act" (*O*, 108/I:1, 287).[135] This discrepancy between physis and speech is the sublime word mocking the tragic one. An "experience of the sublimity of linguistic expression" emerges from experience of the discrepancy between "situation" and "tragic word," between the complexity of "image" (Bild) and the morally judgmental "speech" (Rede) (*O*, 107–9/I:1, 286–88). On the basis of such discrepancy, death may appear to be for a community not yet born (106–7/284–85). To recognize a complexity not to be spoken is the simple freedom of the natural community of protest. The new community would be born of the ambiguity that the old community cannot entirely extinguish. The precipitousness of the heroic figure in relation to moral order is indicative of a philosophical (as opposed to a mythic) impulse; the "historico-philosophical [geschichtsphilosophische]" signature is the "profound Aeschylean pull towards justice" inspiring an "anti-Olympian prophecy" in all tragic poetry. The philosophical writing-image or signature releases physis into history otherwise hypostatized by tragic speech (109–10/288–89).[136] Olympian speech ostensibly dominating history is countered in ambiguity maintained by the pull toward justice; justice draws or pulls the counterrhythm that constitutes the historico-philosophical signature.

Justice is associated quite fundamentally with the certain uncertainty. In the irrepressible community of physis, the "askew perspective" in Antigone's "rebellion" (Aufruhr) involves "everything" feeling itself in "an infinite form" that moves it "deeply." Everything feels as though seized by "infinite reversal [unendlicher Umkehr]."[137] The otherwise suppressed physis effects transition. It is the time of music opposing the time of guilt context; the temporality of guilt context is inauthentic, distinct from the "time of redemption, or of music, or of truth" (*W* 1, 204/II:1, 176).

> The ache of conscience ceased and he walked onward swiftly through the dark streets. There were so many flagstones on the footpath of that street and so many streets in that city and so many cities in the world. Yet eternity had no end. (*P*, 139)

The silence of the heroic figure is presentation—performance—surpassing its moral content. Unable to stop at "what is presented [Dargestellte]" and pertaining instead to "presentation itself," art—"in its works"—is no "councillor of conscience" (*O*, 105/I:1, *284*). The performance is defeated by moral content but is not quite subsumed by it. The "philosophical definition of tragedy" attempts to save Attic tragedy from aspects of assessments such as are provided in Wilamowitz-Moellendorff's *Einleitung in die griechische Tragödie* (1907), which treats tragedy as essentially legend that sacrifices the hero in atonement to the gods whose ancient right is to be upheld

(106/284–85).[138] Yet the alternative to aphilosophical history is not ahistorical philosophy. The "signature" of tragedy is not the metaphysical conflict of hero and environment that is outlined in Max Scheler's "Zum Phänomen des Tragischen" (1914) (*O*, 106/I:1, 285). Nor does it justify those elements in studies such as Johannes Volkelt's *Ästhetik des Tragischen*, which develop the philosophy of tragedy as a theory of moral world order (in terms of alleged universally human concepts of "'guilt' and 'atonement'") and include modern works without considering whether the tragic might not be a historically specific form (39/219, 101–2/279–80).[139] The tragic conflict addressed by these various thinkers is considered by Benjamin to be specific to ancient Greece (*O*, 106/I:1, 285). As noted above, however, the performance is not entirely contained by the victorious. The "truth content" of the "whole"—the truth content not circumscribable as presented content—"includes moral admonishments" but "only in the most mediated way." There is no victory of moral admonishment, even in the qualified forms fostered in nineteenth-century German idealist metaphysics (105/*284*).[140] After all, tragedy has no "fully developed consciousness" of "community" that could justifiably dismiss—as "hubris"—the silent, hidden word, which impels defiance (*O*, 115/I:1, 294).

The sublime word remains hidden. It is simply performed as hidden—that is, the performance of the defiance showing itself to have been silenced. This performance is preceded by a Dionysian outburst. With the cry of protest (the Dionysian outburst, the "intoxicated, ecstatic word"), "the regular perimeter of the agon" is pierced; the freedom of logos cuts through the legal judgment and the higher justice is thus evoked in the "persuasive power of living speech" (116/295).[141] Agon is the contest ordinarily contained and restrained by tragic myth; the perimeter is broken only extraordinarily—and ultimately in vain. Yet Nietzsche's *Birth of Tragedy* not only focuses on this breakthrough but also thereby attempts to emancipate the relevant works from tragic morality (*O*, 102/I:1, 281). In this attempt, Nietzsche neglects something. The "moral content" is an "element" (Moment) of the "integral truth content" of tragic poetry, albeit not the "last word" of this poetry (105/*283*). Nietzsche's aestheticization simply overrides the historical, moral-religious force blocking the philosophical impulse of the works. Discounting "historico-philosophical" or "religio-philosophical" considerations (102, 104/*281, 283*), Nietzsche's aestheticization of Dionysian myth amounts to dissolution of Apollonian appearances (102/281). For Benjamin, the morality-myth ultimately stifles Dionysian will in such a way that the tragic remains at best a preliminary level of prophecy. The prophecy is preliminary, for the prophetic voice is no more than linguistic experimentation with past word and past silence, with otherwise forgotten suffering and death. There is no pragmatic redemption of this voice; the defiance necessitated by physis not

compliant with judgment remains unacquainted with any practically redemptive word (118, 115/297, 294).

Destiny of Ethics

Even modern—more openly philosophical—art is, of course, not a dissolution so much as a compounding of the tension of sublime word and pragmatic context. The "power" (Kraft) of destiny emerges only in relation to some guilt-context or other (*W* 1, 377–78/II:1, 267). Destiny is the tension of moral order and philosophical impulse. The latter ethical impulse is, as suggested above, the longing for justice to nature not compliant with moral order. The ethics of art is presentation of the inability of morality to appease nature. With Romanticism, the view became prominent that an art*work* can be comprehended "in and of itself" and without consideration given to its connection to "morality" or to "theory" (*C*, 119/*GB*, Vol. 1, 441). In this formulation by Benjamin, "theory" may mean something along the lines of "theorem"; he says elsewhere that the truth content of art "is never encountered in the abstracted theorem [abgezogenen Lehrsatz], let alone in the moral theorem" (*O*, 105/I:1, *284*). If Benjamin once conceived his dissertation as having the task of proving "Kant's aesthetics" to be "an essential presupposition of Romantic art criticism" (*C*, 119/*GB*, Vol. 1, *441*), this project would obviously have followed from the argument of the *Critique of Judgement* that aesthetic ideas are independent of determinate ends.[142] As aesthetic idea in the work, truth content is encountered "only in the critical, commentatorial unfolding of the work itself," the work in the independence of its truth content from moral or otherwise narrowly historical content (*O*, 105/I:1, *283–84*). Destiny is not pure nature; nor, however, is it pure history. Destiny is, rather, the elemental force of nature in historical events (129/308). As noted already, Benjamin rejects Kant's ultimate relegation of aesthetics to subjective judgment. With the work conceived as very concrete instantiation of the tension of determinateness and transcendence, Benjamin's increased turn to literary criticism, particularly following World War I, may be considered at least somewhat similar to the Romantics' departure from Kantian formalism in the wake of the political and social turmoil of Europe during the 1790s.[143] While in agreement with Kant's view that art transcends the determinate character of any given work and is not itself a determinate law, Benjamin considers this transcendence less removed from sensible, speakable experience.[144] For Benjamin, an ethics of wild sensibility enters art as a constant tension with historical moral order. It does so, moreover, even where the Romantics themselves may tend to consider the tension aesthetically sublated.

It is as performance of the tension of sensation and moral order that mourning play seems exemplary to Benjamin. Whereas ancient Greek drama gradually reduces (secularizes, so to speak) "mystery" ("Mysterium") into a mythic worldview, the "language of the new drama" is the "purely dramatic [Reindramatisches]" that resurrects mystery. An inextinguishable resistance of physis to judgment lends, of course, residual drama to tragedy. As suggested above, even Socrates' rationalistic war on tragic art is somewhat undermined by the prevailing "spirit" of the Platonic dialogue—that is, by the "pure dramatic language" in the dialogue. In new drama, the "language" of the purely dramatic is above all "the language of the mourning play" (*O*, 117–18/I:1, *297*). Mourning play is intrinsically a "form of mystery" (Form des Mysteriums); unlike tragedy, therefore, it has an open future (113/*292*).[145] Avoiding "the chimera of a new 'tragedy'" and aptly subtitled a "mourning play," Hofmannsthal's *Der Turm* maintains the tension of speech and body in language presenting Prince Sigismund's broken body as that of a martyr refused language (III, 32–33). Such a martyr-motif is extremely important for the mourning play (*O*, 113/I:1, 292). The body is that of a martyr, for the demise lacks any compelling justification. As the "modern tragedy" (Rosenzweig) named "mourning play" adapts elements of martyr-drama, there emerges—as noted already—a "saint" who may fall but does so sustaining transcendent will and without recognizing justification for the fall; more effectively than the loser's body in tragedy, the loser's body in mourning play can be that of a martyr upholding the drama of mystery (112–13/291–92). The body as physis effectively refuses the fall's legitimation.

Individuation may seem a kind of original sin making one accountable to this or that guilt context, but it is less conclusively a closure once conceived as allegory of the grander game overdetermining it. There is no determinable subject of destiny (*W* 1, 56–57/II:1, 135–36). The human is *not* essentially the subject that is made accountable to a specific guilt context. Destiny is indeed "the guilt context of the living," the context that is the "semblance [Schein] not yet wholly dispelled" from human life. Under this semblance, however, the "best part" of the human is "invisible" (*W* 1, 204/II:1, 175). To live the semblance of guilt context is a kind of creaturely destiny of the human. It is what the human does simply as a matter of living; "creaturely guilt" (*O*, 129/I:1, 308) is destiny that is "the natural condition of the living" (*W* 1, 204/II:1, 175). In this natural condition, the "original sin" of having to live a guilt context—some guilt context or other—does not follow from "moral transgression" of an agent. Against the natural condition of adaptation, moreover, there is a natural energy making it possible to place such adaptation in question. To this extent, Benjamin expressly wishes to follow the Counter-Reformation in suggesting a *meaningful* notion of natural history. Destiny is

the natural "entelechy," the energia, of "events within the field of guilt." The energy is a registration of salvation, albeit solely as tension of nature within guilt context. In the "quagmire" of "Adamic guilt," in the destiny of guilt context lived as though it were original sin, the "light of grace [Gnadensonne]" is "reflected from the state of creation," the state free of this sin (*O*, 129/I:1, *308*; see also 89/268 and *W* 1, 377/II:1, 267). Beyond the "natural individual," there can accordingly be belief in a natural development of humanity that is not development in "dull biological unconsciousness" but is rather "*culture*" (II:1, 14). Although the sequential causality in a guilt context is lived as though it entails "laws of nature," art presents destiny deviating from this. This deviation, which could perhaps even emerge as a miracle, concerns an "eternal sense" of determinateness. This sense of determination is a "genuine" notion of destiny (*O*, 129/I:1, 308; see also *W* 1, 377–78/II:1, 266–67). ("So that gesture . . . would be a universal language, the gift of tongues rendering visible not the lay sense but the first entelechy, the structural rhythm." *U*, 427) In the entelechy of destiny, the subject of the guilt context is overdetermined by the rhythm of subjectless universality.[146]

The latter determinant, overdetermining, *time* is empirically indeterminate. It remains "an idea" (*W* 1, 55/II:1, 134). On this basis, natural-historical metaphorics in the mourning play treat the "historical ethos" and "ethical reflection" as subordinate to natural destruction (*O*, 88–91/I:1, 267–70). The mourning play is essentially "unclosed" and the idea of its resolution does not exist within "the dramatic realm" (*W* 1, 57/II:1, *137*). Its drama derives from the entelechy of nature within—but not entirely revealed in—the historical ethos or ethical reflection (*O*, 89–90/I:1, 268–69; *W* 1, 57/II:1, 136). Destructive nature presents itself mourning and playing any historical ethos or acclaimedly self-reflexive moral topos. In *Elective Affinities*, Ottilie's sacrifice is illusory reconciliation, for her "semblance" lacks "everything annihilating" (alles Vernichtende) that is required of "true reconciliation" (*W* 1, 342–43/I:1, *184*). True reconciliation is reconciliation with destructive nature. Reconciled with destructive nature, art is the drama of mourning and playing the moral topos. Not only Ottilie but all the main figures in *Elective Affinities* appear "spellbound" (gebannt) in the "sort of darkness" that is "foreign to artistic creations [Kunstgebilden]" and entails assuming "essence" (Wesen) is recognized in "semblance" (345/*187*). The darkness of the characters' semblance represses or suppresses; it is no release of *night* into *day*. All "affects" (Affekte) are silenced; they appear neither explosively ("enmity, obsession with revenge [Rachsucht], envy") nor implosively ("lament, shame and despair"). Benjamin's summation: "So much suffering, so little struggle" (343/*184*). The suffering is, nonetheless, a hint of those residues of "drama" (Drama) facilitating Benjamin's critical unfolding of Goethe's *Elective Affinities* in opposition to Goethe's own declarations exclud-

ing "inner ethical struggle as an object of poetic forming [dichterischen Bildens]" (312/*144–45*). In the ethical struggle and its drama, the impulse beyond semblance mourns moral topos and thereby opens the prospect or possibility of this topos being played (if not played away) on behalf of the secret that is destructive nature.

Art is ultimately based in a community distinct from the community that is summoned to witness the "cosmic topos" of the tragic stage and to carry through judgment on behalf of this topos. Art is neither to appease nor to establish a moral topos. In mourning play, the stage is not moral topos but unappeased feeling; the stage is "an inner space of feeling without relation to the cosmos"—without relation to the cosmos as moral topos. The play does not elicit the onlooker to find justification in the moral topos but rather accords with the inner resistance of the onlooker to such a topos. Mourning play is for this feeling of resistance; it is for the mournful. The play is not one making "mournful [traurig]" so much as one "through which mourning finds its satisfaction" (*O*, 119/I:1, *298–99*). Mourning is satisfied insofar as topoi can be shown not to satisfy. In the mourning play, neither the figure in the play nor the audience undergoes peripeteia or anagnorisis; there is no Aristotelian purging or catharsis.[147] The satisfaction in dissatisfaction is, as implied already, no psychological condition. Mourning always already exists as the resistance of nature to moral order. In tragedy, the probing "word of genius [Genius]" is ultimately silenced as alleged moral-psychological flaw. In mourning play, there predominates this inner feeling that is physis unable to submit to moral topoi. As opening to physis, mourning play is conceivable without speech—as pantomime. The mourning play "awakens mourning in the spectator," awakens feeling already always there, and this slumbering feeling for physis is independent of speech (or at least of the relationship of speech with moral topos, which is perhaps the same thing as speech). The feeling is awakened, in any case, to mourn openly what might otherwise simply be lived and spoken as tragic (118–20/*297–99*). In art, community feeling mourning not only overdetermines but somewhat overtakes tragic community.

> At the corner of a street the shaft of a lorry shivered the window of the hansom in the shape of a star. A long fine needle of the shivered glass pierced her heart. She died on the instant. The reporter called it a tragic death. It is not. (*P*, 204)

The key to a people's "living tradition" is no longer a clash with god and destiny, no longer the equation of god and destiny in fulfillment of a primordial past of prehistoric imperatives (*O*, 62/I:1, *243*). There is instead "freer scope" for interpretation. However daunting they may be, the constraints in mourning play are not mythic but historical (61–63/*241–43*). The German baroque remake of this or that tragedy (like its counterpart in early

twentieth-century Expressionism) becomes a "mouthpiece" (Sprachrohr) for "the resonance of lament." Instead of adaptation to legend and its edict, there is striving for a new pathos; instead of the muffling of inner protest, there is sustained desire for a language usage united with "the innermost image-power [innersten Bildkraft]." Notwithstanding futile and compensatory outbursts of the will to claim realization of this power, the feeling independent of what can be pragmatically realized in history persists as a philosophical feeling for history; it presents itself as philosophical community unrealized in historical form (53–56/*234–6*).[148] Compounds such as "Trauerbühne" (mourning stage) exemplify the latter philosophical-communal feeling for which the word "mourning [Trauer]" is available to suck "the marrow of significance [Bedeutung] out of its companion words" (*O*, 119–20/I:1, 298–99). Not only is the "word 'Trauerspiel'"—"[l]ike the term 'tragic' in present-day usage" and "with greater justification"—"applied in the seventeenth century to dramas and to historical events alike" (63–64/244) but a "typical downfall [Untergang]" is addressed as the writers describe a work as "mourning play [Trauerspiel]." Whereas the heroic figure in tragedy is extraordinary and has a downfall that mythic community is not supposed to mourn so much as it is to recognize the downfall as morally necessary, the downfall in mourning play is typical downfall before historical constraints and may be mourned in the shared feeling of nature free of any moral, justificatory topoi (89/*268*).[149] The word "Trauerspiel" is still used to evoke this shared possibility of mourning societal and political situations—to rob them of their ostensible necessity.[150]

To note a philosophico-communal feeling underlying such everyday usage of the word "Trauerspiel" does not contradict the view that philosophical terms have no basis in "the conceptual language of the everyday," the language in which (for instance) both a streetcar accident and a work by Aeschylus are deemed "tragic" (I:3, 940). The aforementioned usages of "Trauer" with various compounds are instances of the eternal—the philosophical—breaking into the everyday; the philosophical emerges to sober history. As "philosophical determinations" enter artworks, the "decisive motif" is the eternal sense of determination or determinateness (Determiniertheit)—this "meaning of existence" (*O*, 129/I:1, *308*).[151] This eternal, philosophical meaning of existence mourns closures of history and frees history for play. Eternal nature sends philosophy and art (which, in this respect, also presents the form, *philosophy*) to mourn and to play rather than to submit. In contrast with their "nongenuine stage, the theurgic," "[g]enuine art" and "genuine philosophy" begin in ancient Greece with "the exit of myth." Philosophy and art are equally based "on truth" (*W* 1, 326/I:1, *162*).

Image of Dramatic Beauty 187

The practices of philosophy and art converge in destiny that is in space but is no space. Poets are (as the last stanza of "Blödigkeit" puts it) "geschickt," which could mean "skillful" or "clever" but also "sent" or "destined." The participle "geschickt" temporally "completes [vollendet]" space; it pertains to space in its aptitude for poetic determining. Yet the latter poetic completion is determining by the force that determines the poet, the force sending the poet. The purpose of the poet being sent is the "identity" of the orders of space and time. In the poetic "world," the manifestly manifold is identical with the shapeless "middle" (*W* 1, 27, 32/II:1, 115–16, *121–22*). With the development from "poets of the people" (in the first version of "Dichtermut") to "singers of the people" (second version) and from the latter to "tongues of the people" (third version, "Blödigkeit"), there is obviously an intensified unity of people and poet—but in a destiny so powerfully or intensively sensory that it is a supersensory rupture of mythic unity (28, 34/II:1, 116–17, 124).[152] Although Benjamin criticizes the German baroque mourning play for its transposition of formerly "temporal data" (from Christian eschatology) into "a spatial inauthenticity [Uneigentlichkeit] and simultaneity," isolating this graceless space from the potentially attenuating influence of artistic temporality, he fosters the baroque mourning play generally in its artistic freedom from the temporal ordering by Christian eschatology (*O*, 80–81/I:1, *259–60*). In poetry, too, shapes transformed into "members" of the mythic order uniting poet and people are ultimately juxtaposed with the poetic destiny—the "life" into which the poet walks—that is "outside of poetic existence" (*W* 1, 28/II:1, 116). Mythic "boundedness [Verbundenheit]" is transformed by opening mythic elements to destiny that is indifferent to any life which could be lived, any life organized by myth. Sensory powers and idea uniting around this "indifference [Indifferenz]" preserve the "law" of life that is the law of poetry (20, 35–36/107, *124–26*). This law is indifferent destiny. ("A cold lucid indifference reigned in his soul." *P*, 103) In "destiny-boundedness [Schicksalsverbundenheit]" (*W* 1, 28/II:1, *116*), the living are stirred by the song in destiny that is indifferent and incomprehensible to mythical life (35–36/*124–26*).[153] Art is the freedom and the necessity of sensory orders in the destiny that is perhaps addressed but also ultimately suppressed by myth.

> He was passing at that moment before the jesuit house in Gardiner Street and wondered vaguely which window would be his if he ever joined the order. Then he wondered at the vagueness of his wonder, at the remoteness of his own soul from what he had hitherto imagined her sanctuary, at the frail hold which so many years of order and obedience had of him when once a definite and irrevocable act of his threatened to end for ever, in time and eternity, his freedom. The voice of the director urging upon him the proud claims of the church and the mystery and power of the priestly office repeated itself idly in his memory.

His soul was not there to hear and greet it and he knew now that the exhortation he had listened to had already fallen into an idle formal tale. He would never swing the thurible before the tabernacle as priest. His destiny was to be elusive of social or religious orders. The wisdom of the priest's appeal did not touch him to the quick. He was destined to learn his own wisdom apart from others or to learn the wisdom of others himself wandering among the snares of the world. (*P*, 161–62)

With its claim to unite lives, myth of community addresses or presupposes a theological symbol that itself, however, requires (that which the *Trauerspiel* book characterizes as) allegorization and thus encourages the unraveling of the myth of community from within (*O*, 159–71/I:1, 336–48). The legitimation assumed by myth concerns the theological, symbolic force that mythic community cannot contain. Through the allegorization of myth by this symbolic force, there is an unraveling into community in crisis. The baroque accordingly involves an "eccentric and dialectical movement" alternating between extremes in a problem-ridden religious-political congregation (160–61/*337*). The dissonant dialectic of community in crisis is not completion in anything besides a rhythmic wrenching of space into mysterious time and of time into recalcitrant space. It is not completion of the individual in classicist apotheosis (a "harmonious [gegensatzlose] inwardness") and it is not the Romantically completed, transcendent individual swallowing the "ethical subject" in symbolism of the "beautiful soul"—the aestheticized individual believed (in a lack of "dialectical rigour [Stählung]") to be attained in a "symbolic construct" merging "the beautiful" and the divine "without breach" (bruchlos) (160/*336–37*). The irrepressible theological symbol allegorizes the individual and the lived community into the force presupposed by both but contained by neither; allegory opens to the supersensory force—the symbol—keeping sensory appearances in transition. In the "genuine" (echten) concept of symbol (the "theological symbol"), there remains the "paradox" of the "unity of the sensory and the supersensory object" (159–60/*336*). Theological symbol paradoxically finds expression solely in allegorizing the convention that cannot express symbol; incorporating the conflict of convention and expression, allegory is both convention and expression (175/*351*). The conflict of expression and convention nonetheless makes allegory "expression" (Ausdruck) and not just a "playful image-technique [spielerische Bildertechnik]" (162/*339*). Allegory is not "convention of expression" but rather "expression of convention." While presenting convention, allegory presents its basis on what convention cannot reveal. As convention, allegory has public validity; as expression, as devoted to the constitutive divine symbol, it has an "origin" (Ursprung) with "dignity," a secret authority, the authority of mystery (175/*351*).

The ensuing allegorization of community by the theological is not an antimodern authority.[154] As implied above, theology in art is preparedness for the symbolic force implicitly or explicitly addressed by mythic community and yet simultaneously suppressed by such community. The aforementioned "true reconciliation [Versöhnung]" enabling one to become "conciliated [aussöhnt] with other humans" is, it is suggested in the *Elective Affinities* essay, reconciliation with the destructive force that is God (*W* 1, 342/I:1, *184*). The main characters of *Elective Affinities* have little or no interest in this force; by and large, they wish to avoid it. Constantly avoiding open conflict and having a distance of "noble forbearance" (a distance of "toleration [Duldung] and delicacy [Zartheit]") (343/*184*), the main characters of *Elective Affinities* enter a "semblance-like reconciliation" (342/184) that contrasts with the novella and its "reconciliation" (342–43/184).[155] The gentle toleration or noble forbearance of the characters in the novel seems to be on behalf of semblance; it is intolerant of what is not semblance. The couple in the novella are, in contrast, reconciled with each other by virtue of deciding for the force destroying semblance. They enter that "true reconciliation with God" which requires destruction of everything for the sake of finding it anew "before God's reconciled countenance" (*W* 1, 342/I:1, *184*). Their eventual joining could, of course, as easily turn out be *untrue* as *true*. Yet the young couple's "decision" (Entscheidung), according to Benjamin, remains a "readiness for reconciliation" (Versöhnungsbereitschaft), a readiness that enables them to become "reconciled" (ausgesöhnt), for it ensues from their openness to God's destructive unity of sensory and supersensory (332, 343/170–71, *184*).

Each of us has such destruction within us as the force of most conclusive obligation. With no credible mediator between human and God, "all ethicalness [Sittlichkeit] and religiosity" spring "from being on one's own with God [aus dem Alleinsein mit Gott]" (II:1, 51). Whereas Ottilie sacrifices herself on the basis of sensing God's hand not as "the dearest good" but as "the heaviest burden" (*W* 1, 343/I:1, *184*), Hamlet eventually realizes that God's destiny can be played as one's own. Hamlet ultimately finds satisfaction not in what God's graces "play to him" but "solely in his own destiny" (*O*, 158/I:1, *335*). Being alone with God's destructive force is the basis for mourning ostensible finality and playing it down, perhaps even playing it away. Indicating the transformation of the "bloody fatality of pre-Shakespearean drama into the world of Christian mourning," Hamlet proclaims: "The readiness is all."[156] God's destructive force is within our bodies as physis enabling us to have readiness for it and—on this basis—to mourn and play history. Destructive nature and ethics converge. Contrary to Goethe's asserted "opposition between the sensory [Sinnlichem] and the ethical [Sittlichem]" (*W* 1, 312/I:1, *144*), the "language of the real world" is determined by "laws of the

moral"—ethical—"world" (341/181; 224/I:3, 832). Or conversely, one could say: The ethical is determined by the sensation of destruction.[157]

In the artistic response to this convergence of ethics and necessity, the sublime force of the true appears only as what is without appearance and without expression. On the basis of the expressionlessness determining the world (*W* 1, 340/I:1, 181), the artwork has "the sublime violence of the true" appear (224/I:3, 832; 340/I:1, 181). Appearance of the sublime violence of the true is no theocratic or quasi-theocratic appearance (see page 82 above). The appearance shows dramatically that it is not truth. In literature, the dramatic moment thus projects from its language into a realm that is "higher" and "unattainable." "Mystery" (Das Mysterium) is "the 'dramatic' in the strictest sense"; it can be expressed in no way besides "presentation [Darstellung]" (*W* 1, 355/I:1, *200–201*). "Darstellung" can mean "dramatic performance." In the artwork, presentation is dramatic performance, for mystery—as the dramatic, in the strictest sense—is hope. If the mythic is thesis and the redemptive is antithesis, hope is the dramatic synthesis.[158] Whether or not it was Goethe's intention, Goethe's work presents Ottilie's death as a "mythic sacrifice" (*W* 1, 309/I:1, 140); in this presentation, the sacrifice is required solely by myth and myth is not truth. Myth tries to capture secret but secret refuses myth this possibility. Whereas "[a]ll mythic significance seeks secret [Geheimnis]" (314/*146*), art presents secret—mystery—as always already there, as interminable secret; a "true art work" must present itself "ineluctably as secret [Geheimnis]" (351/*195*). A powerful bond of semblance and "emotion" (Rührung) makes Goethe seem immune to "the power of living beauty" (349/192). The latter living beauty is an opening to the secret, which is life that cannot be lived; the power of this beauty is entirely distinct from Ottilie's "living beauty" that is a semblance imposing itself as "matter [Stoff]" (339/*179*). Ottilie's beauty illustrates an imposition discernible in all main figures in *Elective Affinities*: "choice" (Wahl) as a struggle for freedom so chimerical, so illusory, that it simply conjures destiny or fate over the characters (332/170). The "principles of conjuration" projected by Goethe into this "literary forming" are "daemonic" (339/*179*); the "realm of conjuring formulas" erodes presentational possibilities for "form" (Form)—that is, possibilities for the performative combination of "momentariousness" (Augenblicklichkeit) and "conclusiveness" (Endgültigkeit) that ultimately constitutes "artistic vivification" (340/*180*). Artistic form "enchants chaos" only "momentarily" into "world" (340/180–81; see also 224/I:3, 832). Artistic form shows that it does this only momentarily. The irony of artistic form is that its world cannot be conjured. This is the world of pure mystery that all have as always determinant and never realized. Presentation of this communitarian irony is the ethical achievement of art.

This communitarian irony is demonstrated by the presentational irony of translation—and especially of literary translation. The irony inherent in language is that language as such, pure language, the linguistic community to which all and everything belong, ironizes all languages. The presentation of this irony in literary work was especially appreciated by the Romantics and may—according to Benjamin—be renewed with even greater intensity in translation than in criticism (258, 255/IV:1, 15, 11).[159] The distinct intensity of translation follows from a relatively extreme ironizing of the historical, extensive—semantic, grammatic—elements of language; translation acquires its uniquely intense irony as it shows historical languages not sharing meanings so much as they share ("a priori and apart from all historical relationships") "what they want to say" (*W* 1, 255/IV:1, *12*). What languages want to say is what languages, singly or together, cannot say: pure language. Pure language is the sole common basis of all languages; pure language is the constitutive and essential "kinship" or "affinity" (Verwandtschaft) of all languages (256/13). Unable to reveal or produce this hidden and innermost convergence of languages with one another, the interlinear translation—the translation alienating the receiving language with syntactic structure of the translated language—can "present [darstellen] it" in an intensive way (255/*11–12*; 260–62/18–20).[160] Performing the affinity of languages as purely linguistic rather than as semantic-grammatic, translation of literature performs the irony that mystery is the only nonsurrogate community.

As the Romantics realized, the "multiplicity of the art works" has a harmony that does not derive from "a vague principle peculiar to art alone and immanent in art alone." The multiplicity is harmonious, rather, as appearances of the ideal of the problem for which there is neither question nor answer (*W* 1, 218/I:3, *834*). This relationship of appearance and universal mystery is the constitutive shape of every work of art.

A distance of sentimentality, of pathos, or even of a kind of irony can prevent the "shaped element" (Gestaltes) from entering if creations treat "the world of shapes as a text" to which the creations themselves "deliver the commentary or arabesque." Such self-satisfied creations, which "lead out of themselves" (aus sich herausführen) alone, cannot be "pure art works." Art is indeed, above all, imagination but "imagination" (Phantasie) can never construct an artwork. As "the de-shaping element [Entstaltendes]" in the artwork, imagination must always refer to something shaped that is not imagination— that is "outside" of imagination (281/VI, *116*).[161] Artistic creation does not *make* something out of chaos; it does not "penetrate" chaos. Conjuration might attempt to be "the negative counterpart of the Creation" by producing "the world" from nothingness. This is not, however, art. The artwork emerges not from "nothingness" but from chaos. It must show this (*W* 1, 340/I:1, *180–81*).

As it emerges from "the spirit of art" (distinct from any artist's "will," artist's subjective and powerless wish, and any "play" in the sense of "subjectivism"), the Romantic "form of irony" (*W* 1, 164/I:1, 85) involves the work developing and breaking illusion by ironizing the limited "form" (163/84). As implied already with reference to Friedrich Schlegel's literary output (page 144 above), however, Romantic irony often entails imagination disregarding shape. Benjamin suggests Jean Paul's imagination is so effusive that the powers of imagination actually slip from him (*W* 1, 282, 265/VI, 116, 125). Contending Jean Paul cannot lend shape to his imagination, Benjamin contrasts Jean Paul's works with comedies by Shakespeare (282/VI, 116) and Ludwig Tieck (163/I:1, 84; 265/VI, 125).[162] Literature requires language presenting itself as language and not as the product of imagination. Art requires the aforementioned dialectic of convention and expression, the dialectic that is neither convention nor expression but rather expression of convention. Only in this way may the work have the "force [Gewalt]" to "retain [behalten] the deshaping powers [entstaltenden Mächte]." In the "power [Macht] of language over imagination," "genuine imagination" is fundamentally distinct from "Romantic irony" (*W* 1, 281–82/VI, *116*). *Language* is the shaped element ironizing not only in literature but in every artwork and indeed in everything; *name* is in everything—ironizing each appearance and meaning.

This power of name in everything is not ultimately this or that ironic usage of expressive means but the irony or allegory inherent in any means.[163] Given the persistent role of shape (some shape or other), it may be (as suggested already) better to refer to an allegory rather than to an irony. Such a terminological shift removes the destruction of limited form somewhat from connotations of a Romantic dissolution of shape. Even spaces in Jean Paul's works may be compared with fragmentary, untidy, and disorderly spaces in baroque allegory; indeed, a "true history" of the Romantic "means of expression" would show fragment and irony to be allegorical (*O*, 188/I:1, *363–64*).[164] Such a reading of Romanticism would amount to an alteration of the Romantic tendency to view irony as the basis of the comparatively minor form called allegory.[165] Benjamin's concept of criticism could correlatively be conceived as an attempt to allegorize the Romantic concept of criticism (although he does not quite say this). In "the name of infinity," Romantic critical intensification presumes "the completed creation of form and idea" (*O*, 176/I:1, *352*); the "affinity" (Verwandtschaft) of artwork and critical destruction is considered to be based on a continuum of reflection and the latter continuum is considered to facilitate fulfillment of presentation in a transformation of limited work into absolute, Romanticized Work (*W* 1, 153–54, 163–64, 165–66/I:1, 69–70, 84–86, 88). The continuum given priority by Benjamin is not so much the Romantic, reflexively ironizing one as it is the allegorically ironizing one;

in other words, the recalcitrance of shape (some shape or other) interrupts reflection or thought and—only on this basis—renews reflection or thought. "[E]xpressionless" (Ausdruckslose) is an ethical—"moral" (moralisches)—word, for the "expressionless" is "the critical force [Gewalt]" that prevents semblance and "essence" (Wesen) from being mixed in art. Yet (and this seems the noteworthy emphasis in the context of the above discussion) the power is also "unable to separate" semblance and essence (340/*181*). The ethics of expressionless destiny is that the correlative power of name in everything opens everything to the constant contact and the constant tension of semblanced shape and semblanceless music.

Mask, Art, Criticism

Criticism and artworks present themselves as masks. Rebelling against the attempt to fill space compensatorily (with a conformist Protestant ethic or anything else), a "feeling" of mourning may have "an enigmatic satisfaction" in looking at the emptied world as a kind of mask (*O*, 139/I:1, 318). No aesthetic symbol destroys mask; no aesthetic symbol has the transfigured countenance of nature show itself in a momentary, revelatory redemption (166/343). The empty mask opens, nonetheless, into something amorphous. This emphasis by Benjamin contrasts with the early Romantics' adaptation and transformation of Fichte's absolute "I," which is an "I-consciousness" as a constant of time in relation to the non-I as a constant of space (*W* 1, 123–24, 134–35/I:1, 22, *40*). The Romantic "self" (Selbst) is a thinking so opened that it is entirely independent of objects (128/29–30). For the Romantics, this reflexive self is pertinent to the artwork as well as to criticism. "[T]he infinite" is "the universe," "the essence of all things," "the absolutely free and religious," into which "all appearances [Erscheinungen]" are dissolved by the "movement" that is the "poetic art of Romanticism."[166] Even Shakespeare is a "Romantic" insofar as he does not belong to the tradition and the spirit of the mask-drama (II:2, 612).[167] Contrary to Romanticism, however, drama is fundamentally a drama of mask (II:2, 612).[168] Whatever appears is indeed mask. History is a death mask—a *"facies hippocratica,"* a countenance entering the mystery of death. As neither pure history nor pure nature, space is a landscape with a rigidity that is petrification by the primordial force of death (*O*, 166/I:1, 343). There is mediation, some mask or other, but with an intransigence deriving from the mystery of death already in the mediation. It is this intransigent mediation that is disregarded in "the primal schema [Urschema] of all reflection," the thinking of thinking, interpreted by Friedrich Schlegel around 1800 as "aesthetic form, as the primal cell [Urzelle] of the idea of art" and thus as the basis of criticism (*W* 1, 134–35/I:1, 40). Expressly in contrast with the Romantics'

"cult of the infinite" (125/25), Benjamin rejects notions of aestheticist annulment of mediation.[169] Benjamin's view of critically ironic destruction is not quite a version of what he describes as Romantic critical irony. The aforementioned falling star is thus a "moment of presentation"; it is "analogous" to the drama inherent in mystery. Unable either to express or to deny mystery, art and criticism present themselves in the drama of mystery (*W* 1, 355–56/I:1, *200–201*). This drama is more a performance of mediateness than an overcoming of it. Art and criticism present themselves as mask-dramas of mystery.

The mask-dramas of philosophy and art are, as implied already, dramas of name. Baroque mourning play and monadology mark a breakthrough of this drama of name, and this breakthrough is furthered by modern *art* (in Benjamin's sense of art) and (at least some of what gets called) the practice of philosophy. For Benjamin, practices of art and philosophy are inconceivable without the mystery drama of name. Secular drama is "play" presenting itself as "roundabout ways" or "detours" (Umwege) (*O*, 80–84/I:1, 259–63); also presenting itself as detours, philosophical inquiry performs itself as determined by—so to speak, en route to—a force entirely distinct from the historical road taken, the historical genesis (I:3, 926, 946; *O*, 45/I:1, 226). In this dramatic relationship of history with metaphysics, practices of art and philosophy are the sock turned inside-out; the sock is not only a surface and a pocket but also an image of the mystery of surface.[170] As the image is accordingly performed with regard for what cannot be appearance, this performance is indicative of the aforementioned theologically acoustic impetus that hears a mystery with no correlate in what can or could be seen. The "art work, the style, the genre etc." thus entails that "the religious content [Gehalt] of periods is made apprehensible [sich vernehmbar macht]," made hearable (I:3, 918). If the "content of the material" (Gehalt der Sache) is "comprehensible [erfaßbar] solely in the philosophical experience" of the "divine imprint" in the material, the content of the material in such experience is "evident solely to the blessed intuition [Anschauung] of the divine name" (*W* 1, 299–300/I:1, *128*). Such intuition of name as philosophical experience of divine movement in material requires a correlative performative completion—"completed [vollendete] insight" (300/*128*)—whereby mystery is performed as heard but otherwise imperceptible.

Most obviously perhaps in the *Trauerspiel* book, criticism is premised on name as idea independent of referents assigned to the name. There exists no pure tragedy, pure comic drama, or pure mourning play correlating with the words "tragic," "comic," or "mourning play," but the latter ideas or essential meanings have enduring value for the philosophy of art (I:3, 939, 945; *O*, 44–45/I:1, 224–25). The name-language is *fallen*—so to speak—but critical analysis does not only have recourse to specific works. Whereas "tragedy" is

"no generic-concept [Gattungsbegriff]" in the sense of a "complex of rules" to be applied to every relevant drama, it is a "structure" incommensurable with any drama and yet with no less "reality" and "density" than a specific drama (I:3, 945).[171] In tragedy, this critical structure is the protest silenced by mythic moral order. The critical structure of *mourning play* is the sustained transformation of this protest into persistent philosophical impulse. The autonomy of this impulse or idea is not discredited if it is not quite realized in any specific play.[172] Some variation of the "Romantic" motif of completion is relevant to the criticism proposed by the prologue and undertaken in the main chapters of the *Trauerspiel* book.[173] Benjamin refers to his attempt to carry out a "Romantic concept of philology" (*C*, 238/*GB*, Vol. 2, *437*). His Romantic completion is transformation of works into their philosophical basis. If Benjamin conceives of his *Trauerspiel* study as a natural-historical monograph in the tradition of treatises on a single species, genus, or larger group (of plants, animals, or minerals) (I:3, 948), the philology is moved toward chronicle that writes image into the course of the world, lets macrocosm interpolate microcosm (*C*, 176/*GB*, Vol. 1, 137).[174] Criticism performs the philosophical interpolation constitutive of the artwork itself. Even according to the Hölderlin essay, no "element" of the poetized leaves "the intensity of the world-order," the world order that "is felt" as intensity (*W* 1, 25/II:1, 112). One may say that to feel the world order in this way is to feel language as such.[175] Out of respect for the artwork but also thereby out of respect for the name-drama performed with intensity by art, critical name must be an attenuation of predication; it must itself perform the aporia—the aporia of predicative (spiritual) being and prepredicative (linguistic) being—that is name.[176]

The name as word (and not simply sign) keeps open to the extreme. As suggested already (page 46 above), the attachment of two people in love is above all an attachment of each to the other's name, for love is without denotative, constative assurance. This is especially so for hopeless love (which is hope in a hopeless situation). One loving "without hope" "knows" (kennt) the loved one, knows in a performative way that is devoid of constative, denotative reinforcement (*W* 1, 467/IV:1, 119). As love of knowing, philosophy especially cannot be a conceptual cover against extreme. This is not to say that philosophy is an empirically based celebration of the extreme; it is no identification with what the extreme might seem empirically. The practice of philosophy recognizes simply that any "linguistic form," including "the uncommon or isolated," may be considered "not only as evidence of the one who coined it but also as document of the life of language and its current possibilities" (*O*, 49/I:1, *230*). If name were not word, the uncommon or isolated—the ostensibly least significant—would and could not be linguistically significant. If the extreme did not pull name into word that is more than concept, the practice

of philosophy would be neither possible nor necessary. Critical unfolding of a linguistic form correlatively requires the "fruitful skepticism" enabling thought to pause and, in this pause, to contemplate what is least significant (44–45/225). The concept "baroque" does pertain to a century, the seventeenth century, in which principles of literary composition remained fairly constant. Such a credible outline of a synthesis of phenomena is occasionally possible for concepts. It cannot, however, be "legitimated"; name as idea or word is a legitimation crisis for the outline of synthesis. For Benjamin, the baroque is critically important precisely by accentuating this crisis in which synthesis is compelled to be open for the extreme (40–41/220–21).[177] The work of art is such crisis or name-drama. In the context of philosophical criticism, the extreme for the concept of a work or form elicits the word in name.

If philosophy "is to name the idea" (as Adam named and elevated nature) and if the correlative "task" of interpreting artworks is "to gather [versammeln] creaturely life in the idea" (*C*, 224–25/*W* 1, *389*/*GB*, Vol. 2, *393*), name requires that such chronicle—like translation—interpret without suppressing the tension of the semantic-referential element and the resistant theological element (*W* 1, 285/VI, 97). Whereas inductive reasoning tends to treat the popularly understood sense of a concept as the formal basis of this concept, an anti-inductionism in the "art-philosophical" (kunstphilosophischen) treatise treats the mourning play, for example, as an "idea" (*O*, 38–39/I:1, 218–20; see also I:3, 938–39). The concept as sign entails the word being "depotentiated." For a philosophical science, words are not simply signs (*O*, 42/I:1, 222). If the paradox of name—predicative being emerging from prepredicative being—is the presentational paradox of art and of criticism, genre analysis does not concern "form" as "abstraction on the body of literature": the "idea of a form" is, as suggested already, "no less something living [Lebendiges] than any concrete literary work" (49/*230*).[178] In the *Trauerspiel* book at least, Benjamin is quite emphatic about the unique relationship of genre analysis and art's objective structure. "[A]ny art form—and far more genuinely than any individual work—contains the index of a certain, objectively necessary structuring of art [einer bestimmten objektiv notwendigen Gestaltung der Kunst]" (*O*, 49/I:1, *230*). If the objective structure of art is silence transformed into persistent philosophical impulse, the concentration of genre criticism on the problem of belonging (and correlatively on extremes) makes it distinctly amenable to consideration and performance of predicative being with regard for preponderantly prepredicative being.[179] Although the exercise in genre analysis may thus be a unique intensification, every critical study by Benjamin indicates performance of the aporia of name.

As noted already, Adorno eventually criticizes Benjamin for disregarding the importance and potential of conceptual mediation.[180] For Adorno, each

artwork distinctly poses the "riddle" (Rätsel) of "truth content" for which solely "philosophical reflection" can provide "the solution."[181] The specifically artistic posing of the riddle is semblance. "The answer," Adorno says in an early work, "stands ... in strict antithesis to the riddle, requires construction out of the elements of the riddle, and destroys the riddle, which is not meaningful [sinnvoll], but meaningless [sinnlos], as soon as the answer is convincingly given [schlagend erteilt] to it."[182] The "medium" of essay— "concepts"—is accompanied, as Adorno later puts it, by the "claim to truth devoid of aesthetic semblance."[183] Adorno would presumably agree both as Benjamin notes that the solution exists "objectively" and as Benjamin suggests it is "subjective" to attempt "to capture this mysterious [geheimnisvolle] side in a presentation [Darstellung] which refers to the mysterious side as the riddle refers to its solution." Benjamin insists that an attempt to win "a 'mysterious' [geheimnisvolle] side" from "artifact or event" (from "profane objects in a narrower sense") is an attempt "condemned never to reach its goal." Especially noteworthy for the contrast with Adorno, however, is Benjamin's further implication that respect for insoluble objectivity requires avoidance of solutions that seem to break the "semblance of secret [Schein des Geheimnisses]" entirely (*W* 1, 267/VI, *17*).[184] In artworks, but also in criticism, according to Benjamin, a semblance of secret—a kind of aesthetic semblance—cannot be dissolved during the process of opening semblance to the destruction prevailing over it. Criticism is also semblance. The art of criticism presents itself as a struggle with and for mystery, but never entirely dissolving its own semblance-character.

The semblance of criticism is scholarship. Scholarship is the mask of criticism. This mask is distinct from the mask of an artwork, although intertwining of the masks of art and philosophy expressively enhances each. As art, criticism is indeed—like the artwork—a performance of mystery. The early Romantics suspend "the difference between criticism and poetry" by calling for "poetic criticism" (*W* 1, 153/I:1, 69). Criticism is "in principle" indistinguishable from an artwork in the following way: although the "genesis [Entstehung]" of criticism entails that it "is occasioned" by something (by the artwork), criticism is artistic in openly being "independent" of whatever occasions it (177/*108*). Insofar as Benjamin follows this Romantic outlook, it may well seem that a "fascinating, (perhaps) indestructible life force" makes the *Trauerspiel* book, for example, no normal "sample of 'secondary literature.'"[185] The tension of criticism with its mask of scholarship is distinct, however, from entirely dispensing with this mask. Whereas the young Lukács regards an aesthetic autonomy of the essay as an indication of criticism being not only "an art" but also "not a science [Wissenschaft],"[186] Benjamin's proposed distance from "the scholarly [Wissenschaftlichen]" is based on his

proposed alternative of a philosophical "scholarship [Wissenschaft]" (*W* 1, 294–95/II:1, *244–45*). Although he could conceivably share de Man's view of literature and criticism as "condemned" or "privileged" to being "the most rigorous and, consequently, the most unreliable language" drawn upon as humans "name and transform" themselves, Benjamin might hesitate at de Man's attendant formulation that "the difference between" literature and criticism is "delusive."[187] Semblance is delusion and yet not entirely surmountable. Although (or precisely because) it could be conceived as *allegory*, Benjamin's criticism still presents itself as limited by its scholarship (albeit in the elastic, ultimately indeterminable, character of this limitedness).[188] It is integral to their shared longing for justice to mysterious nature that criticism and the artwork present themselves as independent of, yet also inextricable from, semblance. Neither artwork nor criticism denies mediation by mask or rests in any form of mask. That is their beauty; they present themselves hearing what they cannot realize "historically." The artwork presents itself as artwork but keeps itself open for criticism. Criticism presents itself as scholarship but keeps its terminology open for modification. Each thereby sustains an image of dramatic beauty.

Community of the Dead

Respect what you do not understand.

—Hölderlin, *The Death of Empedocles* (first version)

What I do not understand, I respect.

—Cixous, "From the Scene"

[T]he community of all the dead is so immense that even the person who only reports death feels [verspürt] this community.

—Benjamin, *Selected Writings*

FROM ANOTHER PLANET

The closing words of the prose-poem known as "In lovely blueness . . ." are: "Life is death, and death is also a life" (Leben ist Tod, und Tod ist auch ein Leben).[1] Graffiti on the wall of a walkway under the railway bridge in the Niddapark, Frankfurt am Main, proclaimed to passers-by in the early to mid-nineties (perhaps earlier and later too): "Germany must die, so that we can live" (Deutschland muß sterben, damit wir lebe' können).[2] Whether this was written by an "Ausländer" (foreigner, an out-land-er) or by a "German" (the dropping of the "n" of "leben" would anyhow suggest reproduction of a Rhein-Main dialect), a life of the "we" is bound with the death of "Germany." "Germany" is a threat or at least an encumbrance to the unfolding of "our" life. This could well have been the "Germany" associated with the attacks on "foreigners" in places such as Solingen or Hoyerswerda, which were fatal or almost fatal attacks. It could also have been some other, perhaps related, Germany. As most

Germans may gradually come to accept, only a Germany prepared to die (for instance, by discontinuing the laws confining so many inhabitants to the politically disempowered status of "guest workers") will offset myths of Germany. "Germany" is myth; a Germany regularly prepared to die might counteract myths of "Germany." Kurt Tucholsky hates "Germany" and loves Germany.[3]

The myth "Germany" dies in the word *Germany*. The word cannot be subsumed by myth. The relatively recent German unification was welcomed by much of the world. Yet its style and rapidity initially provoked some dissent—especially among Jews outside Germany and non-Germanic Europeans (but also among some Germans). Even the prominent news magazine *Der Spiegel*, which welcomed a united Germany with editorial denunciations of prominent naysayers, begrudgingly carried a postunification lead article giving voice to international concerns about this "Hegelian" society with an intolerance of what it considers "foreign" (fremd).[4] Such intolerance is, of course, pervasive. Irrespective of whether the (sometimes murderous) outbursts and political hostility toward "foreigners" in the unified Germany eventually diminish, moreover, there will be no state—including in a European Union—that is not somehow spellbound in myth. Against the myth that is law, however, word remains open to the strange, the foreign, in specific ways. In the philosophical conception of community, specific strangeness or foreignness is above all an awakening to—a reminder of—the limitless, inextinguishable, and ultimately silent music of the word.

> ... he raised his eyes towards the slow-drifting clouds, dappled and seaborne. They were voyaging across the deserts of the sky, a host of nomads on the march, voyaging high over Ireland, westward bound. The Europe they had come from lay out there beyond the Irish Sea, Europe of strange tongues and valleyed and woodbegirt and citadelled and of entrenched and marshalled races. He heard a confused music within him as of memories and names which he was almost conscious of but could not capture even for an instant. (*P*, 167–68)

Benjamin's eventual turn to Paris could be conceived as a way of ironizing "Germany." *One-Way Street* is regarded by Benjamin as the first product of what would be a very intensively developed interest in Paris (*C*, 325/*GB*, Vol. 3, 331). It more or less marks the beginning of a new phase (following the period in Germanic studies that is, in some sense, concluded with the *Trauerspiel* book) (322/455). In terms of his interests, Benjamin feels thoroughly "isolated" among the Germans of his generation; the Surrealist movement, especially Louis Aragon, and various other French figures, such as Jean Giraudoux, instead represent concerns of importance to him (315/446). This feeling with regard to Germany seems to extend beyond narrowly intellectual or artistic matters. In *One-Way Street*, he suggests the "isolation of Germany in the eyes

of other Europeans" is completed by "the violence, incomprehensible to outsiders and wholly unconscious [unbewußte] to those imprisoned by it, with which circumstances, squalor, and stupidity here subjugate people entirely to collective forces [Gemeinschaftskräften]. . . . The most European of all accomplishments, the more or less discernable irony with which the life of the individual claims the right to run its course disparately of the community into which it is cast, has completely deserted the Germans" (*W* 1, 452–53/IV:1, 97–98). An indication of such annulment of irony by false community—by collective forces—would be a liar who believes the lies that he or she can tell. This inability to keep societal expression even privately open to irony is noted in Adorno's aphorism stating that "[a] German is someone who cannot tell a lie without believing it."[5] If the life of the individual includes a significant capacity for irony, there is tacit recognition of something—perhaps even a kind of community—beyond collective community. To a great extent, Benjamin's works comprise a performance of community ironizing, allegorizing, the collective.

To be irony-resistant is to live hypostatization of collective formation, a hypostatization that can be perilous for those not fitting into such formation.

> —What is your nation if I may ask, says the citizen.
> —Ireland, says Bloom. I was born here. Ireland.
> The citizen said nothing only cleared the spit out of his gullet. . . . (*U*, 330)
>
> —And after all, says John Wyse, why can't a jew love his country like the next fellow?
> —Why not? says J.J., when he's quite sure which country it is.
> —Is he a jew or a gentile or a holy Roman or a swaddler or what the hell is he?, says Ned. Or who is he? . . .
> —We don't want him, says Crofter the Orangeman or presbyterian. . . .
> —Saint Patrick would want to land again at Ballykinlar and convert us, says the citizen, after allowing things like that to contaminate our shores. (*U*, 335–36)

Only the irony, or allegory, of community draws the collective (the semblance of community) out of itself and into the power of word. The collective is thereby drawn into community as writing-image, and writing-image deforms semblance.

People automatically afraid of what is strange are afraid of image as writing-image; as Cixous remarks, people disliking "what I call 'the text'" are "phobic," generally intolerant.[6] With expressions such as "from another planet," antipathy to the strange—"Fremdenfeindlichkeit"—can seem to bolster against death, against the catastrophe of textual irony, against allegorization. In a public discussion in a German city some time ago, a "Dozent" of "Germanistik"

dismissed attempts to consider Benjamin's works in relation to theoretical tendencies that he summarily addressed as a fixation on "text." ("I told her of Paris. . . . / —What have you there? Stephen said. /. . . / He took the coverless book from her hand. Chardenal's French primer. / —What did you buy it for? he asked. To learn French? / She nodded, reddening and closing tight her lips." *U*, 242) The exercise of considering Benjamin's works with regard for an extended notion of text, it was claimed, is so alien as to give the Dozent the feeling of encountering something "from another planet." The aggression and the agitation of this man suggested that such an encounter was unwelcome, perhaps repulsive. Insofar as he spoke in a setting that affirmed his repulsion, the collective atmosphere had perhaps indeed become phobic, untextual, allowing for little death in its images.

Writing-image breaks through sometimes when something such as scholarship is so unironic that it becomes unwittingly ironic. An article in a past issue of *New German Critique* contains passages attributing some of Benjamin's views concerning language and death to various psychological quirks. Benjamin's resistance to prevailing criteria of identity and his correlative linguistic views are characterized as symptomatic of a castration complex, of a "failed paternal identification," of "skewed Oedipal resolution," and of "compensatory narcissism."[7] If Benjamin's identification with the ironizing force of death has provoked intolerance, this is not surprising in view of a general tendency for death to be something that science bullies—or buries—with concepts used in disregard of their own death. That this can make mournful and can even seem sadly funny attests to a resonance of the ironizing force of death, a resonance of the writing in image.

—There's one thing it hasn't a deterrent effect on, says Alf.
—What's that? says Joe.
—The poor bugger's tool that's being hanged, says Alf.
—That so? says Joe.
—God's truth, says Alf. I heard that from the head warder that was in Kilmainham when they hanged Joe Brady, the invincible. He told me when they cut him down after the drop it was standing up in their faces like a poker.
—Ruling passion strong in death, says Joe, as someone said.
—That can be explained by science, says Bloom. . . .

And then he starts with his jawbreakers about phenomenon and science and this phenomenon and the other phenomenon.

The distinguished scientist Herr Professor Luitpold Blumenduft tendered medical science evidence to the effect that the instantaneous fracture of the cervical vertebrae and consequent scission of the spinal cord would, according to the best approved traditions of medical science, be calculated to inevitably produce in the human subject a violent ganglionic stimulus of the nerve centres, causing the pores of the *corpora cavernosa* to rapidly dilate in such a way as to

instantaneously facilitate the flow of blood to that part of the human anatomy known as the penis or male organ resulting in the phenomenon which has been denominated by the faculty a morbid upwards and outwards philoprogenitive erection *in articulo mortis per diminutionem capitis*. (*U*, 303)

Notwithstanding attempts to terminate its irony, death remains familiar solely as the inalienably alien. Death ironizes—allegorizes—living. In Bernhard's short novel *The Cheap-Eaters* (*Die Billigesser*), Koller's life ends without him ending the project that had somehow defined his existence in the course of the novel: writing a physiognomy of the circle of eating companions.[8] Even if Koller had finished the project and had not died in the novel, death would have written Koller's life into substantive incompleteness. Death is God's refusal of the living but also God's refusal in the living. Hölderlin refers to an "attentive man" recognizing death as God's "light," as the world's "conceptless, nameless" wrath.[9] Death keeps living from being a complete substance; this applies to living scholarship as well as to any other kind of living. In denial of this ironizing force of death, scholarship could be at least potentially no less dubious than the more infamous deniers of death who thought they were masters of death. Heiner Müller suggests that Hitler's fanaticism was its orientation toward "total presence"; Hitler could not accept that death "is the sole victor."[10] Celan's "Todesfuge" registers horror before the lack of self-irony in the German who dreams that "death is a master from Germany."[11] In its inextinguishable mystery, even or particularly against those who want to be its masters, death perpetually ironizes; it is the perpetually ironizing force.

In its inaccessibility to the living, death is the force always available to ironize whatever might be called "life." In its ultimate intractability, death is the underlying force of transformation, and fundamental angst concerning transformation is angst concerning death.[12] Death is the transformative force leading from one planet to another, from one language to another, from one entity to another. Death is the force in someone quite strange to us who may bring us something that is ostensibly even more ours than hers or his.

 —Do you understand what he says? Stephen asked her.
 —Is it French you are talking, sir? the old woman said to Haines.
 Haines spoke to her again a longer speech, confidently.
 —Irish, Buck Mulligan said. Is there Gaelic on you?
 —I thought it was Irish, she said, by the sound of it. Are you from west, sir?
 —I am an Englishman, Haines answered. (*U*, 20–21)

Yet the authentic is not this or that particular to be claimed anew as our own but rather the process stretching our sense of what is or could be our own. In contrast with Hegel's "attitude," "[t]he authentic [Echte]" may be rediscovered

"in the most singular and eccentric of phenomena, in both the weakest and clumsiest experiments as well as in the overripe appearances." This precept is formulated by Benjamin, of course, with regard to artistic experiments and to overripe artistic appearances (of "the end of a period") (*O*, 46/I:1, *226–27*). Precisely as ostensibly less generic or as beyond the obviously generic, however, anything most singular and eccentric can facilitate rediscovery of philosophical origin. Insofar as this philosophical process occurs, collective form is ironized by the encounter with—not by the specific content or appearance of—what it deems eccentric or singular. The philosophical process is this stretching of collective form into the rhythm of the community of the dead to which all and everything always already belong.

HONEST RHYTHM

The rhythm of the community of the dead is the rhythm of writing. In the rhythm of writing, community is devoid of solution in appearances. The young Benjamin thinks many around Wyneken are so oriented toward consolidation that they will regard Wyneken as well as the discussion hall as "a 'movement.'" These people want to commit themselves and "can no longer see the spirit where it appears freer, more abstract." In this context, freedom and abstractness comprise a condition of not being committed to a specific notion; the notion of youth culture should, according to Benjamin, solely be an "illumination" that draws "the most remote spirit into the gleam of light [Lichtschein]." This dynamic of light with the most remote attests to the free, abstract, pure spirit for which youth is the "constantly reverberating feeling" (*C*, 54–55/*GB*, Vol. 1, *175*).[13] The constantly reverberating feeling cannot be incorporated in collective movement. As noted already, Wyneken's prewar followers were decidedly more suspicious of Germanic nationalism and traditional education than were most German young people; they comprised a very atypical part of German youth.[14] With Wyneken's later endorsement of the war effort, Benjamin may well have wondered if his foreboding about collective commitment had previously been too reserved in its expression. By 1914–1915, he expressly refers to the "people [Volk]" as "sign and writing [Schrift] of the infinite extension" (*W* 1, 28/II:1, 116). In this context, the sign is writing. As writing of the infinite extension of "destiny," the people are no mythological or mythic unity; instead, death's temporality—like a byzantine mosaic perhaps—gives a great, holy shape in a flattening that seems to remove shape from the human (114–16, 122–24/26–28, 32–34). In contrast with any shape for which one might be expected to die heroically or as sacrifice, destiny in death's time appears solely as the rhythm of writing; in this rhythm, there remains feeling that is blind to—and produces exception to—solution in appearances.

Tap. Tap. Tap. Tap. Tap. Tap. Tap. Tap. . . .
Tap. A youth entered. . . .
Bloom viewed a gallant pictured hero. . . .
—True men like you men.
—Ay, ay, Ben.
—Will lift your glass with us.
—They lifted.
Tschink. Tschunk.
Tip. An unseeing stripling stood in the door. . . . Hee hee hee hee. He did not see.
Seabloom, greaseabloom viewed last words. . . . *When my country takes her place among*. . . .
Nations of the earth. No-one behind. . . . *Let my epitaph be*. Karaaaaaaa. *Written I have*. (*U*, 288–90)

The only epitaph relevant to nonmythological, nonmythic destiny is one that is writing, one that has writing as its prototype. In its distinct or unique potential of destroying semblance, writing is already a kind of epitaph that deprives living appearances of final solution. It presents itself in a rhythm that cannot be incorporated in living appearances or meanings. The rhythm of death is effective in contents or meanings as the destiny that displaces, for example, unification of nation or group. The rhythm of death ironizes the attempt to transform death into life completely. How not to repress this ironizing force of death is increasingly a theme in discussions of war monuments and of other memorials such as those to people driven into emigration, rounded up, or exterminated during the Nazi period. Death resists ideology.[15] The World War I monuments at Verdun are discussed by Kluge and Müller as "Legitimationskitsch" erected out of the bad conscience and helplessness felt with regard to the masses of the dead.[16] Even the dying of soldiers who die doing something like liberating concentration or extermination camps cannot entirely remove the independence of death from any significance that the living might bestow upon it. Concerning those who died as prisoners in such camps, the dilemma of epitaph is incomparably acute. After such a death, nothing can be said that seems fitting as epitaph. This dilemma was among the many factors contributing to recent controversies concerning the "holocaust" memorial in Berlin or the memorial in Vienna to Jews who fled, were put in camps, or were murdered during the 1930s and 1940s. Contrary to a common view, art is not irrelevant to—or a hindrance for—consideration of this dilemma. It is rather practically constituted by it. Unlike the mythic, the artistic is a feeling so in death that it has no basis in significance which could be established in life.[17] As writing-image, art eludes the consoling and yet warm or muggy darkness of myth; it eludes this bond that holds human collectives together on a day-to-day basis. It eludes too, perhaps correlatively,

the answers of science; it unfolds equations into the cold, companionless darkness for which they will never have an answer.

> He recalled . . . the words of Shelley's fragment upon the moon wandering companionless, pale for weariness. The stars began to crumble and a cloud of fine stardust fell through space.
>
> The dull light fell more faintly upon the page whereon another equation began to unfold itself slowly and to spread abroad its widening tail. It was his own soul going forth to experience, unfolding itself sin by sin, spreading abroad the bale-fire of its burning stars and folding back upon itself, fading slowly, quenching its own lights and fires. They were quenched: and the cold darkness filled chaos. (*P*, 103)

Such companionless feeling of death is a feeling for chaos of the cold, dark, indifferent Messianic nature common to all. It is a feeling for exception to solution in social form. The young Benjamin suggests that religion grows—and a new religion will grow—from the uncontainable wealth of personality. This is no personalization of religion or religion of person. Seriousness about socialist maxims would require, however, acknowledgment that the individual's "inner life" is "forced and darkened," forced and darkened in a way that is mythic and not Messianic. To acknowledge this "distress," to recognize "the pressure and the untruth" compelling "us" with "the dualism of social morality and personality," would be a step toward regaining the "wealth," the "natural being," of the "personality." We expect this to be the concern of artists. It could, however, become the concern of "a new species" (II:1, 26). This new species would be based on the religious—the Messianic—feeling already in us as the determinant force of nature. The credibility of state, law, scholarship, and even much (that is considered) art is diminished by their disregard or renunciation of this religiosity (44). Benjamin opposes conventional socialism with a socialism honest about the relationship of personality and social morality. The religious feeling will be unleashed all the more necessarily as personality becomes more and more hopelessly entangled in "the social mechanism" (26–27; see also 18–19). Experiencing entanglement in the social mechanism as hopeless will spawn its opposite: the drama of mystery. A social mechanism increasingly entangling in ways devoid of credible regard for the religious feeling will spawn the unfolding, if not the explosion, of this feeling for the unincorporable Messianic nature common to all as the feeling of exception.[18]

This feeling, the religious need, will always be dangerous in politics. In politics, there could be at least embarrassment among those indulging this feeling. ("It pained him that he did not know well what politics meant and that he did not know where the universe ended." *P*, 17) Should they worry much

about this? Does whatever is called politics warrant such worrying? In a note of 1919 or 1920, Benjamin defines politics as "the fulfillment of unheightened humanness [der ungesteigerten Menschhaftigkeit]" (*W* 1, 226/VI, 99). In the somewhat earlier period of his first serious consideration of "the problem of politics for the intellectual," Benjamin comes to the tentative summation that politics is a consequence of "spiritual conviction [Gesinnung]" that is no longer carried out spiritually. The idea "never appears" in politics, "always the party." The idea would or could appear only in appearance showing that it is not the idea; this kind of humility is to be found less in politics than in many other realms of life. Confronting politics as "the choice of the least evil," the young Benjamin does "not yet know with certainty" whether he shall find his place in left-liberalism or in a social-democratic wing (letter to Strauß, January 7, 1913, *GB*, Vol. 1, 81–83). As the tension of freedom and social morality, the religious feeling is the philosophical impulse behind many of Benjamin's reflections on politics. Especially following encounters, in 1919 and later, with Bloch (who had been active in the foiled attempt to establish the Bavarian Council Republic in 1919), Benjamin attempts to develop an approach considering politics philosophically and perhaps even the possibility for a philosophical politics.[19] Adapting writings by Gustav Landauer, Erich Unger, and others, Benjamin's "moral philosophy" (Moralphilosophie) is to include the task of unfolding a theory that may be called "anarchism" (*W* 1, 233/VI, 106).

As both historical and philosophical, freedom is place and yet puts place in suspension. Freedom is a "historico-philosophical place" determining the "significance of anarchy for the profane realm." Freedom follows a religious, not a profane, law. The profane realm is religiously lawless "bodiliness [Leiblichkeit]" (226/99). The religious law elevates body into the mystery that profane law cannot contain. There is thus an admittedly futile politics of "ethical anarchism," which is evidenced in the anarchism characteristic of disempowered children, youth, or adults and in the "'gesture' of nonviolence" that may result in martyrdom (233/107). If there is martyrdom, however, it is for nothing and against everything. Ethical anarchism must show independence from the criteria of survival prevailing in politics; it is distinct from the anarchist politics that might let itself be defined by loyalty to ideologues' priorities of survival. Given the dominance of the latter kind of priorities in politics, there is no political martyrdom, only a "religious" one ("Notizen zu einer Arbeit über die Lüge II" [1922–1923], VI, 63–64). Lacking a command from God to resist violently, congregations of Galician Jews let themselves be beaten down in their synagogues; according to Benjamin, their suffering may have elevated morality to "its greatest heights" and their nondefense may be a kind of sacred moral action in the sense that

they presented the unjustifiability of the action against them (*W* 1, 233/VI, 107). This is not quite the forsaking of "formation" (Bildung) by an ostensibly "noble being" saving nothing besides a "sacrifice" to earthly law and remaining thoroughly subordinate to this law (302, 343/I:1, *131*, 185). As Benjamin emphasizes freedom over hesitancy, clarity over silence, and decision over acquiescent forbearance, the point seems to be that "the area [Gebiet] of freedom" must somehow rise above accommodation of a specific shape (302/*131*). It must rise to presentation of the inherent contradiction of "ethicalness" (Sittlichkeit)" with law and state (233/VI, *106*). Divine violence "breathes destruction" in "the earthly world" (226/99).

Reservations about Benjamin's theory of divine violence especially focus on his remarks suggesting that there is "no contradiction in principle . . . between violence and ethicalness" (232–33/*106*). For the relevant "theory" of anarchism, however, "the ethical law [das sittliche Recht]" not incompatible with "violence as such" is incompatible with "every human institution, community, or individuality that awards itself a monopoly of violence or gives itself the right to violence" (233/*106–7*). The historico-philosophical place of freedom is no assertion of place; as implied already, it is no assertion of specific shape.

It may be unsettling to read Benjamin's lines suggesting that divine violence may appear in "true war" or in the multitude's "divine punishment" (Gottesgericht) of a criminal. Yet many of us could perhaps imagine scenarios almost worthy of such formulations: war against Nazi Germany or the punishment of certain war criminals and committers of *crimes against humanity*. True war or divine punishment would be recognizable solely in its opposition to rule that appropriates or has appropriated a monopoly of violence, perhaps above all a correlatively egregious monopoly of violence; true war or divine punishment would be defined by the mythic rule that it opposes. However much Benjamin may indeed momentarily underestimate the complications of war and punishment, he continues to stress that there can be no certain recognition of divine violence even while he suggests the truth of a war or the divinity of a punishment can consist in the opposition to a specific mythic violence (see *W* 1, 251–52/II:1, *202–3*).[20]

Benjamin's frequently stressed cautionary proviso is, moreover, that freedom must maintain the legitimation-crisis intrinsic to any specific shape. That is the only sustained violence compatible with freedom. Freedom is in every particular case as the latter's necessity of returning to the mysterious condition of its possibility. A legal institution can be an occasion for the ethical impulse of freedom that is otherwise independent of law. Benjamin does not, therefore, follow Kant's infamous reduction of marriage to a property claim of two people of different sexes to one another's sexuality. (In *The Meta-*

physics of Morals, Kant refers to marriage as the "union of two people of different sexes with a view to the lifelong mutual possession of each other's sexual attributes.")[21] Kant's inability to imagine "same-sex" marriage is obvious. It is also obvious that his own ethical writings could be used to qualify his legalistic conception of marriage. This legalistic conception is indicative, however, of Kant's participation in the German (if not European) Enlightenment; it succumbs to a tendency to base experience on paltry material contents, "the barren woods of the real [Wirklichen]" (*W* 1, 298/I:1, *126*). In this vein, Kant erroneously equates the "ethical potentiality" (sittliche Möglichkeit) of marriage with its "legal reality" (299/*127*). He does not simply reduce marriage to legality but simultaneously contrives an elevation of legal role to ethical standing; the legal value of facilitating production and raising of children is considered evidence of the ethical "necessity" of marriage (298–300/ 126–28). Every particular case has, however, an ethical potential that is not law; law is no basis for this potential. If this potential is considered a law, it is no secular law but rather a religious one. It is the violence to be honored as a divine power's "gift [Gabe]"; the gift is the absolute power, the "*perfection of power [Machtvollkommenheit]*," in the particular case (233/VI, *107*). This gift of perfection is a power perfect and absolute not in any particular shape but rather as the mystery within every particular shape. This mystery is the sole ethical potential and necessity.

As this potential and necessity, mystery is not the basis for a Romanticism that seems to have no history. Benjamin's is no Romanticism attempting to see "the extraordinary" in "everything infinitely particular," everything isolated from setting. The extraordinary appears, rather, in "the becoming of the human," "the history of humanity" (II:1, 44). There are contexts such as "the history of labour." Benjamin's new Romanticism can, therefore, involve experiencing and acting "extremely unromantically and soberly [nüchtern]" (46). Integral to the soberness of art, for example, is that neither the artist's nor the audience's history is romanticized in ostensible isolation from human history; art is no insulation or inoculation of its practitioners or its beholders against human history (47).

> for he felt that the spirit of beauty had folded him round like a mantle and that in revery at least he had been acquainted with nobility. But when this brief pride of silence upheld him no longer he was glad to find himself still in the midst of common lives, passing on his way amid the squalor and noise and sloth of the city fearlessly and with a light heart. (*P*, 176)

Opposed to the schools' tendency to foster a Romanticism serving as an "anaesthetic" immersing pupils in "a harmless and general past," Benjamin (in his youthful words) chastises an attempt "to emasculate [entmannen] a torrent of feelings" (II:1, 47) and objects to the resultant "unpolitical youth"

dilettantishly limited to relatively banal art, literature, and love experiences (44). The schools' "false Romanticism" is so grotesquely isolated from "becoming" and is so void, so emptily abstract, that many youth become blasé and "belief itself" becomes void. The remaining ideallessness is a "last remnant" of youth's honesty (44, 47). There is a biting and jubilant honesty of admitting that there can be no personality or honor (28).[22] Such honesty is not the honesty of those objectively lying by claiming to live — and expecting others to live — an honest life. It is rather the honesty that does not forget or forgive wounds that one is not allowed to express. It is, moreover, the honesty that does not hold anything human for divine, anything expressed as realization of the essentially silent (VI, 60–62). Sober Romanticism concerns a "*will*" — to beauty, to truth, to deed — that is not overcome; this will is "the invincible [Unüberwindliche]" and does not let itself get cajoled into complacency (II:1, 46). This will cannot be cajoled into behaving as though it is already fulfilled.

The invincible will is Messianic in history. It is the convergence of freedom and necessity in history. Kant's "Ich" and its spontaneity are not the freedom of the individual or the will to freedom. Kant's ethics tends to regard independence from "bodies" (Leiber) solely as a possibility of turning away from history rather than as also a possibility of turning toward it. Whereas Kant considers the concept of "inclination" (Neigung) to be "ethically indifferent or anti-ethical," this concept can — "through a change in meaning" — "be turned into one of the supreme concepts of morality [Moral]" ("Zur Kantischen Ethik" [early summer 1918], VI, 55). (To define inclination in terms of sex would be to succumb to the division of spirit and nature that inclination enables us to overcome.)[23] Inclination has a power that overcomes Kant's bifurcation of ethics and sensibility. Péguy (in a somewhat insensitive choice of metaphor) says Kantian ethics has clean hands but, in a manner of speaking, actually no hands.[24] Benjamin thinks inclination could perhaps even take the ethical place occupied by "love" (VI, 55). The "dark end" — in which the "demon" of Eros cannot dispense with inclination — is not "a naked failure." It is, rather, "the true redemption [wahrhafte Einlösung] of the most profound imperfection" in "the nature of the human." This imperfection prevents "the completion [Vollendung] of love"; it prevents the completion that is redemption "through God's workings [Gottes Walten]." In God, love is elevated above love's nature, above the human's nature. In the nature of the human, inclination is simultaneously the failure of love and the redemption of love's imperfection (*W* 1, 344–45/I:1, *187*). Inclination does not complete love, but it also prevents the attempted subordination of the body to any acclaimed completion. Insofar as his doctrine of "'reasonable beings' as subject<s> of ethics" conceives of ethical subjects independent of "human bodies [Leiber],"

Kant's ethics opens the possibility of breaking with any closed unity; this is a possibility of regaining "the inconclusiveness [Unabschliessbarkeit] of the indivisible unity," the inconclusiveness of the individual, the inconclusiveness of the ethical subject. Indivisible unity is disregarded by Kant, however, insofar as he does not recognize that the subjects (as he ultimately conceives of them) amount only to "the comparative, concurrent unity"—the unity concurrent, and to be compared, with the inconclusive, indivisible unity that they essentially are but, as living beings, also are not. The "constituents" of the former unity are only "humans" and whatever "*brothers*" (*Brüder*) they might have ("for example, on other stars") (VI, 55). The other unity—the inconclusive, indivisible unity—is so unlimited that one should perhaps not even consider it as object of a will (*W* 1, 114/VI, 55). The conclusively invincible is ethical as the indivisible, inconclusive necessity that sobers individuals in history and thereby recovers freedom in history.

With a correlative philosophical conception of "truth content," Benjamin attempts to complete "Kant's thesis" concerning marriage (300/I:1, 128)—Kant's "strict reference" to the "natural," the sexually possessive, moment of marriage (326/*163*)—by moving this thesis into a demonstration of its wrongness (299–300/127–28).[25] Kant's thesis is wrong insofar as it does not seek its conclusive completion in the inconclusive natural rhythm. From various writings by Benjamin, it may be inferred that the latter rhythm is the one into which we die; until death, the body is a pressure gauge for this force that eventually kills it.[26] The ethics of Messianic nature is that it keeps the body open to—free for—this pressure of necessity. Marriage is neither antithetical nor endemic to this rhythm of nature. Noting the approximate contemporaneity of Kant, Mozart, and Goethe, Benjamin considers Kant's view to be a profound extreme that has its profound antithesis in the cheerful elevation of marriage in Mozart's *Magic Flute* (first performed in 1791). In this respect, like Kant's thesis, Mozart's opera circumvents resonance of truth-content; it does so by advancing not only the theme of marital love but thereby also a "content [Inhalt]" that is less the "longing" of lovers than the "steadfastness" of spouses (*W* 1, 300/I:1, *128–29*). Benjamin's response to implications of this view is perhaps most emphatically conveyed in his dismissal of the brutal "mysticism" enabling Gundolf to discuss *Elective Affinities* with regard for an alleged magic of two people entering the "sacrament" of marriage and producing a so-called "legitimate child" (326/163).[27] In its capacity as artwork, Goethe's book (1809) cannot be an attempt to justify marriage as legal institution (let alone an endorsement of Mittler's fanatical elevation of this legal institution to ethical law). Not ultimately about marriage, Goethe's work simply shows mythic powers of law emerging from marriage "in decline"; such marriage carries out a "downfall" not even necessarily following from marriage (*W* 1, 300–301/I:1,

130).²⁸ In a foundering marriage, the legal bond—the mythic bond—becomes primary (*W* 1, 302, 346/I:1, 131, 189). Ethical powers are, however, neither antithetical nor intrinsic to marriage. In its ethical powers, art simply cannot be defined by an institution (and, least of all, a legal one) regardless of how great a role may be played by the encounter with institutions.²⁹ Art subjects marriage, along with other institutions, to what could be called Messianic rhythm. The Messianic is the middle time, the qualitative infinity, facilitating a rhythm that can conceivably elasticize each moment of history (*W* 1, 168, 196 n. 245, 185–86 n. 3/I:1, 92, 12 n. 3).³⁰

As implied above, Benjamin eventually discusses this elasticization as entirely distinct from will. In presuming unlimited form, will is evil, totalizing, and collapses into conditioned, limited, terrestrial will. "Silent prayer" (Andacht) may be unlimited (*W* 1, 114/VI, 55). It can be free of control and imposition. Even Benjamin's earlier invoked will relevant to the "pure and . . . solely valid ethical law" is supposed to be a "pure will" and so inherently elasticizing that it is unapproachable by the educator. It is not something to be motivated or legalized. The greatest "danger" of moral teaching lies precisely in "the motivation and legalization of the pure will," for such an attempt is "suppression of freedom" (II:1, 49–51). Freedom is uncircumscribable. The goodness of freedom is its danger to education and law. The good is freedom, says Dostoevsky's Grand Inquisitor as he initially chooses to have the returned Christ burned before the latter can stir up feelings of freedom.³¹ In his early Catholic-ecclesiastic imperialism, Carl Schmitt denounces this returned Christ—this rejecter of "every earthly power [Macht]"—as "the worst inhumanity."³² Mythic violence, Benjamin could almost be said to counter in anticipation (1921), is not only bloody and threatening but also lawmaking, boundary-setting, and full of guilt and retribution, whereas divine violence is not only "lethal without spilling blood" but also law-destroying, boundlessly destructive, expiatory (*W* 1, 249–50/II:1, 199). Divine violence is lethal without spilling blood, for it is simply the violence of Messianic nature; it is lethal simply as the force that kills, the force of transience. If blood-spilling occurs, this is unnecessary from the perspective of divine violence; blood-spilling is not an integral potential of it. Divine violence expiates or compensates, moreover, as the elasticizing feeling of freedom. Unlike "the brutal [gewalttätigen] rhythm of impatience" constituting the existence and the "tempo [Zeitmaß]" of law, Messianic happenings proceed in the "good (?) rhythm of expectation" (231/VI, *104*). The good (if one wishes to call it that) of this rhythm is the expectation of freedom. This rhythm does not entail expectation of rule—either to rule or to be ruled; it expects transience. Transience "shakes" or "quakes" (bebt) in "all of those with soul [den Beseelten allen]" (VII:1, 37). Ethics presupposes

only transience, only the rhythm of Messianic nature; in its identification with transience, ethics is freedom from rule.

Although the "quest of free humanity for happiness" is a profane goal and thus opposed by Messianic nature, the quest of free humanity for happiness seeks downfall of the earthly and may thus—insofar as it has good fortune—be released into the happiness of destructive restitution in eternal transience. The rhythm of eternal transience is the rhythm of Messianic nature; nature is Messianic in its "eternal and total passing away [Vergängnis]." The method of the world-political task of destroying "legal violence"—of destroying mythic violence—releases suffering and sacrifice for the force legitimizing no rule and thereby counters—if not delegitimates—rule demanding suffering and sacrifice on its behalf (*W* 3, 305–6, *W* 1, 249–50/II:1, 203–4, 199–200). In their inherent opposition to rule appropriating a monopoly of violence, ethics and freedom cannot be based on the particular living in consensus with rule. In their very reciprocity, ethics and freedom emerge solely in the rhythm of the extraordinary—the exception—unsettling, elasticizing, rule. The honesty of ethics and freedom is that they do not deny the rhythm producing exception to rule; they do not deny that this is the determinant rhythm common to all.

PHILOSOPHICAL RACE OF RIDICULED EXCEPTION

The "necessary tendency towards the extreme"—the tendency of necessity toward the extreme—is the "norm" of "concept-formation" in philosophical examination, according to the "Epistemo-Critical Prologue" (*O*, 57/I:1, 238). In philosophical presentation, the "unique and extreme" (Einmalig-Extreme) is idea (35/215). A number of Benjamin's texts at least imply that exception facilitates philosophy as a practice, for idea is elasticization of rule. Exception is philosophically significant not as event but as suspension of rule. The philosophical significance of exception may include the latter's propensity to bring about a suspension of itself as mere event. In any case, for the "Prologue," philosophical history as the "science of origin" lends "configuration" to idea only by juxtaposing extremes—"remote extremes," "apparent [scheinbaren] excesses"—of development, and this exercise concerns history not as endless series of events but "inwardly" ([i]nnen), with regard for "essential being" (wesenhafte Sein) (47/227). Philosophical rendering of extremes demonstrates that the alternative to "hypostatization of general concepts" (40/221) is not solely "uncritical induction" (38/220); the latter unnecessarily shies from matter, from what is *in re*.[33] For much of Benjamin's work, it may be said, matter itself produces exception and thus makes way for a generality

that is not conceptual generality. On the basis of the former generality, the "Prologue" rejects an inductive nominalism simply clinging to variety and disregarding "intellectual rigour" (*O*, 39–41/I:1, 220–21). Presentation of ideas involves an intellectual rigor concerned with a generality shunned both by nominalist induction and by deduction of a conceptual continuum presumed "logical" and yet simply concealing multiplicity, incommensurability, and discontinuity (43–46/223–27). The basic complementarity of exception and philosophical generality is that exception—multiplicity, incommensurability, discontinuity—is uniquely prone to take concept beyond itself (and idea is the necessity and the freedom taking concept beyond itself).

The "Prologue" formulates this relationship of philosophy and exception as motherly, and indeed in a certain traditional or proverbial sense. Suggesting a mother seems to begin living "in the fullness of her power only when the circle of her children, out of the feeling of her proximity, closes around her," Benjamin extends this image to indicate how "ideas come to life only when extremes are assembled around them." Extremes are the idea, much as children are the mother. Extremes and children push beyond the "average" (Durchschnittliches) to the determinant "general" (Allgemeine), to the idea (35/215). Open to the extreme, to the child, the idea and the mother know in the preponderant unknown. ("STEPHEN: [*Eagerly*] Tell me the word, mother, if you know now. The word known to all men." *U*, 516) The idea and the mother know in the determinant and universal but never entirely revealed generality of revelation, the generality presupposed if the extreme or the child is not to be ignored by philosophy and mother, respectively. Blanchot refers to the Law that is pronounced—"the exception or the extra-ordinary which cannot be enounced in any already formulated language."[34] In somewhat this vein, Benjamin suggests ideas in philosophy cannot be the objects of an attempt to relativize "differences and extremes" so that the "generality" (Allgemeinheit) of a genre or of a historical form may be conceptualized in terms "of the average" (des Durchschnitts) (*O*, 38/I:1, 218). Ideas or ideals (Goethe) are Faustian "Mothers" (goddesses inaccessible and unrecognized but only negligently unheeded) (35/215, I:3, 934).[35] Ideas or ideals are resonance of linguistic being, resonance of the determinant, revealed and yet not entirely revealed, generality that is the invisible, unspeakable word in thing and in concept. Quoting Hamann, Benjamin refers to "[*l*]*anguage, the mother* of reason and *revelation*" (*W* 1, 67/II:1, 147).[36] It might be said that Messianic hearing is the motherly reason that listens to and for the extreme that can scarcely be translated into anything tolerable for an average or for a concept. ("Messiah! He burst her tympanum." *U*, 482) Such hearing translates the extreme into the expressionless power that is discussed in the *Elective Affinities* essay as like a commanding word insofar as both expres-

sionless power and commanding word interrupt subterfuge holding—or trying to hold—this or that finitude for the truth (*W* 1, 340, 224/I:1, 181, I:3, 832). Such hearing of the extreme is interruption by the expressionless power of the form, philosophy.

Precisely as a practice of philosophy, genre analysis—according to the "Prologue"—has its concepts guided by the precept that "what appears diffuse and disparate" can be conceptualized into a "synthesis" that is no surrogate synthesis, no surrogate community. In a correlatively philosophical genre analysis (one concerned with what is most eccentric), "prejudices of stylistic classification and aesthetic judgement" are suspended so that due consideration may be given to the German baroque mourning play (*O*, 58/I:1, *238–39*). As suggested above, the eccentricity is important less on its own terms than for changing the comprehension of genre; phenomena do not determine the idea and do not determine the scope and the content of the concepts pertaining to idea (34/214–15). Whatever is comprehended in the idea of origin concerns history in its natural substance and not as "events" (Geschehn). It should perhaps be reiterated that the practice of philosophy follows extremes principally in order to revive presentation of virtuality. The presentation of an idea requires inspection of the "range of extremes possible in the idea" but this range is at best only "virtually" inspected. Whatever is perceived as extreme is not—as phenomenon—itself the natural substance; philosophical inspection must show itself to be virtual in relation to this substance (47/227).[37] In its philosophical power, extreme recalls that the idea "as such" is not in history (not even in the extreme as history); extreme recalls the virtuality of history. Especially for the philosophy of art, extremes are "necessary" and the historical process is "virtual" (*O*, 38/I:1, 218). The boundary-opening power of art requires a correlatively philosophical presentation in criticism that concentrates on genre. Insofar as it is a translation of extremes into presentation of the virtuality of the history (in relation to which extremes are extreme), genre analysis is such a philosophical criticism.

The extreme of utmost philosophical relevance is one most ridiculed in a specific historical context. This extreme may be openly most ridiculed, implicitly considered most disreputable, or simply through disregard most endangered. The philosophical importance of the ridiculed extreme is *not* that it could someday become celebrated. The most ridiculed is philosophically significant less as potential elasticization of specific confirmation criteria than as potential elasticization of attitude concerning the relationship of history and truth. Very early on, Benjamin remarks that elements of the final condition emerge, and are "embedded deep in every present," as "the most endangered, most disreputable, and most ridiculed creations and thoughts" (*W* 1, 37/II:1, 75). The ridiculed extreme is philosophically important insofar as it instills in

history a preparedness for the determinant force that history cannot entirely reveal; this capacity of the ridiculed extreme is philosophical. In a historical and contemporary relevance not subordinate to popular opinion, the Romantics' *Athenäum* is exemplary (for Benjamin in the early 1920s) as neither unwavering adherence to tradition nor superficial enthusiasm for the new or the newest enter into Benjamin's outlook (292–93/241–42).[38] Not deferring to the questionable or the ridiculed as event, philosophy presents such an extreme instead as an opening to—and only thereby an instantiation of—nature in transience. Art is philosophically important for its presentation of event in the force that is no event. Embedded deeply within material content, the enduring "truth" of artworks is discussed in the *Elective Affinities* essay as the force more resonant over time as the "realia" (Realien) become clearer, more conspicuous, and thus die in their event-relevance (*W* 1, 297–98/I:1, *125*). The extreme at least implicitly ridiculed through becoming archaic is an opening to the force making everything somehow already archaic, already subordinate to transience. The incipient philosophy in the artwork is the force that is always extreme in relation to history. As suggested in various texts by Benjamin, this force or form is extreme not as phenomenon resting in itself but as rhythm that cannot rest in history. In accordance with the correlative Messianic elasticizing of history (185–86 n. 3/12 n. 3), the practice of philosophy affirms the "questionable" or "dubious" (Fragwürdige) in order to "redeem" it (292/II:1, *241*). Philosophy redeems the questionable in the enduring questionability of history.

Their respective approaches to extreme distinguish philosophy and myth. The death penalty is not, of course, the only illustration of a society as myth, but perhaps a specific kind of mythic tendency in the United States could be considered to be demonstrated in its comparatively high usage of the death penalty to deal with certain extremes. The distinct way in which the United States seems particularly to emerge as mythic (among highly industrialized and relatively affluent countries that, of course, all have their ways of appearing mythic) pertains at least partly to its relative disregard (sometimes also ridicule) for the uncelebrated extremes in it—extreme poverty, extreme depravation with regard to medical benefits, extreme crime, and so on. After all, as Benjamin would variously suggest in later writings, the existence of even a single beggar is a demonstration that the social form is myth (e.g., *W* 2, 688/VI, 208). In this scenario, a myth of the United States battles against the tendency of the extreme to render history philosophical about itself. It battles against the force of philosophy in history. The United States is, however, no tragedy. In tragedy, of course, there is the Dionysian "triumph of extraordinariness [Außerordentlichkeit] over orderliness [Ordentlichkeit]," the liberation by logos (Rang, in Benjamin, *C*, 235/*GB*, Vol. 2, *427*). The "community" (Gemeinde) recognizing the agon—the contest, the race—and perhaps even

considering the outcome a victory of the human (as well as of gods) must, nonetheless, accept that the grace of freedom at play in the race does not ultimately offset godly annulment of freedom (Rang, *C*, 231–32, 233–34/*GB*, Vol. 2, 417, *425–26*). As the form, philosophy, is more indulged in the mourning play, nature breaks through as the constant resistance of exception—some exception or other—to will. In the German baroque mourning play, the monarch's "Janus-faces" are the extremes of tyrant and martyr; the monarch falls victim—is martyr—not to the gods (as in tragedy) or even for God (as in Christian martyr-drama) but rather to the natural history thwarting tyrannical will. From the baroque perspective, the standing of royalty may entail the monarch suffering as Christ suffered (that is, in the name of humanity); this martyr-drama concerns, however, the suffering and the defeat of a stoically asserted divinity that is broken by historicality, by exception to the asserted order (*O*, 69–74/I:1, 249–53; see also *W 1*, 368/II:1, 253). Correlative to this scenario, the decadent artistic will (says Benjamin, adapting Riegl) is in conflict with—and subverted by—the history that it desperately seeks to subsume (*O*, 55/I:1, 235–36). The aforementioned myth of the United States could be considered decadent in the refusal, for example, to consider acclaimed capitalistic necessity in the natural-historical context that subverts the will of myth, creates extremes and exceptions in relation to myth, and turns these into the basis for mourning play.[39] Whereas the outburst of the extraordinary in tragedy (regardless of how common the feeling in favor of this outburst may be) is largely defeated by myth, the exception in the mourning play unfolds as the common—some might say, the communitarian—force of nature breaking through and beyond myth.[40] The form of philosophy shows its invincibility. As noted already, Benjamin seems to come to associate (what has been called here) the form of philosophy less with a will and more with an involuntary breakthrough. Conceived under the norm of extreme, philosophy—whether as form or as alliance of practice with form—is solely the work of natural history that can no longer credibly be denied.

This breakthrough of philosophy accords, in many respects, with Carl Schmitt's methodological precept that "the exception confounds the unity and the order of the rationalist scheme."[41] Origin (Ursprung) does not concern the relationship between superordinate concept and what is classified or specified by this concept, for the derivation of the latter from the former is coincidence (a coincidence not acknowledged as coincidence in the superordinate concept); the derivation is "only semblance [nur Schein]." Neither essence nor sovereignty can be contained by classification (*W* 1, 273/VI, 24). (Benjamin notes the relationship of king and people but any sovereignty could be mentioned in this comparison.) In any case, Benjamin finds Schmitt's political analyses indicative of the sort of "eidetic" (rather than "historical") manner

of consideration that he—Benjamin—tries to achieve in the analysis of artworks (*W* 2, 78/VI, 219).

Schmitt tends, however, to side with the view (lingering in the baroque) that "the most important function of the prince" is "to exclude"—that is, to control—"the exceptional condition" (Ausnahmezustand) in order to secure rulership (*O*, 65–66/I:1, *245–46*).[42] Schmitt regards exception as confirmation, sole sustaining force, and reinforcement of nonrationalist rulership. Benjamin is wary of much that calls itself *rational* but regards exception as rational disproof, disconfirmation, of all rulership.[43] As he would put it toward the end of his life, the tradition of the oppressed teaches us that the only "rule" (Regel) is exception or emergency (*W* 4, 392/I:2, 697). He is rarely far from his early plea on behalf of free scholars and artists who are estranged from, or antagonistic toward, the state (*W* 1, 42/II:1, 81).[44] Unlike Schmitt, Benjamin correlatively renounces mythification of violence.[45] Interested in Roman Catholicism above all for its potential to secure theocracy, Schmitt objects to Dostoevsky's "angst of form" (formenfeindliche Angst), Dostoevsky's "anarchistic" (and for Schmitt, therefore, "atheistic") rejection of all earthly power.[46] Benjamin rejects "political" theocracy (*W* 3, 305/II:1, 203). As Benjamin objects to Catholic refusal to recognize "the situation of decision," the object of his criticism is the "practical" (rather than the "theoretical-dogmatic") "Catholic authority." This practical "administration of justice in church-discipline and confessional judgement" is the "Catholic, bad, deferment [Verschiebung] of the last judgement"; this amounts to a deferment—a blocking—of decision for the expressionless and may be contrasted with the "Jewish, good, postponement [Aufschub] of the last judgement" (VI, 60–63, especially 60, 63). Benjamin regards "the (false, earthly) theocracy" as the "problem of Catholicism." His principal interest in Catholicism is evidently a very un-Schmittian one: Catholicism as an emergence of "anarchy." Until the coming world and fulfillment are one, divine violence is only destructive, particularly of rulership (*W* 1, 226/VI, 99).[47] Such destruction is not the exception exploited on behalf of rulership but rather the exception so presented that rulership is shown to be unreal. In the latter way, the exception is the force, the form, of philosophy.

NATURAL ETHICS: LOYALTY TO THINGS

This force or form of philosophy is knowledge unincorporable in history. In the biblical story of the fall from paradise, the attempt to "recognize" (erkennen) good and evil abandons "knowledge [Wissen] of the world" (*W* 1, 361/VI, *133–34*). The lost world is the truth in things. "[O]bjectivity [Sachlichkeit] lies in truth" and there "is truth only in things [Sachen]"

(326/I:1, *162*). The biblical story recalls the nature that is oblivious to—innocent in relation to—all judgment of good and evil, all moral and legal order. "Knowledge [Wissen] of good and evil" is a human invention. It is the "opposite [Gegensatz] of all objective knowledge [sachlichen Wissen]," is "'prattle' [Geschwätz] in the profound sense in which Kierkegaard conceived the word." It is "basically only knowledge [Wissen] of evil," for it reduces knowledge to judgment. "[K]nowledge of evil" has "no object whatsoever," "is not in the world"; "with the desire for knowledge [Lust am Wissen]—rather, for judgement [Urteil]," this knowledge—knowledge of evil—"alights in the human itself" (*O*, 233/I:1, *407*).[48] The force or form of philosophy is knowledge of things that is not evil knowledge.

As this or that guilt-context defining good and evil, myth is nonetheless inextinguishable in human life—even in the lives of those doing philosophy in some way or other. If the relationship of myth and truth is ultimately one of "mutual exclusion" (as Benjamin more and more emphatically stresses), there can be no "truth about" myth, only "recognition [Erkenntnis]" concerning "the spirit of myth," recognition of myth as myth. Recognition of myth as myth is, however, the precondition of recognizing truth. The sole resonance of truth is recognition of guilt-context as betrayal of nature. Only in "recognition [Erkenntnis] of myth, namely the recognition [Erkenntnis] of its crushing indifference to truth," is "presence [Gegenwart] of truth" possible (*W* 1, 326/I:1, *162*). ("It was strange too that he found an arid pleasure in following up to the end the rigid lines of the doctrines of the church and penetrating into obscure silences only to hear and feel the more deeply his own condemnation." *P*, 106) Myth condemns and judges, but such condemnation and judgment also occasion the possibility that they are heard and felt in silences which myth cannot quite incorporate. These silences echo back as the *form*, philosophy.

Whereas this form—philosophy—is guilt about myth, myth is the guilt that makes accountable to the society in which we survive. If we did not live myth, we would not survive. The specific guilt-context may seem to have a beginning, a now, and even an end, but the destiny of having some guilt-context or other does not. The "time of destiny" stands "under the order of guilt"; this condition determines that the "time of destiny" is "an unindependent [unselbständige] time," a time that has no beginning, no end, no now—no past, no end, no present (VI, 91). As "the true order of eternal return," destiny can be named only in relation to context. In this respect, destiny can be described only "inauthentically, parasitically" (*O*, 135/I:1, *313*). Destiny is unindependent time, for there is always some determinant guilt-context, regardless of what those subject to it may or may not have done. In *Elective Affinities*, a baby is

born into a guilt-context defined by the "lie" of its conception; it is conceived as Eduard and Charlotte attempt to act as though their relationship of earlier years is still aflame in their eroded marriage (*W* 1, 307–8/I:1, 138). Being born of this betrayal of feeling to a mythic guilt-context (in this case, of a marriage) is a variation of what happens to every child; every baby is born into a guilt-context that is a betrayal of nature by myth. Nazi Germany is a guilt-context that remains an incomparably consequent myth; this context remains inextricable from much (if not all) human inheritance, even in the attempts of many to put it behind them. Almost all babies today, moreover, grow into a guilt-context of living the "nature" that is capitalistic judgment; they do so regardless of any doubts that they may come to have about the justifiability of such judgment. The very exercise of recognizing is permeated by myth; it is permeated by the process making us societal beings who survive. "[R]ecognition [Erkennen] is guilt" (*W 1*, 361/VI, *133*). As implied already, recognition is guilt in two basic ways: it is guilt determined by the moral-legal order of good and evil; it is the guilt of betraying nature through this moral-legal order. It is mythic guilt and it is natural, philosophical guilt. If there were no mythic guilt, there would be no philosophical guilt; there would be nothing about which there could be philosophical guilt.[49]

To recognize the lack of innocence is already the emergence of the form, philosophy. Insofar as recognition includes recognition of itself as mythically imbued (as betrayal of nature), it has shown character, which is paradoxically a kind of innocence vis-à-vis myth. Character is the innocence of nature that is beyond or beneath myth. In relation to myth, character seems individual. This is not the individual that Western culture increasingly associates with the first personal pronoun; it is not the individual heralded by liberalism as agent giving itself into, and taking from, the public sphere (II:1, 26). As the realm of freedom facilitating the "individual imprint [Ausprägung] of spirit" and "the individual imprint of propriety [des Schicklichen]" (*W* 1, 302/I:1, 131), the sole "unequivocalness [die Eindeutigkeit]" of character is "unity of individual spiritual life," but this unity is "expression" of natural innocence (335/174). It is expression of nature that is essentially expressionless. If "individuality" has its unity solely in the innocence of nature (335/174), the "individual" (Individuum) is "an indivisible" but also "incomplete [unabgeschlossene] unity" (VI, 71). Character is in things and humans as nature in its indivisible innocence, in its inability to be completed by moral order (*W* 1, 307/I:1, 138). Physiognomic concepts—morally indifferent physiognomic concepts—are required for consideration of character. This physiognomy reads surfaces but is not defined by them; it is no topography, moral or otherwise. Its object, its truth, is colorless (205–6/II:1, 178–79). As natural innocence, character is not subordinate to construed appearances; character re-

quires that construing be conceived as construing. Without character, the form of philosophy would be without effect.

In the human, character is a philosophical humanity. The relevant "humanity" gives the "body" (Leib) a "principle" of "individuality" standing "higher" than specific bodily individualities (395/VI, 80). A "fateful [schicksalhafte] sort of existence" may indeed enclose "living natures in a particular context of guilt and atonement" (307/I:1, *138*). The innocence of nature revolts, however, against the bodily individual constructed in simply suffering and exploiting a specific guilt-context. Human revolt is, as Bataille suggests, revolt against the human figure.[50] Although always within some guilt-context defining guilt and innocence (good and evil), the human is also a possibility of decision on behalf of the revolt of innocent nature (*W* 1, 307–8, 326–27, 335, 346–47/I:1, *138–39, 163, 174, 189*). Destiny is not "the life of innocent plants"; the human living in a specific guilt-context is accountable to this guilt-context (307/*138*). It is this destiny unfolding inexorably in implicated life, however, that is also responsibility for decision recovering the tension of innocent nature and the mythic guilt-context. It would be "subhuman" (a lowly kind of demonism and ghostliness) to attempt to bind "the ethical world" and "destiny" with a nature considered innocent in its simple appearance—its "innocent appearance of simplicity." According to Benjamin, this subhumanity is the humanity celebrated by Stifter (112/II:2, *609, 608*). Insofar as "mute diffidence [Befangenheit]" in the realm of "human, indeed bourgeois custom" is supposed to save "the life of passion" in *Elective Affinities*, Goethe shows a Stifter-like tendency (343/I:1, *185*). The marriage of Charlotte and Eduard seems to turn into a "fate" (Geschick). Ottilie's death is celebrated as a "sacrifice" necessary to atone for the "guilty" (Schuldigen) who had broached feelings deviating from this fate (308–9, 334, 336/*139–40, 173*, 175). So "dangerous" is Ottilie's "magic of innocence," an innocence that is not "purity but its semblance [Schein]" (335–36/175). Notwithstanding destiny as "the guilt-context of the living," it is disregard of the indeterminable human (204/II:1, 175–76)—disregard of what is human (Menschliches) (308/I:1, 138–39), disregard of the free "*human*" (VI, 71)—to confine destiny to any particular guilt-context. Such confinement is the pseudonecessity of resignation, complacency, intrigue, and tyranny; it is not the necessity of the philosophical.

Art is a demonstration of free humanity; the free, indeterminate humanity is the sine qua non of art. This free humanity is not the loyalty associated with person (VI, 71). It is not ultimately loyalty to one's person or to other people. Courage for art is no obligation to person or people. Hölderlin's title "Dichtermut"—focusing on the virtue of a person (the courage [Mut] of the poet [Dichter])—is unsuitable, as is the suggestion that constitution of this

virtue by the Parcae (the Greek Parcae, the Fates) assures "kinship [Verwandtschaft]" of poet with all the living (*W* 1, 22–24, 26/II:1, 109–11, 114). The determinant force of poetry is neither the person of the poet nor an automatic, god-given affinity of poet and people, let alone of poet and all of the living. The determinant force of poetry is destiny freeing spaces for "activity," for "positing" (Setzung); there can, moreover, only be acquaintance with "many" living who may then be "bearers," may be a spatial "*extension*," in which this force of destiny extends itself (*W* 1, 26–29/II:1, 113–17).[51] Courage for art remains, above all, loyalty to the force that is no person, no persons, no people, not even all people. Much as sacred texts must ultimately devalue constraints of meaning (*W* 1, 262–63/IV:1, 21), no poem is aimed at the reader, no picture at the beholder, no symphony at the listener (253/9). Art requires courage for the freedom loyal to destructive nature and to the correlatively indeterminate destiny of the human. Art requires the philosophical impulse.

Saturnine unfaithfulness to humans can be devotedly contemplative, immersive loyalty to things and can be the correlative feeling for the unlivable yet essential being of nature that mourns appearances and forms of recognition. In myth, things may seem dead simply by lacking engagement with the mystery of death. As the "life of seemingly dead things" assumes "power," as the "thing-like" emerges in a mythic way, the passive figure of Ottilie seems especially to define appearance in Goethe's novel (*W* 1, 308–9, 334/I:1, 139–40, 173). Things seem dead as nothing besides transient appearances. There may too be a correlative melancholy that "betrays the world for the sake of knowledge [Wissens]" and does so with the kind of loyalty to "the thing-world" that surrounds itself "with fragments of the thing-world"; these fragments are taken by this loyalty as its "ownmost, not-too-demanding objects." Yet such contemplative immersion in dead objects—objects not surviving beyond their empty appearances—can turn into a persistent "intention of mourning"; this persistence is capable of redeeming what Péguy characterizes as the intrinsic resistance of things to knowledge. The "truth" expressed by melancholic loyalty is this intention to redeem—to know—by contemplative immersion (*O*, 156–57/I:1, 333–34). This intention is a mourning that is true precisely in its inability not to persist; it is true in its inability to be satisfied, its devotion to the resistance of nature.

Such a practice of mourning attests to the persistence of music against semblance. This music is largely missing in *Elective Affinities*. The middle-aged marriage partners (Gatten), Charlotte and Eduard, enjoy a comfortable marriage on a secluded country estate, but this isolated, "particular harmony" undergoes strains following the separate arrivals of two guests, Ottilie and the

Captain. A strong bond grows between Eduard and Ottilie (Charlotte's young niece), and Charlotte and the Captain become attracted to one another. These figures' "wondrous flickers of emotion [Regungen]" do not establish, however, "a whole heartedly spiritual harmonizing [innig-geistiges Zusammenstimmen] of beings" (*W* 1, 304/I:1, *134*). The figures' emotional flickers do not rise to engagement of semblance-free music. Although the relationship of Ottilie and Eduard receives impetus from her eagerness to adapt her piano playing to his mediocre flute playing, their "harmony" (Harmonie) is "deceptive," devoid of music (304, 349/*134*, *192*). If extended beyond its observations concerning the playing, this verdict may seem harsh; yet it belongs to a broader critique of the conformity stifling the figures of the novel. Their particular harmony is a harmony of "natural strata" that are "deeper" only in the sense of being (in a manner of speaking) lower; the naturalizing of the particular harmony is indicative of how low humans can sink in adaptation. Those natural strata comprise "what is slightly amiss" in the "conjunctures" (Fügungen) among figures in the novel (304, 308/*134*, *139*). The figures' "harmony" does not bring them the expected "peace," for—in contrast with the novella where there is a "thunderstorm" and then peace—the "mugginess" just gets "more stifling," a "lull" before the storm that ultimately shatters the figures' precious world (343/*185*). The storm erupting in the novella and vainly suppressed in the rest of the novel is the storm of destructive nature. The divine music of things shatters the naturalizing of putrefied thingness in this or that particular harmony.

The divine music of things is the ethics of nature. Against this convergence of necessity and ethics, there are things hypostatized by mythic morality. The Apollonian hypostatizes against the Dionysian. Even the flight from moral-legal order can become a shrine to this order. Ottilie's "[p]lant-like muteness" seems to recall Daphne seeking to escape Apollo, imploring to be turned into a bay tree, and thereafter existing as Apollo's shrine with "pleading upraised hands" (336/*175*). On the basis of this "[p]flanzenhaftes Stummsein," some interpreters formulate Goethe's novel as a tragedy; Gundolf addresses "the 'pathos of this work', 'no less tragically sublime and shattering [erschütternd]'" than the pathos underlying Sophocles' Oedipus (337/*175–76*).[52] Yet even the pathos of the tragic heroic figure includes coming to a self-consciousness in which the "demonic jurisdiction" of mythic guilt is outgrown (*O*, 131/I:1, 310); momentarily introducing the "word" that broaches the "edge of decision" where mythic guilt and innocence are wrenched into a confusing abyss, the figure acquires an independence from such guilt and innocence (*W* 1, 337/I:1, *176–77*). Ottilie, "the hesitating maiden," does not get this far (337/*177*). She just seems abandoned to her end; without "resolution," her silent death wish is a "drive" (336/*176*). There is, moreover, no credible

tragic imperative in her end. Unlike the tragic situation where myth must ultimately be a kind of conclusive determinant, Ottilie could have effectively questioned the necessity for the end that befell her. Whereas tragic guilt ultimately subsumes alternatives to it (*O*, 131/I:1, 310), Ottilie's thoroughly silent suicide—unannounced to those around her but also somehow inconceivable for herself—is sacrifice to a "morality" that is "questionable" (*W* 1, 336/I:1, 176). Her end is "mournful," but could not be more untragic (337/177). She simply lets myth make ethics irrelevant to her, notwithstanding the breakthroughs of destructive nature presenting themselves here and there against the naturalizing of her particular harmony.

In the ethics of nature, humans explore feeling that cannot quite ally itself with moral topographies. According to "ethical laws," "passion" has no right and no happiness if it tries to ally itself with "the bourgeois, affluent, secure life" (343/185). In such an alliance, the community of definite indeterminateness—the common destiny of certain uncertainty—is simply suppressed or oppressed by constructs that are indeterminate solely as a result of an unreal definiteness. Classical mythology may be presented as indeterminateness of unreal definiteness once it can effectively be contrasted with art. The "traditional and simple" predominance of "indeterminate" (unbestimmte), mythological "Zugehörigkeit"—affiliation, membership, or state of belonging—can be surpassed, "sublated" ([a]ufgehoben), by a "powerful" (gewaltige) belonging (24/II:1, *111–12*), by something "more primordial" (ursprünglicher) (26/114). For the sake of "what is decent" (das Schickliche), however, the main figures in *Elective Affinities* lose "feeling" for "the ethical" (304/I:1, *134*). They lose feeling for nature that is more primordial than either myth or the aforementioned mythology. They lose feeling for the ethical tension of destructive nature and adaptive nature.

Benjamin's assessment of *Elective Affinities* is not an equation of aesthetics and ethics. Figures in an artwork are not to be subjected to ethics. "[E]thical judgement" is, after all, "executable only on humans." The tension of destructive nature and natural adaptation emerges in humans, for they cannot survive without attesting to the latter "natural power [Naturgewalt]." They have not "outgrown nature" (Benjamin evidently means adaptive nature) (303–4/I:1, *133*). Certain artworks highlighting a lack of freedom from adaptive nature are even praised by Benjamin (although his aesthetic assessment tends to favor works accomplishing a better integration of natural adaptation into presentation of divine nature). Never letting lived life become a dream, the German *Trauerspiele* are "morally" (moralisch), though not "artistically," "more responsible" than plays by Calderón (*O*, 84/I:1, 263). It is not entirely clear that Benjamin's aesthetic assessment does not even sometimes hold

with such moral responsibility rather than with works that are more oblivious of the tension of moral adaptation and art (see pages 173–74 above). The moral responsibility of the German plays is that they do not romantically erase adaptive nature. Yet aesthetic criteria are not bound by such moral responsibility, and to imply or attempt such containment of art is considered by Benjamin to be the aesthetic failure of the German plays. Figures in an artwork may well rise above or even irredeemably sink below the tension of adaptation and divine truth (*O*, 104–5/I:1, 283; *W* 1, 303–4/I:1, 133–34). From the perspective of moral philosophy, the figures in an artwork can seem either beyond or beneath ethical judgment. The main figures of *Elective Affinities* are, for example, beneath it. They surrender themselves to the naturalizing of particular harmony. The occurrences in *Elective Affinities* can simply be comprehended morally, noted in their specific moral context (*W* 1, 303–4/I:1, 133–34). As figures in an artwork, these main figures do not have to live with the tension of adaptation and the ethics of destructive nature. As suggested already, this contrasts with what must somehow be felt by humans outside art; humans exist in the tension of ethical, destructive nature with lived, lower, adaptive nature. (Hence, Goethe's novel may often seem what is commonly called "stylized.")

It is obvious, nonetheless, that Benjamin's criticism has an ethical dimension. Art and criticism have this dimension, although it is not their task to assess what exactly figures in a work could or should be doing. The ethics of criticism concerns the work, not the figures in it. Benjamin's "judgement" of the figures in *Elective Affinities* is not about their "action" (Handeln) but about their language (304/134). It is about the language predominant in the novel. Language is the ethical importance of art; art presents the power of *language* within languages of things and humans. If Benjamin's assessment of *Elective Affinities* may be said to include an ethical judgment of the characters, this concerns Goethe's tendency not to move his creation much beyond the characters' suppression or denial of necessity and freedom (302–5/131–34). There is a forsaking of the "destiny" that is movement into unfathomable nature. Besides art, there are other forms of expressing unfathomable nature. These lead, however, to annihilation. Unfathomable nature has its sole "conciliatory effect" in art. Art is conciliatory, for it is movement emerging out of—and not simply into—the unfathomable (396/VI, *81*). Art is presentation that enters the cycle of descension into, and ascension from, the unfathomable. The figures in *Elective Affinities* avoid this cycle. In their very language, they avoid it; Goethe does not quite want his work to go beyond this incapacity. Figures in an artwork do not have to rise to the tension of ethics and adaptation, but an artwork itself must somehow do so. Ethical failing and aesthetic failing converge in the lack of responsiveness to the form, philosophy.

Such lack of philosophy is an inability to mourn. Mourning is an ability to descend into, and ascend from, the irredeemability, recalcitrance, resistance, of things to the particular contexts in which they are conjured. The play of mourning has a saturnine, faithful "rhythm" of descension; as rhythm, its descension emanates (*O*, 157/I:1, *334*). Its descension ascends. Not descending directly from God, literature ascends from "the unfathomable of the soul," from "the deepest self of the human" (*W* 1, 323/I:1, *159*). Yet the most profoundly unfathomable in humans is, in a way, God. The figures of *Elective Affinities* cannot ascend to much, for they have not descended into the mysterious depths of God; they are "[d]eaf to God" and, therefore, "mute before the world" (305/134). It is necessary to descend into these mysterious depths and—on that basis—to mourn history, if there is to be much philosophically worthwhile to say, to present, to perform, to history. Mourning is philosophical by presenting its significance as unfulfilled in history.

For this ethics of mourning, history is guilty before nature. Nature—this prehistoric world—reflects such guilt into history. The "prehistoric world [Vorwelt]," as the Kafka essay of 1934 puts it, holds up a mirror of guilt (*W* 2, 807/II:2, 427). This guilt mirrors into history solely by interrupting tendencies to have history rest with itself. It allegorizes history. "[T]he allegorically significant" cannot find "fulfillment of its meaning [seine Sinnerfüllung] in itself" (*O*, 224/I:1, *398*). Underlying the style and the content of allegory, mourning is on behalf of nature determining but not determinable; mourning is "the mother of allegories and their content [Gehalt]" (230/403). Nature mourns. From the perspective of the object, meaning is unrevealed and meanings issued by humans must be allegorized. The object mourns, for instance, before name; the object intimates that being named (even by a "God-like and blessed" namer) is "perhaps always a presentiment of mourning." Nature mourns on account of its muteness; more essentially, however, nature's "sadness makes it become mute." In the latter respect, mourning tends "towards being without language [Sprachlosigkeit]." This state of being without language "is infinitely more than inability or reluctance to communicate"; it is a feeling for the essentially incommunicable and unrecognizable. The "sorrowful [Traurige] feels itself completely recognized by the unrecognizable [Unerkennbaren]" (224–25/*398*).[53] In the human, the guilt requiring silence on behalf of the incommunicable turns into an ethical basis. "The highest moral interest of the subject is," therefore, "to remain anonymous to itself," to keep itself open to the self that is determinant yet unrecognizable ("Grundlage der Moral" [note from late 1920s or early 1930s], VI, 59–60).

This philosophical feeling for the anonymous self is the feeling for justification. A feeling for justification is pure simply in being unable to find fulfillment in extant justification. The "ultimate metaphysically constant purity"

does not exist without "struggle" (Ringen) for "the view of the highest and outermost legitimacies [Gesetzlichkeiten]" (*W* 1, 112/II:2, *609*). Conceived as natural moral impulse and not as naturalized moral order, moral is philosophical; the term "moral philosophy" is "a dumb [dumme] tautology" ([note from around 1918] VI, 93). Reason cannot function as though appearances or words are the fulfillment of nature. Reason belongs rather to the inherent justificatory function or demand of words. Logos is where words "ought to stand and give an account of themselves [stehen und Rede stehn sollten]" (*W* 1, 327/I:1, 163). Logos is the necessary overflow, the necessary supplement, that interrupts justification with the demand for justification. In contrast with the figures in *Elective Affinities* not letting this tension emerge in their language, logos is "the truly divine"; it is an impulse grounding "life not without truth, rite not without theology" (326/*163*).[54] Logos is the norm and the rhythm inherent in the name-language. Even the "poorest wretch" has not yet been able to extinguish this emanation of the *ratio* of language (*W* 1, 327/I:1, 164). Some may, of course, seem to silence the rhythm of language. It is in this way that the figures in *Elective Affinities* "fall silent" (305/*134*); they lack justification through their very "being [Sein]" (304–5/*134*). They scarcely let themselves feel beyond beautiful semblance. At least implicitly, they deny that "the beautiful" (das Schöne) should or could be interrupted by the requirement to "justify itself [sich . . . verantworten]." For Benjamin, such interruption is necessary; it is necessity itself. In such interruption, the expressionless immortalizes the "quiver," "quake," or "shaking" (Beben) of anguishing, "trembling" (zitternde) harmony. This immortalization is the expressionless opening the harmony of anguish to that of quaking mystery within it. The harmony of anguish truncates responsibility, perhaps even with a claim of responsibility. In the course of "responsibility" (the giving account, the *Verantwortung*), however, the requirement of justification can interrupt the beautiful semblance of responsibility; it can interrupt once again with "immortalization" (Verewigung) (340, 224/I:1, *181*, I:3, 832). The form—philosophy—interrupts guilt under adaptive nature with guilt before a different rhythm of nature.

In this rhythm of philosophy, "immortality [Unsterblichkeit]" in an artwork is produced by the critical disjoining of material content and truth content. The critical disjoining of material and truth emerges from their contact. This contact is the rhythm of history passing. The critical distinctness of material and truth is much less recognizable for the poet or the contemporary public and criticism (regardless of quality) than for a subsequent age. "[H]istorical distance" increases the "power" of works; their "history" "prepares" their criticism (*W* 1, 297–98/I:1, 125–26; see also 235/VI, 126–27). A profound translation also does not appear until after the age of the work's appearance, for

such a translation is survival of the work in its inorganic nature, in the nature that is not the work's specific scene of history (254–55/IV:1, 10). That debate about a work, and such debate in its later reception, may accompany the afterlife of a work, indicates the emergence of this afterlife in another scene, which is also a scene of history. From Benjamin's perspective, the debates should be, nonetheless, about the artwork as accentuation of the passing of history in it. The survival of the inorganic work is the rhythm of nature destroying history, a survival more evident after the age of the work has passed. The role of myth in every living social order (including, therefore, the living orders of a work's later reception) does not disqualify the definition of the work as preparedness for destruction.[55] Nowhere "the highest material content," the mythic is "everywhere a strict reference" to this content (*W* 1, 309/I:1, *140*). In its critical force, the artwork suspends such strict reference in favor of the highest material content; myth is presented as inadequate to the highest material content.[56] The highest material content is the persistence of the form, philosophy, which is also the persistence of decay.

Truth is no classicist presence. Goethe's "quest for the seeds of eternal growth" brings attachment to "formed contents" preserved in "life and language" (*W* 1, 298/I:1, 126) and results in little more than a "mythic shadowplay" in the costumes of his age (309/140–41). Goethe's classicism may seem a corrective to Kant's map for the Enlightenment's barren version of the real, a corrective to Enlightenment thinkers unable to rise to a view or intuition of material content in any relationship with idea (298–99/126–27). Goethe's classicism suppresses, however, the critical tension of material content and truth content. There is "no truth" in myth (Benjamin comes increasingly to stress) and myth accordingly cannot admit error (326/162). Myth can mourn nothing, for it is to provide an all-encompassing cover for feeling. Natural guilt is mourning; natural guilt is mourning of the observer and it is mourning of the object that is fallen with this observer, this creature (*O*, 224/I:1, 398). Myth lacks such *unequivocalness* or *clarity* ("Eindeutigkeit") and indeed simplicity with which character recognizes the lived guilt-context as erroneous (*W* 1, 326, 335/I:1, 162, 174). Myth is beautiful semblance. As suggested above, however, the "eternity" (Ewigkeit) of the "content" (Gehalt) of the beautiful can emerge in a "protest" (Einspruch) interrupting the beautiful (181/*340*). The determinant force in artistic extension is a "temporally inward intervention" (31–32/II:1, 120–21) that interrupts spatial closure and is entirely distinct, for example, from the subsumption of natural guilt by "tragic guilt" (*O*, 131–32/I:1, 310). The persistence of the form, philosophy, is natural guilt that cannot be subsumed by mythic guilt.

The persistence of philosophy, the persistence of the form of philosophy, is the persistence of action. Contrary to many clichés associating philosophiz-

ing with vacuous contemplation, the effect of the form of philosophy is fundamentally interruption by action. Unrecognizable, irrepressible action is felt. Insofar as this feeling prevails, all recognition may be regarded as guilt and "all action [Handeln]" as "innocence" (*C*, 51/*GB*, Vol. 1, 162). Action is felt to be in the "absolute" but recognition has an "as if" relationship with this (52/164). This "as if" is not Vaihinger's neo-Kantian notion of the "as if" as a means by which we may treat the untrue of life as though it is real. Benjamin's "as if" is performed as an "as if," as unreal. Benjamin's outlook is obviously also no endorsement of some kind of antitheoretical actionism; it is opposed to that. Simply as an irrepressible irritant, however, action is the basis of any effect of the form, philosophy. The guilt of recognition with regard to action enables recognition to become a philosophical calling. This calling requires "the most active, most fervent, and blind fulfillment of duty" (51/162). The fulfillment of that duty is, however, blindness to recognition; the duty is to keep recognition open to its "as if" relationship with action. The duty is constant, for action is constantly not recognition. The duty interrupts claims to, and upon, recognition. One could say: Images felt as guilt enter the obligation to be presented as allegories. "[T]he more nature as well as antiquity were felt as guilt-laden, the more obligatory [obligater] became their allegorical interpretation, as the only redemption which is really foreseeable" (*O*, 225/I:1, *398*). The only foreseeable redemption is of action or nature requiring allegorization of recognition. The persistence of the philosophical impulse is allegorical; allegory attests to the persistence of the form, philosophy.

The ethical function of action is this interruption taking place in recognition and yet allegorizing recognition with the unrecognizable. "[M]orality [Moral]" (in the philosophical rather than mythic sense) is from the "realm of recognition [Erkenntnis]" but as "nothing other than the refraction [die Brechung] of action [der Handlung] in recognizability [in der Erkennbarkeit]" (VI, 93). The "sense" of the "action [Handelns]" in "the seconds of decision" (by the figures in the novella within *Elective Affinities*) is accordingly "courageous resolution" breaking an ostensible "fate [Schicksal]" (*W* 1, 332/I:1, *170–71*). Such built-up "Schicksal" is "fate," for it is a betrayal of "Schicksal" as free and unfathomable destiny. Knowledge of the good is open to nature that interrupts knowledge and keeps knowledge in a secondary standing. The image of the mother discussed above (page 214) would be an illustration of good in which knowledge is secondary. If knowledge is primary, there is evil; if knowledge is secondary, there is good. ("Knowledge of evil" [Das Wissen vom Bösen] is "primary" [primär] "as knowledge" [als Wissen]; "knowledge of good" [Das Wissen vom Guten] is "secondary" [sekundär] "as knowledge.") Knowledge becomes secondary on the basis of the good that is action interrupting knowledge, action interrupting evil. Knowledge of evil "ensues from contemplation

[Kontemplation]"; knowledge of good "ensues from practice [Praxis]" (*O*, 233/I:1, *407*).[57] As evil, contemplation does not mourn recognition and thus does not open recognition to interruption by unrecognizable action; it is not the effect of the form, philosophy, but rather of resignation and domination in forms of recognition. In its attempted dissociation from philosophical guilt, contemplation is incapable of knowing good.

Yet contemplation can only surreptitiously dissociate itself from philosophy, from philosophy as an inextinguishable form. The empty and evil knowledge-drive seeking to secure infinity will eventually open into an "abyss of bottomless profundity" (bodenlosen Tiefsinns) showing that no hypostasis of subject or object can be upheld against the allegorizing force of nature (*O*, 231–33/I:1, *404–6*).[58] In the "transfigured apotheosis" (verklärte Apotheose) achieved by Calderón (but not by the German baroque mourning play), superior development of the intrigue enables "[t]he powerful design" (Der gewaltige Entwurf) of the form *baroque mourning play* to "be thought to the end." Further development of intrigue in the German drama would have so entered the allegorical totality that there could have been apotheosis in an image simultaneously giving mourning "entry and exit" (*O*, 235/I:1, *408–9*). This process of mourning entering and exiting is, of course, cyclical. In this cycle, the mourning over representational being is released into non-representational being and returns again to confrontation with representational being. The possibility of this cycle is intimated as "melancholic immersion" tries to assure itself of "what is depraved" and its "ultimate objects turn into allegories" (232–33/*406*). The "absolutely evil" in allegory may be cherished as "enduring profundity [bleibende Tiefe]" but—existing "only in allegory," being "solely allegory"—it "means [bedeutet] something other than it is." Its being, its representational being, is a nonbeing; its meaning, the meaning that cannot be represented, presents this representational being as nonbeing (233/*406*). That unrepresentable meaning presents representation as an unreal moment in the allegorizing force of nature.

Evil is the catalyst of its own allegorization; the forced, abstract element—"knowledge" (Wissen) of evil, evil as knowledge—is paradoxically the "origin of all allegorical consideration [Betrachtung]." In the baroque allegory, there is—on the one hand—"the triumph of subjectivity and the beginning of tyranny [Willkürherrschaft] over things" (233/*407*). The "absolute vices" represented by tyrants and intriguers are, on the other hand, "not real." What they seem to be is what they are only in "the subjective view of melancholy." Signifying nothing other than the "blindness [Blindheit]" of this view, the vices are the "offspring" of this view and yet destroy it; the view blind to all outside it is destroyed by this unreality of its vices. Tyranny and intrigue, which are absolute only in being absolutely unreal, come to point to this "absolutely

subjective profundity to which alone they owe their existence." The "allegorical shape [Gestalt]" of the absolutely evil shows "the absolutely evil" to be "a subjective phenomenon" (233/*406*). The subjectivist and absolutistic basis cannot quite contain the allegorizing force that shows it to be subjectivistically absolutistic. Evil is broken by things with death already in them, things revolving around that which cannot be represented (134–35/312–14). This ultimately irresistible force in things, which pushes evil into presentation of its unreality, is the force—form—of philosophy.

If the catalytic relationship of evil and allegory—myth and philosophy—is to be purposeful in humans and not just the outcome of decay and decline, there must be decision to engage the cycle of lamenting and interrupting adaptive nature. With the title *Die Wahlverwandtschaften* (*Elective Affinities*), Goethe refers—half-unconsciously perhaps—to the dilemma in the novel that "choice" (Wahl) is unable to reach "the greatness of decision" (*W* 1, 346/I:1, 188). Choice belongs to natural "elements" and their sequences of adaptation (346/189).[59] Bataille remarks on an authoritarianism intrinsic to elective affinity: elective affinity cannot deal with a moment being wrenched from sequences of adaptation. Out of such intolerance, parts of the Communist party did not like Kafka's writing.[60] Such authoritarianism is brought to the fore by adaptation to the elements that is openly vice ridden, openly Satanic—for example, in the manner of Shakespeare's Richard III. In Shakespeare's dramas, such an elemental tendency is paramount. Yet even here an allegorizing component tends to break through to be juxtaposed with the "elemental [Elementare] of the world of senses" (*O*, 228–29/I:1, *402*). Such a breakthrough is against tyrants and intriguers but also against the resigned, for they too suppress the allegorical. Goethe's figures under the "spell of elective affinities [Wahlverwandtschaften]" (*W* 1, 304/I:1, 134) do not rise to more than "choice" (Wahl), which does not strengthen the development of "affinity" or "kinship" (Verwandtschaft) and does not provide any basis for "the spiritual" (das Geistige) in affinity (346/*189*). Benjamin uses the word "spiritual" in various ways but its usage here—as on many other occasions—evidently concerns a potential for thinking beyond adaptive nature. Only "kinship" or "affinity" (Verwandtschaft) as "object of a resolution" can proceed over the level of choice to decision (346/189). The animal-innocent "cannot engage in good action." Nonhuman animals seeming to take on such responsibility would presumably be considered by Benjamin to be something exceptional, a reminder of the limits of generic distinction. The mourning by things (in their character, in their natural innocence) and even the plant-innocence hinting at such suffering as human sociality prevails over it do not, however, basically rise to the distinctly human culpability and responsibility. An early letter by Benjamin elaborates animality as "physiological" solitude—as the innocent

"without remorse," as a relatively reactive living organism—which is redeemed in human "sociability" (Geselligkeit) (*C*, 51–52/*GB*, Vol. 1, 162–63).[61] Sociality is human culpability and responsibility for the mediation of nature—the mediation of action, the mediation of the good, the mediation of natural innocence, the mediation of character—by the evil of recognition. Bataille also associates "rigorous morality" with a feeling for "complicity in the knowledge of Evil"; "[a]ction alone has its rights" and is "necessity," whereas literature is not innocent but guilty and should admit this.[62] For Benjamin, recognition is the guilt to be constantly confronted anew by the human on behalf of the action of natural innocence that cannot be recognized. The human's embroilment in sociality, "a sluggish manliness" experienced "daily" as guilt, has its counterpart in the innocence which must every day be "earned anew" by the human and "*as an other* innocence" (*C*, 51/*GB*, Vol. 1, *163*).

In this cycle, destiny is recalled and enacted as the force exceeding the myth that otherwise dominates daily life. The human mourns sociality (mourning plays are thus "for the sorrowful" [*O*, 119–20/I:1, *298–99*]) but also engages it. Art for the sorrowful is, therefore, never entirely without something for the playful in us. Character has freedom in which the relevant "individual [Individuum]" can be a "sun" casting a "shadow" of "comic action." (Such an individual even enables a "comic shadow" to be cast in every tragedy.) This sun is a black sun; it casts a shadow over color. Blocking out color, the individual is the prevalence of anonymity over semblance. The individual is a sun in "the colourless (anonymous) sky of the human" (*W* 1, 206/II:1, *178*). The conditional evaluations (evaluations of conditions) ensuing from this individuality are morally indifferent—that is, they are not based on moral color, moral accent, or moral topoi. They assess, provide valuation, on behalf of anonymous unconditionality (204–6/*177–78*).[63] There can be no certainty about whether a specific valuation or condition is actually on behalf of such unconditionality (there can always be further debate and discussion). It is certain, however, that nature mourning history enters history as colorlessness amidst color; colorlessness—unconditionality—enters color as play of mourning. Helping to create baroque mourning plays "more significant" than the "rigid" German type, comedy (Lustspiel) enters works by Calderón and Shakespeare (*O*, 127–28/I:1, *306–7*); "comedy [die Komik]" attests to the allegorizing power to play the profane, to keep semblance moving, to keep it from holding too much of itself (191/368). If there is only seriousness, "unprepossessing being" (Unscheinbarkeit) is lost (48, 191/229, *368*). As the "light" of character—the light of colorless anonymity—falling upon actions, a comic "beacon" (Leuchter) provides the "beam" (Strahl) that makes the "freedom" of "deeds" (Taten) "visible" (sichtbar) (*W* 1, 202–3, 205–6/II:1, 173, *177–78*). As the freedom of the colorless, character is the eternal return;

the human can seem—as Hölderlin says of the blissful gods—to be devoid of destiny, to have no destiny as something entirely external (202–3/173–74).[64] At least recalling the destiny that is not only myth, human character is the inextinguishable philosophical guilt which emerges to mourn and play history on behalf of secret.

In the correlative ethical dimension of the human language of name, a magical wordless dimension unites word and action (*C*, 80/*GB*, Vol. 1, 326–27). This dimension surpasses the "act of choosing" (Wahlakt) that cannot reach beyond "what is seized" (*W* 1, 346/I:1, 189). Whereas choice neither hears nor expresses anything beyond what can appear, a "moving deed [bewegender Tat]" has a correlate in the word that descends into and ascends from innermost muteness (*C*, 80/*GB*, Vol. 1, *327*). "[L]inguistic shape [sprachliche Gestalt]"—that is, becoming "an object of communication"—is necessary for "ethical resolution [sittlicher Entschluß]" to enter life—to enter the "moral world" (die moralische Welt)—but this moral world can be "illuminated by the spirit of language" only in ethical resolution (*W* 1, 336/I:1, *176*). As illustrated by literature, name as ethical resolution or task is so devoid of moral color that referring to a task may seem too moralistic. Whereas "all representation [Stellvertretung] in the moral [moralischen] realm"—from "the patriotic [vaterländischen] 'one for all' to the martyr-death of the redeemer"—is "of a mythic nature" (322/*157*), literature originates where the word frees itself from task, from "the spell of even the greatest task" (323/159). ("You talk to me of nationality, language, religion, I shall try to fly by those nets." *P*, 203) If it is to be conceived at all as task, ethical freedom is the necessity that is the aforementioned infinite task (pages 59–74); for this philosophically conceived task, name is the eternal return of colorless nature. The supernatural is this name-nature that is the object of philosophical loyalty. "[L]oyalty" as a "divine" moment (*W* 1, 326/I:1, *163*) breaks through the "mere life" in which the human's relationship with "supernatural" life has disappeared (308/139). The eternal return is death in life. Loyalty to the eternal return in things is memory of death; "memory" (Erinnern) seeks its "loyal spouse [Gatten]" in death (VII:1, 60). The supernatural, the eternal return, is physis making death—in its very mystery—unforgettable. A "'memento mori' guards [wacht] in physis and in the mneme [memory] itself" (*O*, 218/I:1, *392*). Physis destroying semblance is the unforgettable name that is in things as no living semblance. Philosophical loyalty is based on the inorganic community of name.

IN NAME OF INORGANIC COMMUNITY: ETHICAL BODY

Even though there is no unmediated recognition, "concrete elements"—concrete relations with nature—are rooted in name (*O*, 234/I:1, 407; *W* 1, 72/II:1,

154). Benjamin does, of course, articulate a contrast of paradisal naming (as a completion of God's creative word) with nonparadisal naming (as an "uncreative imitation of the creative word") (71/*152–53*). Paradisal "immediacy" is "the name," and this name is "communication of the concrete"; nonparadisal "immediacy" is something "judging" (richtend), something sunk into "the abyss [Abgrund] of prattle," into "the abyss of the mediateness of all communication, of the word as means, of the vain [eitlen] word" (72/*154*). Between these two kinds of immediacy, however, there can be intimations of the relationship that "recognition" (Erkenntnis) and "deed" (Tat) have within "linguistic magic" (*C*, 80/*GB*, Vol. 1, 326). In nonparadise, there can be paradisal play of name. There can be "recognition [Erkenntnis] of things" that is not only based in name (*W* 1, 71/II:1, *153*) but also based in name as the expressionless word interrupting the talk of the liar (224/I:3, 832), interrupting talk presuming to evade the secret (340/I:1, 181).[65] In this capacity of interruption, name is the form, philosophy. "Truth is discovered in the essence of language [Wesen der Sprache]" (*W* 1, 353/I:1, 197). As the essence of language, name cannot be fulfilled; it is the *form* of philosophy, the *form* that is philosophy, interrupting ostensible fulfillment. Although anywhere and everywhere, the form, philosophy, unites in no living order, no order of the living. The form, philosophy, unites in the community of what cannot be lived. In a different, yet not removed, context, Christa Wolf writes: "Unlebbares Leben. Kein Ort, nirgends."[66] Lévinas too refers to metaphysical desire as desire not seeking return, in the sense of not desiring the "land of our birth" but rather a "land" that is "foreign to every nature" and has never been and never will be anyone's "land."[67] For Benjamin, this form, philosophy, is the inorganic community of name.

The philosophically communitarian power of name is its interruptive power as residue of paradise in nonparadisal social order. For paradise as the Bible presents it, good and evil are "unnameable," are "nameless," are "outside" of the language in which the human named things. Entering "the abyss" of the "question [Fragestellung]" of good and evil, the human then "abandons" the language of names (*O*, 234/I:1, *407*). In the fallen condition of the "language-spirit," the "*human word*" has stepped out of the name language; the name "steps outside itself" (*W* 1, 71/II:1, *153*). With this abstraction or lack of concreteness, there is less name and more judgment. There is pervasive and unavoidable evil. As the snake seduces to "recognition [Erkenntnis]," the latter "knowledge [Wissen]" of good and evil had hitherto been the "only evil" (71/*152–53*). The only evil had been outside of name, outside the paradisal *language* in name. In nonparadisal conditions, human existence (along with the name, which is inextricable from it) is the perpetuation of evil under the order of judgment. As suggested above, however, this does not en-

tirely annul resonance of name as linguistic being rather than mere agency of judgment. There is a linguistic—a philosophical—basis for considering "action" (Tat) weakened if it is treated as simply having its source in "sayable and articulable motives" (*C*, 80/*GB*, Vol. 1, *326*). Resisting subjugation of youth to a past represented during World War I in chauvinistically nationalist terms, the young Benjamin refers to a law that he and his kindred spirits are still not "able to name" and yet "feel" as "duty"; they "feel" "related by blood" (blutverwandt) to history that is "coming [kommenden] history" ("Gedanken über Gerhart Hauptmanns Festspiel," II:1, 59–60). This blood-affinity is no feeling for a mythological familial or racial bond; it is, rather, a bodily feeling for the ultimately unrecognizable, yet always coming and always effective, colorless physis that is the nameless in name, the word in name, the inorganic community of name.[68]

In contrast, evil is knowing formed against this inorganic power of name. Social order will not, of course, function without basic knowledge of good and evil. Such knowledge of good and evil permeates what can or cannot be called knowing in a specific social context. This knowing is the evil intrinsic to social order. With the story of the serpent promising the first humans that they will come to recognize good and evil (Gen. 3:5), the Bible "introduces evil under concept of knowledge [Wissens]" (*O*, 233/I:1, *407*). Benjamin's adaptation of this biblical notion has been elaborated above. The evil of knowledge is that it functions as closure amounting (however momentarily) to absolutization, to fanaticism. Evil is a mirage, a "*fata morgana*," of an "empire" (Reich) of "absolute"—"Godless"—"spirituality" (230/*403*). Evil is "fanatic spirituality" (230/*404*). These strong formulations could perhaps be lent credibility if we think of cases in which ostensibly beneficial knowledge has unwittingly led to obviously detrimental results—for example, to often fatal cases of pollution, poisoning, explosion, "side effects," and so on. For Benjamin, these would only be very dramatic demonstrations of the evil of knowledge. An evil empire of spirituality is a "counterpart" (Gegenstück) of the specifically "material element" (dem Materialischem) to which it binds itself (230/*403*). To put this another way: Such a material element—a person, an event, an appearance, some kind of living body—is the hypostatized counterpart of Godless significance. As imposition of spirit on matter, knowledge is evil. The "data" of "knowledge" (Wissen) are "incapable of entering philosophical constellations" (231/*404*). Philosophy is not the evil closing off allegory but the *good* keeping it open.[69]

The only home of philosophy is the nature common to all and everything but uncorporable in any representation of life. As suggested already, evil is the nonbeing that is representational reality (*O*, 233/I:1, 406). Disillusionment with this nonbeing of evil does not lead into a "dizziness" of

"bottomless depths," for the bottomless abyss has a profundity in which the images—whether sacred or hell-like—are ultimately forced into allegories of redemption (232–33/405–6). Evil—"immense anti-artistic subjectivity"—"converges . . . with the theological essence of the subjective" (233/406–7): the confrontation of subjectivity with the emptiness of its representations turns subjectivity into something that is neither "semblance [Schein]" nor "satiated being [gesättigtes Sein]" but rather "the real reflection [die wirkliche Spiegelung] of empty subjectivity in the good" (234/*407*).[70] There emerges the "Körper" as "a moral instrument" (*W* 1, 396/VI, 82). This body (Körper) within, yet also independent of, the body as "Leib" is the possibility of "decision" (Entscheidung) with regard to the resurrection of "körperliche" nature (395/80). Such allegorization, the "allegorical image of the world," is an entire inclusion of "the subjective perspective" in "the economy of the whole," in "God" (*O*, 234/I:1, 407).[71] Whether or not this is eventually acknowledged by the initially hypostatized subject, destructive materiality compels transformation; images become allegories of the origin that they cannot represent. This is recognized in the inextinguishable philosophical body that resurrects destructive nature and thereby pushes recognition beyond lived or livable forms. This body does not die; it is the force of death and philosophy prevailing within and over every lived body.

In Benjamin's theological ethics, hope is the necessary home that allegorizes every lived home. The "house of the outermost hope" is "the semblance of reconciliation" (Versöhnung) which "may, indeed . . . ought, to be wanted." The hope for mystery—the "most paradoxical, most fleeting hope"—is the sole justification for the semblance of reconciliation (*W* 1, 355/I:1, *200*). The semblance of mysterious, invisible nature is justifiable (may—indeed ought—to be wanted), for this outermost hope is semblance already presented in semblanceless; this most essential home is already presenting itself in secret nature. Hope is the sole presentation of the essential home; it is the sole presentation of ethics. The moral essence of the human is the secret body perceptible solely in ironizing, in allegorizing, the perceptible. The old edict against making a graven image does not simply ward off idolatry; so prohibiting "the presentation of the body [Leibs]" deters any presumption of being able "to portray [abzubilden]" "the sphere in which the moral essence [das moralische Wesen] of the human is perceptible" (*O*, 105/I:1, *284*). The convergence of hope with necessity is theological, for hope is the paradoxical glimmer of mystery independent of semblance. Hope is allegorical. It is a glimmer of invisibility; it is a glimmer of God's nature. Nature "incapable of being unveiled" is nature "that keeps safe a secret [ein Geheimnis verwahrt]" as long as God allows this nature to exist (353/*197*).[72] God is the determinant of nature incapable of being unveiled. God's nature is the home of allegory and hope.

In this theological sense, hope is identification with the allegorizing home to which all and everything belong. As identification with the universally ironizing (allegorizing) body, all hope—even the "richest" hope—is based on only the "slightest" glimmer, a glimmer like Venus. This planet is evening star and morning star; it is the evening star that—by virtue of its size and its distinct position between sun and earth—rises in the twilight and outlasts the night as long as the sun remains somewhat dim for us (*W* 1, 355/I:1, 200). Hope is a Venus-like glimmer of mystery. In any case, hope is a star-like reflection of the revelatory sun that cannot be seen. The "symbol" of the star (descending over the lovers) is a form of expression suited to "mystery [Mysterium]" in *Elective Affinities* (355/199–200). As long as the "sun of revelation" (*C*, 224/*W* 1, 389/*GB*, Vol. 2, 393) has not dawned, Benjamin says in another context, reflection of its imperceptible mystery is an idea and indeed is integral to any idea; ideas are "stars" (224/389/393). (See page 150 above.) The evil of the presumption to bear the sun of revelation is opposed by stars recovering mystery. ("murderers of the sun" *U*, 411) Hope kills presumption to the revelatory sun. Any presumed semblance of revelation may be wrenched or elicited into presentation of its illusoriness; this is wrenching or eliciting into the force of death, for death is the sole concrete world. If they encounter one another only "indirectly" through "mediation" by a mythological sun god, human and death remain rigidly opposed to one another, without a "concrete [anschauliche] world" that is "common" to them (*W* 1, 33/II:1, *123*). The concrete world common to human and death makes itself perceived as the force that cannot be perceived. The death's head is all-pervasive, for things are subject to the force perpetually changing appearances. The relationship of this force of death with the faint glimmering of hope is illustrated by *the place of the skull*—Golgotha, where Christ was crucified (*O*, 232/I:1, 405). The poignancy of Jesus's death is not the Christian martyr-drama but rather an allegorical power. With his death, the hope placed in Jesus enters allegory; Jesus's death is, above all, a resurrection of allegory.

—Did the idea ever occur to you, Cranly asked, that Jesus was not what he pretended to be?
—The first person to whom that idea occurred, Stephen answered, was Jesus himself. (*P*, 242)

Considered apart from myth, Jesus's death is the prototype for the rich tension of death and significance in allegory. As the allegorical combines "insight [Einsicht] into the transience [Vergängliche] of things" with "concern [Sorge] to redeem [retten] things in the eternal [Ewige]" (*O*, 223/I:1, *397*), "significance [Bedeutung]" increases correlative to the "subjection to death [Todverfallenheit]" (166/343). Drawn into community with death, significance is

drawn beyond semblance—is enriched—by physis. The star of hope shines into the communal body extinguishing all suns supposed to reveal this body.

Evil is catalyst of hope, for hope is the tension of death with evil significance. Whereas the Romantics consider a work too bad to be criticized if it does not contain an "immanent seed [immanenten Keim]" of "reflection" (*W* 1, 159/I:1, *78*) and conceive of the work's alignment to "the absolute" as criticism completing the work through the latter's decline (164/85), Benjamin comes to suggest the allegorically bad (the nonallegorical, nonironic semblance) is a never entirely extinguishable denial of death, the sluggish everyday denial in which representation is lived as though it is not unreal—is lived as though its death were not within it. Death and evil significance are seeds in existence but there is no grace annulling the tension between them; death and significance "mesh with one another as seeds in the creature's graceless state of sin." The meshing does not extinguish gracelessness in significance; there remains a significance that functions as denial of death. The meshing of death and significance has grace solely in an allegorical way. Notwithstanding the spell of representational significance cast on the functioning of lived life, significance can be—and indeed, ultimately is—allegorized by death; as long as nature is always subject to death, it is also always allegorical (*O*, 166/I:1, *343*). Correlatively, no artwork may appear "thoroughly alive" (durchaus lebendig) (*W* 1, 224/I:3, *832*), may appear "completely unspellbound alive [gänzlich ungebannt lebendig]" (340/I:1, *181*), without becoming mere semblance and thereby ceasing to be an artwork (224, 340/I:3, 832, I:1, 181). It must show itself in life but must show this living appearance to be a spell. As it grounds its appearances in secret, the artwork is congealment of death. It is petrification (340, 224/I:1, 181, I:3, 832). Art gives way to the death in significance; showing living appearances to be a spell, the artwork opens to a significance that is no longer a spell. As "death digs most deeply the jagged line of demarcation between physis and significance," significance is compelled to be allegorical, to show itself to be other than what it represents or could represent (*O*, 166/I:1, *343*). The hope intrinsic to art is this other, which is inorganic community ironizing—allegorizing—the inextinguishable evil that is living appearance, appearance of or for living.

In contrast, law cannot concede its own "immense irony": its mythic origin in a court judging as though it could provide what it cannot possibly provide—true knowledge of good and evil (*W* 1, 71–72/II:1, 153–54). The youthful especially feel this irony; they have a feeling for ambiguity that law cannot tolerate. The young Benjamin remarks: "[t]he unfree will always be able to show us the canon of their laws"; left with a "feeling" giving it "courage for what others call cliché," for action prompting others to call youth "muddled," youth is indeed "muddled"—just like "the spirit of history" (II:1, 60).

Insofar as it is distinct from imposition, the spirit of history is in the inorganic body that survives and ironizes judgment, life, and even death (the event of death isolated from irony). No period has entirely quashed the notion of some sort of life beyond "organic corporeality" (organischen Leiblichkeit) (*W* 1, 254–55/IV:I, 11). The two "universal contexts" of "body" as "Leib" and of body as "Körper" (corporeal substance) involve respectively "dissolution and resurrection," although the boundaries of these two contexts waver or fluctuate. In the "Leib," the human belongs to "humanity" (Menschheit), which is evidently humanity in living social order, in some order of the living; in the "Körper," the human belongs to God (395/VI, *80*). As the "Körper" ironizes the "Leib," death ironizes the body belonging to this life and it ironizes the notion that death is no more than the end of this life. In the body belonging to God, death ironizes the body belonging to the court—the body over which the court in some countries or states can still rule as judgment over life and death. The court functions as though oblivious to the ironizing inorganic body.

Yet even the tragic law is overdetermined. Tragic death is "overdetermined"; the "origin of tragic irony" is that death is "an ironic immortality [Unsterblichkeit]" (*W* 1, 56/II:1, 135). The ostensible immortality is overdetermined, ironized, by a force not contained by the law. Although tragic death is supposed to uphold ancient right, it is also "a first sacrifice" announcing "new aspects of the life of the people" (neue Inhalte des Volksleben). As the latter prophetic element of agon frees death of epic-didactic justification, death is a "crisis." This crisis becomes "salvation [Rettung]" insofar as it disempowers Olympian law and—"as the first fruits of a new harvest of humanity"—is offered "to the unknown god [unbekannten Gott]" that is free of the guilt-context for which the death is otherwise a sacrifice. The hero or heroine is annihilated on behalf of the law, but there can be benefit to "the life of the as yet unborn community of the people [Volksgemeinschaft]" (*O*, 106–7/*285–86*). Mythic moral content cannot be the last word (105/*283–84*). As implied already, the historico-philosophical signature of tragedy includes the agonal death keeping the end paradoxical (109–10/*288–89*). The end is paradoxical, for it is ultimately no end. As experience of the resistant force of death, the agonal death ironizes the mythic seal of tragic law.

As suggested already (pages 166–67), Socrates lacks even this much agon. Socrates' "brilliant unfolding of speech and consciousness" lacks agon vis-à-vis the legal forces bringing about his death. This follows partly from his elevation of speech and of consciousness over death. The tragic hero and heroine at least recoil before death as an inescapable power that is already personally familiar. Socrates regards his death as "something alien, beyond which, in immortality, he expects to return to himself." Parodying the moral

finality of tragedy and thus helping to free death from tragic justification, Socrates' death is indeed the birth of martyr-drama—drama presenting the justification for the death sentence as questionable. Like Christian heroic faith, however, Socrates' lack of agon toward his sentence is denial of death; he implies "perfect awareness" and no "natural shudder before death" (*O*, 113–14/I:1, 292–93).[73] Notwithstanding Socrates' apparent certainty, there is no certainty that he will return after death. There is no assurance that "I" shall survive death, whether I am Socrates or anyone else. To believe otherwise is to be unphilosophical about history. The philosopher's task is one of understanding "all of natural life" from this life of history. The task of understanding all of natural life requires understanding that is willing *not* to understand (in a conceptual sense). The concept of life receives its due only if the natural life independent of organic corporeality is credited to anything "from which there is history," anything that "is not only a scene of history" (*W* 1, 254–55/IV:1, *11*). A scene of history is never simply a scene of history, although there may be great temptation to ignore this. The "scene of history" is subordinate to a "great process of decomposition." Redemption is lent to history solely by a liberatory force accompanying this process of decomposition (226/VI, 98). The ensuing drama of redemption is the ironizing that law ultimately disallows. Socrates' lack of agon vis-à-vis law indicates his own disregard for this dramatic, ironizing force of inorganic life.

The philosophical value of inorganic community is the latter's ironizing force. In the "tragic experience," as the young Lukács notes, death is an immanence making beginning and end simply elements of one predetermined time.[74] Contrary to such presumption prevailing in tragic legal identity, there is no immanent justification for death or for life. Death is crisis, drama, in life (*O*, 106–18/I:1, 284–97). In the tragic life, death seems an individualized fate subordinate to the "immortality" requiring atonement (109, 136/288, 314). Lacking this tragic predetermination of life and death, the mourning play shows death at least implying a kind of martyr-like appeal that is a charge—a desperate plea—against death. Hamlet's death by poisoned rapier has, after all, a merely accidental, external character (136–37/314–16). Life and death belong to the inorganic. It is, therefore, legitimate to mourn a fate; all-encompassing organic life—as tragically defined legal space—does not rule. As stage properties acquire the independence befitting a nontragic, profane world, these realia ultimately belong to a temporality of the hereafter; the daytime of tragedy is gone and "manifestations" of "destiny" stand instead in midnight, in the midnight hour (Hamlet's "the very witching hour of night" [III, 2]), in a temporal hole, a time without spatial correlate. Unlike the subhuman ghostliness of Stifter's figures who integrate themselves into predominantly visual-spatial nature (pages 139, 178–79, and 221 above), the

"ghostly image" (Geisterbild) in the mourning play constantly reappears in the "opening in the passage of time," in the "spirit world [Geisterwelt]" that is "ahistorical" (geschichtslos) (*O*, 132–35/I:1, 311–14). This ahistorical world of death takes away figures' named individuality but not the "vitality [Lebenskraft] of the role." Defined neither in visual nature nor in tragically defined individual life, death is a ghostlike summoning that is "communal destiny" (gemeinschaftliches Schicksal) (136/314–15). As communal destiny of crisis and drama in life, death annuls predetermination in appearances and prevents legal material content from being the highest material content (*W* 1, 297–98, 309/I:1, 125–26, 140).

> ... Asked if he had any message for the living he exhorted all who were still at the wrong side of Māyā to acknowledge the true path. ... *We greet you, friends of earth, who are still in the body.* (*U*, 300)

If the true path, the path of philosophy, is love, the love of wisdom, it is a love that mourns and plays *life*. This path cannot be lived entirely; in that sense, it is death in life. Death in life as the norm of love is fostered quite prominently in certain works by Benjamin. As certain marriages show, the "norm of law" is "master" over "vacillating love." However unwittingly, Goethe defers to this standard while unable to let "true love reign" in either of the principal pairs in *Elective Affinities* (Ottilie and Eduard, Charlotte and the Captain) (*W* 1, 345/I:1, 188). One cannot have true love reign entirely in life. Yet one separates oneself from the force of love only in a futile secession from the necessity of the inorganic, the necessity that is the theological basis of love. Attempted secession from the community with its soul in destructive materiality (in materiality not indulging such attempts of secession) is independence that is the "illusion [Schein]" of "secession from the community of the pious" (*O*, 230/I:1, 404).[75] Law is such a secessionist illusion. In the soul not indulging such secessionist illusions, subjectivity is "acknowledged" so that there may be opening to wisdom and love triumphing over "every deceptive objectivity of law [Rechts]"; the "hell" (Hölle) of subjectivity can be incorporated into "divine omnipotence" (*O*, 234/I:1, *407*). Subjectivity may be so conceded that there is a beginning of its incorporation into the theological love greater than subjectivity and greater than any ostensible objectivity (such as law) defining subjectivity. As Benjamin traces "[s]ubjectivity" that crashes down like an angel into the depths, is overtaken by allegories, and held fast in heaven—in God—by the mysterious weighing (the "ponderación misteriosa") (235/408–9), neither the overtaken subjectivity nor Benjamin's criticism constituted in this moment entails a subject dominating in the manner of Schmitt's dictator.[76] Incorporation into divine omnipotence is no omnipotence of subject; it is opening of subject to the soul that is physis. Soul is

death in life. Love is performance of incompleteness in relation to this soul. Had true love reigned in *Elective Affinities*, the characters would have opened to "inclination" (Neigung) as a force freeing them from the ostensible completeness of semblance. This has been stressed already (pages 139, 157, and 210–11). With inclination, the body would have broken beautiful semblance. In love, passion and inclination pass in and out of one another; passion may give way, therefore, to inclination. The importance of inclination in love is to recall that it is not love itself; it breaks down the association of love with beautiful semblance. As the work of death in Eros (Eros thanatos), inclination enters all loving as a demonstrative admission that "the human is not able to love" (*W* 1, 345/I:1, *187*). This admission of incompleteness redeems love as death, the force that cannot be lived. The beauty not relinquished in love will eventually fall to death (353/198). As a force ill-disposed to beautiful semblance, love is inorganic community.

Love involves philosophical beauty, the beauty derived from the power of death in life. Opposed to beautiful semblance, the only philosophically justifiable beauty mortalizes semblance. Not able to be beautiful, the basis of philosophico-historical beauty is imperceptible to the living (350–51/196–97; VII:1, 53). Perceptible only as the imperceptible, the basis of philosophico-historical beauty is death. Weakness, indefiniteness, may proclaim death beautiful; this proclamation does not, however, realize death as "shape in its most profound bond [Bindung]" (*W* 1, 23/II:1, *110*).[77] As the latter bond, death is semblance-destroying; it is the destruction largely lacking in *Elective Affinities*. While the dead bodies of Eduard and Ottilie are placed beside one another, Goethe remarks: "Peace hovers about their abode, smiling angelic figures (with whom too they have an affinity) look down upon them from the vault above, and what a happy moment it will be when one day they awaken again together."[78] This concluding Nazarenism is a Christian mysticism out of place in an artwork (*W* 1, 355/I:1, 200). As implied already, such Christian mysticism has nothing to do with the allegorically rendered death of Jesus. Infinite love is no "simple love" willingly facing death on the assumption that it shall outlast death (348/191–92). The artistic counterpart of the utopian "certainty of blessing" (borne by the two main figures in the novella within *Elective Affinities*) is a "hope for redemption" that is the hope harbored for all dead persons. This hope is harbored, for our own bodies are essentially membership in the community of the dead. As "the sole right of the belief in immortality [Unsterblichkeitsglaubens]," moreover, this hope cannot be bound with our person, with our lived body to the exclusion of its death. A last hope is never for the one hoping. Perhaps like Socrates, I can have a last illusion or arrogance about some semblance of my person; such illusion or arrogance is, however, distinct from a last hope. Certain uncertainty legitimizes no

beautification of death or concerning death. It is "only as a trembling [zitternde] question" that the "'how beautiful' resounds [klingt] . . . after [nach] the dead persons who, we hope, awaken, if ever, not in a beautiful world but rather in a blessed one" (355/*200*). No belief in the lived body to the exclusion of its death, this hope for blessedness is hope for unity with the transformative, destructive force contained in no semblance. The immortal, destructive force also gives courage. Just as belief in immortality may never be kindled on "one's own existence" (355/200), the courage important for Benjamin involves a "deeper boundedness" (tiefrer Verbundenheit) than any personal feeling for living to the exclusion of death within living (33/II:1, *123*). On the basis of such courage for death within living, Joyce's Gabriel somehow registers the love in his wife that is not love for him and not a love that he has felt for anyone. Love is death removing attachment to semblance.

> Generous tears filled Gabriel's eyes. He had never felt like that himself . . . but he knew that such a feeling must be love. The tears gathered more thickly in his eyes. . . . His soul had approached that region where dwell the vast hosts of the dead. He was conscious of, but could not apprehend, their wayward and flickering existence. (*D*, 220)

In the secret that is God's nature, the human must be death and love; before God, the "human appears to us as corpse and the human's life as love" (*W* 1, 353/I:1, *197*). The living human is not God's nature but rather an allegory of this nature that the human cannot live; in allegorical majesty, the body is love and death. Allegorical majesty, Benjamin later says, is destruction of the organic and living, the extinguishing of semblance (*W* 4, 172/I:2, 669–70). According to his *Elective Affinities* study, love and death enter the "human body [Körper]" as the power to divest, as the power without semblance, the power that is the secret of God's nature (*W* 1, 353/I:1, 197). Whereas Ottilie's "living body" (lebendiger Leib)—subordinate to the living and their law—is only a beauty of semblance (scheinhafte Schönheit) (353/197), the "veilless nakedness"—the naked "body" (Körper)—of the young woman in the novella is scarcely noticeable in the wake of her majestically sublime deed (351–52/196; see also page 155 above).[79] The woman's attempted suicide is not surrender to the order of semblance so much as a rebellion against it. In this rebellion, her leap into the water initiates the destruction of semblance by her and by the young man lovingly risking his life by attempting the rescue of her. At least in this utopian context, Benjamin still refers to a divine will; this will is semblanceless overcoming semblance. With the "death leap" (*W* 1, 332/I:1, *170*) of the young woman and the young man's rescue of her, the "moment" of common "readiness for death through divine will" gives the pair "the new life" on which "the old rights lose their claim"

(345/188). Preparedness for death is divine insofar as it is the force of love devoted to freedom from societal semblance.[80] Unlike the figures in the novel, the two main figures in the novella do not attempt to buy "their peace through sacrifice" to such semblance (*W* 1, 332/I:1, *170*). Not peace with semblance but peace with semblancelessness is their priority. If it follows this priority or insofar as it follows this priority, even marriage can become supernatural in the "power of true love" (345/188). The sacramental can, of course, be transformed into semblance, into myth (402–3/I:3, 837–38). As loving engagement of death's forces ("Über Ehe," VI, 68–69), however, marriage can involve the "Verwandtschaft" (kinship or affinity) that is "the closest human boundedness [Verbundenheit]" in terms of both "value" and "grounds"; in marriage, the bond can become strong enough to qualify as literalization of metaphorical kinship (*W* 1, 346/I:1, *188–89*). In this grand affinity, life is no longer simply nondeath and death is no longer simply nonlife.[81]

This divine sense of community opens to its home in the allegorizing force of physis. In death, "the body [Körper] . . . first gains its highest right," for only in the corpse does allegorization of physis prevail "vigorously"; only as corpse does one enter "the allegorical homeland" (*O*, 217/I:1, *391–92*; see also 217–20/391–93). In love, insofar as it is love in this sense of community, we are prophets of death; we are phantoms lending the grace of death to life. ("Twilight phantoms are they yet moulded in prophetic grace of structure. . . ." *U*, 411) Courage for death as the home of life is not a "characteristic" (Eigenschaft) so much as it is a "relation" (Beziehung) of human with world and of world with human (*W* 1, 33/II:1, *122–23*). As implied already perhaps (page 203 above), every "angst" (Angst) is angst concerning death (*W* 1, 317/I:1, *151*). Rather than confront the death inherent in life, angst seeks solace and security in mythic guilt-contexts (316–17/150–51). Heidegger regards angst as a stepping-stone to understanding Being. Benjamin discusses angst, rather, as desperate clinging to myth, although he thinks it can be catalytic evil—a prelude to collapse into, and perhaps engagement of, the allegorizing force that is destructive physis. More openly than is the case for Heidegger, Benjamin's rebellious preparedness for the force of death in life is theological; in advance (so to speak), it seems to resist the understanding of "authentic Being-towards-death" as outlined in *Being and Time*.[82] Benjamin's theological excess or surplus is, however, no "mysticism of the negative" in the sense long alleged by some Benjamin critics.[83] In this theological excess or surplus, an interactive relationship with death is, as suggested above, an interactive relationship with life.[84] Courage for death in life is resurrection or redemption of the allegorical homeland. In an objection that Benjamin forecloses "the possibility of indicating general historical tendencies capable of leading to a state of reconciliation,"

Benjamin's Messianic philosophy of history has been associated with the risk of political quietism or resignation.⁸⁵ Yet Benjamin's theological wariness of reconciliation is intrinsically a danger to quietism and resignation.⁸⁶

Benjamin's Messianism is the danger of awakening hope, which is indeed a danger for general historical tendencies. ("That it was a Utopia, there being no known method from the known to the unknown. . . ." *U*, 622) In its intrinsic danger, divine hope requires courage for the "pure ground of shaping." Courage is a "spiritual principle" attached to no specific shape, or at least it does not rest with any specific shape (*W* 1, 33/II:1, *123*). It is an inexhaustible shaping power. The divine drama (226/VI, 98–99) must be in transient shape but is not such shape; it ensues from the immortally ironizing life that is a "basically eternal continued life" (255/IV:1, *11*). Courage for the death in shape is a passivity but a very distinct passivity. The authenticity of "timidity" (Blödigkeit) is its courage that is an "innermost identity" with "the world"; in the "middle of life," there is nothing besides "motionless existence"—the "complete passivity" that is "the essence" of the courageous: the courageous can give up "entirely" to the "relation" (Beziehung) (34/II:1, *124–25*). Giving up entirely to the relation is no effete posturing in a relation; this courage for relation is courage for the death in relation and is thus a dangerous undertaking (*W* 1, 33–34/II:1, 123–24). Such abandonment to the shaping power, which is dangerous in being no shape, is anticipated in the heroic moment of "complete passivity" that is an ultimately silent but ironic counterpoint to fateful tragic time (56/*135*); tragic passivity is distinct from Ottilie's "perfect [vollkommener] passivity," which in no way introduces dissonance in her mythic sacrifice (334/I:1, *173*). Beyond myth (including tragic myth), in any case, there can be no clinging to a specific "veil" (343–44, 352–53/185–86, 196–97). Courage for the death in shape is passivity of the middle that can be no veil and cannot be unveiled.⁸⁷ The history of Eros is death reminding hope—inclination reminding passion—that the most beautiful has not been reached. Hope and passion are intertwined and revived in love's memento mori (*W* 1, 342–56/I:1, 184–201).

This revival of hope and passion is based on the aforementioned relationship of memento mori with the eternal return (or at least with eternal return as Benjamin sometimes conceives it). Memento mori is physis relativizing—ironizing—this star with determinant yet unattainable eternal stars ("loves own star . . . loves young star" *U*, 697): "Before you get strong for the battle on your star / I sing to you of struggle and victory on higher stars"; "[b]efore you grasp the body [leib] on this star / I invent for you the dream among eternal stars." The "[s]ublime irony" of "[b]efore you grasp the body" is, of course, that this body is never grasped (*W* 1, 355–56/I:1, *200–201*).⁸⁸ This

body is permeated by the ironizing body; intractable physis makes ungraspable what is ostensibly graspable. As courage for the power of death in life, love has its "origin" (Ursprung) in anticipation or premonition—*Ahnen*—of "the blissful life." It does not force, imagine, or reminisce happiness into appearances of this life. It is not that fleeting and rare contemplative satisfaction "in the 'halcyonic' stillness of the soul" (*W* 1, 352/I:1, *196*). It is not the love so unplayful that it is considered, in the *Trauerspiel* book, to be secondary to mourning (see pages 170–71 above). The love advanced in Benjamin's works is no will to still the dynamic of passion and inclination, of hope and death. Its eternal return is no stilling of appearances, no entwinement of anticipation and nostalgia.

> the picture of halcyon days where a young gentleman . . . was offering a bunch of flowers to ladylove. . . . The colours were done something lovely. . . . She often looked at them dreamily . . . and felt her own arms that were white and soft just like hers with the sleeves back and thought about those times because she had found out in Walker's pronouncing dictionary . . . about the halcyon days what they meant. (*U*, 353)

> How fast are they fled, halcyon days, how fast (*PE*, 58)

> BLOOM: . . . Halcyon days.
>
> *(Halcyon Days, high school boys in blue and white football jerseys and shorts)*
>
> THE HALCYON DAYS: Mackerel! Live us again. Hurray!
>
> *(They cheer.)* (*U*, 498)

No sentimental stilling of appearances, the inorganic is reason. Having lived from 1596 to 1650, Descartes belongs to the "baroque" era. What Benjamin depicts as a baroque motif may, however, illustrate the problematic aspect of Descartes's thinking self. Bringing spirit or reason into contact with the world, physical influences break Cartesian "dualism" with suffering that is not just ache, injury, and lust but—incorporating all of these—death (*O*, 217–18/I:1, 391–92). This baroque motif could be construed as a burgeoning modernist motif. With developments such as obvious sexual lust, decaying skin, thinning hair, or the increasing propensity of certain surfaces to stink, the body is physis reminding us that we are no self-contained consciousness; impending death is somehow already here.[89] Any bodily transformation—including aging, amputation, the need for sex, the need to urinate and defecate, and simply the need of the body for cleansing—is death knocking at the door of consciousness. Concerning the aforementioned baroque motif but also in-

dicating his own philosophical emphases, Benjamin summarizes: The "corpse-like" includes not only changes brought with aging but also limb loss and all processes of "excretion [Ausscheidung]" and "cleansing [Reinigung]" (*O*, 218/I:1, *392*). Kristeva considers such changes and processes to "stand for the danger to identity coming from without" ("the ego threatened by the non-ego, society threatened by its outside, life by death").[90] For Benjamin, the danger of death is identity.

Without identity in death, spirit and reason would be semblance. They would have no philosophically productive force. The latter concerns the source that also makes life the "output [Produktion] of the corpse"; this source is an often uncomfortable force, as graphically illustrated by nails and hair growing again on the corpse but "cut away like something dead from the living" (*O*, 218/I:1, *392*). Albeit curtailed by the life functioning through maintenance of semblance ("the abscission of such divine excrescences as hair and toenails" *U*, 624), this productive basis pushes spirit and reason beyond semblance. Precisely the lack of command over death ("Yea, after death time tends to play with us / when rot / maggot and worm burrow in our corpses. . . .")[91] is the basis for the passivity or timidity whereby we are *not* simply the "transient" (Vergänglichen) held in "fleeting time" ("Dichtermut" [second version]); "the persevering, the duration [das Beharrende, die Dauer]," exists within the very "shape [Gestalt] of time and of humans" (*W* 1, 31/II:1, *119*). The identity-relation leading intensively to the time-sculpting space leads extensively to the shape-form, "to an infinite shape-form [unendlichen Gestaltform]," a death-shape, "a sculpture [Plastik] that is—as it were—coffined [zu einer gleichsam eingesargten Plastik]," a sculpture "in which the shape becomes identical with the shapeless" (31/*120*). Shapelessness is the power for shaping, the power keeping shape in transience that is not semblance.[92] Death-shape is identity of reason.

In the reception of Benjamin's work, there is occasionally a tendency to underemphasize shapelessness—death within shape—as the basis of obligation. It would be misleading to suggest that "Verbundenheit" in the Hölderlin essay ultimately concerns a communicated or communicative "Solidarität." Lexically speaking, "Verbundenheit" can mean "solidarity." Yet the Hölderlin essay does not use the noun "Solidarität," the adjective "solidarisch," or any such formulation. "Verbundenheit" is indeed obligation as well as bond.[93] For Benjamin's early philosophy, however, "Verbundenheit" would be less a communicatively mediated "solidarity," which seems anyway so often a cloak for domination or intrigue or some other kind of moralizing swindle, and more a "boundedness" in the shapelessness of shape.[94] Although the boundedness emphasized by Hölderlin and Benjamin is no shunning of the "living" or the "people" as influence and reception (*W* 1, 24–26/II:1, *111–13*),

the relevant "growing determinateness of intensified shapes" (26/*113*) requires that the "innermost context" remain a "shaping" on the basis of the deep middle (24/*111*). As noted already, the middle is no narrowly aestheticist concern. It is necessity; it is death. Not only does song or poetry have its "origin" in the middle but this origin also underlies "all functions"; ideas of "art" and of "the true" emerge from, are founded by, and express the "unity" that is death. Death unites "all recognized [erkannten] relations"; death is the shape of "return [Einkehr]" (34/124).[95] Death is the shape of (that which the early Benjamin sometimes conceives as) eternal return; perhaps noteworthy in this context is that "communion"—in the sense of reflection upon oneself—is among the possible translations of "Einkehr." Communion with death presents obligation to the middle in which all things and all people, all epochs and all generations, converge. In this middle, as not only Benjamin notes, things and people, epochs and generations, above all communicate incommunicability.

> The voices blend and fuse in clouded silence: silence that is the infinite of space: and swiftly, silently the soul is wafted over regions of cycles of generations that have lived. . . . Elk and yak, the bulls of Bashan and of Babylon, mammoth and mastodon, they come trooping to the sunken sea, *Lacus Mortis*. . . . They moan, passing upon the clouds, horned and capricorned, the trumpeted with the tusked, the lionmaned the giantantlered, snouter and crawler, rodent, ruminant and pachyderm, all their moving moaning multitude. . . . (*U*, 411)

The dead are with the living and are moaning or mourning on behalf of the silence that the living are so unwilling to hear. The silence of *Lacus Mortis* (the lake of death) is hearable as the inorganic middle—the inorganic community. This community is the necessity and the obligation disregarded as certain theoretical tendencies turn "[c]ommunication" into "a sacred term."

"[N]on-communicative" texts are treated as "non-texts." The allegedly incommunicative is "suspicious" and "the center of communication theory" amounts to "exclusion in the name of universal inclusion." Exclusion is perpetrated "in the name of communication." It is hoped, "of course," that help can be found for the "pathological cases of individuals with private language deformations."[96] The irrationality of this outlook consists in its authoritarian desperation to be the answer of reason.[97] ("LYNCH: He likes dialectic, the universal language. . . . Get him away, you. He won't listen to me." *U*, 527) Under the ostensible expunging of the inorganic in this outlook, ghosts of the slaughtered can expect at most pity (Mitleid).[98]

Contrary to what is sometimes assumed, Benjamin does not imagine that we could now let "dead victims" assume "anew the form of animated beings"; he does not think "personal integrity" could or should be "restored ret-

rospectively" by admitting them into the "moral community" of humankind. For Benjamin, there is no current moral being who is to bring about "a communicative disclosure of the past" for the sake of "a symbolic restitution of the victims' moral integrity."[99]

It is the school sometimes going by the name of discourse ethics that suggests personal integrity and moral integrity are delegated by living beings—or at least by those among us deemed to be correctly communicative. Unlike the living, the dead don't know how to talk; they are real dummies that way.[100] In this perspective on the dead, humans have no ethical connection with being deceased and the deceased have no ethical connection with life.

The living and the dead are, however, inextricably connected in inorganic community. This community is an integral element of the only sense of humanity that Benjamin might wish to defend. The human is not simply on the way to the "end" (Ende) of "historical life" ("the *Leib*" functioning as the human's "historical present"). As elaborated often above, the human is also a relationship of historical life with "körperliche," resurrective nature (*W* 1, 395/VI, 80).[101] This human is not shy about the latter nature. Art cannot, for example, be a matter of "shyly" ([s]chüchtern) singing a cosmos for which decline is simply the singer's own death (*W* 1, 22/II:1, *109*). As medieval and baroque humans demonstrate, a "death-obsession [Toddurchdrungensein]" can be much more than being impressed by consideration of the end of our respective lives (*O*, 218/I:1, 392). The obsession of art with death is expression of corporeal, resurrective nature amid otherwise bodily, adaptive nature. Adorno also discusses this. To avoid getting caught in adaptive nature (the societal mesh that art somehow opposes), art (as Beckett's *Endgame* shows in an "exemplary" way) eliminates or attacks "the nature for which it is meant" (the nature "der sie gilt," translated not entirely inappropriately by Lenhardt with the interpolation "living nature"); the "sole single *parti pris* possible for art is that in favour of death."[102] Death is art's sole permissible bias. Any other lasting attachment is semblance. The so-called second Vienna school of composition unfolds and revives musical tradition by refusing it the possibility of resisting decay.[103] For Benjamin, resurrection of decay opposes not only communicative dismissal of death but also communicative dismissal of the dead. In somewhat this vein, Cixous has a chorus asking why the dead should be incessantly killed as punishment for having been killed.[104] Horkheimer thinks that past injustice is over and done with; the murdered are murdered. Benjamin counters: the Last Judgment—or at least a theological faculty independent of "Wissenschaft"—is always already somehow with us demonstrating our ability to consider ostensibly concluded suffering as unconcluded (V:1, 588–89).[105] As Cixous suggests, those open to such an ability are obviously those for whom "the dead / are never as dead as one thinks"; the ensuing

resurrection—as would be the case in Cixous's play concerning a mother of children who were killed through official negligence that led to them receiving transfusions of HIV-infected blood—may even unsettle the present on behalf of a subversive future.[106]

> Would the departed never nowhere nohow reappear?
> Ever he would wander, selfcompelled, to the extreme limit of his cometary orbit, beyond the fixed stars and variable suns, . . . to the extreme boundary of space, passing from land to land, among peoples, amid events. Somewhere imperceptibly he would hear and somehow reluctantly, suncompelled, obey the summons of recall. . . . [H]e would somehow reappear reborn . . . and after incalculable eons of peregrination return an estranged avenger, a wreaker of justice on malefactors, a dark crusader, a sleeper awakened. . . . (U, 648–49)

The dead do not need us and do not need to be like us; their resurrection simply wreaks the justice of keeping the present in a state of suspension about itself and, therefore, about the future. As inorganic life in the present and in the present of the future, the dead are effective—whether welcome or not. "One must accept the presence [Anwesenheit] of the dead as dialogue partner or dialogue disturber. Future consists solely of dialogue with the dead."[107] Philosophically conceived obligation to the dead simply saves the living for the necessity of an open time. The ethical element is that the return of the dead saves life from being lived as though it is justice or even could be justice. Saving oneself, Aloysha says to Ivan in *The Brothers Karamasov*, is possible only if loving life is accompanied by bringing back the dead "who, perhaps, may never even have died."[108] They have not died; they are the inorganic haunting organic life. Marx and Benjamin sensed that the dead are not dead in history.[109] The language of ghosts is not a possibility that the dead can become more like us living, *morally animated* beings. ("What is a ghost? Stephen said with tingling energy. One who has faded into impalpability through death, through absence, through change of manners." U, 188) The redemptive power of the dead (as implied above by Aloysha) is that they snap us out of any ostensible victory in life. This relationship of death and ethics is not particularistic, although it is not subordinate to universalistic claims of an ethics based on certain communicative principles and procedures.[110] Even as hatred on behalf of those dying or dead under an especially brutal victory of life over death, Benjamin's memory of the dead is an obligation to death as a universal condition keeping communication in the conclusive resonance—the rhythm—of philosophical inconclusiveness.

As universal basis of ethics, death in life is unfolded by Benjamin with regard to many contexts. Among these are the country of his birth and most of his education (Germany) and the occupation (scholarship) for which he was

trained. Concerning Germany, Benjamin's intertwining of ethics and death seems noteworthy in various respects. Nazi Germany's presumption of life having power over death was apparent in the choice to bring about the deaths of so many and in the claim to give many something in life for which it would be worth dying. Fassbinder's movies often suggest that this presumption of life over death continues as the post-Holocaust inability to mourn.[111] Benjamin discusses a German intolerance of death in life and does so with reference to a period long before Nazism and post-Holocaust Germany. This empowerment of life over death emerged in the "illusion" (Schein) of empty shape exploited as though it is "infinity" (Unendlichkeit), as though it is "freedom" to penetrate the "forbidden." Such inability to mourn history—an inability to let death into history—emerges sometimes as something called consciousness. This "consciousness" (Bewußtsein) is a "swindler's [gauklerische] synthesis" of materiality and spirit, a synthesis aping "the genuine [echte] synthesis, that of life" (*O*, 230/I:1, *404*). The genuine synthesis, which is life, is dying shape—shape in death. Death must be heeded if history is not simply to be an abstraction in the Satanic manner that swindles with its synthesis of material and spirit—that swindles with an imposition of spirit upon matter. The "terrors and promises of Satan" are undermined in the genuine synthesis, the life or soul resurrecting destructive materiality (226–30/400–404).

Revolt of the inorganic also seems to be at play in some of Benjamin's remarks concerning scholarship and career. The young Benjamin suggests that the student capable of loving will learn from the "scholarship" (Wissenschaft) of the teacher but not regard the occupation of the teacher as a desirable end (*W* 1, 42/II:1, *82*). The university is "completely seized" by the "occupational spirit," the occupationalism isolating the university from "the unofficial creative life of spirit" (41–42/*81*). The unofficial creative life of spirit is a power of death in life. Benjamin later contrasts this power with the occupational subject dominated by careerist ethos—by the empty and absolutistic moralism of the Lutheran "Berufsethik" presuming to unite ethics with everyday occupational life (*O*, 84/I:1, 263). This ethos is an untenable emblem of life, for it ultimately devalues the force of death in life. Robbing the dead and death of their productive power in life, religions or religiously imprinted ideologies often cultivate collective compulsions that are supposed to dispel the feeling of being alone with one's death.[112] The German baroque playwrights are somehow aware of this. These playwrights, who (as Lutherans) cannot believe in salvation through penance or merit filtered through Church hierarchy, are also incapable (as distinctly reflective Lutherans) of having their anxiety quelled by a morality of petty loyalty and upright living. This anxiety is crystallized in their fear of death. As existence seems a rubble of "partial, inauthentic actions," life is horrified by this existence

and by the death simply looming at the end of it. Life lashes out. Life "feels deeply that it is not there merely to be devalued by faith" (138–39/*317–18*). Such devaluation of life is devaluation of death in life. As the young Benjamin says, self-preservation becomes self-betrayal. "[T]he I [das Ich] self-preserves itself [selbst-erhält sich]" by clinging to "the instrument," to "the time, which the I ought to play." With no time remaining for the "timelessness" in the middle of which "incomprehensible death lurks," death looms instead as the inconspicuous killer behind the everyday; the clinging to the time of self-preservation simply continues until "the great death" comes to it, until death "falls from the clouds" like a hand no longer permitting this life to continue (*W* 1, 10–11/II:1, 97). With regard to the effect of this on scholarship, even Max Weber's otherwise relatively sanguine discussion of "Wissenschaft als Beruf" (1918) could be construed to imply a point also cropping up here and there more emphatically throughout Benjamin's work: the inorganic revolts against its devaluation by occupational life—by organic life, by the life facilitated by occupationally surviving and advancing.[113]

There is a sense in which Benjamin considers philosophy to be interminably unofficial, inorganic communal form. The young Benjamin proclaims: Letting "youth and cultural values come to terms with one another in a new philosophical pedagogy" ("Ziele und Wege der studentisch-pädagogischen Gruppen an reichsdeutschen Universitäten [mit besonderer Berücksichtigung der 'Freiburger Richtung']" [1913], II:1, 65), the student will belong to a community with no hold on the student besides philosophy; "Wissenschaft" will be based on this community that receives "its general form"—its pertinence to anything and anyone—"solely from philosophy" (*W* 1, 42–43/II:1, 82). As Benjamin conceives it, philosophy is not a job; it cannot work under the constraints of occupational survival and advancement. This is thematized somewhat in the *Trauerspiel* book. Pondering whether the chief purpose of humans is simply survival, Hamlet wonders whether God really would have given us "capability and godlike reason / To fust in us unused." Benjamin refers to Hamlet's expression of the "philosophy of Wittenberg" as also "a revolt against it" (*O*, 138/I:1, *317*).[114] For Benjamin, the chief purpose of the human is to have transient shape (the "doom of dead form" [Verhängnis der toten Form]) descend upon the divine and have the divine turn shape inside out, have the divine turn fully into object of sculpting (*W* 1, 32/II:1, *121–22*). The doom of dead form may at least be purposefully attenuated by the death force. Variations of this as a poetic move are often traced by Benjamin. In the *Trauerspiel* book, this tracing concerns and completes a move beyond constraints imposed by a Germanic pagan-Protestant subjection of reason to strict conformity with a fate of abstract spatiality emptied of any notion of "good works" (*O*, 138–39/I:1,

317–18). Against the Wittenberg betrayal of reason, Benjamin's philosophy revives itself in and as inorganic community.

Occupational morality and the denial of death in life converged most brutally in Nazi Germany. As portrayed by Klaus Mann, Nazism and illusionistic Protestantism intertwine in a number of ways amounting to presumed expungement of (what Benjamin might regard as) the philosophical impulse; the revolt of Hamlet is, for example, suppressed by the Nazi-doting actor (modeled on actor-director Gustaf Gründgens) playing a Prussian Hamlet.[115] As implied already, Benjamin's *Trauerspiel* book lends itself to being read as an anticipatory critique of such a condition.[116] Benjamin is not lamenting the Catholic church opposed by the Reformation; he is lamenting the unnecessary loss attending Lutheran denial of death—denial of good—in life (*O*, 138–39/I:1, 317–18).[117] If God is death requiring philosophical revolt, God cannot be appeased with a morality of occupation or by any other secular authority (including ecclesiasticism, Catholic or otherwise).

—Do you fear then, Cranly asked, that the God of the Roman catholics would strike you dead and damn you if you made a sacrilegious communion?
—The God of the Roman catholics could do that now, Stephen said. I fear more than that the chemical action which would be set up in my soul by a false homage to a symbol behind which are massed twenty centuries of authority and veneration....
You do not intend to become a protestant?
—I said that I had lost the faith, Stephen answered, but not that I had lost self-respect. What kind of liberation would that be to forsake an absurdity which is logical and coherent and to embrace one which is illogical and incoherent? (*P*, 243)

Inorganic logic and coherence is the revolt of necessity. Benjamin is supposed to have said to Scholem in 1916 that any "philosophy of my own," if it is developed, "somehow will be a philosophy of Judaism."[118] Such a philosophy would seem to be distinct from Judaism identifying revelation with a "people" (Volk) and its "law" (Gesetz) (VI, 90). God "opposes myth" in "all spheres" (*W* 1, 249/II:1, 199). The Judaism to be advanced by Benjamin would seem to include the Christian precept identifying revelation with a humanity that is "nobody" and no law (VI, 90). This is also Gide's "Jewish seriousness" (for which Gide's non-Jewishness is irrelevant); it is detectable in *La porte étroite* as a renunciation or privation in Alissa that is independent of the Church's rules and values (*C*, 148/*GB*, Vol. 2, 47; II:2, 616–17).[119] The ghost heard by Hamlet is also a ghost of inorganic nature; hearing this voice of death, Hamlet hears the divine body break upon the body in lived order. In turn, Hamlet helps us hear the ghost of philosophy.

—He will have it that *Hamlet* is a ghoststory [H]e wants to make our flesh creep....

My flesh hears him: creeping, hears....

—The play begins.... It is the ghost, the king, a king and no king, and the player is Shakespeare who has studied *Hamlet* all the years of his life ... in order to play the part of the spectre. He speaks the words ...:

Hamlet, I am thy father's spirit

bidding him.... To a son he speaks, the son of his soul, the prince, young Hamlet and to the son of his body, Hamnet Shakespeare, who has died in Stratford that his namesake may live for ever. (*U*, 188–89)

Shakespeare's namesake is his work, which may live forever as ghost of its constitutive, inorganic force. Hamlet hears the father, who is death, and he thereby hears Shakespeare's art. Hamlet becomes the work through his father as ghost. The ghost, the artwork, enters the son. The father once had the secular authority of king but is no longer such a king; he is instead the specter becoming the son who rebels against secular authority. As the artwork, the son is the voice of the dead (in the name of the Father, the Son, and the Holy Ghost).

He is a ghost, a shadow now, ... a voice heard only in the heart of him who is the substance of his shadow, the son consubstantial with the father. (*U*, 197)

Consubstantiality with the creative substance of shadow is entry into the light of the night. Zarathustra says: "Night is also a sun."[120] The night has its own light, which is quite distinct from the darkness of myth (II:1, 26; *W* 1, 314/I:1, 147). This night of philosophy is distinct from any mythic day or night. As the younger Thomas Mann tries to compress art into the cause of the warring German nation, he makes dubious leaps from national to universal or from universal to national.[121] In explicit contrast, Benjamin addresses a struggle against the night that is a struggle requiring "its deepest darkness"—the night's deepest darkness—to be moved to deliver "*its*" light"; this light of the night is the light of everything and belongs to nothing (*C*, 83/*GB*, Vol. 1, 348). As difficult as it may be to deliver light of night into the day-to-day affairs of politics, any politics attempting to disregard this light of night entirely is myth. In a discussion of immigration procedures in Germany, it was remarked that the "right to democratic self-determination certainly includes" the earlier citizens' "right" to "insist on the character of their political culture," a political culture securing "the society against collapse into unconnected [beziehungslose] subcultures."[122] It may seem doubtful that the relevant subcultures so obviously are, or would often remain, unconnected in the implied way. The severity of the dismissal of so-

called subcultures is chauvinistic insofar as it hypostatizes its culture and denigrates those not fitting into this hypostasis. This would be an unnecessary abandonment of critical and productive spirit. For Benjamin, an ultimate priority is the "productivity" and the criticism requiring that "the life in spirit" be sought "only with all names, words and signs," for "[w]e"—all of us—"are in the middle of the night" (*C*, 83/*GB*, Vol. 1, 348).[123] In this or that political situation, it is obviously not possible to accommodate every potentially relevant empirical particular. It is possible, however, to attempt having productivity and criticism performatively based on—or at least not detached from—the inextinguishable light of the night to which all essentially belong anyway.

This inorganic community is always unassimilable, is always somehow youth. Youth is "the pure word for life in its immortality" (*W* 1, 80/II:1, 240). In *The Idiot*, therefore, Prince Myshkin's life is "most certainly immortal [ganz gewiß unsterblich]," "internally and spiritually" immortal (80/*239*). As internally and spiritually immortal, the life of youth remains a hope even as it is externally more or less lost.[124] The immortal life of youth is not practically fulfillable; it remains, however, as reminder that the practical constraints on it are somehow not true. Youth remains as loss, and thus as a hope. Youth continues as the abyss of the crater left by youth itself. Youth remains the immense abyss of a crater from which we may hope great forces could sometime be released. The paradox, indeed the impossibility, of destructively resurrective humanity is the catastrophe of youth; youth performs its humanity by destroying itself—"humanity [das Menschentum]" is reached "only in a catastrophic self-destruction [nur in einer katastrophalen Selbstvernichtung]" (*W* 1, 81/II:1, *240–41*). As crater, imprint, resonance of this self-destruction, youth remains as a basis of lament. Youth as inorganic humanity is unrealized yet inextinguishable. Dostoevsky's "great lament" in *The Idiot* is "the failure of the movement of youth" (80/*240*), and Gide, who cannot find what he seeks in childhood, can nonetheless be shaken by, and lament, the "frustration" (Vereitlung)—"the inner insulting [Kränkung]"—of childhood, the movement of a love that Alissa comes to believe she can find only through a privation that is ultimately suicidal (II:2, 616–17). Benjamin obviously is not suggesting that the inorganic—immortal—life is a demand (in the guise of ethics or anything else) for suicide or even asceticism. The lasting beauty of youth is, however, youth's unsustainable indulgence of the resistance of death to living order.[125] In all beauty, after all, there is a kind of secret mourning on behalf of what cannot be sustained in organic life (VII:1, 53).

As inorganic community, youth is no automatic readiness to die. Aging might provide one with a "readiness to die" (Bereitschaft zum Sterben), whereas youth is simply "readiness for death" (*W* 1, 353/I:1, 198). The latter readiness can conceivably lead to dying but it is not defined by this

possibility. ("Better pass boldly into that other world, in the full glory of some passion, than fade and wither dismally with age." *D*, 220) Youth is, above all, a creative energy simultaneously based on struggle against the life depriving this energy and on lament about this life. Although the creativity can be carried out only by those grown up enough to develop and effectively show the feeling of solitude in life, the latter "acknowledged yearning for a beautiful childhood and worthy youth" is the sole "condition of creation" and a constant power of renewal (*W* 1, 45–46/II:1, *86*). Even as Benjamin focuses less exclusively on youth, he suggests that some variation of such yearning is the lament basic to creation and indeed criticism. To say the very least, there is no reproaching the artist who—instead of examining "moral countenance" from the perspective of adulthood toward childhood—does the opposite, as does Gide: "the narrow doorway" (la porte étroite, die enge Pforte) is the entry to heaven less for the "virtuous [Tugendhaften]" than for "the childlike [kindlichen] humans." This artist is struggling for an "unfeigned" outlook on "guilt and salvation" (Schuld und Seligkeit) (II:2, 615–16). An unfeigned outlook on guilt and innocence keeps prevailing forces of life somewhat in suspension, showing them to be questionable. This unfeigned outlook is the aforementioned readiness for death. It is indicative of her youth that Ottilie "knows her way to death [Todesweg]"; although she betrays this knowledge by ultimately dying as a compulsive sacrifice to living semblance, she is at least less fixated than Charlotte on living (*W* 1, 353/I:1, *198*). Youth and death converge in their inability to be realized in social order, whether this be state, military, father, or some other realm.[126] Benjamin is outraged as Wyneken basically exhorts his young followers to die for such living authority.[127] To die for such semblance is a variation of living for it. It is not youth.

> —Try to be one of us, repeated Davin. In heart you are an Irishman but your pride is too powerful. . . .
> —No honorable and sincere man, said Stephen, has given up to you his life and his youth and his affections from the days of Tone to Parnell, but you sold him to the enemy or failed him in need or reviled him and left him for another. And you invite me to be one of you. I'd see you damned first.
> —They died for their ideals, Stevie, said Davin. Our day will come yet, believe me. . . .
> —. . . Ireland first, Stevie. You can be a poet or a mystic after.
> —Do you know what Ireland is? asked Stephen with cold violence. Ireland is the old sow that eats her farrow. (*P*, 202–3)

The nation eats its children—leads them to die or at least terminates their youth—insofar as nation and humanity are not recognized as mutually depen-

dent "metaphysical laws," as metaphysical laws that are "absolutely mutually dependent" (*W* 1, 78/II:1, *237*). Although Benjamin does not mention this, it is integral to Dostoevsky's opposition to the ecclesiastical universalism of the Roman Catholic church that he regards—as Benjamin notes—"national heritage" (Volkstum) as the only "medium" in which "humanity [die Humanität] can unfold" (78/*237*) and that his political teachings suggest "the last hope" is "regeneration" of national tradition (80/*240*).[128] A kind of Dostoevskian association of "Volk" and humanity could conceivably also be effective in Benjamin's anti-assimilationist interest in Zionism.[129] Without endorsing Dostoevsky's variant of nationalism, Benjamin's logic in the Dostoevsky review could be developed today on behalf of some nationalisms: various aboriginal or "First Nations" concerns with regard to dominance by various "European" cultures; French and Quebecois concerns about Anglo-cultural domination; comparable opposition in various forums to socioeconomic priorities generally more prominent in the United States than in other places; some nationally oriented tensions correlatively surfacing against the political, socioeconomic, or cultural imperatives of so-called globalization. These nationalisms are philosophically justifiable solely in their opposition to myths of usurpation; from this philosophical perspective, they cannot themselves succumb to such myth-making. In Benjamin's philosophical emphasis, nationalism is no psychological condition gluing nation, home, individual, and society into a mannequin-like representation; that would be "childish" (kindisch), says Benjamin (*W* 1, 78/II:1, *237*). If it produces "pure humanity," the national is in transition, a "fiery primordial gas" (78/237). Following the Shoah, the metaphor of gas is not one that would be so readily used in a discussion of the national. The national might be referred to as gaseous, however, as idea resisting solidification or consolidation. Lack of humanity in the extant nation is, therefore, more than characters in *The Idiot* can stand; without the "nature" or the "childhood" to reach "humanity" (Menshentum), Dostoevsky's characters (especially the female ones) talk in a manner disintegrating into an overwrought yearning for childhood (81/*240*). As Benjamin conceives them, the national and the humane in Dostoevsky's work are congruent ideas and not congruent with any existing nation. That is the dilemma for various characters in *The Idiot*. The "national" and the "humane [Humanen]" are important in terms of "metaphysical identity"; they are to be considered with regard to "idea" (79/*238*). It could well be as a translation of the early Romantic "basic mystical conviction" concerning "the indestructibility of the work" (165/I:1, 87) that Benjamin says the "episode" of Myshkin's life emerges to make the "immortality" of this life "visible symbolically" (79/II:1, 239). This symbolic visibility of the immortal and indestructible is apparently what is formulated elsewhere by Benjamin as allegorical. As Dostoevsky "presents" the "destiny of the world" in "the

medium" of his people's "destiny" (78/*237*), national destiny is world-destiny or universe-destiny that is felt, but felt as not lived or livable.

Along with his remarks that the music and lyric poetry of the German "nation are superior to those of every other people," Dilthey reiterates his methodological precept that "the key to understanding poetry is to be found in the lived experience [Erlebnis]."[130] The "task" or "precondition" of a poetic expression of life, Benjamin seems to counter, is not communication of "the process of lyrical creation" or the "person," "world-view" (*W* 1, 18/II:1, 105), or "individual life-mood" of the artist; it is rather "a life-context . . . determined by art" (20/*107*). Regardless of how close it may be to the eternal life of nature, moreover, this immortal life (the life-context of art) is distinct in giving infinity its "highest lustre," which may be the luster of catastrophic decline (80–81/*239–40*). From the perspective of criticism, Benjamin notes Schlegel's reference to a blooming of the whole from the individual death as one gives death to the single work with regard for "the work, which none of the / mortals finishes" (163/I:1, 84–85).[131] Benjamin does not quite follow Schlegel's emphasis on bloom.[132] The immortal force nips bloom in the bud. In the sense in which Benjamin fosters them, melancholy and mourning are the persistence of the immortal work against mortal attempts to bloom for it. For baroque writers, nature is a "great teaching mistress [große Lehrmeisterin]" appearing not "in bud and bloom" but in "overripeness and decay." Nature appears as "eternal transience [ewige Vergängnis]"; this baroque view thus also recognizes "history" as eternal transience (*O*, 179/I:1, *355*). Natural history is history as ruin, death mask, death's head (166, 177–8/*343, 353*). For Benjamin as well, only "the transient" (das Vergängliche) is "eternal" ([E]wig]); or to put it more precisely: images arise "in the name of death," arise in the name "of transience as the highest category of natural existence."[133] In the artwork, according to Benjamin, death is the duration or the perseverant moment that is the shapeless and colorless (in this sense, primordially gaseous) immortal.[134] Only the perseverant, enduring, colorless force of death revives passion and hope against claims to complete, or even to bloom for, them. Not any "lived experience," this force of death is the basis of art and criticism.

This inorganic force of love and beauty is name in things. The name in things is inorganic as the force opening appearances to the destructive materiality — the transience — within them. As late as 1931, Benjamin insisted that his early philosophy of language had nothing to do with "the aseity [Saturierheit] of bourgeois scholarship" and that the *Trauerspiel* book's "strict observance of genuine academic research methods" diverges from "the bourgeois-idealist business of scholarship" (*GB*, Vol. 4, 18). Benjamin's very early concept of "objective [sachlichen]" and simultaneously "highly political style and writ-

ing" is also to lead "to what was denied to the word" (*C*, 80/*GB*, Vol. 1, 326); objective usage of name, as has been elaborated often above, presents—that is, performs—nature's withholding from name. Objective usage of name presents the force of the wordless word, the nameless name, in objects. Bourgeois aseity and its business of scholarship are diminishment of thoughts about death, diminishment of thoughts about the wordless word in name. The theological dimension in Benjamin's criticism does not entail hermeticist elitism or presumption of being immediately for God; such tendencies have nothing to do with Benjamin's quest for "true" contemporaneity (a quest illustrated by the Talmudic legend about angels who—at each moment and in innumerable flocks—sing their hymns before God in order to cease and pass into "nothingness" [*W* 1, 296/II:1, 246]).[135] Benjamin's reading—his attempted contemporaneity—is preparing for its death. A reading without death has stopped reading. It is presumption to judgment outside the name, or to name outside the word. Benjamin's reading inherits and bequeaths name as word more than judgment. His reading thereby inherits and bequeaths community as death. Preparing for its death, Benjamin's reading inherits and bequeaths obligation to the necessity of inorganic community. The storyteller, Benjamin would later say, borrows authority from death, an "authority which even the poorest wretch in dying possesses for the living around him" (*W* 3, 151/II:2, 450; see also 93–95/449–51). Even the poorest wretch dies in this power that is also the intrinsic power of the name. Everything and everyone passes into this power that destroys semblance, this power of the rebellious thing, the rebellious body; the name is the human's constitutive possibility of resurrecting this power of death anywhere. In this way, name is inorganic community.

BEQUEST: UNFORGETTABLE, WILD SOLITUDE

The association of philosophy and death is apparently made quite early by Benjamin; the "alluring name" of a deceased first schoolmate, the first name on which he "consciously heard fall the accent of death," "stood unuttered" as— toward the end of his school days—he wrote his "first philosophical essay" (*W* 2, 624/VI, 504). Yet each human's proper name already betokens the potential for philosophical participation in the community of the dead. Indicating no property of the person that it names, the proper name always already takes each human beyond living semblance and thus is a force of philosophy accompanying each human. As elaborated throughout this study, things also have character independent of living appearances and such character could be called name-character. Humans do, moreover, give proper names to many things and

animals.[136] It is, however, the human experience of the proper name—the human experience of this name not communicating any property—that is the basis of Benjamin's theory of the proper name. The human's proper name marks the solitude of the human in community not defined, or in any way oriented by, its existence as organic being (see pages 43–48 above). This solitude in inorganic community is the moment of potential philosophizing in humans.

Philosophizing is the human inheritance and bequest of feeling in death—a feeling that is withheld from, and thus somehow beyond, living. In the decision to philosophize, humans may resurrect their relationship with inorganic solitude. The solitude of death in life is the time—or timelessness—that is more fundamentally common than is lived time. In the "distance" or "interval" (Abstand) based on "our being [Wesen]," which is time shining "as I that we are," the "I" in the diary loosens itself from the time of clocks, calenders, and stock markets (*W* 1, 11–12/II:1, 97–98). I am not the "murky inwardness" of that "experiencing being [Erlebenden]" who calls me "I" and "torments me with familiarity." More essentially, I am the "beam [Strahl] of time" (11/97). This time "befalls all things around us as our destiny"; it is, Benjamin says in a somewhat Lévinasian formulation, "the immortal [Unsterbliche] in which others die" (12/98). The situation with the diary is indicative of the freedom enabling humans recurrently to present community with the dead—community with familiarly alien destiny that is quite distinct from any alien security such as might be provided, for instance, by mythology (24–25, 28/109, 116). As the familiarly alien destiny, freedom in life is no "venial" life-feeling leaving a dualism of human and death (33/123), a dualistic "tension" between these "two worlds" (33/122). As a mortal feeling for the immortal, freedom is a feeling for death as the threat of "reality" (32–34/122–24). As real life, death is familiar alienness constantly confronting humans anew and taking them into themselves by taking them out of the selves that seem to keep them from lending expression to their solitude. ("[T]hat I may learn in my own life and away from home and friends what the heart is and what it feels. . . . Welcome, O life! I go to encounter for the millionth time the reality of experience and to forge in the smithy of my soul the uncreated conscience of my race. . . ." *P*, 253).

The uncreated conscience of any race is death as the necessity, but (as indicated already) also the obligation, to think beyond any established moral topos. "[I]mmortal [unsterbliche] life," the "imperishable [unvergängliche]" life, is unlivable for it has no "vessel or form," no "monument" or "keepsake" (Andenken), perhaps even no "witness." Precisely as vesselless and unrecognizable, immortal life is unforgettable; its sign is simply that it is "unforgettable." It "cannot be forgotten," for it is the irrepressible, uncontainable life force making every vessel of life transient (*W* 1, 80/II:1, *239*). The un-

forgettable life so prevails as object of devotion in Myshkin that his final illness is one in which he forgets about what might be called his lived life; his "loss of memory [Erinnerungslosigkeit]" is "symbol of the unforgettable [des Unvergesslichen] in his life" (80/*239–40*). The idiocy of youth is that its life is the unforgettable, the immortal, life that cannot be lived. "The life of youth remains immortal but it gets lost in its own light: 'the idiot'" (80/*240*). The light of semblance is blind to what is outside it; the light of youth is blind to semblance. Youth's own light so darkens the dark—the semblance, the gleam—of myth that survival is threatened. It may seem idiotic to try to have a life that, after all, cannot be lived. ("O anything no matter who except an idiot" *U*, 692) Yet the ethical correlate of the irrepressible immortal life is that the latter "is not to be forgotten" (*W* 1, 80/II:1, 239). Ethics may thus be considered the idiot necessarily in all of us, although relatively few of us so heed ethics that we risk seeming idiotic in the context of survival or indeed advancement. The convergence of ethics and unlivable necessity has been discussed often above. As "Hamlet's heart is embittered" and he "feels disgust before the world" (whatever is construed as prevailing sociohistorical world), this is not renunciation of the world "in misanthropic willfulness" but opening to "the feeling of a mission" living in him, the feeling that he came to this world "to set it right [einzurenken]" (II:1, 9).[137] Hamlet's curse is his strong identification with the dead; he feels compelled to amend the lived time that is disjointed by its disregard of the dead. "The time is out of joint. O cursed spite, / That ever I was born to set it right!" (*Hamlet*, act I, scene 5).[138] The idiotic convergence of ethics and life incapable of being lived is implied in Benjamin's very early view that the "spiritual principle" of "becoming-one [Einswerdung]" with the world (*W* 1, 34/II:1, *124*) requires "total submission" (Hingabe) to the "danger" of death (34/123). Benjamin is more explicit somewhat later: "Everything moral [Alles Moralische] is bound to life in its drastic [drastischen] sense, namely there where it holds itself in death as the abode of danger as such" (*O*, 105/I:1, *284*).

As life in the danger of withdrawing from the living and their laws, ethics is obviously solitude. From the perspective of such solitude, prevalence of "office" and "profession" is abandonment of "scholarship" (Wissenschaft). With "an easy conscience" and realizing the distinctness of scholarship from "bourgeois" certainty or security, the student may lovingly and dangerously surrender to youth and "Wissenschaft" (*W* 1, 42/II:1, *81–82*). Career scholars and scientists hardly ever feel able to announce publicly the solitude in which they are dead to career and collegiality. Peer review has, of course, understandably been considered a kind of progress beyond *more openly* nepotistic and *more openly* arbitrary institutional forms. Whether in or out of a career context, however, it may be questionable to identify peer review and moral rectitude. The latter identification

is, for example, an opinion that presumably makes it easier for certain states to be comparatively complacent about enacting the death penalty (at least somewhat on the basis of peer review). Inorganic solitude cannot celebrate peer review or indeed any other identification of moral rectitude with institutional form. It mourns these institutional identifications and cannot support them with epic-didactic endorsement. Particularly when a career-context enters the process of review among peers, moreover, an adaptive morality may very easily flourish that is especially dangerous for inorganic solitude. Refusing to support the cover-up by medical scientists of a scandal concerning HIV-infected blood, Mme. Löwe says simply: "How alone I am. Adieu, my brothers and my teachers / I see you flee. Everything is fear and cowardice." Doctor Brulard decides to join her: "Madame! May I accompany you? I feel so alone."[139] The young Benjamin asks: "Where are those who are lonely [einsam] nowadays?" (*C*, 50/ *GB*, Vol. 1, 161)

Just as ethics is the lonely danger of death in life, truth and career are inherently incompatible. Truth cannot, of course, be defined as the kind of honesty that does not permit the telling of lies. As death, however, truth contrasts with career that is saturated with imperatives of sheer organic survival and advancement. Although the coupling of "Wissenschaft" and career develops in many places to an ostensible coupling of truth and intersubjective adjudication, intersubjective adjudication mediated by a career-context is a particularly irresolute ground for "Wissenschaft" and truth. Concern about these developments seems to have contributed to the explorations by Benjamin and Scholem of theological notions of truth. A "non-bourgeois way" of answering and posing "the linguistic questions" is sought by the young Scholem. Although a "religious standpoint" is the obvious alternative, he contends (presumably with Benjamin in mind) that "precisely the greatness of the coming philosopher must lie" in the achievement of a religious "perspective even *without* religion."[140] The sole exemplary religious perspective is that of being alone with God; this philosophical perspective is that of being alone with death, with the immortal life that cannot be lived in religion or anywhere else. The ethical dimension of this perspective is that it performatively resurrects the necessity of inorganic life and thereby performatively suspends criteria of good and evil prevailing in social life.

As implied already, this philosophical solitude takes place in the body belonging to God. The "Körper" is the corporeal substance that is "seal" (Siegel) of the human's "solitude" (Einsamkeit), which is "nothing other than the consciousness of . . . immediate dependence on God." This concept of "Körper" does not legitimize any presumption of expunging mediation. In the "Körper" as seal of solitude, however, the body is no longer contained in the historical body. As something other than the body (Leib) that simply lives and

dies, the body is corporeal substance—seal—which "will not break [zerbrechen]" even in death (*W* 1, 395/VI, *80*). The body belonging to immortal life is seal of solitude, for I am alone with this body—this corporeal substance—into which I die; I belong to this body and it belongs to no person, no persons, and no social form. The singularity of my experience of this nature is, moreover, fairly irrelevant to this nature; nature is "to the singularity of the body [Körper]" as currents in the sea are to a single drop of water (395/81). The singularity of the body is submerged in nature, in God's nature. This may be Benjamin's most profound Judaism.[141] It would be the Judaism to which Scholem refers as he says: "in the innermost basis of Judaism the concept of an answer does not exist."[142] In that sense, the de-anthropomorphized God is ultimately the de-*Volk*ed, de-legalized, and indeed de-Benjamined God. This has been stressed often above. The ahistorical, immortal, imperishable element is the body as the intense feeling, exemplified by Hamlet, of disgust and agony before the socialized body. ("He sprang from the bed, the reeking odour pouring down his throat, clogging and revolting his entrails. Air! The air of heaven. . . . [C]lasping his cold forehead wildly, he vomited profusely in agony." *P*, 138) Even a rebellion of the inorganic body will not, of course, manifest itself as divine. The inorganic body involves constant solitude in relation to bodily manifestation. To be shown at all, this solitude must constantly perform itself anew. Philosophical loneliness is no loneliness for which there is or could be a livable solution.

> Some instinct, waking . . . , stronger than education or piety, quickened within him . . . , an instinct subtle and hostile, and armed him against acquiescence. The chill and order of the life repelled him. He saw himself rising in the cold of the morning and filing down with the others to early mass and trying vainly to struggle with his prayers against the fainting sickness in his stomach. He saw himself sitting at dinner with the community of a college. What, then, had become of that deep-rooted shyness of his . . . ? What had come of the pride of his spirit which had always made him conceive himself as a being apart in every order? (*P*, 161)

Ethical solitude is inorganic community in the sense that each is alone (all are alone) with the body recalling truth as what cannot be lived. Those deciding to open to this feeling of solitude—"the humans with soul" (die seelischen Menschen)—want "something entirely the same [ein ganz Gleiches]." The same in this regard is, however, a symbol. It cannot be comprehended. Those wanting it must, therefore, perform it anew as unrealized; if those currently "sleeping unawares" are to be awakened to this "symbolic" community, those with soul must constantly change what they want (*C*, 52/*GB*, Vol. 1, *164*). The symbolic same may be wanted but only as solitude from any

lived or livable same. Addressing young Zionists, Scholem formulates this as follows: Not "the possibility of together wanting the same but solely the common solitude establishes [begründet] community."[143] As Benjamin suggests, this common solitude has no spatial correlate. Based on no body that we *live* or *could live* in or as social order, the "ethicalness of community" exists "independently" of the "ethicalness of its members"—that is, "in spite of their unethicalness" (*C*, 52/*GB*, Vol. 1, *164*). Constantly requiring performance of itself anew and as unrealized, ethicalness keeps us open to the common solitude in inorganic life.

The idea is so asocial that ethical progress in history is "only the free deed of very few" (52/*164*). Inorganic solitude may be common to all, but those performing it are few. Müller contends that minorities are the sole basis of thinking. Each of us has a biography that is of minority status in relation to the majority life (which we live for the sake of survival and advancement), but most of us have let this biography be "exterminated" (ausgerottet). Composed of those living out this extermination and not letting themselves get too "alone," the majority notices minorities mostly as it "drives over" them. "The exterminated biographies form the basis for the majority, and the pain over one's own extermination turns into hatred towards minorities."[144] Inorganic solitude is in conflict with the organic solidarity that is the day-to-day functioning necessary for the survival of a specific social order. Integrity of inorganic solitude is maintained only insofar as those feeling it continue to explore, performatively, exceptions to prevalent rule. Those performing inorganic solitude must—implicitly or explicitly—be generally ridiculed. They must be few. Usually, each performance simply involves new and different— perhaps younger—people inclined to risk or provoke such ridicule. As stressed often above, the inorganic community thereby served is never realized; it is, at most, performed (and never contained) in exception. In that respect, the few have no definite representation for what they are doing.

To be attentive to idea is to be wary of definiteness in the realm of representation or articulation.[145] Such wariness is agonistic. Dissociating from the "cowardice" of conventions and becoming "dirty and dusty" in the transformation of "harmless" and "private" "existence" (Existenz) into something "harmful" and "public," the artist is a "legionary" believing in a "higher service" that is incomprehensible (II:1, 70).[146] Unlike the dilettantism purportedly revealing the artist's "personality," "seriousness," and "moral purity," the "ethics of the artist" and the right of the artist derive from the scarcely fathomable in and of the "*work*" (II:1, 70).[147] The idea is possessed by nobody. If poetry may be so conceived that there is eventually to be nothing besides "the existence [Dasein] of the poet" (*W* 1, 33/II:1, 122), this existence is a reflection—a thoughtful, collected, and sober conduct—that is antithet-

ical to effete "rapture [Verzückung]" of the particular (II:1, 68) and to Platonic ecstasy, mania, frenzy (*W* 1, 175/I:1, 103–4). The latter—as ecstatic—presumes a being-outside-oneself so divine that Benjamin regards it as denial of the insurmountable tension of history and truth; although Benjamin does not mention them specifically, some of Socrates' remarks in the *Phaedrus* claim this kind of ecstasy. For Benjamin, those believing they ecstatically or otherwise expressively account for true community have already betrayed it.

The "most profound solitude," a solitude of "the ideal human in relation to the idea," may involve a solitude or loneliness in relation to other humans but above all involves an idea destroying "what is human" (Menschliches) (*C*, 50/*GB*, Vol. 1, *161*). As a humanity that cannot be what might be called a *lived* humanity, the idea is no loneliness which would be dissolved by other human beings. The "Ich" comes to itself in the "Ich" that cannot be lived; this is the interminable loneliness. "[R]eally lonely [wirklich einsam]" is solely "a human who has taken up the idea (no matter 'which')" (50/*161*). This solitude is real, for it resurrects idea; it opens to destructive nature. Genius is, moreover, solely this critical productivity that is no person or assembly of persons. Genius is solely the force again and again facilitating new performance of real solitude. Real solitude is necessary loneliness, regardless of how much it may be disregarded; it is feeling for the philosophically necessary, which is no necessity appeased in this or that social form. Benjamin seems to associate the "mysticism" of solitary genius ("Genius" that is "einsam") with the "forcing of community" (Erzwingung der Gemeinsch<aft>) (VI, 90). As noted already, only a few perform this forcing of community into the feeling of necessity; or perhaps it would be more accurate to say simply that the performance is rare, for those performing inorganic solitude do not—indeed could not—do so constantly. Life in social order could not function performing the community of inorganic solitude. The community of inorganic solitude persists, nonetheless, and must somehow be performed if there is to be any philosophical antidote to myth of this or that living social form.

> . . . I will not serve that in which I no longer believe, whether it call itself my home, my fatherland, or my church: and I will try to express myself in some mode of life or art as freely as I can and as wholly as I can, using for my defence the only arms I allow myself to use—silence, exile, and cunning. (*P*, 247)

Ingenious loneliness resurrects necessary loneliness. Necessary loneliness is loneliness of destructive nature in lived nature. Carla Seligson may thus well wonder whether a new youth movement would result in youths missing being alone (*C*, 53 n. 2/*GB*, Vol. 1, 166). For some, such solitude intrudes whether or not it is consciously wanted.

> To merge his life in the common tide of other lives was harder for him than any fasting or prayer and it was his constant failure to do this to his own satisfaction which caused in his soul at last a sensation of spiritual dryness together with a growth of doubts and scruples. (*P*, 151–52)

The philosophical solitude developing doubts and scruples concerning (whatever seems construed as) the social body emerges from the destructive mystery of the soul. ("The soul . . . has a slow and dark birth, more mysterious than the birth of the body." *P*, 203) In accordance with the inorganic body—the soul—that is mystery irreducible to anything conceivable as *lived* body, the modest and humble Myshkin is "completely unapproachable"; his is "the most complete [völligste] solitude" and all relations with him enter a "force-field" prohibiting "nearing" (das Nähern). As indicated by this unity of independence and irresistibility in Myshkin's force field, the power of inorganic life is unapproachable and yet is in everyone and everything. This inorganic community makes unapproachability and independence what is essential in everyone and everything. The "middle [Mitte]" of the order emanating from Myshkin's life is a "solitude" so developed, so mature, that it practically disappears: it seems to come very close to carrying everyone and everything around Myshkin in its "gravitational pull" (Gravitation, Gravitieren) (*W* 1, 79/II:1, *238*). The solitude does not disappear, however, for it is never sublated in appearance; it never entirely appears. Ethical conscience pains are stirred by inorganic solitude, which cannot quite be appeased. The end of inorganic solitude would be the end of the practice of philosophy.

There will be those who find all this unimportant. They will want to get on with living and will recognize no need to be alone in a philosophical sense. Precisely this tendency to reject philosophy is, however, a necessary counterpart of inorganic solitude in its ethical dimension. The myth of the living organism shows itself in ridicule, which can also simply be disregard, for that solitude and its unappeasable cold eyes.

> A woman had waited in the doorway as Davin passed by that night and, offering him a cup of milk, had all but wooed him to her bed; for Davin had the mild eyes. . . . But him [Stephen] no woman's eyes had wooed. (*P*, 238)

Even if one instead has mild eyes that are wooed, this will not entirely extinguish inorganic loneliness. That may even be why Davin cannot quite stop talking to the mournful Stephen; it may also be a source of hope for Stephen. That all emerge from—and, in some sense, can never entirely extinguish—ridiculed, disregarded inorganic life is the basis for hope among those feeling a need to revive our relationship with death.

How could he hit their conscience or how cast his shadow over the imaginations of their daughters, before their squires begat upon them, that they might breed a race less ignoble than their own? And under the deepened dusk he felt the thoughts and desires of the race to which he belonged flitting like bats across the dark country lanes, under trees by the edges of streams and near the pool-mottled bogs. (*P*, 238)

The light of night (the light of the thinking day) preserves thoughts and desires against the mythic day (or night). It is the community of inorganic solitude preserving hope against myths of organic life. There will perhaps always be those who find it *odd* that solitude and community would be considered mutually dependent.[148] The oddness of this community of inorganic solitude is, however, simply that no one need pretend not to be irredeemably lonely. No one has to pretend not to belong to the community of inorganic solitude.

Times may be better or worse for inorganic solitude. A "feeling [Empfindung] of the idea" and the correlative "feeling [Empfindung] of the I" are both very "unfamiliar to our time," said Benjamin in 1913 (*C*, 50/*GB*, Vol. 1, *161–62*). In the mid-1920s, he said the "people cooped up" in Germany "no longer discern the contour of the human person"; "[e]very free person appears to them as an eccentric" and "a heavy curtain shuts off Germany's sky [Himmel]" as though the air, with everyone under it, had solidified (*W* 1, 453–54/IV:1, 99). The human and free person cannot be solidified. Notwithstanding what may have been the very warranted pessimism of Benjamin's remarks about the time before and after World War I, moreover, inorganic solitude always somehow persists. Even the mythic solution in tragedy cannot extinguish ethical ambiguity, and such ambiguity persists more openly in post-ancient times. Although continually relinquished (in some way or other) for the social *Ich* (whatever that might be), the idea of the *Ich* is an inextinguishable wildness. Each human is (as "Blödigkeit" suggests) "a lonely beast [ein einsam Wild]" (*W* 1, 34/II:1, *125*). "Wild" is also a concept for game, an animal that is hunted. As inorganic solitude, the human is—like everything else—hunted if not caged by mythic life-context, by destiny under the imperatives of organic survival and advancement. The lonely wildness persists, however, as character theoretically, if not pragmatically, subverting the hunt. In the human, this wild character subverts with another destiny, one that is not simply driven by organicist imperatives. Philosophical humanity, which is our ability to conceive of a humanity distinct from mythic humanity, is the wild "I" as inorganic creaturliness. Humanity experiences this wild sensation as a philosophical (not a mythic) culpability and responsibility for the moral order mediating nature. Philosophical creaturliness is inorganic solitude that breaks through mythic destiny (adaptation to alleged imperatives of organic survival and advancement) to the possibility of play.

The clouds were drifting above him silently and silently the seatangle was drifting below him and the grey warm air was still and a new wild life was singing in his veins. . . .

. . . Where was the soul that had hung back from her destiny, to brood alone upon the shame of her wounds and in her house of squalor and subterfuge to queen it in faded cerements and in wreaths that withered at the touch? Or where was he?

He was alone. He was unheeded, happy and near to the wild heart of life. He was alone and young and wilful and wildhearted, alone amid a waste of wild air and brackish waters and the sea-harvest of shells and tangle and veiled grey sunlight and gayclad lightclad figures of children and girls and voices childish and girlish in the air. (*P*, 171)

Performance of various versions of girl, nature, youth, and child inherit and bequeath inorganic solitude. The human in immortality "lives," of course, "in no time" (*W* 1, 10/II:1, 96–97). Living in no time, wild solitude may nonetheless be performed. (This solitude is, as suggested already, what Benjamin sometimes suggests youth especially performs.) Hearing a "precaution of the subject represented by the 'I', which is entitled not to be sold cheap," Benjamin tries to write "better German than most writers of my generation" by refraining from using "the word 'I'" ("except in letters") (*W* 2, 603/VI, 475–76).[149] The subject requiring such respect is incorporated in no living order, no order of—or at least by—the living. To an unusual extent perhaps, Benjamin's inorganic "I" is able to prevent his social "I" from acting as though it has already realized the former. ("Or was that I? Or am I now I?" *U*, 167) The succession, sequence, and simultaneity experienced as organic self may be transient but this does not amount to transience itself; as organic I, I am not the inorganic I. Play of the inorganic is, moreover, no play of a Romantic subject.[150] At any rate, it can be no "hermetic aestheticization" incapable of effectiveness in social order.[151] There can, after all, be a style of hermetic monadism, such as Mallarmé's, so in tune with history that it is startlingly prescient (*W* 1, 456/IV:I, 103). More importantly, however, a performance of inorganic solitude bequeaths "being alone" (Alleinsein) (*C*, 51/*GB*, Vol. 1, *162*). It bequeaths an antiegoistic tradition of being alone. Prince Myshkin is no ego but rather a windowless monad, insofar as he performs the inexhaustible, unrealizable, ultimately invisible power of inorganic solitude.[152] He performs the power uncontained in, and yet determining, social order. He bequeaths the loneliness that is interminable ground. The "human lonely in sociality [in der Gesellligkeit einsam] grounds society [gründet die Gesellschaft]" (*C*, 50/*GB*, Vol. 1, *163*). Incapable of acquiescing or desisting, inorganic solitude is the only inexhaustible and constant grounding power. As inorganic community, as the unincorporable ground keeping each

human in solitude, the loneliness perpetually "dead" to society is the perpetual basis for performing society anew.

This societal ground, which is dead to society, receives—however involuntarily—performance by those simply ostracized, including those dying under the duress of ostracization. As stressed above, even the tragic victim faintly attains this kind of performance. Less sealed by mythic legitimation, the modern victim is all the more drawn into performance of the illegitimacy of mythic seal. Werner Kraft poeticizes to the dead Benjamin that the enemy (victimizing them and driving Benjamin to suicide) is right: Benjamin and Kraft are indeed "the victims [Opfer] as the founders of the community [Stifter der Gemeinde]."[153] As in tragedy but entirely without anagnorisis on behalf of tragic law, the victim resonates as the threat of a future distinct from that envisioned by the victimizer. Blanchot says: If "[e]very society, and in particular Christian society, has had its Jew" in order to affirm itself via "relations of general oppression," being Jewish—being in the constant exile or foreignness of God—nonetheless (or precisely thereby) preserves being-other as a gift.[154] Without glorifying or celebrating the specific empirical event of ostracization, it may be said that those perceived not to participate, not to participate properly, simply not allowed to participate, or under the threat of being murdered for any of these reasons are more readily open to the "bequest of the dead."[155] They are, as one says so brutally in English, already "deadwood." The ostracized and even those killed under ostracization perform, however unwillingly or unwittingly, the freedom of the dead or at least the freedom that our ignorance of death enables us to associate with the dead. This stubborn freedom of the dead (vis-à-vis meaning given to life or death) is the basis of any attempt to perform the inextinguishable common ground anew. That is the transformative power of the dead.[156] The dead rob society of its mythic seal.

According to Bloch, Benjamin remarks that "[o]ver a dead person, more than ever, nobody has power."[157] Bataille also says that there is no subservience in death.[158] Resistance—the community's resistance—is formulated by Nancy as the freedom always presented by the dead person, the freedom breaking loose more than ever by this person's "being-dead"; this person's death—"whatever its cause"—gives this person "back to an inappropriable freedom."[159] Whether or not he sensed the prospect of a Nazi concentration camp or felt his life was threatened, Benjamin "destroyed the torturable body [quälbaren Leib]"; he "committed suicide"—"disembodied himself," *sich entleibte*, as the archaic expression used by Brecht puts it—"in flight from Hitler."[160] If some think Benjamin underestimated or was simply uninterested in alternatives, they do so with an apparent sense that there was more death—more freedom—in life than he realized or was willing to accept effectively. In any case, Ottilie so abandons her body to society that her will

to suicide is ultimately irresolute, not quite admitted by her (I:3, 839; *W* 1, 336/I:1, 176). Insofar as she does martyr herself solely to the society—to the living semblance—stigmatizing her, her life and her death are conservative, are myth.[161] If the "destructive character" does not commit suicide, this is not out of acquiescence. The destructive character "lives from the feeling, not that life is worth living, but that suicide is not worth the trouble" (*W* 2, 542; "Der destruktive Charakter" [1931], IV:1, 398). The destructive character lacks that naïveté enabling Ottilie to respect societal semblance so much as to commit suicide for it. The destructive character would at most perhaps be prepared to die out of defiance to such authority—that is, on behalf of freedom of the dead.

In its prosaic soberness, writing is the freedom—the solitude—of death in life. Solitude of death in life may be construed as writing. The essential solitude, Blanchot suggests, is being-in-the-work—in literature—which is not only substitution of the first personal pronoun by the third but, more profoundly, also entry into "a language no one speaks, a language that is not addressed to anyone, that has no center, that reveals nothing"—an entry into "the 'One'" that is "closest to one when one dies."[162] In somewhat more Benjaminian terms: inorganic solitude is writing as a sobering of existence by the middle or center that is familiarly alien death. As Benjamin later says with regard to Kafka, the transformation of existence into writing takes place in a "reversal" made possible by a wind from the "nethermost regions of death," a wind blowing from the "prehistoric world" (*W* 2, 815/II:2, 436–37).[163] In the power of prehistory reversing history, in the power of the inorganic reversing the organic, writing sobers picture.

Especially for those not coping with "lived" life, the semblance-destroying power of writing may provide the solace of the perspective of ruination. ("Are you not happy in your home, you poor little naughty boy? . . . I must answer. Write it in the library." *U*, 167) To see ruination is to see not only differently but also "more" than others.[164] Insofar as Benjamin may be said to express as though dead, this must involve a calm and sober recognition otherwise scarcely found in living beings.[165] His writing must so soberly present the catastrophe of the confrontation of death time with lived time that a kind of release from the catastrophe is achieved. In a similar sense, a diary can be devoid of catastrophe; the "I" is on the threshold of immortal, indestructible, distant, silent "pure time," the "I's" "own" time independent of lived developmental time (*W* 1, 11–12/II:1, 97–98). In this semblance-destroying power of writing, the time of immortality is broached; being "dead" in one's "own lifetime" makes one "the real survivor."[166] In this sense, writing survives as the death, the unlivable solitude, that cannot and must not be forgotten. It cannot be forgotten, for wild

solitude is there even if all seem to forget it; it must not be forgotten, for this real world of death—the danger of necessity—is the destiny that humans can inherit and bequeath as the power of the sobering writing-image against the ecstacy of societal semblance.

DEATH OF ART AND PHILOSOPHY

No practice of art or of philosophy, and indeed none of the thinking or the experience facilitating such practices, would be possible without (that which has been called above) *death in life*. Decline of the priority of death in life would be decline of art and philosophy. It may seem sometimes that socioeconomic and technological developments are so pervasive, penetrating, and (in their way) even so potentially liberating that they render art and philosophy irrelevant or indeed impossible. Aside from this kind of outlook concerning an alleged overcoming of art and philosophy, there has been much discussion of the leveling of art and philosophy. Consideration of Benjamin's writings has not always risen above the self-satisfied polemic that often characterizes discussions of the viability or the relationship of art and philosophy. By and large, however, the writings do so.

Even many of Benjamin's later writings continue to emphasize the contemporaneous noncontemporaneity that is both the community based on solitude of death in life and the *sine qua non* of art and philosophy; other later writings by him seem, however, to leave this emphasis behind as they give greater consideration to developments in media, technology, and communist politics. In a well-known letter (of May 29, 1926) to Scholem, Benjamin says he is not ashamed of his "earlier anarchism." The "anarchist methods" are, however, "useless" (untauglich) in politics. Neither communist goals nor indeed most political goals are real or meaningful in politics. Communist "action [Aktion]" is "the corrective" of communist goals (*C*, 301/*GB*, Vol. 3, 159–60).[167] Benjamin's earlier emphasis on sobriety is echoed as, in 1929, he expresses reservations about the ecstatic anarchism in surrealism; somewhat new, however, is that this wariness is on behalf of "methodical and disciplinary preparation for revolution" (*W* 2, 215–16/II:1, 307). Along these lines, various writings of the 1920s and 1930s discuss workers' organizations and newspapers,[168] as well as developments in advertising (e.g., *W* 1, 456/IV:1, 103), photography, and film.[169] In some way or other, all of these writings concern a new popular authority. It is this new authority that Benjamin suggests would emerge, for example, as possession of "adequate material content" in internationally recognized statistical and technical image writing (*W* 1, 456–57/IV:1, 103–4).[170]

According to Benjamin, the new adequation to material content involves a "new positive concept of barbarism" that is advanced by "designers" (Konstrukturen). Benjamin's considerations go as far back as Descartes but mainly mention contemporaries (such as Einstein, Adolf Loos, Klee, Brecht, and Scheerbart); these designers not only constantly begin anew but also construct from very little. Klee's figures, for instance, are conceived on, and respond to, the drawing board—just as the bodywork of a good automobile is conceived according to the requirements of the motor. Such developments are indicative of the dissociation of objects from "aura" and "secret," as are certain late nineteenth- and early twentieth-century literary and architectural usages of glass (*W* 2, 732–34/II:1, *215–17*). Developments such as photography and cinema correlatively typify a "new function" whereby not only any "cult" value but also what was still regarded as "artistic" value of objects may become increasingly incidental (I:2, 716/*W* 4, 257/I:2, 484). With the political developments accompanying the flourishing of new media and technologies, Benjamin remarked in early May 1925 (while he skeptically awaits the formal reception of the *Trauerspiel* study) that he "cannot artificially narrow" the "horizon" of his labor and it is "no longer the old horizon" (*C*, 268/*GB*, Vol. 3, *39*). Various McLuhanesque discussions of media and computer technology tap into Benjamin's later horizon.[171] This horizon has, moreover, been adopted to indicate Benjamin's political "maturity" in contrast with the alleged "ethical puritanism" of many earlier works;[172] "socially grounded" later views are critically juxtaposed with early works.[173]

Benjamin does indeed suggest that common participation in an increasingly extensive and penetrating means of production could enable "producers"—literary, critical, manual, and otherwise—to become "collaborators" (Mitwirkende) (*W* 2, 777–78/II:2, 696). In this interaction on the basis of increasingly socialized and technologized development, moreover, "body [Leib] and image space [Bildraum]" could "interpenetrate" in a "revolutionary tension" that is "bodily collective [leibliche kollektive] innervation"; "all the bodily innervations of the collective" could become "revolutionary discharge." Then "reality" would transcend itself "to the extent demanded by the *Communist Manifesto*" (*W* 2, 217–18/II:1, 310). For this potential to be exploited, the barriers of competence (such as those of material and intellectual labor) must be broken by the very productive forces that those barriers were supposed to separate; those barriers must be broken by the productive forces joining. So *experiencing* the pertinent "solidarity [Solidarität] with the proletariat," the "author as producer"— for instance—simultaneously "experiences" or "discovers" (erfährt) "solidarity with certain other producers" with whom there earlier seemed little to discuss (*W* 2, 775/II:2, *693–94*).

Literature and the study of literature, Benjamin says, undergo or should undergo changes correlative *to* the newly manipulable, yet also intrusive, material content and *to* the newly collective basis for the experience of this materiality. As "[t]he construction [Konstruktion] of life" is pushed into the "power of facts," the "circumstances" deprive "true literary activity" of any right to take place "within a literary framework"—a framework indicative of "sterility" (Unfruchtbarkeit). It might not seem incompatible with Benjamin's early works to say that "[s]ignificant literary effectiveness" only emerges "in the strict alternation of action [Tun] and writing [Schreiben]" or even to suggest that the new literary effectiveness "must cultivate the inconspicuous [unscheinbare] forms" more suited to having "influence in active communities" than is "the pretentious, universal gesture of the book." The relevant action and new inconspicuous forms are, however, differently entwined with empirical aspects of daily life than are those emphasized elsewhere by Benjamin; the new alternation of action and writing concerns those forms inconspicuous only in being so much a part of *the time* (and not discontemporaneous in it). These inconspicuous yet very contemporary forms are required in literary activity if there is to be adequation to the heightened experience of transience in the everyday. Benjamin mentions "leaflets, brochures, magazine articles and placards"; "[o]nly this prompt language shows itself effectively equal to the moment" (*W* 1, 444/IV:1, *85*). Experiences (Erfahrungen), not theories or phantasms, are at stake in the *profane illumination*—the "materialistic, anthropological inspiration"—as the surrealists produce writings that "are not literature but something else—demonstration, watchword, document, bluff, forgery if you will, but at any rate not literature" (*W* 2, 208–9/II:1, *297*).[174] Under new conditions, moreover, art and criticism interweave in a dissolution of their earlier forms. Soviet worker-correspondents writing to newspapers about work experiences and about public issues exemplify "[l]iterary license" becoming "polytechnic" rather than "specialized"; workers are, additionally, the subject matter, the public, the authors, and the critics of writing.[175] Brecht's "epic theatre" also challenges circumscriptive conceptions of art and correlative "privileges" of criticism (*UB*, 10/II:2, 528). Furthermore, the numerical growth of those able to write requires the new sociology of the reading public, of writers' organizations, and of the book business. To attain contemporary relevance, scholarship on literature must not simply be analysis of (more traditionally) literary and poetic writing but also of the pervasive "anonymous" literature like calender literature and forms of writing that traditional criticism would dismiss as trash (*W* 2, 462/III, 288).

As implied already, these new emphases are obviously not entirely incompatible with Benjamin's earlier (and sometimes concurrent) writings concerned with the semblance-destroying force of art and criticism. This is

particularly evident in the writings on cinema. Cinema depreciates uniqueness as the actor's performance, mediated by demands and possibilities of camera and technical reproduction, is deprived of the aura of personal presence—the "beautiful semblance"—that a stage actor might evoke before a live audience; the artificial buildup of the cinematic "personality" is a reaction to this "shrivelling" of aura by film technique and technical reproducibility of image (W 4, 259–62/I:2, 487–92).[176] Cinema also has the potential of destroying beautiful semblance by socializing or collectivizing the reception of the work. Whereas paintings since the Middle Ages were generally for private enjoyment by one or a few persons or contracted through a hierarchy that controlled public reception, cinema is pictorial representation more subject to collective critical reception somewhat in the manner that architecture always was and epic poetry used to be (W 3, 116/VII:1, 374–75). The heightened potential for such critical interweaving of creation and public is indicated in certain post-1917 Russian films. Peasant farmers were not only the objects and most significant audience of film but also took over the acting roles. Films often involved people portraying themselves in their own labor process (W 2, 14/II:2, 749; W 3, 114–15/VII:1, 372). Such situations are part of what Benjamin regards as most new and promising: with the "revolution of technology," space could turn increasingly into collective space, problems into collective problems (W 2, 17–19/II:2, 753–55). More generally, cinema is an indication of technological reproducibility, profanization, and collectivization advancing and even compounding the power of disenchantment that Benjamin had already associated with art and criticism.

The potentials of new profanization and collectivization are, however, fostered by Benjamin on behalf of use-value for which (what has been presented in this study as) the community of inorganic solitude often seems irrelevant. In the new socialized technology and technologized sociality, loyalty is less to things than to the use that can be made of them. It would be oversimplification to suggest that Benjamin is criticizing himself (in other incarnations) as he denounces Kästner's left-wing melancholy for assuming an attitude without any corresponding possibility of effect in the realm of political action. The melancholy fostered in Benjamin's writings was never to rest enjoying itself "in a negativistic quiet."[177] By the late 1920s and later, there nonetheless often emerged in Benjamin's writings a new shift from loyalty to what society cannot do and toward loyalty to what society seemingly can do. The priority of having "works [Arbeiten]" directed "towards the utilization (transformation) [Benutzung (Umgestaltung)]" of "institutes and institutions" (W 2, 775/II:2, 691)[178] is not much of a departure from Benjamin's earlier critical or aesthetic outlook; yet the new "methods of mechanical reproduction" are

conceived as "a technique of diminution" and as assistance for the human to achieve a useful level of "control [Herrschaft] over works [Werke]" (*W* 2, 523/II:1, *382*).

This new emphasis on the priority of useful control is evident in the concentration of certain writings by Benjamin much more on vision than on the earlier emphasized (and, sometimes, continually emphasized) theological hearing. Benjamin's new approach to vision shows a certain retention of impulses from his earlier works, but also an adoption of tendencies diverging considerably from those works.

There are many ways in which the de-auraticization of vision by technology converges with Benjamin's earlier outlooks. Much as iron brings a constructivist freedom to architecture, the dioramas (with scenes of three-dimensional figures, viewed through a window) do so for pictorial presentation and thus open the way for photography and indeed cinema (*AP*, 3–6/V:1, 45–49).[179] The constructivist freedom removes image from organicist semblance. Like movies, of course, photography can be auratic by perpetuating a kind of personality cult—for example, portrait photography encouraging cultic receptions (the "melancholic [schwermutvolle], incomparable beauty" of the aura of dead or living loved ones) (*W* 4, 258/I:2, *485* [445, 718]; *W* 3, 108/VII:1, *360*; see also *W* 2, 518/II:1, 377–78).[180] Photographs such as those (of objects and city scenes without people) by Eugène Atget (1856–1927) or portraits by August Sander (1876–1964) indicate, however, a "physiognomic," "scientific" (wissenschaftlich[. . .]) outlook sometimes fulfilling Goethe's precept of a "delicate empiricism" becoming "theory" in the intimacy of its identity with its object. The surroundings are estranged and given over to their "nameless appearance" (*namenlosen Erscheinung*, which one English translation interpolates as "anonymous physiognomy") (*W* 2, 517–20/II:1, 378–81).[181] So challenging the viewer, this photographic perspective on places is "sociological" (II:3, 1137)[182] and "historical" and has "political significance" (*W* 4, 258/I:2, *485* [445, 718]; *W* 3, 108/VII:1, 360–61).[183] The sociological, historical, and political significance of photography concerns, of course, not simply the opening to forces destroying semblance but also the very technology of reproducibililty further accentuating this destruction of aura.

Yet these same technological and sociohistorical developments facilitating destruction of aura also give vision a primacy removing humans from (that which has been presented in this study as) the acoustics of inorganic solitude. Less and less do we look down in reflection; more and more, we look up—commanded by images coming at us. Before even coming "to open a book," the contemporary has eyes over which there has fallen "such a dense flurry of variable, colorful, conflicting letters that the

chances of . . . penetrating the archaic stillness of the book are slight." The former letters are not so much writing as subordination to the visual—albeit perhaps very chaotic and heteronomous—priorities of the market. Whereas it once "found in the printed book a refuge in which to lead an autonomous existence," "writing" (Schrift) is now "pitilessly dragged out into the street by advertisements and subjected to the brutal heteronomies of economic chaos." Newspapers, film, and advertisements increasingly tend to take our experience of writing from the more horizontal position (in which writing has tended for centuries to be considered and experienced) to a more vertical one, an increasingly "dictatorial vertical" (*W* 1, 456/IV:1, *103*). The vertical becomes dictatorial, for it keeps us in the visuality of image rather than letting us think—that is, hear—image. The primacy of politics in certain later works by Benjamin (e.g., *W* 4, 256–57/ I:2, 481–82 [442, 714–15]; *W* 3, 106/VII:1, 356–57) pertains to a "space of political action [Handlung]," which is a "space that is one hundred percent image space [den hundertprozentigen Bildraum]" (*W* 2, 217/II:1, 309). The visual dominates—dictates to—other faculties and to thinking. The image may be construed as textual image or image of writing, for it is still an image of the mystery that remains invisible, that is ultimately not seen.[184] Benjamin's proposed "dialectical optics" recognizes "the everyday as impenetrable [undurchdringlich], the impenetrable [Undurchdringliche] as everyday." Especially wishing to avoid any kind of Romantic fanaticism or pathos mystifying "the enigmatic [rätselhafte] side of the enigmatic [Rätselhaften]," however, Benjamin moves to increased emphasis on penetration of "the secret [Geheimnis]" as a regaining of it "in the everyday" (*W* 2, 216/II:1, *307*). In the current everyday, the flow of images yanks this way and that with heightened rapidity. This highly demanding, dictatorial optic life has pretty well won a kind of primacy. Even as Benjamin still admiringly concedes the primacy of "language" for Breton (208/297) and invokes, as a sort of profane illumination, the "most terrible drug," which we consume in "solitude" (Einsamkeit) (216/308), there is little chance or toleration for hearing inorganic solitude. Perhaps, however, there is more chance of maneuvering with the visual.

In any case, Benjamin suggests that the kind of primacy acquired by the optical requires a new adaptability. Fools "lament" the decline of criticism; the "hour has long expired" for criticism as "a matter of the correct distance." "[I]mpartiality" and "innocent eye" (freie Blick) are "lies, if not the wholly naive expression of plain incompetence." "[M]ost essential" today is rather the advertisement—"the mercantile gaze into the heart of things" (*W* 1, 476/IV:1, *131–32*).[185] No work by Benjamin defends an alleged impartiality of an innocent eye. Among the new nuances, however, is Benjamin's acceptance that every

form of life—criticism included—is increasingly a mercantile battle, an advertising war, a war of images for sale (*W* 1, 458–59/IV:1, 108–9). From Benjamin's perspective, as suggested above, this battle is perhaps to be conducted on behalf of some sense of collective use-value. Yet this would seem to be a value—a mercantile value—in which the hearing of theological-philosophical solitude elsewhere emphasized by Benjamin has no significant role.

The pervasive battle for institutional dominance has more recently been discussed in terms of an alleged imperative to adapt to the sport. The consolation offered to those feeling unwilling or unable to "unite" (vereinigen) with others in the game is simply the reminder that "we are members of a liberal democracy."[186] As indicated by the eager proximity of politicians to the teams in world championship sports, this kind of ecstatic celebration of political context is often characteristic of sport enthusiasts.

> —There's the man, says Joe, that made the Gaelic sports revival. There he is sitting there. . . . The champion of all Ireland at putting the sixteen pound shot. What was your best throw, citizen?
> —*Na bacleis*, says the citizen, letting on to be modest. There was a time I was as good as the next fellow anyhow.
> —Put it there, citizen, says Joe. You were and a bloody sight better. . . .
> So off they started about Irish sport and shoneen games the like of the lawn tennis and about hurley and putting the stone and racy of the soil and building up a nation once again and all of that. (*U*, 314–15)

On behalf of fusing "protestlessly [widerspruchslos]" with the media-technological "tool [Werkzeug]," certain writings by Benjamin (along with some by Ernst Jünger and Marshall McLuhan) on mechanization have been invoked against "pacifistic raissonnement" and in favor of "the laughter of the barbaric collective."[187]

Regardless of what there might be of Benjamin in such an outlook, the highly conformist formulations given in that outlook diverge considerably (albeit perhaps unwittingly) from Benjaminian barbarism. Benjamin's new barbarians (Klee, Loos, Einstein, Descartes, Brecht, Le Corbusier, Scheerbart) contribute to a humanity that is expressly considered by him to outlast "culture." This humanity does so "laughing," and it outlasts "culture" especially insofar as these barbarians bequeath this destructive "humanity" to "masses" that might give it back much more strongly. These barbarians are not simply laughing with established or burgeoning power. The conduct of those among them living during the 1930s would attest to this (*W* 2, 731–36/II:1, 213–19). They were, by and large, quite distinct from the sort of people invoked as "smart" ones to be joined by all who are willing to abandon noncontemporaneous feelings for the sake of driving ahead without protest.[188]

—And I belong to a race too, says Bloom, that is hated and persecuted. Also now. This very moment. This very instant. . . .
—I'm talking about injustice, says Bloom. . . .
. . . says Martin. . . . That'll do now. Drive ahead. . . .
Gob, the citizen made a plunge back into the shop.
—By Jesus, says he, I'll brain that bloody jewman for using the holy name. By Jesus, I'll crucify him so I will. . . . (*U*, 331, 340)

The holy name—or at least the highest priority—for some recent media theorists has been the driving ahead much more than any destructive potential that might or might not best be found in this driving ahead. In the name of adaptation, untimely protest—including the untimeliness of irony—is strictly denounced.

Adorno's priority of irony is in many respects inherited from works by Benjamin, and this priority could be said to underlie his reservations about some of Benjamin's later works.[189] More recently, such later works by Benjamin (albeit on the basis of often questionable readings) have been cited to accuse Adorno of a "pathos of untimely reflection" airing "the mask of ironic modesty": "To interpret the disfavour of the hour as historical index of the truly contemporaneous [Aktuellen] is a piece of secularized Christology" arming "Adorno against every imaginable reproach." Adorno is accused of simply attempting to present "weakness of thinking" as though it were "a secret strength."[190] Many of Benjamin's own writings stress, of course, that true contemporaneity ironizes the favor of the hour; such ironizing is, for example, the justice of allegory. Some of Benjamin's later writings even suggest such irony can be the work of technology.[191] Various remarks quoted above, including some of those on the impossibility of critical distance, may give an inkling of something in Benjamin's later works which accords with those who insist that we "do justice" to technical developments by reorienting "aesthetics from a theory of the arts into a theory of media-technological *aisthesis*"; it seems as though a reorientation away from distancing and toward what new media make near overcomes not only extensive distance but also intensive distance.[192] Benjamin endorses collective driving ahead and collective laughter at untimely irony much less, however, than do some more-recent media theorists. From the perspective of much if not all of Benjamin's work, moreover, those theorists on behalf of new technologized sociality and socialized technology may be said to ascribe to humans an inner need for an ostensibly secularized, yet ultimately conformist and authoritarian, salvationism. Joyce vividly anticipates such dogmatic conformism.

Are you a god or a doggone clod? If the second advent came to Coney Island are we ready? Florry Christ, Stephen Christ, Zoe Christ, Bloom Christ, Kitty

Christ, Lynch Christ, it's up to you to sense the cosmic force. Have we cold feet about the cosmos? No. Be on the side of the angels. Be a prism. You have something within, the higher self. You can rub shoulders with a Jesus, a Guatama, an Ingersoll. Are you all in this vibration? . . . You once nobble that, congregation, and a buck joyride to heaven becomes a back number. You got me? It's a lifebrightener, sure. The hottest stuff ever was. It's the whole pie with jam in. It's just the cutest snappiest line out. It is immense, supersumptuous. It restores. It vibrates. I know and I am some vibrator. . . . Got me. That's it. You can call me by sunphone any old time. . . . Now then our glory song. All join heartily in the singing. (*U*, 473)

Salvationism concerning technologized sociality is a closure, part of a general institutional closure against incomprehensible death (*W* 3, 150–51/II:2, 448). Countering such closure, Benjamin cites Baudelaire trying instead to unfold commodity fetishism into inspirational "empathy with the inorganic" (*W* 4, 32/I:2, 558).[193] A "completion" of the "reification" in life, a completion into "the inorganic," is a "restitution" for "distorted" life; Adorno thinks this idea of saving the dead is the "middle [Mitte]" of Benjamin's philosophy.[194] Some of Benjamin's later writings may desert this middle. As much of this study has elaborated, however, most of his writings either explicitly or implicitly foster this middle; this middle will interrupt the choral society of techno-socio-salvationists.

Encore! (*He sings*) Jeru. . .

THE GRAMOPHONE: (*Drowning his voice*) Whorusalaminiyourhighhohhoh.
. . . (*The disc rasps gratingly against the needle.*) (*U*, 473)

Collective collaboration and competition ultimately depend on, and are only completed by, untimeliness—noncontemporaneity—of death; they cannot incorporate—are interrupted by—death. ("Was Du verlachst wirst Du noch dienen." *U*, 197)

It is suggested by many of Benjamin's writings considered in this study that the noncontemporaneity of death may be formulated as the basis of art and philosophy; practices of art and philosophy would not arise if death and its untimeliness were not already "in" life. The untimely, unlivable moment of death is the basis for a mysticism permissible in art and philosophy. A late eighteenth-century encounter of mysticism and enlightenment grounded authority for the community only on what cannot be heard fully or at least on more than members can bear to hear fully.[195] It is sometimes thought that Benjamin's work was the last such encounter of mysticism and enlightenment, as Adorno suggests while also noting the importance of the untimeliness of death for Benjamin's work.[196] From this perspective, in any case, death is the ghost whose untimely ironizing power haunts even the most socialized production and the most tech-

nologized body. As constant contemporaneity of the noncontemporaneous, death has more recently been formulated as the justice protecting secret or mystery from disregard.[197] Science-fiction or indeed science might conceive of ways for the living body not to die; yet fulfillment of such visions would not remove death as secret. The association of art with death (as the force of noncontemporaneous contemporaneity) need not, moreover, require as strong a rejection as Adorno's of Benjamin's interest and praise for many new incursions of heterogeneity and mundaneness upon art. Joseph Beuys conceived and practiced art as no specialization but as a feeling with a certain kind of effectiveness in the sociopolitical world and as incompatible with specialist criticism; this attitude of opening to otherwise unimagined perspectives on all objects could be said to be one of exploring the community of inorganic solitude, the community dead in life.[198] This community seems to be what Robert Rauschenberg addressed as he said (in an interview shown a number of years ago on Austrian television) that he thought his works might make people feel less lonely. Such views concerning community of inorganic solitude could be sustained concerning mechanical reproducibility and its attendant heterogeneity or despecialization of art; in such technological transformation of art, there may even be more effective accentuation rather than implied overcoming of the contemporaneous noncontemporaneity of death in life. Some think the future "belongs" to those prepared to adapt for it.[199] No more than the past or present, however, does the future belong to anyone. Practices of art and philosophy let themselves be carried by the death force that ironizes—reverses—each and every property claim on time. Contemporaneous noncontemporaneity of death is the condition of constant ironizing reversal, and thus the fundamentally necessary condition of practicing art and philosophy. In this condition, art and philosophy belong to the prehistory that never was anywhere.

> The speech (his lean unlovely English) is always turned elsewhere, backward. . . . He goes back, weary of the creation he has piled up to hide him from himself, an old dog licking an old sore. But, because loss is his gain, he passes on towards eternity in undiminished personality, untaught by the wisdom he has written or by the laws he has revealed. (*U*, 197)

The association of art and philosophy with a kind of mystical, noncontemporaneous contemporaneity is a theological element in Benjamin's works that has—as noted often in this study—provoked diverse responses. Writing about the first Benjamin boom (that of the late 1960s and early 1970s), Habermas regrets that Benjamin—as the redemptive or rescuing "theologian"—does not conceive of "consciousness-raising" critique, which (in Habermas's opinion) assures an "immanent" relationship with political practice; he regrets that a *theological* bent made it impossible for Benjamin

"to make the messianic theory of experience serviceable [dienstbar] for historical materialism."[200] These regrets were later (1985) at least temporarily set aside to suggest that Benjamin's intertwining of mysticism and enlightenment (including its usage of "the conceptual tools of historical materialism") may be exemplary, particularly for the purpose of polemics against "negative fundamentalism." Whether or not it enters the eighteenth-century juncture "where mysticism once turned into enlightenment," Derrida's work is considered by Habermas to invoke "the one, concealed, world-transcending God" as a force mediated by a "comprehensive, all-embracing text-context [Textzusammenhanges]." Habermas underestimates the extent to which such a context pervades much of Benjamin's work. In any case, he says that this text-context in Derrida's work ultimately dissolves "all genre-distinctions" in vocabularies of rhetoric or literary analysis; Derrida allegedly advances a "levelling of the genre distinction between philosophy and literature," a "pretention to sublate [aufzuheben] the genre-distinction of philosophy and literature."[201] No more than Benjamin's writings, however, do the Derrida writings considered by Habermas (often not insignificantly via fleeting readings of Culler, Rorty, and others) advance such subsumption. For Benjamin, such leveling is kept in suspension by the familiar strangeness or the strange familiarity, the contemporaneous noncontemporaneity, of death. With their basis in death, practices of philosophy and art are strangely familiar or familiarly strange to us. In this familiar strangeness or strange familiarity, moreover, they have a strangeness to each other that can also be an allure for each other (see pages 106–7 and 193–98 above), one arising from the philosophical character of the artwork and from the art within philosophy. In their interaction, the respective institutional or generic masks are not annulled or overcome but rather kept in fluidity. In many respects, writings by Derrida seem consistent with the relationship of death, art, and philosophy that is formulated in the writings by Benjamin that have been the primary focus of this study.

For Derrida, a "rhetoric" of philosophy would be as dubiously dominative as any metaphysics that such a rhetoric might seek to renounce or expose as rhetorical. Derrida does not wish to attempt answering the question of how "figures of speech" (especially metaphor) in the philosophical text are to be deciphered; he does not venture "metaphorics." The "*condition for the impossibility* of such a project"—or at least a kind of "limit" for such a project—is that "metaphor remains, in all its essential characteristics, a classical philosopheme"; metaphor remains (as Derrida calls it) "a metaphysical concept."[202] It is a concept based on the assumption that figurality could be metaphysically and entirely isolated from nonfigurality; it is based on the assumption that there could be an entirely nonfigural discourse about figurality.

Contrary to what Habermas alleges concerning Derrida, a field or domain of rhetoric is not to level genre distinctions. Notwithstanding those who imagine philosophy itself is a "field" that could be dominated by "a general metaphorology of philosophy," this field is a "network," a "stratum" of tropes, that "cannot be dominated."[203] Giving broader currency to terms formerly more confined to rhetoric and literary analysis, the effectiveness of earlier deconstruction derives partly from the depreciation, the exclusion, and the denial with which "philosophy" has tended to regard such terms. Along with others such as Lacoue-Labarthe, Derrida advances not a paramountcy of rhetoric and literary analysis but rather the admission that "literature"—as something entirely other than philosophy—is an invention of what sometimes came to be "philosophy."[204] Attempted extrication of "philosophy" from figurality is a denial of the death that metaphor "always carries . . . within itself," the death that "surely is also the death *of* philosophy." The death of philosophy has tended to have two basic and divergent meanings in the tradition of "philosophy." In the prevalent tradition, the tradition represented by Plato and Hegel, the "heliotrope"—the light metaphor—of philosophy (implicitly if not explicitly) involves claim to a practice that thinks and summarizes the death of the genre of philosophy. A second stream, represented by Nietzsche and Bataille, undertakes philosophy as no practice connoting this claim; there is, rather, "the death of a philosophy which does not see itself die," a death "no longer to be refound within philosophy."[205]

Benjamin has been taken in this study to present the form of philosophy as death that is found in no practice of philosophy. Philosophy as death is to be performed as unfound in the practice of philosophy. Death is philosophy as the requirement that the practice of philosophy perform itself constantly anew as detour (pages 102–3 and 108–19 above). The heliotrope discussed by Benjamin in a very late piece (page 7 above)—and, in some way or other, effective in most of his writings—would put his work in the second stream mentioned above by Derrida. The dead, Benjamin suggests, are profoundly felt as ultimately unapproachable through understanding. If someone close to us is dying, we may have a feeling that is the "being distant" (Fernsein) which the dying person is about to become or may well already be; in this being distant, the dying person ultimately no longer understands the language with which we greet her or him (W 1, 450/IV:1, 94). In its power or rhythm of resisting semblance, writing reenacts such community with the dead. It reenacts the juncture and the tension of understanding and death. The destructive power underlying such reenactment is the literature—the name, the writing—that is performed in all art. The community of death can, however, indulge no leveling of genre. Genre is limit, albeit in an elastic and ultimately indeterminable limitedness. Belonging to the ultimately indeterminable realm or form of philosophy that is death, the practices of philosophy and literature maintain flu-

idity of genre, above all in their relations with each other (see pages 193–98 above). Philosophy in literature may thus be considered the freedom that obviates surrender to myth. Literature in philosophy keeps philosophy philosophical, keeps philosophemes from closure—from denial of figurality in their concepts, from denial of death. This intertwining is no abolishment of genre; yet genre is sustained by the death—the fluidity—keeping it indeterminate. In their various attestations to the community of death, most of Benjamin's works considered in this study perform the death and, therefore, the survival of philosophy.

IR(R)ENSTRAßE

There are often debates about immigrants that revolve around formulations such as "melting pot," on the one hand, and "salad" or "mosaic" ("going out to Canada" *D*, 37), on the other. The claim implicit or explicit among those favoring terms such as "salad" or "mosaic" tends to be that ethnic entities or groups have the right or the possibility of doing something distinct from "melting." Legally and practically, provision (however conflict-ridden) is supposed to be made for a kind of lack of common sense. Insofar as it effectively indulges philosophical form (as explored in this study), a nation effectively presenting itself as mosaic involves mosaic in constant fluctuation. The pieces, the fragments, of the mosaic are not to melt into a fixed myth and are to keep on changing. Apart from the changes forced upon them by what might seem the most obvious and effective myth—the mercantile form, the selling-and-buying form—of the day, fragments of the mosaic belong, and present themselves belonging, to the night moving them in a round-dance of bridges.

> MAGINNI: . . . *Les ronds! Les ponts!*
>
> *(Twining, receding, with interchanging hands, the night hours link, each with arching arms, in a mosaic of movements. . . .)* (*U*, 514)

Insofar as nation in the night of the moving mosaic can release somewhat from the prevailing myth of the day, it does not melt the "Schnee von gestern" ("snow from yesterday," an expression used by German speakers much in the way that an English-language speaker would refer to "spilt milk" over which one should not cry). As Benjamin suggests in the theses on history (1940), tolerance for the persistence of some echo of yesterday may keep today more open to a variegated tomorrow (*W* 4, especially 390–92, 394/I:2, 694–98, 700).

Philosophically considered, a risk of certain kinds of "melting" is the relative forgetting and intolerance of—perhaps aggression toward—what is not "there" effectively selling itself in the mercantile form. From the perspective of Benjamin's philosophy as outlined in the preceding study, it might be suspected that such melting was effective in the alliance of elements of "Anglo-American philosophy" and certain German theories of communicative competence. It could at least be contended that both the latter kind of theory and Anglo-American culture (including much of its "philosophy") tend, relatively speaking, to dismiss the dead or, more precisely, what is dead to prevailing communicative life. In the prevalence of the melting culture, disregard for death in life manifests itself in many ways, perhaps including a contempt for art and for much non-"Anglo-American" philosophy. Such disregard for death in life can also entail disregard for the societally weak, who often find themselves handled as either pathological and in need of therapy or as dispensable garbage.[206] Relatively early writings of Horkheimer and Adorno discuss streams of Anglo-American philosophy in relation to a "culture industry" helping its audience melt into a "culture," helping that audience to live without much consideration for what seems dead to this culture. From the perspective of such writings by Horkheimer and particularly by Adorno, too much would be lost by adherence to the reconstruction, revision, and melting of those writings by (that which was often called) discourse ethics and its so-called communicative turn. In any case, most of the writings by Benjamin considered above may be formulated in terms of the notion that ethics involves death more than discourse. This death is death as the foreignness that will not, that cannot, melt. For the priorities or concerns raised in this study, it would be philosophically salutary to foster foreignness that maintains its foreignness not as hypostatization but as countermovement to myth, particularly the capitalistic myth, which cannot ultimately avoid being unreal. Even while its specific contents do indeed change, and often do so quickly, the latter myth is unreal in being so unallegorical, unironic, as its relatively strict form prevails in denial of virtuality. This life, this form, only ostensibly prevails, for it cannot quite snuff the stubborn mourning of contents knowing life and death differently than is encouraged or generally permitted "communication" in this form. In the face of the devaluation of life and death by this form, stubborn mourning lashes out.

Stubborn mourning involves a distinct kind of stubbornness. Dictionaries suggest that usage of the word "Irish" as a general term of disparagement entered the language of the conquering British centuries ago.[207] ("My hell, and Ireland's is in this life.... my crime." *U*, 409) "Stubbornness" is perhaps accordingly considered by some to be a trait prevalent among Irish people; the

persistence of expressions such as "Irish stubbornness" attests to this. This usage has often been extended to include "Irishness" of various people, such as the "Irishness" of someone born in England of Irish parents, or of someone born of Irish parents and living in various countries (or even of someone with a possibly Irish name and no other obvious attachment to Ireland).

> —Prove that he was a jew, John Eglinton dared, expectantly. Your dean of studies holds he was a holy Roman....
> —He was made in Germany, Stephen replied, as the champion French polisher of Italian scandals. (*U*, 205)

Like many such epithets, the one of "Irish stubbornness" tends to be used with little indication or elaboration of what this Irish stubbornness is supposed to be. It does not seem to pertain to the Catholicism, to which many Irish adhere, albeit in increasingly jaded ways. ("Saint Patrick converted him to Christianity. Couldn't swallow it all however." *U*, 169) In any case, the stubbornness of the aforementioned stubborn mourning is not so easily explained or explained away.

Whether or not one is loyal to it, the most stubborn feeling must be a kind of mourning or lament that cannot be explained away as "Irish." On the basis of such a familiarly strange or strangely familiar feeling, one must somehow welcome Joyce wrenching "Irish" virginal and confessional moralism into the dance of death.

> TUTTI: Encore! Bis! Bravo! Encore!
>
> SIMON: Think of your mother's people!
>
> STEPHEN: Dance of death....
>
> *(Stephen's mother, emaciated, rises stark through the floor in leper grey with a wreath of faded orange blossoms and a torn bridal veil, her face worn and noseless, green with grave mould. Her hair is scant and lank. She fixes her bluecircled hollow eyesockets on Stephen and opens her toothless mouth uttering a silent word. A choir of virgins and confessors sing voicelessly.)* (*U*, 515)

Insofar as they assume an antihistorical semblance of innocence, virgins and confessors are so abstract or bombastic that they set themselves up for ruination. The vibrancy of inner or outer exile Irish ("the black and sinister arts / Of an Irish writer in foreign parts") is its offense to "Ireland's" hypertrophic ecclesiasticism and moralism, its offense to "Ireland" ("This lovely land that always sent / Her writers and artists to banishment." *PE*, 107).

> "The fact is," said Gabriel, "I have just arranged to go—"
> "Go where?" asked Miss Ivors....

"Well, we usually go to France or Belgium or perhaps Germany," said Gabriel awkwardly.
"And why do you go to France and Belgium," said Miss Ivors, "instead of visiting your own land?"
"Well," said Gabriel, "it's partly to keep in touch with the languages and partly for a change."
"And haven't you your own language to keep in touch with—Irish?" asked Miss Ivors.
"Well," said Gabriel, "if it comes to that, you know, Irish is not my language." . . .
"And haven't you your own land to visit," continued Miss Ivors, "that you know nothing of, your own people, and your own country?"
"O, to tell you the truth," retorted Gabriel suddenly, "I'm sick of my own country, sick of it!" (*D*, 186–87)

Going foreign can be philosophically salutary, less perhaps in simply appearing not to belong than in stubbornly showing oneself to be sick in shape—somehow strangled into shape; this performance is a philosophical possibility of ruining shape.

STEPHEN: (*Strangled with rage*) Shite! (*His features grow drawn and grey and old.*)

BLOOM: (*At the window*) What?

STEPHEN: *Ah non, par exemple!* The intellectual imagination! With me all or not at all. *Non serviam!* . . .

THE MOTHER: (*In the agony of her deathrattle*) Have mercy on Stephen, Lord, for my sake! . . .

STEPHEN: *Nothung !*

(*He lifts his ashplant high with both hands and smashes the chandelier. Time's livid final flame leaps and, in the following darkness, ruin of all space, shattered glass and toppling masonry.*) (*U*, 517)

As Benjamin tries to extract from Dostoevsky a notion of national stubbornness that would be stubborn enough to survive everything, this stubbornness is the national persisting against national myth. It is the stubbornness of ruin, which can obviously also be presented as a force entering constructions. The stubbornness of ruin presented in construction is construction in readiness for death. This involves no dying for the sake of a construction but rather a construction on behalf of death. On the level of nation, this stubbornness of ruination would be a feeling for community intrinsically resistant to chauvinists, ecclesiastics, and conquerors, which so often ally ("Where Christ and Caesar are hand in glove!"

PE, 107). As stubbornness of ruin, resonance of the national may evoke a stubborn innocence disregarded by much alleged internationalism and globalization.

The stubbornness of ruin is the sole resonance of innocence in language. Language in its innocence is the "angel of death," the angel announcing death.[208] As ruination, the innocence of language seems a perpetually falling snow. It is not snow to be melted away entirely; it is not snow to be forgotten. As perpetually falling snow, this snow cannot be forgotten even if all seem to forget it. Never quite melted away by anyone or anything, the perpetually falling snow of language in its innocence is ruination uniting the living and the dead, the nation and the universe.

> Yes, the newspapers were right: snow was general all over Ireland. It was falling on every part of the dark central plain, on the treeless hills, falling softly upon the Bog of Allen and, further westward, falling softly into the dark mutinous Shannon waves. It was falling, too, upon every part of the lonely churchyard on the hill where Michael Furey lay buried. It lay thickly drifted on the crooked crosses and headstones, on the spears of the little gate, on the barren thorns. His [Gabriel's] soul swooned slowly as he heard the snow falling faintly through the universe and faintly falling, like the descent of their last end, upon all the living and the dead. (*D*, 220)

The most stubborn Ireland, Ireland under the snow of language in its innocence, is Ireland in ruination. It is never realized; it is a ghost, and not even a particularly green ghost. This ghost may break through as the pissed-on green—the green pissed on by clergy and conquerors and other insulters of the beautiful art of Irish stubbornness. ("Calf covers of pissedon green. Last word in art shades. Most beautiful book come out of Ireland my time." *U*, 421) There could well be an innocent desire to be pissed on; it could be a desire from language in its innocence. If being pissed on became a widely expressed or admitted desire, however, another metaphor would obviously be needed. In accordance with the old metaphor of being pissed on, the Irish may be said to be pissed on every time they speak in their currently most used language; the ghost of stubbornness—the stubborn ghost—is the reminder that this is the language "of" forces which all but brought about the disappearance of the "Irish" language.

> They say they used to give pauper children soup to change to protestants in the time of the potato blight. Society over the way papa went to for the conversion of poor jews. Same bait. Why we left the church of Rome? (*U*, 180)

> My ancestors threw off their language and took another, Stephen said. They allowed a handful of foreigners to subject them. (*P*, 202)

If the ghost of Irish stubbornness is, however, not ultimately green (not even pissed-on green), this is because it is ultimately colorless. It would not manifest itself in an Irish language; it would certainly not manifest itself *as* an Irish language. The Irish language is no innocent language; there is no innocent language besides the ghost of language in its innocence. Certain Gaelic usage could perhaps involve performance evocative of this ghost. In some contexts, simply the usage of certain kinds of Gaelic probably did this and probably sometimes still does. Yet the ghost is no specific human language. It is language in its innocence, language as death, recalling language as neither used nor owned by anybody.

There might be a greater inclination to use—or, more accurately, to feel and perform—a language philosophically when that language historically dissociates one from it. Philosophical performance of language is performance of language as belonging to nobody. Working with Benjamin's occasionally difficult German may lead us to recall Scholem's insistence that Benjamin was not a German writer but a Jew writing in German. Scholem wonders, however, whether Benjamin would have been "at home" in Israel; like Kafka or Freud, he came from the "foreign" (Fremde).[209] In Germany, Benjamin did not know Hebrew and yet his Hebrew heritage was officially and unofficially a stigma among many of those whose language was also his first language. ("What points of contact existed between these languages [ancient Hebrew and ancient Irish] and between the peoples who spoke them?" *U*, 609) A socially, societally, communicatively, discursively disadvantageous relationship with a specific language can paradoxically facilitate going into a foreignness that would not otherwise so readily be explored.[210] The "final solution" was supposed to put an end to this potential of the Jew in German and in other languages. Yiddish may be very unique, as may be Hebrew (in a different way, of course). In a Benjaminian perspective, however, the potential of the Jew in other languages could especially concern the sobering, disenchanting force of *writing* in a language that otherwise tends to be spoken as though it were somehow a given and not something acquired. This sobering, disenchanting force is that philosophical propensity to attend to the agon taking place between the lines.

—That? said Stephen. Is that called a funnel? Is it not a tundish?
—What is a tundish?
—That. The . . . funnel.
—Is that called a tundish in Ireland? asked the dean. I never heard the word in my life.
—It is called a tundish in Lower Drumcondra, said Stephen, laughing, where they speak the best English.

—A tundish, said the dean reflectively. That is a most interesting word. I must look that word up. Upon my word I must.

His courtesy of manner rang a little false....

The little word seemed to have turned a rapier point of his sensitiveness against this courteous and vigilant foe. He felt with a smart of dejection that the man to whom he was speaking was a countryman of Ben Jonson. He thought:
—The language in which we are speaking is his before it is mine. How different are the words *home, Christ, ale, master,* on his lips and on mine! I cannot speak or write these words without unrest of spirit. His language, so familiar and so foreign, will always be for me an acquired speech. I have not made or accepted its words. My voice holds them at bay. My soul frets in the shadow of his language. (*P*, 189)

I looked it up and find it English and good old blunt English too. Damn the dean of studies and his funnel! What did he come here for to teach us his own language or to learn it from us. Damn him one way or the other. (*P*, 251)

With regard to the ghostly stubbornness of innocent language, consideration might be given to minorities trying to maintain a kind of tension in cultural settings intolerant of such tension. The extraordinary stubbornness in Joyce's English lends at least artistic precedence for indulging the ghost whose demand is no more "American," "German," "French," or whatever than the demand of Joyce's determining ghost is "Irish." The demand could be considered the death within language, the demand of language in its innocence. Those at home in a language or a way of using a language might not think very much about language in its innocence; they might speak as though their usage is innocent. For those not so at home, the only home is the uncomfortable one of innocent language demanding allegorization of every usage of language. Although no usage is innocent, innocent language is an inexhaustible allegorizing force precisely by never being used. It may no longer be possible to live as an author in English without becoming "American"; even people writing in French or German might find themselves somehow writing "American," not only in untranslated usage of certain terms but also in some kind of finite form or rhythm—perhaps in acquiescence to an anti-artistic and antiphilosophical "coherence," in certain usages of superlatives, or in a prevalence of certain concepts or gestures of alleged clarity, simplification, or expedience. The term "America" in English is often already an instance of the latter kind of gesture; as has often been noted, the alleged name of a country is used to usurp the name of a continent, or more precisely, two continents.[211] Yet the ghost of innocent language requires that the failure of "Americanized" language be presented. On the most basic level, the failure is the failure of any usage of language. A specific problem

may be that "Americanized" language could seem oriented to the celebration of "success," the celebration of "life" and its expressive achievement. The ghost of innocent language emerges, however, as a stubbornness requiring performance of failure in any usage of language.

For Benjamin, the practice of philosophy would not be possible or necessary if there were not this linguistic stubbornness. Even if his associations of *language* with "the human's language" seem not entirely credible or seem overdrawn, these do *not* entail a notion of *language* as something that the human commandeers; the name—the language of the human—is not the human's language as something through which the human communicates (see pages 28–31 above). To try practicing philosophy in accordance with the predominance of language over any human may, to some, seem an offense against humanity. ("And sign crisscross with reverent thumb / Memento homo upon my bum." *PE*, 110) There may be a concern, of course, that the practice of philosophy not fail at failing. It has to succeed at failing. It presents itself solely insofar as it succeeds at performance of the resistance of ground to grounding; it presents itself solely insofar as it performs its basis on the ground that is perpetual exception to rulership. ("all these men of whom I speak / Make me the sewer of their clique." *PE*, 104) No one, of course, lives the life of the philosopher-saint. Rosenzweig thus detects the philosopher-saint solely in certain dramatic works.[212] Playing life for the sake of a certain ambiguity, for the sake of *death in life,* requires the suprahuman in the human. Effective performance of the *impossibility* of this requirement may be, in a philosophical sense, the only success that may be expected of the practice of philosophy, and the only success that may be expected of language in its stubborn innocence.

Even if effective (that is, philosophically effective), a decision to try to live a little more death is an impertinence that can end up a prelude to defeat. ("And he that had erst challenged to be so doughty waxed pale as they might all mark and shrank together and his pitch that was before so haught uplift was now of a sudden quite plucked down and his heart shook within the cage of his breast as he tasted the rumour of that storm." *U*, 392)

The rumor of the storm opens, nonetheless, a freedom to conceive of the storm as rumor.[213] This catalyzing is possible, regardless of how powerful the rumor may be. Insofar as it refuses to be considered rumor, this storm is a lie ("lying rumours" *PE*, 196). It is a specific kind of lie. Benjamin refers to "objective untruthfulness [objektive Verlogenheit]," which conducts itself as though honesty is realized or fulfilled (VI, 60–61). By some criteria, to lie may be wrong and dishonest; it need not, however, be objective untruth (63). Objective untruth is living as though whatever is conceived as lived life were truth. Truth has a constitutive relationship with silence (64) in the sense that

truth is not "lived," is not *erlebt*. In the power of writing to be dead to the "living" context (to the pervasive, mythic, guilt-context of living humans), philosophy as a discipline, as some other practice, or as a force or form performatively effective in various practices such as artworks, involves performance of the constitutive relationship of truth with silence. Philosophy makes tragedy unviable, insofar as tragedy concludes in favor of the will or *Weltanschauung* that seems or presumes to usurp or annul performance of silence. Philosophy facilitates the play of mourning. The hunted may withhold from the hunt and may even open space for the genius of comedy, the genius of image reversal. Mourning is the basis for an ironizing—an allegorizing—of the hunt. ("[T]he eyes of the photograph . . . answered coldly." *D*, 80) The withholding from the hunt, or the comedy concerning the hunt, cannot be extricated from the philosophical admission that life is permeated by some myth or other. As mourning, however, this admission will attest to a freedom, the freedom of death in life, whereby the melody heard in the *rain* of death is the *lore* of freedom. ("Sing to mine ear, O rain, / Thine ultimate melody; / That the dearest loss is gain / In a holier treasury." *PE*, 69) Loss is never simply loss, no matter how much it may seem to be, and even though it is also never simply gain. Death is always effective in it. As the ineradicable stubbornness of ruination, death is the author of this work.

Prince Misch(lings)kin(d), Paddy O'Dradek, Brendan Patrick Moran ("Mesdames Gerald and Stanislaus Moran" *U*, 519; "Father Moran" *P*, 220; "Is it on account of that certain young lady and Father Moran?" *P*, 202)-Burke ("Pisser Burke" *U*, 519; "One of these gentlemen was Mr. O'Madden Burke. . . . His magniloquent western name was the moral umbrella upon which he balanced the fine problem of his finances. He was widely respected." *D*, 143)-O'Callaghan ("'So do I,' said Miss O'Callaghan." *D*, 208)-Ryan-Johnston-Bowen-Riordan ("Mrs. Riordan" *U*, 519; "that old faggot Mrs Riordan . . . and her gabby talk about Mr Riordan there I suppose he was glad to get shut of her" *U*, 659)-Leitch-Fitzgerald-Ambrose-Mellet-Hennessy-Sheahan-Hickey . . . Adam-Eve ("The Nameless One" *U*, 519) . . . ("Poor Saint James Joyce" *PE*, 89) . . . Poor Saint Brendan Moran . . . Monad Rrenban . . .

Notes

AN INTRODUCTION

1. "Walter Benjamin," *On Jews and Judaism in Crisis*, 180/*Walter Benjamin und sein Engel*, 17.
2. Jameson, "Benjamin's Readings," 32.
3. Scholem suggests label-sticking was characteristic of Ernst Cassirer's lectures (*WB*, 34/*48*). For expressions of frustration over Cassirer's lectures, see Scholem, *Tagebücher*, 423–24, 442–43.
4. Lacoue-Labarthe, *Heidegger, Art, and Politics*, 3, 6 nn. 1–2; Guattari, "L'impasse post-moderne."
5. For a simplistic instance, see Buck-Morss, *The Dialectics of Seeing*, 54, 339, 477 n. 35. Although Wolin finds aspects of Buck-Morss's usage of this terminology to be "somewhat risky," his own usage seems comparably platitudinous (Wolin, xxii–iv, liii).
6. This emphasis on the intertwining of philosophy or word—as linguistic being—with perception and meaning is obviously distinct from Caygill's recent attempt to foster a disjuncture of experience and philosophy (or language), a disjuncture that he considers evident in certain writings—including certain "early" writings—by Benjamin. Cf. Caygill, *Walter Benjamin*, xiv–v, 13, 17–21.
7. In *One-Way Street* (published in 1928 and written to a considerable extent in conjunction with the *Trauerspiel* book), Benjamin says: "The work is the death-mask of its conception [Konzeption]" (*W* 1, 459/IV:1, 107).
8. Jabès, *The Book of Questions*, Vol. 1, 189.
9. Deleuze and Guattari, *What Is Philosophy?* 107–8. The young Benjamin says, a little pathetically perhaps, that the "academy" has turned into "the university" and students into "academicians" (Aphorism from 1916–1917, II:2, 601).
10. Although certain aspects of her article are specific to universities in German-speaking Europe, a refreshingly candid and witty discussion is provided by Schmid-Bortenschlager ("Ratschläge für junge Kolleginnen"). Certain passages of Readings's *The University in Ruins* show a comparable candor.

11. Cixous, *La ville parjure, ou Le réveil des Érinyes*, 124 (X2).
12. Wolf, *Kein Ort*, 137.
13. Cixous, *Three Steps on the Ladder of Writing*, 53.
14. Novalis, *Schriften*, Vol. 2, 179 (fragment no. 21).
15. To reiterate: The following study will acknowledge and explore continuities, consistencies, or complementarities of "early" and various later works by him. It seems warranted—through such references to later writings—to keep the border lines between "early" and "late" fairly open in certain ways. As noted, the issue of "early" and "late" Benjamin (and of the relationship between them) will be discussed somewhat in the section on "Death of Art and Philosophy" in the part on "Community of the Dead."
16. Nietzsche, *The Gay Science*, 181.

PHILOSOPHICAL COMMUNITY

1. Such dogmatism has, nonetheless, been alleged in Bröcker, "Sprache," 744.
2. Gen. 2:19, 20.
3. Available in translations in *W* 1, 55–61, "Trauerspiel und Tragödie" (II:1, 133–37) and "Die Bedeutung der Sprache in Trauerspiel und Tragödie" (II:1, 137–40) were written a few months before Benjamin wrote "On Language as Such and on the Language of the Human" and, like that text, not published in Benjamin's lifetime. According to a dedication to Benjamin's wife, the *Trauerspiel* book was "conceived" or "sketched" (entworfen) in 1916.
4. Some remarks by Agamben seem noteworthy in this context. Agamben contends Derrida "believed he had opened a way to surpassing metaphysics, while in truth he merely brought the fundamental problem of metaphysics to light. For metaphysics is not simply the primacy of the voice over the *gramma*. If metaphysics is that reflection that places the voice as origin, it is also true that this voice is, from the beginning, conceived as removed, as Voice. To identify the horizon of metaphysics simply in that supremacy of the *phone* and then to believe in one's power to overcome this horizon through the *gramma*, is to conceive of metaphysics without its coexistent negativity. Metaphysics is always already grammatology and this is *fundamentology* in the sense that the *gramma* (or the Voice) functions as the negative ontological foundation" (*Language and Death*, 39). Whether or not one agrees with this as a critical consideration of Derrida (the notion of a *negative ontological foundation* seems an unlikely one for Derrida), the articulation of metaphysics might be helpful in the context of Benjamin's various adoptions of metaphysics or the metaphyscial. Those adoptions still sit uneasily in some of the reception of Benjamin's works, so that the term "metaphysical" is dissociated from Benjamin's works (e.g., Richter, 228, 242–43).
5. If the old saying with the motif of nature lamenting while being able to speak concerns the Last Judgment, it may well make "no sense" (Agamben, *The Coming Community*, 39). It indicates perhaps the role of the motif of paradise (rather than the motif of Last Judgment) in Benjamin's linguistic theory that he interprets this old say-

ing as pertaining to a situation in which there is still a hint of lament even while nature is, in a way, given language.

6. This distinction of spiritual being and linguistic being is somewhat more emphatic than is suggested by Düttmann's reference to spiritual being as "communicability itself," as designating "what makes communicability what it is and makes it communicate itself as communicability" and thus as designating "the incommunicable and untranslatable at the heart of communicability, of language, of the name" (*The Gift of Language*, 43). Particularly the latter designation pertains more to Benjamin's notion of linguistic being than to his notion of spiritual being; only in its ultimate being is spiritual being identifiable with linguistic being. (*The Gift of Language*, which first appeared in French in 1989, was overlooked until this book was being prepared for the typesetter. It is particularly relevant to concerns raised in this part on "Philosophical Community," although it does not share the concern of exploring an identification or a convergence of the linguistic and the philosophical.)

7. *Arrested Language*, 203–5.

8. The modifications made here to the available English translation seem noteworthy; especially the usage of definite instead of indefinite articles—before "hypothesis" and "abyss"—gives a quite different sense to the sentence.

9. Reijen, *Der Schwarzwald und Paris*, 162.

10. *WB*, 59/77.

11. On numismatism, see Derrida, *Margins of Philosophy*, 209–19, and *Writing and Difference*, 270–73. Also relevant in this context: *Given Time*, Vol. 1, *Counterfeit Money*.

12. Müller, *Zur Lage der Nation*, 37; Agamben, *Homo Sacer*.

13. Scholem claims that both he and Benjamin consider "the central concepts of language-theory"—as addressed in Benjamin's 1916 essay "On Language"—to be the "genuine basis of any philosophy" (letter of August 3, 1917, in Scholem, *Briefe an Werner Kraft*, 16).

14. See also "Fortsetzungsnotizen zu Arbeit über die Sprache," VII:2, 786–88.

15. "The medium [Das Mediale]" is the *immediacy* of all communication. The medium is thus "the fundamental problem of linguistic theory," a problem that Benjamin suggests could be called a problem of magic just as this immediacy could be called "magic." The "notion of the magic of language" points to the infinitude of language, the infinitude "conditioned by" the immediacy of language. Linguistically considered, this immediacy is uncircumscribable infinitude. "For precisely because nothing communicates itself *through* language, what communicates itself *in* language cannot be externally limited or measured, and that is why there inheres in each language its own incommensurable, uniquely constituted infinitude. Its linguistic being, not its verbal contents, marks its frontier" (*W* 1, 64/II:1, *142–43*). The frontier of language is everywhere as immediate opening to infinitude.

16. Lexically speaking, Benjamin's usage of the noun "language" is not a figurative extension of it, although his usage gives priority to one of the less-common meanings. In dictionaries, usages such as "the language of flowers" and "the language of technology" are cited as examples of the definiens. In *One-Way Street*, Benjamin discusses "stamp-language" and the "language of flowers" (*W* 1, 480/IV:1, 137) ("the language of stamps singing" *U*, 680).

17. Benjamin elaborates: "In the realm of language, the name solely has this sense and this incomparably high significance: that it is the innermost being of language itself.... The name as the inheritance of the human language guarantees ... that *language as such* [*die Sprache schlechthin*] is the spiritual being of the human; and only for this reason is the spiritual being of the human, alone among all spiritual beings [Geisteswesen], completely communicable [restlos mitteilbar]. On this is founded the difference of the human language from the language of things" (*W* 1, 65/II:1, *144*).

18. Holz, "Philosophie als Interpretation," 235–42, especially 238. The distinction of name as linguistic from name as referential is overlooked by Jacobson, who says Benjamin is claiming "we" are currently "in possession" of "a language ... that is perfect" and suggests Benjamin does not recognize that "our language is not the same as Adam's or the language of creation" (97–98).

19. Benjamin's linguistic theory has been articulated as a transformation of the Husserlian *epochē*—the abstention or bracketing of language from judgment. Fenves refers to "paradisal *epochē*" involving "spheres in which subjects remain unaffected by things and are, for this reason, not—or not yet—subjects, properly speaking" (*Arresting Language*, 199, 194–95). Although the section "Paradisal Play" was titled and written before the publication of Fenves's book, the emphasis on play rather than *epochē* may indicate a difference between this book and Fenves's. There is in Fenves's study an association of the paradisal in humans with the child's pure vision or what Schiller calls the "naive." As will be indicated below, especially in the part titled "Image of Dramatic Beauty," such associations are either very qualified or rejected by Benjamin.

20. Benjamin is quoting Hamann, "Des Ritters von Rosencreuz letzte Willensmeynung über den göttlichen und menschlichen Ursprung der Sprache" (1772). See Hamann, *Vom Magus im Norden und der Verwegenheit des Geistes*, 82.

21. The emphasis on incommunicable linguisticality seems, to a significant extent, to keep Benjamin's usage of the motif of paradisal naming free from a "metaphysics of presence." Benjamin's remarks on the play of language are not incompatible with Derrida's on "différance," "play," and "strategy"; the latter do not reduce language to a conceptual means, to the "arbitrariness of the sign," and the linguistic "origin" discussed by Benjamin (see pages 70–74, 81–84, and 101–4 in this volume) is not a variation of the "origin"—cause with effect able to be delineated—that is criticized by Derrida in his earlier writings. For an attempt, nonetheless, to contrast Benjamin's work and Derrida's earlier writings in precisely these terms, see Wohlfarth, "On Some Jewish Motifs," especially 163–66, 179–82. The aforementioned distinction of Benjamin's notion of origin from that criticized by Derrida's earlier work is implicit and explicit in remarks by Pizer; nevertheless, his comparisons of Benjamin and various more-recent theorists also suffer from a fairly caricatured version of so-called poststructuralism (9–10, 45, 57–70, 183–84). A problem with Wohlfarth's remarks on sign is, moreover, insufficient emphasis that Derrida's work is a critique of Saussure, a "transformation of general semiology into grammatology" (Derrida, *Margins of Philosophy*, 3, 7, 11–12, 15). Similarly misleading remarks concerning Benjamin and more-recent tendencies in linguistic theory are to be found in Handelman's comments

on studies such as those of de Man, Jacobs, and Hillis Miller (Handelman, *Fragments of Redemption*, 63, 136–137; in this respect too, see again Pizer, 56).

22. This relationship of music and play makes it questionable to say Benjamin insists that "Trauerspiel is forced to leave the realm of performance" (Jacobson, 43). Benjamin's conception of an integration of play and mourning offsets or confuses, moreover, the dichotomy of "modern" and "postmodern," at least as this dichotomy is noted by Kristeva, whereby the modern is closer to "abyssal discontent" or "the winter of discontent" or "the whiteness of boredom" and the postmodern to "the human comedy" or "the artifice of seeming" or "the heartrending distraction of parody." Cf. Kristeva, *Black Sun*, 258–59.

23. It is perhaps a slightly over-Freudian suggestion of Samuel Weber to say that, for Benjamin, melancholy, sadness, and mourning are the pain associated with "dislodging that which is, by forcing it into a mode of self-imparting, self-departing, wrenching it free from its established sites." The pain, the "sense of loss," for Benjamin is more clearly associated with a lack of such dislodging, the lack of self-departing, the lack of wrenching free from established sites. Cf. Weber, "Benjamin's Writing Style," 263.

In 1915, Freud wrote "Mourning and Melancholia," which was published in 1917—the year following the writing of Benjamin's then-unpublished "On Language." Freud distinguishes mourning from melancholy. "Mourning" is the *normal* response to a death—to a "real loss." For Freud, "melancholy" is a delusional projection whereby all, or abnormally many, potential love-objects are regarded in terms of their perceived propensity to be unobliging. Benjamin uses the terms "mourning" and "melancholy" somewhat more interchangeably. For Benjamin's philosophical sense, mourning and melancholy pertain to what might be considered a kind of *object-loss* (Freud) permeating experience. This is mourning and melancholy over the abstractness of the *communication*-mediating experience of objects. Cf. Freud, 251–68, especially 252, 258–59, 266–67. Lepenies discusses melancholy in relation to the quest for legitimation and considers Benjamin's *O* relevant for this discussion. Lepenies also examines Gehlen's cultural pessimism and concludes with a critique of Gehlen (1904–1976) based significantly on Adorno's refusal to reduce melancholic nonidentity to unredeeming neurosis (Lepenies, 214–53).

24. See *C*, 80, but also, in order to appreciate better the wordplay in German, *GB*, Vol. 1, 326. In July 1916, a few months before writing "On Language," Benjamin wrote this letter to explain why he could not accept an invitation to contribute to Buber's newly founded periodical, *Der Jude* (*The Jew*, a periodical that ran from 1916 to 1926). Benjamin is repelled by the prowar tendencies of *Der Jude*; this repulsion is part of his wariness about treating the word as instrument, as "means"(*C*, 79–80/ *GB*, Vol. 1, 325–27). Buber never answered the letter, although he expressed anger about it in a conversation with Scholem (Scholem, *WB*, 27/40). Scholem's own early reservations about Buber's outlook, reservations which were cast somewhat in Benjaminian formulations concerning word and deed, are summarized in Biale, 20–21. Also relevant in this regard are Scholem's open letter "Farewell," *On Jews and Judaism in Crisis*, 54–60, especially 56–57; "Abschied," especially 126–27; and the letter of August 11, 1917, in Scholem, *Briefe an Werner Kraft*, 22.

25. Rochlitz, 17.

26. Gen. 2:20–23: "but for the man himself no partner had yet been found. And so the LORD God put the man into a trance, and while he slept, he took one of his ribs and closed the flesh over the place. The LORD God then built up the rib, which he had taken out of the man, into a woman. He brought her to the man, and the man said:
'Now this, at last–
bone from my bones,
flesh from my flesh!–
this shall be called woman [Hebrew: ishshah],
for from the man [Heb.: ish] was this taken.'"

27. Benjamin does not, however, note the Hebrew (*W* 1, 69/II:1, 149). Gen. 3:20 says: "The man called his wife Eve, because she was the mother of all who live." Although the Hebrew words for "man" and "Adam" are identical, the word does not appear without the definite article until Gen. 3:21, after the fall (see the footnote in the Oxford Study Edition of *The New English Bible*, 4). Not all translations refrain from using "Adam" prior to the fall. The translations apparently consulted by Benjamin for his writings seem, however, to accord roughly with the Hebrew in this respect: Martin Luther's translation in "On Language"; and in the *Trauerspiel* book, the translation edited in 1835 by Leopold Zunz (Genesis in this edition is translated by H. Arnheim). Neither translation uses "Adam" until Gen. 3:20, after the fall (although this is one verse earlier than is suggested by the practice and editorial annotation in the Oxford Study Edition).

28. Benjamin quotes Theophrastus Paracelsus, *Erster Theil Der Bücher und Schriften* (Basel: 1589).

29. "Über Ehe" is a note (written sometime between 1918 and 1920) discussing marriage.

30. Recalling his poet friend Fritz (Friedrich Christian) Heinle, Benjamin says that the latter brought a pious, wild, nonconformist child into Benjamin's life, one inducing mourning; Heinle gave birth to this child "[w]ithout pregnancy" ("Sonette," VII:1, 55).

31. Weigel, "'The Female-Has-Been,'" 27.

32. At least expressly, nonetheless, Benjamin rejects aestheticization of prostitution. He regrets the bifurcation of Eros by a division of intellectual independence of the creative (in the student fraternities) and unmastered natural power (the male students' employment of prostitutes) (*W* 1, 44/"Das Leben der Studenten" [an essay based somewhat on Benjamin's 1914 inaugural lecture as president of the Berlin "Free Students" and published twice—in 1915 and 1916]), II:1, 84). This critical nuance is overlooked in the account given in Weigel, "Eros," 306, 308. The prostitute represents something unreined and yet required (by financial control) to be obedient ("Die Dirne" [from around 1921], VI, 75). At least the prostitute is ethical in the sense that she displays the selling in which we all participate (we are all prostitutes); her sexualization of spirit is, moreover, ethically salutary in driving nature from any would-be sanctuary of private sexuality (*C*, 35–36/*GB*, Vol. 1, 127–28). Familial "unculture" (the would-be private sanctuary) and prostitution (the public admission that the sanctuary is not what it is touted to be) belong to "erotic unculture"

("Erotische Erziehung: Anlässlich des letzten studentischen Autorenabends in Berlin" [a piece appearing in *Die Aktion* in 1914], II:1, 71–72).

33. "Kann von Grillparzers 'Sappho' gesagt werden, daß der Dichter 'mit Goethes Kalb gepflügt hat,'" (VII, 535; see also 533, 535–36). This essay contrasting Goethe's *Torquato Tasso* with Franz Grillparzer's *Sappho* was, it should probably be noted, written in Benjamin's closing year of high school (1912).

34. In a letter of July 1918 to former schoolmate Ernst Schoen (1894–1960; composer, writer, translator, future prominent figure in the beginnings of German radio—specifically at "Sudwestdeutscher Rundfunk," then in Frankfurt am Main, from 1924 to 1933), Benjamin comments on a book encountered in preparation for the dissertation on early German Romanticism: Luise Zurlinden, *Gedanken Platons in der deutschen Romantik* (Leipzig: 1910). Benjamin recounts an indescribable "horror" overcoming one when women wish to have a say in these matters (*C*, 133/*GB*, Vol. 1, 468) ("that old Bishop that spoke off the alter his long preach about womans higher functions about girls now riding the bicycle and wearing peak caps and the new woman bloomers" *U*, 682). Almost a decade later, he says (in a review of February 26, 1928, in the *Frankfurter Zeitung*) concerning Eva Fiesel's *Sprachphilosophie der deutschen Romantik* (Tübingen: 1927): "Originally a dissertation or grown from a dissertation, this work is high above the average of dissertations in Germanic studies. This assessment is to be stated in advance in order that the second assessment be protected from misunderstandings: it is a typical womens' work [Frauenarbeit]. That is to say: the training, the niveau, the care are out of proportion to the low measure of inner sovereignty and true involvement with the material." The limits of the "capable work" are typical "for an unmanly historicism" (III, 96–97).

35. Scholem recalls that in 1916 Benjamin pejoratively characterized Buber's thinking as "frauenhafte" (Scholem, *WB*, 29/42—the relevant entry in Scholem's diary is available in Scholem, *Tagebücher*, 388). The remark is a pejorative rendering of the characterization of Buber initially advanced as a compliment by Gustav Landauer.

36. As a student in Freiburg, Benjamin attended Heinrich Rickert's 1913 seminar concerned with establishing an entirely new philosophical discipline: philosophy of the perfected life. Woman is representative, which Benjamin finds interesting but problematic. Rickert simultaneously elevates the woman and prohibits her from any realm of moral conduct. What Rickert says regarding woman and "the 'principle of femininity'" is unacceptable in its declaration of the woman as "in principle incapable of the highest moral perfection [Vollendung]—she receives her asylum in the 'perfected life' [vollendeten Leben]" (*GB*, Vol. 1, 117; see also *C*, 31/*GB*, Vol. 1, 112). A little later, Benjamin says women should be included in attempts at attaining a community of the creative. His aside that women are "not productive in the sense of the man" is not clear and is difficult to construe as depreciation, praise, or an ambiguous mix of both (*W* 1, 44/II:1, *84*).

37. For instance, Cixous, *Three Steps on the Ladder of Writing*, 21, and Kristeva, "Stabat Mater," in *Tales of Love*, 235–63.

38. See Cixous, *Three Steps*, 73–74.

39. This reading of Benjamin diverges, therefore, from that offered by Weigel ("The Female," 27). Alternative readings of Benjamin with regard to gender are offered by Geulen ("Toward a Genealogy of Gender") and Jacobs (91–113).

40. Noteworthy in this context are some of the aphorisms on "books and harlots" in *One-Way Street*, *W* 1, 460–61/*IV*:1, 109–10.

41. Although very early writings discuss the genius as person (das Genie), Benjamin increasingly refers instead to genius (der Genius), which is the productive force lending expression to expressionlessness, lending expressionlessness to expression. See n. 60 for "Image of Dramatic Beauty" below.

42. See also the second postscript, which quotes Wyneken (*C*, 36/*GB*, Vol. 1, 129). Such views developed here and elsewhere by Benjamin do not confirm the summation of them as saying "that women . . . are . . . banished to that mute region of another productivity" (cf. Weigel, "The Female," 27). Benjamin's earlier writings do not entirely have women as a "sex" or "gender" banished to silence (cf. 26, 28–29).

43. That Benjamin could encourage the woman becoming *masculine* ("God I wouldnt mind being a man and get up on a lovely woman" *U*, 691) is evident in a letter of July 11, 1913 (to his friend Franz Sachs) where Benjamin discusses the merits of a particular female candidate (a Fraulein Cohen) for the presidency of the Berlin Free Students' Association (*C*, 42–43/*GB*, Vol. 1, 142). The group of students involved in the journal *Der Anfang* included Benjamin and were expressly committed to changing societal norms concerning womanly conduct. Gustav Wyneken (1875–1964), the mentor of these students, led a school where girls competed with boys in the two-mile race and improvements in the girls' achievements were especially lauded (Laqueur, 59–60). Wyneken's attitude to coeducation was, nevertheless, much more skeptical than that of Paul Geheebs, with whom Wyneken ran the Free School Community at Wickersdorf. At Wickersdorf, coeducation was introduced against the vote of Wyneken (Olenhusen, 113–14). A former member of the Free Students' Association recalls an unusual number of "Mädchen" participating but suggests they were mostly "our listeners" and were more an "ideological" legitimation than an active part (Gumpert, 55). For an indication of Benjamin's own very early endorsement of new developments concerning women, as well as of some of the ambiguity in his formulation on these matters, see "Die Freie Schulgemeinde" (published in *Der Anfang* in 1911), VII:1, especially 11–13.

44. Contrary to certain attempts to demonstrate affinities of Benjamin and Carl Schmitt (cf. Heil, 162, 196–97), Benjamin's critique of overnaming is not intolerance of multiplicity; its emphasis on resistance to understanding is not antipluralistic.

45. In this context, the *Trauerspiel* book draws from or adapts above all the appendix of *Fragments from the Estate of a Young Physicist: A Pocketbook for Friends of Nature* (*Fragmente aus dem Nachlasse eines jungen Physikers: Ein Taschenbuch für Freunde der Natur*, 1810) by the Romantic physicist-philosopher Johann Wilhelm Ritter (1776–1810). Benjamin spoke of Ritter's work as early as 1916 (Scholem, *WB*, 30/43) and continued to refer to it in writings of the 1930s.

The Romantic philosopher Franz von Baader (1765–1841) is also a likely influence on Benjamin's linguistic writings. Baader's writings on the Lutheran mystic Jacob Böhme (1575–1624), as well as on other philosophical issues, had considerable ap-

peal for Benjamin at least as early as 1917 (Scholem, 21–22, 38/32–33, 53; *C*, 86, 88, 89/*GB*, Vol. 1, 357–58, 361, 364). Also noteworthy is Baader's student Franz Joseph Molitor (1779–1860), a liberal Catholic in whose work both Benjamin and Scholem expressed interest as early as 1917. They were primarily interested in Molitor's four-volume *Philosophie der Geschichte oder Über die Tradition* (1827–1857), which was written to introduce a projected discussion of the Kabbalah (Scholem, 38/53; *C*, 86/*GB*, Vol. 1, 357). Insofar as Benjamin at least partly read this work, the latter could have influenced some of his linguistic views, including those concerning images as writing images (Schobinger, 94–101; Speth, 221–22).

46. See also other notes from around 1917 on perception: "Wahrnehmung ist Lesen" and "Über die Wahrnehmung in sich" (VI, 32). A translation of the former is available in *W* 1, 92.

47. Derrida, *Margins of Philosophy*, 29–67, especially 66–67; *Of Spirit*, 9–10. See also Derrida's emphasis—against Heidegger's existential analytic of (proper) dying—on inextinguishable mourning and ruination (*Aporias*, 30, 39, 61, 66–80).

48. As has been emphasized from diverse perspectives: Seel, 338; Andrew Benjamin, *Translation and the Nature of Philosophy*, 28–29; Caygill, "Benjamin, Heidegger, and the Destruction of Tradition," 10; Tiedemann, 16. The emphasis seems to be reiterated in the book on Heidegger and Benjamin by Willem van Reijen, 206–7. For remarks dismissing the conception of time that was formulated by Heidegger in an essay appearing in 1916, see *GB*, Vol. 1, 344.

49. In these two notes entitled "Agesilaus Santander" and written in Ibiza on August 12 and 13, 1933, respectively, Benjamin discusses his own secret name. Scholem believes an actual secret name is not at issue. (Scholem's essay initially appeared as "Walter Benjamin und sein Engel," in Siegfried Unseld, ed., *Zur Aktualität Walter Benjamins*, 87–138, and shall be quoted from: "Walter Benjamin and His Angel," *On Jews and Judaism in Crisis*, 198–236/*Walter Benjamin und sein Engel*, 35–72.) Several years after Scholem's essay first appeared (1972), however, it was discovered that Benjamin (as a newborn) was given the "secret name" Benedix Schönflies (Fuld, "Agesilaus Santander oder Benedix Schönflies."). "Schönflies" is the family name of Benjamin's mother (Scholem, "Ahnen und Verwandte Walter Benjamins," *Walter Benjamin und sein Engel*, 128–60). On the basis of his discovery, Fuld accuses Scholem of a contrived theological interpretation, one that not only overlooks the actual "secret name" but also too readily downplays the possible influence of an illness Benjamin was undergoing in the summer of 1933. In his reply, Scholem notes that his initial essay—on the basis of letters (*Correspondence*, 69, 72/*Briefwechsel*, 91, 94–95) and friends' recollections—does mention the possible influence of illness. Scholem argues, however, that neither this possibility nor Fuld's discovery (in Nazi SS records on Benjamin) disqualifies his own extrapolations on the notes ("Die geheimen Namen Walter Benjamins," *Walter Benjamin und sein Engel*, 73–77). For an essay attempting to refine rather than dispute Scholem's interpretation, see Ebach, "Agesilaus Santander und Benedix Schönflies." Proposed refinements or corrections, particularly concerning Scholem's attribution of Satanic and female form to the angel, may be found in Agamben, "Walter Benjamin und das Dämonische," especially 193–94. The following usage of Benjamin's notes on the angel will obviously not subscribe to the

assessment that they are "extremely slender" in their "theoretical content" (cf. Roberts, 197).

50. Scholem, "Walter Benjamin and His Angel," 216/50. Benjamin had a penchant for toying with the letters and syllables of words and especially anagrams (215–16/50; see also Selz, 357). Concerning this play-potential as unique to name (and distinct from picture), see Holz, "Prismatisches Denken," 78–79.

51. Of this fallen angel (the Angel Satan, Angelus Satanas), Scholem notes: "Such an Angel-Satan is spoken of not only in Hebrew texts, as for example, the Midrash Rabba for Exodus, Section 20, paragraph 10, but also in New Testament texts, where in Paul's Second Letter to the Corinthians, Chapter 12:7, there is talk of the *Angelus Satanas*, who is identical with the fallen, rebellious Lucifer" ("Walter Benjamin and His Angel," 216/51).

52. Müller, "Glückloser Engel 2." As revenge for Benjamin becoming a distraction from previous singing before God, the angel sends a "feminine shape" (*W* 2, 715/*521* [first version]), which Scholem plausibly suggests is the sculptor Jula Cohn ("Walter Benjamin and His Angel," 221–22/55–56).

53. Foucault, *This Is Not a Pipe*, 32–33.

54. Adorno, "Commitment," *Notes to Literature*, Vol. 2, 94/"Engagement," *Noten zur Literatur*, 430.

"Angelus Novus" (New Angel) — a watercolor painting by Klee (1879–1940) — was bought by Benjamin in 1921. For various usages of the image of "new angel," see: *W* 1, 292–97, especially 296/II:2, 241–46, especially 246; *W* 2, 457/II:1, 367; the theses "On the Concept of History," *W* 4, 392/I:2, 697–98. Thesis 9 quotes a verse from a poem, "Greeting from Angelus" (Gruss vom Angelus), which Scholem gave to Benjamin on the occasion of the latter's birthday in 1921. Scholem's poem, in its entirety, is available in *C*, 184–85/*GB*, Vol. 2, *174–75*. For some comments on Benjamin's relationship with the painting see: Letters from Benjamin to Scholem of November 8, 1921, and November 27, 1921, *GB*, Vol. 2, 207–9, 211–13 (variations on the theme of angel play a role in many of Benjamin's letters to Scholem around this time); Scholem, "Walter Benjamin and His Angel," 208–14/44–49; Adorno, "Introduction to Benjamin's *Schriften*," 16/*Über Walter Benjamin*, 51.

55. Such compensatory egoism is, nonetheless, attributed to Benjamin and "Angelus Novus" by Witte (*Walter Benjamin: Der Intellektuelle als Kritiker*, 34–35, 130, 211 n. 311) and Werckmeister ("Walter Benjamin, Paul Klee, und der 'Engel der Geschichte,'" 25–26, 31). Werckmeister's allegations are based partly on statements that Klee made about his situation as an artist (16–26). As Werckmeister acknowledges, however, Benjamin could not have been aware of these statements; the diaries in which they appear were not published until 1957 (17). An artist's statements do not, moreover, dictate the terms in which a work may be received. Witte follows some characterizations of Klee's works by Gehlen, who regards Klee's works and much of their reception as symptomatic of societal conditions under which humans "live in an external world constructed industrially, thoroughly technicalized, harboring millions of ego-centered, self-conscious individuals, all seeking to enrich their own psychic existence" (Gehlen, 83/63; see also 121/90).

56. Man, *The Rhetoric of Romanticism*, 262.

57. Müller, *Jenseits der Nation*, 43. Müller's response is not cited here for its interpretation of Adorno's remark, which is more complex and nuanced than Müller's response might imply (cf. Adorno, *Prisms*, 34/*Prismen*, 26). That complexity and nuanced character become obvious in much that Adorno wrote on the predicament of art after Auschwitz. (For a collection of some of Adorno's pertinent reflections, see Kiedaisch, ed., *Lyrik nach Auschwitz?* 27–72.) Adorno also later suggested poetry may retain rights as expression of "perennial suffering"; "hence it may have been wrong to say that after Auschwitz you could no longer write poems" (*Negative Dialectics*, 362/*Negative Dialektik*, 355).

58. Discussing Klee and René Magritte, Foucault continues: "In order to deploy his plastic signs, Klee wove a new space. Magritte allows the old space of representation to rule, but only at the surface, no more than a polished stone, bearing words and shapes: beneath nothing" (*This Is Not a Pipe*, 41; see also 34–35). Whereas Magritte collapses old spaces, Klee—as befits an associate of the Bauhaus school, perhaps—not only destroys criteria of ordinary spatio-temporal experience but also creates new spaces irreducible to such experience (see Gay, 98–99).

59. Blanchot, *The Writing of the Disaster*, especially 12, 49–50.

60. Claiming that what "'we' call proper names were once all appelatives" (*Arrested Language*, 215), Fenves overlooks that people—in North America, at least (it would be illegal in some other places, such as Germany)—can and do "invent" proper names; certain letters are thrown together to form a word that has apparently hitherto been used neither as an appelative nor as a proper name. This is legally acceptable, at least for first names, and may indicate a practice somewhat in the spirit of Benjamin's remark that "no name ought (in its etymological meaning) to correspond to any human being" (*W* 1, 69/II:1, *150*). As Fenves notes, Benjamin overlooks the extent to which Genesis itself has God and Adam give proper names as appelatives: in the case of God, man ('adam) from the earth ('adamah); in the case of Adam, woman ('ishshah) from man ('ish), Eve (hawwah) as mother of all the living (hay). Fenves also notes Eve doing this kind of proper naming (*Arrested Language*, 216). Benjamin gives an "imperative" ("there shall be no names by way of antonomasia"); yet it is one "that neither God, nor Adam, nor Eve respect." This contradiction in Benjamin's 1916 essay is taken by Fenves as an indication that Benjamin underestimates the "limit" posed by "the finitude of human language" to its "creative—as opposed to its cognitive—dimension" (217). Fenves notes the reference by Benjamin to "die mythologische Weisheit" expressed in the "Anschauung . . . (die sich wohl nicht selten findet), daß sein Name des Menschen Schicksal sei." Fenves translates "Schicksal" as "fate." For reasons that will be elaborated somewhat, "Schicksal" will often be translated below as "destiny" and often given interpretations less incompatible with a relative—not complete—creativity proposed by Benjamin and considered dubious by Fenves (216–17).

Correlative to Fenves's more fatalistic elaboration of the aforementioned "mythological intuition," he contends that in death the reason for one having this or that specific name becomes "known" (217–18). This is not an assumption in Benjamin's theory of the proper name.

61. Lyotard, *Der Widerstreit* (translated by Joseph Vogl). For some of Lyotard's relevant remarks on proper name, see *The Differend*, 35.

Benjamin's emphasis on the scene of conflict is overlooked as Stiegler outlines Benjamin's theory as though it advances proper name as a basis for expressionless origin to overcome the conflict; such a view of proper name would indeed be a revalorization of myth, but that is not what Benjamin does in his various discussions of proper name (cf. Stiegler, especially 44–50).

Notwithstanding some impressive (often iconographically based) arguments against Scholem's association of the "new angel" with Satanic connotations, Agamben's insistence (in an essay initially appearing in Italian in 1982) on Benjamin's dissociation or indeed opposition of the angel and happiness on the one hand, and catastrophe and melancholy on the other, is obviously at odds with much that has been, and will be, suggested in the study at hand (cf. Agamben, "Walter Benjamin und das Dämonische," especially 192–97, 200–201).

62. Roth, 65.

63. "I never thought that would be my name Bloom when I used to write it in print to see how it looked on a visiting card or practising for the butcher and oblige M Bloom youre looking blooming Josie used to say after I married him well its better than Breen or Briggs does brig or those awful names with bottom in them Mrs Ramsbottom or some other kind of bottom Mulvey I wouldnt go mad about either or suppose I divorced him Mrs Boylan my mother whoever she was might have given me a nicer name the Lord knows after the lovely one she had" (*U*, 682–83); "Dedalus I wonder its like those names in Gibraltar Delapaz Delagracia they had the devils queer names there father Vial plana of Santa Maria that gave me the rosary Rosales y OReilly in the Calle las Siete Revueltas and Pisimbo and Mrs Opisso in Governor street O what a name Id go and drown myself in the first river if I had a name like her" (*U*, 700)

64. See *Elective Affinities*, 86/*Die Wahlverwandtschaften*, 58.

65. For discussions pertaining to this case, see "Ein Germanist und seine Wissenschaft: Der Fall Schneider/Schwerte," and König, Kuhlmann, and Schwabe eds., *Vertuschte Vergangenheit*.

66. Anders, *Wir Eichmannsöhne*, especially 97.

67. The proper name is a constant opening to "God," whereby God is not "addressant" of communication but rather "emblem of the breaking off [Abbruchs] of certainty about the givenness" of the triad confining language to word, thing, and human. Such formulations by Schestag may depart from Benjamin's view, however, in suggesting that God is not "summum ens" of communication. As indicated above, and as will be elaborated below, the convergence of God and linguistic being in Benjamin's linguitic theory would seem to allow for a notion of God as *summum ens*— the highest or the supreme being. Cf. Schestag, *Asphalt*, 8, and see as well his *Parerga*, 127–28. With regard to Benjamin's notion of the proper name, Schestag's discussions explore somewhat the question posed in early notes for the *Passagen-Werk* (*AP*, 868/V:2, 1038): "Am I the one who is called W.B., or am I simply called W.B.?" (Bin ich der, der W.B. heißt, oder heiße ich bloß einfach W.B.?) (*Asphalt*, passim; *Parerga*, especially 10–11, 117–18, 125–27, 141, 167–68). For another formulation of the question concerning W.B., see *AP*, 866/V:2, 1036.

68. Derrida, "Roundtable on Translation," trans. Peggy Kamuf, in *The Ear of the Other*, 107; see also 106–8, 110.

69. Goethe remarks: those superstitious about "the significance of names" maintain that the name Mittler, which means mediator, had impelled him into this very role (*Elective Affinities*, 34/*Die Wahlverwandtschaften*, 16).

70. Derrida, "Otobiographies: The Teaching of Nietzsche and the Politics of the Proper Name," trans. A. Ronell, in *The Ear of the Other*, 7.

71. Joyce alludes presumably to Juliet's reflection: "What's in a name?" She is somehow urging herself and Romeo to break with the hitherto prevailing societal associations of their names (*Romeo and Juliet*, 86 [II.2, 43]).

72. "Der Moralunterricht" (the first essay published in his own name) first appeared in July 1913 in *Die Freie Schulgemeinde*, a journal edited by Wyneken as the "Organ des Bundes für Freie Schulgemeinden" (II:1, 48–54).

73. "Dialog über die Religiosität der Gegenwart" (1912), II:1, 16–35, especially 22. The "Dialogue on the Religiosity of the Present," which was not published in Benjamin's lifetime but was circulated by him among friends, is between an Enlightenment-influenced figure and a more Benjaminian figure. A didactic story with concerns somewhat close to the dialogue did appear under the pseudonym "Ardor" in a hectographic precursor of *Der Anfang* produced in 1910 ("Die drei Religionssucher," II:3, 892–94).

Maintaining a very cautious position regarding organized Zionism in Palestine and in Europe, Benjamin is interested in religion largely independent of narrowly nationalistic purposes and cites the quasi-Hegelian educational ideals of Wyneken as exemplary of the services to which he hopes to enlist Judaism. See the letters of September 11, 1912 (*GB*, Vol. 1, 61–65); October 10, 1912 (69–72); November 21, 1912 (74–79); and January 7–9, 1913 (81–85). These are letters to the young Buberian Zionist, Ludwig Strauß (1892–1953). Strauß was a literate, an essayist, and eventually a translator and a scholar (who became husband of Buber's daughter) but not (cf. Jennings, 65 n. 30) Leo Strauss, whom Benjamin did not meet until much later (*C*, 347/*GB*, Vol. 3, 437) than his early exchanges with Ludwig Strauß. Concerning Ludwig Strauß, see Horch, ed., *Ludwig Strauß 1892–1992*; the essay by Shedletzky is focused on Strauß's thinking during the period in which his exchanges with Benjamin took place.

74. Quoting the remark of a schoolmaster in Goethe, *Elective Affinities*, 206/*Die Wahlverwandtschaften*, 149.

75. Scholem, "The Name of God," 193–94/*Judaica* 3, 69. Scholem's essay on language did not appear until more than five decades after Benjamin completed his essay of 1916. While Benjamin wrote his essay, the nineteen-year-old Scholem (whom Benjamin had befriended a little more than a year earlier) had barely begun his own Judaic studies—even though Scholem had been a self-proclaimed Zionist since 1911, a radical departure from his assimilationist upbringing. Although it is hard to demonstrate the direction of influence in a close friendship, it is thought "that Benjamin developed his views on language before Scholem, who was five years his junior, and he may be considered one of Scholem's predominant sources" (Biale, 136). It was only from 1915 onward that Scholem seriously began to read books about the Kabbalah and it was later that he attempted to read original Kabbalistic and Hasidic texts. In 1919, Scholem planned a study on linguistic theory of the Kabbalah; in 1920, he abandoned the study, which did not materialize—as noted above—until 1970 (Scholem, *From Berlin to Jerusalem*, 113, 115/*Von Berlin nach Jerusalem*, 145, 148).

76. Scholem, "Abraham Abulafia and the Doctrine of Prophetic Kabbalism," in *Major Trends in Jewish Mysticism*, 133. The collection of essays first published in 1941 (in English) had a dedication beginning with the statement: "To the memory of WALTER BENJAMIN (1892–1940)."

77. Scholem, "The Name of God," 70/*Judaica* 3, 19.

78. Scholem, "The Name of God," 193–94/*Judaica* 3, 69.

79. Scholem, *WB*, 56/73–74. It might be that Benjamin's view of the Bible as initially indispensable for his linguistic theory is "exaggerated" (Menninghaus, *Walter Benjamins Theorie der Sprachmagie*, 34). It does not as readily seem, however, that his emphasis on the Bible being *only* initially indispensable is evidence of "an intended non-theological functionality" (42), which is supposedly necessary if "linguistic-philosophical reason" is to be detected in the "strangeness" of the early language-theory (43; see also 21–22). Apart from the repeated theological emphases noted above and to be elaborated at various stages below, see the notes, schemata, and diagram developed toward planned continuation of the 1916 work on language (VII:2 and especially 786–89). The strangeness of the theological may even be integral rather than antithetical to Benjamin's linguistic philosophy. Although in wording often quite different from Benjamin's, Nancy also explores an inextinguishable irritant or resistance that he sometimes characterizes as divine (e.g., *The Inoperative Community*, 150).

80. Gasché, "Saturnine Vision," especially 89, 92, 94–95.

81. This reading does not follow the contrast of God and language detected by Hirsch with regard to the relevant passages of Benjamin's 1916 essay on language (cf. *Der Dialog der Sprachen*, 87). To a slight extent, Hirsch attempts to de-theologize the reading of Benjamin's linguistic theory (85). Jacobson's very theological reading, on the other hand, also contrasts "pure language" (erroneously limited to humans speaking "in names") and God (96, 119). With regard to the 1916 essay, as well as other writings by Benjamin, it has been suggested above that pure language and God tend to converge.

82. Of course, the "bourgeois" conception of language found its way into Marxist discourse as well. See "On the Concept of History" (1940) (*W* 4, 389–400, especially 393–95/I:2, 691–704, especially 698–701) for remarks on the complacency and conformism attending scientistic assumptions about progress, as these assumptions were made by Engelsian Social Democrats.

83. Benjamin's critique of "bourgeois" approaches to name is echoed somewhat in the account of names that is developed in *Dialectic of Enlightenment* by Horkheimer and Adorno. "Enlightenment is mythical fear turned radical. The pure immanence of positivism, its ultimate product, is nothing other than a so to speak universal taboo. Nothing at all may remain outside, because the mere idea [Vorstellung] of outsideness is the very source of fear" (*Dialectic of Enlightenment*, 16/*Dialektik der Aufklärung*, 18). Such frightened fearlessness might sometimes arise in the reception of Benjamin's works. One blurb praises a book on Benjamin for "a lucidity all the more imperative given Benjamin's celebrated opacity" (Smith on behalf of the work by Mehlman). There is often an expectation or a wish that language be subordinate to understanding. For an attempt to explore nonunderstanding as inextinguishable condi-

tion of understanding, see Hamacher, *Entferntes Verstehen* (English translation: *Premises*).

84. Scholem, letter of August 3, 1917, *Briefe an Werner Kraft*, 17; see also 16–18.

85. "<Es ist seltsam. . .>," and "Das Skelett des Wortes," VI, 15. These roughly formulated notes were written around 1920–1921. Benjamin later (during the 1930s) notes Karl Kraus's remark (in *Pro domo et mundo* [Munich: 1912]): "The closer one looks at a word, the more distantly it looks back" (*W* 2, 453/II:1, *362*, and *W* 4, 354 n. 77/I:2, *647*).

86. This note on Duns Scotus was written toward the end of 1920. Benjamin was aware of Heidegger's habilitation thesis, which was accepted at the University of Freiburg in 1914 (under the aegis of the neo-Kantian philosopher, Heinrich Rickert) and was published as a book in 1916. See Heidegger, *Die Kategorien- und Bedeutungslehre des Duns Scotus*, *Frühe Schriften*, 131–353 (it has been suggested that Heidegger's study should have been titled *Die Kategorienlehre des Duns Scotus und die Bedeutunglehre des Thomas von Erfurt*). Benjamin says he finds it unbelievable that anyone could habilitate with such a work, the conception of which requires "*nothing* other than great diligence and command of scholastic Latin"; in spite of all the philosophical makeup, it is "basically" only a piece of good translation work. Heidegger's "contemptible grovelling" before Rickert and Husserl does not make the reading more pleasant. Philosophically considered, the book leaves the linguistic philosophy of Duns Scotus unrevised; the book thereby bequeaths "no small task" (*C*, 168/ *GB*, Vol. 2, 108). For an attempted Benjaminian critique of Heidegger's book, see Tiedemann, 43–45. Remarks suggesting affinities of the book with Benjamin's translation-theory may be found in Samuel Weber, "Un-Übersetzbarkeit," 137–38.

87. Also relevant are other notes from 1916–1917: "Lösungsversuch des Russellschen Paradoxons," VI, 11; "Der Grund der intentionalen Unmittelbarkeit . . .," VI, 11–14 ("The Ground of Intentional Immediacy," *W* 1, 87–89).

88. See also "Das Wort," VI, 19–21, and the outline for a planned "Habilitationsschrift," *W* 1, 269–70/VI, 21–22.

89. Derrida, "Ulysses Gramophone," 265.

90. Witte says: "Benjamin defines the name as the true human word" (*Walter Benjamin: Der Intellektuelle als Kritiker*, 9). Menninghaus replies: "Benjamin neither used the term 'true human word', which is as monstrous as it is empty, nor did he at all 'define' the name as such a 'word'—for him it depends, after all, precisely on the distinction of 'word' and 'name'" (*Walter Benjamins Theorie der Sprachmagie*, 236 n. 110). Menninghaus is correct to stress the distinction, as Scholem might also be with his recollection that even in the 1930s Benjamin insisted that the distinction of "God's word" and the "human word" is "the foundation of all linguistic theory" (*WB*, 209/*260*). As noted above and as will be elaborated below, however, Benjamin also maintains the name is unique in its relationship with word: it communicates linguistic being that is also constitutive spiritual being of the entity communicating in it (the human as namer); it is the language to which all other languages communicate (the "human word is the name of things") (*W* 1, 69/II:1, 150).

91. Jacobson notes the creation of Eve in this context, but he says: "One . . . has to wonder why Benjamin decided that this portion of creation should suddenly be

understood symbolic [as distinct from material], whereas, for example, naming should not be." As suggested already, and as will be elaborated below, the story of material in creation is important precisely for its relevance to Benjamin's allegation of a unique freedom in naming. The "material element" is not, therefore, considered by Benjamin to be "an impediment to the linguistic analysis of creation," although this is contended by Jacobson (101).

92. This passage at least alludes to the possibility that the disjunction of word (God's nameless word) and name may obviate Benjamin's onamatology (concerning this teaching on name formation, see Schobinger, 21–23) and above all his pneumatology—teaching on unique intermediary relations of the human, or at least of *the language of the human*, with God. The allusion perhaps attenuates the contrast that could be drawn between Benjamin's advancement of these teachings—albeit on an expressly analytical, and implicitly and explicitly limited, level—and Derrida's early elaborations of "text" and "writing" for the purpose of undermining pneumatology as a quasi-hieratic elevation of the *human* (e.g., *Of Grammatology*, 10–26).

93. The alignment of the linguistic theory of the early Benjamin and the early Wittgenstein's proscription of nonpictorial propositions risks neglecting Benjamin's "theory of the 'magic' transcending [Transzendierens] of 'verbal contents'" (Menninghaus, *Walter Benjamins Theorie der Sprachmagie*, 41 [and 235–36 n. 110]). Although not without acknowledging certain incompatibilities, some attempts to draw parallels between Benjamin and Wittgenstein focus on *Tractatus Logico-Philosophicus* (1921) and its emphasis on being silent about what one cannot speak (189, 27): See, for instance, Wiesenthal, especially 88–97. Partly following from such an approach, there has been a tendency to ascribe unduly to Benjamin a straightforward spirit-nature dualism (see Jennings, 64, 105, 122), albeit not without slight qualification (97, 122). Adorno's suggestion that Benjamin's "metaphysics of language" "almost literally" agrees with Wittgenstein's "formulation" at least includes reference to a "dialectical tension between" Benjamin and Wittgenstein, a tension evident, for example, in Benjamin's tendency to view art as a way in which "the ontological asceticism of language" arises as "the only way to say the unsayable [das Unsagbare]," a possibility of particularity accentuating its mysterious source (*Aesthetic Theory*, 293 [L]/ 205 [HK]/*Ästhetische Theorie*, 305). A relatively early comparison of Benjamin's and Wittgenstein's philosophies of language (drawing on both the *Tractatus* and the much later *Philosophical Investigations*) convincingly suggests qualified similarities between Benjamin and Wittgenstein, although the vocabulary used in the comparisons, particularly in those identifying Wittgenstein on logic with Benjamin on language, is sometimes unsuited to Benjamin's views (see Bense, 46–51, especially 49). For more recent remarks contrasting Wittgenstein and Benjamin, see Rochlitz, 20, 262–63 n. 6. For general remarks, see Cavell.

94. This is not an allegation, as has been suggested (e.g., Jacobson, 110–11), that judgment and naming stand in a similar relation to the divine. Name has a "residuum of the divine," but—as indicated above—the abstractness and "magic" of judgment are lamented rather than celebrated by the *linguistic*, according to Benjamin (notwithstanding readings suggesting otherwise, such as Jacobson, 110–14, 153, 163).

95. Rosenzweig and Buber differed from Benjamin by regarding "the Bible as an act of direct communication between a divine I and a human Thou" (Jay, "Politics of Translation," 19). Rosenzweig died in 1929, and Buber went on to complete the Bible translation by 1960, three and a half decades after he and Rosenzweig began. Scholem comments: "Benjamin, incidentally, was no great admirer of Buber's Bible translation but a keen reader of the old translation edited by Leopold Zunz whose austerity deeply impressed him" ("Walter Benjamin," 193–94/*Walter Benjamin und sein Engel*, 30; see also Scholem, *WB*, 14/23). For further remarks contrasting the views of Rosenzweig and Benjamin on translation, see Moses, "Walter Benjamin and Franz Rosenzweig," 240.

96. Nancy, *The Inoperative Community*, 81.

97. There is a tendency sometimes to discuss as spiritual being what Benjamin actually calls linguistic being. See, for example, Hirsch, *Der Dialog der Sprachen*, 95–98, 101, 103–5 (or, for more severe confusion in this regard, Jacobson, 92–93, 109, 149). Benjamin's extrapolation of the notion of revelation does concern the identity of pure language and pure spirit. The quintessence of the language spirit, the spirit of language, is the revelation in which spiritual being and linguistic being unite (*W* 1, 66–67/II: 1, 146–47; Hirsch, 108–9). This spiritual being is only effective, however, as linguistic being defying circumscription. Exemplary translations between specific human languages or from things to name are not primarily concerned with "spiritual being" (Hirsch, 110–11) but with the linguistic being entering spiritual being as resistant to spiritual being. Hirsch seems to understand it this way as well, but uses the expression "spiritual being" where Benjamin would probably say "linguistic being." This is particularly in 95–97, where Hirsch says, for example, that "every 'spiritual being' possesses its own linguistic being and the respective language can actually only communicate what the 'spiritual being' allows it to communicate." Spiritual being is indeed almost always a constraint on the expression of linguistic being but—as indicated in Hirsch's further paraphrasing, quoting, and elaboration of Benjamin's notions—language is a medium and not a means of spiritual being. The medium is not determined by spiritual being, by what communicates in (not through) the medium (96–97).

98. The journal *Der Anfang* is "only a symbol" and whatever inner effect it has beyond its symbolic one is "mercy, something incomprehensible [Gnade, Unbegreifliches]" (*C*, 52/*GB*, Vol. 1, 164).

Der Anfang (*The Beginning*) was the journal of those students who advocated the radically reformist educational philosophy of Gustav Wyneken (partly formulated in *Schule und Jugendkultur* [1913]). He taught Benjamin in 1905 at Haubinda, a rural boarding school in Thuringia attended by Benjamin from 1905 to 1907. (Until 1912, Benjamin attended the somewhat liberal Kaiser-Friedrich School at Savignyplatz in Berlin.) Although Benjamin encountered Wyneken as teacher at Haubinda, it was through the latter's activity in the Wickersdorf "Free School Community" (1906–1910) and later in various associations with the pre–World War I youth movement that Wyneken especially influenced Benjamin. During 1910–1912, Benjamin wrote under pseudonym for *Der Anfang*, which was established by students at the Wickersdorf school founded by Wyneken. After his "Abitur," Benjamin went to the University of Freiburg (in the summer of 1912). He was encouraged by Wyneken to

participate in the Free Students' Association there and participated for a couple of years in the groups in Freiburg and Berlin, an involvement that culminated with his election as president of the Berlin Free Students' Association in May 1914. During the prewar period of his university education, Benjamin wrote for, and assisted in the preparation of, the revived *Der Anfang* (Fuld, *Walter Benjamin*, especially 26–56; Brodersen, chaps. 2 and 3; Tiedemann, Gödde, and Lonitz, especially part 2).

99. "Die Schulreform, eine Kulturbewegung" ("School-Reform, a Cultural Movement"), written by Benjamin (under the pseudonym "Eckhart, phil."), first appeared as a contribution to the booklet *Student und Schulreform* (1912) (*Student and School Reform*), edited by the Freiburg Division for School Reform of the Free Student Body (II:1, 12–16).

100. See Spinoza, especially 259–62.

101. Bataille, *L'Abbé C*, 107.

102. Notwithstanding noteworthy advice that the Benjamin reception remain loyal to the silence of Benjamin's texts, Felman's discussion of "Benjamin's Silence" becomes somewhat affected, or at least very focused on the person of Benjamin, in psychoanalytically attributing Benjamin's emphases on silence to personal and historical traumas, such as events surrounding World War I.

103. Jacobs, especially 79–83, 87–88. Although the translation essay does not repeat the theory of the proper name outlined above and mentioned in the 1916 essay, it does not amount to a basic departure from the earlier essay (or the latter's reformulations in various notes and in *O*). The paradise discussed in the earlier essay is not a time without mystery; nature withholds itself and thus preserves ineradicable secret. See pages 22–23. This emphasis may be lost if Benjamin's portrayal is labeled essentialist (in a sense often given to the term "essentialist"). Andrew Benjamin has, nonetheless, characterized Benjamin's notion of paradise in this way (*Translation and the Nature of Philosophy*, especially 97, 99–107). This view is apparently reiterated in his more recent criticism that Benjamin's notion of paradise brings with it the baggage of a notion of "loss . . . structured by the interpretive hold of mourning and melancholia," which are (according to Andrew Benjamin) hindrances to the "recall" that does "no more than mark the ineliminability of the linguistic Absolute" ("The Absolute as Translatability,"112). In various passages of the study at hand, it has been and will be argued that mourning and melancholy, as advanced by Benjamin, are on behalf of mystery. Precisely the denials of mystery are mourned; mourning or melancholy is thus indispensable to *decision* on behalf of mystery. Yet Andrew Benjamin thinks Benjamin's notion of loss and correlative mourning or melancholia pertains to paradise as "pure presence" (119), as a supposedly "once-completed translation" or a "presence" that was "actualization" (121), which it does not. A note written around the time of the translation essay reiterates the bond of paradisal name and secret (*W* 1, 268/ VI, 18).

The concentration of the translation essay on literature and literary translation does not, however, necessarily imply a pneumatic-onamotological elevation of the "language of the human." The 1916 essay distinguishes the "human" (associated with the language of the human) from art (including poetry), for art is based not on the revelatory language-spirit of the human but rather on the language-spirit of things (*W* 1,

67/ II:1, 147). Such an implication of pneumatic-onamotological elevation of the human is not as obviously effective in the translation essay. This may partly be behind Derrida citing "On Language" but setting it aside in favor of Benjamin's less "enigmatic" essay on translation (see "Des Tours de Babel," especially 175; see also remarks stressing the distinctness of the translation essay and the 1916 essay in Menke, *Sprachfiguren*, 104–5). Adorno suggests "the incommunicative element"—"unyielding in the earlier writings"—is "reflected most compellingly in . . . 'The Task of the Translator'" ("Introduction to Benjamin's *Schriften*," 13/*Über Walter Benjamin, 47*). This incommunicative element would seem to have a great deal to do with the attention the essay has received in the last few decades. In addition to essays, books, and discussions already cited or cited below, see Fynsk, 177–89.

104. Hölderlin's translations and Hellingrath's dissertation on Hölderlin's translations of odes by Pindar (*Pindarübertragungen von Hölderlin: Prolegomena zu einer Erstausgabe* [1910]) were of interest to Benjamin and to many of his generation.

105. This contention is nonetheless often made; quoted here is Handelman, *Fragments of Redemption*, 353 n. 5 (see also 94–95), which adapts views of Emil Fackenheim and attempts to deploy views of Lévinas and Rosenzweig.

106. Brodersen, 101–2.

ON PERFORMING PHILOSOPHY

1. *What Is Philosophy?*, 50.

2. The roughly formulated note ("Die unendliche Aufgabe") was written in December 1917. In late 1917 and early 1918, Benjamin was planning a doctoral dissertation on Kant's works, initially focusing on the topic of Kant and history (*C*, 98–99/*GB*, Vol. 1, 390–91) and then on the concept of the "infinite task" (*C*, 103–4, 105/*GB*, Vol. 1, 402–3, 408). For remarks on Hermann Cohen's works in this context, see Deuber-Mankowsky, especially 106–20. For reasons that should become clearer below, the study at hand will not quite share her view that Benjamin's notion of the nonexisting question is one of a question to be posed as a "*speculative* question" (115).

3. Aristotle, *Metaphysics*.

4. "On Perception" (*W* 1, 93–96/VI, 33–38) is a note that Benjamin wrote in October 1917 in preparation for his longer essay "On the Programme of the Coming Philosophy" (*W* 1, 100–110/II:1, 157–71), which was written between November 1917 and March 1918 and was left in a somewhat roughly formulated state.

5. As will have been evident from the preceding discussions of "linguistic being" (sprachliches Wesen) and should now be evident from the association of "Sein" with a quasi-Platonic linguistic transcendentalism, Benjamin intertwines "being" and transcendence to an extent that would not be acceptable or credible to Lévinas (not even to Lévinas's reading of Plato [*Alterity and Transcendence*, 50, 61]). (The paucity of references to Benjamin in Lévinas's texts is striking.) Whereas Lévinas's religiosity involves, moreover, a correlative dissociation of immanence and transcendence, Benjamin's involves an intertwining—a convergence—of immanence and transcendence

(as has been suggested already and will be elaborated below in the section titled "Immanence" in the part titled "Image of Dramatic Beauty"). For Lévinas on transcendence (and language) as other than being, otherwise than being, beyond being, piercing being through subjectivity, see especially *Otherwise than Being*. Lévinas regards "being" as more inherently constrictive than does Benjamin. Benjamin's writings, on the other hand, often place a much greater (perhaps more demanding) stylistic strain on the conceptual coherence or lucidity of philosophical discourse.

6. Although it was the major philosophical current in German universities from about 1870 to 1920, neo-Kantianism was quite diverse. Benjamin was well acquainted with much of the relevant writing and attended seminars and lectures by some of the major representatives during his years at university. While studying in Freiburg, he was (as suggested already) disappointed by Heinrich Rickert (1863–1936), who shortly afterward succeeded Wilhelm Windelband (1848–1915) as leading figure of the Heidelberg (sometimes called "Baden" or "Southwest German") school of neo-Kantianism. For further sarcastic comments on Rickert's teaching, see the already cited letter of June 1913 (*C*, 31/*GB*, Vol. 1, 112); this does not, of course, preclude an affinity with certain aspects of Rickert's Kant-reading—for example, its antipsychologism, as Fenves notes (*Arrested Language*, 187). Of all the current and prominent neo-Kantian writings, those of Hermann Cohen (1842–1918, who—along with Paul Natorp [1854–1924]—founded the Marburg school of neo-Kantianism) probably exerted the greatest influence on Benjamin. Although Benjamin's written remarks on Cohen are critical more often than not, he shares with Cohen (1) an attempt to reformulate Kantian epistemology through an expressly Platonic transcendentalism whereby the "thing in itself," "the idea," becomes an "infinite task" and thus a limit and regulative principle of systematic thinking and (2) a correlative attempt to integrate Judaic motifs into a German philosophical perspective. See, for example, Cohen, *Kants Theorie der Erfahrung*, especially 730, 763–64, 796, and *Religion der Vernunft aus den Quellen des Judentums*. Deuber-Mankowsky's book is devoted to suggesting that Cohen's work was of considerable importance for the young Benjamin. Benjamin's writings, his letters, Scholem's biography, and Scholem's own diaries and letters indicate that other neo-Kantians with whom Benjamin was—usually disapprovingly—familiar include Alois Riehl (1844–1924), Bruno Bauch (1877–1942), Ernst Cassirer (1874–1945), Emil Lask (1875–1915), and Richard Hönigswald (1875–1947). In the broadest possible terms, it may be said Benjamin was inspired by neo-Kantian transcendentalism (albeit in a very qualified way) and, to some extent, by neo-Kantian aspirations of relating philosophy to concrete experience. He was uncomfortable with the neo-Kantians' deference to logic modeled on mathematics and to related scientific-mechanical approaches to nature. For a selection of writings by neo-Kantians, see Ollig, ed., *Materialien zur Neokantianismus-Diskussion*.

7. "On Language" is supposedly a response to some reflections by Scholem on the relationship of mathematics and language (Scholem, *WB*, 34/48). Scholem's fascination with the theme of mathematics in a linguistic, religious, and philosophical context is documented in various letters of 1917 (e.g., *Briefe an Werner Kraft*, 23–24, 31) and in diary entries or notes of 1916–1917 (*Tagebücher*, especially 264–68, 274–76, 351–54, 381–82, 390, 403–7, 417–18, 426–28, 433, 445–46, 467–68). One letter sug-

gests that Kraft contribute to Benjamin's essay "the second part on language and symbol" and that Scholem himself write "the third part on language and mathematics" (*Briefe an Werner Kraft*, 54).

8. Cf. Nancy, *The Experience of Freedom*, 60–65, 107, 109, 115, 148–50. In the chapter titled "Necessity of the Theme of Freedom," however, Nancy's elaboration of a remark by Heidegger includes the comment: "That there is no existence, that nothing exists, or at least that no one exists, except in freedom, is the very simple proposition that philosophy not only will always have indicated or foretold, but will always have more or less clearly recognized as its ownmost motif and motivation, the *primum movens* of its enterprise" (19).

9. See Nancy, 109.

10. It has not been possible to keep entirely abreast of the secondary literature on Benjamin (not even in the three main languages informing this study—English, German, and French), but Fenves's book, *Arresting Language*, seems to contain the most extensive discussions of Benjamin in relation to Leibniz.

11. Nancy, 107. For extensive discussion of this given that obliges us and to which we are given up, see Nancy, *L'Impératif catégorique*.

12. In this regard, also see Agamben, *The Coming Community*, especially 10–15, 43–45. Hans Sahl's recollection of a discussion in 1940 in which Benjamin rejected the concept of guilt may be an oversimplification (cf. Sahl, 25).

13. See the rough note (written in 1916) "Eidos und Begriff" (VI, 29–31), which examines Paul F. Linke's "Das Recht der Phänomenologie," an essay that appeared in the journal *Kantstudien* in 1916.

14. Adorno, "Introduction to Benjamin's *Schriften*," 13/*Über Walter Benjamin*, 46.

15. Such Romanticism is, nonetheless, occasionally attributed to Benjamin. See, for example, Jennings, 95–96, 131.

16. Helpful in Gasché's "The Sober Absolute" is its underlining of many ways in which the main text of Benjamin's Romanticism study is to be read as a critique of Romanticism. Such a critique is somewhat obvious in the conclusion, which Benjamin appended to the published form of his thesis, but determining Benjamin's own views in the main text is sometimes difficult, not least because he purposely tried to conceal them (*C*, 125/*GB*, Vol. 1, 188).

17. Quoting Schlegel, "Über die Unverständlichkeit," in *Kritische Schriften und Fragmente*, Vol. 2, 235–42, especially 235–36.

18. The title of this roughly formulated note from around 1917–1918 suggests an earlier note and a "lost conclusion." Neither of these has been found. See the editors' speculations on these lost pieces (VI, 658). See also a continuation of this note: "Nachträge zu: Über die Symbolik in der Erkenntnis," VI, 40.

The note itself, and many texts cited throughout the study at hand, seem to call for greater qualification of those interpretations suggesting that Benjamin's notions of "Being" or pure language removed from phenomenality resemble certain sinister attempts, through the preoccupation with Being, to foster humans presuming to dispense with or be uncorrupted by the "realm of empirical or ontic beings" (cf. Vries, "Anti-Babel," 465). Against such interpretations, Benjamin's anti-Romanticism, as elaborated already above and as will be further elaborated in this study, seems particularly noteworthy.

19. Helfer formulates a Kleistian dynamic of visible and invisible pretty much in terms such as these as she favors Kleist's version of *Darstellung* over Kant's, Fichte's, and Novalis's (*The Retreat of Representation*, passim but especially 172–73, 176).

20. In an earlier version of the prologue (or at least a part of it), however, Benjamin does indeed say: "[The ideas] are given in the revelatory primordial language [offenbarten Ursprache]" (I:3, 937). Even here, however, Benjamin stresses that philosophy cannot presume "to speak as revelation" (als Offenbarung zu reden) (937). He refers instead to the possibility of considering phenomena on the basis of recalling or remembering the "Ursprache" (937), the "forgotten contexts of revelation" (936). Such remarks do not seem, however, to corroborate those readings detecting in Benjamin's writings a setting of "the revelatory character of language . . . in a mythical past" (Mosès, "Walter Benjamin and Franz Rosenzweig," 239) or at least not those more straightforwardly attributing to his writings "a religious or theological desire to restore a lost or broken totality and identity" (Vries, "Anti-Babel," 443; see also 471 n. 89). Even in the early version of part of the prologue, Benjamin refers to the necessary incompleteness of any attempt at restoration of "revelation" or "origin," which have little or nothing to do with a genealogical past and impel rather the presentation of ideas, the presentation of the hidden words in names (I:3, 935). On the other hand, the aforementioned interpretations concerning Benjamin's assumption of a lost totality are presumably encouraged by remarks, perhaps simplifications, which seem particularly unclear in that text. Benjamin refers, for example, to the "empirical languages into which the words of the revelatory [offenbarten] language have decomposed [sich zersetzt haben]" (937). Even in the eventually published prologue, the difficulties might not seem avoided by the revised reference to "empirical hearing [Vernehmen], in which the words have decomposed" (*O*, 36/I:1, *216*).

21. It does not seem quite right, therefore, to suggest that this kind of inconclusiveness is considered by Benjamin to be Fichtean and not Romantic (cf. Caygill, *Walter Benjamin*, 42–43).

22. Fichte relates reflection only to an "Ich" acquiring "Selbst" correlative to a positing "Ich," but the Romantics relate reflection to "mere thinking." The latter is the self as reflection or thinking independent of any positing "Ich"; "everything is self" (alles ist Selbst) for the Romantics, for everything can be in thinking once the latter is freed of the positing "I" (*W* 1, 128/I:1, 29). Through a somewhat misleading usage of quotations, Rochlitz's reading of Benjamin's reading of Fichte and the Romantics neglects Benjamin's emphasis on the role of self in Romanticism (Rochlitz, 54), although this is also a problem with the translation (of Rochlitz's book), which translates a passage discussing the Romantic view of "eines denkenden Wesens, das kein Ich zu sein braucht" (I:1, 55) as "a thinking being, which does not have to be a Self" when it should read: a thinking being "which does not need to be an 'I'" (*W* 1, 145). Benjamin adds: For Schlegel and Novalis, the Fichtean "I" as counterpart and opposition to the "not-I" (to nature) signifies only an inferior instance of the infinite number of "forms of the self [Selbst]" (*W* 1, 145/I:1, 55). It is not "a self-less existence" (as suggested by the translation of Rochlitz's text [56]) that is the Romantic reflection in the absolute of art but "reflection free of the 'I'" (Ich-freie Reflexion), or as the published English translation of Benjamin's text puts it: "[r]eflection without the 'I'" (*W* 1, 134/I:1, 40).

The Romantic "self" contrasts with Fichte's "theoretical *Ich*" by admitting "no restriction imposed upon it by a posited world" (Seyhan, 91; see also 92, 42).

23. Adorno, "Introduction to Benjamin's *Schriften*," 8/*Über Walter Benjamin*, 40. For extensive discussion of stupidity, as well as analyses of texts by Benjamin in this regard, see Ronell, *Stupidity*.

24. Yet this is often alleged concerning Benjamin's views (e.g., Speth, 227–30, 237–38, 253).

25. The prologue of *O* contrasts with earlier writings in the mostly pejorative connotations of its usage of the word "system." System is more a discursively closed unity than a symbolic-linguistically open one. The most disparaging remark on "system" is directed at "the nineteenth century [presumably Hegelian] concept of system" with its risk of "a syncretism which weaves a spider's web between recognitions" in an attempt "to ensnare the truth as if it were something which came flying in from outside" (28/*207*).

26. In a letter of February 19, 1925, to Scholem, Benjamin refers to the prologue as an "introduction" that has the outright "chutzpah" of outlining "a prolegomena to the theory of knowledge [Erkenntnistheorie]" and thus "a second—I know not whether better—stage" of his earlier work on language, but done up as "a theory of ideas [Ideenlehre]." While preparing the prologue, he reread the 1916 essay (*C*, 261/*GB*, Vol. 3, *14*). From Güntert's book on divine language (49), Benjamin quotes the suggestion that Plato's theory of ideas was facilitated by Plato's appreciation of word, by "a deification of the verbal concept [Wortbegriffs], a deification of words." In this admittedly "one-sided" reading, Plato's "ideas" are basically "nothing other than deified words and verbal concepts" (*O*, 36/I:1, *216*; see also *W* 1, 273–74/VI, 25–26, where this passage and others from Güntert's book of 1921 are quoted and addressed).

27. As in "a woven fabric [Gewebe]," the coherence—"form"—of constellation has an "extremely taciturn [verschlossener] character" (Adorno, "Introduction to Benjamin's *Schriften*," 13/*Über Walter Benjamin*, *46*). For instances of Adorno's adaptation of the notion of constellation, see the inaugural lecture of 1931 at the University of Frankfurt ("The Actuality of Philosophy," 131/*Gesammelte Schriften* 1, *Philosophische Frühschriften*, 341) and *Negative Dialectics*, 162–66/*Negative Dialektik*, 164–68.

28. Scholem, "Walter Benjamin," 182/*Walter Benjamin und sein Engel*, *19*. The Latin noun "textus" belongs to the verb "texere" (weave). In the late Middle Ages, the coherence of words came to be called "text." On "Text," see Kluge, 778.

29. Rosenzweig, *The Star of Redemption*, 5–7/*Der Stern der Erlösung*, 7–9.

30. For remarks on Benjamin in relation to Husserl as well as Kant and aspects of neo-Kantianism, see Fenves, "The Genesis of Judgement" (especially 84–85, 224 n. 6, 226–27 n. 11) and also the revised and considerably elaborated remarks in *Arresting Language*. For very brief comments, see Adorno, "Introduction to Benjamin's *Schriften*," 6–7/*Über Walter Benjamin*, 38–39. Phenomenology and Husserl's writings were of particular interest to Benjamin while he attended the seminar of (former Husserl student) Moritz Geiger (1880–1937) in Munich during 1915–1916 (*GB*, Vol. 1, especially 301–2).

31. Kant, *Critique of Practical Reason*, 70–74.

32. The reference to dialectics is presumably an allusion to Hegel's philosophy. In the letter to Ernst Schoen on February 28, 1918, Benjamin simply declares: "Hegel seems to be awful!" (*C*, 109/*GB*, Vol. 1, 438) In a letter of January 31, 1918, to Scholem, he comments that what he has thus far read by Hegel "thoroughly repelled" him. Benjamin refers to Hegel's as "the spiritual physiognomy of an intellectual brute, of a mystic of violence [Gewalt], the worst kind that there is" (*C*, 112–13/*GB*, Vol. 1, 423). In addition to noting that Benjamin had only a superficial acquaintance with Hegel's works, Scholem notes that Benjamin's scurrilous remarks about Hegel were at least once qualified by expressed admiration for Hegel's philosophy of nature (*WB*, 30/43). See Scholem's reference to discussions with Benjamin on sentences from Hegel's *Phenomenology of Spirit* (Scholem, *Tagebücher*, 389).

33. See Schlegel, fragment 53 in *Kritische Schriften und Fragmente*, Vol. 2, 109.

34. Hofmannsthal, "Ein Brief," 472. While discussing an earlier version of material from the study at hand, Hermann Schweppenhäuser suggested the relevance of this text by Hofmannsthal. For some remarks by Benjamin in 1940 concerning this text, see Adorno and Benjamin, *The Complete Correspondence*, 328–9/ *GB*, Vol. 6, 448–9.

35. Scholem appears even more confident than Benjamin about the intrinsic potential of old words to retain their linguistic force. Once invoked, the "old names" do not let us keep the powers (Potenzen) of language distant. Language breaks through. "For the names have their life; if they did not have it, woe to our children, who would be hopelessly abandoned to emptiness" (Scholem, "Bekenntnis über unsere Sprache: An Franz Rosenzweig zum 26.XII.1926," 2–3). God "will not remain mute" in a language so calling God "back into our life" (3). This letter expresses reservations concerning wishes for greater "secularization" of the Hebrew language. (Thanks to Prof. Joseph Dan and others in Jerusalem who facilitated consideration of a copy of this letter for the study at hand. As noted in the bibliography, English translations of this letter are available. The German text is also available in the German translation of Mosès's book, *Der Engel der Geschichte*, 215–17.)

36. Concerning Heidegger's views of poetic naming as something beginning, something foundational, see Düttmann, *Das Gedächtnis des Denkens*, 172, 164–66, 260–62. See also the discussion of this in relation to Heidegger's Naziism, 173–75.

37. Arendt, "Introduction," in Benjamin, *Illuminations*, 14.

38. Adorno, *Über Walter Benjamin*, 97–98.

39. Tiedemann, 56–57. This juxtaposition of Benjamin and Heidegger somewhat resembles critical remarks concerning the late Heidegger made in Ricoeur, *The Rule of Metaphor*, especially 311–13. "Differance" is among neologisms that have been fostered in a quasi-Romanticism (see n. 204 for "Community of the Dead"), indicative perhaps of risks that can accompany neologism, notwithstanding the importance of deconstruction as a breaking-up of much conceptual encrustment in the usage of philosophemes.

40. This reading of Benjamin diverges, therefore, from critical ones given in Derrida, "Force of Law" (38–39, 41, 43), and Düttmann, *Das Gedächtnis des Denkens*, 224. Insofar as there can be any destruction of myth by the linguistic element of the name, moreover, it can be neither a first nor a final solution for Benjamin. Cf. Derrida, 62, as well as Vries, who echoes Derrida's suggestion that Benjamin advances a no-

tion of human founding in which God gives presence in name ("Anti-Babel," especially 470). For Benjamin, however, as for Derrida, a divine name or pure performative (Vries, 462), if there were such a dimension, would indeed perform nothing. Derrida's objections to Benjamin are, nonetheless, also echoed in the study by Stiegler, where it is suggested that Benjamin advances a myth of name comparable to Ernst Jünger's approach (Stiegler, 17, 26); a lack of differentiation seems evident in remarks such as one saying Jünger and Benjamin "attempt in destruction—be it in war, be it in reading—to release the origin" (274). Contrary to what is alleged by Stiegler, Benjamin conceives of no "occupation" (Besetzung) of the freed space (cf. 276), if indeed there is for Benjamin a freed space. As will be elaborated below, grounding or founding is an interminable task that must be constantly performed anew and in new ways, for no space is exempt from *contamination* and freedom does not occupy space. The old words of philosophy recall this requirement of performing anew, and this requirement entails that they themselves be continually freed from conceptual encrustment or any other kind of occupation. Concerning grounding, see "Bequest: Unforgettable, Wild Solitude" in "Community of the Dead."

41. Revelation is not expressly as prominent a concern in the published version of the prologue as in the version (of the first more obviously philosophical part) written in 1924 and available in I:3, 925–48.

42. Suggesting that the "<Theologico-Political Fragment>" is from Benjamin's late period (*Prisms*, 241/*Über Walter Benjamin*, 26), Adorno thought that the fragment was from around 1937–1938. Jennings's book follows Adorno in this respect, arguing that the "nihilism" of the fragment is more akin to late works than to early ones (59). Scholem and the editors of *GS* (II:3, 946–49) are correct, however, in viewing the fragment as at least compatible with other works of the early 1920s (c. 1920–1921). The editors of *W* have decided, with "hesitancy," to place it among writings of 1937–1938 and to regard it as "an early formulation of the complex of ideas" leading to "On the Concept of History" (1940) (*W* 3, n. 1, 306).

43. Letter of February 5, 1920, cited in Scholem, *WB*, 89/114.

44. These letters partly concern a review that Benjamin was writing, at Bloch's request, in order to garner the book more interest. See also letters of September 1919 (*C*, 146–47, 148/*GB*, Vol. 2, 44–45, 46–47). In the spring of 1919 in Bern, Benjamin had met and become friendly with Bloch, who impressed him greatly (Scholem, *WB*, 79/101–2). Bloch's *Spirit of Utopia* (see *Geist der Utopie*) had just been published, but Benjamin had not yet read it. Later in the year, he studied it carefully for the review (which was never published, and is still lost). As late as May 1925, Benjamin says his review will appear (*C*, 267/*GB*, Vol. 3, 37–38).

45. Rabinbach, 113.

46. Holz, "Prismatisches Denken," 98–99. See Bloch, *The Principle of Hope*. More recently, Holz has noted that, in comparison with Bloch, Benjamin is more strongly bound "to the rabbinic reserve with regard to the 'ultimate'" ("Idee," 462–63).

47. Wolin, 106. There are comments noting differences between Bloch and Benjamin (e.g., 26).

48. In addition to texts already mentioned, various brief contrasts of Bloch and Benjamin are abundant in the secondary literature; see, for example: Adorno, "Intro-

duction to Benjamin's *Schriften*," 7/*Über Walter Benjamin*, 39; Adorno, *Über Walter Benjamin*, 83; Tiedemann, 34–35, 52; Günther, 115–17; and B. Schmidt, 6, 29, 42, 68–70. For a somewhat more recent discussion of the early Benjamin and the early Bloch, see Eidam (especially 20–21, 83—for suggestions that the contrasts are not as great as asserted in Benjamin's letters cited above—and 62–66, 74, 80—for acknowledgment that Bloch's "*anticipation* of truth in system" and his contrast of human and death are not shared by Benjamin).

49. That fatherly version of "logos" is, of course, the "logos" to which Derrida has tried to oppose motherly energies (*On Name*, 89–93, 124–26).

50. For a very different conception of the relation of Kant and Benjamin in this area, see Figal, "Recht und Moral bei Kant, Cohen, und Benjamin," especially 182–83. For further discussions of the relationship of Benjamin's proposals for a critique of violence with Kant's ethics, see the contributions by Figal and Folkers in *Zur Theorie der Gewalt und Gewaltlosigkeit bei Walter Benjamin*.

51. Quoting and diverging from aspects of the reading of Benjamin in Derrida's "Force of Law" (46, 43). Although in different ways than Derrida, Jacobson also refers somewhat misleadingly to Benjamin's fostering of a "messianic . . . return to origins" (50) as "a return to a natural state" (217), "a state of existence beyond the passing of nature" (49).

52. Notwithstanding certain parallels, this notion of the performative seems somewhat distinct from the notion of the performative fostered by Butler via a critical adaptation of J. L. Austin, particularly insofar as Butler focuses performativity on what is "enabling" for the "speaking subject." Cf. Butler, 32–33, as well as 28, 160. The performative, as variously stressed in Benjamin's work, is associated with a linguistic excess that renders the subject meaningless. The destruction and the liberation are indistinguishable.

53. Derrida, "Force of Law," 44–45.

54. The Historical School includes Leopold von Ranke (1795–1868), Jacob Burckhardt (1818–1897), and Johann Gustav Droysen (1808–1884). The extent to which such figures represent a "late Romanticism" is a complicated matter. For some discussions of this point, see Schnädelbach, *Philosophy in Germany, 1831–1933*, and *Geschichtsphilosophie nach Hegel*. The Historical School developed, in any case, partly as accompaniment to certain German Restoration ideologies opposed to the Napoleonic Code and its basis in a "theory of natural human rights" (inherited from the Enlightenment and the French Revolution) (*Geschichtsphilosophie nach Hegel*, 26–27). According to Benjamin, "[t]he philosophy of history of the Restoration" becomes trivial insofar it considers "growth" to be the "sole movement" of "history [Historie]." The ensuing "apparent [scheinhafte] insights" substitute for "insight into the appearance [den Schein]" that prevails in history. Insight into appearance would require insight into layerings which cannot be subordinated to the organicist insistence that growth is the movement of history (*W* 1, 284–85/VI, 95–97).

55. A passage appears in the new edition of the letters (*GB*, Vol. 1, 363) that does not appear in *C* or *B*. It refers to the Romantic recourse to "the *Catholic tradition*."

56. Perhaps noteworthy in this context is Benjamin's high regard for Gustav Wyneken. See, for example, the praise and compliment in letters of June 1913 (*C*, 29/

GB, Vol. 1, 108 and 117). Proposing a small gathering for an evening in Wyneken's honor, Benjamin suggests that in the course of the evening someone could speak of how through him "we" have enjoyed "the good fortune" of growing up aware of "a leader [Führer]" (*C*, 47/*GB*, Vol. 1, 155).

The youth movement had blossomed in the hiking associations around the turn of the century, cultivating not only mythic Germanic pride but also an undemocratic leadership cult which the Nazis later found so fertile among Germans (see Laqueur, Pross). Notwithstanding incipient elitism in Benjamin's very early writings (Witte, *Walter Benjamin: Der Intellektuelle als Kritiker*, 15–22) and correlative tendencies in Wyneken and his followers, conceptions of leadership in Benjamin's faction also entail relatively radical interest in pedagogical reform (Wizisla, especially 617, 619 n. 26, 622). The leftist-liberal tendencies in the Wyneken faction were, moreover, anomalous in relation to the youth movement at large (Laqueur, 53–5; Pross, 130–59; translator's note, *W* 1, 47 n. 1). Recalling this, one former member notes that (as far as he knows) no former member became a Nazi, although he thinks this "freideutsche Jugendbewegung" did entail the kind of mysticism that had some connection with the rise of national socialism (Gumpert, 54).

57. The first part (II:1, 35–39) of "Unterricht und Wertung" appeared in the first issue of the newly founded version of *Der Anfang* (May 1913); the second part (39–42) appeared in the third issue (July 1913).

58. Contrasts with Deleuze and Guattari are invited by Benjamin's pejorative usage of the word "nomadically" (nomadisierend) and by his countering in this letter with references to the "palace" of language. Deleuze and Guattari invoke "nomad science" against "royal science": the former is ambulant, expressly contingent, and innovative; the latter is fixed, priestly, and appropriative (*A Thousand Plateaus*, 367–69, 373–74). Given his emphases on discontinuity and nonappropriativeness, however, Benjamin may not be said to defend what Deleuze and Guattari call "royal science."

59. In a note titled "Psychologie" and written around 1918, Benjamin remarks: The specialist "dogma" in "present-day science [Wissenschaft]" entails "limitations" (Einschränkungen) that are "hostile to the truth." Such an "untrue limitation and field-definition lies at the basis of psychology" (VI, 64–65).

60. Tiedemann, 51–52, 39; see also 18, 36. Tiedemann also criticizes Benjamin for not sufficiently abiding Kant's critical distinction of phenomenal and theological experiences (25–26). Even as the very young Benjamin—apparently under the influence of Wyneken—grants something to Hegel's philosophy of "objective spirit," he insists this must be supplemented by a "religious consciousness," which alone can be the "last answer" to the question of "purpose" (Zweck) (VII:1, 10). A tendency—in the manner of Tiedemann—to favor Adorno's more Hegelian conception of ideas over Benjamin's "mystic-influenced theory" is evident in Buck-Morss, *The Origin of Negative Dialectics*, 90–95. Referring to the "writings of Benjamin's youth," Adorno's foreword to Tiedemann's book says that Tiedemann "translates Benjamin's . . . often esoteric language back into traditional language" (Adorno, in Tiedemann, 9 [also in Adorno, *Über Walter Benjamin*, 87]). (Contrary to a book-cover blurb on the English translation of Rochlitz's book, Tiedemann's book of 1965 and not Rochlitz's of 1992 was "the first book to lay claim to his [Benjamin's] status as a philosopher.") In

Fenves's *Arresting Language*, the discussion of Benjamin's work in terms relying so heavily on Leibniz, Kant, Kantianism, and Husserl may result in overstatement of the potential for integration of Benjamin's work into such more-established streams of the philosophical tradition.

61. Adorno, *Minima Moralia*, 152/200–201.

62. Scholem, *WB*, 56/74; see also 60–61/79.

63. Scholem, 55/73.

64. Such disclaiming of finishedness is betokened in Gagnebin's title *Zur Geschichtsphilosophie Walter Benjamins: Die Unabgeschlossenheit des Sinnes*.

65. As will be clear below, this usage of the term "esoteric" where "mystical" could be expected is indicative of some of Benjamin's own usage of the term "esoteric." Such usage is not generally employed by scholars of religion, who might define mysticism as "knowledge" not directly communicable, expressible only "through symbol and metaphor," and " [e]soteric knowledge" as "in theory" transmissible, with "those who possess it" either being "forbidden to pass it on" or not wishing "to do so." These definitions are given by Scholem (*Kabbalah*, 4). For Benjamin, the esotericism of philosophy is transmission of the inherently intransmissible; there is no possession of a knowledge. Mosès notes a comparable version of esotericism in the Kabbalah as sometimes rendered by Scholem (Mosès, *L'Ange de l'Histoire*, 233–34).

66. See Kant, *Critique of Pure Reason*, 299. As is well known, however, the "Dialectic" of *Critique of Pure Reason* sometimes uses the term "transcendental" where the term "transcendent" would be expected. Benjamin's approach to Kant around this time was influenced by Felix Noeggerath (1885–1960). Benjamin praises the latter's dissertation concerning Kant—*Synthesis und Systembegriff in der Philosophie: Ein Beitrag zur Kritik des Antirationalismus*—or at least those bits of this unpublished study filtering through to him (*C*, 86–87, 98/*GB*, Vol. 1, 358–59, 390; Scholem, "Walter Benjamin und Felix Noeggerath," *Walter Benjamin und sein Engel*, 78–127, especially 98, 100, 116–17; Brodersen, 105–6). The most relevant discussions with Noeggerath took place in Munich in 1915–1916, while Benjamin was studying there. For discussion of this period as well as of later meetings of the two, and for some comparison of Noeggerath and Benjamin concerning philosophy, see Deuber-Mankowsky, 38–50.

67. Derrida, "Faith and Knowledge," 65.

68. The announcement for *Angelus Novus* was written in December 1921 and January 1922. The journal was to be published by Richard Weißbach (Heidelberg), who was also the publisher of *Die Argonauten* (edited by the Expressionist poet Ernst Blass and where Benjamin's "'Der Idiot' von Dostojewskij" and "Schicksal und Charakter" appeared in 1921). *Angelus Novus* was a major concern for Benjamin from the late summer of 1921 until late 1922, when Weißbach's financial support was finally withheld because of inflation. See II:3, 994–95; *GB*, Vol. 2, especially 98–99, 178–86, 207–8, 252, 272–73, 279–80, 282–83, 295–96, 310–11. Some of the cited letters or passages from letters are available in *C*, 186–87, 193–94, 203.

69. Scholem's diary entry for August 23, 1916, mentions a discussion with Benjamin on Buber; Scholem complains of Buber's treatment of religious teachings as

"philosophemes": "He [Buber] philosophizes on religion, instead of leading religion to the point where it is philosophy" (Scholem, *Tagebücher*, 387).

70. Hamacher has formulated Benjamin's translation theory in terms of a kind of ethics of translation, whereby each language is required—by the *language* within it—to open itself to translation into another language. The requirement emerges as a "law of immediate self-transgression [Selbstüberschreitung] and transformation [Veranderung]" ("Intensive Sprachen," 182–83).

71. In 1912, Benjamin thinks that the "only concrete element" in religion is the "feeling" of a suffered, new, unprecedented "actuality [Gegebenheit]," which has already had "prophets" (Tolstoy, Nietzsche, Strindberg) and will enable the "pregnant" time to find "a new human" (II:1, 34).

72. All is read as writing regardless of whether it is writing (in the narrow sense), speech, or perception. The text is not simply "text" (in the narrow sense). Britt's notion of a "scriptural function" in Benjamin's view of all communication—all perception and expression—need not entail Britt's attendant worry that Benjamin thereby shows a bias in favor of the textually based religions. Cf. Britt, chaps. 1, 2, and 6, especially p. 32 n. 29.

73. Cf. Vries, *Theologie im Pianissimo*, especially 31 and 143, but also 28–35, 56–58, 141–43. De Vries fosters Lévinas's (and Celan's) association of ethics (and alterity) with intersubjectivity rather than with (what de Vries describes as Benjamin's, as well as Kafka's and Adorno's) dissemination of the impersonal (299, 306–7).

74. This elaboration of Benjamin's outlook is contrary to Berman's statement that Benjamin's linguistic views (in his theory of translation, for example) are "Romantic" or have a "metaphysical aim" (searching for "pure language" beyond "empirical languages") but no "ethical aim" (*The Experience of the Foreign*, 7; see also 100). Berman's critique of early Romanticism seems actually similar to Benjamin's—at least insofar as it involves juxtaposing Romantic views with those of Goethe and especially with those of Hölderlin (e.g., 102). Hirsch (in his turn to Lévinas and somewhat away from Benjamin) may rightly point out, however, that "limits" of Benjamin's translation theory include a relative lack of specification concerning concrete obligation with regard to "meaning" of the original ("Die geschuldete Übersetzung," 406; see also *Der Dialog der Sprachen*, 300). Rendering pragmatic constraints into a performance of their transience is, it would seem, required by Benjamin's ethics of necessity.

75. Adorno, *Prisms*, 234/*Über Walter Benjamin*, 16.

76. Scholem, "Walter Benjamin," 178/*Walter Benjamin und sein Engel*, 15.

77. Adorno, *Über Walter Benjamin*, 71. For early Kabbalah, according to Scholem, human interpretation shows itself as a "relativization" of the absolute, divine meaninglessness with which it is concerned (Scholem, *On the Kabbalah and Its Symbolism*, 43/*Zur Kabbala und ihrer Symbolik*, 63).

78. Abulafia's science of letter combination is to be a "music" of God's "pure thought," a movement of "the letters of the great Name" (Scholem, *Major Trends in Jewish Mysticism*, 133–35). A more recent study of Abulafia's linguistic and "hermeneutic" views refers to the "monadistic approach to text and language" whereby each and every letter has a distinct relationship with the divine (Idel, *Language, Torah, and Hermeneutics*, xv).

Although not as explicitly as Idel's later work (e.g., *Kabbalah*), this Abulafia study already shows signs of the more practical-experiential relevance attributed by Idel to Kabbalistic writings. Handelman's *Fragments of Redemption* contains attempts to relate recent Kabbalah debates to Benjamin's works, and her critique of Scholem relies somewhat on Idel's arguments that Scholem philosophizes the Kabbalah and thereby underestimates the latter's practical and experiential relevance (e.g., 60–61, 96–97, 105, 111, 113–14, 355 n. 15). To the very slight extent that this critique of "assumptions" underlying Scholem's "method of interpretation" is extended to Benjamin's early works (cf. 77), the practical and experiential implications of those works are underestimated. Such implications may even follow from Benjamin's inclusion (I:3, 926–27) of non-gnostic writings among those religious writings that he considers exemplary for his method of maintaining various levels of meaning.

79. Adorno, *Prisms*, 234/*Über Walter Benjamin*, 16.

80. One hears or reads the vague but oft-repeated insistence (against so-called poststructuralism) that Benjamin restates something called "the classic Western dream about the origin and goal of language and history" (McCole, 256 n. 3, citing Wohlfarth, "Walter Benjamin's Image of Interpretation," 73).

81. Scholem, *Tagebücher*, 157.

82. This formulation diverges somewhat, therefore, from a remark made by Adorno. Suggesting a spellbinding, compelling quality of philosophical gesture is inherited by Benjamin from the circle of Stefan George, Adorno refers to a "monumentality of the momentary [Monumentalität des Momentanen]" as a decisive tension of Benjamin's form of thinking (Adorno, "Introduction to Benjamin's *Schriften*," 7/*Über Walter Benjamin*, 39).

83. Scholem, "Walter Benjamin," 181/*Walter Benjamin und sein Engel*, 17–18.

84. Adorno refers to the "doctrinal tone" in Benjamin's early texts but also contrasts Benjamin and Heidegger more or less in this way ("Introduction to Benjamin's *Schriften*," 10, 7–8/*Über Walter Benjamin*, 43, 39–40). This sort of contrast of Heidegger and Benjamin has been advanced by the very Adorno-influenced Tiedemann (17–18, 56–57) but also by others. For reasons that should become clearer below, however, Tiedemann's suggestion that Benjamin is "doing justice to the central theme of the Enlightenment" (18) must be qualified. For a less encumbered (and yet often remarkably kindred) contrast of Heidegger and Benjamin, see Andrew Benjamin, "Time and Task": whereas Heidegger sacrifices or gives away the present (229), Benjamin's exercise of "continual restoration" is not "to restore the original paradisiac site nor aim at completion"; it is rather to be "a continual restoration in which each restorative moment is new" (235). See also 239, 242–47.

85. A possible influence on Benjamin's approach to Goethe's concept of "Urphänomen" is a work written via the perspective of Hermann Cohen's philosophy: Rotten, *Goethes Urphänomen und die platonische Idee*. With a certain qualification concerning the conclusions of this book, Benjamin cites it as an influence on the Goethe reading given in the last section of the Romanticism study (*W* 1, 199 n. 308/I:1, 110 n. 300).

86. Even in a later phase, Benjamin claims he has never been able to research and think other than in "a, if I may say so, theological sense"—namely in accordance with the "Talmudic teaching [Lehre]" concerning the forty-nine levels of meaning in each passage of the Torah (letter of March 7, 1931, to Max Rychner [editor of *Neue Schweizer Rundschau*], *C*, 372/*GB*, Vol. 4, *19–20*). In 1960, Rychner recalls that (after commenting on the difficulty of the *Trauerspiel* book) he was advised by Benjamin to skip the prologue; the prologue would be understandable only "if one were familiar with the Kabbalah" ("Erinnerungen," 25). Both Rychner and Adorno were sufficiently impressed by such remarks of Benjamin around 1930 that they asked Scholem about their validity. Scholem is skeptical of the suggestion that appropriate appreciation of the "Epistemo-Critical Prologue" presupposes an acquaintance with the Kabbalah, but concedes a certain "contiguity" between the *Trauerspiel* book and the Kabbalistic theory of language (Scholem, *WB*, 125/158). At least by the 1920s, Benjamin was indeed fascinated with epistemological implications of Kabbalistic theories of language; Scholem was by then immersed in these theories and could inform his friend about them (92/118–19).

87. Citing Goethe, "Vorwort," in *Zur Farbenlehre*, 5.

88. Adorno, *Prisms*, 234/*Über Walter Benjamin*, 16.

89. Adorno, *Minima Moralia*, 151–52/200. In a strident yet sensitive way, Adorno says Benjamin "ignored the philosophical tradition and the current rules of scientific logic," not out of ignorance or out of "undisciplined imagination [Phantasie]" but rather out of suspicion that they are too sterile, futile, and worn out and "because the force of the unatrophied, unadjusted truth was too powerful" for him to have been "intimidated by the raised forefinger of intellectual control" ("Introduction to Benjamin's *Schriften*," 5/*Über Walter Benjamin*, 36). Those familiar with the correspondence of Benjamin and Adorno might well wonder if Adorno, during the mid- and late 1930s, did not represent such a raised forefinger.

90. See *Etymologisches Wörterbuch des Deutschen*, 83, and *Duden: Deutsches Universal Wörterbuch*, 198.

91. In *Das Passagen-Werk*, Benjamin conceives of his method as one of literary montage in which he does not have to say anything (*AP*, 460/V:1, 574).

92. For a similar characterization of Karl Kraus's quotation practices, see *W* 2, 455/II:1, 365. Benjamin's theory and practice of quotation have received a varied reception. See essays by Voigts, Fürnkas, Balfour, and B. Menke as well as a chapter in Konersman's book (52–57) and one in Perret's (133–86).

93. Benjamin says Heidegger's habilitation thesis "does perhaps repeat what is most essential in scholastic thought for my problem," albeit "in a wholly unilluminated way" (*C*, 172/*GB*, Vol. 2, *127*). In the context of Benjamin's attempt to shift the notion of transcendental consciousness from ego to the transcendent, it may be worth noting Heidegger's later attempt to draw on Kant's notion of imagination (Einbildungskraft) as the bond prevailing over, if not overcoming, the Kantian division of transcendental and transcendent; see *Kant and the Problem of Metaphysics* (1929).

94. See also *AP*, 475/*Das Passagen-Werk*, V:1, 594. Partly through very polemical references to difference (that do not always include consideration of difference),

Pizer's contrast of Benjamin with (an occasionally caricatured version of what he calls) "post-structuralism" unduly dismisses the potential for working with Benjamin's notion of origin within the context of certain more-recent theoretical outlooks. Cf. Pizer, 5–6, 8, 10, 42–43, 52.

95. Derrida, "On a Newly Arisen Apocalyptic Tone in Philosophy," 121, 156–57; see also 145–46, 151, 160.

96. Benjamin suggests Simmel's presentation of Goethe's concept of truth (in Georg Simmel, *Goethe*, Leipzig: 1913), and especially Simmel's "excellent elucidation of the *Urphänomens*," confirm "irrefutably" that Benjamin's own concept of *Ursprung* in the *Trauerspiel* book is "a strict and compelling transpostion [Übertragung]" of this basic Goethean concept from the realm of nature into that of history (I:3, 953–54; see also *AP*, 462/V:1, 577, and 474/592).

A standard (and at least somewhat justifiable) objection to Wiesenthal's book (chap. 1, especially part 3, 17–34) is that it scarcely deals with the theological dimension of Benjamin's "Wissenschaftstheorie" and thus overemphasizes associations not only with Goethe's conceptions of researching "Urphänomene" but also with variants of natural scientific epistemology.

97. A book on German philosophy between 1833 and 1933 forgoes a chapter on aesthetics "because the philosophy of art at that time—insofar as it did not simply continue along the paths marked out by Hegel—was above all historical and psychological in tendency; it was only through Hermann Cohen's *Ästhetik des reinen Gefühls* (Aesthetics of Pure Feeling) of 1912 that the 'beautiful' became once more a specifically philosophical theme" (Schnädelbach, *Philosophy in Germany*, ix). In university philosophy, at least, this relative disinterest in aesthetics was accompanied by disinterest in any "aesthetics" of philosophy.

98. Regardless of how much Kant must be reconstructed, "[e]very faulting of his philosophical style is . . . pure philistinism and profane twaddle" (*C*, 98/*GB*, Vol. 1, *389–90*). As should become clear below, nonetheless, Benjamin would not likely be in accord with Kant's balking at the notion that philosophy, as "prosaic," could also be poetic. Kant says: "At bottom, all philosophy is indeed prosaic; and the suggestion that we should now start to philosophize poetically would be just as welcome as the suggestion that a businessman would in the future no longer write his account books in prose but rather in verse" ("On a Newly Arisen Superior Tone," 72 n. 6).

99. Quoting Goethe, *Geschichte der Farbenlehre*, 76. See also VI, 47–48. Concerning this epigraph to the prologue of *O*, see *C*, 261/*GB*, Vol. 3, 14.

100. Adorno, "Thesen über die Sprache des Philosophen," in *Gesammelte Schriften*, Vol. 1, 366–71, especially 367–70. These ten "Theses on the Language of the Philosopher" are from the early 1930s and were unpublished in Adorno's lifetime.

101. Holz, "Prismatisches Denken," 96, and "Idee," 477; Cowan, 114; Samuel Weber, "Criticism Underway," 317; Lacoue-Labarthe, "Introduction," 12–13. There may be, however, reasons to qualify characterizations of philosophy or philosophical criticism as literature; this will be elaborated below, especially in the concluding pages of the section of "Image of Dramatic Beauty" concerning "Mask, Art, Criticism" and in the concluding pages of the section of "Community of the Dead" concerning

"Death of Art and Criticism." Those qualifications do not, however, detract from the tendency of Benjamin and some of his commentators to characterize the practice of philosophy as art. Usage of the word "montage" in this context does not, for instance, necessarily imply a heterogeneity whereby parts are entirely devoid of a "plan" relating them. Such an implication has been alleged by Schöttker (10), although his book is concerned with giving the "literary structure" of Benjamin's works an equality in relation to the "philosophical content" that has hitherto been "rather one-sidedly appreciated" (11). For relevant works by Benjamin, the main issue would seem to be that such structure and such content are indistinguishable.

102. This philosophical aspect of criticism is not simply an affinity with the realm of philosophy, the ideal of the problem, but constitutes criticism as philosophy, as what has been called above a practice of philosophy. The Romantics conceive of "Kunstkritik" not only as a philosophical furtherance, a furtherance by philosophy, of the artwork but also as a philosophical furtherance, a furtherance by philosophy, of the Kantian "Kritik." The practice of philosophy is thus freed of Kantian fetters. Benjamin also conceives of criticism (Kritik) as philosophy. He does not, as has apparently been suggested by some (e.g., Ferris, 190–95), consider "the methodology of philosophical inquiry" (190) incompatible with the *system* of philosophy, the whole that cannot be approached by questions. Philosophy must perform this impossibility of question (or answer) attaining the whole, and it would not be philosophy if it did not so perform. Affinity with the realm of philosophy, with the ideal of the problem that cannot be posed or asked, is necessary for art, for criticism, and for any kind of philosophical inquiry (of which criticism is an instance).

103. Deleuze and Guattari suggest the "birth of philosophy" happened in the conjunction, alignment, or connection of a "relative deterritorialization" (occurring via immigrants in ancient Greek society) with "absolute deterritorialization" (*What Is Philosophy?*, 93).

104. In a note for the theses on history that were done toward the end of his life, Benjamin contrasts "liberated prose, which has burst the shackles of writing," and "written" universal history. He also associates "[t]he idea of prose" with "the Messianic idea of universal history" (I:3, 1235).

105. The remarks quoted and paraphrased in this paragraph are partly preliminary formulations for *O*, 29/I:1, 209.

106. Menninghaus, *Unendliche Verdopplung*, 63–64. See also Gasché, "The Sober Absolute," 51–52. Although Menninghaus and Gasché have other criticisms of Benjamin's Romanticism study, this "stylistic" one seems most relevant here. With regard to the style of the study, it has recently been argued that its "tendency . . . to present . . . a dense sequence of quotations with relatively little expository matter or commentary, is designed to be a parallel procedure to Schlegel's, inviting an intuition of the *Zusammenhang* that is nowhere explicit or reducible to a proposition" (Phelan, 77–78).

107. Erich Rothacker's rejection (or call for revisions, which were not undertaken) (letter of April 26, 1923, to Benjamin, quoted in *GB*, Vol. 2, 331–32). The Diltheyian Rothacker (1888–1965) was answering in his capacity as coeditor of *Deutsche Vierteljahrsschrift für Literaturwissenschaft und Geistesgeschichte*.

Benjamin had some difficulty finding a publisher for his long essay. He had been thinking of publishing it in *Angelus Novus*, but began to seek another publisher as the prospects for that journal became shaky (*C*, 201/*GB*, Vol. 2, 271). By November 1922, Rang was corresponding with Hugo von Hofmannsthal about Benjamin. Hofmannsthal had just started the journal *Neue Deutsche Beiträge* and had published an essay by Rang ("Goethes 'Selige Sehnsucht'") in the first issue. After a rejection from the Berlin publisher Paul Cassirer and the rejection from the *Deutsche Vierteljahrsschrift*, Benjamin's manuscript was sent to Hofmannsthal in the autumn of 1923; Hofmannsthal published parts 1 and 2 in April 1924 and Part 3 in January 1925. Hofmannsthal praised the "high beauty of presentation in such an unprecedented penetration into secret" (letter of November 20, 1923, from Hofmannsthal to Rang, "Briefwechsel, 1905–1924," 440).

108. As should be evident, the study at hand is in disagreement with the view that Benjamin is disinterested in "the epistemological consequences of his own discursive means" (cf. Ruin, 149).

109. Concerning Benjamin's exclusion of the long "philosophical" introduction, see *GS*, I:3, 924–25. For a version of that introduction written in 1924, see *GS*, I:3, 925–48. The eventually published *Trauerspiel* book evidently contains a reworking of the 1924 pages.

110. "Erstes Referat über die Habilitationsschrift von Dr. Benjamin," VI, 771–72. The initial reader at the university was Franz Schultz, a member of the German department, under whom Werner Kraft would successfully receive a doctorate in 1925. Benjamin had contacted Schultz in early 1923, sending him *The Concept of Art Criticism in German Romanticism* and *Goethe's Elective Affinities*. This was arranged under the "not unfavorable auspices" of a young Frankfurt sociologist, Gottfried Salomon (*C*, 205/*GB*, Vol. 2, 311). After receiving the final official version of the *Trauerspiel* study in May 1925, Schultz decided that he did not want any responsibility for the submission of Benjamin's work to the faculty. The study was then forwarded to Cornelius, a philosopher responsible for the area of aesthetics and with a supplementary teaching contract for "Allgemeine Kunstwissenschaft." The official second reader, Rudolf Kautzsch, taught art history. In his general confusion, Cornelius even consulted a couple of people outside of the committee, including his young assistant, Horkheimer, who (on the basis of a three-page summary written by Benjamin [I:3, 950–52]) seems to have replied that he too was unable to understand what was taking place in the thesis. In July, Cornelius and Kautzsch formally issued their negative verdict on Benjamin's habilitation thesis. Benjamin was asked by Schultz, who was also dean of the philosophical faculty (which encompassed aesthetics as well as other fields), to withdraw the study so that a public rejection could be avoided.

The editors of *GS* stress that Horkheimer, by then involved with the newly developed "Institut für Sozialforschung," had only passed judgment on the exposé, despite Cornelius's claim that Horkheimer had read excerpts. The editors also speculate that the judgment might not have been as severe as Cornelius claimed; they are not sure, moreover, that Horkheimer knew his judgment would be cited in Cornelius's report (I:3, 950–52; VI, 772–73). It has been said that

Adorno encouraged Benjamin to make a second attempt at habilitation with the *Trauerspiel* study, and that Horkheimer rejected suggestions this take place through his assistance (Fuld, *Walter Benjamin*, 171). Horkheimer had successfully submitted his habilitation thesis (*Kants Kritik der Urteilskraft als Bindeglied zwischen theoretischer und praktischer Philosophie*) to Cornelius earlier in 1925.

111. Unlike Benjamin, Cornelius and others would not have considered such an approach to text to be a "guarantee of literary culture" (*W* 1, 448/IV:1, 90).

Scholem attributes his own academic advancement to luck and Benjamin's situation simply to bad luck: the committee appointing him knew as little about his work as the one that rejected Benjamin's knew his. Contending that "no one could have accused them of ill will in their attitude towards Benjamin," Scholem notes that Schultz and Cornelius later told Salomon that they simply could not understand a word of Benjamin's study (*WB*, 129/163). Scholem does not quite condone suggestions that Benjamin's failure displays inherent limitations of the habilitation system (long after World War II, the aforementioned Erich Rothacker—"a highly cultivated representative" of "Literaturwissenschaft"—allowed himself, concerning the failure of this academic attempt, "the infamous and impudent statement: 'one cannot habilitate spirit [Geist]'"). Scholem does, however, consider the rejection of Benjamin's thesis to be "a symbol of the state of literary scholarship and of the spiritual state [Geistesverfassung] of scholars in the now much-praised Weimar era" ("Walter Benjamin," 184/*Walter Benjamin und sein Engel*, 21). Some of this spiritual state became dramatically evident during the 1930s, as so many German professors acquiesced or participated in the Nazification of intellectual life. Franz Schultz, whose right-wing tendencies were known by Benjamin, eventually became an explicit Nazi supporter and is reported to have appeared at book burnings wearing his professorial robe (Fuld, *Walter Benjamin*, 139, 153; see also Lindner, "Habilitationsakte Benjamin," 329). Cornelius cannot so easily be brought into disrepute. Evidently taking an even less sanguine outlook than Scholem, however, Benjamin reports the comment of Leon Kellner (Benjamin's Viennese father-in-law, contributor to Zionist newspapers and editor of Theodor Herzl's writings, and formerly a professor of English at the university in Czernowitz) that "Cornelius and Kautzsch—the first perhaps well-disposed, and the second more likely wishing ill—wanted to understand nothing of the work" (*C*, 275/*GB*, Vol. 3, 59).

112. Kracauer, "Zu den Schriften Walter Benjamins," 249. This review of the *Trauerspiel* book and *One-Way Street* first appeared in the *Frankfurter Zeitung*, July 15, 1928.

113. On the dealings of Horkheimer, Adorno, and Benjamin with Cornelius, see Wiggerhaus, 44–47, 70–71, 81–82. In a letter of May 7, 1940, to Adorno, Benjamin says, "I, of course, am a student of Rickert (just as you are a student of [Hans] Cornelius)" (*C*, 635/*GB*, Vol. 6, 455). This statement, which does not seem a good comparison in many respects, was made in the context of Benjamin's enthusiastic anticipation of a piece of writing by Adorno on Rickert and may thus imply—as suggested by editors of the Harvard edition of English translations of Benjamin's writings (*W* 1, 495)—a respect or reverence of Benjamin for Rickert and of Adorno for Cornelius.

The editors of the new edition of Benjamin's letters suggest, however, that there is a certain irony in Benjamin's remark (*GB*, Vol. 2, 175).

114. Cornelius, 3–4.

115. Frey, 145.

116. The quotation is from I. M. Lange's review of *O*, which originally appeared in *Die Weltbühne* 24 (1928), 649, and is available as an appendix in Rumpf, *Spekulative Literaturtheorie*, 184–85.

117. Lindner, "Habilitationsakte Benjamin," 328–29.

118. Benjamin considered making this retelling of *The Sleeping Beauty* into a foreword for the eventual publication of the *Trauerspiel* study (*C*, 293/*GB*, Vol. 3, 133). On December 24, 1926—while in Moscow—Benjamin read this planned preface aloud before Asja Lacis. Apparently she did not think that he should include it in the published book. It might become important to him, he records in his diary, that she thought "despite everything I should simply write: rejected by the University of Frankfurt-on-Main" (*MD*, 43/*Moskauer Tagebuch*, VI, 326). This also did not appear in the published book.

119. See the eventually published version of the lecture: Werckmeister, "Walter Benjamins Passagenwerk," 169.

120. Wohlfarth, "Resentment," 253.

121. Glogauer, 124.

122. Derrida, "The Time of a Thesis," 44. See also "Living On," 94–95.

123. Although the title of the *Tractatus* is an innovation of an English translator, it met with Wittgenstein's approval and the German text in the "Werkausgabe" at Suhrkamp Verlag carries the new title as well as the initial German one (*Logisch-philosophische Abhandlung*).

124. The first available English translation does not reproduce all of this, and indeed leaves out almost all of the subheadings (except in the table of contents).

A study of Benjamin's book as a treatise would presumably consider circumstances leading to decisions made concerning the makeup of the first edition (published by Rowohlt in 1928). There are certain features distinguishing it from later editions. These include not only the Gothic print but also features such as the beginning of chapters (prologue and the two main chapters) by title pages with nothing on them besides the pertinent title. The first edition also does not start new numeration of the endnotes for each cluster of sections; notes for the book are simply listed (with no divisions) at the end of the book. Extensive consideration of stylistic issues would, of course, also require examination of Benjamin's manuscripts and notes—especially the original written text, which is (along with other manuscripts such as the original text of the *Elective Affinities* essay) at the National and University Library in Jerusalem (Garber, *Zum Bild Walter Benjamins*, especially 143–48).

125. Adorno, "Introduction to Benjamin's *Schriften*," 13/*Über Walter Benjamin*, 46.

126. Benjamin constantly conferred "incomparably greater significance to pictorialness [Bildlichkeit] than is customary in philosophy." His own language usage is often pictorial and indeed often only consists of "images" (Bildern) (Tiedemann, Gödde, and Lonitz, 260).

127. In a letter in which Benjamin refers to the relationship of the systematic and the fragmentary in the 1916 essay on language, he refers to the essay as "einer kleiner Abhandlung," which could be translated as "a little essay," "a little article," "a small discourse," or even "a little treatise" (although Benjamin does not use the word "Traktat") (*C*, 81/*GB*, Vol. 1, *343*). In any case, at a late stage in the writing, the manuscript of the *Trauerspiel* study seems to consist "almost entirely of quotations" and Benjamin says the "craziest" imaginable "mosaic technique" seems "so odd" for works of this sort and he will probably touch it up here and there for the final copy (*C*, 256/*GB*, Vol. 2, 508). The mosaic technique nonetheless remains a constructive principle.

128. The suggestion in the *Symposium* that "truth" is "beautiful"—that "truth" ("the realm of ideas") is "the essential content [Wesensgehalt] of beauty"—is not only of utmost importance for the philosophy of art but also cannot be ignored in "the determination of the concept of truth itself" (*O*, 30/I:1, *210*). It has been implied that solely the attraction of criticism to artworks is at issue in the section of the prologue titled "Philosophical Beauty" (Wolin, 89). Yet criticism is not mentioned at all in the section entitled "Philosophical Beauty" and is not really a focus of the prologue until the implicit concern with it in the section entitled "Idea Non-classificatory" ("Idee nicht klassifizierend") (*O*, 38–39/I:1, 218–20). In the section "Philosophical Beauty," art is mentioned only in the remark noted above (which goes beyond the philosophy of art) and toward the end in a contrast of philosophy, research, and art. It would seem wrong, therefore, to suggest the section "Philosophical Beauty" is not concerned with philosophy other than criticism—even though an early version of part of the prologue does bring a long discussion of beauty and truth to a close with a remark that "criticism" (Kritik) gives endurance to what "the beautiful in its presentation" obtains from ideas. The latter passage continues with a contention that the relation of truth and beauty may contain the "key" to the "contemporaneity" (Aktualität) somehow maintained by various "old systems of philosophy," despite antiquated scientific value (I:3, 930).

129. Adorno, "The Essay as Form," in *Notes to Literature*, Vol. 1, 23/*Noten zur Literatur*, 32–33.

130. Adorno, *Negative Dialectics*, 53/*Negative Dialektik*, 62.

131. Menninghaus once confusingly refers to "idea" in terms of the realm identified in the 1916 essay as "spiritual being," communication-oriented being (although he almost simultaneously notes the bond of "idea" and linguistic intention, language as such) (*Walter Benjamins Theorie der Sprachmagie*, 82).

132. This "Response" to Rang's *Deutsche Bauhütte* (1924) is also in IV:1, 2, 791, and Rang, *Deutsche Bauhütte*, 185.

133. This reading counters that in Rochlitz (8, 33, 36). That Benjamin eventually demonstrates less of a preference for outlining philosophy than for doing it as criticism could be said, moreover, to confirm rather than contradict his performative priority. Openly maintaining contact with the extensive realm increasingly became a precept of his philosophical work. If, on the other hand, one's priority is instruction on how all this is to be "controlled" (Rochlitz, 36), Benjamin's early writings may indeed have little to offer. Rochlitz has similar difficulties with Benjamin's later linguistic theory (44–45).

134. Schings, 673.

135. For instance, in Speth's book, the more exclusively philosophical sections of Benjamin's prologue—those sections formulated independently of the theory of criticism and the remarks on the baroque mourning play—are declared incompatible with the possibility of "scholarship" (Wissenschaft) (Speth, 213–15, 218–19, 224, 234–40, 260).

136. Badiou's remarks on the alleged age of subordinating philosophy to poetry are made in a number of studies, for example, *Manifeste pour la philosophie* (especially 30, 47, 48, 68–69, 79, 83–85, 91–92) and "L'âge des poètes" (22). For responses to these views of Badiou, see Lacoue-Labarthe, "Poésie, philosophie, politique" (59, 61–63) and "Courage de la poésie" (248).

137. This is, nonetheless, contended by Schings (673).

138. Here as elsewhere, a source of comparison could be the work of Deleuze and Guattari. See especially the formulations in *What Is Philosophy?* distinguishing the plane of immanence in philosophy, the plane of composition in art, and the plane of reference (or coordination) in science.

139. In a note of around 1917–1918, Benjamin says: Philosophy and "philosophical recognition [philosophischen Erkenntnis]" are "radically" oriented toward "truth and the totality of truth" and are to be distinguished from "insight into truths or into a particular truth." The latter insight is disclosed, for example, to "every meticulous consideration of an art work" and "presumably now and then to each artist in his creation." The truths at stake in certain reflections—by Goethe, by Jean Paul or Balzac or Humboldt theorizing on language, or by Kandinsky on color—do, moreover, "contain [enthalten] 'truth'"—that is, the truth of concern to the philosopher—but they "do not point to truth" in the way possible for "the philosophical truth . . . through the philosophical systematology [Systematik] . . ." ("Nachträge zu: Über die Symbolik in der Erkenntnis," VI, 40). The symbolic harmony has theoretical expression in the mentioned writings but the discursive system or systemotology of philosophy uniquely sustains openness to the symbolic harmony. It sustains an attitude described a few years earlier by Benjamin: In its creative function, the student body is to be "the great transformer" leading "new ideas"—which tend to awaken in art and in social life sooner than in "scholarship [Wissenschaft]"—into "scientific [wissenschaftliche] questions through the philosophical attitude [Einstellung]." This attitude of philosophy in the concrete would be the Eros of the students (*W* 1, 43–44/II:1, *83–84*).

140. Friedrich Schlegel, *Kritische Schriften und Fragmente*, Vol. 2, 165.

141. Novalis, "Fragmente (aus der Nachlese von Bülow)," in *Schriften*, Vol. 3, 17. This part of the passage is not quoted by Benjamin.

142. Adorno, "The Actuality of Philosophy," 132–31/"Die Aktualität der Philosophie," in *Gesammelte Schriften*, Vol. 1, 343–44. For an account of these developments in German philosophy and "Wissenschaft," see Bahti, especially 3–133.

143. Adorno, *Über Walter Benjamin*, 86 (in Tiedemann, 8).

144. Derrida, "Some Statements and Truisms," 75.

145. Christoph Menke, 291, 293.

IMAGE OF DRAMATIC BEAUTY

1. Agamben, *Stanzas*, xvi.
2. Art somewhat recovers a childlike experience (*W* 1, 51/VI, 111–12). The child is more inclined than others to experience colours as "contouring" whereby things are not "objectified [versachlicht]" but are rather "filled by an order in infinite nuances." The singularity of color is not, therefore, any "obstinate individuality" or "dead matter" (tote Sache) (50–51/*110–11*). With color instead as something winged or inspired—*Beflügeltes*—which "flits from one shape [Gestalt] to another," children take special pleasure in soap bubbles, colored pickup sticks, sewing kits, decals, tea sets, drawing books, oil color prints, magic lanterns, paper-braid constructions, and other objects accentuating variation or expressiveness of color. In such contexts, color seems never quite dry (50/*110*). Also relevant in this context is a dialogue (probably written around 1915) with formulations close to—sometimes almost identical with—the text quoted above ("Der Regenbogen: Gespräch über die Phantasie," VII:1, 19–26). Caygill's attempt to portray this "pure seeing of colour," "pure colour," "absolute colour of imagination," and "pure seeing" (VII:1, 19–24) as incompatible with the view of language developed in some of Benjamin's writings is contrary to much that will be argued below in this discussion of "Image of Dramatic Beauty." Cf. Caygill, especially 9–13, 15. For remarks akin to those in "Der Regenbogen" and other writings by Benjamin on color and art, see "Der Regenbogen oder die Kunst des Paradieses," VII:2, 562–64.
3. Noteworthy here is Benjamin's account (around 1919 or 1920) of blushing as a way in which one has oneself pass from the gaze of others. "The colour of shame is pure," for this "colouring" is "the red of transience from the palette of the imagination [Phantasie]." This red is not "couloured [Farbiges]" or even "colour [Farbe]" but rather "colouring [Färbendes]" (VI, 71).

Elsewhere, Benjamin discusses the relation of shame and imagination. Whereas children (with their "highly developed feeling of shame") are so often ashamed as a result of the abundance of imagination (that they especially have when very young) (VI, 120), such a "connection of imagination with shame" is countered by a "tendency to shamelessness in fantasy (grotesque)" (122). Perhaps the latter is the context in which children are not ashamed but exhibit—have "show" (Schau)—without reflection; perhaps too a correlative order of colorfulness enters art (*W* 1, 51/VI, *111–12*).

In the grotesque (the "single legitimate form of the fantastic [Phantastischen]"), imagination "does not destructively deform [zerstörend entstaltet] but rather destructively overforms [überstaltet]." Fantastic creations, however, ultimately have an element of the "constructive" or (if one wishes to speak from the perspective of "the subject") an element of "spontaneity," whereas "[g]enuine imagination [Phantasie]" is "unconstructive, purely deforming [entstaltend] or (from the standpoint of the subject) purely negative" (*W* 1, 280/VI, *115*). The similarity of the German words often used for "imagination" and "fantasy"—*Phantasie* and *Phantastik*, respectively—is nonetheless indicative of an overlap of these contrasted elements. In the *Deutsches Wörtherbuch von Jacob Grimm und Wilhelm Grimm*, "Phantasie" is associated (not least through citations of Kant and others) somewhat with artistic, unconscious, or

fantastic "Einbildung" (VII, 1822–23). Apparently to avoid confusion with Kant's notion of imagination (Einbildungskraft), some translate Benjamin's usage of "Phantasie" as "fantasy" (e.g., Fenves, *Arresting Language*), although Benjamin's usage of "Phantasie" seems very different from definitions of "fantasy" or "phantasy," at least as these are given in the *OED* and its supplement. "Phantasie" has, and will be, translated in this study as "imagination," albeit in a sense distinct from many, if not all, connotations of Kant's term "Einbildungkraft."

4. As is recognized by Livingstone's translation, "Taktischen" should evidently be read here as "tactile" (Tastischen or Taktilen) rather than as "tactical."

5. Cixous, *La ville parjure*, 170.

6. Hölderlin, "Der blinde Sänger" (1801), in *Sämtliche Werke und Briefe*, Vol. 1, 308.

7. Contending that "mystical experience" does not presuppose religious background and can be "secular," Scholem suggests works such as Kafka's have enormous importance as ways of retaining the force of mystical impulses amid increasingly pervasive secularization ("Religious Authority and Mysticism," *On the Kabbalah and its Symbolism*, 12, 16–17/*Zur Kabbala und ihrer Symbolik*, 22, 27–29). Scholem also contends, nonetheless, that Benjamin's disillusionment with idealist philosophy resulted in literary interpretations eventually regarded as preliminary to commentary on sacred texts. On Benjamin's wavering preparation for study of Hebrew religious texts, see Scholem, "Walter Benjamin," 181/*Walter Benjamin und sein Engel*, 17. Scholem elsewhere elaborates on Benjamin's plans for—and attempts at—Hebrew studies, as well as Benjamin's abandoned plans for emigration to Palestine (*WB*, 150–56/187–95).

8. The aura associated by Benjamin with "Mal" makes the word "mark" seem a very inadequate translation. Some have preferred not to translate it at all. "Mal" is "an untranslatable term" (Wellbery, 56).

9. Without endorsing philistinism or rationalistic pedagogy, Benjamin is anything but averse to naturalistic, graphic drawing in children's books as a way of introducing language and script to the child. Citing books in which words simply give the drawn pictures their meaning or the "sense" (Sinn) of a picture "requires" (verlangt) the word, Benjamin outlines a situation less oriented to the ear than to the eyes and to touch ("Über die Fläche des unfarbigen Bilderbuches" [a note from 1918 or 1919], VI, 112–13). The child's often creative and scribbling response is, of course, a breaking of the limits of ostensible descriptivism. The initial pictures remain, however, something other than art; neither an artwork nor imaginative elements but only "portraying [abbildende<n>] presentations" can be regarded from a strictly descriptivist perspective (113).

10. Goethe, *Maximen und Reflexionen*, 470–71. See *O*, 161/I:1, 337–38.

11. For some of Schopenhauer's remarks to this effect, see *The World as Will and Representation*, Vol. 1, 237–42.

12. The association, the tense yet complementary association, of physis and metaphysics is overlooked somewhat in Willem van Reijen's tendency to suggest Benjamin associated physis (as nature) with mythical closure (cf. *Der Schwarzwald und Paris*, especially 38, 207–11). The association of physis and beauty also makes it somewhat questionable to contend Benjamin's determinations of allegory address the

artwork that is "without semblance or without beauty." This contention by Kambas ("Kunstwerk," 530) may be contrasted not only with the aforementioned passage from *O*, 176–77/I:1, 352–53, but also with others, such as 235/409 and 181–82/357–58 (part of which is quoted by Kambas, 531–32).

13. *Symbolik und Mythologie der altern Völker, besonders der Griechen* (1819) by Georg Friedrich Creuzer (1771–1858), various writings by Johann Joseph von Görres (1776–1848), and even the occasional remark by Novalis come to conceptions of allegory that (very indirectly) seem to point to the view of allegory later formulated by Benjamin (*O*, 186–88/I:1, 362–63). For discussion of Benjamin's approach to Creuzer's treatment of symbol and allegory, see Naeher, 190–99.

14. The Lutheran mystic Jacob Böhme (1575–1624) may compensate somewhat for the lack of German baroque "philosophical reflection" on the relationship of speech and writing (*O*, 201/I:1, 377), but Böhme's view of divine sound resonating in things and in human speech is more serene than the view evident in *Trauerspiel* (201–5/377–80). The *Trauerspiel* writers regard "the word" (das Wort, evidently here meaning, as the English translator suggests, "the spoken word") as the creaturely "ecstasy" subject to an "unmasking" or "exposure" (Bloßstellung) showing the creature's "presumptuousness, impotence before God," but they also regard "writing (die Schrift)" as the creature's "composure [Sammlung]," a composure entailing "dignity, superiority, omnipotence over things of the world" (201/*377*). Benjamin's provisional adaptation of Johann Wilhelm Ritter's "divination" to address a dialectic (in which all images are writing and writing is the tense synthesis of speech [the thetic, placing, positing element] and musical impulse) (214/388) is distinct from the baroque monumentalization of the book as the place of contemplation immune to history (141–42/320). Action is inhibited by the latter monumentalization, by the overestimation of the contemplative control ensuing from writing and by the neglect of the "writing" ultimately freeing action by destroying will to control it. Not writing, as Garber implies, but the monumentalization of it as contemplative exile is considered by Benjamin to lead to the German baroque "inhibition of action" (Handlungshemmung) (cf. Garber, *Zum Bilde Walter Benjamins*, 210–11).

15. Although Ritter's "virtual" theory of allegory attests to the "affinity [Verwandtschaft] of the baroque and Romanticism," the baroque theological emphasis, indeed theological philosophizing generally, is a more effective corrective to symbolist pretensions in art than is comparatively untheological, aestheticist Romantic "intuitions"—even where Friedrich Schlegel uses the word "allegory" in a way that might initially seem akin to Benjamin's. Benjamin thinks such remarks simply substitute the word "allegory" where classicism uses the word "symbol" (*O*, 214/I:1, 388). Cf. Schlegel, "Gespräch über die Poesie" (1800), in *Kritische Schriften und Fragmente*, Vol. 2, 206. For implicit disagreement with at least aspects of Benjamin's conclusion, see de Man's discussion of the tension in the Romantic-classicist tradition on how to read and formulate or reformulate the statement from Schlegel's "Gespräch" (Man, "Allegory and Symbol," in "The Rhetoric of Temporality," in *Blindness and Insight*, especially 190–91).

16. For a summary, see again *O*, 174–77/I:1, 350–53.

17. Benjamin accordingly may well be the first to provide a "philosophical foundation for the aesthetic paradox of avant-gardism," although too much conniving is

suggested by the view that Benjamin's "great boldness and decisiveness" in the *Trauerspiel* book is simply to have used the occasion "quite undisguisedly" to address the contemporary avant-gardist literature and to impute "cleverly" decisive features of the latter to the baroque. Cf. Lukács, "The Ideology of Modernism," in *The Meaning of Contemporary Realism*, 41/"Die weltanschaulichen Grundlagen des Avantgardismus," *Wider den Missverstandenen Realismus, 42–43*; see also 41–43/43–45. (This essay—"The Ideological Foundations of Avant-gardism"—was written in late 1955, the year of the first posthumous publication of the *Trauerspiel* book.) Whether or not Benjamin interprets Baroque (and Romanticism) from the perspective of outlooks and artistic needs of his own time, the "spirit" of the book does indeed go "far beyond" the "narrow framework" of its historical theme. See Lukács, *Ästhetik*, Part 1, Vol. 2, 760; see also 760–66. (Part 1 of the *Aesthetics* was published in 1963.) Bürger gives a more elaborate formulation along these lines. Benjamin's concept of allegory was in some sense "developed" "as he was studying the literature of the Baroque" but finds "its adequate object" "only in the avant-gardist work"; Benjamin's "experience in dealing with works of the avant-garde" facilitated, in other words, "the development of the category and its applications to the literature of the Baroque"—"and not the other way around" (*Theory of the Avant-Garde*, 68–72). Although such declarations about alleged contemporary influences might be irritating (Steiner, "Kritik," 515), the least to be claimed is that Benjamin associates allegory with a modernism that is open-ended and thus considered integral to the future of what he could call art. This has been intimated above and shall be elaborated below.

18. In one effort to distinguish de Man and Benjamin, there is accordingly something quite dubious about the insistence that Benjamin's criticism is anti-allegorical, an attempt to salvage "meaning" (*Bedeutung* or *Sinn*) against "Figur" or "Text," mortification, and decline or transience. Geyer-Ryan's analysis ascribes to Benjamin a bifurcation of writing or ruination, on the one hand, and action or body on the other. As will be elaborated in the remainder of the study at hand, there is a great deal in Benjamin's writings that is concerned with a complementarity, even a convergence, of writing, ruination, body, and action (cf. Geyer-Ryan, "Irreale Präsenz").

19. The expression "alien theory" is taken from Hübscher's "Barock als Gestaltung antithetischen Lebensgefühls," which appeared in 1922 and is cited in a number of places in the *Trauerspiel* book.

20. Benjamin's formulation of the conflict of sensation and will is an adaptation of Alois Riegl's *Die Entstehung der Barockkunst in Rom*.

21. For this last sentence of *O*, it is especially worthwhile to consult the German text.

22. As will be elaborated below (especially in "Community of the Dead"), it seems warranted to interpolate this priority of ruination into the *Elective Affinities* essay.

23. The review (unpublished in Benjamin's lifetime and written sometime between 1917 and 1919) of *Lesabéndio: Ein Asteroiden-Roman* (1913) is one sample from the mostly lost writing of Benjamin on works by Paul Scheerbart (1863–1915).

24. This relationship of allegory and criticism is complementary, and not one of allegory opposing criticism (as is contended in Düttmann, *The Gift of Language*, 60).

25. Scholem, "Walter Benjamin," 185/*Walter Benjamin und sein Engel*, 22.

26. Benjamin does not detest natural history, as is sometimes contended (Pizer, 60), nor advance a straightforward dualism of nature and history (Jennings, 64); for Benjamin, natural history is not the pagan mythification of natural appearance, which is implied by Pizer (63). The ultimate force of nature in history is rather the allegorical one that Benjamin considers inherently philosophical. Allegory has no pure nature or pure history. Modern allegory, which seems to be allegory that is inherently modern, has its genesis in a unique emblematics of the interchange of history and nature—a highly distinct emblematics at least somewhat appreciated by Johann Gottfried Herder (1744–1803) and given its first elaborate research in Karl Giehlow's *Die Hieroglyphenkunde des Humanismus in der Allegorie der Renaissance, besonders der Ehrenpforte Kaiser Maximilian I: Ein Versuch* (1915). The latter historical study contributed greatly to facilitating the "historico-philosophical [geschichtlich-philosophischer] investigation" undertaken by Benjamin (*O*, 167–68/I:1, *344–45*).

27. Adorno, *Minima Moralia*, 222–23/298.

28. The pastoral play (Schäferdrama) is one of three main dramatic genres (along with mourning play and comedy [Lustspiel]) of the German baroque. "The tendency of the pastoral play towards total art work [Gesamtkunstwerk] manifests itself in the epic love-lament monologues [Liebesklagemonologen] . . . and in the songs, arias, ballets and masquerades (all pointing to opera and often supplementing a very inadequate plot)" (Alexander, 148).

29. Although he does not mention mourning in this regard, some of Lacoue-Labarthe's remarks and reservations concerning Adorno's reflections on various operas seem to move in the direction of an emphasis on the philosophical importance in music for performative mediateness, for presentation of music as writing-image. See, for instance, *Musica Ficta*, especially 138–45.

30. For this remark and others given above on speech, writing, and music, Benjamin borrows from or—more accurately—adapts passages of the "Anhang" in Ritter's *Fragmente aus dem Nachlasse eines jungen Physikers Ein Taschenbuch für Freunde der Natur* (225–69). For relevant passages on letter, writing, and the arts, see especially 227–30, 242–47.

31. For such an objection, see Steinberg, 7.

32. The formulation "creative indifference" is presumably an allusion to Salomo Friedlaender's *Schöpferische Indifferenz* (1918). In this regard, see also *W* 2, 133/III, 138.

33. Haverkamp, *Laub voll Trauer*.

34. Szondi, "Überwindung des Klassizismus: Der Brief an Böhlendorff vom 4. Dezember 1801," in *Schriften*, Vol. 1, 345–66, especially 358–59, 364. Hölderlin's poetry had very high stature in Benjamin's circles during the years of 1911 to 1914, a stature ensuing largely from the rediscovery of Hölderlin by Stefan George and by George's followers (*WB*, 17/26–27).

35. For some of his comments on Hölderlin's "baroque" phase in poetry, see Hellingrath's "Vorrede," in Hölderlin, *Gedichte*, Vol. 4, xvi–xx.

36. Adorno, "Introduction to Benjamin's *Schriften*," 8/*Über Walter Benjamin*, 41.

37. The two notes on the writing of Adalbert Stifter were sent to Ernst Schoen along with a letter of June 17, 1918. The cited remarks are from the second note, which was written in 1918. There is considerable reason to think the first note was written in the summer of 1917 and not in 1918 (as suggested in the editorial note of *W* [1, 112]). See the editorial notes in *C*, 132, II:3, 1415–18, and *GB*, Vol. 1, 451, 465–66.

38. Scholem, *WB*, 84/108. Scholem is reporting remarks made in private conversation during 1919. The published English translation drops a negative and thereby reverses the sense of the formulation. Contrary to the translation saying "the spheres could be separated," the spheres are not to be separated.

39. See also Scholem, 84/108.

40. A confusion in Corngold's reading of Benjamin's study is the tendency to discuss Ottilie's vanishing or withdrawal as a literary connection with the power of the expressionless ("Genuine Obscurity," 158–60, 165). For Benjamin, the figure of Ottilie is largely identified with a semblance that is in decline, and this identification suppresses and represses decline as the power of the expressionless.

41. Corngold translates "Neigung" as "affection," which is more commonly a translation of "Zuneigung," although it is also a secondary translation of "Neigung." For Benjamin's discussions, which often appear to be critiques of Kant's treatment of "Neigung" (in various moral-philosophical writings), "inclination" seems a more precise and inclusive translation. "Neigung" has accordingly been translated as "inclination" here and below.

42. His notion of allegory is somewhat distinct, therefore, from that advanced in Maureen Quilligan's *The Language of Allegory*, e.g., 25–26, 29–33, 67–69, 72–73, 224–25, and "Allegory, Allegoresis, and the Deallegorization of Language," 163–64. Following and attempting to improve on arguments in Frye's work, Quilligan's definition is to distinguish allegory from "allegoresis," whereby the latter is considered to involve formulations in disregard of "manifest literal meaning" ("Allegory," 164, and Frye, *The Anatomy of Criticism*, 90). In Benjamin's aesthetics of dissonance, allegory and allegoresis are too intertwined to be so distinguished.

43. On this kind of relationship of allegory and irony, see: Teskey, 59–76; and Man, "The Concept of Irony," in *Aesthetic Ideology*, 163–84, especially 165, 179.

44. Hellingrath, *Pindarübertragungen von Hölderlin*, 1–3; see also 4–7. Also in *Hölderlin-Vermächtnis*, 20–22, 23–25.

45. A rational foundation does not require, as Rochlitz implies, dissociation from Benjamin's linguistic theory (215–16).

46. For this sentence, it is especially helpful to consult the German.

47. The two poems compared by Benjamin are the second version of "Poet's Courage" ("Dichtermut"), written around 1801, and "Timidness" ("Blödigkeit"), a third writing of the poem that stems from around 1802 or 1803. According to the Hölderlin edition that Benjamin may have consulted (*Gesammelte Werke*, Vol. 2, *Gedichte*, ed. Paul Ernst [Jena: 1905]), the version of "Dichtermut" discussed most by Benjamin is the first version. Subsequent collections, including that initially edited by Hellingrath (*Gedichte, 1800–1806*, Vol. 4 [1916], 41–42) indicate otherwise. The version discussed by Benjamin as the "first version" is chronologically the second version.

Quotations in this section are from *Sämtliche Werke und Briefe*, Vol. 1: "Dichtermut (Erste Fassung)," 302–3; "Dichtermut (Zweite Fassung)," 303–4; "Blödigkeit," 318–19.

48. This generic characterization of Weimar classicism is both continued and qualified in later statements. For some qualifications, particularly concerning "baroque" elements in dramas by Schiller, see *O*, 122/I:1, 301–2.

49. Quoting Hölderlin, "Remarks on 'Oedipus,'" in *Essays and Letters on Theory*, 102/*Sämtliche Werke und Briefe*, Vol. 2, 850.

50. See Nägele, "Ornamente des Lebens," especially 136, and "Benjamin's Ground," 27.

51. Hellingrath associates Hölderlin's increasing "linguistic ability" with a "struggle for the greater momentum [Wucht] and more sensuous graphicness [sinnlicheren Bildlichkeit], for the terser expression, the more powerful expression, the harder tone, for soberness where the beauty previously bordered on sentimentality [Empfindsamkeit]." ("Hölderlins Wahnsinn," in *Hölderlin-Vermächtnis*, 166. This is one of two lectures on Hölderlin held by Hellingrath in Munich in March 1915. Benjamin heard neither lecture.) Hellingrath, with whom Benjamin was acquainted in 1915–1916 through the circle around Felix Noeggerath in Munich, suggests that the comparison of "Blödigkeit" with "Dichtermut" (the version also discussed by Benjamin) would show the extent to which Hölderlin's reworking of odes marks a "growth of the pure lyrical skill" (*Pindarübertragungen von Hölderlin*, 52; also in *Hölderlin-Vermächtnis*, 65). This place in Hellingrath's study had allegedly been the "external cause" (äußerlicher Anlaß) for Benjamin's Hölderlin essay, and Benjamin claims to have hoped to give the essay to Hellingrath following the latter's return from military service (*C*, 85/*GB*, Vol. 1, 355). Hellingrath was killed on December 14, 1916, near Verdun.

52. In "Das Glück des antiken Menschen" (in or before June 1916), Benjamin adapts Schiller's "Naive and Sentimental Poetry" (see especially 110).

53. Swiss poet and critic Felix Philipp Ingold has a similar sense of "task" (Aufgabe) as "given" (Vorgabe). Without mention of Benjamin in this context, that sense was so formulated during lectures held by him in 1997 at the Alte Schmiede in Vienna.

54. *Aesthetic Theory*, 27–28, 192 (L)/18–19, 132 (HK)/*Ästhetishe Theorie*, 35–36, 199.

55. Learning in this longing, and the imagination correlative to this longing, are distinct from the quasi-paradisal, dreamy learning in color that might take place in a young child. Whereas the young child is without yearning as colors are remembered, art involves elements of a Platonic anamnesis in the sense that is "not without yearning and regret." Recalling the colorless immanence that cannot be lived, Platonic anamnesis (as fostered here by Benjamin) longs and regrets (*W* 1, 265/VI, 124—but see also VI, 122; *W* 1, 410/III, 18–19; and *W* 1, 435–43/IV:2, 609–15). See too the brief review of Karl Hobrecker's *Alte vergessene Kinderbücher* (Berlin: 1924), III, 12–14; the review appeared in *Das Antiquariats-Blatt* (December 1924).

56. Benjamin is quoting Hölderlin: letter of December 4, 1801, to Casimir Böhlendorf, in Hölderlin, *Essays and Letters on Theory*, 149. "*Junonische Nüchternheit*" is italicized in Hölderlin, *Sämtliche Werke und Briefe*, Vol. 3, 460.

57. The adjective "heilignüchterne" occurs in Hölderlin's lyric poem "Hälfte des Lebens" (1802–1803), in *Sämtliche Werke und Briefe*, Vol. 1, 320.

58. For a summary of Herder's notion of "genius" (Genialität) as creative energy that is historically realizable, particularly in a "Volk," see Jochen Schmidt, *Die Geschichte des Genie-Gedankens*, Vol. 1, especially 135–41, and Vol. 2, 213.

59. The text in *GS* has quotation marks around "wie gelegen dir," whereas the poem (first line, second stanza of "Blödigkeit") simply says: "es sei alles gelegen dir." The available English translation makes the adjustment to Hölderlin's text and has the quotation marks start after *wie*.

60. Although (especially the relatively young) Benjamin does not always consistently distinguish "Genie" (as person) from "Genius" (as temporal relation) and sometimes uses one word where the other could be expected, he recognizes that the notion of the genius as person (das Genie) in the work and in creation is "problematic"; not "das Genie" but "genius" (der Genius) is "important" (*GB*, Vol. 1, 299, 298; see also *W* 1, 328–29/I:1, 166).

A translation of Hölderlin's "Blödigkeit" translates "Genius" as "inspiration," although this might still connote something too bound to the person (see Middleton's translation in Hölderlin and Mörike, *Selected Poems*, 65). For remarks on Benjamin's conception of genius, see Steiner, *Die Geburt der Kritik aus dem Geiste der Kunst*, 60–63. On Hölderlin, see Jochen Schmidt, "Hölderlin: Die idealistische Sublimation des naturhaften Genies zum poetisch-philosophischen Geist," in *Die Geschichte des Genie-Gedankens in der deutschen Literatur, Philosophie, und Politik*, Vol. 1, 404–29, especially 415–29.

61. Quoting Hölderlin, "Remarks on 'Oedipus,'" in *Essays and Letters on Theory*, 102/*Sämtliche Werke und Briefe*, Vol. 2, 850.

62. "Chiron," in *Sämtliche Werke und Briefe*, Vol. 1, 314. This passage is cited in *W* 1, 30–31/II:1, *119*, and *W* 1, 175/I:1, *104*.

63. Handke, *Versuch über den geglückten Tag*, especially 90–91.

64. This crisis intrinsic to name is not, of course, the historical crisis and climax for which many philosophers in or close to the Nazi party claimed to provide diagnosis and analytical remedy. For discussion of those philosophers, see Sluga, especially 60–74.

65. The highly specific, usually technical, "scientific, rational principle" (*W* 1, 208/VI, 44) of analogy contrasts with a principle of affinity pertaining to "the whole being" and not to any "particular expression." The "essence [Wesen] of affinity is enigmatic [rätselhaft]"; there is always "the expressionless of the affinity" (Ausdrucksloses der Verwandtschaft) (207/*43*). With regard to music, for example, the affinity is a "pure feeling" that cannot be adequately rendered by means of analogy. The rationality, the law, of music cannot be translated into this or that specific descriptive image (208/44). In apparent disregard of this text, the term "analogy," in a qualified sense, has been used (cf. Ferris, 190) for "affinity" as discussed by Benjamin at the outset of the third part of the *Elective Affinities* study.

66. Benjamin is critical of Humboldt's neglect of "the magical side of language," which was "most profoundly" disclosed by Stéphane Mallarmé (*W* 1, 424/VI, *26–27*). (In the thirties, Benjamin's "Reproducibility" essay would be critical of Mallarmé.)

As a young university student in Berlin, Benjamin had participated in Ernst Lewy's course on Humboldt's philosophy of language. In a letter of August 2, 1925, to Hofmannsthal, Benjamin favorably recalls this course (*C*, 282/*GB*, Vol. 3, 71). In April 1916, Benjamin expresses favorable views of the seminar to Scholem (Scholem, *WB*, 22/33). Such views are repeated in his last available curriculum vitae (written at the end of 1939 or the beginning of 1940), where he notes the importance of the course for awakening his "linguistic–philosophical interests" (VI, 225). During the mid- to late 1920s, Benjamin was engaged in preliminary preparation for collaborating on a collection of Humboldt's writings (see *C*, 278, 282/*GB*, Vol. 3, 63, 71 [as well as elsewhere in this volume], and the editors' notes, VI, 648–50).

67. The later Heidegger would critically place Humboldt's theory of language in an all-too-humanizing lineage of language theory going back to ancient Greece. Humboldt's way to language is less determined "by language as language" than by "human subjectivity," so that the "activity of the subject" is ultimately the inner form, the energeia, and Humboldt's way to language takes the human direction; it passes through language to something else: "demonstration and depiction of the intellectual development of the human race." This approach does not show the "essence of language," the "Sprachwesen," which would require showing language unfolding "as language," language preserving or remaining gathered in what it "grants itself on its own as language." See Heidegger, *On the Way to Language*, 116–19/*Unterwegs zur Sprache*, 245–50. (For another translation of the relevant passages, see Heidegger, *Basic Writings*, 402–5.) It has been suggested above and will be reformulated below, at least provisionally, that Derrida's reservations concerning Heidegger's usage of expressions such as "essence of language" may be extended to Benjamin only in a qualified way, albeit in a less qualified way insofar as Benjamin too regards "the human" as *the* responder to the essence of language (see, for instance, Derrida, *Of Spirit*, 135–36 n. 5).

68. Humboldt, 86–89.

69. Humboldt, 48–49, 51; see also 81–87. For remarks by Hellingrath on "innere Form" as a basis for creation of "an entirely new outer form" for "new circumstances," see *Pindarübertragungen von Hölderlin*, 33 n. 1, 36 (also in *Hölderlin-Vermächtnis*, 48 n. 1, 51). For remarks contrasting "ergon" (as "work") and "parergon" (as "supplement outside the work"), see Derrida, *The Truth in Painting*, especially 54–56.

70. To this extent, Benjamin's account of mourning play focuses on the futility inherent in the attempt to usurp secret and does not consider that attempt itself to be definitive of mourning play. This reading of Benjamin's account diverges somewhat from that by Hanssen (*Walter Benjamin's Other History*, 178 n. 10). For more on secret in relation to *O*, see pages 172, 174, and 188.

71. This anticlassicism may be stressed, notwithstanding a statement in the Romanticism study suggesting the "classical work" necessarily functions as "criticism" in "creation" (Gebilde) and "process" (*W* 1, 178/I:1, *109*). Although overlooking this passage, a recent commentary has articulated a notion of the classical as the constant, the enduring, of criticism in a work (Steiner, "Kritik," 499–501). It is not surprising,

perhaps, that Benjamin has also been called a "classicist with anti-classicist consequences" (Kambas, "Kunstwerk," 531).

72. Even though Goethe—especially in his later period—wrote criticism and thereby indicated some disinterest in implications posed by his theory, such criticism is often characterized by a certain ironic reserve toward the work and toward the "business" of criticism. The purpose of these critical writings was apparently "only exoteric and pedagogical" (*W* 1, 179/I:1, *110*).

73. From March 1918 until June 1919, Benjamin worked on his dissertation. Stages in the writing of the dissertation may be roughly traced as follows: plans in late 1917 and early 1918 to write a dissertation on Kant's works; a subsequent shift of topic by early 1918 to the influence of Kant's *Critique of Judgement* on the German Romantic conception of art criticism; a gradual disenchantment with Kant as Benjamin becomes more concerned with the concept of art criticism in early German Romanticism—especially in early writings of Schlegel. Although Benjamin's disenchantment with Kant and Kantianism was quite advanced by the time he completed the dissertation, the paucity of references to the *Critique of Judgement* resulted partly from expedience. Benjamin had major reservations about Kant's epistemology, moral philosophy, and aesthetic philosophy by the spring of 1918, but doing the dissertation on the concept of art criticism in early German Romanticism (Novalis, August Wilhelm Schlegel, and especially Friedrich Schlegel) was partly an accommodation of the interests of Richard Herbertz, his main teacher and advisor at the university in Bern. (The provisional dissertation title, to which Herbertz agreed, was "The Philosophical Bases of Romantic Art Criticism.") Within a few months of beginning the dissertation, moreover, Benjamin realized that extensive consideration of the *Critique of Judgement* would not be possible in the confines of the dissertation. Among the letters documenting these shifts in focus, see especially *C*, 103–4, 105–6, 115, 119, 125/*GB*, Vol. 1, 402–3, 408–9, 415–16, 440–41, 455–56. In June 1919, Benjamin completed the dissertation under the title "The Concept of Art Criticism in German Romanticism" (Der Begriff der Kunstkritik in der deutschen Romantik). As noted already, a somewhat different version was published in 1920, and it is the latter that appears in *GS* and *W*.

74. See Schlegel, "Über Goethes Meister," in *Kritische Schriften und Fragmente*, Vol. 2, 161. (*Wilhelm Meisters Lehrjahre* appeared in 1796 and was reviewed by Schlegel in 1798 for *Athenäum*.) In his discussion "The Early Romantic Theory of the Knowledge of Art [Kunsterkenntnis]," Benjamin emphasizes Schlegel's remark about the need to understand the book from the work itself ("aus sich selbst") (*W* 1, 155/I:1, 72). As early as November 8, 1918, he suggested that viable modern concepts of art and criticism follow in considerable measure from Romantic concepts (*C*, 136/*GB*, Vol. 1, 486–87). The early German Romantic theory of criticism (in both its niveau and methodological considerations) is, he later says, far superior to "the modern depraved and directionless practice of art criticism." Benjamin's study of this theory of criticism is accordingly to indicate certain features "for authentic criticism" ("<Selbstanzeige der Dissertation>," I:2, 708). (With the publication of the manuscript as a book, Benjamin wrote the latter short notice that appeared in the journal *Kant-Studien* in 1921.)

75. Quoting Schlegel, "Über Goethes Meister," in *Kritische Schriften und Fragmente*, Vol. 2, 162.

76. On the relinquishment of beauty by the story in the novella, see page 139. After hearing the story, Charlotte departs in agitation and is followed by Ottilie (Goethe, *Elective Affinities*, 245/*Die Wahlverwandtschaften*, 179).

77. Jianou, 21 (quoting from A. Rodin and P. Gsell, *L'Art: Entretiens réunis par Paul Gsell* [Grasset, 1951], 35–36).

78. For Kant, supersensibility is *more* exclusively the realm of the sublime (Kant, "Critique of Aesthetic Judgement," in *Critique of Judgement*, 118). (It is also obvious, of course, that Benjamin does not consider the beautiful or the sublime to be determined on subjective grounds [*W* 1, 351/I:1, 195–96; cf. Kant, 119]). Although Benjamin distinguishes the beautiful and the sublime less strictly than Kant does in the *Critique of Judgement*, he advances a conception of the sublime that is not far from Kant's notion of the sublime as "limitlessness" (Kant, 90). The "Kantian distinction of the beautiful and the sublime returns this way, and as in Kant, the latter is connected with God's creation; therefore it is superior to beauty" (Radnóti, "The Early Aesthetics," 82).

79. For some relevant remarks, see Stockhausen, "Moment-Forming and Momente," in *Stockhausen on Music*, 66.

80. Benjamin quotes Scholem, "Lyrik der Kabbala?," 61.

81. "The Wayward Young Neighbours: A Novella," *Elective Affinities*, 236–44/"Die wunderlichen Nachbarskinder: Novella," *Die Wahlverwandtschaften*, 172–79.

82. As has been implied at various points of this study, Benjamin does not advance a straightforwardly "dualistic" conception of the relation of humanity and semblance—contrary to what is often suggested (e.g., Jennings, 181–82, as well as 64–68, 75, 78).

83. Quoting from a diary entry of December 1809, recording a conversation of Goethe with Riemer. See Goethe, *Sämtliche Werke*, Vol. 33, 516.

84. Benjamin opposes the tendency of Friedrich Gundolf (1880–1931; one of the most esteemed academic members of Stefan George's circle) to identify Goethe's entire life and work with "colours" (*W* 1, 324/I:1, 160). Benjamin suggests Gundolf's reduction of the light of Goethe's life and work to colors somehow accords with a remark in the forward of Goethe's *Farbenlehre* referring to colors as "deeds of the light, deeds and tribulations" (Taten des Lichts, Taten und Leiden) (*Zur Farbenlehre*, 5). It is indicative perhaps of the "clear paradox" detected by Benjamin in this image (*W* 1, 324/I:1, *160*) that a review written in the late 1920s tends to transplant Goethe's remark into a context of struggle of light (and away from an implication that colors are realizations of inner light). (The review originally appeared in *Die Literarische Welt* 4, no. 46 [November 16, 1928] as "Johann Wolfgang von Goethe, *Farbenlehre*, hg. und eingel. von Hans Wohlbold, Jena: 1928.") See III, 149. See too an essay written in 1926–1928 for the *Great Soviet Encyclopedia* (the article was not published), especially *W* 2, 173/II:2, 721.

85. In addition to the quotations in works cited here, Novalis's remark ("Each art work has an a priori ideal, an immanent necessity to be there") is paraphrased in *O* 52/I:1, 233. For Novalis's remark, see Novalis, "Fragmente vermischten Inhalts," in *Schriften*, Vol. 2, 231.

86. Even in a note that indicates continued interest in philosophy as a conceptual "system" in which truth as "symbol" expresses itself, Benjamin characterizes artworks as involving "truths" that are not "the truth" but rather recall truth as unrecognizable symbol (*W* 1, 278/VI, 47).

87. In this paragraph, summarized passages of the Romanticism study are from the closing section (*W* 1, 178–85/I:1, 110–19) appended to the dissertation manuscript for its publication as a book and after its acceptance as a *Doktorarbeit*. In a letter of May 1919 to Ernst Schoen, Benjamin mentions the addition of "an esoteric afterword," which was written for those to whom he would communicate the work "as *my* work" (*C*, 141/*GB*, Vol. 2, 26).

88. The quotations given in this paragraph, along with others given in this study, indicate that there is reason to be wary of too strictly referring to Benjamin's *early* work as idealist in contrast with later materialism. The emphasis on nature, or at least on a kind of nature, is also incompatible with the contention (made by Hartung, 568–70) that Benjamin's "spiritualism" devalues all nature, within and outside the human.

89. Rüffer, "Zur Physiognomie des Erzählers."

90. "Novelle" is, as noted already, Goethe's subtitle. Goethe, *Elective Affinities*, 236/*Die Wahlverwandtschaften*, 172.

91. *Meyers kleines Lexikon: Literatur*, 301–3.

92. See the discussions in Menninghaus, *Unendliche Verdopplung*, 155–72, 196–207.

93. Benjamin quotes from fragment 252, "Athenäums-Fragmente [1798]": see Schlegel, *Kritische Schriften und Fragmente*, Vol. 2, 129. Indicating perhaps that the celebration of the novel form should not be taken as a devaluation of benefits specific to other forms, Benjamin's Romanticism study earlier suggests a unique amenability of drama to irony. "Among all literary forms, dramatic form can be ironized to the greatest extent and in the most impressive way, because it contains the highest measure of the power of illusion and thereby can receive irony into itself to a higher degree without fully dissolving" (*W* 1, 163/I:1, *84*).

94. Lacoue-Labarthe and Nancy, *The Literary Absolute*, 56. The word "poiesy" draws on the etymology of the Greek word "poiesis"—that is, on an association with production, not "artistic geniality" but rather "the structure of the System-Subject" to be found "in the necessary auto-production and the auto-production of necessity" (56; see also 11–12, 49). In the text at hand, the German "Poesie" is generally translated as "poetry" but attempts are made—where it seems appropriate—to indicate the broader sense mentioned here by Lacoue-Labarthe and Nancy.

95. Lukács's *The Theory of the Novel* (1915) was to have been the groundwork for an eventual examination by Lukács of Dostoevsky's works, an examination that never appeared (Löwy, 117–21). In his preface of 1962, Lukács remarks that one may justifiably smile at the "primitive utopianism" proclaiming both Dostoevsky's overcoming of the novel form and a correlative onset of a "new world" (*The Theory of the Novel*, 20/*Die Theorie des Romans*, 14). Along with the young Lukács, however, many young contemporaries saw some such promise in Dostoevsky's works. At least as early as the spring of 1919, Benjamin had read and been impressed by *The Theory*

of the Novel. In the midst of the political turmoil of 1918–1919 (which resulted in the turn of many contemporaries, including Lukács, to Marxism), moreover, Benjamin allegedly "still regarded the volume of Dostoevsky's political writings . . . as the most important modern political work that he knew" (Scholem, *WB*, 81/104). In the essay of 1929 on surrealism, Benjamin recalls: "Between 1865 and 1875 a number of great anarchists, without knowing of one another, worked on their infernal machines. And the astonishing thing is that independently of one another they set its clock at exactly the same hour, and forty years later in Western Europe the writings of Dostoevsky, Rimbaud, and Lautréamont exploded at the same time" (*W* 2, 214/II:1, *305*).

96. These remarks are from a note "Towards a new criticism of the 'Idiot'," which Benjamin wrote after writing the review. Whereas Lukács contends that Dostoevsky so belonged to a "new world" that he "did not write novels" (*The Theory of the Novel*, 152–53/*Die Theorie des Romans*, 137), Benjamin's discussions of novels (such as *The Idiot*, Gide's *Strait Is the Gate* [*La porte étroite*, 1909], and *Elective Affinities*—do not seem simply to follow Lukács's characterization of the novel-form as indicative of subjectivity forced into balance or abstraction. Elements of Benjamin's readings seem instead at least to adapt a view of the novel outlined in his Romanticism study and indeed to suggest a "storytelling" potential in the novel greater than is recognized by a somewhat narrow reading of his later critiques of the novel-form (especially the critique advanced in "The Storyteller"), which is a reading sometimes entertained, for instance in Jay, "Experience without a Subject" (especially 149–50, 153, 155), and Rochlitz (190–3).

97. "Über Charaktere im Roman und im Drama" (1902), 491. This dialogue apparently had some significance for Benjamin's aforementioned notes toward a new criticism of *The Idiot* (II:3, 979).

98. Goethe, *Elective Affinities*, 261/*Die Wahlverwandtschaften*, 192.

99. Weigel's essay on Benjamin's *Elective Affinities* study seems confused concerning this role of the work against the work, a confusion especially evident in references to an artist's or author's "stance" supposedly effective in literary characters. Notwithstanding the promising title of her essay, therefore, Weigel suggests Benjamin's critique of Gundolf and the Georgean Goethe cult is on behalf of a "subject position" or "the subject" ("The Artwork as Breach of a Beyond," especially 202, 203, 206). Such suggestions seem to have correlates in declarations about "the exclusion of the artwork from the sphere of the messianic" (202), although there is also a comment that the "expressionless appears in the work of art" (204).

100. As is well known, this statement closes Marcuse's *One-Dimensional Man* (257). In a somewhat similar context, it also appears in Adorno's *Negative Dialectics*, 378/*Negative Dialektik*, 371.

101. It is apparently not a variation of the classicism rejected by him, as Benjamin gives the view that the "supreme reality in art" is the "isolated, finished [isoliertes, abgeschlossenes] work." As will be elaborated below and has been suggested above, this supreme reality is a formal—a rhythmic—and not a substantial conclusiveness or fulfillment.

An ostensible imitation of classics is, moreover, considered by him to be at least sometimes indicative of artistic decline. The Expressionist drama is heralded by Franz Werfel's reworking of Euripides' *The Trojan Woman* (*Die Troerinnen*, 1915), and it is

no coincidence that the beginning of German baroque drama is marked by Martin Opitz's reworking of the same material. In periods of artistic decline, as Riegl says of the last art of the Roman Empire, artistic will may well rework an established form but without being able to attain "a well-made individual work" (*O*, 53–55/I:1, 234–35).

Such reworking can, on other hand, perhaps also be indicative of a dramatic revival, a revival of drama against classicist constraints. See Benjamin's praise of Hofmannsthal's reworkings of *Oedipus*, *Electra*, and *Alcestis*—reworkings compared by Benjamin with the radical (if not artistically very pure) anticlassicism of Opitz's *Troerinnen* (III, 32). This review (III, 32–33), "Hugo von Hofmannsthal, Der Turm. Ein Trauerspiel in fünf Aufzügen (München: Verlag der Bremer Presse, 1925)," was published in *Die literarische Welt* 2, no. 15 (1926).

102. Benjamin writes to Hofmannsthal that *Der Turm* is a "mourning play" (as already suggested by its subtitle) but also a "crowning" in the author's various efforts towards "renewal and rebirth of . . . German baroque form" (June 11, 1925; *C*, 270/*GB*, Vol. 3, 47); it is a "creative testing of the analysis"—delivered in the *Trauerspiel* book—of a "condition of the German drama" that is only superficially a "past" condition (October 30, 1926; *C*, 309/*GB*, Vol. 3, *209*). Hofmannsthal's reworkings of *Der Turm* seem to have been influenced by his encounter with Benjamin's *Trauerspiel* study. See the editorial comments in *Der Turm: Sämtliche Werke*, Vol. 17, 143.

103. Notes for a planned conclusion to the *Trauerspiel* book, I:3, 920. Benjamin initially planned to have a conclusion follow the two main chapters of the study (*C*, 261/*GB*, Vol. 3, 14). Schemata for this conclusion, which would have been a counterpart to the longer (unofficial, eventually published) version of the introduction, are available in I:3, 919–20. Benjamin supposedly decided, however, that he would need an extravagant amount of time to complete such a conclusion (*C*, 264/*GB*, Vol. 3, 26). As early as October 1922, he mentioned pressures upon him to get his habilitation done quickly (*C*, 201–3/*GB*, Vol. 2, 277–83).

104. Concerning various writings, however, this desire is ascribed to Benjamin in Caygill's book (*Walter Benjamin*, 35; see also 9, 28–29).

105. Rosenzweig, *The Star of Redemption*, 210–11/*Der Stern der Erlösung*, *234–36*. Concerning Benjamin's Rosenzweig discussion (especially *O*, 107–8, 112–13, 117/I:1, 286–87, 291–92, 296), see Mosès, "Walter Benjamin and Franz Rosenzweig," 228–46, especially 232–34.

106. Scholem contends that Benjamin (around the time of writing the essay on Socrates) said "he did not know what the purpose [Zweck] of philosophy is," for "the 'meaning of the world' [Sinn der Welt]" is "already in myth" and thus "does not need to be discovered [aufgefunden]." Myth "is everything." Anything else, "including mathematics and philosophy," is only "an obscuration [Verdunkelung], a semblance [Schein]" that arose within myth (*WB*, 30–31/*43–44*). No statements made in available writings or notes by Benjamin attribute quite this preponderance to myth. Scholem is quoting from his own diary, where there is an extensive discussion of Benjamin's view of myth (Scholem, *Tagebücher*, 389–90). A little later, Scholem expresses his own view of myth; this view is somewhat more compatible with views that would be associated with Benjamin: "The loftiest task of Judaism is perhaps to

structure life, in its absolute totality, into an ethical phenomenon. Until now myth—which was the world—did so, and it has yielded that narrow province which we call the moral [or *sittliche*] world. Justice cannot govern in the world as long as people can relate their lives . . . to mythical grounds" (Scholem as quoted from an unpublished manuscript in Smith, "Die Zauberjuden," 238).

107. Hölderlin, "Remarks on 'Antigone,'" in *Essays and Letters on Theory*, 113–14/*Sämtliche Werke und Briefe*, Vol. 2, *918*.

108. It has been noted that Benjamin tends to use the masculine "Held" as a generic term covering heroes and heroines (Samuel Weber, "Genealogy of Modernity," 489 n. 23).

109. Benjamin does not praise either Socrates as pedagogue or Socrates' form of struggle for moral autonomy, at least not as contended by Koepnick (41) and Jacobson (246 n. 81). Benjamin's portrayals of Socrates are largely critical. It is not Socratic irony, as is alleged by Helfer ("Benjamin and the Birth of Tragedy," 188), but rather the dramatic language of Platonic dialogue, that Benjamin considers to be exemplary of the language of the mourning play.

110. Rochlitz, 52.

111. This association of philosophy and art with religiosity distinguishes Benjamin from those more inclined to elaborate art and philosophy as "post-religious." Unlike those theorists, Benjamin does not consider religion to be defined by traditional practices, founding certainties, or escapist immortality (for remarks on behalf of post-religiosity, cf. Critchley, 9, 25, 67, 90).

112. Concerning myth in the Hölderlin essay, see Groddeck, 20. For elaboration of the contrast of mythological and mythic in the Hölderlin essay, and for some remarks on Benjamin's eventual discontinuance of this distinction, see Menninghaus, *Schwellenkunde*, 68–69, 71.

113. At least it seemed to work this way in the 1997–1998 production directed by Philip Tiedemann at the Akademietheater in Vienna.

114. The fragment "Capitalism as Religion" (from the early 1920s) has received some extrapolation since its publication in 1985: for instance, Schweppenhäuser, 146–52, and Steiner, "Kapitalismus als Religion."

115. Steiner, "Allegorie und Allergie," 681, and "Traurige Spiele—Spiel vor Traurigen," 33 (quoting Rang, *Shakespeare der Christ*, 166, contrasting the figure in Dürer's engraving with Hamlet).

116. Without acknowledging it, Benjamin's summation (of the irrepressible basis) that "[t]he rest is silence" (*O*, 158/I:1, 335) is, of course, a restating of Hamlet's last words. Whereas Fenves suggests Benjamin regards Hamlet's remark on silence as a tragic one that conveys *Hamlet* as less effectively a *Trauerspiel* than the German variety (*Arrested Language*, 235–36), it has been suggested here that Hamlet's remark is cited affirmatively by Benjamin as an indication of a uniquely effective *Trauerspiel*.

Benjamin's unclassical Hamlet contrasts with Carl Schmitt's Hamlet. Schmitt ultimately interprets *Hamlet* as an intensification of play whereby the mourning play turns into tragedy, history into myth, so that the scandal of play undermining tragic seriousness is brought to an end (*Hamlet oder Hekuba*, 39–51). Although Schmitt endorses

Benjamin's remarks concerning allegory in *Hamlet* (62, 69 n. 6) and features of Benjamin's distinctions of *Trauerspiel* and tragedy (72–73 n. 21), he contends that Benjamin misinterprets the role of Christianity in *Hamlet* (63–64) and misunderstands the distinctness of the English *Hamlet* in relation to German baroque *Trauerspiel* (64–67).

117. It would not be warranted to infer political implications from Benjamin's discussion of royalty, although his reservations (mentioned on pages 173 and 224–25) about Calderón's plays would indicate certain resistance to Calderón's intermeshing of redemptive motif with political machination. (It may be indicative of Benjamin's reservations about Calderón's "Schicksalsdrama" that he celebrates Hamlet's wish to die by accident; in *Hamlet* ["this *Trauerspiel*"], "the destiny-drama flares up" as contained but "overcome" in the conclusion [*O*, 137/I:1 *315*].) While discussing tragedy, in any case, Benjamin says that royal rank simply assures plausibility for the display of rebellion (110/289). In the baroque mourning play, royal rank would similarly facilitate the formal dialectic of the work.

Calderón's dramatic form has been regarded as the "origin" of the German Romantic destiny-drama; a particular Herod drama by him is considered the "seed" of Romantic destiny-drama, indeed the "first destiny-drama in world literature" (*W* 1, 373–74/II:1, *261*; *O*, 83–84/I:1, *262*). That they may be described as destiny-dramas makes Calderón's mourning plays unique (*W* 1, 380/II:1, 270). The destiny-drama exemplified by works of Calderón and making Calderón's mourning play a "genuine romantic destiny-drama" (*O*, 133/I:1, *312*) shows artistic means fulfilling the two sides of reflection: "introduction of a reflexive infinity of thinking into the closed finitude of a profane destiny-space [Schicksalsraums]" and the "playful miniaturization [Reduzierung] of the real [Wirklichen]" (83/*262*). With play as framing, reduction, miniaturization of the world (83/262), a bringing of the world playfully into the stage (81/260), the "Romantic" role of artistic "reflection" in Calderón's plays involves "the machination" becoming the god of "the new theatre" (82/*261*). Calderón's works show an "unparalleled virtuosity" of "reflection" whereby the heroes "are always able to turn the order of destiny around like a ball in their hands that is to be considered [betrachten] now from one side, now from another" (84/*262*; see also *W* 1, 378–79/II:1, 268). Calderón's plays belong to the genre "baroque mourning play," but also involve a "Romanticism" pointing beyond this.

The German Romantics may have produced enough "bad," "unromantic" so-called tragedies of destiny (*W* 1, 381/II:1, 272) but were not without artistic successes in this regard; Zacharias Werner, before taking refuge in the Catholic church, attempted the destiny-drama (*O*, 84/I:1, 263, II:1, 268) and some of Ludwig Tieck's dramas are exemplary for Benjamin (*O*, 83/I:1, 262).

Although the "destiny-drama" (broadly conceived) may pertain to any drama concerned in any way with the power of destiny (with examples ranging from Sophocles' *Oedipus Rex* to Schiller's *Wallenstein* [1800], Zacharias Werner's *Der 24. Februar* [1810], and Franz Grillparzer's *Die Ahnfrau* [1818]), the usage of the term "Schicksalsdrama" in the *Trauerspiel* book pertains mostly to eighteenth- and nineteenth-century German works, as well as to dramas by Calderón.

As on most other occasions in this study, "Schicksal" is translated as destiny. Although there seems to be a tendency to translate "Schicksalsdrama" and "Schicksal-

stragödie" as "drama of fate" and "tragedy of fate," respectively, at least one English-language manual does suggest "Schicksalstragödie" may be translated as either "fate tragedy" or "destiny tragedy" (Cuddon, 836–37). As should become clearer below, the translation of "Schicksal" as "destiny" often seems more suited than the translation "fate" to the philosophically most important connotations that Benjamin gives to the word "Schicksal."

118. In a note toward a planned second edition of the study, Benjamin suggests it might be better to address Calderón in terms of "an inclusion of δυναμει [strength]" instead of a "virtual inclusion of transcendence." This would indicate clearly "the Aristotelian-Thomist preconditions" (I:3, 953).

119. This note, and indeed the term "Schicksal" in Benjamin's early work generally, have been read somewhat differently in this study than is usually proposed (cf. Menninghaus, *Schwellenkunde*, 96–97).

120. In this respect, therefore, the reading given here of Benjamin's view of mourning is in disagreement with that given by Steiner (see especially "Traurige Spiele—Spiel vor Traurigen," 41–42, 46).

121. Even in the *Trauerspiel* book, Benjamin says the Spanish drama is more "full of form" (formvoll) and more "dogmatic" (dogmatisch) than its German counterpart (*O*, 84/I:1, 263). In the note toward a planned second edition of the study, Benjamin says that he must consider a reproach that he had outlined *Life Is a Dream* "as nothing but the illustration of a Catholic dogma." In this regard, he wonders: "Is there really a dogma in Catholicism that declares life to be a dream?" (I:3, 953).

122. Relevant are writings of the Florentine neo-Platonist Marsilio Ficino (1433–1499), the German neo-Platonic mystic Heinrich von Nettesheim (1486–1535), and the Lutheran Philipp Melanchthon (1497–1560). These are considered by Benjamin to be indicative of the context from which Dürer's engraving emerged (*O*, 151–53/I:1, 329–31).

123. As a distillation and modification of almost two thousand years of theorizing melancholy, the baroque carries a heritage—as part of its inheritance from Renaissance Christianity—in which posterity has a more reliable commentary on the mourning play than could be provided by the German baroque poetics on the play (*O*, 142/I:1, 320–21). Benjamin draws on various studies to elaborate on the contention that the baroque melancholic disposition (the baroque "theory of melancholy") amounts to a development of Renaissance doctrine and emblems as well as certain medieval views of saturnine disposition (145–51/323–29). Especially important is Panofsky and Saxl's *Dürers 'Melencolia I'* (1923), which Benjamin discovered at the end of 1924 after finishing the first draft of the habilitation manuscript (*C*, 256/*GB*, Vol. 2, 509). Panofsky and Saxl develop themes on Renaissance iconography that were already articulated by Aby Warburg. Warburg's *Heidnische-antike Weissagung in Wort und Bild zu Luthers Zeiten* (1920) is also used by Benjamin in a number of places in the *Trauerspiel* book. In the secondary literature, the overlaps of works by Panofsky, Saxl, and Warburg with those of Benjamin are receiving increasing, albeit still sketchy, attention.

Offered an opportunity by Hofmannsthal (at Benjamin's suggestion) to review the published *Trauerspiel* book, Panofsky declined—apparently on grounds of being "by

specialization" only an art historian. In disappointment, Benjamin replied to Hofmannsthal that he had expected greater breadth of interest from Panofsky (*C*, 326/*GB*, Vol. 3, *332*).

124. In contrast with the Renaissance, which "explores the universe," the baroque "explores libraries." The baroque not only meditates with books but also regards the world—both nature and history—as a book (*O*, 141/I:1, 320). Benjamin criticizes solely the German variant, however, as a would-be stoicism. The latter kind of self-satisfied superiority, in the contemplation of history and nature, as writing must fail (141–42, 201/320, 377). For Benjamin, there is indeed "Protestant Stoicism" in the German *Trauerspiel* (Roberts, 134–35), but this stoicism is shown to be an unhistorical, ostentatious, and futile attempt at fortifying a self against emotional crisis (*O*, 73–74, 88–89/I:1, 253, 267–68). With its emphasis on the individual appropriation of religious truth, pietism might be considered a Protestant stoicism. The plays, however unwittingly on the part of playwrights, show such rigidity—"baroque rigidity of the melancholic"—as ultimately "unstoic" and "pseudo-pietistic" (158/335). Stoicism and pietism are broken by the irrepressible play of mourning.

125. Cf. Garber, *Zum Bild Walter Benjamins*, 35, 199–200. Garber elsewhere adapts later works by Benjamin to arrive at a "reception theory" for inquiring sociocritically into the transmission history of works. This turn is undertaken against those *Trauerspiel* book readers whom Garber accuses of "bottomless speculations." See Garber, *Martin Opitz*, 11–16, 177 n. 20. Cf. H. Günther, 91ff. In this vein, Bürger singles out Garber's literary historical approach as a rare instance of criticism learning from Benjamin (*Vermittlung-Rezeption-Funktion*, 224–25 n. 20). The ground, for Benjamin, is bottomless; the bottom of an ostensible container must open to a bottomless depth. Narrowly historical orientations to Benjamin's work forsake most of the intensive orientation that is the basis of his monadology.

Garber tried to refine his initial position. Notwithstanding remarks by Benjamin that seem to imply "a radical and total refusal of any reception-aesthetic notions [Gedanken]," Benjamin is "in truth" concerned with "the reception-theory of works," with a "strictly historical" (allegedly distinct from vulgar historicist) reception theory developed on the basis of "the centre [Zentrum] of the work" (*Rezeption und Rettung*, 10). Although qualified by references to the importance of work-immanent criteria for Benjamin's analysis, a kind of historicocentric bias surfaces with remarks such as those suggesting that "the by far most fruitful work" in Benjamin studies "is achieved today in the source-critical, optimally supported biographical" or "institutional-historical" research (184 n. 242). Despite significant and unique addition of dimension to the discussion of Benjamin's works (see especially the chapter "Benjamin's Image of the Baroque" [59–120]), and despite acknowledgment of the multiple possibilities for addressing these works and of the philosophical impetus in the *Trauerspiel* book, Garber downplays the importance of Benjamin's Platonism, his Jewish theology of name, or his Leibnizian monadology (see, for example, *Zum Bilde Walter Benjamins*, 197, 199–200).

126. The association of the philosophical impulse with a transcendent immanence is not an association with the kind of transcendence criticized by Deleuze and Guattari as they develop their association of philosophy with immanence. They object to the notion of transcendence about which one presumes a stopping of "movement of the infinite"

(*What Is Philosophy?*, 47). Benjamin would, it seems, share a view, later articulated by Deleuze and Guattari, that thought constitutively converges with "infinite movement or the movement of the infinite" (37); he would not adhere to the kind of transcendence rejected by them (and elaborated, for instance, on 48–49). Even his various formulations on recognizability of the now do not involve that kind of transcendentalism.

127. In a caricature of dramatic Expressionism, Willy Haas refers to an attempt to create a magical space in which social and material limits are dissolved (143). Benjamin seems to have a similar image of literary Expressionism in mind as he comments that a critical "terror" must control literary Expressionism (*W* 1, 293/II:1, *242*). Although he admires some Expressionist painting (most notably by Chagall, Kandinsky, and Klee), he accuses literary Expressionism of bad aping of such great creations. An exception seems to be Georg Heym (1887–1912), whose poetry he admires. There is, moreover, the poetry of Benjamin's friend Fritz Heinle, which also seems to be regarded by Benjamin as much better than most Expressionist poetry. (See Scholem, *WB* 65–66/85. For poems by Heinle, see *Akzente* 31, no. 1 [1984], 3–8.) Even if Benjamin's *Trauerspiel* book is "not merely academic research" and "has a direct connection to very relevant problems of contemporary literature," some qualification must be given to the claim (made in this case by Asja Lacis) that the book treats the "drama of the baroque"—in "the search for formal language"—as analogous to Expressionism (*Revolutionär im Beruf*, 44 [recounting remarks of Benjamin]). Among the points stressed by Benjamin in a qualification of the "analogy" of the periods are the following: the baroque writers' commitment to an absolutist constitution in contrast with Expressionists' hostility or indifference to the state; and the significance of baroque writing for a rebirth of German literature, in contrast with the decline represented by early twentieth-century German literature (a decline that might nonetheless be "fruitful and preparatory") (*O*, 56/I:1, 236). The similarity detected by Benjamin between German baroque allegory and early twentieth-century literary Expressionism is basically the desperate bombast, which he criticizes. His critical enterprise may be said to tap into a soberingly objective power that he discerns more in baroque allegory than in Expressionist literature. This power determines Benjamin's own writing (Adorno, *Über Walter Benjamin*, 101; Scholem, "Walter Benjamin," 182/*Walter Benjamin und sein Engel*, 19). For an occasionally somewhat swooping attempt, nonetheless, to situate Benjamin and others (including Buber, Bloch, Heidegger, and the young Lukács) as "Expressionistic philosophers" and their works as "philosophy in Expressionism," see the chapter "Der Hintergrund: Philosophie im Zeitalter des deutschen Expressionismus" in Holz, *Philosophie der zersplitterten Welt*, 7–48. A late comment by Benjamin would suggest that he did not entirely dismiss Lukács's views on relations of Fascism and Expressionism (*AP*, 472/V:1, 590).

128. Nägele, "Das Beben des Barock in der Moderne," 509–10.

129. Contrary to what is asserted (in this case with regard to *O*) by Rochlitz (106).

130. The "Notizen zu einer Arbeit über die Kategorie der Gerechtigkeit" is apparently from a notebook of Benjamin's lent to Scholem, and the notices were copied by Scholem (Scholem, *Tagebücher*, 401–2, under the entry for October 8/9, 1916). Thanks to Friedrich Niewöhner, one of the editors of Scholem's *Tagebücher*,

for information (in an e-mail of April 29, 1999) concerning these notes on justice. See also Schweppenhäuser, "Benjamin über Gerechtigkeit."

131. "André Gide: La porte étroite" (II:2, 615–17) was written in 1919 but never published in Benjamin's lifetime. In 1917, Benjamin wrote his short review of Fyodor Dostoevsky's novel *The Idiot* (1869), or at least of the German translation by E. K. Rahsin (Munich: 1909). This review develops the outlook concerning the child like with reference not only to Myshkin but also to the youngster Koyla (whom Myshkin befriends) (*W* 1, 80/II:1, 240). Concerning Gide's and Dostoevsky's books, see also *C*, 219/*GB*, Vol. 2, 47.

132. See Adorno, *Aesthetic Theory*, 7 (L)/5 (HK)/*Ästhetische Theorie*, 15, and similar remarks throughout (e.g., 257–60/179–81/268–70).

133. "Notizen zu einer Arbeit über die Kategorie der Gerechtigkeit," in Scholem, *Tagebücher*, 402.

134. This passage of "Schicksal und Charakter" (an essay that Benjamin considered his best writing up to that point [*C*, 154/*GB*, Vol. 2, 62]) is echoed and quoted in *O*, 109–10/I:1, 288–89. It invites, of course, a contrast with the reading of tragedy in Hegel, *Phenomenology of Spirit*, 266–93 ("The *true* Spirit. The ethical order.").

135. Quoting Nietzsche, *The Birth of Tragedy*, 105.

136. As Fenves (*Arresting Language*, 246–47) hints, the reference to "the profound Aeschylean pull towards justice" (der tiefe äschyleische Zug nach *Gerechtigkeit*) is taken verbatim from *The Birth of Tragedy*, 70/58), although Benjamin gives no quotation marks and cites as the source Max Wundt, *Geschichte der griechischen Ethik*, Vol. 1, *Die Entstehung der griechischen Ethik* (Leipzig: 1908).

137. Hölderlin, "Remarks on 'Antigone,'" in *Essays and Letters on Theory*, 116, 114/*Sämtliche Werke und Briefe* Vol. 2, 921, 919.

138. Shortly after the release of *The Birth of Tragedy* (1872), as is well known, the young philologist Ulrich Wilamowitz-Möllendorf (1848–1931) attacked Nietzsche's book on historico-philological grounds (*Zukunftsphilologie! Eine Erwiderung auf Friedrich Nietzsches 'Geburt der Tragödie'* [1873] and *Zukunftsphilologie: Zweites Stück: Eine Erwiderung auf die Rettungsversuche für Friedrich Nietzsches 'Geburt der Tragödie'* [1873]). For a discussion of this dispute, see Silk and Stern, 95–105. In a letter of March 5, 1924, Benjamin mentions the polemical attacks made by George-follower Kurt Hildebrandt on Wilamowitz in a publication of 1910 (*C*, 239/*GB*, Vol. 2, 438). In later recollections (published in 1965), Hildebrandt recalls Wilamowitz's anti-artistic and openly proclaimed antiphilosophical philological historicism; for relevant quotations, see *GB*, Vol. 2, 441–42.

139. Volkelt's study was originally published 1897; the revised third edition of 1917 was used by Benjamin.

140. As an example of the criticized German idealism, Benjamin cites an essay on Sophocles by Karl Wilhelm Friedrich Solger (1780–1819) in *Nachgelassene Schriften und Briefwechsel* II (1826), edited by Ludwig Tieck and Friedrich von Rauner. See also the reference to Hegel above (n. 134).

141. Without acknowledgment, Benjamin basically paraphrases Rang's "Theater und Agon," which is available in *C*, 233–35/*GB*, Vol. 2, 425–27; see especially 235/427.

142. Kant, "Critique of Aesthetic Judgement," in *Critique of Judgement*, 220–21.

143. Witte, *Walter Benjamin*, 35. Concerning the dissertation (and other writings) in the context of the war and its aftermath, see Kambas, "Walter Benjamins Verarbeitung der deutschen Frühromantik," 194–202.

144. Bresemann, 179–80.

145. The relevant nontragic tradition is a long one that may be traced in the Middle Ages (in secular drama, Hroswitha and the Mystery Plays), in the baroque (Gryphius and Calderón or various Shakespearean scenes), and onward—in the second part of Goethe's *Faust*, works such as Goethe's *Die natürliche Tochter* or Friedrich Schlegel's *Alarcos*, and works of Jakob Lenz, Christian Grabbe, August Strindberg, and Bertolt Brecht (*W* 4, 304/II:2, 534; *O*, 89, 113/I:1, 268, 292; and *W* 1, 57/II:1, 136).

146. This notion of "Schicksal" is generally overlooked in favor of somewhat one-sidedly fatalistic accounts of Benjamin's formulations concerning "Schicksal" (for example, Menninghaus, *Schwellenkunde*, 96–97, and Jäger, "Schicksal").

147. German baroque manuals show an ultimate indifference to Aristotle's theory of tragic effect (*O*, 61/I:1, 241.—cf. Aristotle, *Poetics*, 1452a–1452b, 1452b–1454, 1454a–1454b; *Introduction to Aristotle*, 637–38, 639–43, 643–44). Insofar as Aristotle's theory of tragic drama was adapted in the German baroque mourning plays, it was coarsened. The German baroque mourning play has accordingly often been regarded as merely a misunderstanding, distortion, and caricature of classical precepts. Although the baroque theory of drama was conceived as Aristotelian, Benjamin's attempt to formulate critically the "life of language" in the German baroque mourning play is directed against more than two centuries of "disregard and misinterpretation" following considerably from an overemphasis on the significance of Aristotle's *Poetics* for the dramas (*O*, 49–50/I:1, 230).

148. Concerning the German baroque, Benjamin mentions neologisms, metaphors, arbitrary (including archaic) coinings, and expressions combining substantives with adjectives that have no adverbial usage (e.g., *Grosstanz*, *Grossgedicht*); the adverbial is bypassed in the desperation for a space free of sequential time (the time of verb tenses and the sequence defined by guilt-context). As in Expressionism, "forcing" (Forcierung) of the latter sort is indicative of a futile will to redeem communal feeling. In German baroque writing and Expressionist writing, works do not emerge from "the existence of the community" but entail rather a compensatory "violent" style or manner, a decadent will, attempting to conceal rather than highlight this lack (*O*, 54–55/I:1, 235–36).

149. The word "Trauerspiel" was employed "more methodically" by the drama than by the criticism (*O*, 89/I:1, 268). Each pertinent play had the word "Trauerspiel" printed on the original title page.

150. Treatment of Benjamin's *Trauerspiel* study (by the authorities reading it as a prospective habilitation thesis or by baroque specialists) has been addressed as a "Trauerspiel" (Lindner, "Habilitationsakte Benjamin. 324–41; Brodersen, "Ein deutsches Trauerspiel," in *Spinne im eigenen Netz*, 146–48; Garber, "Benjamin und das Barock," 207–12). There can, however, also be a colloquial usage of the word "Trauerspiel" to lament the lack of an imperative rather the imposition of one. This

"conservative, anti-liberal" sense would seem, nonetheless, a misusage of the word "Trauerspiel" (at least as Benjamin formulates it), a misusage that has a quite sinister history in Germany (Hillach, 56–57, 67).

151. Sparks's essay (passim, but especially 207–12) may be very generally questioned about its suggestion that Benjamin associates, to the point of convergence, tragedy with the origin of language and philosophy. Sparks's essay seems to overlook Benjamin's own association of mourning (a nontragic mourning) with the "origin" of language and philosophy.

152. Benjamin only contrasts the first and the third formulations by Hölderlin. The "mouth," the *tongue*, of a people opens to the ultimate completion that is simultaneously the meaning of myth and the meaning from which myth cuts itself off. For a somewhat similar elaboration of myth, see Nancy, *The Inoperative Community*, 43–71, especially 49–52.

153. In suggesting such compatibility of Benjamin's Hölderlin essay with somewhat later work, such as the essay on *Elective Affinities* or the *Trauerspiel* book, which more emphatically distinguish myth and truth, this reading is distinct from a tendency among some to detect, in the Hölderlin essay, a submissive identification (albeit qualified) of truth and myth. For a relatively recent instance of the latter reading, see Hanssen, "'Dichtermut' and 'Blödigkeit,'" 148, 151–53, 156–57, 159, 161–62.

154. Rochlitz contends Benjamin has allegory growing out of "an *antimodern* impulse" in which, for example, the German baroque drama cannot attain "radical independence from the social powers of the court and the church" (223). For Benjamin, however, it is precisely the allegorical impulse that moves beyond such powers. In a variation of Goethe's concept of the universal symbol, an aestheticist opposition of reality and art prevails over German aesthetics throughout the nineteenth century (in adaptations by Hegel, Schelling, and the influential aesthetician Friedrich Theodor Vischer [1807–1887]) and into the twentieth (Cassirer). The rehabilitation of allegory is a recovery of the interaction of experience and art (Gadamer, 80–81; see also 70–81 and the short summary of Gadamer's remarks in Man, *Blindness and Insight*, 188–89). Gadamer's references to the allegorical-mythic or his discussions of allegory as mythic-religious may indeed be indicative of conservative priorities only tokenly concealed by his apparent endorsement of Benjamin's *Trauerspiel* book as marking the beginning of a "vindication of allegory" (Gadamer, xxxi n. 8). Gadamer suggests that the new evaluation of allegory can be a mythic-religious restoration of the proximity of symbol and allegory (80–81). For Benjamin, the proximity of symbol and allegory is an inherently modern and ultimately antimythical realization. Contrary to Hirsch's contrast of Gadamer and Benjamin, however, Benjamin fosters allegory less as cold and pertaining to understanding and more as the interruption of such a dimension of sign by the theological-symbolic force that sign cannot incorporate. Allegory is the inextinguishably dissonant juncture of sign and theological symbol. Cf. Hirsch, *Der Dialog der Sprachen*, 156–57.

155. This reading diverges from the available English translation; the noble consideration (adlige Nachsicht) would seem to be the criticized tolerance and gentleness (Duldung und Zartheit) and not the opposite of it. The noble consideration seems to be the tolerance and gentleness contrasted with the supramundane reconciliation

(mentioned in Benjamin's previous sentence). In the sentence being discussed, the contrast with this reconciliation is made by the formulation "gegen sie"; then Benjamin mentions "die adlige Nachsicht, jene Duldung und Zartheit," which "falls short" (bleibt . . . zurück) (*W* 1, 343/I:1, *184*).

156. Quoted and discussed in "Hugo von Hofmannsthals 'Turm': Anläßlich der Uraufführung in München und Hamburg," III, 100–101.

157. The ethical involves being alone (as something other than, or beyond, a "subject") with God's destructive nature as a bodily sensation. This notion of the ethical will be elaborated in "Community of the Dead" especially the sections titled "In Name of Inorganic Community" and "Bequest." As should become clear in those sections, Benjamin often seems to advance this ethics in a way that could be considered compatible with, albeit less emphatic than, Lévinas's focus on the catalytic separation from the other. Lévinas says: "It is not the insufficiency of the I that prevents totalization, but the Infinity of the Other" (*Totality and Infinity*, 80). Benjamin does not suggest, however, that it is in the welcoming or hospitable "subjectivity" that the "idea of infinity is consummated" (27). Although Benjamin's *Elective Affinities* essay is concerned with the awakening or wrenching from complacency of one person by the dramatic potential death of another, and thus might seem to be a dramatization of Lévinas's stipulation that "fear for the death of the other" underlies "responsibility" to the other (*Ethics and Infinity*, 119), Benjamin only occasionally indicates something similar to Lévinas's (albeit adapted or modified) Buberian emphasis on God that signifies for thought primarily through dialogue with the Other (*Of God Who Comes to Mind*, 151).

158. Concerning *Elective Affinities,* Benjamin says: to the "epic foundation in the mythic" (semblance as essence in much of the novel) and to the "lyrical breadth in passion and inclination" (primarily in the novella), there may be added a conception of the "dramatic crowning in the mystery of hope" (*W* 1, 355/I:1, *201*). In a letter of April 16, 1938, Benjamin even suggests to Adorno that the *Elective Affinities* study has a "dialectical" structure that would recur in the schematization of the Baudelaire study (*GB*, Vol. 6/I:3, 822/Adorno and Benjamin, *The Complete Correspondence*, 247). In any case, a layout for the *Elective Affinities* study distinguishes the three main parts of the study as: "First Part: The Mythic as Thesis"; "Second Part: The Redemption as Antithesis"; and "Third Part: The Hope as Synthesis" ("Disposition," I:3, 835–37). Benjamin provides section and subsection titles not given in the study itself, although they are in the prepublication version of the text (I:3, 846–58). In a letter to Hofmannsthal, Benjamin says the titles are not meant for publication (*C*, 230/*GB*, Vol. 2, 411). Variations of the triad—epic, lyrical, and dramatic—are, of course, abundant in the critical tradition: for instance, Rosenzweig, *The Star of Redemption*, 244–45/*Der Stern der Erlösung*, 272–73; various fragments by Novalis; and—of course—Hegel's *Aesthetics*, Vol. 2, 1035–1237. In his usage of the triad, however, Benjamin identifies the novella with the lyrical and not with "epic distance" (as suggested in Steiner, "Kritik," 505). Steiner is interpolating with Benjamin's much later association of storytelling and a kind of epic, but in the *Elective Affinities* essay the association is not yet made. As noted above, moreover, the storytelling attitude in Goethe's novel is associated with the *synthesizing* moment of hope rather than with the *antithetical*, redemptive moment carried by the novella.

159. The Romantics scarcely focused on translation as a theoretical theme; "their own great translations" belong, however, to a "feeling" for "the essence and the dignity of this form" and their criticism "also presents [darstellt] a moment, if a lesser moment, in the continued life of the work" (*W* 1, 258/IV:1, *15*). On the Romantic view of the irony of translation as continuance of the irony of literature, see Berman, 99 (as well as 211 n. 57).

160. Benjamin planned to include "The Task of the Translator" in the first issue of *Angelus Novus* (*GB*, Vol. 2, 218; *C*, 193/*GB*, Vol. 2, 207). The translations in the planned journal were not to follow the custom of transplanting the originals into established meanings of German. Benjamin calls for translations that develop fresh coinings when the German linguistic heritage is otherwise unable to accommodate the original. The journal would, moreover, always include the original alongside the translation (*W* 1, 294/II:1, 243).

"The Task of the Translator" (*W* 1, 253–63/IV:1, 9–21) originally appeared as the translator's introduction to Charles Baudelaire's *Tableaux parisiens*, a bilingual (French and Benjamin's German) collection (Heidelberg: Verlag von Richard Weissbach [Weissbach's "The Press of the *Argonauten*-Circle"], 1923). See IV:1, 22–63. For comparisons of these translations with those of Stefan George (*Die Blumen des Bösen: Umdichtungen von Stefan George*) and in relation to Benjamin's theory of translation, see: Berger, especially 637–48; Brodersen, 124–31; Weidmann, "Wie Abgrunds"; and particularly Schlossman, "Pariser Treiben." Benjamin translated Baudelaire's poems as early as 1914–1915 (see editorial notes, IV:2, 888). Translations (with Charlotte Wolff) of other poems by Baudelaire appeared in the short-lived periodical (edited by the Rowohlt editor-in-chief, Franz Hessel) *Vers und Prosa*, no. 8 (1924). Benjamin's translations, of other parts of *Fleurs du Mal* are available in IV:1, 65–82. For subtle discussions of Benjamin's translations as well as of Hölderlin's translations, and of these in the context of Benjamin's translation theory and linguistic theory, see Nägele, *Echoes of Translation*.

In 1926, the Rowohlt publishing house commissioned Benjamin, along with Franz Hessel, to translate from Proust's *A la recherche du temps perdu*. They completed the second book (*Im Schatten der jungen Mädchen* [Berlin: 1927]) and the third (*Der Herzogin von Guermantes*, Vols. 1 and 2. [Munich: 1930]), which have been reissued as supplements 2 and 3 of *GS*, respectively. For considerations of these translations in the context of Benjamin's theory of language and translation, see Kleiner, *Sprache und Entfremdung,* and Müller Farguell, "Penelopewerk." Other translations by Benjamin are available in supplement 1 of *GS*.

161. One modification of the available English translation should perhaps be emphasized: "aus sich herausführen" is not translated as "point beyond themselves."

162. This may account somewhat for Benjamin's later insistence (in a review in 1934 of Günther Voigt's *Die humoristische Figur bei Jean Paul*) that any application of the *Trauerspiel* book's conception of allegory to Jean Paul's writings not be done without further consideration of the distinctness of those writings (III, 422–23).

163. See Hamacher's "The Word *Wolke*—If It Is One" (especially 153–56, 163, 173–75) and "Afformative, Strike," 137–38.

164. See also the aforementioned review written under the pseudonym "Detlev Holz" for the *Frankfurter Zeitung* in 1934: "Gunther Voigt, *Die humoristische Figur bei Jean Paul*, Halle/Salle: Max Niemeyer Verlag, 1934, 98 S.," III, 421–23.

165. For Schlegel, allegory is but one element in the structural basis that is irony (Manfred Frank, 140).

166. "Shakespeare: Wie es euch gefällt" (a short note written in the last half of 1918), II:2, 610.

167. Shakespeare's discovery of infinity (above all in comedies such as *As You Like It*) is "Romantic" insofar as infinity is borne by nothing and no one. Like the Romantics, Shakespeare (in his comedies) is no "visual" (schauende) poet. As noted above, Benjamin considers Shakespeare's comedies exemplary in their command of the dynamic of imagination and shape, at least in comparison with Jean Paul's effusiveness. In Shakespeare's comedies, a naïveté of solitude based on lack of "longing" (Sehnsucht) is nonetheless dreamier, more thoroughly dissolving, more devoid of mediation, of shape, than even German Romanticism. There is "no remainder . . . in this immense process of dissolution," this "dissolution of the cosmos into infinity [Unendlichkeit]." *The Tempest* (1610–1611) is an exception; infinity breathtakingly nears existence as Prospero ultimately abandons his magical faculties (II:2, 610–11).

168. The mask-tradition, which makes this element of drama explicit, probably precedes dramas of ancient Greece, which it also includes along with the Latin comedies (such as those of Plautus [c.254–184 B.C.E.] and Terence [195 or 185–159 B.C.E.]), works of the Middle Ages (most prominently by Hroswitha), and, of course, Molière.

169. Contrary to what is sometimes asserted (for example in Witte, *Walter Benjamin: Der Intellektuelle als Kritiker*, 74–77, 90–97).

170. There is an allusion to this notion in a note (I:3, 918), but it receives elaborate formulation in later writings, albeit in various contexts (*W* 2, 240/II:1, 314; IV:1, 284; IV:2, 977–78; *W* 3, 374/VII:1, 416–17).

171. By smashing "the doctrine of the art form," Benedetto Croce uncovers "the way to the single, concrete art work" (*W* 2, 78/VI, *218*). Croce's *The Essence of the Aesthetic* (1913) resists any deductive concept of genre in the philosophy of art. A certain wariness is, nonetheless, advisable concerning the Italian philosopher's nominalistic (and psychologistic) tendency to privilege the individual work and to disregard the "density" and the "reality" of "structures" (Gebilde) not "commensurable" with the particular work (*O*, 43–44/I:1, 223–24). See also I:3, 943–46.

172. This reading of *O*, including comments made already in this paragraph, is in disagreement with certain dismissals of Benjamin's theory of ideas (cf. Speth, 255, 258, 260, as well as 242–43).

173. This reading also diverges from what is maintained by Speth (275).

174. With the notion that "genres are abbreviated world-images [verkürzte Weltbilder]" (which could be called *word*-images), Benjamin makes "a decisive contribution to genre-theory" (Schlaffer, 44).

For more on chronicle, see: "<Johann Peter Hebel. 3>," II:2, 637–38. This note (II:2, 635–40) was written in 1929. Among other pieces on, or dealing with, Hebel, see especially *W* 1, 432–34/II:1, 280–83.

175. According to a letter of September 21, 1917 (*Briefe an Werner Kraft*, 31), Scholem regards the 1916 essay on language as a clarification of themes of the Hölderlin essay, which has been cited here.

176. On the aporia of name, see Agamben, *The Coming Community*, 73.

177. For the concept of baroque, Benjamin's *Trauerspiel* book occasionally (and favorably) cites Fritz Strich's "Der lyrische Stil des Siebzehnten Jahrhunderts," first published in 1916.

178. The sentence quoted here is omitted from the published English translation.

179. Relevant in this context is Derrida, "The Law of Genre," especially 230–31, as well as 242 and 245.

180. In addition to remarks noted above (for example, page 116), see especially the otherwise quite favorable response to Benjamin's Kafka-essay (Adorno, *Über Walter Benjamin*, 108–14/*The Complete Correspondence*, 66–71).

181. *Aesthetic Theory*, 185–86 (L)/127–28 (HK)/*Ästhetische Theorie*, 192–94.

182. "[T]he answer of the riddle is not the 'meaning' [Sinn] of the riddle in the sense that both could exist at the same time—that the answer is contained in the riddle, that the riddle formed merely its appearance and contained the answer within itself as intention" ("The Actuality of Philosophy" (1931), 129/"Die Aktualität der Philosophie," in *Gesammelte Schriften*, Vol. 1, *338*) .

183. Adorno, "The Essay as Form," in *Notes to Literature*, Vol. 1, 5/*Noten zur Litterature*, 11.

184. There are attempts to credit Adorno as well with some such proviso (see Burgard, especially 166–67).

185. Schings, 673–75. In an adaptation of Thomas Mann's characterization of Schopenhauer's work, Schings calls the *Trauerspiel* book a "novel of spirit [Geistesroman]" or an "idea-symphony" (673). Such remarks might not seem dismissive. They lead, however, to Schings's conclusion: "Benjamin to the Benjamin-researchers and the baroque mourning plays to the baroque researchers" (676). Against Schings, Steiner stresses Benjamin's emphasis on the anti-aestheticist force of criticism in artwork and in art analysis ("Allegorie und Allergie," 662–63).

An artistic quality of the criticism in the main text has led to the contention that the prologue is the utopian anticipation of divine truth, an anticipation that the main text—the *allegory* about baroque allegory—is unable to fulfill. A "metaphysical dualism" allegedly enters the work as the "opposition [Gegensatz]" of philosophical claim and critical analysis (Witte, *Walter Benjamin*, 61; *Walter Benjamin: Der Intellektuelle als Kritiker*, 107–36; "Allegorien des Schreibens," 132). (For further such discussion of Benjamin's "allegorical method," see Bürger, "Literary Criticism in Germany Today," 215.) Notwithstanding what might seem an "equivocal" or "independent" relation of the philosophically programmatic "Epistemo-Critical Prologue" with the main text (cf. Wolin, 80–81), however, the concept of philosophical criticism developed in the prologue has much explicit and implicit affirmation in the main text.

As elaborated above, this affirmation of the prologue by the main chapters is based significantly on philosophy being inextricable from Benjamin's critical unfolding of the mourning play; the art of the mourning play is inconceivable without the philo-

sophical impetus within the play. There is accordingly no compelling need to follow Menninghaus's suggestion of setting aside more narrowly philosophical passages of the prologue; the passages of the prologue discussing the "'idea' of the mourning play" do not concern the being of this idea from an historical, art-philosophical perspective exclusive of the "philosophical problem of truth" or the truth of this being (cf. Menninghaus, *Walter Benjamins Theorie der Sprachmagie*, 247–48 n. 5). Benjamin's designation of the role of philosophy in art has even led some to contend that this shows how Benjamin "misused" the "similarity of art and philosophy" (Schlaffer, 42). Precisely as philosophical performance, however, neither art nor criticism can entirely dispense with their respective masks (although these are indeterminate).

186. Lukács, *Soul and Form*, 1/"Über das Wesen und Form des Essays: Ein Brief an Leo Popper," in *Die Seele und die Formen*, 7–8; see also 17, 18/29, 31. Lukács's "On the Essence and Form of the Essay" originally appeared in *The Soul and the Forms* (Hungarian, 1910; expanded German edition, 1911).

187. The quotations are from Man, *Allegories of Reading*, 19.

188. On allegory as radically paradoxical "reimaging" of something as "becoming other," see Bahti, 264, 236–37. Benjamin's avoidance of the term "allegory" as a characterization of criticism is stressed by Menninghaus (*Theorie der Sprachmagie*, 249–50 n. 7); somewhat on this basis, a contrast of de Man and Benjamin on allegory is attempted by Kahl (especially 304–5, 312). If the term "allegory" is introduced as a characterization of criticism, such "privileging of allegory" can be perplexing, not least perhaps to those with a background in the formal study of philosophy (Derrida, *Memoires*, 77–79). The question of the convergences and divergences of de Man and Benjamin's conceptions of allegory is largely outside the scope of what could be done in the study at hand.

COMMUNITY OF THE DEAD

1. Hölderlin, "In lieblicher Bläue . . . ," in Hölderlin, *Sämtliche Werke und Briefe*, Vol. 1, 481. As is well known, the influence of Wilhelm Waiblinger on this text (first published in Waiblinger's novel *Phaeton* in 1823) is unclear.

2. This could be playing on the well-known headline concerning German soldiers dying in World War II at Stalingrad: "They died so that Germany may live" (Sie starben, damit Deutschland lebe). The latter was a headline in the *Völkischer Beobachter* (February 4, 1943). It is quoted in Kopelew, 10.

3. Kurt Tucholsky, *Gesammelte Werke*, Vol. II, 1009.

4. "Das häßliche deutsche Haupt," 22.

5. Adorno, *Minima Moralia*, 110/141.

6. *Three Steps on the Ladder of Writing*, 81.

7. Ash, especially 17–37. See also the article by Chow. For some critical remarks on Chow's analysis, see Geulen, "Toward a Genealogy of Gender," 177 n. 4.

8. *Die Billigesser*, especially 150.

9. Hölderlin, "Patmos" (last revision), in *Sämtliche Werke und Briefe*, Vol. 1, 1012.

10. Kluge and Müller, *Ich bin ein Landvermesser*, 83.

11. Celan, *Gesammelte Werke*, Vol. 1, 41–42; Vol. 3, 63–64.

12. Kluge and Müller, *Ich bin ein Landvermesser*, 95, 107, 145, 176. Benjamin's notion of "Erlebnis," which he develops more elaborately in later writings in terms of the contrast of "Erlebnis" and "Erfahrung," has led, and will lead, in the study at hand to considerable usage of the formulation "lived life" and to contrasts of this life with the "Life" that cannot be "lived." The latter contrast, which does not concern a dualism, of "life" and "Life" seems to underlie Derrida's remarks in a critical passage on Heidegger's "existential analysis of death": "*Dasein* does not die or does not properly die (*nicht eigentlich stirbt*) in the course of an experience, of a living, or of a lived experience as one sometimes says somewhat ridiculously in order to translate *Erleben, Erlebnis*. Dasein never has the *Erleben* of its own demise (*Ableben*), or of its own death (*Sterben*)" (Derrida, *Aporias*, 51).

13. If we keep the outlook free to behold the spirit anywhere (not turning ourselves into "the mere worker of a movement"), we will be those "who actualize spirit" (*C*, 55/*GB*, Vol. 1, *175*).

It should perhaps be reiterated that the letter paraphrased and quoted here and in the text says that there are many who want to have Wyneken as a movement; it does not say, as the available English translation suggests, that Wyneken is among those wanting a movement (54–55/175). Such a problem with Wyneken was expressed by Benjamin only somewhat later.

14. Laqueur, 53–55; Pross, 135. It is most sad that "we" "who wanted to be, with Nietzsche, aristocratic, different, true, beautiful" have "no order in truth," "no school of truth," no "place of beauty," but instead "the weary pomp" of the school ("Romantik," II:1, 45). This essay by "Ardor" appeared in *Der Anfang*, June 19, 1913. This newly founded *Der Anfang* was more directly under the mentorship of Wyneken than was a previous version.

15. Koselleck, 13, 19–20.

16. Kluge and Müller, *Ich bin ein Landvermesser*, 177–78.

17. In this respect, the writings by Benjamin of most concern in this study seem to distinguish the aesthetic and the cultic more strictly than does Koselleck, who refers to an aesthetic value enabling different epochs to use the same memorials for various distinct collective, political cults of dying (10–11, 13).This might not be an aesthetic value, especially if an aesthetic value may be distinguished from a cultic one.

18. Scholem tended to think in such terms concerning the relationship of the Jewish people with its religiosity. If the dynamic of religiosity was lost to so-called secularism (or indeed to the rites of orthodox traditionalism), the correlative repression of the uniquely open interpretative tenor of Judaism might not only risk abandonment of something distinctly Jewish but also lead to an eventually explosive return of the repressed religious power. For discussion of this concern of Scholem, see Mosès, "Langage et sécularisation," *L'Ange de l'histoire*, 239–59.

19. In addition to "Towards the Critique of Violence," "<Theologico-Political Fragment>," and various notes, Benjamin's political writing during this period included some material which has been lost. In a letter of April 17, 1920, to Scholem, he mentions a piece entitled "Life and Violence" (*C*, 162/*GB*, Vol. 2, 85); this essay

is also mentioned in some material that was written after April 1920 (*W* 1, 232–33/VI, 106). In a letter of around December 1, 1920, to Scholem, Benjamin mentions his essay on "politics": the first part would deal with Paul Scheerbart's utopian novel *Lesabéndio*; the second part—entitled "The True Politics"—would contain two chapters—"Dismantling of Violence" and "Teleology without Ultimate Purpose" (*C*, 169/*GB*, Vol. 2, *109*).

20. As suggested already ("Philosophical Community," n. 44), this proviso releases Benjamin considerably from Schmittian decisionism and its correlative antipluralistic tendencies. Such a distinction is lost in Heil's comparison of Schmitt and Benjamin (Heil, 155–56, 160–64, 189–90). Plurality is respected precisely by opposition to myth.

21. Kant, *Die Metaphysik der Sitten* (first published in 1797), Part 1, No. 24, 390. Lukács quotes the remark by Kant on marriage as a statement on the commodification of social relations (*History and Class Consciousness*, 100). Up to a point, Benjamin too seems to attribute a certain ironic critique to Kant's remarks, although he is critical of the lack of sustained critique by Kant along these lines.

22. Benjamin is actually commenting on behalf of Swiss poet Carl Spitteler's "Herakles' Erdenfahrt" (the fifth song of the fifth part ["Zeus"] of *Olympischer Frühling* [1910]).

23. This is overlooked in discussions (e.g., Weigel, "Eros," 313–14) that ascribe to the *Elective Affinities* essay a dualism of spirit and sexuality. The natural innocence of life has an antipodal relationship with sexuality only in the sense that phenomena defined by (either abstinent or active) sexuality—"all purely sexual phenomena"—belong to "the demonic [Dämonischen]," not by their sexuality but by defining themselves in terms of sexuality. They define themselves in terms of appearances of nature, not in terms of nature. Only thus is sexual life an expression of natural guilt, a guilt vis-à-vis nature (*W* 1, 335/I:1, 174). Insofar as sexuality isolates the "body" (Körper) from nature, it is the counterpart of "spirit" isolated from nature (395–96/VI, 81). Sexuality is irrelevant for the innocence—the guiltlessness—that is natural spirit, the spirit of nature (335/I:1, 174). On the temptation to exchange "life in its entirety for sex itself," see Foucault, *History of Sexuality*, 156.

24. Paraphrased in Vogl, "Einleitung," 14.

25. As should become clear below if it is not clear already, Benjamin's objection to Kant is not the moralistic one of Hegel. In *Philosophy of Right*, Hegel disputes Kant's view: "To subsume marriage under the concept of contract is . . . quite impossible"; this "subsumption" is "shameful" (Hegel, *Philosophy of Right*, 58). For remarks partly discussing Hegel's moralistic elevation of marriage, see Lacoue-Labarthe, *The Subject of Philosophy*, 130–37.

26. See, for example, "Tod" (VI, 71), a note from around 1920.

27. Quoting Gundolf, 566.

28. The meddlesome retired preacher, Mittler, suggests that whoever "attacks" marriage by word or deed "undermines" the basis of "all moral society," for "[m]arriage is the beginning and the pinnacle of all culture" (Goethe, *Elective Affinities*, 89–90/*Die Wahlverwandtschaften* 60–61). The tirade is quoted at its full and considerable length in *W* 1, 300–301/I:1, *129–30*.

29. The "object [Gegenstand]" of *Elective Affinities* is "not marriage" (*W* 1, 302/I:1, *131*) and "[m]arriage can in no sense be centre of the novel" (346/189), for the "ethical powers" of the novel are to be sought "nowhere in marriage" (302/*131*).

30. The "centre of Romanticism" is this "Messianism" that the constraints of conventional scholarship seemed to prohibit from being more than an indirect concern of the dissertation *The Concept of Art Criticism in German Romanticism* (*C*, 139–40/*GB*, Vol. 2, *23*). Even if this concern remains more implicit than explicit in the actual manuscript, preparation of the dissertation was considered by Benjamin to have provided insight into the relationship of truth with history (*C*, 136/*GB*, Vol. 1, 486).

31. *The Brothers Karamazov*, 298–313.

32. Schmitt, *Römischer Katholizismus und politische Form* (first published in 1923), 54.

33. An earlier version of part of the epistemo-critical prologue objects to Konrad Burdach's "shyness" in relation to "constitutive ideas" as "die Universalia ante rem" or "in re" (I:3, 941), but settles on a view of "res in Universale, nicht Universale in re" (946). The finally published version of the prologue refers and objects, however, to Burdach's "shyness" in relation to "constitutive ideas—the universalia in re" (*O*, 40/I:1, *220*). These discussions are concerned primarily with Burdach's *Reformation, Renaissance, Humanismus* (1918).

34. Blanchot, *The Unavowable Community*, 43.

35. Rosenzweig also refers to such "Mothers"; in this soundless realm, "inaudible elemental words" stand "side by side" without relation and are the "language" of the protocosmos (*Star of Redemption*, 109/*Stern der Erlösung*, 121).

On Faustian "mothers," see especially Goethe, *Faust*, 500–501. Benjamin seems aware of ways in which such mother imagery can become pathetic. A very early story by him concludes its spoof (on the respect of the German educated person for the German classics) with Mephisto seeming to taunt: "To the mothers?" ("Schiller and Goethe: Eine *Laienvision*," VII:2, 639).

For a psychoanalytically oriented consideration of Benjamin's usage of mother imagery, see Geyer-Ryan, "Effects of Abjection."

36. Benjamin quotes Hamann's letter to Jacobi from October 22–30 (the entry for October 28), 1885 (see Hamann, *Briefwechsel*, Vol. 6, 108).

37. This emphasis seems lost or neglected in references to "elements [that] serve to mark out the extremeties of the idea in question—that is, its boundaries," and in contentions that "[i]n fact, proliferation of perspectives is dangerous for Benjamin, it carries us away from the essential hermeneutic task and increases profanity" (Rush, 135, 136).

38. The latter exploitation of the new and the newest can be left to newspapers (and today, we may say, to most other conveyances of news) (*W* 1, 293/II:1, 242). ("'It pulls you down,' he said. 'Press life. Always hurry and scurry, looking for copy and sometimes not finding it: and then, always to have something new in your stuff.'" *D*, 72)

Whether celebratory or antagonistic, there seems (or seemed) to be a related fanaticism about newness among at least some of those discussing "post-" this and that when referring to alleged cultural or intellectual trends. Without suggesting some kind

of prohibition on the prefix "post-," one could well question much usage of "post-" in recent decades. Especially in English-language places, it seems, this usage of "post-" sometimes converged with a kind of *Reader's Digest* approach to intellectual history; in Germanic places, it seems to have functioned—to a significant extent—as a comparably ignorant "Feindbild." For remarks on such tendencies, see Gasché, *Inventions of Difference*, 111, 257 n. 5, 278 n. 14, and Nägele, *Theater, Theory, Speculation*, xii, 55.

39. For remarks on capitalism and the United States as complementary meshings of ostensible pluralism with fundamentalistic and often highly collectivizing intolerance concerning what does not effectively sell itself, see Müller, *Zur Lage der Nation*, 56–57, and *Jenseits der Nation*, 58–60. For reflections on Benjamin's writings in the context of the death penalty, see McCall, "Momentary Violence."

40. The complementary—indeed, necessary—relationship of mourning and the justice of Messianism figures, as has been suggested throughout much of this study, in a lot of Benjamin's work. There is an opposing interpretation: "[T]he very nature of mourning denies any relation to justice. This may come as a shock, and it by no means makes mourning any less imperative, but if Benjamin's analysis [of mourning play] is to be trusted, there is no equivocation on this point: mourning has no relation to the messianic. Mourning and the messianic are mutually exclusive" (Fenves, "Marx, Mourning, Messianicity," 260). Yet even Fenves qualifies this, wondering if there is a "moment" when "mourning and messianicity meet" (267). On the other hand, in more-recent work he reiterates: "Mourning and messianism have absolutely nothing to do with each other; absolutely nothing, because messianism—or to us a more precise term, messianicity . . . —absolves itself of everything mournful. . . ." (*Arresting Language*, 234).

41. Schmitt, *Political Theology* 14/*Politische Theologie*, 20. Schmitt's analysis expressly follows his own *Die Diktatur: Von den Anfängen des modernen Souveränitätsgedankens bis zum proletarischen Klassenkampf* (1921), which Benjamin later says to Schmitt was among works by Schmitt comprising "a corroboration of my ways of philosophically researching art" by Schmitt's "ways of philosophically researching the state" (I:3, 887; *GB*, Vol. 3, 558). Schmitt and Gottfried Salomon had collegial correspondence and contact from early 1924 to April 1931; through the mediation of Albert Salomon, a professor of political sociology in Berlin and a correspondent with (as well as namesake of) Gottfried Salomon, Benjamin sent this letter of December 9, 1930, informing Schmitt of a soon-to-arrive complimentary copy of the *Trauerspiel* book (Kambas, "Walter Benjamin an Gottfried Salomon," 609). Schmitt mentions Benjamin's letter of gratitude in his 1956 study *Hamlet oder Hekuba* (64), where his critical comments on the *Trauerspiel* book are accompanied by citation of it as one of a few major influences on his own study (7).

42. In these pages, Benjamin borrows from Schmitt's portrayal of the seventeenth-century outlook. He also indicates interest in Schmitt's accompanying critique of Kantian "rationalism" in the latter's disregard for exception. For the relevant remarks in Schmitt's portrayal, see Schmitt, *Political Theology*, 9–15/*Politische Theologie*, 15–22.

In the collection of Benjamin's writings published in 1955 as *Schriften* (under the editorship of Theodor and Gretel Adorno), the passages quoting and paraphrasing

Schmitt appear without the endnotes indicating their source as Schmitt's *Political Theology*; see Benjamin, *Schriften*, 183–84.

43. Although not quite in such terms, a contrast somewhat of this sort between Schmitt and Benjamin is undertaken by Makropoulos (especially 37–38, 45). Such a contrast is somehow lost in attempts to read Benjamin as ultimately following a conservative desire for substantive authority (e.g., Bredekamp 260–61, 264–65).

44. The very distinct receptions of Georges Sorel's discussion of anarcho-syndicalism, which Benjamin regards as a rare possibility for divine violence, attests to the basic divergence of Schmitt and Benjamin. For critical remarks by Schmitt on Sorel, see Schmitt, *Political Theology*, 43/56–57. Cf. Benjamin, *W* 1, 245–46/II:1, 193–94.

45. Turk, 331–34, especially 333. See also Samuel Weber, "Taking Exception to Decision," especially 12, 15, 18. A general analysis by Figal ("Vom Sinn der Geschichte") contrasting Benjamin's theological anarchism with Schmitt's "theologischem Etatismus" is noteworthy both for the care taken in it and for the tendency of it to be somewhat overlooked.

46. Schmitt, *Römischer Katholizismus und politische Form*, 54; see also 53–61, 19–32, 36.

47. Benjamin's references to anarcho-Catholicism are noteworthy, given a common tendency to formulate the contrast of Schmitt and Benjamin a bit too strictly as one of the former's Catholicism and the latter's Judaism (see, for example, Heil, 140–41, 206). Scholem is not quite correct in saying Christian ideas had no attraction for Benjamin, although he is correct in saying Benjamin did not share the neo-Catholic enthusiasm of many of his Jewish intellectual contemporaries in Germanic Europe and France (Scholem, "Walter Benjamin," 193/*Walter Benjamin und sein Engel*, 29). In the latter regard, note Benjamin's dismissal of "Catholic expressionism" (*W* 1, 295/II:1, 243). Franz Werfel would presumably be among the Catholic expressionists. Along with Werfel, a variety of European Jewish writers and essayists converted to, or entertained a serious interest in, Roman Catholicism—though sometimes only temporarily, as in the case of Karl Kraus.

48. Notwithstanding all their obvious differences, Benjamin and Sartre share what might be considered a quasi-Kierkegaardian notion of philosophical loyalty. Particularly noteworthy in this regard are Sartre's comments on behalf of the ignorance, irresponsibility, and innocence—exemplified by Dostoevsky's "Idiot"—that facilitate a kind of "*true knowledge*" based on dissociation from the "[p]ractical activity, struggles, fears, interests" preventing us from "seeing the world as it is," preventing us from attaining the "pure wisdom" that recognizes "Evil" as "only an appearance." Within and yet masked by each of us, there is the potential to open to the "Good," the "secret harmony," no longer bound by those standards of good and evil that cannot recognize the potential of "goodness" in "the worst criminal" (Sartre, 54–55).

49. According to Müller, too, thinking and art are "fundamentally" associated with "guilt," for they would not function if they did not get involved with the "trend"—the "reality"—of an epoch (Müller, *Jenseits der Nation*, 57).

50. Hollier, xii.

51. Hölderlin's "Blödigkeit" begins: "Are you not then acquainted with many living?" (Sind denn dir nicht bekannt viele Lebendigen?) Following the practice of editions of his time (including Hellingrath's), Benjamin quotes this first line of "Blödigkeit" as follows: "Sind denn nicht dir bekannt viele Lebendigen?" (II:1, 113)

52. Benjamin quotes Gundolf, 563, 571. Benjamin's *Elective Affinities* essay is dedicated (*W* 1, 297/I:1, 123) to Jula Cohn, who belonged to the wider circle of Stefan George's followers and was friendly with Gundolf. (The dedication did not appear with the publication of the essay in *Neue Deutsche Beiträge*.) Benjamin visited Cohn in July 1921, while she was studying in Heidelberg with Gundolf. See letters to Scholem, *C*, 181, 182/*GB*, Vol. 2, 167, 170, and *GB*, Vol. 2, 156, 164. In 1921–1922, Benjamin developed an overwhelming romantic attachment to this young sculptor and sister of his former schoolmate, Alfred Cohn. In "A Berlin Chronicle," Benjamin says Jula Cohn "never really was the centre [Mittelpunkt] of people but, in the strictest sense, really that of the fates." It was "as if her plant-like passivity and inertia had assigned her to these fates—which indeed, of all human things, seem the most subject to vegetative laws" (*W* 2, 616/VI, *493*). For sonnets written with regard to Jula Cohn, see VII:1, 64–67. Benjamin's own situation had an uncanny parallel to that in *Elective Affinities*. It is not just that Jula Cohn may be compared with Ottilie. Dora Kellner, Benjamin's wife, was in love with Benjamin's friend Ernst Schoen; that situation could be compared with the relationship developing between Charlotte and the Captain. Cohn and Schoen had returned to Berlin at this time, creating an arrival scene not unlike that of Ottilie and the Captain (Fuld, *Walter Benjamin*, 118). As the *Elective Affinities* essay was being written, Charlotte Wolff (then a medical student and later a well-known psychologist) was friendly with Benjamin's wife and with Benjamin himself; she reports that she and Benjamin often discussed the similarity of his situation with the dilemmas portrayed in *Elective Affinities* (Wolff, 209).

53. This is, of course, a reformulation of "On Language as Such," *W* 1, 72–73/II:1, 155. See page 23.

54. In this regard, it may be overstated to say that remarks in the *Elective Affinities* essay preclude "all attempts at a theological foundation of art" (Nägele, *Theater, Theory, Speculation*, 112), although the essay does (as noted on page 226) stress that art does not descend directly from God. As Nägele says with regard to the *Trauerspiel* book, theology is not a signified force but one that is performed (206).

55. Speth nonetheless criticizes Benjamin on the basis of this alleged contradiction (101; see also 96, 99).

56. The remark on the mythic being nowhere the highest material content is incompatible with the assessment that Benjamin's "interpretation of the material content of the novel as essentially mythic" is indicative of a philosophy of history based on "the rigid separation between the historical and the messianic ages" (Wolin, 57). The contact of material content and the Messianic—the historical and transience—facilitates the critical presentation of their disjoining.

This critical tension of material content and truth content does not require what Corngold calls the "unwonted conclusion" that the truth vanishes once the material contents, with which the truth is united, pass away. The passing away of material contents is their becoming archaic, but the aforementioned highest material content is

content in which such passing away is already under way, already performed. Cf. Corngold, "Genuine Obscurity", 162–64. In a somewhat different context, Jacobson as well misleadingly ascribes to Benjamin a view that the "individual's divine potential is the ability to overcome death in choosing fate" (219); he associates Benjamin with the view that righteousness delivers from death (226).

57. Hamacher may not be quite right to formulate Benjamin's as "a theory of the *abstention* from action," but the theory may indeed be construed as a political theory of uncertainty if this refers to a theory for which pure violence "'shows' itself precisely in the fact that it never appears *as such*" ("Afformative, Strike," 126).

58. The usage of the term "hypostasis" here or elsewhere in this study is obviously not quite following the notion of "hypostasis" used sometimes by Lévinas with regard to a positing in which being is "saved" by the "passage going from *being* to a *something*, from the state of the verb to the state of the thing" (*Ethics and Infinity*, 51). By attribution, something is released from anonymous being, as is the subject that may now regard being in terms of attribution (*Time and the Other*, 52). Benjamin might seem, in contrast, to be fostering presentation as release into, or of, anonymous nature.

59. Not long after the Captain's arrival, there is discussion of the concept of "elective affinities." The Captain and Eduard explain it to Charlotte as a concept with fairly recent currency among those interested in relations between chemical substances (*Elective Affinities*, 50–57/*Die Wahlverwandtschaften*, 29–35).

60. Bataille, *Literature and Evil*, 166–67.

61. Although not so much with regard to Benjamin, distinctions of "animal" and human, or various distinctions of stone, animal, and human—perhaps even in the highly qualified way that someone such as Benjamin might make them—have been subject to much scrutiny and criticism in recent years. For some of Derrida's reservations on Heidegger in this regard, see *Of Spirit*, 47–57, and *Aporias*, 35, 39–42, 73–75.

62. Bataille, *Literature and Evil*, ix–x.

63. This indifference to moral topoi is not incompatible with Benjamin's praise, in 1928, of Gide as a challenge to "moral indifference and lax complacency" (*W* 2, 96/IV:2, 509).

64. In addition to this adaptation of Nietzsche's *Beyond Good and Evil* (80) and Hölderlin's "Hyperion's Song of Destiny" ("Hyperions Schicksalslied," in *Sämtliche Werke und Briefe*, Vol. 1, 207), Benjamin says in the *Elective Affinities* essay that the two free figures at the end of the novella (in *Elective Affinities*) seem no longer to have a "Schicksal" (*W* 1, 332/I:1, 171). Benjamin later seems to realize that some of his early notions of eternal return are quite distinct from at least many aspects of Nietzsche's statements concerning "ewige Wiederkehr." Cf. *AP*, 101–19/*Das Passagen-Werk*, *GS*, V:1, 156–78. Concerning Nietzsche's notion of eternal return and Benjamin's usage of it in the *Passagen-Werk*, see Mosès, "Benjamin, Nietzsche," especially 151–58. Even in *Goethes Wahlverwandtschaften*, Benjamin uses the expression "eternal return of everything same" (ewige Wiederkunft alles Gleichen), without indicating any source, but with reference to the "fate" (Schicksal), the guilt-context, to which characters in Goethe's novel unnecessarily sacrifice themselves (*W* 1, 307/I:1, *137*).

65. The latter presumptions are described by Benjamin as the "subterfuge" or "evasion" (Ausflucht) of a "woman (Weibes)" (*W* 1, 340/I:1, *181*)—a characterization of woman that may itself be considered an instance of the very denial (of secret) otherwise criticized by Benjamin. Benjamin elsewhere suggests that such characterization is less a characterization of women per se and more a characterization of the defenseless situation in which women (and children) often find themselves. Elsewhere he refers to "untruths" that are "naked weapons" and seems to regard women and children as prevalent users of such untruths (VI, 60).

66. Wolf, *Kein Ort*, 137.

67. Lévinas, *Totality and Infinity*, 33–34.

68. Benjamin later comes to think that his early "philosophy of language" has a connection with the approach of "dialectical materialism." He also says that the *Trauerspiel* book was "certainly not materialist" but might have already been "dialectical" (letter of March 7, 1931, to Max Rychner, *C*, 372/*GB*, Vol. 4, 18; a copy of this letter was sent to Scholem). The discussion entitled "Natural Ethics: Loyalty to Things" above has, nonetheless, suggested a way in which this book as well as other writings could be read in terms of a priority of action or practice. Such dialectics of matter might be implied by Benjamin's suggestions that his "Passagenarbeit" has a compositional prototype in the *Elective Affinities* work (letter of July 8, 1938, to Scholem, *C*, 567/*GB*, Vol. 6, 131) and an inner construction analogous to the baroque book, "from which it will externally differ very greatly" (letter of May 20, 1935, to Scholem, *C*, 482/*GB*, Vol. 5, 83).

69. This reading is obviously contrary to that suggesting Benjamin equates evil and philosophical constellation (e.g., Samuel Weber, "Genealogy of Modernity," 497–98).

70. It is not quite right to say, as does Hans Mayer, that Benjamin "recognizes . . . only the reality of an evil" (Mayer, 35).

71. There seems a possibility here of comparing this sense of "economy of the whole" with the notion of "general economy" developed by Bataille and Derrida (see the latter's *Writing and Difference*, 251–77).

72. As indicated already, it seems clear that many aspects of Benjamin's analysis of *Elective Affinities* (as well as of a great deal else) pertain to what he elsewhere calls allegory. Yet the *Elective Affinities* study does not invoke terms such as "allegory" or "allegorical" (Lindner, "Allegorie," 69) and, as noted above, Benjamin occasionally makes comments suggesting a specificity in his usages of the term "allegory" that seem belied by his other comments suggesting a universal relevance (albeit a scarcely recognized univeral relevance) of "allegory." Notwithstanding such relevance, it may be that Benjamin was wary of encouraging dogmatic usage of the term. Given the current propensity of academia for fairly aggressive usage of "buzzwords," this possible wariness seems noteworthy.

73. Benjamin quotes from Nietzsche, *The Birth of Tragedy*, 89: Nietzsche regrets that the "dying Socrates" becomes "the new ideal" of "noble Greek youths."

74. "The Metaphysics of Tragedy," *Soul and Form*, 159, 161/*Die Seele und die Formen*, 228, 231. Benjamin quotes a little from this discussion (*O*, 136/314).

75. Emphasis on the soul as continuous potential for productive destruction distinguishes Benjamin's "soul" at least somewhat from the soul lamented—as lost or about

to be lost—by prophets of cultural decline such as Ludwig Klages (1872–1956). Cf. Klages, *Der Geist als Widersacher der Seele*. For respectful comments on Klages, see "Review of Bernoulli's *Bachofen*" (*W* 1, 426–27/III, 44) and *GB*, Vol. 2, 319. See also *W* 1, 397–98/VI, 83–84. For differentiating remarks on Klages and Benjamin, see Wolin, xxx–xxxiv, xxxvii–ix, and McCole, 236–40. In the context of the discussion of nature, it is perhaps also noteworthy that a passage in the *Trauerspiel* book stresses the baroque opposition to an antithesis of nature and history; Benjamin distinguishes this outlook from Rousseau's. Nature is not Rousseau's lost natural life. It is rather a destructive force always already overwhelming historical life (*O*, 91–92/I:1, 270–71).

76. Cf. Witte, *Walter Benjamin: Der Intellektuelle als Kritiker*, 130. According to Witte, the "ponderación misteriosa" is just so much theological garb for Benjamin's "subjectivism." With the statement about German *Trauerspiel* entailing subjectivity crashing down like an angel into the depths, being overtaken by allegories, and held fast in God, the "dubiousness" of the "literary-critical claim" is a correlate of the thickening of "the theological content." The "theological content" shows that Benjamin's "allegorical" interpretation rests on "personal dogmas" and is "therefore closed to rational discussion." This "theological content" entails criticism transcending to "mystical poetry" basically only concerning "its author" (132). The main text of the *Trauerspiel* book ultimately involves the paradox of a subjectivist anthropology—an ostensibly metaphysical statement of the human condition as one in which there can be nothing other than the projection of subjective experiences (134–35). This reading of Benjamin's *Trauerspiel* book and of much of Benjamin's work echoes in various secondary sources (e.g., Pensky, 60–64, 73).

77. This kind of contrast by Benjamin of the two poems—"Dichtermut" and "Blödigkeit"—by Hölderlin is somewhat lost as Corngold accuses Benjamin's Hölderlin essay of presenting and fostering "the myth of a beneficent death" whereby the "myth" signals "an ideological investment in a constructed *belief*" contrived to fend off "the horrible truth" and facilitates "an only mythical leap out of danger" (*Complex Pleasure*, 166–67).

78. Goethe, *Elective Affinities*, 300/*Die Wahlverwandtschaften*, 243.

79. Concerning "Scheinlosigkeit des nackten Körpers," see Menninghaus, "Das Ausdruckslose," 179–80 (or the very slightly altered English version: "Walter Benjamin's Variations of Imagelessness," 169).

80. A comparable notion of love seems to arise in parts of Blanchot's *The Unavowable Community*, where Blanchot surmises, for instance, that the "community of lovers—no matter if the lovers want it or not, enjoy it or not, be they linked by chance, by 'l'amour fou,' by the passion of death (Kleist)—has as its ultimate goal the destruction of society" (48). For elaboration, see especially 48–50.

81. The early note on marriage (written sometime between early summer 1918 and about 1920) discusses passivity that has life as only "a non-death [ein Nicht-Tod]" and death as only "a non-life [ein Nicht-Leben]." A marriage founded on the responsibility of love is a sacrament in which God immunizes love against the danger of sexuality (as a force passively followed) and against the danger of death (as simply nonlife) (VI, 68–69). Those with death in life and life in death are immune to death as something that is simply the opposite of life. Ottilie's passivity is connoted as she

dons the clothes called bridal finery (by Ottilie's attendant) that are actually her death shroud; Benjamin thinks the opposite could be read into the novella: the wedding garments borrowed from an already married couple by the two main figures (to protect themselves from a chill—following their dangerous leaps in the river) could be read as death garments transformed into clothing "immune to death" (*W* 1, 332/I:1, 171).

82. Cf. Heidegger, *Being and Time*, especially 225–35, 304–48. *Being and Time* appeared in 1927, five years after Benjamin wrote the Goethe study. In a 1938 issue of the Moscow German-language journal *International Literatur* (1930–1945), which was under the editorship of Johannes Becher, Alfred Kurella characterizes a part of Benjamin's "Goethes Wahlverwandtschaften" (a part that had appeared in French as "L'angoisse mythique chez Goethe") as worthy of Heidegger. This characterization irritated Benjamin (letter of July 20, 1938, *GB*, Vol. 6, 138).

The relationship of Heidegger with theology, and the extent to which that relationship may be more important than was often suggested by him, have been discussed a great deal of late, particularly following the publication in 1995 of some relevant texts (e.g., *Phänomenologie des religiösen Lebens* [Frankfurt/Main: Klostermann]). See especially Vries, *Philosophy and the Turn to Religion*, 1–304. It seems, however, that the distinctness of Benjamin's usage of the theological would remain relevant for any comparison of the two outlooks.

83. E.g., Witte, *Walter Benjamin: Der Intellektuelle als Kritiker*, 83–84 (and 58–64). A great deal has been made not only of the possibility that Benjamin (while writing the *Elective Affinities* essay) discussed privately "how great works of literature unfold through personal problems" (Wolff, *Innenwelt und Aussenwelt*, 206, quoted in Witte, 62) but also of the contention that Benjamin "wanted and needed" Cohn's "unattainability" (Wolff, 208, quoted by Witte, 201 n. 162). Supplementing contentions concerning "narcissism" and critical subjectivism in Benjamin's *Elective Affinities* essay (64, 87, 96–98), Witte comments that Benjamin turns the beloved nearest to him into the furthest from him, stylizing her to Ottilie—to a loved one fleeing into the furthest distance, "death" (*Walter Benjamin*, 44). Benjamin's essay also concerns death, however, as a destructive power unnecessarily and mythically ignored while Ottilie (along with others) submits to a semblance of life. Although Scholem too suggests the insights of the essay were only possible on the basis of Benjamin's human situation corresponding to that of the novel, he stresses that "the 'plantlike muteness' and beauty of that 'Ottilie' [Jula Cohn]," who so consequentially entered Benjamin's life at the time, inspired Benjamin's views on the beautiful and on "the Luciferian depth" of beautiful semblance (Scholem, "Walter Benjamin and His Angel," 202/*Walter Benjamin und sein Engel*, 38).

As Brodersen notes (140–41), moreover, detection of a mutual relevance of literature and personal life need not amount to a subordination of a literary work to its pertinence for one's specific experiences.

84. This emphasis is overlooked in discussions of Benjamin's alleged early resignation or Stoic submission (e.g., Rumpf, *Aporien und Apologie*, 43, 39, and Roberts, 110).

85. Wolin, 57.

86. If the critique of Goethe's Ottilie portrayal in any way draws on Gnostic inwardness or a Kierkegaardian critique of angst, the redemption is not escapist

(contrary to contentions in Speth, 111, 113–14, 124–25, 138–44, 147, 164–72, 185–86, 199).

87. With regard to Benjamin's Hölderlin essay, parallels might be detected in remarks by Blanchot. For instance: "Where" the writer is, there is dedication "to the pure passivity of being" ("The Essential Solitude," in *The Gaze of Orpheus*, 69). The difficulty had by many with Benjamin's association of courage with such passivity is indicated by efforts to dissociate the courage and the passivity (e.g., Jacobson, 41–42).

88. Eh ihr zum kampf erstarkt auf eurem sterne
Sing ich euch streit und sieg von oberen sternen.
Eh ihr den leib ergreift auf diesem sterne
Erfind ich euch den traum bei ewigen sternen.

This poem, titled "Haus in Bonn," was written by Stefan George for a plaque on the house of Beethoven's birth. In addition to the discussion of the poem at the close of Benjamin's *Elective Affinities* essay, the last two lines of the poem serve as the epigraph for the third and final part of Benjamin's *Elective Affinities* essay (W 1, 333/I:1, 172). A translation of George's poem is available in George, 305.

89. Impending death includes:
- the need to emit sexual juices ("Mr Bloom with careful hand recomposed his wet shirt. O Lord, that little limping devil. Begins to feel cold and clammy. Aftereffect not pleasant. Still you have to get rid of it someway." *U*, 367), a need that also takes a body outside of itself to be together with one or more bodies for varying durations and varying frequencies of recurrence ("I can feel his mouth O Lord I must stretch myself I wished he was here or somebody to let myself go with and come again like that I feel all fire inside me or if I could dream it when he made me spend the 2nd time tickling my behind with his finger I was coming for about 5 minutes" *U*, 675).
- skin drying, flaking, and wrinkling ("there was the face lotion I finished the last of yesterday that made my skin like new I told him over and over again get that made up in the same place and don't forget it God knows whether he did after all I said to him Ill know by the bottle anyway if not I suppose Ill only have to wash in my piss like beeftea or chickensoup with some of that opoponax and violet I thought it was beginning to look course or old a bit the skin underneath is much finer where it peeled off there on my finger after the burn it's a pity it isnt all like that" *U*, 672).
- head-hair changing ("O well look at that Mrs Galbraith shes much older than me . . . her beautys on the wane she was a lovely woman magnificent head of hair on her" *U*, 672).
- the stinking decay of armpits, feet ("he . . . took off each of his two boots . . . detached the partially moistened right sock" *U*, 633), and groin occasioning regular cleansing as a battle with death ("I wanted to kiss him all over also his lovely young cock there so simply I wouldnt mind taking him in my mouth . . . as if it was asking you to suck it so clean . . . he looked . . . I would too in 2 a minute . . . hed be so clean compared with those pigs of men I suppose never dream of washing it from 1 years end to the other the most of them" *U*, 697).

90. Kristeva, *Powers of Horror*, 71.

91. The dedication in Lohenstein, 12–13, is cited at greater length by Benjamin in *O*, 82–83/I:1, 262.

92. "[U]ns die Entschalfenden" (in Hölderlin's "Blödigkeit") refers to "us, who pass away in sleep" (*W* 1, 31/II:1, 120). The emphasis of the word "Entschlafenden" on sleep is so strong that it could even simply refer to "the sleeping ones." The emphasis on sleep is important for Benjamin and presumably for Hölderlin, who uses this word to replace "the transient" (die Vergänglichen), which was used in the second version of "Dichtermut." Benjamin cites Heraclitus's observation that waking is a state of seeing death, but sleep is a state of seeing sleep: to awaken and simply see death is to see isolated transient shape, whereas sleep does not shy from the engagement of shape with shapelessness. Noteworthy in this regard is Hölderlin's "Die Entschlafenen" (in *Sämtliche Werke und Briefe*, Vol. 1, 279).

93. The common expression "ich bin dir verbunden" may be translated as "I am obliged to you" or "I am obligated to you."

94. For this translation of "Verbundenheit," see McCall, "Plastic Time and Poetic Middles," 491–92. Cf. the emphasis on "Verbundenheit" as "communicatively mediated" "solidarity [Solidarität]" in Jäger, "Kosmos und sozialer Raum," 222, 224.

95. With the word "Einkehr," Benjamin quotes Hölderlin's "Blödigkeit."

96. Quoting the criticism by Nägele in *Reading after Freud*, 68.

97. Gasché, "Answering for Reason," in *Inventions of Difference*, 107–28, especially 108.

98. For a critical discussion of this, see Düttmann, *Das Gedächtnis des Denkens*, 302–6.

99. Such formulations are, nonetheless, made (as though Benjamin would make them) in Honneth, 92, 94. Düttmann provides a more credible adaptation of Benjamin: "The historian . . . does not speak in the name of the dead" (*The Gift of Language*, 84).

100. Honneth: It is "still unclear to what extent it would be meaningful to speak of a communicative relationship to people or even groups of people who belong to the realm of the dead" (94).

101. The association of historical life with "Leib" is in accordance with an etymological connection of "Leib" with "Leben" (life). Concerning this connection, see Kluge, *Etymologisches Wörterbuch der deutschen Sprache*, 431. Usage of the distinction between "Körper" and "Leib" is not always maintained by Benjamin. This is evident from some quotations, given above, of Benjamin's texts. It has also been indicated above, however, that the distinction seems relevant to various important texts, most notably the *Elective Affinities* essay. In those texts (including the "Schemata zum psychophysischen Problem" of 1922–1923), moreover, the distinction is not advanced in a dualistic or binary way; Benjamin tries not only to avoid but also to oppose such opposition.

102. Adorno, *Aesthetic Theory*, 194 (L)/133 (HK)/*Ästhetische Theorie, 201*.

103. Lunn, 196–97.

104. Cixous, *La ville parjure*, 136 (the chorus).

105. See the translation of this passage: *AP*, 471. Benjamin partially quotes Horkheimer's letter of March 16, 1937. This letter is available in Horkheimer,

Gesammelte Schriften, Vol. 16, 81–91; for the passage quoted by Benjamin, see 82–83. Horkheimer's letter was one item in the large body of writing material held by the Benjamin archive in East Germany. Thanks to those responsible at the Akademie der Künste in Berlin for their courtesy and assistance during a period of several weeks that was obviously one of considerable transition for them.

106. Cixous, *La ville parjour,* 16 (the mother).

107. Müller, *Jenseits der Nation*, 31. See also Müller, *Zur Lage der Nation*, 87.

108. Dostoevsky, *The Brothers Karamazov*, 277.

109. Müller, "Nämlich die Gespenster schlafen nicht," in the "Programmheft" for *Germania 3*, 24–25.

110. Cf. the dismissal of Benjamin made by Rochlitz (257–58).

111. In this context, the formulation "inability of mourn" is obviously an allusion to the title of the famous study by Alexander and Margarete Mitscherlich and originally published in 1967. It is not possible here, however, to contrast Benjamin's view of mourning with this "pyschohistory" (Mitscherlich and Mitscherlich, 7) of the denial or repression by Germans (after World World II) of the activities of the Third Reich.

112. Müller, *Zur Lage der Nation*, 50, 52, 56, 74.

113. Weber, *From Max Weber*, especially 131–32, 134.

114. Quoting *Hamlet*.

115. Klaus Mann, *Mephisto*, 255, 249.

116. For an attempt at such a reading, see Steiner, "Traurige Spiele," 48–54.

117. Concerning variants of such Protestant spirit, of course, the standard work is Max Weber's *The Protestant Ethic and the Spirit of Capitalism*. On the relationship of this spirit with empirical scholarship, see 249 n. 145. Weber is obviously not as openly critical as Benjamin of this spirit.

118. Scholem, *WB*, 32/45. See the entry for August 24, 1916, in Scholem's *Tagebücher*, 391.

119. In an outlook at least somewhat distinct from Benjamin's, Lévinas suggests the "meaning of Judaism" is "perhaps" that "tolerance can be inherent in religion without religion losing its exclusivity." An "undeclinable responsibility" of Judaism and "its love of God" is the "welcome to the Stranger which the Bible tirelessly asks of us." The "Stranger is one towards whom one is obligated." Concerning the "idea of Israel as a chosen people," Lévinas advances the notion that this "expresses less the pride of someone who has been called than the humility of someone who serves." Such is the inwardly burning, "infinite demand" that is an "infinite responsibility." This is the "message" of tolerance that Judaism continues to bring to the modern world (*Difficult Freedom*, 172–74).

Benjamin seems restless before the constraints of concrete or specific religiosity, as has been elaborated in some detail above, and this restlessness has apparently contributed to the reaction alleging that he unduly disparages anthropomorphic and conceptual idolatry (Vries, *Philosophy and the Turn to Religion*, 26). As indicated above and to be further indicated below, and as one could well note of his "Judaism," openness to the stranger—or at least to the inherent strangeness of the stranger—is indicative of the revelatory dimension in Benjamin's work. One might wonder,

nonetheless, how removed Benjamin would be from the association by Deleuze and Guattari of atheism and philosophy. Although Benjamin's philosophy is obviously not atheistic and he does not wish to extricate philosophy from considering the "death of God" to be some kind of drama, there seems something not entirely removed from Benjaminian sobriety as Deleuze and Guattari refer to atheism as "the philosopher's serenity and philosophy's achievement." Although willing to concede that one "can speak" of developments such as "Chinese, Hindu, Jewish, or Islamic 'philosophy,'" Deleuze and Guattari insist that the "plane of immanence" in such tendencies is "prephilosophical" and that philosophy cannot be identified with such a plane (*What Is Philosophy?*, 92–93). Their concern is that philosophy (or indeed art and science) not follow religions in turning a tentative or provisional "umbrella" against "chaos" into a "firmament," an "*Urdoxa* from which opinions stem" (202), and thereby abandon "struggle" with chaos (201–8). Notwithstanding the importance for Benjamin of revelation as a transcendental impulse of immanence within philosophy, an importance Deleuze and Guattari do not recognize, much said in the study at hand would suggest that Benjamin would share some of their worry about lack of the aforementioned struggle in specific religions. This seems to have led some who are very interested in the relationship of philosophy and religion to find Benjamin to adopt an unduly "*heterological* . . . discourse" (Vries, *Philosophy and the Turn to Religion*, 26) vis-á-vis specific religions. Benjamin may not seem so concerned with what has been expressed as the philosophical and political responsibility of "striking the right balance between historical revelation and a quasi-transcendental revealability" (336). Yet philosophy (or politics insofar as it can be philosophical), for Benjamin, almost automatically calls for avoidance of appropriative pretensions that might be associated with either of these options. Benjamin does not adopt, moreover, the diplomatic religious "syncretism" interested in amalgamating or fusing religions on the basis of certain alleged minimally shared principles. He does not adopt the spirit of reduction and discursive synthesis before which Lévinas expresses "horror" (*Difficult Freedom*, 176) and Bataille (in language occasionally characteristic of him) fears "emasculation" of "the virility" that is "necessary for joining *violence and consciousness*" in the wrenchingly impossible—that is necessary for the sovereign "movement of free and internally wrenching violence" animating "the whole" of human experience (*Theory of Religion*, 109–11). The "narrowness of tradition" is, nonetheless, not considered by Benjamin as integral to maintaining such a wrenching "religious sensibility in time" as it is for Bataille (110). Nor does he share Lévinas's placement of value in the possibility for humans finding "consolations" in the "concrete forms, become religions" (*Ethics and Infinity*, 117, 114). For further remarks on Benjamin that are relevant to much said in this note, see especially the sections above titled "History and the Drama of Philosophy," "Doctrinal Form and Its Esoteric Need," and "Presentation and Its Doctrinal Tone."

120. Quoted in Bataille, *Inner Experience*, xxx.

121. Thomas Mann, "Gedanken im Kriege" (1914–1915), in *Von deutscher Republik*, 7–25, especially 10–12.

122. Habermas, "Die Festung Europa und das neue Deutschland." On March 5, 2004, in a forum at the Sorbonne, "La Loi sur la laicité: Perspectives juridiques et

philosophiques," Alain Finkielkraut adopted somewhat similar formulations for his support of the planned law against the wearing of headscarves ("foulards," which Finkielkraut and others insist on calling "voiles" [veils]) by Muslim girls in the public schools. In the forum, Paul Ricoeur (among others) opposed the law.

123. In Cixous's *La ville parjure; ou, Le réveil des Érinyes*, "The Night" is the "mother" who loves despite everything (185).

124. According to remarks made by Benjamin in 1913, youth has hopeful, lovable, admirable standing for those still children (and thus not yet young) as well as for those no longer young because they have "lost their belief in something better." Benjamin considers this a representative function of youth, which may, therefore, feel itself "youth by the grace of God" (II:1, 42). Although Benjamin occasionally suggests children are distinct from youth in not yet feeling the loss about to befall them and in not yet struggling against this loss (e.g., W 1, 45–46/II:1, 86), he comes to stress the division of youth and child somewhat less emphatically, and also more clearly suggests youth does not emerge in any strict correlation with youngness of age. One can have youth even while quite old, although the younger of age are, or historically have been, more likely to be *youthful*. Even if his age is perhaps beyond what would normally be called "youth," "Prince Myshkin's 'youth' (he is 24)" is not "unquestionably incidental" to *The Idiot*; contrary to Wolin's reading, Benjamin's "discussion of the significance of youth in its relation to immortality" is not incompatible with the professed "notion of immanent criticism" and does not simply have a "personal basis." Cf. Wolin, 46–47, as well as Witte, *Walter Benjamin: Der Intellektuelle als Kritiker*, 28–29.

The personal basis, which is nonetheless relevant, is the suicide of poet Fritz Heinle. Upon reading the piece on *The Idiot*, Scholem wrote to Benjamin that he saw the figure of Heinle behind Benjamin's view of the novel and the figure of Prince Myshkin (Scholem, *WB*, 49/66). Benjamin's reply emphatically affirms Scholem's speculation (*C*, 102/*GB*, Vol. 1, 398). After Heinle's suicide, Benjamin is supposed to have considered Heinle and Hölderlin to be akin (Scholem, 17/27). The Hölderlin essay was written very shortly after the joint suicides of Rika Seligson and Heinle. In months following this, months following the outbreak of World War I, Benjamin worked on his "first larger work"—the Hölderlin essay—and considered this work to be "dedicated" to Heinle, who left behind poems that Benjamin regarded as occupying the few places in him—Benjamin—where "poems" "could still be decisively effective" (II:3, 921). During World War I, Benjamin wrote the cycle of seventy-three sonnets concerned with the death of Heinle and preceded by a quotation from Hölderlin's "Patmos" (VII:1, 27–64).

125. Although Benjamin's discussion of youth cannot be equated with Agamben's discussion of "infancy," the latter is noteworthy here—especially concerning the ineffable as "infancy" that is the "destiny" of differentiating language and discourse, truth and speech (Agamben, *Infancy and History*, especially 50–53).

126. Benjamin's own early literary efforts actually often address death as a power akin to that of youth. See, for example, "Der Tod des Vaters" (1913), IV:2, 723–25, and of course, many passages in the "Sonette," VII:1, 27–67.

127. On March 9, 1915, Benjamin wrote Wyneken a letter juxtaposing Wyneken's conversion to the German war effort with the *idea* previously represented by him (*GB*, Vol. 1, 262–65). For remarks on Wyneken's support of the war, see Olenhusen, 118. It was not youth so much as Wyneken and his followers that had disillusioned Benjamin, even if the suicides of Heinle and Seligson following the outbreak of war in August 1914 came to mark in his memory the end of his views too confined to the schools, too restricted to the rebellions of adolescents against their parents, too effete in their attempts to make Berlin a place "for the words of Hölderlin or George" ("A Berlin Chronicle" [1932], *W* 2, 604–5/VI, 477–78).

128. Concerning Dostoevsky's view of Roman Catholicism as spiritual and material inheritor of the Roman Empire, see Joseph Frank, *Dostoevsky*, Vol. 3, 273–74.

129. Benjamin's interest was never quite the interest that Scholem wished Benjamin would have. For examples of Scholem's references to this theme, see Scholem, *Tagebücher*, 135, 151. Also noteworthy are Scholem's doubts about his own Zionism (176), his remarks on testing his Zionism against Benjamin's criticism (392), and his distinction of the national concept of Judaism from the "inward" goal of Zion (403). With regard to the latter distinction, also see the remarks on Scholem by Mosès in "Langage et sécularisation," in *L'Ange de l'Histoire*, 239–59, especially 257.

130. Dilthey, 278. "[E]very one of the innumerable living conditions gone through by the poet can be described in the psychological sense as lived experience" (125). Dilthey adds: "[T]he condition" of the "extraordinary phenomenon" of Goethe's poetic-literary creation "lay in the history of the German spirit" prepared from Luther and Lessing onward as an "inner harmony" of religion, scholarship, and literature (127). For Dilthey's approach to Hölderlin's poetry, see especially 278–87; Benjamin seems to have read this Hölderlin essay when he was a pupil at school (*C*, 16–17, 146/*GB*, Vol. 1, 58–59, Vol. 2, 37); two somewhat reworked editions of *Lived Experience and Literature*, which appeared initially in 1906, appeared before Dilthey's death in 1911. The book is not on the reading list available in VII:1, which is only partial but begins from around the end of 1916 or the beginning of 1917. Another text by Dilthey is on the list (VII:1, 443—item no. 611), but it is one that Benjamin found useless (*GB*, Vol. 2, 37). *Das Erlebnis und die Dichtung* is mentioned or cited in some of Benjamin's later writings.

131. For Schlegel's text, see Schlegel, "Herkules Musagetes," in *Kritische Schriften und Fragmente*, Vol. 2, 266.

132. Even if Benjamin's critical outlook may be construed in terms of a Romantic motif of morphological criticism bound not to a single organism but rather immediately to "life" (*W* 1, 200 n. 315/I:1, 115 n. 307), it is misleading to suggest that this "life" is "organic life" (Pizer, 54)—at least as far as Benjamin is concerned. Benjamin's affinity with what he takes to be Schlegel's view is, nonetheless, indeed at least somewhat evident in his summary of it: criticism relates the work fully to the "universal work" (without losing the "relative unity" of the particular work) in an ironizing that "unveils" (enthüllt) as "mystery" (Mysteriums) not only "the transcendental order of art" but also "the immediate existence of the work in it" (*W* 1, 164/86). Benjamin's objectivizing interpretation of the Romantic theory of irony is a critique of the Hegelian dismissal of this theory as a theory of whimsical subjectivism or

personality imposition (162–63/82–84). In this regard, see Menninghaus, *Unendliche Verdopplung*, 67–68, and Bohrer, 27, 36–37. Briegleb (222) notes Benjamin's overstating of the objectivistic emphasis in Schlegel's theory of art.

133. Adorno, "Introduction to Benjamin's *Schriften*," 10/*Über Walter Benjamin*, 42. Müller thanks Benjamin for the notion that repression of death is an absurdity of the bourgeois relationship with death (Kluge and Müller, *Ich schulde der Welt einen Toten*, 103: see also Müller, *Gesammelte Irrtümer*, Vol. 3, 224).

134. "[T]he peculiar ground of the art work [den ihm eigenen Boden]" is, therefore, a ground not respected if the work is handled in terms of characters' psychology (the "psyche" of Myshkin as epileptic) or in terms of national "psyche" (*W* 1, 78–79/II:1, *237*). Myshkin's "immortal life" is not a "duration" (Dauer) of person or of nature as any specifiable spatial entity. Nor is it immortality in the "ordinary sense" for which life is mortal but "flesh, strength, person, spirit"—in their "various," successive versions—are "immortal." Myshkin's life is rather the shapeless immortality, the immortality that "gives shape" to life (80/*239*). Myshkin's life is the life of the Work. In another context, Benjamin refers to duration that is "the turning of time" (quoting from Hölderlin, "Blödigkeit"), that is the "moment [Augenblick]" of "perseverance [Beharrung]," the "moment [Moment] of inner sculpture [Plastik] in time" (31/*119–20*).

135. Witte thinks the rise of mass media and the larger educated public make Benjamin's plans for a journal to be read mainly by those writing in it less excusable than was the case for the Romantics' *Athenäum*, which faced a numerically very small German intelligentsia (Witte, *Walter Benjamin: Der Intellektuelle als Kritiker*, 34). Benjamin is indeed suspicious of the potential public of his day. In a letter of August 8, 1921, to Scholem, he comments on his plan to establish a journal showing not the least consideration for the public "*capable of paying*" so that "the intellectual public" may be served all the more decisively. Benjamin's plan is for a journal that would survive on the subscriptions of a small number of loyal supporters. Subscriptions will have to serve as a kind of patronage to assure that the journal will not have to dance to the public's tune. Beyond the printing of subscription copies, Benjamin planned the production of a sufficient number of complimentary copies for those who could not afford to pay (*GB*, Vol. 2, 182–83). The letter is quoted in Scholem, *WB*, 103–4.

136. For discussion of Benjamin's remarks on names of streets and arcades in Paris, see Stiegler, 78–82, 272.

137. The young Benjamin cites inheritors of this "hamletische" consciousness of "the badness of the world and of the calling [Berufung] to improve it" (II:1, 10), figures suffering for "the ideal." These include figures in works by Schiller, Goethe, Ibsen, and especially Carl Spitteler; particularly with regard to the latter, Benjamin mentions a strongly pronounced "universal ideal of humanity," a longing for "a new humanity with courage for truth." Youthful pessimism overcomes itself with this longing (12, but also 9–10). This essay by Benjamin (under the pseudonym "Ardor-Berlin" and titled "Das Dornröschen") first appeared in *Der Anfang*, March 11, 1911.

138. On Hamlet's life as untimely in uniquely converging with the dead, see Derrida, *Specters of Marx*, 18–23. Derrida's book was first consulted after the discussions

of Hamlet (including those involving Joyce's use of Hamlet) had been written for the study at hand. Consideration of convergence and divergence between Benjamin and Derrida on Hamlet will not be claimed to have been made even implicitly here.

139. Cixous, *La ville parjure*, 170.

140. Letter of August 3, 1917, *Briefe an Werner Kraft*, 19. Such remarks may offset at least somewhat the view, expressed by Derrida (with regard to Scholem's letter of December 1926 to Rosenzweig), that Scholem identifies philosophy with the "bourgeois" notions of language rejected by him and by Benjamin ("The Eyes of Language," 223–24). Benjamin and Scholem do distance themselves from the epistemologies of most neo-Kantianism, which they indeed consider bourgeois somewhat in the sense that Lukács does in the critique of Kant advanced in *History and Class Consciousness*, especially "The Antinomies of Bourgeois Thought," 110–49. The theological correctives (however qualified) introduced by Scholem and, somewhat differently, by Benjamin are nonetheless obviously not shared by Lukács. The latter's Hegelian emphasis on potential sublation of bourgeois (Kantian) subjectivity through proletarian intersubjective constitution of truth is correlatively very distinct from Benjamin's emphasis on the persistence of solitude in inorganic community. Upon his first encounter with Lukács's book, Benjamin proclaims his wish to study it as soon as possible but anticipates that his nihilistic foundations will remain in animosity to Lukács's meshing of communism with Hegelian dialectic (letter to Scholem of September 16, 1924, *C*, 248/*GB*, Vol. 2, 483). Whereas Lukács ultimately values the proletariat as potential living bearer of truth, even the later Benjamin comes to value it above all as dead to the victory of present claims to truth (*W* 4, 389–400/I:2, 693–704).

141. There have been a number of discussions of Benjamin's early work in terms of a socio-historical "ascertainment of his Jewish identity." See, for instance, Smith, "'Das Jüdische versteht sich von selbst,'" especially 334. This article draws on valuable material from archives and other such research-sources, although its argumentative basis (a rebuttal of the legend of Scholem's influence on Benjamin's very early views concerning Judaism [e.g., 318, 334]) kicks in a door previously opened (especially by Biale but also by various biographical accounts of the few years preceding Benjamin's acquaintance with Scholem).

142. Scholem, "On Jonah and the Concept of Justice," 356.

143. See the already mentioned open letter written for (and yet against) the Buberian-Zionist journal of Jewish youth ("Farewell," in *On Jews and Judaism in Crisis*, 55; "Abschied," *126*) There is an exhortation that "the power [Macht] of Jewish youth" is not based on how it steps out or on what it demands but rather on "the seclusion [Zurückgezogenheit] in which it takes on its task" and on "the greatness of the renunciation in which its fullness assumes shape [Gestalt]" (60/*130*). "Seclusion" is perhaps not the best translation for "Zurückgezogenheit," which could be translated as "state of being drawn back," state of being withdrawn; this would also accord better with the later reference to renunciation and fullness of shape. If there may be a fullness of shape, it is shape performing the shapelessness withheld from it.

144. Müller, *Jenseits der Nation*, 54.

145. Benjamin agrees with his former schoolmate Franz Sachs that there is "a 'yet to be developed' [herauszubildenden] tone of *Der Anfang*" but adds that generally one must guard against bringing along concepts "all too definite about what youth and 'Anfang' are" (*C*, 41/*GB*, Vol. 1, *141*).

146. "Studentische Autorenabende" is apparently a lecture that Benjamin was supposed to hold at a student-authors' evening in late 1913. A jury, however, rejected it. It appeared in a journal edited by the Free Students' Association in Berlin: *Der Student* 6 (1913–1914).

147. Benjamin is evidently using the word "personality" somewhat differently than he does elsewhere (see pages 206 and 209–10 in this volume, as well as II:1, 12).

148. See, for instance, the remark by Pensky (255 n. 9) on "one of the odder dimensions of Benjamin's involvement in the youth movement—a dimension that persists throughout"; see also 33. In its characterization of the community of solitude as odd, Pensky's book adapts criticisms of Benjamin developed by Witte.

149. Regardless of how one might then assess Benjamin's frequent usage of the "I" in the work cited, this remark in that work—"A Berlin Chronicle" (1932)—might well be contrasted with the increasing intolerance for emphases on, and accentuations of, the passive middle. The translator of the Hölderlin essay comments that "one of the peculiarities of Benjamin's style in this essay is the cultivation of the passive voice to a degree unheard of even in bad academic writing" (*W* 1, 36 n. 2). This assessment is repeated in Corngold, *Complex Pleasure*, 152–53 (also see Corngold's criticism of Benjamin's association of "Blödigkeit"—timidity—with courage, 166–68). For Benjamin, theory is a productive force to which I may or may not be open; it is certainly not a correlate of most that gets called "I." The age of so-called globalization has been accompanied by a tendency to attempt subordinating theory to a beautiful semblance of possessive individualism in spectacle. Some may more and more readily universalize the pedagogical outlook that a "good definition" of an "intellectual" is someone with "the power" to begin with and to "back . . . up" the words "I have a theory that" (see Graff, 1133). For seemingly relevant criticisms of the identification of freedom and public subject, the "ontology of subjectivity," see Nancy, *The Experience of Freedom*, 4–6, 13, 34, 57, 88–95, 143, 153.

150. Doubts about whether Goethe gave his text the contrast of choice (novel) and decision (novella) detected by Benjamin (Schödelbauer, 105–6) are not particularly devastating for a criticism devoted not to authorial intention but to the work. The latter is not entirely the former. So conceived by Benjamin, the work and its criticism are based on presentation as play—but not in any sense that would seem to warrant the tendency to refer to a Romantic "subjectivism" or "subjective prejudice" (cf. Jennings, 25, 137–38). Even Jennings's study acknowledges a tendency of Benjamin's own Romanticism study to suppress Schlegel's subjectivism and irrationality (183). For some remarks pertinent to subjectivism, see pages 226–27, 229–30, and 235–36.

151. Especially the closing pages of *O* and the theory of melancholy and mourning developed mostly in the third part of its first chapter (*O*, 138–58/I:1, 317–35)— the part published separately in the last issue of Hofmannsthal's *Neue Deutsche Beiträge* (second series, no. 3 [1927])—are said by Witte to foster a style based on "allegorical images" of a characteristically modern (especially Weimar) melancholic,

narcissistic inwardness incapable of "a historical presentation" and "knowledge" (Erkenntnis) (Witte, *Walter Benjamin: Der Intellektuelle als Kritiker*, 136, and *Walter Benjamin*, 61).

Much earlier, Lukács criticizes Benjamin's book for abandonment of the penetrative capacities of typification ("The Ideology of Modernism," *The Meaning of Contemporary Realism*, 42–43/"Die weltanschaulichen Grundlagen des Avantgardismus," *Wider den missverstandenen Realismus*, 44–45), the favoring of art that resists anthropomorphism and norms of objective knowledge, the advancement of a self-destructive creative subjectivity, and the introduction of a correlative disappearance not only of seriously objective but also of seriously subjective realms (*Ästhetik*, Part 1, Vol. 2, 764–66).

Its relative popularity has, moreover, been dismissed as the result of "theological-historical" garb, the result of an "aura [Hauch] of the mysterious and ambitious," enabling it to discourage philosophical, aesthetic, literary-historical, or philological scrutiny (Rumpf, *Spekulative Literaturtheorie*, 177, 176; see also 177–83 and 123–25). Even Witte's attempt to account historically for Benjamin's allegedly "Weimar" arbitrariness and subjectivism is said to be too mild for what is ultimately a personal obscurantism (Rumpf, *Aporien und Apologie*, 25). Thus Rumpf also questions Witte's usage of the phrase "allegorical method"; Benjamin's criticism is too "subjective" to warrant the appellation "method" (28). Benjamin's Hölderlin essay is chastised for philological laziness and disregard of "all rules of communicative and discursive scholarship" (44–45). Rumpf objects to the "veil of incomprehensibility" disguising the conceptual inadequacy and arbitrariness of Benjamin's terminology (34; see also 32–33). The closing pages of the *Trauerspiel* book are "pathetic" and read "like a sermon, not like an analysis." In the name of scholarship, Rumpf despairs such a "return" of the "Messiah" into "philosophical, literary-critical, literary-historical," or otherwise "secular" texts (66–68, 76).

152. Contrary to Wohlfarth's contention ("The Birth of Revolution," 164), the anti egocentric middle or center does not represent "the precise opposite of a windowless monad." For a discussion of the notion of monad eventually developed in the "Epistemo-Critical Prologue," see Pizer, 50–52. This notion seems quite compatible with Myshkin's middle.

153. Kraft, "Grab in Spanien." Although it would be presumptuous to subsume Benjamin entirely under the concept of "political martyr" (who knows exactly why a suicide happens?), it seems no less presumptuous to isolate the death entirely from the imposing myth of the expanding Nazi empire at the time and to claim that "exhaustion, not persecution . . . was presumably the reason for Benjamin's suicide, if one can give credibility to the reports and scanty documents" (as claimed in Schöttker, 122).

154. Blanchot, "The Indestructible," in *The Infinite Conversation*, 123, 124–30.
155. Anders, "Das Vermächtnis."
156. Kluge and Müller, *Ich bin ein Landvermesser*, 106–7.
157. Bloch, "Recollections of Walter Benjamin," 339/"Erinnerungen," *16*.
158. Bataille, *Literature and Evil*, 160.

159. Nancy, *The Experience of Freedom*, 169.

160. Brecht, "Zum Freitod des Flüchtlings W. B." and "An Walter Benjamin, der sich auf der Flucht vor Hitler entleibte."

161. It is only on the basis of myth that Goethe can conjure an innocence whereby Ottilie dies "leaving behind miraculous mortal remains" (*W* 1, 309/I:1, *140*). Benjamin's later view of heroic suicide concerns suicide that is not mythically sacrificial. This view is developed in various later writings; see, for instance, *W* 4, 45–46/I:2, 578.

162. "The Essential Solitude," in *The Gaze of Orpheus*, 66, 69, 74.

163. Benjamin quotes the last line of Kafka's story "The Hunter Gracchus."

164. Kafka, *Diaries*, 196 (entry of October 19, 1921). Cited by Arendt, 19.

165. Adorno, *Über Walter Benjamin*, 82.

166. Kafka, *Diaries*, 196. Also cited in Arendt, 19.

167. It seems a simplification to say Benjamin's early wariness of politics was abandoned only in favor of a politics that no longer had possibilities of being effective (e.g., Radnóti, "Benjamin's Politics," 73–74).

168. See, for instance, "The Political Groupings of Russian Writers," *W* 2, 6–11/II:2, 743–47; "Neue Dichtung in Russland," II:2, 755–62; "The Author as Producer," *W* 2, 770–72/II:2, 686–89; and "The Work of Art in the Age of Its Technological Reproducibility," *W* 3, 114/VII:1, 371–72.

There are three German versions of "Das Kunstwerk im Zeitalter seiner technischen Reproduzierbarkeit": I:2, 431–69; VII:1, 350–84; and I:2, 471–508 (*W* 4, 251–83). There is also a French version (1936), which Benjamin prepared with Pierre Klossowski—L'Oeuvre d'art a l'époque de sa reproduction mécanisée," I:2, 709–39.

169. See, for example, "On the Situation of Russian Film," *W* 2, 12–15/II:2, 747–51; "Reply to Oscar A. H. Schmitz," *W* 2, 16–19/II:2, 751–55; "Little History of Photography," *W* 2, 507–30/II:1, 368–85; "The Work of Art in the Age of Its Technological Reproducibility," *W* 3, 101–33/VII:1, 350–84. For remarks on relevant nineteenth-century developments, see "Paris, the Capital of the Nineteenth Century," *W* 3, 34–36/*AP*, 5–6/V:1, 48–49; *AP*, 671–92, 786–87/V:2, 824–26, 946–48.

170. *One-Way Street* was published in 1928 but finished in 1926, written partly while work was being done on the *Trauerspiel* book, and is especially notable for the extent of its incorporation of both newer and older strains in Benjamin's thinking.

171. For instance: Bolz, *Theorie der neuen Medien* and *Eine kurze Geschichte des Scheins*.

172. Roberts, e.g., 16ff.

173. See the two books, plus various articles, by Witte, including "Benjamin and Lukács" and "Negative Ästhetik." Not surprisingly, Witte is critical of certain later works, such as the Kraus essay, the Kafka essay, the Baudelaire studies, and the *Passagen-Werk* (e.g., "Benjamins Baudelaire" and "Paris–Berlin–Paris"). Witte suggests that such later work is symptomatic of Benjamin's shift (from about 1934 onward) away from a journalistic career. After 1925, Benjamin had often sought to eke out an existence as a reviewer and essayist (primarily for leftist newspapers and journals), but this option became severely hampered as relevant newspapers and journals in Germany were increasingly forced to censor, shut down, or go into exile after 1933. Benjamin moved toward (what Witte characterizes as) the less politically oriented affiliation with Horkheimer's Institute for Social Research.

174. Also see: "Surrealistische Zeitschriften," IV:1, 595–6, a review which was published in *Die literarische Welt* (Nov 7, 1930); and "Dream Kitsch: Gloss on Surrealism," *W* 2, 3–5/II:2, 620–2.

175. Quoting *W* 4, 262/I:2, 493, and *W* 3, 114/VII:1, *372*. See also "The Political Groupings of Russian Writers," *W* 2, 6–11/II:2, 743–47; "Neue Dichtung in Russland" (1927), II:2, 755–62; and "The Author as Producer," *W* 2, 770–72/II:2, 686–89. Concerning Moscow, see "Moscow," *W* 2, 22–46/IV:1, 316–48, and a diary that Benjamin kept during this visit in the winter of 1926–1927, *MD/Moskauer Tagebuch*, VI, 292–409.

176. The destruction of aura as beautiful semblance could be said to be vindicated rather than contradicted by portrayal of movie-star or pop-star culture in Warhol's pictures of twenty Marilyns, two Elvises, and so on. It seems, nonetheless, indicative of the tensions in Benjamin's work (not to mention those in Warhol's) that Benjamin's writings have also been used to criticize these pictures as a furtherance of auraticization in pop culture (see Engelhardt, "Reproduktion der Reproduktion," 265).

It does not seem that academia can resist such auraticization. Directly following a workshop in Berlin, a moderator referred to a fellow Benjamin specialist, who happened to be standing next to him, as "a star"—apparently drawing on the Hollywood vocabulary and advancing the term as a compliment. In Germany (and indeed elsewhere), the photographic image of Benjamin may also have acquired a kind of cultic value. Perhaps not surprisingly, the fiftieth anniversary of Benjamin's death and the hundreth anniversary of his birth occasionally inspired a kind of auraticism of the person Walter Benjamin in Smith, "Benjaminiana," and in editorial remarks in Puttnies and Smith, *Benjaminiana* (notwithstanding otherwise theoretically interesting texts assembled there). Given some of the analyses offered by Benjamin on aura, it has been remarked that Benjamin's readers should not be surprised that his auratic image often dominates in receptions of the writings, despite Benjamin's wariness of biographical criticism (Osborne, 29). For recent advocacy, nonetheless, of "Benjamin's portrait [photograph], laden with pathos," as a "potential antidote" in "a postmodern age marked by the deadening or waning of affect," see Hanssen, "Portrait of Melancholy," 188. It might seem questionable to claim that this is an age of deadening or waning of affect. In any case, a bolstering of pathetic affect would seem, according to much of Benjamin's work, to amount to an evocation of nothing besides beautiful semblance.

177. "Left-Wing Melancholy," *W* 2, especially 425/III, 281.

178. Quoting Brecht's *Versuche*. Also see "Bert Brecht," *W* 2, 366/II:2, *661*.

179. See also "Letter from Paris (2): Painting and Photography," *W* 3, 236–48/III, 495–507, and the review of Gisèle Freund's *La photographie en France au dix-neuvième siècle*, *W* 4, 120–22/III, 542–44.

Iron is said by Benjamin to be the first "artificial" building material. See *AP*, 4/V:1, 46; see also *AP*, 150–70, 885–87/V:1, 211–31, V:2, 1060–63. Adorno questions whether iron was the first artificial building material: "(bricks!)" (letter of August 2, 1935, Adorno and Benjamin, *The Complete Correspondence*, 109/*B*, Vol. 2, 678).

180. Adorno's preference for "A Little History of Photography" over "The Work of Art in the Age of Its Technological Reproducibility" is somewhat confusing (cf. *Aesthetic Theory* [82 (L), 56/89 (HK)]). He says that the former essay approvingly cites the auratic

character of early photography. At least explicitly, this is not the case. If anything, the latter essay is more sympathetic in its discussion of auratic portrait photography (*W* 4, 258/I:2, 485 [445, 718]; *W* 3, 108/VII:1, 360). On the other hand, Benjamin's sympathy for auratic portrait photography does not extend so far that his "technology-essay" amounts to a lament for lost nature or for the potential to "memorialize tradition and past experiences," although this has recently been maintained in Hanssen, "Portrait of Melancholy," especially 169, 182. The latter essay also confuses in citing Benjamin's comments (in the technology essay) on cultic forms of melancholy as though those comments are not critical and indeed could be identified with the defense, in the *Trauerspiel* book, of philosophical melancholy and mourning (cf. Hanssen, 169–72, 182).

181. For the remarks by Goethe quoted here, see Goethe, *Maximen und Reflexionen*, 435.

182. Benjamin's characterization of photographs by Sander partly follows Alfred Döblin's introduction to Sander, *Antlitz der Zeit* (especially 13–15), as well as the announcement (1) given with the original publication by Kurt Wolff Verlag in 1929 (*W* 2, 520/II:1, 380).

183. With this challenge to the viewer, the photography is quite distinct from "free-floating contemplation"—"freischwebende Kontemplation," says Benjamin in an apparent allusion to Mannheim's view of intellectuals. Cf. Mannheim, *Ideology and Utopia* (1929 [German], 1936 [English]). Continuity of Benjamin's views on photography with his earlier views has been variously developed in secondary literature. For instance, see Amelunxen or Cadava.

184. Bettine Menke, *Sprachfiguren*, 333–48.

185. Citations by Bolz ("Schwanengesang der Gutenberg Galaxis," 243) from *One-Way Street* to suggest a move from the optical to tactileness and nearness are misleading. In *One-Way Street*, there is indeed rejection of the presumption to an innocent eye and to a critique in correlative distance. As indicated by quotations already given, however, *One-Way Street* suggests that the optical is becoming more rather than less prominent in this new tactileness and nearness.

186. Sloterdijk, 18.

187. Bolz, "Schwanengesang der Gutenberg Galaxis," 246–48.

188. Cf. Sloterdijk, 32.

189. This priority seems to be at play as Adorno expresses concern about the tendency of some of Benjamin's later works spuriously to subordinate art to practical ends (*Aesthetic Theory*, 429 [L]/310–11 [HK]/*Ästhetische Theorie*, 460). In contrast with collaborative and competitive bundling and collectivization in newly technologized sociality, the "distancing" of the artwork is its distancing from itself as practical existence or being (e.g., 386, 429/274–75, 310–11/409, 460). Benjamin's distinctions of auratic and mechanically reproduced art are sometimes unduly strict as he overlooks the extent of potential interchange between the auratic (yet noncultic) and the mass-reproduced (e.g., 82–83/56/89–90).

190. Bolz, "Schwanengesang der Gutenberg Galaxis," 234–35. In a somewhat similar vein, the "particular interest of the organizers" of a Benjamin conference was expressly not "the speculative thinker or the esoteric Marxist who today can be criticized with little effort" ("Tagesprogramm").

191. On "destructive" continuities between the early linguistic views and the later views of technology, see Düttmann, "Tradition and Destruction," especially 36–37, 52. Those later views on technology indeed push the destructive tendencies further in many respects. See Gasché, "Objective Diversions," and Geulen, "Zeit zur Darstellung."

192. Bolz, "Schwanengesang der Gutenberg Galaxis," 238, 243. Fascist aestheticization of politics (which is criticized by Benjamin) and Benjamin's invocation of a techno-politicization of the aesthetic (e.g., "The Work of Art in the Age of Its Reproducibility") sometimes have more in common than Benjamin acknowledges (Düttmann, *Das Gedächtnis des Denkens*, 167–68, 199–202).

193. The second Baudelaire essay, "On Some Motifs in Baudelaire" (*W* 4, 313–55/I:2, 605–53), was published in *Zeitschrift für Sozialforschung* as a revision after Adorno's editorial censure of the "Second Empire" study (*W* 4, 3–92/I:2, 511–604). The ostensibly contradictory views of aura developed in Benjamin's later works cannot be elaborated here in any detail. Especially in the late 1920s and after, Benjamin attempted to make his work a "scene of contradictions." It has been contended that this "self-understanding" shows Benjamin practicing "in his way what is discussed today as decentering of the subject" (Lindner, "Links hatte noch alles," 8). Benjamin refers to his "Janus head" (Janushaupt) in this regard (*C*, 347/*GB*, Vol. 3, 438), and Scholem too refers to Benjamin's "Janus face" (Janusgesicht) (*WB*, 197/246). The Roman god Janus had two faces on one head: it seems likely that Benjamin's ambivalence is indeed for the sake of exploring what he considers differently compelling—and, in some respects, opposed—directions.

194. "A Portrait of Walter Benjamin," in *Prisms*, 241/*Über Walter Benjamin*, 25.

195. Scholem, "Religious Authority and Mysticism," in *On the Kabbalah and Its Symbolism*, 29–31.

196. Adorno, "A Portrait of Walter Benjamin," in *Prisms*, 241/*Über Walter Benjamin*, 25; see also 234/16.

197. Derrida, *The Gift of Death*, passim.

198. For a discussion of Beuys, see Ulmer, 225–64.

199. Sloterdijk, 31–32.

200. Habermas, "Walter Benjamin," 155, 152/*Philosophisch-politische Profile*, 368, 364–65. Habermas regards Benjamin's redemptive critique as "conservative" (138, 155, 161/346, 368, 376), thereby underestimating its "destructive" elements (cf. Witte, *Walter Benjamin: Der Intellektueller als Kritiker*, 186 n. 11).

201. Habermas, *The Philosophical Discourse of Modernity*, 183–84, 190, 210/*Der philosophische Diskurs der Moderne*, 217–18, 224, 246; see also 177–210/209–47, especially 192, 208–10/226, 244–46. In certain respects, Habermas follows Handelman's "Jacques Derrida and the Heretic Hermeneutic," from her *Slayers of Moses*. See also Habermas, *The Philosophical Discourse of Modernity*, 9–16/19–25 and "Modernity: An Incomplete Project," 5–6/"Die Moderne: Ein unvollendetes Projekt," 47.

202. Derrida, "White Mythology: Metaphor in the Text of Philosophy," in *Margins of Philosophy*, 219.

203. Derrida, *Margins of Philosophy*, 219; see also 215.

204. Lacoue-Labarthe, "The Fable (Literature and Philosophy)," in *The Subject of Philosophy*, especially 2, 9, 11. See also Gasché, "Literature in Parentheses," in *The Tain of the Mirror*, 255–70. This is not to deny that Derrida's works were taken up (and not very carefully read) by some literary critics to bully philosophy and a great deal else with an allegedly pervasive, but very narrowly conceived, literary writing (or text)—an aggression seeming to vindicate certain clichés advanced by opponents of deconstruction. The "Romanticism" of some so-called deconstructive criticism is discussed in Gasché, *The Tain of the Mirror*, e.g., 141–42, 274.

205. Derrida, 271. As suggested already, the disregard of death and of its relevance for philosophy can also involve a claim upon death, a killing of the dead (see pages 248–50).

206. For comments along these lines, see Müller, *Jenseits der Nation*, 23–24, 43, 54, and *Gesammelte Irrtümer*, Vol. 3, 223–24.

207. *The Compact Edition of the Oxford English Dictionary*, Vol. 1, 477.

208. Agamben, *Idea della prosa*, 97. Thanks to I. A. for help with the Italian. A published English translation is, of course, now available: *Idea of Prose*, 129.

209. Scholem, "Walter Benjamin," 190–91/*Walter Benjamin und sein Engel*, 27–28.

210. Deleuze and Guattari, *Towards a Minor Literature*, passim but especially 25–27.

211. Some languages can be more effectively precise. Various languages thus have formulations for "U.S. American"; German, for example, has "US-amerikanisch."

212. *The Star of Redemption*, 210/*Der Stern der Erlösung*, 234–35.

213. For reflections on rumor that draw somewhat on Benjamin's work, see Ronell, "Street-Talk," 119–45.

Bibliography

Adorno, Theodor W. "The Actuality of Philosophy." *Telos*, no. 31 (Spring 1977): 120–33.
———. *Aesthetic Theory*. Trans. C. Lenhardt. London: Routledge and Kegan Paul, 1984. / Trans. R. Hullot-Kentnor. Minneapolis: University of Minnesota Press, 1997. / *Ästhetische Theorie*. Frankfurt/M.: Suhrkamp Verlag, 1970.
———. *Gesammelte Schriften*. Vol. 1, *Philosophische Frühschriften*. Frankfurt/M.: Suhrkamp Verlag, 1973.
———. "Introduction to Benjamin's *Schriften*." Trans. R. Hullot-Kentor. In G. Smith, ed. *On Walter Benjamin: Critical Essays and Recollections*. Cambridge: MIT Press, 1988, 2–17.
———. *Minima Moralia*. Trans. E. F. N. Jephcott. London: New Left Books, 1974/*Minima Moralia*. Frankfurt/M.: Suhrkamp Verlag, 1985.
———. *Negative Dialectics*. Trans. E. B. Ashton. New York: Seabury Press, 1973/*Negative Dialektik*. Frankfurt/M.: Suhrkamp Verlag, 1966.
———. *Notes to Literature*. 2 vols. Ed. R. Tiedemann. Trans. Sherry Weber Nicholsen. New York: Columbia University Press, 1991–1992. / *Noten zur Literatur*. 4 vols. Frankfurt/M.: Suhrkamp Verlag, 1974.
———. *Prisms*. Trans. Samuel and Sherry Weber. London: Neville Spearman, 1967. / *Prismen*. Frankfurt/M.: Suhrkamp Verlag, 1976.
———. *Über Walter Benjamin*. Rev. and exp. ed. Ed. R. Tiedemann. Frankfurt/M.: Suhrkamp Verlag, 1990.
Adorno, Theodor W., and Walter Benjamin, *The Complete Correspondence, 1928–1940*. Ed. H. Lonitz. Trans. N. Walker. Cambridge: Harvard University Press, 1999.
"Adornos Seminar von Sommersemester 1932 über Benjamins *Ursprung des deutschen Trauerspiels*: Protokolle." *Frankfurter Adorno Blätter* 4 (1995): 52–77.
Agamben, Giorgio. *The Coming Community*. Trans. M. Hardt. Minneapolis: University of Minnesota Press, 1993.
———. *Homo Sacer: Sovereign Power and Bare Life*. Trans. D. Heller Roazen. Stanford: Stanford University Press, 1998.

———. *Idea of Prose*. Trans. M. Sullivan and S. Whitsitt. Albany: State University of New York Press, 1995. / *Idea della Prosa*. Milan: Giangiacomo Feltrinelli Editore, 1985.

———. *Infancy and History: Essays on the Destruction of Experience*. Trans. L. Heron. London: Verso, 1993.

———. *Language and Death: The Place of Negativity*. Trans. K. E. Pinkus with M. Hardt. Minneapolis: University of Minnesota Press, 1991.

———. *Stanzas: Word and Phantasm in Western Culture*. Trans. R. Martinez. Minneapolis: University of Minnesota Press, 1993.

———. "Walter Benjamin und das Dämonische: Glück und geschichtliche Erlösung im Denken Benjamins." Trans. G. Giacomazzi. In U. Steiner, ed. *Walter Benjamin, 1892–1940, zum 100. Geburtstag*. Bern: Peter Lang AG, 1992, 189–215.

Alexander, Robert J. *Das deutsche Barockdrama*. Stuttgart: J. B. Metzlersche Verlagbuchhandlung, 1984.

Amelunxen, Hubertus von. "Skiagraphia—Silberchlorid und schwarze Galle: Zur allegorischen Bestimmung des photographischen Bildes." In W. van Reijen, ed. *Allegorie und Melancholie*. Frankfurt/M.: Suhrkamp Verlag, 1992, 90–108.

Anders, Günther. "Das Vermächtnis." In E. Wizisla and M. Opitz, eds. *Glückloser Engel: Dichtungen zu Walter Benjamin*. Frankfurt/M.: Insel Verlag, 1992, 98.

———. *Wir Eichmannsöhne. Offener Brief an Klaus Eichmann*. Munich: Verlag C.H. Beck, 1988.

Arendt, Hannah. "Introduction: Walter Benjamin, 1892–1940." In W. Benjamin. *Illuminations*. Ed. H. Arendt. Trans. H. Zohn. New York: Schocken Books, 1969, 1–51.

Aristotle. *Metaphysics*. Trans. H. G. Apostle. Grinell, Iowa: Peripatetic Press, 1979.

———. *Poetics*. Trans. I. Bywater. In *Introduction to Aristotle*. Ed. R. McKeon. New York: Random House, 1947, 624–67.

Ash, Beth Sharon. "Walter Benjamin: Ethnic Fears, Oedipal Anxieties, Political Consequences." *New German Critique*, no. 48 (Fall 1989): 2–42.

Athenaeum: Eine Zeitschrift, 1798–1800. 2 vols. Ed. Curt Grützmacher. Hamburg: Rowohlt Verlag, 1969.

Bachmann, Ingeborg. "Das dreißigste Jahr." In *Das dreißigste Jahr: Erzählungen*. Munich: Deutscher Taschenbuch Verlag, 1996, 17–58.

Badiou, Alain. "L'Age des poètes." In Jacques Rancière, ed. *La politique des poètes*. Paris: Éditions Albin Michel, 1992, 21–38.

———. *Manifeste pour la philosophie*. Paris: Éditions du Seuil, 1989.

Bahti, Timothy. *Allegories of History: Literary Historiography after Hegel*. Baltimore: Johns Hopkins University Press, 1992.

Balfour, Ian. "Reversal, Quotation (Benjamin's History)." *MLN* 106, no. 3 (April 1991): 622–47.

Bataille, Georges. *Inner Experience*. Trans. L. A. Boldt. Albany: State University of New York Press, 1988.

———. *L'Abbé C*. Trans. P. A. Facey. London: Marion Boyars, 1985.

———. *Literature and Evil*. Trans. A. Hamilton. London: Marion Boyars, 1985.

———. *Theory of Religion*. Trans. R. Hurley. New York: Zone Books, 1989.

Benjamin, Andrew. "The Absolute as Translatability." In B. Hanssen and A. Benjamin, eds. *Walter Benjamin and Romanticism*. New York: Continuum, 2002, 109–22.

———. "Time and Task: Benjamin and Heidegger Showing the Present." In A. Benjamin and P. Osborne, eds. *Walter Benjamin's Philosophy: Destruction and Experience*. London: Routledge, 1994, 216–50.

———. *Translation and the Nature of Philosophy: A New Theory of Words*. London: Routledge, 1989.

Benjamin, Walter. *The Arcades Project*. Trans. H. Eiland and K. McLaughlin. Cambridge: Belknap Press of Harvard University Press, 1999.

———. *Briefe an Siegfried Kracauer (mit vier Briefen von Siegfried Kracauer an Walter Benjamin)*. Ed. T. W. Adorno Archiv (R. Tiedemann and H. Lonitz). Marbach am Neckar: Deutsche Schillergesellschaft, 1987.

———. *The Correspondence of Walter Benjamin*. Ed. G. Scholem and T. W. Adorno. Trans. M. R. Jacobson and E. M. Jacobson. Chicago: University of Chicago Press, 1994. / *Briefe*. Vols. 1 and 2. Frankfurt/M.: Suhrkamp Verlag, 1966.

———. *Gesammelte Briefe*. Vols. Ed. C. Gödde and H. Lonitz. Frankfurt/M.: Suhrkamp Verlag, 1995–2000.

———. *Gesammelte Schriften*. 3 vols. and supplements. Ed. R. Tiedemann, H. Schweppenhäuser, et al. Frankfurt/M.: Suhrkamp Verlag, 1974–1999.

———. *Moscow Diary*. Ed. G. Smith. Trans R. Sieburth. Cambridge: Harvard University Press, 1986.

———. "Notizen zu einer Arbeit über die Kategorie der Gerechtigkeit." Cited in this study from Scholem, *Tagebücher*, Vol. 1 :1, but also available in *Frankfürter Adorno Blätter* 4 [1995], 41–42.)

———. *The Origin of German Tragic Drama*. Trans. J. Osborne. London: New Left Books, 1977.

———. *Reflections*. Ed. P. Demetz. Trans. E. Jephcott. New York: Harcourt Brace Jovanovich, 1978.

———. *Schriften*. Ed. T. W. Adorno and G. Adorno. Frankfurt/M.: Suhrkamp Verlag, 1955.

———. *Selected Writings*. 4 vols. Ed. M. W. Jennings, et al. Cambridge: Belknap Press of Harvard University Press, 1996, 1999, 2002, 2003.

———. *Understanding Brecht*. Trans. A. Bostock. London: New Left Books, 1977.

———. *Ursprung des deutschen Trauerspiels*. Berlin: Ernst Rowohlt Verlag, 1928.

Bense, Max. "Exkurs über Walter Benjamin und Ludwig Wittgenstein." *Programmierung des Schönen: Allgemeine Texttheorie und Textästhetik: Aestetica*, vol. 4. Baden-Baden: Agis-Verlag, 1960, 46–51.

Berger, Willy. "Walter Benjamin als Übersetzer." In B. Allemann and E. Koppen, eds. *Teilnahme und Spiegelung: Festschrift für Horst Rüdiger*. Berlin: Walter de Gruyter, 1975, 634–63.

Berman, Antoine. *Experience of the Foreign: Culture and Translation in Romantic Germany*. Trans. S. Heyvaert. Albany: State University of New York Press, 1992.

Biale, David. *Gershom Scholem: Kabbalah and Counter-History*. Cambridge: Harvard University Press, 1982.

Blanchot, Maurice. *The Gaze of Orpheus and Other Literary Essays.* Trans. L. Davis. Barrytown, N.Y.: Station Hill Press, 1981.
———. *The Infinite Conversation.* Trans. S. Hanson. Minneapolis: University of Minnesota Press, 1993.
———. *The Unavowable Community.* Trans. P. Joris. Barrytown, N.Y.: Station Hill Press, 1988.
———. *The Writing of the Disaster.* Trans. A. Smock. Lincoln: University of Nebraska Press, 1995.
Bloch, Ernst. *Geist der Utopie.* (1918, first version) Frankfurt/M.: Suhrkamp Verlag, [1918] 1985.
———. *The Principle of Hope.* Trans. N. Plaice, S. Plaice, and P. Knight. Oxford: Basil Blackwell, 1986. / *Das Prinzip Hoffnung.* 3 vols. Frankfurt/M.: Suhrkamp Verlag, 1959.
———. "Recollections of Walter Benjamin." Trans. M. Jennings. In G. Smith, ed. *On Walter Benjamin: Critical Essays and Recollections.* Cambridge, Mass.: MIT Press, 1988, 338–45 / "Erinnerungen." In T. W. Adorno, et al. *Über Walter Benjamin.* Frankfurt/M.: Suhrkamp Verlag, 1968, 16–23.
Bohrer, Karl Heinz. "Walter Benjamins Objektivierung der romantischen Ironie." *Die Kritik der Romantik.* Frankfurt/M.: Suhrkamp Verlog, 1989.
Bolz, Norbert. *Auszug aus der entzauberten Welt: Philosophischer Extremismus zwischen den Weltkriegen.* Munich: Wilhelm Fink Verlag, 1989.
———. "Charisma und Souveränität: Carl Schmitt und Walter Benjamin im Schatten Max Webers." In J. Taubes, ed. *Der Furst dieser Welt: Carl Schmitt und die Folgen.* Munich: Wilhelm Fink/Ferdinand Schöningh Verlag, 1983, 249–62.
———. *Eine kurze Geschichte des Scheins.* Munich: Wilhelm Fink Verlag, 1991.
———. "Schwanengesang der Gutenberg Galaxis." In W. van Reijen, ed. *Allegorie und Melancholie.* Frankfurt/M.: Suhrkamp Verlag, 1992, 224–60.
———. *Theorie der neuen Medien.* Munich: Raben-Verlag von Wittern KG, 1990.
Bolz, Norbert, and Willem van Reijen. *Walter Benjamin.* Frankfurt/M.: Campus Verlag, 1991.
Brecht, Bertolt. "Zum Freitod des Flüchtlings W. B." and "An Walter Benjamin, der sich auf der Flucht vor Hitler entleibte." In E. Wizisla and M. Opitz, eds. *Glückloser Engel: Dichtungen zu Walter Benjamin.* Frankfurt/M.: Insel Verlag, 1992, 86 and 88.
Bredekamp, Horst. "From Walter Benjamin to Carl Schmitt, via Thomas Hobbes." Trans. M. Thorson Hause and J. Bond. *Critical Inquiry* 25, no. 2 (Winter 1999): 247–66.
Bresemann, Vera. "Ist die Moderne ein Trauerspiel? Das Erhabene bei Benjamin." In Christine Pries, ed. *Das Erhabene: Zwischen Grenzerfahrung und Größenwahn.* Weinheim: VCH Acta Humanoria, 1989, 171–84.
Briefe in Werner Kraft. Ed. Werner Kraft. Frankfurt/M.: Suhrkamp Verlag, 1986.
Briegleb, Klaus. *Ästhetische Sittlichkeit: Versuch über Friedrich Schlegels Systementwurf zur Begründung der Dichtungskritik.* Tübingen: Max Niemeyer Verlag, 1962.
Britt, Brian. *Walter Benjamin and the Bible.* New York: Continuum, 1996.
Bröcker, Michael. "Sprache." In M. Opitz and E. Wizisla, eds. *Benjamins Begriffe*, Vol. 2. Frankfurt/M.: Suhrkamp Verlag, 2000, 740–73.
Brodersen, Momme. *Spinne im eigenen Netz. Walter Benjamin: Leben und Werk.* Bühl-Moos: Elster Verlag, 1990.

Buck-Morss, Susan. *The Dialectics of Seeing: Walter Benjamin and the Arcades Project*. Cambridge, Mass.: MIT Press, 1989.

——. *The Origin of Negative Dialectics: Theodor W. Adorno, Walter Benjamin, and the Frankfurt Institute*. New York: Free Press, 1977.

Burgard, Peter J. "Adorno, Goethe, and the Politics of the Essay." In *Deutsche Vierteljahrsschrift für Literaturwissenschaft und Geistesgeschichte* 66, no. 1 (March 1992) 160–91.

Bürger, Peter. "Literary Criticism in German Today." In J. Habermas, ed. *Observations on "The Spiritual Situation of the Age."* Trans. A. Buchwalter. Cambridge, Mass.: MIT Press, 1984, 207–20.

——. *Theory of the Avant-Garde*. Trans. M. Shaw. Minneapolis: University of Minnesota Press, 1984.

——. *Vermittlung-Rezeption-Funktion: Ästhetische Theorie und Methodologie der Literaturwissenschaft*. Frankfurt/M.: Suhrkamp Verlag, 1979.

Butler, Judith. *Excitable Speech: A Politics of the Performative*. New York: Routledge, 1997.

Cadava, Eduardo. *Words of Light: Theses on the Photography of History*. Princeton: Princeton University Press, 1997.

Cascardi, Anthony J. "*Comedia* and *Trauerspiel:* On Benjamin and Calderón." *Comparative Drama* 16, no. 1 (Spring 1982): 1–11.

Cavell, Stanley. "Benjamin and Wittgenstein: Signals and Affinities." *Critical Inquiry* 25, no. 2 (Winter 1999): 235–46.

Caygill, Howard. "Benjamin, Heidegger, and the Destruction of Tradition." In A. Benjamin and P. Osborne, eds. *Walter Benjamin's Philosophy: Destruction and Experience*. London: Routledge, 1994, 1–31.

——. *Walter Benjamin. The Colour of Experience*. London: Routledge, 1998.

Celan, Paul. *Gesammelte Werke*. Vols. 1 and 3. Ed. B. Allemann and S. Reichert with R. Bücher. Frankfurt/M.: Suhrkamp Verlag, 1983.

Chow, Rey. "Walter Benjamin's Love Affair with Death." *New German Critique*, no. 48 (Fall 1989): 63–86.

Cixous, Hélène. "From the Scene of the Unconscious to the Scene of History." In R. Cohen, ed. *Future Literary Theory*. New York: Routledge, Chapman and Hall, 1989, 1–18.

——. *La ville parjure; ou, Le réveil des Érinyes*. Paris: Théâtre du Soleil, 1994.

——. *Three Steps on the Ladder of Writing*. Trans. S. Cornell and S. Sellers. New York: Columbia University Press, 1993.

Cohen, Hermann. *Kants Theorie der Erfahrung*: *Werke*. Vol. 1. (5th ed., reprint of 3rd ed. [1918]). Hildesheim: Georg Olms, 1987.

——. *Religion der Vernunft aus den Quellen des Judentums: Werke*. Vol. 11. Hildesheim: Georg Olms, 1987.

The Compact Edition of the Oxford English Dictionary. Oxford: Oxford University Press, 1971.

Cornelius, Hans. *Das philosophische System von Hans Cornelius: Eigene Gesamtdarstellung*. Berlin: Junker und Dünnhaupt Verlag, 1934.

Corngold, Stanley. *Complex Pleasure: Forms of Feeling in German Literature*. Stanford: Stanford University Press, 1998.

———. "Genuine Obscurity Shadows the Semblance Whose Obliteration Promises Redemption: Reflections on Benjamin's 'Goethe's Elective Affinities.'" In G. Richter, ed. *Benjamin's Ghost's: Interventions in Contemporary Literary and Cultural Theory*. Stanford: Stanford University Press, 2002, 154–68.

Cowan, Bainard. "Walter Benjamin's Theory of Allegory." *New German Critique*, no. 22 (Winter 1981): 109–22.

Critchley, Simon. *Very Little . . . Almost Nothing: Death, Philosophy, Literature*. London: Routledge, 1997.

Cuddon, J. A. *A Dictionary of Literary Terms and Literary Theory*. 3rd ed. Oxford: Basil Blackwell, 1991.

Cysarz, Herbert. *Deutsche Barockdichtung*. Hildesheim: Georg Olms Verlag, [1924] 1979.

"Das häßliche deutsche Haupt." *Der Spiegel*. 46, no. 6 (February 3, 1992): 18–24.

Deleuze, Gilles, and Félix Guattari. *Kafka: Towards a Minor Literature*. Trans. D. Polan. Minneapolis: University of Minnesota Press, 1986.

———. *A Thousand Plateaus: Capitalism and Schizophrenia*. Trans. B. Massumi. Minneapolis: University of Minnesota Press, 1987.

———. *What Is Philosophy?* Trans. H. Tomlinson and G. Burcell. New York: Columbia University Press, 1994.

Derrida, Jacques. *Aporias*. Trans. T. Dutoit. Stanford: Stanford University Press, 1993.

———. "Des Tours de Babel" (trans. J. F. Graham) and "Appendix: Des Tours de Babel." In J. F. Graham, ed. *Difference in Translation*. Ithaca, N.Y.: Cornell University Press, 1985, 165–207 and 209–48.

———. *The Ear of the Other: Otobiography, Transference, Translation*. Ed. C. McDonald and C. Levesque. Lincoln: University of Nebraska Press, 1988.

———. "The Eyes of Language: The Abyss and the Volcano." Trans. G. Anidjar. In *Acts of Religion*. Ed. G. Anidjar. New York: Routledge, 2002, 189–226.

———. "Faith and Knowledge: The Two Sources of 'Religion' at the Limits of Reason Alone." Trans. S. Weber. In J. Derrida and G. Vattimo, eds. *Religion*. Stanford: Stanford University Press, 1998, 1–78.

———. "Force of Law: The 'Mythical Foundation of Authority.'" Trans. M. Quaintance. In D. Cornell, M. Rosenfeld, and D. G. Carlson, eds. *Deconstruction and the Possibility of Justice*. New York: Routledge, 1992, 3–67.

———. *The Gift of Death*. Trans. D. Wills. Chicago: University of Chicago Press, 1995.

———. *Given Time*, vol. 1, *Counterfeit Money*. Trans. P. Kamuf. Chicago: University of Chicago Press, 1992.

———. "The Law of Genre." Trans. A. Ronell and D. Attridge. In *Acts of Literature*. Ed. D. Attridge. New York: Routledge, 1992, 221–52.

———. "Living On: Border Line." In H. Bloom, P. de Man, J. Derrida, G. Hartman, and J. Hillis Miller. *Deconstruction and Criticism*. New York: Seabury Press, 1979, 75–176.

———. *Margins of Philosophy*. Trans. A. Bass. Chicago: University of Chicago Press, 1982.

———. *Memoires: For Paul de Man*. Trans. C. Lindsay, J. Culler, and E. Cadava. New York: Columbia University Press, 1986.

———. *Of Grammatology*. Trans. G. C. Spivak. Baltimore: Johns Hopkins University Press, 1976.
———. *Of Spirit: Heidegger and the Question*. Trans. G. Bennington and R. Bowlby. Chicago: University of Chicago Press, 1989.
———. "On a Newly Arisen Apocalyptic Tone in Philosophy." Trans. J. Leavey, Jr. In P. Fenves, ed. *Raising the Tone of Philosophy*. Baltimore: Johns Hopkins Unviersity Press, 1993, 117–71.
———. *On the Name*. Ed. T. Dutoit. Stanford: Stanford University Press, 1995.
———. "Some Statements and Truisms about Neo-logisms, Newisms, Postisms, Parasitisms, and Other Small Seismisms." Trans. A. Tomiche. In D. Carroll, ed. *The States of "Theory": History, Art, and Critical Discourse*. New York: Columbia University Press, 1990, 63–94.
———. *Specters of Marx: The State of the Debt, the Work of Mourning, and the New International*. Trans. P. Kamuf. New York: Routledge, 1994.
———. "The Time of a Thesis: Punctuations." Trans. K. McLaughlin. In A. Montefiore, ed. *Philosophy in France Today*. Cambridge: Cambridge University Press, 1983, 34–50.
———. *The Truth in Painting*. Trans. G. Bennington and I. McLeod. Chicago: University of Chicago Press, 1987.
———. "Ulysses Gramophone: Hear Say Yes in Joyce." In *Acts of Literature*. Ed. D. Attridge. New York: Routledge, 1992, 253–309.
———. *Writing and Difference*. Trans. A. Bass. Chicago: University of Chicago Press, 1978.
Deuber-Mankowsky, Astrid. *Der frühe Walter Benjamin und Hermann Cohen: Jüdische Werte, Kritische Philosophie, vergängliche Erfahrung*. Berlin: Verlag Vorwerk 8, 2000.
Deutsches Wörterbuch von Jacob Grimm und Wilhelm Grimm. Vol. 7. Ed. Deutsche Akademie der Wissenschaften zu Berlin. Leipzig: S. Hirzel Verlag, 1962.
Die Bibel. Trans. Martin Luther. Berlin: Britische und Ausländische Bibelgesellschaft, 1888.
Dieckhoff, Reiner. *Mythos und Moderne: Über die verborgene Mystik in den Schriften Walter Benjamins*. Cologne: Janus Presse, 1987.
Die vier und zwanzig Bücher der Heiligen Schriften (according to the Masoretic text). Translation ed. Leopold Zunz. Berlin: Verlag von Veit, 1838.
Dilthey, Wilhelm. *Das Erlebnis und die Dichtung*. Göttingen: Vandenhoeck and Ruprecht, [1921] 1950.
Döblin, Alfred. "Vom Gesichtern, Bildern, und ihrer Wahrheit." In A. Sander. *Antlitz der Zeit*. Munich: Schirmer/Mosel Verlag, 1990, 7–15.
Dörr, Thomas. *Kritik und Übersetzung: Die Praxis der Reproduktion im Frühwerk Walter Benjamins*. Gießen: Focus Verlag, 1988.
Dostoevsky, Fyodor. *The Brothers Karamazov*. Trans. A. H. MacAndrew. New York: Bantam Books, 1981.
———. *The Idiot*. Trans. D. Magarshack. Harmondsworth, Middlesex, England: Penguin Books Limited, 1955.
Duden: Deutsches Universal Wörterbuch. 3rd rev. and exp. ed. Mannheim: Dudenverlag, 1996.

Düttmann, Alexander García. *Das Gedächtnis des Denkens: Versuch über Heidegger und Adorno*. Frankfurt/M.: Suhrkamp Verlag, 1991.

———. *The Gift of Language: Memory and Promise in Adorno, Benjamin, Heidegger, and Rosenzweig*. Trans. A. Lyons. London: The Athlone Press, 2000.

———. "Tradition and Destruction: Walter Benjamin's Politics of Language." Trans. D. Keates. In A. Benjamin and P. Osborne, eds. *Walter Benjamin's Philosophy: Destruction and Experience*. London: Routledge, 1994, 32–58.

Ebach, Jürgen. "Agesilaus Santander und Benedix Schönflies: Die verwandelten Namen Walter Benjamins." In N. W. Bolz and R. Faber, eds. *Antike und Moderne: Zu Walter Benjamins "Passagen."* Würzburg: Königshausen und Neumann, 1986, 148–53.

———. "Der Blick des Engels. Für eine 'Benjaminische' Lektüre der hebräischen Bibel." In N. W. Bolz and R. Faber, eds. *Profane Erleuchtung und rettende Kritik*. Würzburg: Königshausen und Neumann, 1982, 57–107.

Eidam, Heinz. *Strumpf und Handschuh: Der Begriff der nichtexistenten und die Gestalt der unkonstruierbaren Frage: Walter Benjamins Verhältnis zum "Geist der Utopie" Ernst Blochs*. Würzburg: Königshausen und Neumann, 1992.

"Ein Germanist und seine Wissenschaft. Der Fall Schneider/ Schwerte." *Die Erlanger Universitätsreden* no. 53 (1996).

Engelhardt, Hartmut. "Reproduktion der Reproduktion: Wenn Warhol sich den Benjamin anzieht." In B. Lindner, ed. *Walter Benjamin im Kontext*. 2nd ed. Frankfurt/M.: Athenäum, 1985, 258–277.

Etymologisches Wörterbuch des Deutschen. Munich: Deutscher Taschenbuch Verlag, 1995.

Felman, Shoshana. "Benjamin's Silence." *Critical Inquiry* 25, no. 2 (Winter 1999): 201–34.

Fenves, Peter. *Arresting Language: From Leibniz to Benjamin*. Stanford: Stanford University Press, 2001.

———. "The Genesis of Judgement: Spatiality, Analogy, and Metaphor in Benjamin's 'On Language as Such and on Human Language.'" In D. S. Ferris, ed. *Walter Benjamin: Theoretical Questions*. Stanford: Stanford University Press, 1996, 75–93.

———. "Marx, Mourning, Messianicity." In H. de Vries and S. Weber, eds. *Violence, Identity, and Self-Determination*. Stanford: Stanford University Press, 1997, 253–70.

Ferris, David S. "Benjamin's Affinity: Goethe, the Romantics, and the Pure Problem of Criticism." In B. Hanssen and A. Benjamin, eds. *Walter Benjamin and Romanticism*. New York: Continuum, 2002, 180–96.

Figal, Günther. "Die Ethik Walter Benjamins als Philosophie der reinen Mittel." In *Zur Theorie der Gewalt und Gewaltlosigkeit bei Walter Benjamin*. Heidelberg: Forschungsstätte der Evangelischen Studiengemeinschaft, 1979, 1–24.

———. "Recht und Moral bei Kant, Cohen, und Benjamin." In H.-L. Ollig, ed. *Materialien zur Neukantianismus-Diskussion*. Darmstadt: Wissenschaftliche Buchgesellschaft, 1987, 163–83.

———. "Vom Sinn der Geschichte: Zur Erörterung der politischen Theologie bei Carl Schmitt und Walter Benjamin." In E. Angehrn, H. Fink-Eitel, C. Iber, and

G. Lohmann, eds. *Dialektischer Negativismus: Michael Theunissen zum Geburtstag*. Frankfurt/M.: Suhrkamp Verlag, 1992, 252–69.
Folkers, Horst. "Zum Begriff der Gewalt bei Kant und Benjamin." In *Zur Theorie der Gewalt und Gewaltlosigkeit bei Walter Benjamin*. Heidelberg: Forschungsstätte der Evangelischen Studiengemeinschaft, 1979, 25–57.
Foucault, Michel. *History of Sexuality*. Vol. 1. Trans. R. Hurley. New York: Pantheon, 1978.
———. *This Is Not a Pipe*. Ed. and trans. J. Harkness (with illustrations and letters by René Magritte). Berkeley: University of California Press, 1983.
Frank, Joseph. *Dostoevsky*. Vol. 3, *The Stir of Liberation, 1860–1865*. Princeton: Princeton University Press, 1987.
Frank, Manfred. "Allegorie, Witz, Fragment, Ironie: Friedrich Schlegel und die Idee des zerrissenen Selbst." In W. van Reijen, ed. *Allegorie und Melancholie*. Frankfurt/M.: Suhrkamp Verlag, 1992, 124–46.
Freud, Sigmund. "Mourning and Melancholia." In *On Metapsychology: The Theory of Psychoanalysis*. Trans. and ed. J. Strachey. Ed. A. Richards. Harmondsworth, Middlesex, England: Penguin Books, 1984, 251–68.
Frey, Hans-Jost. "On Presentation in Benjamin." Trans. M. Shae. In D. S. Ferris, ed. *Walter Benjamin: Theoretical Questions*. Stanford: Stanford University Press, 1996, 139–64.
Frye, Northrop. *Anatomy of Criticism: Four Essays*. Princeton: Princeton University Press, [1957] 1971.
Fuld, Werner. "Agesilaus Santander oder Benedix Schönflies. Die geheimen Namen Walter Benjamins." *Neue Rundschau* Vol. 89, no. 2 (1978), 253–63.
———. *Walter Benjamin. Eine Biographie*. Hamburg: Rowohlt Verlag, 1990.
———. "Walter Benjamins Beziehung zu Ludwig Klages." *Akzente* Vol. 28, No. 3 (June 1981), 274–286.
Fürnkas, Josef. "Zitat und Zerstörung: Karl Kraus und Walter Benjamin." In J. Le Rider and G. Raulet, eds. *Verabschiedung der (Post-)Moderne*. Tübingen: Narr, 1987, 209–26.
Fynsk, Christopher. *Language and Relation . . . That There Is Language*. Stanford: Stanford University Press, 1996.
Gadamer, Hans-Georg. *Truth and Method*. 2d rev. ed. Translation revised by J. Weinsheimer and D. Marshall. New York: Continuum, 1989.
Gagnebin, Jeanne-Marie. *Zur Geschichtsphilosophie Walter Benjamins: Die Unabgeschlossenheit des Sinnes*. Erlangen: Verlag Palm und Enke, 1978.
Garber, Klaus. "Barock und Moderne im Werk Walter Benjamins." *Literaturmagazine*, no. 29 (April 1992): 28–46.
———. "Benjamin und das Barock: Ein Trauerspiel ohne Ende." *Euphorion* 84 (1990): 207–12.
———. *Martin Opitz, "der Vater der deutschen Dichtung": Eine kritische Studie zur Wissenschaftsgeschichte der Germanistik*. Stuttgart: J. B. Metzlersche Verlagsbuchhandlung, 1976.
———. *Rezeption und Rettung: Drei Studien zu Walter Benjamin*. Tübingen: Max Niemeyer Verlag, 1987.

———. *Zum Bilde Walter Benjamins: Studien, Porträts, Kritiken*. Munich: Wilhelm Fink Verlag, 1992.

Gasché, Rodolphe. *Inventions of Difference: On Jacques Derrida*. Cambridge: Harvard University Press, 1994.

———. "Objective Diversions: On Some Kantian Themes in Benjamin's 'The Work of Art in the Age of Mechanical Reproduction.'" In A. Benjamin and P. Osborne, eds. *Walter Benjamin's Philosophy: Destruction and Experience*. New York: Routledge, 1994, 183–204.

———. "Saturnine Vision and the Question of Difference: Reflections on Walter Benjamin's Theory of Language." In R. Nägele, ed. *Benjamin's Ground*. Detroit: Wayne State University Press, 1988, 83–104.

———. "The Sober Absolute: On Benjamin and Early Romantics." In B. Hanssen and A. Benjamin, eds. *Walter Benjamin and Romanticism*. New York: Continuum, 2002, 51–68.

———. *The Tain of the Mirror: Derrida and the Philosophy of Reflection*. Cambridge: Harvard University Press, 1986.

Gay, Peter. *Weimar Culture: The Outsider as Insider*. New York: Harper and Row, 1968.

Gehlen, Arnold. *Man in the Age of Technology*. Trans. P. Lipscomb with a foreword by P. L. Berger. New York: Columbia University Press, 1980. / *Die Seele im technischen Zeitalter: Sozialpsychologische Probleme in der industriellen Gesellschaft*. Hamburg: Rowohlt Verlag, 1957.

George, Stefan. *The Works of Stefan George Rendered into English*. 2d rev. and enl. ed. Trans. O. Marx and E. Morwitz. Chapel Hill: University of North Carolina Press, 1974.

Geulen, Eva. "Toward a Genealogy of Gender in Walter Benjamin's Writing." *German Quarterly* 69, no. 2 (Spring 1996): 161–80.

———. "Zeit zur Darstellung: Walter Benjamin's 'Das Kunstwerk im Zeitalter seiner technischen Reproduzierbarkeit.'" *MLN* 107, no. 3 (April 1992): 580–605.

Geyer-Ryan, Helga. "Effects of Abjection in the Texts of Walter Benjamin." *MLN* 107, no. 3 (April 1992): 499–520.

———. "Irreale Präsenz: Allegorie bei Paul de Man and Walter Benjamin." In H. Kunneman and H. de Vries, eds. *Enlightenments: Encounters between Critical Theory and Contemporary French Thought*. Kampen: Kok Pharos, 1993, 342–56.

Gide, André. *Strait Is the Gate*. Trans. D. Bussy. New York: Vintage Books, n.d.

Glogauer, Walter. "Widerspruch, Paradoxie oder 'Rettung': Zum Begriff der Wahrheit in Walter Benjamins 'Ursprung des deutschen Trauerspiels.'" *Neophilolgus* 69 (1985): 115–25.

Goethe, Johann Wolfgang von. *Die Wahlverwandtschaften*. In J. W. Goethe, *Sämtliche Werke*, Vol. 19. Munich: Deutscher Taschenbuch Verlag, 1963.

———. *Elective Affinities*. Trans. R. J. Hollingdale. Harmondsworth, Middlesex, England: Penguin Books, 1971.

———. *Faust: Der Tragodie erster und zweiter Teil*. In J. W. Goethe, *Sämtliche Werke*, Vol. 9. Munich: Deutscher Taschenbuch Verlag, 1962.

———. *Geschichte der Farbenlehre: Erster Teil*. In J. W. Goethe, *Sämtliche Werke*, Vol. 41. Munich: Deutscher Taschenbuch Verlag, 1963.

———. *Maximen und Reflexionen*. In J. W. Goethe, *Werke*, Vol. 12. Munich: C. H. Beck, 1973.
———. *Sämtliche Werke*. Vol. 33, *Briefe, Tagebücher, und Gespräche*, Frankfurt/M.: Deutscher Klassiker Verlag, 1993.
———. *Weimarer Dramen*. In J. W. Goethe, *Sämtliche Werke*, Vols. 10–11. Munich: Deutscher Taschenbuch Verlag, 1963.
———. *Wilhelm Meisters Lehrjahre*. In J. W. Goethe, *Sämtliche Werke*, Vols. 15–16. Munich: Deutscher Taschenbuch Verlag, 1962.
———. *Zur Farbenlehre: Didaktischer Teil*. In J. W. Goethe, *Sämtliche Werke*, Vol. 40. Munich: Deutscher Taschenbuch Verlag, 1963.
Graff, Gerald. Letter to the editor. *PMLA* 112, no. 5 (October 1997): 1132–33.
Groddeck, Wolfram. "Ästhetischer Kommentar: Anmerkungen zu Walter Benjamins Hölderlinlektüre." *Le pauvre Holterling*, no. 1 (1976): 17–21.
Guattari, Félix. "L'Impasse post-moderne." *La Quinzaine littéraire*, no. 456 (February 1, 1986): 21.
Gumpert, Martin. *Hölle im Paradies: Selbstdarstellung eines Arztes*. Hildesheim: Gerstenberg Verlag, [1939] 1983.
Gundolf, Friedrich. *Goethe*. Berlin: Georg Bondi, 1916.
Güntert, Hermann. *Von der Sprache der Götter und Geister: Bedeutungsgeschichtliche Untersuchungen zur homerischen und eddischen Göttersprache*. Halle: Verlag von Max Niemeyer, 1921.
Günther, Henning. *Walter Benjamin: Zwischen Marxismus und Theologie*. Olten: Walter-Verlag, 1974.
Haas, Willy. *Die literarische Welt*. Munich: Paul List Verlag, 1960.
Habermas, Jürgen. "Die Festung Europa und das neue Deutschland." *Die Zeit*, no. 22 (May 28, 1993): "Politik" section, 3.
———. "Modernity: An Incomplete Project." Trans. S. Ben-Habib. In H. Foster, ed. *The Anti-Aesthetic: Essays on Post-Modern Culture*. Port Townsend, Wash.: Bay Press, 1983, 3–15.
———. *The Philosophical Discourse of Modernity*. Trans. F. Lawrence. Cambridge, Mass.: MIT Press, 1987 / *Der philosophische Diskurs der Moderne*. Frankfurt/M.: Suhrkamp Verlag, 1985.
———. *Philosophisch-politische Profile*. 3d exp. ed. Frankfurt/M.: Suhrkamp Verlag, 1981.
———. "Walter Benjamin: Consciousness Raising or Rescuing Critique." In *Philosophical-Political Profiles*. Trans. F. G. Lawrence. Cambridge, Mass.: MIT Press, 1985, 131–65.
Hamacher, Werner. "Afformative, Strike: Benjamin's 'Critique of Violence.'" Trans. D. Hollander. In A. Benjamin and P. Osborne, eds. *Walter Benjamin's Philosophy: Destruction and Experience*. London: Routledge, 1994, 110–38.
———. *Entferntes Verstehen: Studien zu Philosophie und Literatur von Kant bis Celan*. Frankfurt/M.: Suhrkamp Verlag, 1998. / *Premises: Essays on Philosophy and Literature from Kant to Celan*. Trans. P. Fenves. Stanford: Stanford University Press, 1999.
———. "Intensive Sprachen." In C. L. Hart Nibbrig, ed. *Übersetzen: Walter Benjamin*. Frankfurt/M.: Suhrkamp Verlag, 2001, 174–235.

———. "The Word *Wolke*—If It Is One." Trans. P. Fenves. In R. Nägele, ed. *Benjamin's Ground*. Detroit: Wayne State University Press, 1988, 147–75.
Hamann, Johann Georg. *Briefwechsel*. Vol. 6, *1785–1786*. Ed. A. Henkel. Frankfurt/M.: Insel Verlag, 1975.
———. *Vom Magus im Norden und der Verwegenheit des Geistes: Ein Hamann-Brevier*. Ed. S. Majetschak. Munich: Deutscher Taschenbuch Verlag, 1993.
Handelman, Susan A. *Fragments of Redemption: Jewish Thought and Literary Theory in Benjamin, Scholem, and Levinas*. Bloomington: Indiana University Press, 1991.
———. *The Slayers of Moses: The Emergence of Rabbinic Interpretation in Modern Literary Theory*. Albany: State University of New York Press, 1982.
Handke, Peter. *Publikumsbeschimpfung und andere Sprechstücke*. Frankfurt/M.: Suhrkamp Verlag, 1996.
———. *Versuch über den geglückten Tag*. Frankfurt/M.: Suhrkamp Verlag, 1991.
Hanssen, Beatrice. "'Dichtermut' and 'Blödigkeit': Two Poems by Friedrich Hölderlin, Interpreted by Walter Benjamin." In B. Hanssen and A. Benjamin, eds. *Walter Benjamin and Romanticism*. New York: Continuum, 2002, 139–62.
———. "Portrait of Melancholy: Benjamin, Warburg, Panofsky." In G. Richter, ed. *Benjamin's Ghosts: Interventions in Contemporary Literary and Cultural Theory*. Stanford: Stanford University Press, 2002, 169–88.
———. *Walter Benjamin's Other History: Of Stones, Animals, Human Beings, and Angels*. Berkeley: University of California Press, 1998.
Hartung, Günter. "Mythos." In M. Opitz and E. Wizisla, eds. *Benjamins Begriffe*, Vol. 2. Frankfurt/M: Suhrkamp Verlag, 2000, 552–72.
Hauptmann, Gerhart. *Festspiel in deutschen Reimen*. Berlin: S. Fischer Verlag, 1913.
Haverkamp, Anselm. *Laub voll Trauer: Hölderlins späte Allegorie*. Munich: Wilhelm Fink Verlag, 1991.
Hegel, G. W. F. *Aesthetics: Lectures on Fine Art*. 2 vols. Trans. T. M. Knox. New York: Oxford University Press, 1975.
———. *Phenomenology of Spirit*. Trans. A. V. Miller. Oxford: Oxford University Press, 1982.
———. *Philosophy of Right*. Trans. T. M. Knox. New York: Oxford University Press, 1952.
Heidegger, Martin. *Basic Writings*. Ed. David Farrell Krell. San Francisco: Harper, 1993.
———. *Being and Time*. Trans. J. Macquarrie and E. Robinson. New York: Harper and Row, 1962.
———. *Frühe Schriften*. Frankfurt/M.: Vittoria Klostermann, 1972.
———. *On the Way to Language*. Trans. P. D. Hertz. San Francisco: Harper and Row, 1982 / *Unterwegs zur Sprache*. Pfullingen: Verlag Günther Neske, 1959.
Heil, Susanne. *"Gefährliche Beziehungen": Walter Benjamin und Carl Schmitt*. Stuttgart: Verlag J. B. Metzler, 1996.
Heinle, Friedrich. "Gedichte." *Akzente* 31, no. 1 (1984): 3–8.
Helfer, Martha B. "Benjamin and the Birth of Tragedy: The Trauerspiel Essays, 1916–1926." *Kodikas/Code: Ars Semeiotica* 11, nos. 1/2 (1988): 179–93.
———. *The Retreat of Representation: The Concept of* Darstellung *in German Critical Discourse*. Albany: State University of New York Press, 1996.

Hellingrath, Norbert von. *Hölderlin-Vermächtnis*. Munich: F. Bruckmann, 1936.
———. *Pindarübertragungen von Hölderlin: Prolegomena zu einer Erstausgabe*. Leipzig: E. Diedrichs, 1910.
———. "Vorrede." In F. Hölderlin, *Sämtliche Werke*, Vol. 4. Ed. Norbert von Hellingrath. Munich: Georg Müller, 1916, xi–xxii.
Heym, Georg. *Gedichte*. Leipzig: Verlag Philipp Reclam jun., 1987.
Hillach, Ansgar. "Über Schwulst, Allegorie, und Eigensinn: Für eine politische Lektüre von Benjamins Trauerspielbuch." *Literaturmagazin*, no. 29 (April 1992): 56–69.
Hirsch, Alfred. *Der Dialog der Sprachen: Studien zum Sprach- und Übersetzungsdenken Walter Benjamins und Jacques Derridas*. Munich: Wilhelm Fink Verlag, 1995.
———. "Die geschuldete Übersetzung: Von der ethischen Grundlosigkeit des Übersetzens." In A. Hirsch, ed. *Übersetzung und Dekonstruktion*. Frankfurt/M.: Suhrkamp Verlag, 1997, 396–428.
Hofmannsthal, Hugo von. "Der Turm: Ein Trauerspiel" (Neue Fassung 1926). In *Gesammelte Werke*, Vol. 3. Ed. B. Schoeller and R. Hirsch. Frankfurt/M.: S. Fischer Verlag, 1979, 383–469.
———. *Der Turm: Sämtliche Werke*. Vol. XVI.I. Ed. W. Bellmann. Frankfurt/M.: S. Fischer Verlag, 1990.
———. "Ein Brief." In *Gesammelte Werke*, Vol. 7. Ed. B. Schoeller and R. Hirsch. Frankfurt/M.: S. Fischer Verlag, 1979, 461–72.
———. "Über Charaktere im Roman und im Drama: Gespräch zwischen Balzac und Hammer-Purgstall in einem Döblinger Garten im Jahre 1842." In *Gesammelte Werke*, Vol. 7. Ed. B. Schoeller and R. Hirsch. Frankfurt/M.: S. Fischer Verlag, 1979, 481–94.
Hofmannsthal, Hugo von, and Florens Christian Rang. "Briefwechsel, 1905–1924." *Die Neue Rundschau*. 70, no. 3 (1959): 402–48.
Hölderlin, Friedrich. *Essays and Letters on Theory*. Trans. T. Pfau. Albany: State University of New York Press, 1988.
———. *Gedichte, 1800–1806*. In *Sämtliche Werke*, Vol. 4. Ed. Norbert von Hellingrath. Munich: Georg Müller, 1916.
———. *Sämtliche Werke und Briefe*. 3 vols. Ed. J. Schmidt. Frankfurt/M.: Deutscher Klassiker Verlag, 1992–1994.
Hölderlin, Friedrich, and Eduard Mörike. *Selected Poems*. Trans. and introduction by C. Middleton. Chicago: University of Chicago Press, 1972.
Hollier, Denis. *Against Architecture: The Writings of Georges Bataille*. Trans. B. Wing. Cambridge, Mass.: MIT Press, 1989.
Holz, Hans Heinz. "Idee." In M. Opitz and E. Wizisla, eds. *Benjamins Begriffe*, Vol. 2. Frankfurt/M.: Suhrkamp Verlag, 2000, 445–78.
———. "Philosophie als Interpretation." *Alternative* 10, nos. 56/57 (October–December 1967): 235–42.
———. *Philosophie der zersplitterten Welt: Reflexionen über Walter Benjamin*. Bonn: Pahl-Rugenstein Verlag, 1992.
———. "Prismatisches Denken." In T. W. Adorno, et al. *Über Walter Benjamin*. Frankfurt/M.: Suhrkamp Verlag, 1968, 66–110.

Honneth, Axel. "A Communicative Disclosure of the Past: On the Relation between Anthropology and Philosophy of History in Walter Benjamin." Trans. J. Farrell. *New Formations*, no. 20 (Summer 1993): 81–94.

Horch, Hans Otto, ed. *Ludwig Strauß, 1892–1992: Beiträge zu seinem Leben und Werk: Mit einer Bibliographie*. Tübingen: Max Niemeyer Verlag, 1995.

Hörisch, Jochen. "Objektive Interpretation des schönen Scheins: Zu Walter Benjamins Literaturtheorie." In N. W. Bolz and R. Faber, eds. *Walter Benjamin: Profane Erleuchtung und Rettende Kritik*. Würzburg: Königshausen und Neumann, 1982, 37–55.

Horkheimer, Max. *Gesammelte Schriften*. Vol. 16, *Briefwechsel, 1937–1940*. Ed. G. Schmid Noerr. Frankfurt/M.: S. Fischer Verlag, 1995, 81–91.

Horkheimer, Max, and Theodor W. Adorno. *Dialectic of Enlightenment*. Trans. J. Cumming. New York: Seabury Press, 1972. / *Dialektik der Aufklärung: Philosophische Fragmente*. Frankfurt/M.: Fischer Taschenbuch Verlag, 1969.

Hübscher, Arthur. "Barock als Gestaltung antithetischen Lebensgefühls: Grundlegung einer Phraseologie der Geistesgeschichte." *Euphorium* 24 (1922): 517–62 and 759–805.

Humboldt, Wilhelm von. *On Language: The Diversity of Human Language-Structure and Its Influence on the Mental Development of Mankind*. Trans. P. Heath with introduction by H. Aarsleff. Cambridge: Cambridge University Press, 1988.

Idel, Moshe. *Kabbalah: New Perspectives*. New Haven: Yale University Press, 1988.

———. *Language, Torah, and Hermeneutics in Abraham Abulafia*. Trans. M. Kallus. Albany: State University of New York Press, 1989.

Ingold, Felix Philipp. Lectures held at the Alte Schmiede in Vienna, February 24–25, 1997 (organized under the auspices of the Viennese Lectures on Literature).

Jabès, Edmond. *The Book of Questions*. Vol. 1. Trans. R. Waldrop. Hanover, N.H.: University Press of New England, 1991.

Jacobs, Carol. *In the Language of Walter Benjamin*. Baltimore: Johns Hopkins University Press, 1999.

Jacobson, Eric. *Metaphysics of the Profane: The Political Theology of Walter Benjamin and Gershom Scholem*. New York: Columbia University Press, 2003.

Jäger, Lorenz. "Kosmos und sozialer Raum: Varianten eines Benjaminschen Motivs." In M. Opitz and E. Wizisla, eds. *Aber ein Sturm weht vom Paradiese her: Texte zu Walter Benjamin*. Leipzig: Reclam-Verlag, 1992, 218–49.

———. "Schicksal." In M. Opitz and E. Wizisla, eds. *Benjamins Begriffe*, Vol. 2. Frankfurt/M.: Suhrkamp Verlag, 2000, 725–39.

Jameson, Fredric. "Benjamin's Readings." *Diacritics* 22, nos. 3–4 (Fall–Winter 1992): 19–35.

Jay, Martin. *The Dialectical Imagination: A History of the Frankfurt School and the Institute of Social Research, 1923–1950*. Boston: Little, Brown, 1973.

———. "Experience without a Subject: Walter Benjamin and the Novel." *New Formations*, no. 20 (Summer 1993): 145–55.

———. "The Politics of Translation: Siegfried Kracauer and Walter Benjamin on the Buber-Rosenzweig Bible." *Yearbook of the Leo Baeck Institute* (1976): 3–24.

Jennings, Michael W. *Dialectical Images: Walter Benjamin's Theory of Literary Criticism*. Ithaca, N.Y.: Cornell University Press, 1987.

Jianou, Ionel. *Rodin*. Trans. K. Muston and G. Skelding. Paris: Arted, Éditions d'Art, 1989.

Joyce, James. *Dubliners*. Harmondsworth, Middlesex, England: Penguin Books, 1972.

——. *Poems and Exiles*. Harmondsworth, Middlesex, England: Penguin Books, 1992.

——. *A Portrait of the Artist as a Young Man*. Harmondsworth, Middlesex, England: Penguin Books, 1973.

——. *Ulysses*. Harmondsworth, Middlesex, England: Penguin Books, 1979.

Kafka, Franz. *The Complete Stories*. Ed. N. N. Glatzer. New York: Schocken Books, 1976.

——. *The Diaries of Franz Kafka, 1914–1923*. Ed. M. Brod. New York: Schocken Books, 1965.

Kahl, Michael. "Der Begriff der Allegorie in Benjamins Trauerspielbuch und im Werk Paul de Mans." In W. van Reijen, ed. *Allegorie und Melancholie*. Frankfurt/M.: Suhrkamp Verlag, 1992, 292–317.

Kambas, Chryssoula. "Kunstwerk." In M. Opitz and E. Wizisla, eds. *Benjamins Begriffe*, Vol. 2. Frankfurt/M.: Suhrkamp Verlag, 2000, 524–51.

——. "Walter Benjamin an Gottfried Salomon: Bericht über eine unveröffentliche Korrespondenz." *Deutsche Vierteljahrsschrift für Literaturwissenschaft und Geistesgeschichte* 56, no. 4 (December 1982): 601–21.

——. "Walter Benjamins Verarbeitung der deutschen Frühromantik." In G. Dischner and R. Faber, eds. *Romantische Utopie—Utopische Romantik*. Hildesheim: Gerstenberg Verlag, 1979, 187–221.

Kant, Immanuel. *Critique of Judgement*. Trans. J. C. Meredith. Oxford: Clarendon Press, 1952.

——. *Critique of Practical Reason*. Trans. L. White Beck. Indianapolis: Bobbs-Merrill, 1956.

——. *Critique of Pure Reason*. Trans. N. K. Smith. New York: St. Martin's Press, 1965.

——. *Die Metaphysik der Sitten*. In I. Kant, *Werkausgabe*, Vol. 8. Frankfurt/M.: Suhrkamp Verlag, 1991.

——. "On a Newly Arisen Superior Tone in Philosophy." Trans. P. Fenves. In P. Fenves, ed. *Raising the Tone of Philosophy*. Baltimore: Johns Hopkins University Press, 1993, 51–72.

Kiedaisch, Petra, ed. *Lyrik nach Auschwitz? Adorno und die Dichter*. Stuttgart: Philipp Reclam jun., 1995.

Klages, Ludwig. *Der Geist als Widersacher der Seele*. With a commentary by Hans Eggert Schröder. In *Sämtliche Werke*, Vols. 1 and 2. Ed. E. Frauchiger, G. Funke, K. J. Groffmann, R. Heiss, and H. E. Schröder. Bonn: Bouvier Verlag, 1966.

Kleiner, Barbara. *Sprache und Entfremdung: Die Proust-Übersetzungen Walter Benjamins innerhalb seiner Sprach- und Übersetzungstheorie*. Bonn: Bouvier Verlag, 1980.

Kluge, Alexander, and Heiner Müller. *Ich bin ein Landvermesser: Gespräche*. Hamburg: Rotbuch Verlag, 1996.

———. *Ich schulde der Welt einen Toten: Gespäche.* Hamburg: Rotbuch Verlag, 1995.
Kluge, Friedrich. *Etymologisches Wörterbuch der deutschen Sprache.* 19th ed., rev. by Walter Mitzka. Berlin: Walter de Gruyter, 1963.
Koepnick, Lutz. *Walter Benjamin and the Aesthetics of Power.* Lincoln: University of Nebraska Press, 1999.
Konersman, Ralf. *Erstarrte Unruhe: Walter Benjamins Begriff der Geschichte.* Frankfurt/M.: Fischer Verlag, 1991.
König, Helmut, Wolfgang Kuhlmann, and Klaus Schwabe, eds. *Vertuschte Vergangenheit: Der Fall Schwerte und die NS-Vergangenheit der deutschen Hochschulen.* Munich: Verlag C. H. Beck, 1997.
Kopelew, Lew. "Stalingrad: Lehre und Mahnung." Foreword to G. Knopp. *Entscheidung Stalingrad.* Munich: C. Bertelsmann Verlag, 1992, 6–12.
Koselleck, Reinhart. "Einleitung." In R. Koselleck and M. Jeismann, eds. *Der politische Totenkult: Kriegerdenkmäler in der Moderne.* Munich: Wilhelm Fink Verlag, 1994, 9–20.
Kracauer, Siegfried. "Zu den Schriften Walter Benjamins." In *Das Ornament der Masse: Essays.* Frankfurt/M.: Suhrkamp Verlag, 1977, 249–55.
Kraft, Werner. "Friedrich C. Heinle." *Akzente* 31 (1984): 9–21.
———. "Grab in Spanien (Walter Benjamin) (1941)." In E. Wizisla and M. Opitz, eds. *Glückloser Engel: Dichtungen zu Walter Benjamin.* Frankfurt/M.: Insel Verlag, 1992, 92.
———. "Über einen verschollenen Dichter." *Neue Rundschau* 78, no. 4 (1967): 614–21.
Kramer, Sven. *Walter Benjamin zur Einführung.* Hamburg: Junius Verlag, 2003.
Kristeva, Julia. *Black Sun: Depression and Melancholia.* Trans. L. S. Roudiez. New York: Columbia University Press, 1989.
———. *Powers of Horror: An Essay on Abjection.* Trans. L. S. Roudiez. New York: Columbia University Press, 1982.
———. *Tales of Love.* Trans. L. S. Roudiez. New York: Columbia University Press, 1987.
Lacis, Asja. *Revolutionär im Beruf: Berichte über proletarisches Theater, Brecht, Benjamin, Piscator.* Ed. H. Brenner. Munich: Rogner und Bernhard, 1971.
Lacoue-Labarthe, Philippe. "Courage de la poésie." In Roger-Pol Droit, ed. *L'art est-il une connaissance?* Paris: Le Monde Éditions, 1993, 241–48.
———. *Heidegger, Art, and Politics: The Fiction of the Political.* Trans. C. Turner. Oxford: Oxford University Press, 1990.
———. "Il faut." *MLN* 107, no. 3 (April 1992): 421–40.
———. "Introduction to Walter Benjamin's *The Concept of Art Criticism in German Romanticism.*" Trans. D. Ferris. In B. Hanssen and A. Benjamin, eds. *Walter Benjamin and Romanticism.* New York: Continuum, 2002, 9–18.
———. *Musica Ficta: Figures of Wagner.* Trans. F. McCarren. Stanford: Stanford University Press, 1994.
———. "Poésie, philosophie, politique." In Jacques Rancière, ed. *La politique des poètes.* Paris: Éditions Albin Michel, 1992, 39–63.
———. *The Subject of Philosophy.* Ed. T. Trezise. Minneapolis: University of Minnesota Press, 1993.

———. *Typography: Mimesis, Philosophy, Politics*. Trans. and ed. C. Fynsk. Intro. by J. Derrida. Cambridge: Harvard University Press, 1989.

Lacoue-Labarthe, Philippe, and Jean-Luc Nancy. *The Literary Absolute: The Theory of Literature in German Romanticism*. Trans. P. Barnard and C. Lester. Albany: State University of New York Press, 1988.

Lange, I. M. "Review of *Der Ursprung des deutschen Trauerspielbuchs*" (1928). Appendix in M. Rumpf. *Spekulative Literaturtheorie: Zu Walter Benjamins Traverspielbuch*. Königstein: Forum Academicum in der Verlagsgruppe Athenäum, Hain, Scriptor, Hanstein, 1980, 184–85.

Laqueur, Walter Z. *Young Germany: A History of the German Youth Movement*. London: Routledge and Kegan Paul, 1962.

Leibniz, Gottfried Wilhelm von. *Discourse on Metaphysics*. Trans. P. G. Lucas and L. Grint. Manchester: Manchester University Press, 1965.

———. *Monadology and Other Philosophical Essays*. Trans. with intro. and notes by P. Schrecker. Indianapolis: Bobbs-Merrill, 1965.

Lepenies, Wolf. *Melancholie und Gesellschaft*. Frankfurt/M.: Suhrkamp Verlag, 1969.

Lévinas, Emmanuel. *Alterity and Transcendence*. Trans. M. B. Smith. New York: Columbia University Press, 1999.

———. *Difficult Freedom: Essays on Judaism*. Trans. S. Hand. Baltimore: Johns Hopkins University Press, 1997.

———. *Ethics and Infinity: Conversations with Philippe Nemo*. Trans. R. A. Cohen. Pittsburgh: Duquesne University Press, 1985.

———. *Of God Who Comes to Mind*. Trans. B. Bergo. Stanford: Stanford University Press, 1998.

———. *Otherwise than Being; or, Beyond Essence*. Trans. A. Lingis. The Hague: Martinus Nijhoff, 1981.

———. *Time and the Other*. Trans. R. Cohen. Pittsburgh: Duquesne University Press, 1985.

———. *Totality and Infinity: An Essay on Exteriority*. Trans. A. Lingis. The Hague: Martinus Nijhoff, 1979.

Lindner, Burkhardt. "Habilitationsakte Benjamin" and "'Links hatte noch alles sich zu enträtseln . . .': Zu diesem Band." In Lindner, ed. *Walter Benjamin im Kontext*. Königstein: Athenäum Verlag, 1985, 324–41 and 7–11.

Lohenstein, Daniel Casper von. *Sophonisbe*. Stuttgart: Philipp Reclam Jun., 1970.

Löwy, Michael. *Georg Lukács: From Romanticism to Bolshevism*. Trans. P. Camiller. London: New Left Books, 1979.

Lukács, Georg. *Ästhetik*. Part 1, 2 vols. Neuwied am Rhein: Hermann Luchterhand Verlag, 1963.

———. *History and Class Consciousness: Studies in Marxist Dialectics*. Trans. R. Livingstone. Cambridge, Mass.: MIT Press, 1971.

———. *The Meaning of Contemporary Realism*. Trans. J. and N. Mander. London: Merlin Press, 1963. / *Wider den Missverstandenen Realismus* (original title *Die Gegenwartsbedeutung des kritischen Realismus*). Hamburg: Classen Verlag, 1958.

———. *Soul and Form*. Trans. A. Bostock. Cambridge, Mass.: MIT Press, 1974. / *Die Seele und die Formen: Essays*. Neuwied: Hermann Luchterhand Verlag, 1971.

———. *The Theory of the Novel: A Historico-philosophical Essay on the Forms of Great Epic Literature*. Trans. A. Bostock. London: Merlin Press, 1978. / *Die Theorie des Romans: Ein geschichtsphilosophischer Versuch über die Formen der grossen Epik*. Darmstadt: Hermann Luchterhand Verlag, 1971.

Lunn, Eugene. *Marxism and Modernism: An Historical Study of Lukács, Brecht, Benjamin, and Adorno*. Berkeley: University of California Press, 1982.

Lyotard, Jean-François. *The Differend: Phrases in Dispute*. Trans. G. Van Den Abbeele. Minneapolis: University of Minnesota Press, 1988. / *Der Widerstreit*. Rev. ed. Trans. J. Vogl. Munich: Wilhelm Fink Verlag, 1989.

Makropoulos, Michael. *Modernität als ontologischer Ausnahmezustand? Walter Benjamins Theorie der Moderne*. Munich: Wilhelm Fink Verlag, 1989.

Man, Paul de. *Aesthetic Ideology*. Ed. A. Warminski. Minneapolis: University of Minnesota Press, 1996.

———. *Allegories of Reading: Figural Language in Rousseau, Nietzsche, Rilke, and Proust*. New Haven: Yale University Press, 1979.

———. *Blindness and Insight: Essays in the Rhetoric of Contemporary Criticism*. 2d ed. Minneapolis: University of Minnesota Press, 1983.

———. *The Resistance to Theory*. Minneapolis: University of Minnesota Press, 1986.

———. *The Rhetoric of Romanticism*. New York: Columbia University Press, 1984.

Mann, Klaus. *Mephisto*. Trans. R. Smyth. Harmondsworth, Middlesex, England: Penguin Books, 1991.

Mann, Thomas. *Von deutscher Republik: Politische Schriften und Reden in Deutschland: Gesammelte Werke*. Vol. 17. Ed. P. de Mendelssohn. Frankfurt/M.: S. Fischer Verlag, 1984.

Mannheim, Karl. *Ideology and Utopia: An Introduction to the Sociology of Knowledge*. Trans. L. Wirth and E. Shils. New York: Harcourt, Brace and World, 1974.

Marcuse, Herbert. *One-Dimensional Man: Studies in the Ideology of Advanced Industrial Society*. Boston: Beacon Press, 1964.

Mayer, Hans. *Der Zeitgenosse Walter Benjamin*. Frankfurt/M.: Judischer Verlag im Suhrkamp Verlag, 1992.

McCall, Tom. "Momentary Violence." In D. S. Ferris, ed. *Walter Benjamin: Theoretical Questions*. Stanford: Stanford University Press, 1996, 185–206.

———. "Plastic Time and Poetic Middles: Benjamin's Hölderlin." *Studies in Romanticism* 31 (Winter 1992): 481–99.

McCole, John. *Walter Benjamin and the Antinomies of Tradition*. Ithaca, N.Y.: Cornell University Press, 1993.

Mehlman, Jeffrey. *Walter Benjamin for Children: An Essay on His Radio Years*. Chicago: University of Chicago Press, 1993.

Menke, Bettine. "Das Nachleben im Zitat: Benjamins Gedächtnis der Texte." In A. Haverkamp and R. Lachmann, eds. *Gedächtniskunst: Raum und Schrift*. Frankfurt/M.: Suhrkamp Verlag, 1991, 74–110.

———. *Sprachfiguren: Name–Allegorie–Bild nach Walter Benjamin*. Munich: Wilhelm Fink Verlag, 1991.

Menke, Christoph. *Die Souveränität der Kunst: Ästhetische Erfahrung der Kunst nach Adorno und Derrida*. Frankfurt/M.: Suhrkamp Verlag, 1991.

Menninghaus, Winfried. *Schwellenkunde: Walter Benjamins Passage des Mythos*. Frankfurt/M.: Suhrkamp Verlag, 1986.
———. *Unendliche Verdopplung: Die frühromantische Grundlegung der Kunsttheorie im Begriff absoluter Selbstreflexion*. Frankfurt/M.: Suhrkamp Verlag, 1987.
———. *Walter Benjamins Theorie der Sprachmagie*. Frankfurt/M.: Suhrkamp Verlag, 1980.
———. "Walter Benjamin's Variations of Imagelessness." Trans. T. Bahti and D. C. Hensley. In T. Bahti and M. Sibley Fries, eds. *Jewish Writers, German Literature: The Uneasy Examples of Nelly Sachs and Walter Benjamin*. Ann Arbor: University of Michigan Press, 1995, 155–74. / "Das Ausdruckslose: Walter Benjamins Metamorphosen der Bilderlosigkeit." In I. and K. Scheurmann, eds. *Für Walter Benjamin*. Frankfurt/M.: Suhrkamp Verlag, 1992, 170–82.
Meyers kleines Lexikon: Literatur. Mannheim: Meyers Lexikonverlag, 1986.
Miller, J. Hillis. "Re-reading Re-vision: James and Benjamin." In J. H. Miller, *The Ethics of Reading*. New York: Columbia University Press, 1987, 101–27.
Missac, Pierre. *Passage de Walter Benjamin*. Paris: Éditions du Seuil, 1987.
Mitscherlich, Alexander, and Margarete Mitscherlich. *Die Unfähigkeit zu trauern: Grundlagen kollektiven Verhaltens*. Gütersloh: Bertelsmann Club, [1967, 1977] 1988.
Mosès, Stéphane. "Benjamin, Nietzsche, et l'idée de l'éternel retour." *Europe* 74, no. 804 (April 1996): 140–58.
———. *L'Ange de l'histoire*. Paris: Éditions du Seuil, 1992. / *Der Engel der Geschichte*. Frankfurt/M.: Jüdischer Verlag, 1994.
———. "Walter Benjamin and Franz Rosenzweig." Trans. D. Johnson. In G. Smith, ed. *Benjamin: Philosophy, Aesthetics, History*. Chicago: University of Chicago Press, 1989, 228–46.
Müller, Heiner. *Germania 3: Gespenster am toten Mann*. Programmheft (Akademietheater 1996/97). Vienna: Burgtheater Wien, 1996.
———. *Gesammelte Irrtümer*. Vol. 3. Frankfurt/M.: Verlag der Autoren, 1994.
———. "Glückloser Engel 2." In E. Wizisla and M. Opitz, eds. *Glückloser Engel: Dichtungen zu Walter Benjamin*. Frankfurt/M.: Insel Verlag, 1992, 29.
———. *Jenseits der Nation* (Interviews with Frank Raddatz). Berlin: Rotbuch Verlag, 1991.
———. *Zur Lage der Nation* (Interviews with Frank Raddatz). Berlin: Rotbuch Verlag, 1990.
Müller Farguell, Roger W. "Penelopewerk des Übersetzens: Walter Benjamins *En traduisant Proust—Zum Bild Prousts*." In C. L. Hart Nibbrig, ed. *Übersetzen: Walter Benjamin*. Frankfurt/M: Suhrkamp Verlag, 2001, 325–52.
Naeher, Jürgen. *Walter Benjamins Allegorie-Begriff als Modell: Zur Konstitution philosophischer Literaturwissenschaft*. Stuttgart: Klett-Cota, 1977.
Nägele, Rainer. "Benjamin's Ground." In R. Nägele, ed. *Benjamin's Ground*. Detroit: Wayne State University Press, 1988, 19–37.
———. "Das Beben des Barock in der Moderne: Walter Benjamins Monadologie." *MLN* 106, no. 3 (April 1991): 501–27.
———. *Echoes of Translation: Reading between Texts*. Baltimore: Johns Hopkins University Press, 1997.

———. "Ornament des Lebens: Leben und Kunst bei Benjamin und Lukács." In L. Lambrechts and J. Nowé, eds. *Texte zwischen Dichten und Denken: Festschrift für Prof. Dr. Ludo Verbeeck.* Louvain: Universitaire Pers Leuven, 1990, 135–58.

———. *Reading after Freud: Essays on Goethe, Hölderlin, Habermas, Nietzsche, Brecht, Celan, and Freud.* New York: Columbia University Press, 1987.

———. *Theater, Theory, Speculation: Walter Benjamin and the Scenes of Modernity.* Baltimore: Johns Hopkins University Press, 1991.

Nancy, Jean-Luc. *The Experience of Freedom.* Trans. B. McDonald. Stanford: Stanford University Press, 1993.

———. *The Inoperative Community.* Ed. P. Connor. Trans. P. Connor, L. Garbus, M. Holland, and S. Sawhney. Minneapolis: University of Minnesota Press, 1991.

———. *L'Impératif catégorique.* Paris: Flammarion, 1983.

———. *L'Oubli de la philosophie.* Paris: Éditions Galilée, 1986.

The New English Bible with the Apocrypha: Oxford Study Edition. New York: Oxford University Press, 1976.

Nietzsche, Friedrich. *Beyond Good and Evil: Prelude to a Philosophy of the Future.* Trans. W. Kaufmann. New York: Vintage Books, 1966.

———. *"The Birth of Tragedy" and "The Case of Wagner."* Trans. and commentary by W. Kaufmann. New York: Random House, 1967. / *Die Geburt der Tragödie oder Griechentum und Pessimismus*: *Werke.* Vol. 1. Frankfurt/M.: Verlag Ullstein, 1984, 7–114.

———. *The Gay Science.* With a prelude in rhymes and an appendix of songs. Trans. W. Kaufmann. New York: Vintage Books, 1974.

Novalis. *Schriften.* Vols. 2 and 3. Ed. J. Minor. Jena: Eugen Diederichs, 1907.

Olenhusen, Irmtraud, and Albrecht Götz von. "Walter Benjamin, Gustav Wyneken, und die Freistudenten vor dem Ersten Weltkrieg: Bemerkungen zu zwei Briefen Benjamins an Wyneken." *Jahrbuch des Archivs der Deutschen Jugendbewegung* 13 (1981): 98–128.

Ollig, Hans-Ludwig, ed. *Materialien zur Neokantianismus-Diskussion.* Darmstadt: Wissenschaftliche Buchgesellschaft, 1981.

Osborne, Peter. "Philosophizing beyond Philosophy: Walter Benjamin Reviewed." *Radical Philosophy*, no. 88 (March/April 1998): 28–37.

Panofsky, Erwin, and Fritz Saxl. *Dürers Melencolia.* Vol. 1, *Eine quellen- und typengeschichtliche Untersuchung.* Leipzig: B. G. Teubner, 1923.

Pensky, Max. *Melancholy Dialectics: Walter Benjamin and the Play of Mourning.* Amherst: University of Massachusetts Press, 1993.

Perret, Catherine. *Walter Benjamin sans destin.* Paris: La Différence, 1992.

Phelan, Anthony. "*Fortgang* and *Zusammenhang*: Walter Benjamin and the Romantic Novel." In B. Hanssen and A. Benjamin, eds. *Walter Benjamin and Romanticism.* New York: Continuum, 2002, 69–82.

Pizer, John. *Toward a Theory of Radical Origin: Essays on Modern German Thought.* Lincoln: University of Nebraska Press, 1995.

Plato. *The Collected Dialogues.* Ed. E. Hamilton and H. Cairns. Princeton: Princeton University Press, 1961.

Pross, Harry. *Jugend, Eros, Politik: Die Geschichte der deutschen Jugendverbände*. Bern: Scherz Verlag, 1964.

Puttnies, Hans, and Gary Smith, eds. *Benjaminiana: Eine biographische Rechereche*. Gießen: Anabas Verlag, 1991.

Quilligan, Maureen. "Allegory, Allegoresis, and the Deallegorization of Language: The *Roman de la rose*, the *De planctu naturae*, and *Parlement of Foules*." In M. Bloomfield, ed. *Allegory, Myth, and Symbol*. Cambridge: Harvard University Press, 1981, 163–86.

——. *The Language of Allegory: Defining the Genre*. Ithaca, N.Y.: Cornell University Press, 1979.

Rabinbach, Anson. "Between Enlightenment and Apocalypse: Benjamin, Bloch, and Modern German Jewish Messianism." *New German Critique*, no. 34 (Winter 1985): 78–124.

Radnóti, Sándor. "Benjamin's Politics." Trans. J. Fekete. *Telos*, no. 37 (Fall 1978): 63–81.

——. "The Early Aesthetics of Walter Benjamin." Trans. G. Follinus. *International Journal of Sociology* 7, no. 1 (1977): 76–123.

Rang, Florens Christian. "Agon and Theater." In Benjamin, *C*, 231–32/*GB*, Vol. 2, 416–17.

——. *Deutsche Bauhütte: Ein Wort an uns Deutsche über mögliche Gerechtigkeit gegen Belgien und Frankreich und zur Philosophie der Politik*. Sannerz: Gemeinschafts–Verlag Eberhard Arnold, 1924.

——. "Goethes 'Selige Sehnsucht.'" *Neue Deutsche Beiträge* 1, no. 1 (1922) 83–125.

——. *Shakespeare der Christ: Eine Deutung der Sonette*. Heidelberg: Verlag Lambert Schneider, 1954.

——. "Theater und Agon." In Benjamin, *C*, 233–35/*GB*, Vol. 2, 425–27.

Raulet, Gérard. *Walter Benjamin*. Paris: Ellipses, 2000.

Readings, Bill. *The University in Ruins*. Cambridge: Harvard University Press, 1996.

Reijen, Willem van. *Der Schwarzwald und Paris: Heidegger und Benjamin*. Munich: Wilhelm Fink Verlag, 1998.

Richter, Gerhard. *Walter Benjamin and the Corpus of Autobiography*. Detroit: Wayne State University Press, 2000.

Ricoeur, Paul. *The Rule of Metaphor: Multi-disciplinary Studies in the Creation of Meaning in Language*. Trans. R. Czerny with K. McLaughlin and J. Costello. Toronto: University of Toronto Press, 1977.

Riegl, Alois. *Die Entstehung der Barockkunst in Rom*. 2d edition. Ed. A. Burda and M. Dvorak. Vienna: Schroll, 1923.

Ritter, Johann Wilhelm. *Fragmente aus dem Nachlasse eines jungen Physikers*. With a foreword by H. Schipperges. Heidelberg: Verlag Lambert Schneider, 1969.

Roberts, Julian. *Walter Benjamin*. London: Macmillan, 1982.

Rochlitz, Rainer. *The Disenchantment of Art: The Philosophy of Walter Benjamin*. Trans. J. M. Todd. New York: Guildford Press, 1996.

Ronell, Avital. "Street-Talk." In R. Nägele, ed. *Benjamin's Ground: New Readings of Walter Benjamin*. Detroit: Wayne State University Press, 1988.

———. *Stupidity*. Urbana: University of Illinois Press, 2001.
Rosenzweig, Franz. *The Star of Redemption*. Trans. W. W. Hallo. Notre Dame, Ind.: University of Notre Dame Press, 1985. / *Der Stern der Erlösung*. Frankfurt/M.: Suhrkamp Verlag, 1988.
Roth, Joseph. *Juden auf Wanderschaft*. Cologne: Verlag Kiepenheuer und Witsch, 1985.
Rotten, Elizabeth. *Goethes Urphänomen und die platonische Idee*. Gießen: Verlag von Alfred Töpelmann, 1913.
Rüffer, Ulrich. "Zur Physiognomie des Erzählers in Benjamins Wahlverwandtschaften-Essay." In N. Bolz, ed. *Goethes Wahlverwandtschaften: Kritische Modelle und Diskursanalysen zum Mythos Literatur*. Hildesheim: Gerstenberg Verlag, 1981, 45–51.
Ruin, Hans. "Origin in Exile: Heidegger and Benjamin on Language, Truth, and Translation." *Research in Phenomenology* 29 (1999), 141–60.
Rumpf, Michael. *Aporien und Apologie: Zur Kritik an Walter Benjamin und seiner Rezeption*. Cuxhaven: Junghans-Verlag, 1991.
———. *Spekulative Literaturtheorie: Zu Walter Benjamins Trauerspielbuch*. Königstein: Forum Academicum in der Verlagsgruppe Athenäum, Hain, Scriptor, Hanstein, 1980.
Rush, Fred. "Jena Romanticism and Benjamin's Critical Epistemology." In B. Hanssen and A. Benjamin, eds. *Walter Benjamin and Romanticism*. New York: Continuum, 2002, 123–36.
Rychner, Max. "Erinnerungen." In T. W. Adorno, et al. *Über Walter Benjamin*. Frankfurt/M.: Suhrkamp Verlag, 1968, 24–29.
Sahl, Hans. *Memoiren eines Moralististen*. Darmstadt: Luchterhand, 1985.
Sartre, Jean-Paul. *Truth and Existence*. Trans. A. van den Hoven. Chicago: University of Chicago Press, 1992.
Sauerland, Karol. *Diltheys Erlebnisbegriff: Entstehung, Glanzzeit, und Verkümmerung eines literaturhistorischen Begriffs*. Berlin: Walter de Gruyter, 1972.
Scheerbart, Paul. *Lesabéndio: Ein Asteroiden-Roman*. Frankfurt/M.: Suhrkamp Verlag, 1986.
Scheler, Max. "Zum Phänomen des Tragischen." In *Die Zukunft des Kapitalismus und andere Aufsätze*. Ed. M. S. Frings. Munich: Franke Verlag, 1979, 91–115.
Schestag, Thomas. *Asphalt: Walter Benjamin*. Munich: Klaus Boer Verlag, 1992.
———. *Parerga*. Munich: Klaus Boer Verlag, 1991.
Schiller, Friedrich von. *Naive and Sentimental Poetry: On the Sublime: Two Essays*. Trans. J. A. Elias. New York: Frederick Ungar, 1966.
Schings, Hans-Jürgen. "Walter Benjamin, das barocke Trauerspiel, und die Barockforschung." In N. Honsza and H.-G. Roloff, eds. *Daß eine Nation die ander verstehen möge: Festschrift für Marian Szyrocki zu seinem 60. Geburtstag*. Amsterdam: Editions Rodopi, 1988, 663–76.
Schlaffer, Heinz. "Walter Benjamins Idee der Gattung." In N. Bolz und R. Faber, eds. *Walter Benjamin: Profane Erleuchtung und rettende Kritik*. 2d ed. Würzburg: Königshausen und Neumann, 1985, 41–49.
Schlegel, Friedrich. *Kritische Schriften und Fragmente: Studienausgabe*. 6 vols. Ed. E. Behler and H. Eichner. Paderborn: Ferdinand Schöningh, 1988.

———. *Lucinde*. Frankfurt/M.: Insel Verlag, 1985.
Schlossman, Beryl. "Pariser Treiben." Trans. R. Nägele. In C. L. Hart Nibbrig, ed. *Übersetzen: Walter Benjamin*. Frankfurt/M: Suhrkamp Verlag, 2001, 280–310.
Schmid-Bortenschlager, Sigrid. "Ratschäge für junge Kolleginninen, wie frau an der Universität Karriere macht: Von einer, die geglaubt hat, daß es auch anders gehen müßte." *Script*, no. 5 (May 1994): 3–6.
Schmidt, Burghart. *Benjamin zur Einführung*. Hannover: SOAK Verlag, 1984.
Schmidt, Jochen. *Die Geschichte des Genie-Gedankens in der deutschen Literatur, Philosophie, und Politik, 1750–1945*. 2 vols. Darmstadt: Wissensschaftliche Buchgesellschaft, 1985.
Schmitt, Carl. *Hamlet oder Hekuba: Der Einbruch der Zeit in das Spiel*. Stuttgart: Ernst Klett-Cotta Verlag, [1956] 1985.
———. *Political Theology: Four Chapters on the Concept of Sovereignty*. Trans. G. Schwab. Cambridge, Mass.: MIT Press, 1985. / *Politische Theologie: Vier Kapitel zur Lehre von der Souveränität*. 2d ed. Berlin: Duncker und Humblot, [1934] 1990.
———. *Römischer Katholizismus und politische Form*. 2d ed Stuttgart: Ernst Klett-Cotta Verlag, [1925] 1984.
Schnädelbach, Herbert. *Geschichtsphilosophie nach Hegel: Die Probleme des Historismus*. Freiburg: Karl Alber Verlag, 1974.
———. *Philosophy in Germany, 1831–1933*. Trans. E. Matthews. Cambridge: Cambridge University Press, 1984.
Schobinger, Jean-Pierre. *Variationen zu Walter Benjamins Sprachmeditationen*. Basel: Schwabe Verlag, 1979.
Schödelbauer, Ulrich. "Der Text als Material: Zu Benjamins Interpretation von Goethes *Wahlverwandtschaften*." In P. Gebhardt, et al. *Walter Benjamin: Zeitgenosse der Moderne*. Kronberg/Ts.: Scriptor Verlag. 1976, 71–93.
Scholem, Gershom (Gerhard). "Abschied: Offener Brief an Herrn Dr. Siegfried Bernfeld und gegen die Leser dieser Zeitschrift." *Jerubbaal: Eine Zeitschrift der jüdischen Jugend* 1 (1918–1919), 10, 126–30.
———. *The Correspondence of Walter Benjamin and Gershom Scholem, 1932–1940*. Ed. G. Scholem. Trans. G. Smith and A. Lefevere. New York: Schocken Books, 1989. / *Briefwechsel, 1933–1940*. Ed. G. Scholem. Frankfurt/M.: Suhrkamp Verlag, 1980.
———. *Judaica*. 6 vols. Frankfurt/M.: Suhrkamp Verlag, 1963–1997.
———. *Kabbalah*. New York: New American Library, 1978.
———. "Lyrik der Kabbala?" *Der Jude* 6 (1921–1922), 55–69.
———. *Major Trends in Jewish Mysticism*. Trans. G. Lichtheim, et al. New York: Schocken Books, 1961.
———. *The Messianic Idea in Judaism and Other Essays on Jewish Spirituality*. Trans. M. Meyer and H. Halkin. New York: Schocken Books, 1971.
———. "The Name of God and the Linguistic Theory of the Kabbala." Trans. S. Pleasance. *Diogenes*, no. 79 (Fall 1972): 59–80 and no. 80 (Winter 1972): 164–94.
———. *On Jews and Judaism in Crisis: Selected Essays*. Ed. W. J. Dannhauser. New York: Schocken Books, 1976.

———. "On Jonah and the Concept of Justice." Trans. E. J. Schwab. *Critical Inquiry* 25, no. 2 (Winter 1999): 353–61.

———. "On Our Language: A Confession." Trans. O. Wiskind. *History and Memory* 2, no. 2 (1990): 97–99. / "Confession on the Subject of Our Language." Trans. G. Anidjar. In J. Derrida, *Acts of Religion*, 226–27 / "Bekenntnis über unsere Sprache: An Franz Rosenzweig zum 26.XII.1926." Copy of original letter.

———. *On the Kabbalah and Its Symbolism*. Trans. R. Manheim. New York: Schocken Books, 1965. / *Zur Kabbala und ihrer Symbolik*. Frankfurt/M.: Suhrkamp Verlag, 1989.

———. *Tagebücher (nebst Aufsätzen und Entwürfen bis 1923)*. Vol. I:1 (1913–1917). Ed. K. Gründer and F. Niewöhner in collaboration with H. Kopp-Oberstebrink. Frankfurt/M.: Jüdischer Verlag, 1995.

———. "Walter Benjamin." Trans. L. Furtmüller. "Walter Benjamin and His Angel" and "Two Letters to Walter Benjamin." Trans. W. J. Dannhauser. In *On Jews and Judaism in Crisis: Selected Essays*. Ed. W. J. Dannhauser. New York: Schocken Books, 1976, 172–97, 198–236, 237–43.

———. *Walter Benjamin: The Story of a Friendship*. Trans. H. Zohn. Philadelphia: Jewish Publication Society of America, 1981. / *Walter Benjamin: Die Geschichte einer Freundschaft*. Frankfurt/M.: Suhrkamp Verlag, 1975.

———. *Walter Benjamin und sein Engel: Vierzehn Aufsätze und kleine Beiträge*. Ed. R. Tiedemann. Frankfurt/M.: Suhrkamp Verlag, 1983.

Schopenhauer, Arthur. *The World as Will and Representation*. 2 vols. Trans. E. F. J. Payne. New York: Dover Publications, 1969.

Schöttker, Detlev. *Konstruktiver Fragmentarismus: Form und Rezeption der Schriften Walter Benjamins*. Frankfurt/M.: Suhrkamp Verlag, 1999.

Schulte, Christoph. "'Die Quintessenz der Moderne': Walter Benjamins Bemerkungen zum Selbstmord." In N. W. Bolz and R. Faber, eds. *Antike und Moderne: Zu Walter Benjamins "Passagen."* Würzburg: Königshausen und Neumann, 1986, 224–32.

Schweppenhäuser, Hermann. "Benjamin über Gerechtigkeit: Ein Fund in Gershom Scholems Tagebüchern." *Frankfurter Adorno Blätter* 4 (1995), 43–51.

———. *Ein Physiognom der Dinge: Aspekte des Benjaminschen Denkens*. Lüneburg: Dietrich zu Klampen Verlag, 1992.

Seel, Martin. "Sprache bei Benjamin und Heidegger." *Merkur* 46, no. 4 (April 1992): 333–40.

Selz, Jean. "Benjamin in Ibiza." Trans. M. Martin Guiney. In G. Smith, ed. *On Walter Benjamin: Critical Essays and Reflections*. Cambridge, Mass.: MIT Press, 1988, 353–66.

Seyhan, Azade. *Representation and Its Discontents: The Critical Legacy of German Romanticism*. Berkeley: University of California Press, 1992.

Shakespeare, William. *As You Like It*. Ed. H. J. Oliver. Harmondsworth, Middlesex, England: Penguin Books, 1968.

———. *Romeo and Juliet*. Ed. T. J. B. Spencer. Harmondsworth, Middlesex, England: Penguin Books, 1996.

———. *The Tempest*. Ed. A. Righter (A. Barton). Harmondsworth, Middlesex, England: Penguin Books Ltd., 1968.

———. *The Tragedy of Hamlet, Prince of Denmark.* Ed. E. Hubler. New York: New American Library, 1963.

Shedletztky, Itta. "Fremdes und Eigenes: Zur Position von Ludwig Strauß in den Kontroversen um Assimilation und Judentum in den Jahren 1912–1914." In H. O. Horch, ed. *Ludwig Strauß, 1892–1992.* Tübingen: Max Niemeyer, 1995, 173–83.

Silk, M. S., and J. P. Stern. *Nietzsche on Tragedy.* Cambridge: Cambridge University Press, 1981.

Sloterdijk, Peter. "Sendboten der Gewalt: Zur Metaphysik des Action-Kinos: Am Beispiel von James Camerons 'Terminator 2.'" In A. Rost, ed. *Bilder der Gewalt.* Frankfurt/M.: Verlag der Autoren, 1994, 13–32. (A slightly shortened version appeared as "Sendboten der Gewalt: Der Mensch als Werfer und Schütze—zur Metaphysik des Action-Kinos," *Die Zeit,* no. 18 (April 30, 1993): 57–58.)

Sluga, Hans. *Heidegger's Crisis: Philosophy and Politics in Nazi Germany.* Cambridge: Harvard University Press, 1993.

Smith, Gary. "Benjaminiana: Die Spuren des Sammlers." In the magazine for the exhibition "Bucklicht Männlein und Engel der Geschichte." *Walter Benjamin: Theoretiker der Moderne.* Berlin: Werkbund-Archiv, 1990, 78–82.

———. "'Das Judische versteht sich von selbst': Walter Benjamins frühe Auseinandersetzung mit dem Judentum." *Deutsche Vierteljahrsschrift für Literaturwissenschaft und Geistesgeschichte* 65, no. 2 (June 1991): 318–34.

———. "'Die Zauberjuden': Walter Benjamin, Gershom Scholem, and Other German-Jewish Esoterics between the World Wars." *Journal of Jewish Thought and Philosophy* 4, no. 1 (1995): 227–43.

———. "Thinking through Benjamin." In G. Smith, ed. *Benjamin: Philosophy, Aesthetics, History.* Chicago: University of Chicago Press, 1989, vii–xlii.

Sparks, Simon. "Fatalities: Freedom and the Question of Language in Walter Benjamin's Reading of Tragedy." In M. de Beistegui and S. Sparks, eds. *Philosophy and Tragedy.* London: Routledge, 2000, 193–218.

Speth, Rudolf. *Wahrheit und Ästhetik: Untersuchungen zum Frühwerk Walter Benjamins.* Würzburg: Königshausen und Neumann, 1991.

Spinoza, Benedict de. *"On the Improvement of the Understanding," "The Ethics," "Correspondence."* Trans. R. H. M. Elwes. New York: Dover Publications, 1955.

Steinberg, Michael P. "Introduction: Benjamin and the Critique of Allegorical Reason." In M. P. Steinberg, ed. *Walter Benjamin and the Demands of History.* Ithaca, N.Y.: Cornell University Press, 1996, 1–24.

Steiner, Uwe. "Allegorie und Allergie: Bemerkungen zur Diskussion um Benjamins Trauerspielbuch in der Barockforschung." *Daphnis: Zeitschrift für Mittlere Deutsche Literatur* 4 (1989): 641–701.

———. *Die Geburt der Kritik aus dem Geiste der Kunst: Untersuchungen zum Begriff der Kritik in den frühen Schriften Walter Benjamins.* Würzburg: Königshausen und Neumann, 1989.

———. "Kapitalismus als Religion: Anmerkungen zu einem Fragment Walter Benjamins." *Deutsche Vierteljahrsschrift für Literaturwissenschaft und Geistesgeschichte* 72, no. 1 (1998): 147–71.

———. "Kritik." In M. Opitz and E. Wizisla, eds. *Benjamins Begriffe*, Vol. 2. Frankfurt/M.: Suhrkamp Verlag, 2000, 479–523.

———. "'Traurige Spiel—Spiel von Traurigen: Zu Walter Benjamins Theorie des barocken Trauerspiels." In W. van Reijen, ed. *Allegorie und Melancholie*. Frankfurt/M.: Suhrkamp Verlag, 1992, 32–63.

———. "'Zarte Empirie': Überlegungen zum Verhältnis von Urphänomen und Ursprung im Früh- und Spätwerk Walter Benjamins." In N. W. Bolz and R. Faber, eds. *Antike und Moderne: Zu Walter Benjamins "Passagen."* Würzburg: Könighausen und Neumann, 1986, 20–40.

Stiegler, Bernd. *Die Aufgabe des Namens: Untersuchungen zur Funktion der Eigennamen in der Literatur des zwanzigsten Jahrhunderts*. Munich: Wilhelm Fink Verlag, 1994.

Stifter, Adalbert. *Bunte Steine*. Munich: Goldmann Verlag, 1989.

Stockhausen, Karlheinz. *Stockhausen on Music: Lectures and Interviews*. Ed. R. Maconie. London: Marion Boyers, 1989.

Strich, Fritz. "Der lyrische Stil des Siebzehnten Jahrhunderts" (1916). In W. Barner, ed. *Der literarische Barockbegriff*. Darmstadt: Wissenschaftliche Buchgesellschaft, 1975, 32–71.

Szondi, Peter. *Schriften*. Vol. 1. Ed. J. Bollack with H. Beese, W. Fietkau, H.-Hagen Hildebrandt, G. Mattenklott, S. Metz, and H. Stierlin. Frankfurt/M.: Suhrkamp Verlag, 1978.

"Tagesprogramm." Program of the conference "Walter Benjamin und die Kunst," July 3–5, 1992, Frankfurt am Main.

Teskey, Gordon. *Allegory and Violence*. Ithaca, N.Y.: Cornell University Press, 1996.

Tiedemann, Rolf. *Studien zur Philosophie Walter Benjamins*. Frankfurt/M.: Suhrkamp Verlag, 1973.

Tiedemann, Rolf, Christoph Gödde, and Henri Lonitz. "Walter Benjamin, 1892–1940." *Marbacher Magazin*, no. 55 (1990). (The catalogue of an exhibition presented by the Theodor W. Adorno Archiv [Frankfurt/M.] and the Deutscher Literaturarchiv [Marbach am Neckar] at the Schiller-Nationalmuseum in Marbach am Neckar August 28–October 14, 1990. The exhibition was also at the Literaturhaus in Berlin October 21–December 9, 1990.)

Tucholsky, Kurt. *Gesammelte Werke*. Vol. 2, *1925–1928*. Ed. M. Gerold-Tucholsky and F. J. Raddatz. Reinbek bei Hamburg: Rowohlt Verlag, 1960.

Turk, Horst. "Politische Theologie? Zur 'Intention auf die Sprache' bei Benjamin und Celan." In S. Mosès and A. Schöne, eds. *Juden in der deutschen Literatur: Ein deutsch-israelisches Symposium*. Frankfurt/M.: Suhrkamp Verlag, 1986, 330–49.

Ulmer, Gregory L. *Applied Grammatology: Post(e)-Pedagogy from Jacques Derrida to Joseph Beuys*. Baltimore: Johns Hopkins University Press, 1985.

Vogl, Joseph. "Einleitung." In J. Vogl, ed. *Gemeinschaften: Positionen zu einer Philosophie des Politischen*. Frankfurt/M.: Suhrkamp Verlag, 1994, 7–27.

Voigts, Manfred. "'Die Mater der Gerechtigkeit': Zur Kritik des Zitat-Begriffs bei Walter Benjamin." In N. Bolz and R. Faber, eds. *Antike und Moderne: Zu Walter Benjamins "Passagen."* Würzburg: Könighausen und Neumann, 1986, 97–115.

———. "Zitat." In M. Opitz and E. Wizisla, eds. *Benjamins Begriffe*. Frankfurt/M.: Suhrkamp Verlag, 2000, 826–50.

Vries, Hent de. "Anti-Babel: The 'Mystical Postulate' in Benjamin, De Certeau, and Derrida." *MLN* 107, no. 3 (April 1992): 441–77.

———. *Philosophy and the Turn to Religion*. Baltimore: Johns Hopkins University Press, 1999.

———. *Theologie im Pianissimo und Zwischen Rationalität und Dekonstruktion: Die Aktualität der Denkfiguren Adornos und Levinas'*. Kampen: J. H. Kok, 1989.

Warburg, Aby. *Heidnisch-antike Weissagung in Wort und Bild zu Luthers Zeiten*. Heidelberg: Carl Winters Universitätsverlag, 1920 (*Sitzungsberichte der Heidelberger Akademie der Wissenschaften* [Philosophisch-historische Klasse], no. 26 [1920 (1919)]).

Weber, Max. *From Max Weber: Essays in Sociology*. Trans. H. H. Gerth and C. Wright Mills. New York: Oxford University Press, 1964.

———. *The Protestant Ethic and the Spirit of Capitalism*. Trans. T. Parsons. New York: Charles Scribner's Sons, 1976.

Weber, Samuel. "Benjamin's Writing Style." In M. Kelly, ed. *Encyclopedia of Aesthetics*, Vol. 1. Oxford: Oxford University Press, 1998, 261–64.

———. "Criticism Underway: Walter Benjamin's *Romantic Concept of Criticism*." In K. R. Johnston, G. Chaitin, K. Hanson, and H. Marks, eds. *Romantic Revolutions: Criticism and Theory*. Bloomington: Indiana University Press, 1990, 302–19.

———. "Genealogy of Modernity: History, Myth, and Allegory in Benjamin's *Origin of the German Mourning Play*." *MLN* 106, no. 3 (April 1991) 465–500.

———. "Taking Exception to Decision: Walter Benjamin and Carl Schmitt." *Diacritics* 22, nos. 3-4 (Fall–Winter 1992): 5–18.

———. "Un-Übersetzbarkeit: Zu Walter Benjamins *Aufgabe des Übersetzers*." In A. Haverkamp, ed. *Die Sprache der Anderen: Übersetzungspolitik zwischen den Kulturen*. Frankfurt/M.: Fischer Verlag, 1997, 121–45.

Weidmann, Heiner. "'Wie Abgrunds Licht den Stürzenden beglücket': Zu Benjamins Baudelaire-Übersetzung." In C. L. Hart Nibbrig, ed. *Übersetzen: Walter Benjamin*. Frankfurt/M: Suhrkamp Verlag, 2001, 311–24.

Weigel, Sigrid. "The Artwork as Breach of a Beyond: On the Dialectic of Divine and Human Order in Walter Benjamin's 'Goethe's *Elective Affinities*.'" In B. Hanssen and A. Benjamin, eds. *Walter Benjamin and Romanticism*. New York: Continuum, 2002, 197–206.

———. "Eros." In M. Opitz and E. Wizisla, eds. *Benjamins Begriffe*, Vol. 1. Frankfurt/M.: Suhrkamp Verlag, 2000, 299–340.

———. "'The Female-Has-Been' and the 'First-Born Male of His Work': From Gender Images to Dialectical Images in Benjamin's Writings." Trans. R. McNicholl. *New Formations*, no. 20 (Summer 1993): 21–32.

Wellbery, David E. "Benjamin's Theory of the Lyric." In R. Nägele, ed. *Benjamin's Ground*. Detroit: Wayne State University Press, 1988, 39–59.

Werckmeister, O.K. "Walter Benjamin, Paul Klee, und der 'Engel der Geschichte.'" *Neue Rundschau* 87, no. 1 (1976): 16–40.

———. "Walter Benjamins Passagenwerk als Modell für eine kunstgeschichtliche Synthese." In A. Berndt, P. Kaiser, A. Rosenberg, and D. Trinkner, eds. *Frankfurter Schule und Kunstgeschichte*. Berlin: Dietrich Reimer Verlag, 1992, 165–81.

Wiesenthal, Lieselotte. *Zur Wissenschaftstheorie Walter Benjamins*. Frankfurt/M.: Athenäum Verlag, 1973.
Wiggerhaus, Rolf. *The Frankfurt School: Its History, Theories, and Political Significance*. Trans. M. Robertson. Cambridge, Mass.: MIT Press, 1994.
Witte, Bernd. "Allegorien des Schreibens: Walter Benjamins Trauerspielbuch." *Merkur* 46, no. 2 (February 1992): 125–36.
———. "Benjamin and Lukács: Historical Notes on the Relationship between Their Political and Aesthetic Theories." *New German Critique*, no. 5 (Spring 1975): 3–26.
———. "Benjamins Baudelaire: Rekonstruktion und Kritik eines Torso." *Text und Kritik*, nos. 31/32 (2 ed., July 1979): 81–93.
———. "Feststellungen zu Walter Benjamin und Kafka." *Neue Rundschau* 84, no. 3 (1973): 480–94.
———. "Krise und Kritik: Zur Zusammenarbeit Benjamins mit Brecht in den Jahren 1929 bis 1933." In P. Gebhardt, et al. *Walter Benjamin: Zeitgenosse der Moderne*. Kronberg/Ts.: Scriptor Verlag, 1976, 9–36.
———. "Negative Ästhetik: Zu Benjamins Theorie und Praxis der literarischen Kritik." *Colloquia Germanica* 12, no. 3 (1979): 193–200.
———. "Paris–Berlin–Paris: Zum Zusammenhang von individueller, literarischer, und gesellschaftlicher Erfahrung in Walter Benjamins Spätwerk." In N. Bolz and B. Witte, eds. *Passagen: Walter Benjamins Urgeschichte des XIX. Jahrhunderts*. Munich: Wilhelm Fink Verlag, 1984, 17–26.
———. *Walter Benjamin*. Hamburg: Rowohlt Verlag, 1985.
———. *Walter Benjamin: Der Intellektuelle als Kritiker: Untersuchungen zu seinem Frühwerk*. Stuttgart: J. B. Metzlersche Verlagsbuchhandlung, 1976.
Wittgenstein, Ludwig. *Philosophical Investigations*. Trans. G. E. M. Anscombe. Oxford: Basil Blackwell, 1978.
———. *Tractatus Logico-Philosophicus*. Trans. C. K. Ogden. London: Routledge and Kegan Paul, 1981.
———. *Werkausgabe*. Vol. 1. Frankfurt/M.: Suhrkamp Verlag, 1984.
Wizisla, Erdmut. "'Die Hochschule ist eben der Ort nicht, zu studieren': Walter Benjamin in der freistudentischen Bewegung." *Wissenschaftliche Zeitschrift der Humboldt Universität zu Berlin* (Gesellschaftswissenschaftliche Reihe) 36, no. 7 (1987): 616–23.
Wohlfarth, Irving. "The Birth of Revolution from the Spirit of Youth: Walter Benjamin's Reading of *The Idiot*." *Internationale Zeitschrift für Philosophie*, no. 1 (1993), 143–72.
———. "On Some Jewish Motifs in Benjamin." In A. Benjamin, ed. *The Problems of Modernity: Adorno and Benjamin*. London: Routledge, 1989, 157–216.
———. "Resentment Begins at Home: Nietzsche, Benjamin, and the University." In G. Smith, ed. *On Walter Benjamin: Critical Essays and Reflections*. Cambridge, Mass.: MIT Press, 1988, 224–59.
———. "Walter Benjamin's Image of Interpretation." *New German Critique*, no. 17 (Spring 1979): 70–98.

Wolf, Christa. *Kein Ort: Nirgends*. Frankfurt/M: Luchterhand Literaturverlag, 1981.

Wolff, Charlotte. *Innenwelt und Aussenwelt: Autobiographie eines Bewußtseins*. Trans. C. Buschmann. Munich: Rogner & Bernhard, 1971. (English original: *On the Way to Myself: Communications to a Friend*. London: Methuen and Co., 1969.)

Wolin, Richard. *Walter Benjamin: An Aesthetic of Redemption*. Berkeley: University of California Press, 1994.

Wyneken, Gustav. *Schule und Jugendkultur*. Jena: Eugen Diedrichs, 1913.

Index

Abulafia, Abraham, 322 n. 78
Adorno, Gretel, 362 n. 42
Adorno, Theodor Wiesengrund, 4, 44, 66, 68, 71, 80, 88, 97, 98, 100, 104, 105, 111, 114, 116, 118, 119, 137, 144, 196–97, 201, 249, 258, 270, 278, 279, 280, 284, 297 n. 23, 302 n. 54, 303 n. 57, 306 n. 83, 308 n. 93, 311 n. 103, 315 n. 27, 315 n. 30, 316 n. 34, 317 n. 42, 318 n. 48, 320 n. 60, 321 n. 73, 322 n. 82, 322 n. 84, 323 n. 86, 323 n. 89, 324 n. 100, 327 n. 110, 327 n. 113, 335 n. 29, 343 n. 100, 349 n. 127, 356 n. 180, 356 n. 182, 356 n. 184, 362 n. 42, 379 n. 179, 379 n. 180, 380 n. 189
Aeschylus, 180, 186, 350 n. 136
Agamben, Giorgio, 26–27, 104, 119, 287, 294 n. 4, 294–95 n. 5, 301 n. 49, 304 n. 61, 313 n. 12, 356 n. 176, 372 n. 125, 382 n. 208
Alexander, Robert L., 335 n. 28
Ameluxen, Hubertus von, 380 n. 183
Anders, Günther, 269, 304 n. 66
Apollo, 223
Aragon, Louis, 200
Arendt, Hannah, 80, 378 n. 164, 378 n. 166
Aristophanes, 162, 167

Aristotle, 60, 94, 130, 176, 185, 347 n. 118, 351 n. 147
Ash, Beth Sharon, 202
Atget, Eugène, 275
Austin, J. L., 318 n. 52

Baader, Franz von, 300 n. 45
Bachmann, Ingeborg, 121
Badiou, Alain, 117, 330 n. 136
Bahti, Timothy, 330 n. 142, 357 n. 188
Balfour, Ian, 323 n. 92
Balzac, Honoré de, 163, 330 n. 139
Bataille, Georges, 55, 56–57, 221, 231, 232, 269, 282, 365 n. 71, 371 n. 120
Bauch, Bruno, 312 n. 6
Baudelaire Charles, 354 n. 160
Becher, Johannes, 367 n. 82
Beckett, Samuel, 249
Beethoven, Ludwig von, 368 n. 88
Béguin, Albert, 68
Benjamin, Andrew, 301 n. 48, 310 n. 103, 322 n. 84
Benjamin (Kellner), Dora, 294 n. 3, 363 n. 52
Benjamin, Walter (letters and many preparatory or small texts by Benjamin, which are cited in the book, are *not* listed below): "Agesilaus Santander," 43–45; "Analogy and

413

Relationship," 149, 338 n. 65; "André Gide: La porte étroite," 178, 253, 255, 256, 350 n. 131; "Announcement of the Journal *Angelus novus*," 91, 93, 94, 95, 175, 197–98, 216, 259, 302 n. 54, 320 n. 68, 349 n. 127, 354 n. 160, 360 n. 38, 362 n. 47; *The Arcades Project*, 106, 275, 304 n. 67, 323 n. 91, 324 n. 94, 324 n. 96, 364 n. 64, 365 n. 68, 369 n. 105, 378 n. 173, 379 n. 179; "The Author as Producer," 272, 272–73, 274–75, 378 n. 168, 379 n. 175; "Baudelaire," 218–19, 220; "Berlin Childhood around 1900," 355 n. 170; "A Berlin Chronicle," 110, 259, 268, 363 n. 52, 373 n. 127, 376 n. 149; "Calderón's *El mayor monstruo, los celos* and Hebbel's *Herodes und Mariamne*," 30, 172, 176, 182, 184, 217, 346 n. 117; "Capitalism as Religion," 169, 345 n. 114; "A Child's View of Colour," 122, 331 n. 2, 331 n. 3; *The Concept of Criticism in Germann Romanticism*, 67, 68, 70, 71, 74–75, 77, 78, 79, 96, 106, 109, 118, 121–22, 138, 145, 150, 151, 152, 154, 158, 159, 160, 162–63, 165, 182, 192, 193–94, 197, 212, 216, 238, 257–58, 265, 313 n. 16, 314 n. 22, 323 n. 85, 325 n. 106, 326 n. 110, 338 n. 62, 339 n. 71, 340 n. 72, 340 n. 73, 340 n. 74, 342 n. 87, 342 n. 93, 343 n. 96, 360 n. 30, 373–74 n. 132, 376 n. 150; "Critique of Violence," 83, 84, 86, 208, 212, 213, 253, 358 n. 19, 362 n. 44; "The Destructive Character," 10, 270; "Dialog über die Religiösität der Gegenwart," 48, 52, 87, 90, 92, 93, 105, 142, 206, 210, 220, 254, 305 n. 73, 321 n. 71; "Diary Entries," 130; "Die Dirne," 298 n. 32; "Das Dornröschen," 261, 374 n. 137, 375 n. 147; "Dream Kitsch," 379 n. 174; "Die drei Religionssucher," 305 n. 73; "Erotische Erziehung. Anlässlich des letzten studentischen Autorenabends in Berlin," 298 n. 32; "Erröten im Zorn und Scham," 331 n. 3; "Experience and Poverty," 272, 277; "Fate and Character" ("Schicksal und Charakter"), 166, 178, 179, 180, 183, 220–21, 232, 232–33, 320 n. 68, 350 n. 134; "Franz Kafka," 226, 270, 356 n. 180, 378 n. 173; "Die Freie Schulgemeinde," 300 n. 43, 319 n. 60; "Gedanken über Gerhart Hauptmanns Festspiel," 235, 238; "A Glimpse into the World of Children's Books," 126, 337 n. 55; "Das Glück des antiken Menschen," 144, 337 n. 52; "Goethe's Elective Affinities," 18, 35, 46, 47, 47–48, 60–61, 99, 100–101, 106, 107, 107–8, 109, 123, 131, 133, 134, 136, 139, 141, 145, 146, 146–47, 147, 149, 150, 151, 152, 153, 155, 156, 157, 158, 159, 160, 161–62, 163–64, 166, 175, 184–85, 186, 189, 190, 191, 193, 194, 208, 209, 210, 211, 215, 216, 219, 220, 221, 222, 223–24, 225, 227, 228, 229, 231, 233, 234, 236, 237, 241, 242–44, 245, 246, 254, 256, 270, 326 n. 107, 326 n. 110, 328 n. 124, 338 n. 60, 338 n. 65, 340 n. 78, 343 n. 99, 352 n. 153, 352 n. 155, 353 n. 157, 353 n. 158, 359 n. 23, 359 n. 28, 360 n. 29, 363 n. 52, 363 n. 54, 363 n. 56, 364 n. 64, 364 n. 65, 365 n. 68, 365 n. 72, 366 n. 81, 367 n. 82, 367 n. 83, 367 n. 86, 368 n. 88, 369 n. 101, 378 n. 161; "Grundlage der Moral," 226; "Hugo von Hofmannsthal, Der Turm. Ein Trauerspiel in fünf Aufzügen," 173, 183, 343 n. 101, 353 n. 156; "*The Idiot* by Dostoevsky," 32, 159, 163, 255, 257–58, 260–61, 266, 268–69, 320 n. 68, 350 n. 131, 372 n. 124, 374 n. 134, 377 n. 152; "Imagination," 122–23, 140, 158, 191, 192, 331 n. 3; "Karl Kraus," 302 n. 54, 307 n. 85,

323 n. 91, 378 n. 173; "Left-Wing Melancholy," 274; "The Life of the Students," 60, 66, 83, 84, 87, 215–16, 218, 251, 252, 256, 261, 298 n. 32, 330 n. 139, 372 n. 124; "Literary History and the Study of Literature," 273; "Little History of Photography," 275, 378 n. 169, 379 n. 180, 380 n. 182; "Lucinde," 144; "Metaphysics of Youth," 32, 33, 34, 36, 56, 105, 252, 260, 268, 270–71; "Molière: Der eingebildete Kranke," 168, 193; "Der Moralunterricht," 48, 51, 55, 78, 189, 212, 305 n. 72; "Moscow," 379 n. 175; *Moscow Diary*, 328 n. 118, 379 n. 175; "Neue Dichtung in Russland," 378 n. 168, 379 n. 175; "Notes for a Study of the Beauty of Colored Illustrations in Children's Books," 145, 192, 337 n. 55; "Notizen über 'Objektive Verlogenheit,'" 102, 210, 218, 290–91, 365 n. 65; "Notizen zu einer Arbeit über die Kategorie der Gerechtigkeit," 178, 179, 349 n. 130; "Notizen zu einer Arbeit über die Lüge II," 207, 218, 291; "Old Forgotten Children's Books," 126, 337 n. 55; "On Language as Such and on the Language of the Human," 11, 18, 21–32, 39–40, 43, 45, 47, 48, 49, 50, 51, 53, 54, 55, 64, 82, 107, 109, 136, 149, 214, 233–34, 238, 294 n. 3, 295 n. 15, 296 n. 16, 297 n. 24, 298 n. 27, 303 n. 60, 306 n. 81, 307 n. 90, 309 n. 97, 310 n. 103, 312 n. 7, 315 n. 26, 329 n. 127, 329 n. 131, 356 n. 175, 363 n. 53; "On the Concept of History," 7, 218, 284, 302 n. 54, 306 n. 82, 317 n. 42, 325 n. 104, 375 n. 140; "On the Image of Proust," 355 n. 170; "On the Present Situation of Russian Film," 274; "On the Programme of the Coming Philosophy," 61, 62, 63, 64, 76, 77, 88, 89–90, 90–91, 92, 92–93, 93, 102, 311 n. 3; "On Semblance,"

69; "On the Situation of Russian Film," 378 n. 169; "On Some Motifs in Baudelaire," 307 n. 85, 378 n. 173, 380 n. 193; *One-Way Street*, 46, 74, 101, 105, 110, 114, 195, 199, 200, 200–201, 267, 271–72, 273, 276, 276–77, 282, 293 n. 7, 295 n. 16, 300 n. 40, 327 n. 111, 378 n. 170, 380 n. 185; *Origin of the German Mourning Play*, 2, 6, 10, 18, 26, 30, 32, 33, 35, 37, 40, 42, 43, 45, 60, 61, 62, 65, 66, 69–70, 72, 73, 74, 75, 76, 77, 78, 79, 80, 81–82, 87, 89, 90, 94, 98, 99, 101, 102, 103, 105, 110–19, 122, 125–33, 135–37, 140, 142, 150, 152, 161, 164–65, 167, 168, 170–74, 175, 176, 177, 179–82, 183–84, 185, 186, 187, 188, 189, 192, 193, 194, 195, 196, 204, 213–14, 215, 217, 218, 219, 222, 223, 224, 225, 226, 228, 229, 229–31, 232, 233–42, 244, 246, 247, 251, 252–53, 258, 261, 272, 298 n. 27, 310 n. 103, 314 n. 20, 315 n. 25, 315 n. 26, 317 n. 41, 323 n. 86, 324 n. 96, 324 n. 99, 325 n. 105, 326 n. 109, 326 n. 110, 328 n. 118, 328 n. 124, 329 n. 127, 329 n. 128, 332 n. 10, 333 n. 12, 333 n. 13, 333 n. 14, 333 n. 15, 334 n. 16, 334 n. 17, 334 n. 19, 335 n. 26, 335 n. 30, 337 n. 48, 339 n. 70, 341 n. 85, 343 n. 101, 344 n. 102, 344 n. 103, 345 n. 116, 346 n. 117, 347 n. 121, 347 n. 122, 347 n. 123, 348 n. 124, 349 n. 127, 349 n. 129, 350 n. 134, 351 n. 145, 351 n. 147, 351 n. 148, 351 n. 149, 351 n. 150, 352 n. 153, 352 n. 154, 354 n. 162, 355 n. 171, 356 n. 177, 356 n. 178, 356 n. 185, 360 n. 33, 361 n. 41, 363 n. 54, 365 n. 74, 366 n. 75, 366 n. 76, 369 n. 91, 376 n. 151, 377 n. 152, 378 n. 170; "Outline of the Psychophysical Problem," 52, 152, 221, 236, 239, 249, 262–63, 366 n. 75, 369 n. 101; "Painting, or Signs and Marks,"

124–25, 158; "Paris, the Capital of the Nineteenth Century," 279, 378 n. 169, 379 n. 179, 380 n. 193; "The Paris of the Second Empire in Baudelaire," 378 n. 161, 378 n. 173, 381 n. 193; "Paul Scheerbart: Lesabéndio," 141; "Philosophy of History of the Late Romantics and the Historical School," 86, 100, 196, 318 n. 54; "The Political Groupings of Russian Writers," 378 n. 168, 379 n. 175; "Psychologie," 87, 319 n. 59; "Reflections on Humboldt," 339 n. 66; "Der Regenbogen. Gespräch über die Phantasie," 331 n. 2; "Der Regenbogen oder die Kunst des Paradieses," 331 n. 2; "Die religiöse Stellung der neuen Jugend," 92, 95; "Reply to Oscar A. H. Schmitz," 274, 378 n. 169; "Review of Béguin's *Ame romantique et le rêve*," 68; "Riddle and Mystery," 50, 54, 197; "The Right to Use Force," 207, 208, 209, 212, 359 n. 19; "The Role of Language in *Trauerspiel* and Tragedy," 23, 30–31, 40, 42, 43, 134, 294 n. 3; "Romantik—die Antwort des 'Ungeweihten,'" 178, 209, 210; "Romantik—eine nicht gehaltene Rede an die Schuljugend," 209, 210, 358 n. 14, 372 n. 124; "Die Schulreform, Eine Kulturbewegung," 56, 310 n. 99; "Shakespeare: Wie es euch gefällt," 193, 355 n. 166, 355 n. 167; "Socrates," 33, 34, 36–39, 166–67, 344 n. 106; "<Sonette>," 139, 213, 233, 242, 255, 298 n. 30, 363 n. 52, 372 n. 124, 372 n. 126; "Stifter," 138, 139, 179, 221, 226–27, 326 n. 37; "The Storyteller," 137, 149–50, 168, 177, 179, 259, 279, 343 n. 96; "Studentische Autorenabende," 264–65, 376 n. 146; "Surrealism," 271, 272, 273, 276, 343 n. 95; "Surrealistische Zeitschriften," 379 n. 174; "The Task of the Translator," 21, 50, 54–55, 56, 57, 92, 95, 97, 191, 222, 227–28, 239, 240, 245, 310 n. 103, 354 n. 159, 354 n. 160; "<Theological-Political Fragment>," 82, 213, 218, 317 n. 42, 358 n. 19; "The Theory of Criticism," 61, 79, 149, 150, 155, 158–59, 160, 190, 191, 215, 234, 238; "Tod," 220, 221, 359 n. 26; "*Trauerspiel* and Tragedy," 130, 134, 183, 184, 239, 245, 294 n. 3, 351 n. 145; "Two Poems by Friedrich Hölderlin," 18, 35, 127–28, 140–46, 151, 152, 154, 159, 167, 168–69, 169, 176, 187, 195, 204, 222, 224, 228, 237, 242, 243, 244–45, 247–48, 249, 252, 258, 260, 261, 265, 267, 336 n. 47, 338 n. 59, 338 n. 62, 345 n. 112, 352 n. 152, 352 n. 153, 356 n. 175, 366 n. 77, 368 n. 87, 369 n. 92, 369 n. 95, 372 n. 124, 374 n. 134, 376 n. 149; "Über das Mittelalter," 168; "Über die Scham," 331 n. 3; "Unterricht und Wertung," 87, 127, 319 n. 57; "What is Epic Theatre? (I)," 273; "What is Epic Theatre? (II)," 102, 351 n. 145; "The Work of Art in the Age of Its Technological Reproducibility," 272, 273, 274, 275, 276, 378 n. 168, 378 n. 169, 379 n. 180, 380 n. 183, 381 n. 192; "World and Time," 83, 207, 208, 218, 240, 245; "Ziele und Wege der studentisch-pädogogischen Gruppen an reichsdeutschen Universitäten [mit besonderer Berücksichtigung der 'Freiburger Richtung']," 252; "Zur Kantischen Ethik," 210, 210–11

Bense, Max, 308 n. 93
Berger, Willy, 354 n. 160
Berman, Antoine, 321 n. 74, 354 n. 159
Bernhard, Thomas, 203
Beuys, Joseph, 280, 381 n. 198
Biale, David, 297 n. 24, 305 n. 75, 375 n. 141
Blanchot, Maurice, 16, 45, 104, 214, 269, 270, 366 n. 80, 368 n. 87

Blass, Ernst, 320 n. 68
Bloch, Ernst, 75, 82–83, 104, 207, 269, 317 n. 44, 318 n. 46, 318 n. 47, 318 n. 48, 349 n. 127
Blumenthal (Belmore), Herbert, 38
Böhlendorff, Casimir Ulrich, 335 n. 34, 338 n. 56
Böhme, Jacob, 300 n. 45, 313 n. 14
Bohrer, Karl Heinz, 373 n. 132
Bolz, Norbert, 277, 278, 378 n. 171, 380 n. 185
Brecht, Bertolt, 269–70, 272, 277, 351 n. 145, 379 n. 178
Bredekamp, Horst, 362 n. 43
Bresemann, Vera, 182
Breton, André, 276
Briegleb, Klaus, 373 n. 132
Britt, Brian, 321 n. 72
Bröcker, Michael, 294 n. 1
Brodersen, Momme, 309 n. 98, 311 n. 106, 351 n. 150, 354 n. 160, 367 n. 83
Buber, Martin, 35, 52, 297 n. 24, 299 n. 35, 305 n. 73, 309 n. 95, 321 n. 69, 349 n. 127, 375 n. 143
Buck-Morss, Susan, 293 n. 5, 320 n. 60
Burckhardt, Jacob, 318 n. 54
Burdach, Konrad, 360 n. 33
Burgard, Peter J., 356 n. 184
Bürger, Peter, 334 n. 17, 348 n. 125, 356 n. 185
Butler, Judith, 318 n. 52

Cadava, Eduardo, 380 n. 183
Cage, John, 156
Calderón de la Barca, Pedro, 129, 172–74, 176, 224, 230, 232, 346–47 n. 117, 347 n. 118, 351 n. 145
Cassirer, Ernst, 293 n. 3, 312 n. 6, 352 n. 154
Cassirer, Paul, 326 n. 107
Cavell, Stanley, 308 n. 93
Caygill, Howard, 166, 293 n. 6, 301 n. 48, 314 n. 21, 331 n. 2, 344 n. 104
Celan, Paul, 203, 321 n. 73
Cervantes Saavedra, Miguel de, 162

Chagall, Marc, 349 n. 127
Chow, Rey, 357 n. 7
El Cid, 130
Cixous, Hélène, 8, 36, 124, 199, 201, 249, 249–50, 262, 372 n. 123
Cohen, Hermann, 125, 311 n. 2, 312 n. 6, 318 n. 50, 323 n. 85, 324 n. 97
Cohn, Alfred, 363 n. 52
Cohn, Jula, 302, 363 n. 52, 367 n. 83
Constellation, 13, 73, 130, 315 n. 27
Cornelius, Hans, 110, 111, 112, 326 n. 110, 327 n. 111, 327 n. 113
Corngold, Stanley, 336 n. 40, 363 n. 56, 366 n. 77, 376 n. 149
Cowan, Bainard, 325 n. 101
Creuzer, Georg Friedrich, 333 n. 13
Critchley, Simon, 345 n. 111
Croc, Benedetto, 355 n. 171
Cuddon, J. A., 347 n. 117
Culler, Jonathan, 281

Dan, Joseph, 316 n. 35
Daphne, 223
Deleuze, Gilles, 5, 8, 59, 288, 319 n. 58, 325 n. 103, 330 n. 138, 348 n. 126, 370 n. 119
Derrida, Jacques, 5, 47, 51, 81, 84, 91, 104, 113, 119, 280, 281–82, 294 n. 4, 295 n. 11, 296 n. 21, 301 n. 47, 308 n. 92, 311 n. 103, 317 n. 40, 318 n. 49, 318 n. 51, 339 n. 67, 339 n. 69, 356 n. 179, 357 n. 188, 358 n. 12, 364 n. 61, 365 n. 71, 374 n. 138, 375 n. 140, 382 n. 204
Descartes, René, 2, 246, 272, 277
Deuber-Mankowsky, Astrid, 311 n. 2, 312 n. 6, 320 n. 66
Dilthey, Wilhelm, 258, 373 n. 130
Dionysus, 139, 181, 216, 223
Döblin, Alfred, 380 n. 182
Dostoevsky, Fyodor, 32, 163, 178, 212, 250, 255, 257–58, 286, 342 n. 95, 343 n. 96, 350 n. 131, 362 n. 48, 372 n. 124, 373 n. 128
Droysen, Johann Gustav, 318 n. 54

Dürer, Albrecht, 171–72, 174, 177, 345 n. 115, 347 n. 122
Düttman, Alexander García, 295 n. 6, 316 n. 36, 317 n. 40, 335 n. 24, 369 n. 98, 369 n. 98, 381 n. 191, 381 n. 192

Ebach, Jürgen, 301 n. 49
Eichmann, A. K., 46–47
Eidam, Heinz, 318 n. 48
Einstein, Albert, 272, 277
Engelhardt, Hartmut, 379 n. 176
Engels, Friedrich, 306 n. 82
Euripides, 344 n. 101
Expressionism, 176, 185–86, 349 n. 127, 351 n. 148

Fackenheim, Emil, 311 n. 105
Fassbinder, Rainer Werner, 251
Felman, Shoshana, 310 n. 102
Fenves, Peter, 25, 296 n. 19, 303 n. 60, 312 n. 6, 313 n. 10, 315 n. 30, 320 n. 60, 332 n. 3, 345 n. 116, 350 n. 136, 361 n. 40
Ferris, David S., 325 n. 102, 338 n. 65
Fichte, Johann Gottlieb, 12, 70–71, 193, 314 n. 19, 314 n. 21, 314 n. 22
Ficino, Marsilio, 347 n. 122
Fiesel, Eva, 299 n. 34
Figal, Günther, 318 n. 50, 362 n. 45
Finkielkraut, Alain, 372 n. 122
Folkers, Horst, 318 n. 50
Foucault, Michel, 5, 302 n. 53, 303 n. 58, 359 n. 23
Frank, Joseph, 373 n. 128
Frank, Manfred, 355 n. 165
Freud, Sigmund, 288, 297 n. 23
Freund, Gisèle, 379 n. 179
Frey, Hans-Jost, 111
Friedländer, Salomo, 335 n. 32
Frye, Northrop, 336 n. 42
Fuld, Werner, 301 n. 49, 309 n. 98, 327 n. 110, 327 n. 111, 363 n. 52
Fürnkas, Josef, 323 n. 92
Fynsk, Christopher, 311 n. 103

Gadamer, Hans-Georg, 352 n. 154
Gagnebin, Jeanne-Marie, 320 n. 64
Garber, Klaus, 328 n. 124, 333 n. 14, 348 n. 125, 351 n. 150
Gasché, Rodolphe, 49, 248, 313 n. 16, 325 n. 106, 361 n. 38, 381 n. 191, 382 n. 204
Gay, Peter, 303 n. 58
Geheebs, Paul, 300 n. 43
Gehlen, Arnold, 297 n. 23, 302 n. 55
Geiger, Moritz, 316 n. 30
George, Stefan, 322 n. 82, 335 n. 34, 341 n. 84, 343 n. 99, 354 n. 160, 368 n. 88, 373 n. 127
Geulen, Eva, 300 n. 39, 357 n. 7
Geyer-Ryan, Helga, 334 n. 18, 360 n. 35
Gide, André, 178, 253, 255, 256, 343 n. 96, 350 n. 131, 364 n. 63
Giehlow, Karl, 335 n. 26
Giraudoux, Jean, 200
Glogauer, Walter, 113
Gödde, Christoph, 309 n. 98, 329 n. 126
Goethe, Johann Wolfgang von, 35, 86, 98–99, 100–101, 104, 105, 106, 118, 125, 127, 138, 146, 151, 153, 154, 158, 159, 160, 161–62, 164, 165, 166, 184–85, 190, 211, 212, 214, 222, 225, 228, 231, 241, 242, 275, 299 n. 33, 304 n. 64, 305 n. 69, 305 n. 74, 321 n. 74, 323 n. 85, 323 n. 87, 324 n. 96, 324 n. 99, 330 n. 139, 340 n. 72, 341 n. 76, 341 n. 81, 341 n. 83, 341 n. 84, 342 n. 90, 343 n. 96, 343 n. 98, 351 n. 145, 352 n. 154, 359 n. 28, 360 n. 35, 364 n. 59, 366 n. 78, 367–68 n. 86, 373 n. 130, 374 n. 137, 376 n. 150, 378 n. 161, 380 n. 181
Görres, Johann Joseph von, 333 n. 13
Grabbe, Christian, 351 n. 145
Graff, Gerald, 376 n. 149
Grillparzer, Franz, 35, 299 n. 33, 346 n. 117
Grimm, Jacob and Wilhelm, 332 n. 3
Groddeck, Wolfram, 345 n. 112

Gründgrens, Gustaf, 253
Gryphius, Andreas, 351 n. 145
Guattari, Felix, 5, 8, 59, 288, 319 n. 58, 325 n. 103, 330 n. 138, 348 n. 126, 370 n. 119
Gumpert, Martin, 300 n. 43, 319 n. 56
Gundolf, Friedrich, 211, 223, 341 n. 84, 343 n. 99, 359 n. 27, 363 n. 52
Güntert, Hermann, 315 n. 26
Günther, Henning, 318 n. 48, 348 n. 125

Haas, Willy, 349 n. 127
Habermas, Jürgen, 17, 254–55, 281–82, 296 n. 20, 381 n. 201
Hamacher, Werner, 306 n. 83, 321 n. 70, 354 n. 163, 364 n. 57
Hamann, Johann Georg, 63, 76, 214, 360 n. 36
Handelman, Susan A., 296 n. 21, 311 n. 105, 322 n. 78, 381 n. 201
Handke, Peter, 148, 169
Hanssen, Beatrice, 339 n. 70, 352 n. 153, 379 n. 176, 379 n. 180
Hartung, Günther, 342 n. 88
Haverkamp, Anselm, 137
Hebel, Johann Peter, 355 n. 174
Hegel, Georg Wilhelm Friedrich, 2, 7, 13, 72, 75, 76, 81, 88, 119, 175, 200, 203, 282, 305 n. 73, 315 n. 25, 316 n. 32, 319 n. 60, 324 n. 97, 350 n. 134, 350 n. 140, 352 n. 154, 353 n. 158, 359 n. 25, 373 n. 132
Heidegger, Martin, 13, 43, 80, 98, 151, 244, 301 n. 47, 301 n. 48, 307 n. 86, 313 n. 8, 316 n. 36, 322 n. 84, 323 n. 93, 339 n. 67, 349 n. 127, 358 n. 12, 364 n. 61, 367 n. 82
Heil, Susanne, 300 n. 44, 359 n. 20, 362 n. 47
Heinle, Friedrich C., 298 n. 30, 349 n. 127, 372 n. 124, 373 n. 127
Helfer, Martha B., 314 n. 19, 345 n. 109
Hellingrath, Norbert von, 137, 140–41, 151, 311 n. 104, 336 n. 35, 336 n. 44, 337 n. 47, 337 n. 51, 339 n. 69, 362 n. 51
Herbertz, Richard, 340 n. 73
Herder, Johann Gottfried, 145, 335 n. 26, 338 n. 58
Herzl, Theodor, 327
Hessel, Franz, 354
Heym, Georg, 1, 349 n. 127
Hildebrandt, Kurt, 350 n. 138
Hillach, Ansgar, 352 n. 150
Hirsch, Alfred, 306 n. 81, 309 n. 97, 321 n. 74, 352 n. 154
Hitler, Adolf, 203
Hofmannsthal, Hugo von, 79, 163, 173, 183, 316 n. 34, 326 n. 107, 339 n. 66, 344 n. 101, 344 n. 102, 348 n. 123, 376 n. 151
Hölderlin, Friedrich, 21, 57, 124, 137, 140–43, 145, 146, 148, 160, 168, 180, 187, 199, 203, 221, 233, 247, 267, 311 n. 104, 321 n. 74, 335 n. 34, 336 n. 35, 336 n. 47, 337 n. 49, 337 n. 51, 338 n. 56, 338 n. 57, 338 n. 59, 338 n. 60, 338 n. 61, 338 n. 62, 352 n. 152, 354 n. 160, 357 n. 1, 362 n. 51, 364 n. 64, 366 n. 77, 369 n. 92, 369 n. 95, 372 n. 124, 373 n. 127, 373 n. 130, 374 n. 134
Hollier, Denis, 362 n. 50
Holz, Hans Heinz, 29, 82–83, 302 n. 50, 318 n. 46, 325 n. 101, 349 n. 127
Hönigswald, Richard, 312 n. 6
Honneth, Axel, 369 n. 99, 369 n. 100
Horch, Hans Otto, 305 n. 73
Horkheimer, Max, 104, 111, 249, 284, 306 n. 83, 326 n. 110, 327 n. 113, 370 n. 105, 378 n. 173
Horst, Carl, 125
Hroswitha of Gandersheim, 351 n. 145, 355 n. 168
Hübscher, Arthur, 334 n. 19
Humboldt, Wilhelm von, 151–52, 330 n. 139, 339 n. 66, 339 n. 67
Husserl, Edmond, 75, 296 n. 19, 307 n. 86, 315 n. 30, 320 n. 60

Ibsen, Henrik, 374 n. 137
Idel, Mosche, 322 n. 78
Ingold, Felix Philipp, 337 n. 53

Jabès, Edmond, 7
Jacobi, Friedrich Heinrich, 360 n. 36
Jacobs, Carol, 296 n. 21, 300 n. 39, 310 n. 103
Jacobson, Eric, 296 n. 18, 297 n. 22, 306 n. 81, 307 n. 91, 308 n. 94, 309 n. 97, 318 n. 51, 345 n. 109, 363 n. 56, 368 n. 87
Jäger, Lorenz, 351 n. 146, 369 n. 94
Jameson, Fredric, 4
Jay, Martin, 309 n. 95, 343 n. 96
Jennings, Michael W., 305 n. 73, 308 n. 93, 313 n. 15, 317 n. 42, 335 n. 26, 341 n. 82, 376 n. 150
Jianou, Ionel, 155
Job, 139
Joyce, James, 7–9, 23, 26, 28, 32–39, 41, 42, 43, 46, 47, 49, 52, 63–64, 67, 72–73, 83, 85, 86, 91, 93, 94, 97, 100, 103, 103–4, 108, 111, 117, 128, 129, 134, 135, 139, 140, 142, 143, 143–44, 144, 145, 146, 147, 154, 168, 171, 172, 178, 180, 184, 185, 187, 187–88, 200, 201, 202, 202–203, 203, 205, 206, 207, 209, 214, 219, 233, 237, 241, 243, 244, 245, 246, 247, 248, 250, 253, 254, 256–57, 260, 261, 263, 265, 266–67, 268, 270, 277, 278, 279, 280, 283, 284, 285–86, 287–89, 290, 291, 295 n. 16, 299 n. 34, 304 n. 63, 305 n. 71, 360 n. 38, 368 n. 89, 374 n. 138
Jünger, Ernst, 277, 317 n. 40
Jupiter, 145, 174

Kafka, Franz, 1, 9, 45, 226, 231, 270, 271, 288, 321 n. 73, 332 n. 7, 378 n. 163
Kahl, Michael, 357 n. 188
Kaiser, Gerhard, 113

Kambas, Chryssoula, 333 n. 12, 340 n. 71, 351 n. 143, 361 n. 41
Kandinsky, Wassily, 330 n. 139, 349 n. 127
Kant, Immanuel, 5, 10, 13, 26, 61, 62, 65, 67, 72, 75, 76, 77, 83, 86, 88, 90, 91, 95–96, 96, 105, 111, 121, 142, 153, 155, 182, 209, 210, 228, 311 n. 2, 312 n. 6, 314 n. 19, 315 n. 30, 318 n. 50, 319 n. 60, 320 n. 66, 324 n. 93, 324 n. 98, 325 n. 102, 327 n. 110, 332 n. 3, 336 n. 41, 340 n. 73, 341 n. 78, 351 n. 142, 359 n. 21, 359 n. 25, 361 n. 41, 375 n. 140, 375 n. 140
Kästner, Erich, 274
Kautzsch, Rudolf, 326 n. 110, 327 n. 111
Kellner, Leon, 327
Kiedaisch, Petra, 303 n. 57
Kierkegaard, Søren, 2, 18, 104, 219, 362 n. 48, 367 n. 86
Klages, Ludwig, 365 n. 75
Klee, Paul, 44, 272, 277, 302 n. 54, 302 n. 55, 303 n. 58, 349 n. 127
Kleiner, Barbara, 354 n. 160
Kleist, Heinrich von, 105, 314 n. 19, 366 n. 80
Klopstock, Friedrich Gottlieb, 157
Klossowski, Pierre, 378 n. 168
Kluge, Alexander, 203, 205, 269
Kluge, Friedrich, 315 n. 28, 369 n. 101
Koepnick, Lutz, 345 n. 109
Konersman, Ralf, 323 n. 92
König, Helmut, 304 n. 65
Kopelew, Lew, 357 n. 2
Koselleck, Reinhart, 205, 358 n. 17
Kracauer, Siegfried, 4, 111, 327 n. 112
Kraft, Werner, 269, 312 n. 7, 326 n. 110
Kraus, Karl, 307 n. 85, 323 n. 91, 362 n. 47
Kristeva, Julia, 36, 247, 297 n. 22
Kuhlman, Wolfgang, 304 n. 65
Kurella, Alfred, 367 n. 82

Lacan, Jacques, 5
Lacis, Asja, 328 n. 118, 349 n. 127

Lacoue-Labarthe, Philippe, 5, 163, 282, 325 n. 101, 330 n. 136, 335 n. 29, 342 n. 94, 359 n. 25
Landauer, Gustav, 207, 299 n. 35
Lange, I. M., 328 n. 116
Laqueur, Walter Z., 300 n. 43, 319 n. 56, 358 n. 14
Lask, Emil, 312 n. 6
Lautréamont, Comte de, 343 n. 95
Le Corbusier, 277
Leibniz, Gottfried Wilhelm, 65, 81, 313 n. 10, 320 n. 60, 348 n. 124
Lenhardt, Christian, 249
Lenz, Jakob, 351 n. 145
Lepenies, Wolf, 297 n. 23
Lessing, Gotthold Ephraim, 373 n. 130
Levi, Primo, 8
Lévinas, Emmanuel, 66, 234, 260, 311 n. 5, 321 n. 73, 321 n. 74, 353 n. 157, 364 n. 58, 370 n. 119
Lewy, Ernst, 66
Lindner, Burkhardt, 112, 327 n. 111, 351 n. 150, 365 n. 72, 381 n. 193
Linke, Paul, 313 n. 13
Livingstone, Rodney, 332 n. 4
Lohenstein, Daniel Casper von, 369 n. 91
Lonitz, Henri, 309 n. 98, 329 n. 126
Loos, Adolf, 272, 277
Löwy, Michael, 342 n. 95
Lukács, Georg, 197, 240, 334 n. 17, 342 n. 95, 343 n. 96, 349 n. 127, 357 n. 186, 359 n. 20, 375 n. 140, 377 n. 151
Lunn, Eugene, 249
Luther, Martin, 298 n. 27, 373 n. 130
Lyotard, Jean-François, 5, 45

Magritte, René, 303 n. 58
Makropoulos, Michael, 362 n. 43
Mallarmé, Stéphane, 268, 339 n. 66
Man, Paul de, 44, 198, 296 n. 21, 333 n. 15, 334 n. 18, 336 n. 43, 352 n. 154, 357 n. 187, 357 n. 188
Mann, Klaus, 253
Mann, Thomas, 254, 356 n. 185, 371 n. 121

Mannheim, Karl, 380 n. 183
Marcuse, Herbert, 343 n. 100
Marées, Hans von, 122
Marx, Karl, 2, 7, 250, 272
Mayer, Hans, 365 n. 70
McCall, Tom, 361 n. 39, 369 n. 94
McCole, John, 322 n. 80, 366 n. 75
McLuhan, Marshall, 272, 277
Mehlman, Jeffrey, 306 n. 83
Melanchthon, Philipp, 347 n. 122
Menke, Bettine, 276, 311 n. 103, 323 n. 92
Menke, Christoph, 119
Menninghaus, Winfried, 109, 162, 306 n. 79, 307 n. 90, 308 n. 93, 325 n. 106, 329 n. 131, 342 n. 92, 345 n. 112, 347 n. 119, 351 n. 146, 357 n. 185, 357 n. 188, 366 n. 79, 373 n. 132
Miller, J. Hillis, 296 n. 21
Mitscherlisch, Alexander and Margarete, 370 n. 111
Molière, 168, 355 n. 168
Molitor, Franz Joseph, 301 n. 45
Mosès, Stephane, 309 n. 95, 314 n. 20, 316 n. 35, 320 n. 65, 344 n. 105, 358 n. 18, 364 n. 64, 373 n. 129
Mozart, Wolfgang Amadeus, 211
Müller Farguell, Roger W., 354 n. 160
Müller, Heiner, 16, 26–27, 44, 203, 205, 250, 251, 264, 269, 303 n. 57, 361 n. 39, 362 n. 49, 370 n. 107, 374 n. 133, 382 n. 206

Naeher, Jürgen, 333 n. 13
Nägele, Rainer, 144, 176, 248, 337 n. 50, 354 n. 160, 361 n. 38, 363 n. 54
Nancy, Jean-Luc, 5, 55, 64–66, 163, 269, 306 n. 79, 309 n. 96, 313 n. 8, 313 n. 11, 342 n. 94, 352 n. 152, 376 n. 149
Natorp, Paul, 312 n. 6
neo-Kantianism, 61, 62, 75, 76, 105, 111, 121, 125, 229, 312 n. 6, 315 n. 30, 320 n. 60, 340 n. 73, 375 n. 140
Nettesheim, Heinrich von, 347 n. 122
Nietzsche, Friedrich, 2, 3, 15, 18, 60, 77, 104, 166–67, 179–80, 181, 254,

282, 321 n. 71, 350 n. 135, 350 n. 136, 350 n. 138, 358 n. 14, 364 n. 64, 365 n. 73
Niewöhner, Friedrich, 350 n. 130
Noeggerath, Felix, 320 n. 66, 337 n. 51
Novalis (Friedrich von Hardenberg), 10, 67, 159, 314 n. 19, 314 n. 22, 330 n. 141, 333 n. 13, 340 n. 73, 341 n. 85, 353 n. 158

Olenhusen, Irmtraud and Alfred Götz von, 300 n. 43, 373 n. 127
Ollig, Hans-Ludwig, 312 n. 6
Opitz, Martin, 344 n. 101
Osborne, Peter, 379 n. 176

Panofsky, Erwin, 347 n. 123
Paracelsus, Theophrastus, 32, 33
Péguy, Charles, 210, 222
Pensky, Max, 366 n. 76, 375 n. 148
Perret, Catherine, 323 n. 92
Phelan, Anthony, 325 n. 106
Pindar, 311 n. 104
Pizer, John, 296 n. 21, 324 n. 94, 335 n. 26, 373 n. 132, 377 n. 152
Plato, 2, 3, 60, 62, 66, 67, 72, 74, 76, 81, 90, 94, 99, 109, 115, 116, 121, 160, 167–68, 265, 282, 311 n. 5, 312 n. 6, 315 n. 26, 315 n. 26, 329 n. 128, 337 n. 55, 345 n. 109, 348 n. 125
Plautus, 355 n. 168
Pross, Harry, 319 n. 56, 358 n. 14
Proust, Marcel, 9, 354 n. 160
Puttnies, Hans, 379 n. 176

Quilligan, Maureen, 336 n. 42

Rabinbach, Anson, 82
Radnóti, Sándor, 341 n. 78, 378 n. 167
Radt, Fritz, 71
Rang, Florens Christian, 6, 216–17, 326 n. 107, 329 n. 132, 345 n. 115, 350 n. 141
Ranke, Leopold von, 318 n. 54
Rauner, Friedrich von, 350 n. 140

Rauschenberg, Robert, 280
Readings, Bill, 293 n. 10
Reijen, Willem van, 26, 301 n. 48, 332 n. 12
Richter, Gerhard, 294 n. 4
Richter, Jean Paul, 192, 330 n. 139, 354 n. 162, 355 n. 167
Rickert, Heinrich, 299 n. 36, 307 n. 86, 312 n. 6, 327 n. 113
Ricoeur, Paul, 316 n. 39, 372 n. 122
Riegl, Alois, 217, 324 n. 20, 344 n. 101
Riehl, Alois, 312 n. 6
Rimbaud, Arthur, 343 n. 95
Ritter, Johann Wilhelm, 300 n. 45, 333 n. 14, 333 n. 15, 335 n. 30
Roberts, Julian, 301 n. 49, 348 n. 124, 367 n. 84
Rochlitz, Rainer, 31, 168, 308 n. 93, 314 n. 22, 320 n. 60, 329 n. 133, 336 n. 45, 343 n. 96, 349 n. 129, 352 n. 154, 370 n. 110
Rodin, Auguste, 155
Romanticism, early German, 2, 10, 12–13, 60, 67, 68, 70–71, 78–79, 86, 96, 97, 104, 109, 118, 121–22, 128, 150, 154, 160, 161, 162, 163, 173, 177, 182, 188, 191, 192, 193, 194, 195, 197, 216, 238, 257–58, 268, 299 n. 34, 313 n. 15, 313 n. 16, 314 n. 18, 314 n. 21, 314 n. 22, 319 n. 55, 321 n. 74, 325 n. 102, 333 n. 15, 340 n. 73, 340 n. 74, 346 n. 117, 354 n. 159, 355 n. 167, 360 n. 30, 373 n. 132, 374 n. 135, 376 n. 150. *See also* Novalis (Friedrich von Hardenberg); Schlegel, Friedrich von
Ronell, Avital, 305 n. 70, 315 n. 23, 382 n. 213
Rorty, Richard, 281
Rosenzweig, Franz, 66, 75, 104, 166, 183, 290, 309 n. 95, 311 n. 105, 344 n. 105, 353 n. 158, 360 n. 35, 375 n. 140
Roth, Joseph, 45
Rothacker, Erich, 326 n. 107, 327 n. 111

Index

Rotten, Elisabeth, 323 n. 85
Rousseau, Jean-Jacques, 366 n. 75
Rrenban, Monad, 7
Rüffer, Ulrich, 342 n. 89
Ruin, Hans, 326 n. 108
Rumpf, Michael, 328 n. 116, 367 n. 84, 377 n. 151
Rush, Fred, 360 n. 37
Rychner, Max, 323 n. 86, 365 n. 68

Sachs, Franz, 300 n. 43, 376 n. 145
Sahl, Hans, 313 n. 12
Salomon, Gottfried, 326 n. 110, 327 n. 111, 361 n. 41
Sander, August, 275, 380 n. 182
Sappho, 32, 33, 34
Sartre, Jean-Paul, 362 n. 48
Saturn, 174
Saussure, Ferdinand de, 296 n. 21
Saxl, Fritz, 347 n. 123
Scheerbart, Paul, 141, 272, 277, 334 n. 23, 359 n. 19
Scheler, Max, 181
Schelling, Friedrich Wilhelm, 352 n. 154
Schestag, Thomas, 304 n. 67
Schiller, Friedrich von, 127, 137, 165, 166, 296 n. 19, 337 n. 48, 337 n. 52, 346 n. 117, 360 n. 35, 374 n. 137
Schings, Hans-Jürgen, 116–17, 197, 356 n. 185
Schlaffer, Heinz, 355 n. 174, 357 n. 185
Schlegel, August Wilhelm von, 340 n. 73
Schlegel, Friedrich von, 12, 59, 67, 68, 69, 75, 77, 78, 79, 118, 144, 153, 154, 160, 162, 163, 192, 193, 258, 313 n. 17, 314 n. 22, 316 n. 33, 325 n. 106, 333 n. 15, 340 n. 73, 340 n. 74, 341 n. 75, 342 n. 93, 351 n. 145, 355 n. 165, 373 n. 131, 373 n. 132, 376 n. 150
Schleiermacher, Friedrich Daniel Ernst, 67, 87
Schlossman, Beryl, 354 n. 160

Schmid-Bortenschlager, Sigrid, 293 n. 10
Schmidt, Burghardt, 318 n. 48
Schmidt, Jochen, 338 n. 58, 338 n. 60
Schmitt, Carl, 16, 212, 217, 218, 241, 300 n. 44, 345 n. 116, 359 n. 20, 361 n. 41, 361 n. 42, 362 n. 43, 362 n. 44, 362 n. 45, 362 n. 47
Schnädelbach, Herbert, 318 n. 54, 324 n. 97
Schneider, Hans-Ernst (Hans Schwerte), 46
Schobinger, Jean-Pierre, 301 n. 45, 308 n. 92
Schödelbauer, Ulrich, 376 n. 150
Schoen, Ernst, 82, 299 n. 34, 316 n. 32, 336 n. 37, 363 n. 52
Scholem, Gershom, 4, 26, 43–44, 48, 50, 74, 82, 89, 97, 98, 133, 253, 262, 263, 264, 271, 280, 288, 293 n. 3, 295 n. 13, 297 n. 24, 298 n. 35, 301 n. 49, 302 n. 51, 302 n. 52, 302 n. 54, 304 n. 61, 305 n. 75, 306 n. 76, 307 n. 90, 309 n. 95, 312 n. 7, 316 n. 32, 316 n. 35, 317 n. 42, 317 n. 43, 320 n. 65, 321 n. 69, 321 n. 77, 322 n. 78, 323 n. 86, 327 n. 111, 332 n. 7, 336 n. 38, 339 n. 66, 340 n. 80, 344 n. 106, 349 n. 127, 349 n. 130, 356 n. 175, 358 n. 18, 358 n. 19, 362 n. 47, 365 n. 68, 367 n. 83, 370 n. 118, 372 n. 124, 373 n. 129, 374 n. 135, 375 n. 140, 375 n. 141, 375 n. 143, 381 n. 193
Schopenhauer, Arthur, 125, 332 n. 11, 356 n. 185
Schöttker, Detlev, 325 n. 101, 377 n. 153
Schultz, Franz, 326 n. 110, 327 n. 111
Schwabe, Klaus, 304 n. 65
Schweppenhäuser, Hermann, 316 n. 34, 345 n. 114, 350 n. 130
Scotus, Duns, 307 n. 86
Seel, Martin, 301 n. 48
Seligson, Carla, 265–66

Seligson, Rika, 372 n. 124, 373 n. 127
Selz, Jean, 302 n. 50
Seyhan, Azade, 315 n. 22
Shakespeare, William, 166, 172–74, 176, 189, 192, 193, 231, 232, 240, 252–54, 261, 305 n. 71, 345 n. 115, 345 n. 116, 346 n. 117, 351 n. 145, 353 n. 156, 355 n. 167, 370 n. 114, 374 n. 137, 374 n. 138
Shedletzky, Itta, 305 n. 73
Silk, M. S., 350 n. 138
Simmel, Georg, 324 n. 96
Sloterdijk, Peter, 277, 280, 380 n. 188
Sluga, Hans, 338 n. 64
Smith, Gary, 306 n. 83, 345 n. 106, 375 n. 141, 379 n. 176
Socrates, 2, 3, 36, 37, 60, 105, 121, 166–67, 168, 239–40, 242, 265, 345 n. 109, 365 n. 73
Solger, Karl Wilhelm Friedrich, 350 n. 140
Sophocles, 57, 137, 180, 223, 346 n. 117, 350 n. 140
Sorel, Georges, 362 n. 44
Sparks, Simon, 352 n. 151
Speth, Rudolf, 117, 301 n. 45, 315 n. 24, 330 n. 135, 355 n. 172, 355 n. 173, 363 n. 55, 367 n. 86
Der Spiegel, 200
Spinoza, Benedict de, 56, 60, 310 n. 100
Spitteler, Carl, 359 n. 22
Steinberg, Michael, 335 n. 31
Steiner, Uwe, 172, 334 n. 17, 338 n. 60, 340 n. 71, 345 n. 114, 347 n. 120, 353 n. 158, 356 n. 185, 370 n. 116
Stern, J. P., 350 n. 138
Stiegler, Bernd, 304 n. 61, 317 n. 40, 374 n. 136
Stifter, Adalbert, 178–79, 221, 240, 336 n. 37
Stöckhausen, Karlheinz, 156, 341 n. 79
Strauss, Leo, 305 n. 73
Strauß, Ludwig, 207, 305 n. 73
Strich, Fritz, 356 n. 177

Strindberg, Johan August, 321 n. 71, 351 n. 145
surrealism, 200, 271, 343 n. 95
Szondi, Peter, 335 n. 34

Terence, 355 n. 168
Teskey, Gordon, 336 n. 43
Thomas Aquinas, 347 n. 118
Tieck, Ludwig, 192, 346 n. 117, 350 n. 140
Tiedemann, Philip, 345 n. 113
Tiedemann, Rolf, 88, 301 n. 48, 307 n. 86, 309 n. 98, 316 n. 39, 318 n. 48, 319 n. 60, 322 n. 84, 329 n. 126
Tucholsky, Kurt, 200
Turk, Horst, 362 n. 45

Ulmer, Gregory L., 381 n. 198
Unger, Erich, 207

Vaihinger, Hans, 229
Vischer, Friedrich Theodor, 352 n. 154
Vogl, Joseph, 303 n. 61, 359 n. 24
Voigts, Manfred, 323 n. 92
Volkelt, Johannes, 181, 350 n. 139
Vries, Hent de, 96, 313 n. 18, 314 n. 20, 317 n. 40, 321 n. 73, 367 n. 82, 370 n. 119

Waiblinger, Wilhelm, 357 n. 1
Warburg, Aby, 347 n. 123
Warhol, Andy, 379 n. 176
Weber, Max, 252, 370 n. 117
Weber, Samuel, 297 n. 23, 307 n. 86, 325 n. 101, 345 n. 108, 362 n. 45, 365 n. 69
Weidmann, Heiner, 354 n. 160
Weigl, Sigrid, 34, 298 n. 32, 300 n. 39, 300 n. 42, 343 n. 99, 359 n. 23
Weißbach, Richard, 320 n. 68, 354 n. 160
Wellbery, David E., 332 n. 8
Wellmer, Albrecht, 112–13
Werckmeister, O. K., 112, 302 n. 55, 328 n. 119
Werfel, Franz, 344 n. 102, 362 n. 47

Werner, Zacharias, 346 n. 117
Wiesenthal, Liselotte, 308 n. 93, 324 n. 96
Wiggerhaus, Rolf, 327 n. 113
Wilamowitz-Moellendorff, Ulrich von, 180–81, 350 n. 138
Wilhelm II, 44
Windelband, Wilhelm, 312 n. 6
Winkelmann, Johann Joachim, 137
Witte, Bernd, 46, 182, 244, 302 n. 55, 307 n. 90, 319 n. 56, 355 n. 169, 356 n. 185, 366 n. 76, 367 n. 83, 372 n. 124, 374 n. 135, 376 n. 148, 376 n. 151, 378 n. 173
Wittgenstein, Ludwig, 113, 308 n. 93, 328 n. 123
Wizisla, Erdmut, 319 n. 56

Wohlfarth, Irving, 296 n. 21, 322 n. 80, 328 n. 120, 377 n. 152
Wolf, Christa, 8, 234
Wolff, Charlotte, 354 n. 160, 363 n. 52, 367 n. 83
Wolin, Richard, 83, 244–45, 293 n. 5, 318 n. 47, 329 n. 128, 356 n. 185, 363 n. 56, 366 n. 75, 372 n. 124
Wundt, Max, 350 n. 136
Wyneken, Gustav, 204, 256, 300 n. 42, 300 n. 43, 305 n. 72, 305 n. 73, 309 n. 98, 319 n. 56, 319 n. 60, 358 n. 13, 358 n. 14, 373 n. 127

Zunz, Leopold, 298 n. 28, 309 n. 95
Zurlinden, Luise, 299 n. 34